The American Century

THE
AMERICAN CENTURY

ART & CULTURE
1900–1950

Barbara Haskell

Whitney Museum of American Art, New York

in association with

W. W. Norton & Company New York London

**The American Century
Art & Culture 1900–2000**

Organized by the
Whitney Museum
of American Art
Presented by
Intel Corporation

Additional support for this exhibition
is provided by
the National Endowment for the Arts,
the National Committee of the
Whitney Museum,
Booth Ferris Foundation, and
The Lauder Foundation.
Educational and Public Programs in
conjunction with *The American Century*
are funded by a generous grant from
The Brown Foundation, Inc., Houston.

This publication is made possible by a gift
from Susan and Edwin Malloy.

Research for Museum publications is
supported by an endowment established
by The Andrew W. Mellon Foundation
and other generous donors.

709.73
HAS

7/99

This book was published on the occasion of the exhibition
The American Century: Art & Culture 1900–2000
at the Whitney Museum of American Art.
Part I, 1900–1950
is on view from April 23 to August 22, 1999, and
Part II, 1950–2000
is on view from September 26, 1999 to January 23, 2000.

A complete list of works in the exhibition is available at www.whitney.org.

Library of Congress Cataloging-in-Publication Data
Haskell, Barbara.
 The American century : art & culture, 1900-1950 / Barbara Haskell.
 p. cm.
 Includes bibliographical references and index.
 ISBN 0-393-04723-7
 1. Art, American—Exhibitions. 2. Art, Modern—20th century—United States—
Exhibitions. 3. Arts, American—Exhibitions. 4. Arts, Modern—20th century—United
States—Exhibitions.
I. Whitney Museum of American Art. II. Title.
N6512.H355 1999
709'.73'0747471—dc21 98-32116
 CIP

ISBN 0-393-04723-7 (Norton cloth)
ISBN 0-87427-122-3 (Whitney paper)

©1999 Whitney Museum of American Art
945 Madison Avenue, New York, NY 10021
www.whitney.org

W. W. Norton & Company, Inc.
500 Fifth Avenue, New York, NY 10110
www.wwnorton.com

W. W. Norton & Company Ltd.
10 Coptic Street, London WC1A 1PU

1 2 3 4 5 6 7 8 9 0

Cover: **Jasper Johns,** *Three Flags,* 1958. Encaustic on canvas, 30 7/8 x 45 1/2 x 5 in. (78.4 x 115.6 x 12.7 cm).
Whitney Museum of American Art, New York; 50th Anniversary Gift of the Gilman Foundation, Inc., The Lauder
Foundation, A. Alfred Taubman, an anonymous donor, and purchase 80.32 ©Jasper Johns/Licensed by VAGA, NY

Frontispiece: **Georgia O'Keeffe,** *Black and White,* 1930 (fig. 411).

Back cover (clockwise from top left): **Elie Nadelman,** *Tango,* c. 1919 (fig. 181); **Tiffany Studios,** *Sunset and Landscape
Window,* c. 1900 (fig. 45); **Dorothea Lange,** *Migrant Mother, Nipomo, California,* 1936 (fig. 481); **Edward Hopper,**
Chop Suey, 1929 (fig. 340); **Hugh Ferriss,** *Philosophy,* 1928 (fig. 278); **Miguel Covarrubias,** cover of *The Weary Blues,*
by Langston Hughes, 1926 (fig. 367)

Statement of Collaboration

Intel Corporation is honored to collaborate with the Whitney Museum of American Art in presenting *The American Century: Art & Culture 1900–2000*, a sweeping exhibition that explores the forces of immigration and technology in the context of America's social and cultural landscape during the past one hundred years. Within this landscape, it is the spirit of inventiveness, the openness to new ideas and technologies, and the intellectual rigor found in the work of American artists which speak to us. These are the same dynamics that gave birth to and continue to propel the American high-technology industry.

The American Century is also a record of the evolution and growth of our modern visual culture, from silent film to television to the visual computer. Modern American artists have a tradition of standing in the vanguard—of tackling tough issues and creating new visual languages that force us to look at how new technology impacts our society.

As visual computers, connected to the Internet, change the way we learn and communicate, Intel looks to artists to help our industry develop a new visual and interactive literacy in order to make PCs even more useful to more people. In that spirit, Intel and the Whitney Museum will be working together over the course of *The American Century* to design a range of new interactive and educational tools that will enrich the museum experience and extend the exhibition into homes and classrooms around the world.

We commend the Whitney Museum of American Art for undertaking this ambitious and important exhibition and are pleased to help bring it to the American public.

Andrew S. Grove
Chairman, Intel Corporation

Contents

Foreword
Maxwell L. Anderson 8

The American Century: Art & Culture 1900–1950
Barbara Haskell

America in the Age of Confidence: 1900–1919

The Last Flourish of the Gilded Age 11

Modernity and Urban America 47

Early American Modernism 93

Jazz Age America: 1920–1929

The Culture of Prosperity 131

Precisionism and the Machine Age 145

Consumer Culture and the Search for National Identity 166

America in Crisis: 1930–1939

Rediscovering America 216

Social Realism 275

The American Abstract Art Community 284

War and Its Aftermath: 1940–1949

America Confronts War 305

Geometric Abstraction and the Ideology of Formalism 319

Surrealism in America 322

An Art of Dislocation and Myth 337

Postwar Anxiety and Subjectivity 353

New American Abstraction 362

Notes 380

Selected Bibliography 385

Notes on Contributors 391

Acknowledgments 393

Index 396

Sidebar Texts

1900–1919

The Architecture of Restraint Nicholas Olsberg 12

Silver: Tiffany and Company Kevin Stayton 16

The Old Order in Literature: James, Wharton, Adams Peter Gibian 22

Louis Comfort Tiffany and George Ohr Derek Ostergard 30

Romance and Realism in Illustration May Castleberry 32

Early Modern Dance Sally Sommer 35

Leading the Simple Life: The Arts and Crafts Movement Wendy Kaplan 36

The Arts and Crafts Home Nicholas Olsberg 38

Reordering the City Nicholas Olsberg 50

Naturalist Literature Jonathan Warren 60

Race and African American Selfhood Phillip Brian Harper 72

Vaudeville and the *Follies* Don Wilmeth 73

Early Film: Edison, Biograph, and the Birth of Hollywood Tom Gunning 75

Popular Music, Ragtime, and Early Jazz Charles Hamm 78

Muckraking and Progressivism Jonathan Warren 82

Classicism and Exoticism in Turn-of-the-Century Music Judith Tick 104

Modernist Poetry in Chicago Jon Spayde 108

Theater in the Teens Don Wilmeth 109

1920–1929

New Styles of Social Dance Sally Sommer 131

Jazz Age Cinema Matthew Yokobosky 133

Skyscrapers in the Boom Years Nicholas Olsberg 138

Jazz Age Styling Wendy Kaplan 141

The Maturing of American Drama Don Wilmeth 161

The Jazz Age in Literature Peter Ohlin 166

The Golden Age of Tin Pan Alley Charles Hamm 168

Modernist Poetry—Williams and Stevens Ann Charters 169

Jazz Scott DeVeaux 184

Black and White Popular Music in the Jazz Age Ann Douglas 186

Literature of the Harlem Renaissance Ann Douglas 188

1930–1939

The Architecture of a New Democracy Nicholas Olsberg 218

Federal Writers' Project: The *American Guide Series* Jon Spayde 237

Music in the 1930s: A Usable Past Judith Tick 239

Colonial Revival: Idealizing the Past Wendy Kaplan 240

Cinematic Documentaries for the People Tom Gunning 243

Photo-Essays May Castleberry 250

Big Band Sound Scott DeVeaux 260

Depression-Era Social Dance Sally Sommer 261

Choreography in Film Mindy Aloff 270

Thirties Genre Films Robert Sklar 272

Literary Responses to Catastrophe Jonathan Warren 274

Theater in the 1930s Vera Roberts 276

Biomorphism and Organicism in Design Derek Ostergard 292

Domestic Architecture: Toward a New Geometry Nicholas Olsberg 294

Industrial Design: Streamlined Moderne Wendy Kaplan 300

Architecture: The Streamlined Future Nicholas Olsberg 302

1940–1949

Community and Continuity in Hollywood Film: Ford and Capra Robert Sklar 305

Celebrating America in Dance Mindy Aloff 307

American Musicals Vera Roberts 309

Surrealism and American Publishing May Castleberry 335

Graham and Balanchine Mindy Aloff 345

Literary Responses to War Ann Charters 353

The Big Singers Charles Hamm 354

Theater in the 1940s Vera Roberts 358

Film Noir, Avant-Garde, and Independent Cinema Robert Sklar 361

Bebop and Rhythm and Blues Scott DeVeaux 371

Architectural Prototypes for a New Frontier Nicholas Olsberg 376

Modernism in Music Judith Tick 378

Foreword

Maxwell L. Anderson
Director
Whitney Museum of American Art

Among the more endearing and exasperating features of Americans is the propensity to claim that whatever transpires in our midst is evidence of manifest destiny. While the rest of the world looks upon our hubris with a mixture of admiration, amusement, envy, and resentment, we soldier on, embodying Emerson's happy paradox of being both practical and visionary.

There is no more graphic evidence of our belief in ourselves than the title of this exhibition, taken from the epithet Henry Luce used in 1941 to characterize our era. America, as he saw it, was already "the intellectual, scientific and artistic capital of the world," the nation that would guide the world to "the authentic creation of the twentieth century." As we approach the millennium, it seems essential to test Luce's superlative by examining the role of art in shaping and expressing our national identity, values, and aspirations.

The American Century: Art & Culture 1900–2000 is being presented at the Whitney Museum in two consecutive segments. In *Part I, 1900–1950*, the period covered by this publication, massive immigration, technological progress, and expansionist ambitions combined to catapult the United States into a position of global leadership. The art of these fifty years naturally reflects the tensions and hopes of the time, and richly documents America's tempestuous climb to world leadership.

The ascendancy of American art after 1950 could not have been foreseen in 1900, when American artists found themselves sidelined by a system of patronage that excluded their creative achievements. America's wealthiest families had been amassing collections and building museums on the model of those created by European oligarchs. Most of America's museums, established from the last third of the nineteenth century onward, were hastily erected amalgams of cathedral, palace, and villa. The artworks within were culled from Europe's public and private collections and became the currency of upward mobility, allowing the newly affluent to find their way into a stratum formerly reserved for those born to social or economic aristocracy.

Concomitant with the appetite for art of the Old World was a prevalent disdain for the art of America. In freshly built manors from Fifth Avenue to Newport, self-made industrial barons preferred to surround themselves with pedigreed art. They were reluctant to risk failure in the one arena that money cannot guarantee: taste. Among wealthy patrons of art in the early years of the century, only Gertrude Vanderbilt Whitney would stake her reputation—and her money—exclusively on the quest for quality in contemporary American art. It was she who broke the chain of European acquisitions and asserted the value of American art of her time.

The first commitment Mrs. Whitney made was in 1908, when she purchased four of the seven works sold at the now-celebrated exhibition of the renegade artists known as The Eight. In 1914, she created the Whitney Studio, an exhibition space for contemporary American artists in rooms adjacent to her own Greenwich Village studio. The following year she helped found The Friends of Young Artists, a welcome vehicle for underwriting the needs of American artists, especially those rebuffed by the art establishment. In the Friends exhibitions, typically held in the Whitney Studio, "any entry could be submitted, regardless of aesthetic tendency, as long as it was sincere; the raw, the untried, the unready would get a chance." As a patron of the Society of Independent Artists, founded in 1916, Mrs. Whitney continued to support exhibitions of work by American artists of all backgrounds. The Whitney Studio showcased new work for display and sale until 1917. It was followed by the Whitney Studio Club (1918–28) and the Whitney Studio Galleries (1928–30)—predecessors of the Whitney Museum. It was not Gertrude Vanderbilt Whitney's original intention to institutionalize American art through the creation of a museum. Indeed, such a traditionally stodgy establishment ran counter to the spirit of her patronage, which focused on support for the living artist. But in 1929 The Museum of Modern Art had been founded as an advocate of European modernism. That same year, The Metropolitan Museum of Art declined Mrs. Whitney's offer

to donate her by then extensive collection of twentieth-century American art. If Gertrude Vanderbilt Whitney was to stake a lasting claim for the art of this nation, it had to be on her competitors' terms.

The Whitney Museum of American Art, which opened its doors in 1931, would come to be *the* institution in New York and in the United States giving voice to the concerns of individual American artists (Mrs. Whitney herself and the Museum's first three curators—Hermon More, Karl Free, and Edmund Archer—were artists). Since its inception, the Whitney has honored the efforts of numerous leading American artists in their lifetimes and mounted the first exhibitions of many artists who went on to achieve national and international renown. Unlike the Metropolitan and the Modern, moreover, the Whitney embraced the jumble of styles that punctuated the first fifty years of this century and provided an accommodating stage for acting out the ongoing drama. While it is true that realism in all its incarnations enjoyed a privileged place at the Whitney up until the 1960s, the Museum remained open to abstract art and to the vagaries of American interpretations of movements ranging from Fauvism and Cubism to Surrealism.

Twentieth-century American art, like all creative expressions, is also a response to political, social, and economic conditions. This exhibition and catalog, therefore, take the unusual step of exploring manifestations of American art in their broader societal contexts. Nor are these contexts limited to conventional spheres of influence. The history of American art in the first half of this century is in part a history of collapsing boundaries between high art and all that simmered beneath it. The birth of mass and instantaneous advertising, the visual cacophony of telephone poles, electric outdoor signage, tall buildings, and smoke-belching buses made for a new artistic language, barely intelligible to those invested in the sameness of the Old World. The new dynamism of film, the fresh percussive and syncopated features of jazz, and anti-Victorian styles of furniture and craft were all calculated departures from the comparative stasis of previous generations. To provide a truly comprehensive picture of this era's creative endeavors, *The American Century* offers examples and analyses of developments in all the arts, high and low, visual as well as literary and musical.

It is with particular pride that the Whitney Museum, the first institution devoted to American art, recounts this absorbing and majestic story. The remarkable interplay of individual innovation and external societal pressures makes this a compelling and rewarding enterprise. And it is an enterprise that would not have succeeded without the unprecedented support of Intel Corporation. My predecessor, David A. Ross, and the Whitney's chairman, Leonard A. Lauder, were instrumental in engaging the enthusiasm of Andrew S. Grove, chairman of Intel, and I am deeply grateful to all three for enabling this collaboration. We have been fortunate in attracting major support from the National Endowment for the Arts, the National Committee of the Whitney Museum, Booth Ferris Foundation, and The Lauder Foundation. The Brown Foundation, Inc., of Houston funded the educational and public programs in conjunction with the exhibition. The book itself was made possible by a gift from Susan and Edwin Malloy.

The staff of the Whitney was exemplary at every turn in bringing this highly ambitious project to fruition. Everyone worked tirelessly to plan and implement the project, from the Museum's senior managers to the Publications Department to the art handlers. I can single out only a handful of individuals: Barbara Haskell, curator of the exhibition and author of this catalog; Willard Holmes, our deputy director and chief operating officer; Susan Courtemanche, former associate director of external affairs; and Constance Wolf, former associate director of Public Programs.

On behalf of the Whitney's Board and its president, Joel S. Ehrenkranz, I would like to close by expressing my heartfelt thanks to the dozens of institutions and individuals who so generously lent major works to the exhibition, which allowed it to be the definitive evaluation of American art of the twentieth century.

America
in the
Age of
Confidence
1900–1919

America entered the twentieth century with a youthful confidence about its place in the world. American technological ingenuity and manufacturing efficiency had made the country the world's largest industrial power and showcase of electricity and steel production. In no other nation were cities so dazzlingly illuminated or so assertively vertical; nowhere else was the revolution in communications and transportation so pervasive. Unparalleled economic prosperity among the wealthy elite had given a handful of Americans the highest standard of living in the world. At the same time, the nation assumed a more global and imperialist outlook with its victory in the Spanish-American War (1898) and the acquisition of Cuba, Puerto Rico, Guam, Hawaii, and the Philippines. Once Theodore Roosevelt became president in 1901, following William McKinley's assassination, America became even more prominent in world affairs. Roosevelt, the first American president ever to leave native shores while in office, brought to the presidency an activist foreign and domestic policy. At home, he launched a campaign against monopolies; abroad, he mediated peace in the Russo-Japanese War (1904), secured American rights to build and operate the Panama Canal as an American protectorate, and sent a flotilla of sixteen American naval warships, the "Great White Fleet," on a circumnavigation of the globe (1907–9) to assert America's military strength.

The Last Flourish of the Gilded Age

Notwithstanding his global ambitions and instinct for domestic reform, Roosevelt remained, as did most of genteel America, thoroughly committed to Victorian values and ideals. Within the small world of privilege and wealth, a strong sense of social and moral responsibility attended the conviction that truth and morality were inviolate absolutes. What was prized was not innovation or freedom but discipline and restraint. Art was expected to elevate, to fill the individual with higher aspirations and respect for classical ideals. The custodians of culture did not want art to mirror the present but to express permanence and continuity—to embody divine moral truth and abstract, spiritual values. Artists and architects responded by imposing a sense of unity and order on the chaotic turmoil of everyday life. Deliberately eschewing all suggestions of the contemporary world, painters such as Kenyon Cox and Abbott Handerson Thayer sought refuge in the rationalized and refined aestheticism of the classical and medieval past (figs. 1, 3). Art, for them, was a force for cohesive social ideals, a purveyor of the certitude that seemed lacking in a world that was undergoing extensive economic expansion and social change. They aimed to create a pictorial realm of order and harmony unmarred by the vicissitudes and particularities of a specific time and place. Drawing on images and symbols of the past, they perfected a content that evoked the essential rather than the accidental, the eternal rather than the momentary. In order to avoid overt signs of personal expression, these painters emulated the smooth paint surfaces, detailed execution, and crisp outlines of French-derived Neoclassical art. Convinced, like their patrons, of the ennobling and civilizing power of art, American Neoclassical artists created public art that was didactic, allegorical, and

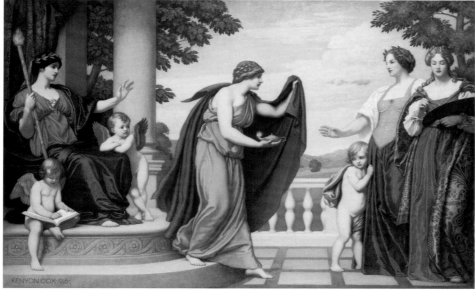

1. **Kenyon Cox**
Tradition, 1916
Oil on canvas, 41� x
64½ in. (106 x 165.5 cm)
The Cleveland Museum of
Art; Gift of J. D. Cox

classical in form: within the first ten years of the century, Daniel Chester French and Augustus Saint-Gaudens had designed public monuments (figs. 6, 8), and Kenyon Cox, H. Siddons Mowbray, Edwin Blashfield, and Edwin Austin Abbey had executed sculptures and murals for public buildings (fig. 7).

Society portraitists likewise looked to art to temper the materialism of modern life, but put their faith in personal gesture and the subject matter of private experience rather than in classical imagery and controlled emotion. These artists

THE ARCHITECTURE OF RESTRAINT

The extravagantly rich magnates of the Gilded Age used conspicuous luxury as a sign of status. Although they derived their wealth from Pittsburgh's steel or Cleveland's oil, New York became the hub of their social lives and, with Newport,

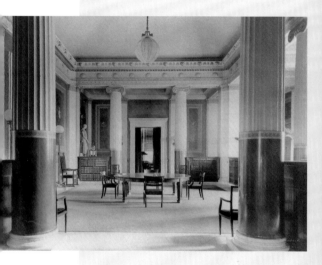

Rhode Island, the site on which they paraded their wealth. Architects such as Richard Morris Hunt and Stanford White, both in their Manhattan town houses and in their Newport cottages, designed grandiloquently, associating this new plutocracy with the styles and manners of European courts of the sixteenth and seventeenth centuries. By the late 1890s, the popular press was already protesting the magnificence of these palaces and the extravagance of the entertainments within—seeing in them an obscene contrast with the turmoil and distress of the times. In the early 1900s, with progressive politics and social reform to the fore, a new aesthetic sensibility began to emerge, characterized by sobriety and dignity, and in tune with a changed moral order. Although the scale of buildings increasingly signified power, the new American aristocracy began to leave its mark on the city through signs of cultivation, philanthropy, and order.

It was McKim, Mead, and White who first and best developed the kind of

2. **McKim, Mead, and White**
University Club, New York, Second Floor Hall, 1896–1900
McKim, Mead, and White Collection, The New-York Historical Society

3. **Abbott Handerson Thayer**
Stevenson Memorial, 1903
Oil on canvas, 81⅞ x 60⅛ in. (208 x 152.7 cm)
National Museum of American Art, Smithsonian Institution, Washington, D.C.; Gift of John Gellatly

proposed a domestic world of studied refinement and romantic idealism in place of the public one of probity and duty. By celebrating an exclusive world of cultivation and elegance, they sought to transcend what was crude, commonplace, and pragmatic in modern life. Portraits abounded of powerful men and beautiful, genteel women, posed in sumptuous interiors. The consumers of high culture favored Victorian elaboration and ornament in both the fine and the decorative arts. What the highly embellished silver of Tiffany and Company was to functional objects (fig. 11), John Singer Sargent's lush brushwork was to portraiture (figs. 9, 10). In contrast to the uninflected paint surfaces of French-derived Neoclassical artists, Sargent's glittering surface effects and painterly virtuosity exemplified the English and German tradition of society portraiture. Artists such as Cecilia Beaux, John White Alexander, and Charles Hawthorne took their cue from Sargent's bravura brushwork and animated surfaces to describe a cloistered world of elegance and opulence, sealed off from contemporary life (figs. 13, 14).

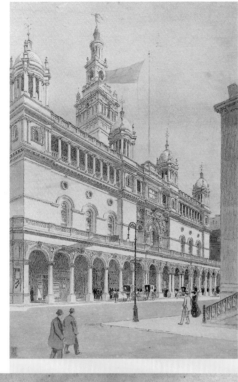

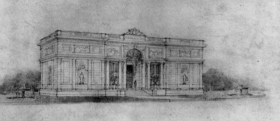

monumental chastity this change in self-presentation required. Even though Stanford White's approach to design was the most playful and luxuriant of the partners, three of his New York buildings nevertheless illustrate the arrival of this new solemnity perfectly. Madison Square Garden, a colorful and exotic palace of the Gilded Age, smacking of Turkish bazaars, marked the end of the old era of lavish public display (fig. 4), while White's clubs and libraries increasingly addressed the new aspiration to show off a sense of civic responsibility. The facades of the University Club, in their massive Florentine severity, spoke of a quiet and literate grandeur; and the interiors (especially the reading room, with its simple neocolonial furniture and plain, classically ornamented fireplace) harked back quite self-consciously to the republican simplicity of the Federalist era (fig. 2). For J. P. Morgan's library, White originally proposed an assertive building, with a great thrusting portico. But Morgan himself called for a more discreet presence, and the barely ornamented pavilion, with a deeply recessed entrance, took its place as a subtly graceful civic presence that served to represent the great financier as a man of deep culture and quiet generosity (fig. 5). Although Morgan's private library maintained a lushly baronial presence inside, the exterior exhibited restraint. Gone from the facade were the armorial bearings or courtly allusions that might have marked it a decade earlier. In their place were carved two chaste Greek friezes—one to the Muse of literature and the other to the Muse of music. The result reflected a veritable revolution in taste, as the rich reclothed themselves in republican virtue. —N. O.

The outward refinement and aristocratic ease among the privileged class that these paintings recorded was disseminated to a mass audience through illustrations that appeared weekly in the pages of *Collier's* and *Ladies' Home Journal*. Taking advantage of the halftone reproduction process, illustrators such as Charles Dana Gibson, Howard Chandler Christy, James Montgomery Flagg, and Walter Granville-Smith transformed the tradition of courtly portraiture carried to America by Sargent into a popular-culture equivalent (figs. 17–19). Gibson had pioneered this transformation by giving visual form to the new American woman. Self-assured and vivacious, the Gibson girl exuded the independence of the modern woman without exhibiting the militant aspects of the suffragette. Although Gibson's great work lay behind him by 1900, the Gibson girl was ubiquitous in the years before World War I. Her countenance was reproduced on wallpaper, ashtrays, teacups, saucers, and tiles (fig. 16); plays, songs, and films were written around her exploits. So popular were Gibson's illustrations that he produced fourteen "tablebook" albums of them, a practice perpetuated by Christy and Flagg, whose book and magazine illustrations confirmed the arrival of a new model of fashion and beauty—one that discarded the bustle for the more slender and relaxed silhouette of the chemise and substituted the older generation's emphasis on chastity and passivity with the

4. **Stanford White**
Madison Square Garden, 1903, perspective rendered by Birch Burdett Long, Wash and graphite on paper on board, 25⅜ x 15¹⁵⁄₁₆ in. (64 x 40 cm) Avery Architectural and Fine Arts Library, Columbia University in the City of New York

5. **Stanford White**
Perspective for *Morgan Library,* 1902 Pencil and wash, 12 x 24 in. (30.5 x 61 cm) McKim, Mead, and White Collection, The New-York Historical Society

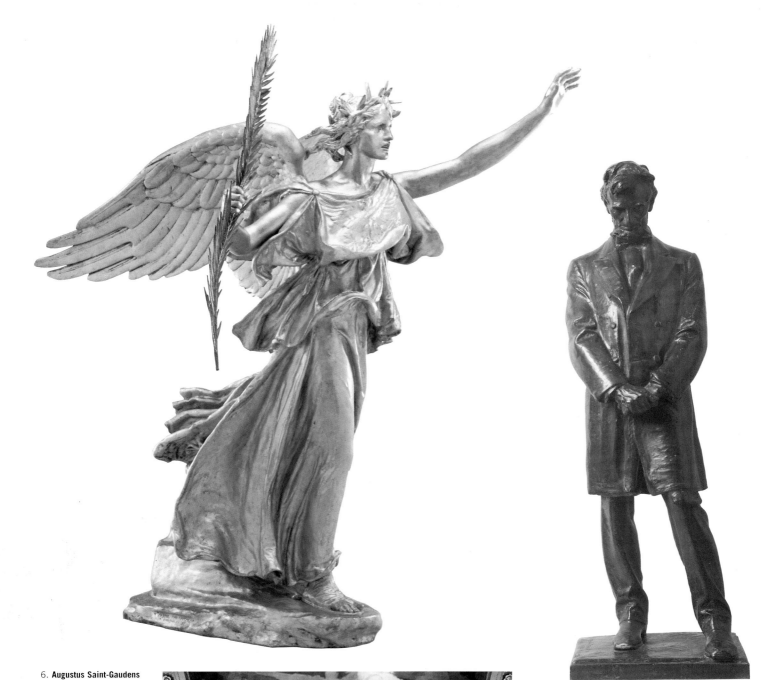

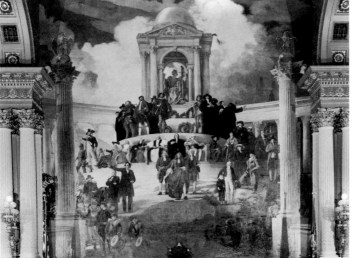

6. **Augustus Saint-Gaudens**
Victory, 1892–1903 (cast c. 1912)
Gilded bronze, 41⅞ x 23 x 35 in. (106.4 x 58.4 x 88.9 cm)
Carnegie Museum of Art, Pittsburgh; Museum Purchase

7. **Edwin Austin Abbey**
The Apotheosis of Pennsylvania, 1907–11
Oil on canvas, 35 x 35 ft. (10.7 x 10.7 m)
House of Representatives, Harrisburg, Pennsylvania

8. **Daniel Chester French**
Standing Lincoln, 1912
Bronze, 37 x 12⅛ x 10¼ in. (94 x 30.8 x 26 cm)
Whitney Museum of American Art, New York; Gift of Gertrude Vanderbilt Whitney 31.25

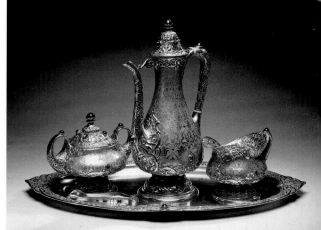

9. **John Singer Sargent**
Mrs. Fiske Warren (Gretchen Osgood) and Her Daughter Rachel, 1903
Oil on canvas, 60 x 40⅜ in. (152.4 x 102.6 cm)
Museum of Fine Arts, Boston; Gift of Mrs. Rachel Warren Barton and the Emily L. Ainsley Fund

10. **John Singer Sargent**
Mrs. Charles Hunter, c. 1904
Charcoal on paper, 23½ x 18¼ in. (59.7 x 46.4 cm)
Memorial Art Gallery of the University of Rochester, New York; Gift of James O. Belden in memory of Evelyn Berry Belden

11. **Tiffany and Company, New York**
Tea Service, c. 1903
Silver, gilt, enamel, and amethyst, 11 in. (27.9 cm) height
High Museum of Art, Atlanta; Purchase, with funds from Mrs. V. Crawford, Virginia Carroll Crawford Collection

spirited femininity described in the novels of Edith Wharton and Henry James.

By the first decade of the century, portrait photography had taken its place alongside painting and illustration as a recorder of the leisured class. Photographers such as Eduard (later Edward) Steichen, Gertrude Käsebier, Rudolf E. Eickemeyer, Jr., Clarence H. White, and Frances Benjamin Johnston enjoyed successful careers as commercial chroniclers of the glamorous and privileged (figs. 15, 20–23). Using limpid, softly muted halftones, they paid homage to the public world of masculine power as well as to a domestic sphere of harmony, tranquillity, and refinement. After 1913, with the appointment of Baron Adolf de Meyer as staff photographer for Condé Nast, fashion photography joined painting as a purveyor of glamour, mystery, and poetic indeterminacy. By combining dramatic backlighting with the soft-focus, form-disintegrating conventions of Pictorialism, de Meyer created an intimate luminosity that transformed fashion photography from a utilitarian documentation of apparel into a vehicle of mood and romance (fig. 24).

In Philadelphia, with the painter Thomas Eakins and his gifted pupil Thomas Anshutz, portraiture began to acknowledge the unsettling changes that the realities of a new century were making in the sheltered world of the privileged class. With a commitment to truth and an unsparing attention to detail, Eakins and Anshutz accommodated pensive melancholy with a full-bodied vernacular realism. Louis Kenton, as Eakins presents him (fig. 25), unwilling to ignore the unsettling complexities of the industrial present, epitomized the ambivalence with which intellectuals bid farewell to the values and traditions of the past and reconciled themselves to an uncertain yet inevitable future.

Similarly, Anshutz's portrait of Rebecca Whelan (fig. 26) simultaneously mirrors the introspective self-absorption that gripped the upper-class world of beauty and privilege at the turn of the century, while boldly announcing the intelligent self-confidence with which

SILVER: TIFFANY AND COMPANY

In the late nineteenth century, dramatic innovations in design and experimentation with technique had made Tiffany and Company an acknowledged leader not just in American silver production but in international production as well, while Louis Comfort Tiffany, the scion of the founding family, was an international leader in the manufacture of art glass. In the twilight years of the Belle Époque and the opening decades of the new century, Tiffany and Company maintained its tradition of providing the highest level of luxury goods to a clientele of America's elite families. Exhibiting to acclaim at international expositions, the firm, under the artistic direction of Paulding Farnham, combined a residual interest in the historical and exotic styles of the old century with the Beaux-Arts classicism of the new.

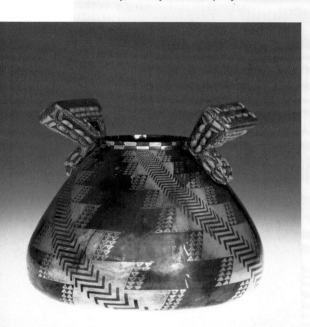

Silver objects in western European culture had always been symbols of wealth and repositories of capital, as well as an art form on which was lavished the highest craftsmanship. Tiffany and Company profited from the desire of wealthy Americans to emulate the European aristocracy, and its work rivaled and often surpassed in originality and sumptuousness that of the best of its European competitors. At the same time, the company tried its hand at experiments with the Arts and Crafts style and at developing purely American expressions. These latter were based on the work of Native American people (fig. 12); the line was developed under the influence of George Frederick Kunz, a gemologist and a vice president of the company who strongly influenced its work. The interest in historical styles and rich surfaces sometimes covered with enamel and set with gems, together with the legacy of superb craftsmanship and a fine control of difficult and unusual techniques—such as enameling and mixed metals—that grew out of nineteenth-century experiments, can be seen in the elaborate coffee sets and other tableware designed to grace the houses of the wealthy (fig. 11).
—K. S.

12. **Tiffany and Company, New York**
Vase, c. 1900
Silver, copper, turquoise, and stones, 7½ in. (19.1 cm) height
High Museum of Art, Atlanta; Purchase, with funds from Mrs. V. Crawford, Virginia Carroll Crawford Collection

the new American woman would face the future. By tempering Eakins' austere composition and sober palette but retaining his descriptive naturalism, Anshutz aesthetically prepared the ground for the generation of urban realists who emerged in New York in the first decade of the century under the leadership of his pupil Robert Henri (fig. 27).

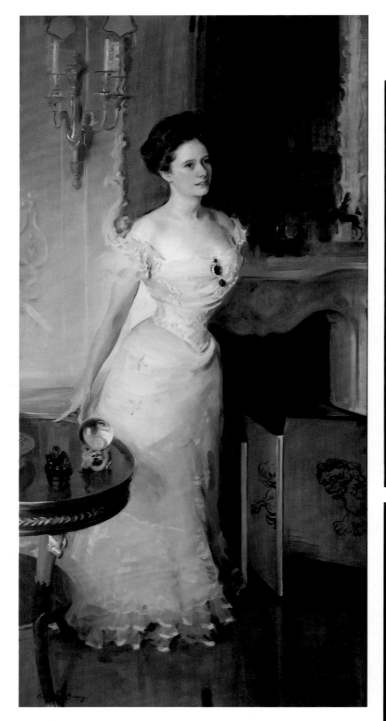

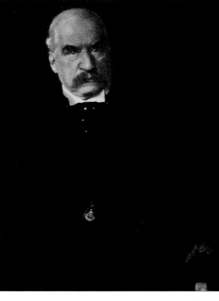

13. **Cecilia Beaux**
Mrs. Larz Anderson (Isabel Weld Perkins), 1900–1
Oil on canvas, 82 x 40 in.
(208.3 x 101.6 cm)
Society of the Cincinnati,
Anderson House,
Washington, D.C.

14. **Charles W. Hawthorne**
Girl in White, 1910
Oil on board, 30 x 25 in.
(76.2 x 63.5 cm)
Museum of Art, Rhode
Island School of Design,
Providence; Bequest of
Isaac C. Bates

15. **Edward Steichen**
J. Pierpont Morgan, 1903
Platinum print, 12¹¹⁄₁₆ x
10 in. (32.2 x 25.5 cm)
The Metropolitan Museum
of Art, New York; Gift of
George Blumenthal, 1941

16. **Charles Dana Gibson**
Bachelor's Wallpaper,
1902
Machine-printed wallpaper
Manufactured by M. H.
Birge & Son Co., Buffalo,
New York
Cooper-Hewitt, National
Design Museum,
Smithsonian Institution,
New York; Gift of the
Philadelphia Museum
of Art

17. **Walter Granville-Smith**
*One of the Winter's Leading
Social Functions,* 1902
Ink wash, charcoal, and
gouache on paper, 27¾ x
20⅜ in. (70.5 x 51.8 cm)
Delaware Art Museum,
Wilmington; F. V. du Pont
Acquisition Fund, 1986

18. **Howard Chandler
Christy**
The Gala, 1900
Watercolor and gouache
on board, 38 x 29½ in.
(96.5 x 74.9 cm)
Private collection; courtesy
Archives of the American
Illustrators Gallery,
New York

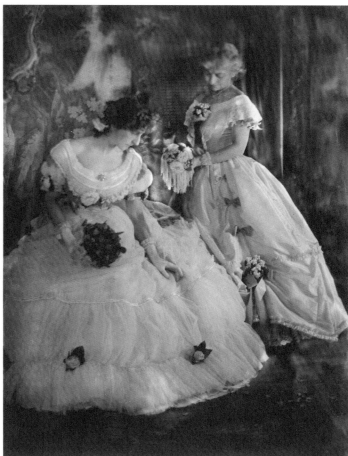

19. Charles Dana Gibson
A Daughter of the South,
1909
Ink on paper, 30 x 25 in.
(76.2 x 63.5 cm)
Cabinet of Illustration,
Library of Congress,
Washington, D.C.

20. Gertrude Käsebier
*Portrait—Miss N.
(Evelyn Nesbit),* c. 1901–2
Platinum print, 8¹⁄₁₆ x 6⅛ in.
(20.5 x 15.6 cm)
National Gallery of
Canada, Ottawa;
Purchase, 1973

**21. Rudolf E.
Eickemeyer, Jr.**
*In My Studio (Evelyn
Nesbit),* 1901
Carbon print, 19 x 24 in.
(48.3 x 61 cm)
The Hudson River Museum
of Westchester, Yonkers,
New York

22. Gertrude Käsebier
Gerson Sisters, 1904
Platinum print, 12¾ x
9½ in. (32.4 x 24.1 cm)
The Museum of Modern
Art, New York; Gift of Mrs.
Hermine M. Turner

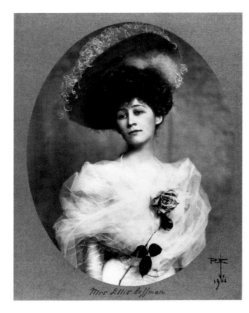

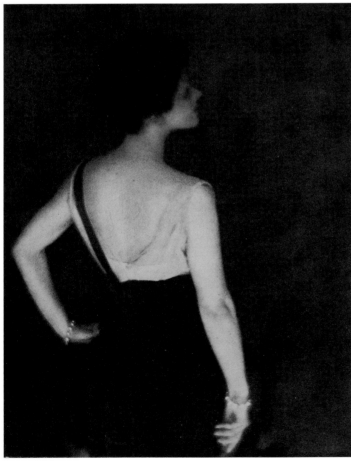

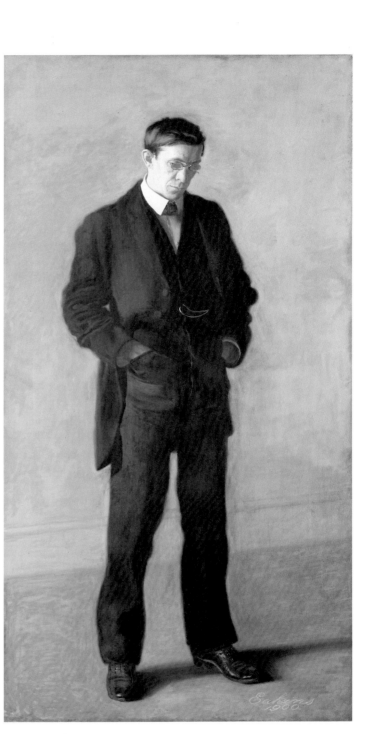

23. **Rudolf E. Eickemeyer, Jr.**
Mrs. Ellis Hoffman, 1903
Platinum print, 8½ x
6½ in. (21.6 x 16.5 cm)
Photographic History
Collection, National
Museum of American
History, Smithsonian
Institution,
Washington, D.C.

24. **Baron Adolf de Meyer**
Rita de Acosta Lydig,
c. 1913
Platinum print, 16⅜ x
12⁷⁄₁₆ in. (41.5 x 30.9 cm)
The Metropolitan Museum
of Art, New York; Gift of
Mercedes de Acosta,
transferred from the
Costume Institute, 1968

25. **Thomas Eakins**
*The Thinker: Portrait of
Louis N. Kenton,* 1900
Oil on canvas, 82 x 42 in.
(208.3 x 106.7 cm)
The Metropolitan Museum
of Art, New York; John
Stewart Kennedy Fund,
1917

26. **Thomas Anshutz**
A Rose, 1907
Oil on canvas, 58 x
43⅞ in. (147.3 x
111.4 cm)
The Metropolitan Museum
of Art, New York;
Marguerite and Frank A.
Cosgrove Jr. Fund, 1993

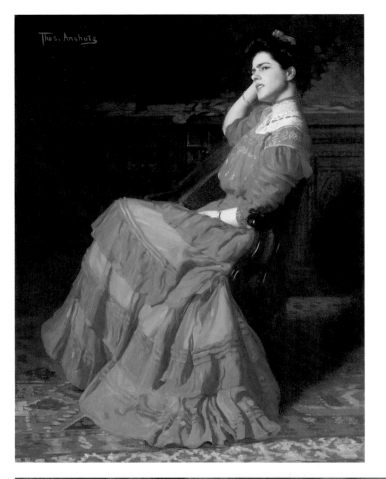

27. **Robert Henri**
*Gertrude Vanderbilt
Whitney,* 1916
Oil on canvas, 50 x 72 in.
(127 x 182.9 cm)
Whitney Museum of
American Art, New York;
Gift of Flora Whitney Miller
86.70.3

The vernacular realism promulgated in Philadelphia represented a dissenting voice in the retreat from modernity expressed by many artists in the early years of the century. Through intimate scenes of quiet meditation, painters and photographers evoked a mood of nostalgia for a now threatened, familiar world. For the modern age brought with it not only materialism and rationalism but also doubts about the meaning of life. With religion and its attendant values challenged by recent scientific discoveries, many turned to self-fulfillment through intense, private

28. **Childe Hassam**
At the Piano, 1908
Oil on canvas, 24⅛ x
26⅛ in. (61.3 x 66.4 cm)
Cincinnati Art Museum,
Ohio; Gift of Mrs. A. B.
Closson

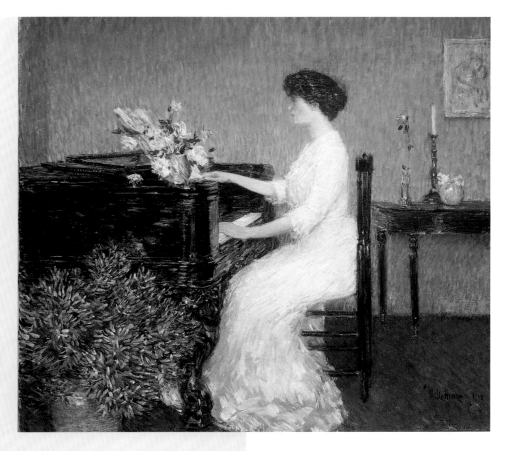

THE OLD ORDER IN LITERATURE: JAMES, WHARTON, ADAMS

For Henry James, Edith Wharton, and Henry Adams, social privilege was not simply an insulating and limiting cocoon but also a vantage point opening up a broad historical perspective on the bewildering changes of the turn of the century. It made possible acutely felt recognitions about vanishing forms of American life, deeply considered criticisms of the cultural status quo, and surprisingly prescient anticipations of developments to come. In some important ways, then, these last representatives of the old order were also among the first of the moderns. In their lives and major writings, these authors, like sensitive barometers, registered the pressure of multiple and contradictory forces pulling at America in this age of transition; more than most of their contemporaries, they were forced to recognize and explore their precarious position between two worlds—the Old World and the New World, the old American order and a new one, old money and new money, old art and new art.

Descended from families that had enjoyed immense wealth and social prestige for generations, these writers found themselves born into a changed system that had transformed the old leadership class into a leisure class; removed from the centers of political power or economic production, the former elite now turned inward to concentrate on an interior life of observation, contemplation, reverie, and often anxious analysis. James, Adams, and Wharton took up roles not as statesmen or businesspeople but as historians of their culture, developing complex studies focused on the operations of power—social, economic, political, and psychological—in a changing world. Historical perspective was central not just to Adams, who taught history and wrote essays on medieval culture and multivolume histories of the United States, but also to James and Wharton, who both saw the novelist as a cultural historian, closely observing and analyzing the nation's changing social mores. All three sought to interpret their own era in terms of earlier forms of European or American culture.

Repelled by the cult of the almighty dollar pervading American life, by the robber barons and their huge new monopolies, and by the aggressive masculinity of Theodore Roosevelt's expansionist "cult of the strenuous life," these writers received much of their education in cosmopolitan Europe and later made second homes in experience and an emphasis on interior states of the mind. This focus on introspection and emotional experience accounted for the receptivity in America to Symbolism and Aestheticism. Pessimism about God and progress, coupled with doubts about free will and causality that sprang from the determinist philosopher Herbert Spencer's application of Darwinian precepts to social relations, produced a compensatory response—an almost spiritual belief in intuition and the creative possibilities of the individual. Artists found in the elusive, transient imagery of dreams and the private pleasure of memories a refuge from the materialist values of the Gilded Age.

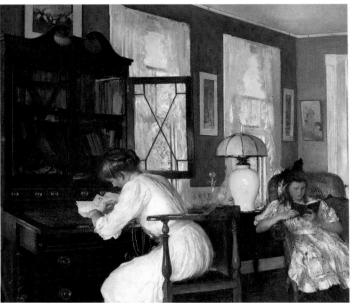

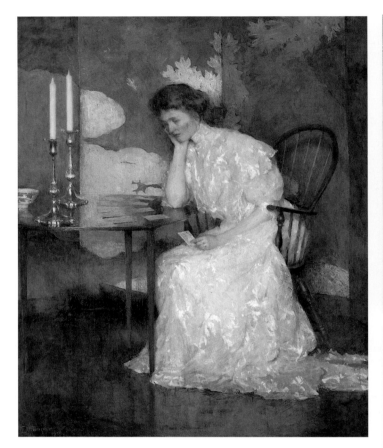

29. **Frank W. Benson**
Girl Playing Solitaire,
1909
Oil on canvas, 50½ x
40½ in. (128.3 x
102.9 cm)
Worcester Art Museum,
Massachusetts; Museum
Purchase

30. **Edmund Tarbell**
Josephine and Mercie,
1908
Oil on canvas, 28¼ x
32¼ in. (71.8 x 81.9 cm)
The Corcoran Gallery of
Art, Washington, D.C.;
Museum Purchase, Gallery
Fund

31. **Lilian Westcott Hale**
The Old Ring Box, 1907
Charcoal and black chalk
on paper, 22½ x 14⅛ in.
(57.2 x 35.9 cm)
Museum of Fine Arts,
Boston; Gift of Miss Mary
C. Wheelwright

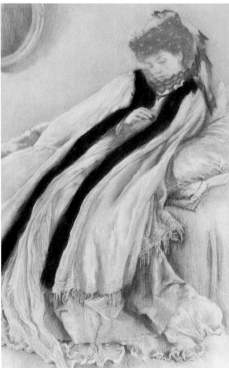

In this world of refinement and cultivation, women were seen as embodying the spirituality and serenity that were absent from the secular, materialistic world. In an effort to evoke poetic feelings and spiritual moods, society artists recorded women in moments of reverie or absorbed in solitary pursuits (fig. 28). This was particularly true in Boston, where the encroachments of modern culture were slower to take effect and where the artists were more directly influenced by Sargent, owing to his many trips there in connection with portrait commissions

England or France. They saw the Old World not simply as a place of retreat from American culture but as a site for the testing and training of the American character. For this first generation of expatriate writers, the basic, recurring "International Theme" plot—the voyage of American innocents abroad, confronting a world of multiple languages, extensive histories, and moral complexities—opened an illuminating, detached perspective on both the powers and the limits of native American culture.

The fiction of all three writers also tended to focus on a world of women, a separate feminine sphere representing an alternative form of American life—an almost utopian realm still sensitive to beauty, nuance, discrimination, and the intricate charting of human relations—that had not yet been wholly overwhelmed by the crude dynamo culture of male businessmen, scientists, and politicians. But these central female characters also register the toll taken on women by the power dynamics of contemporary public and private life. And women, in their powerlessness, often stand as figures for the artist—figures of interiority and reflection rather than action, dreaming of freedom in a fragile inner world constrained by the swirl of surrounding social forces. Female figures are central in many of Wharton's novels, such as *The House of Mirth*

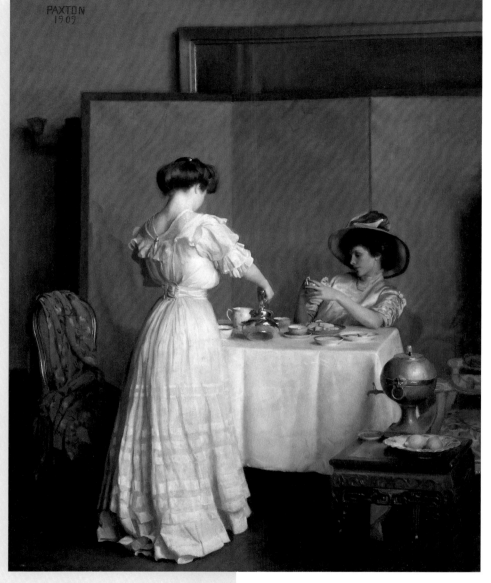

32. **William M. Paxton**
Tea Leaves, 1909
Oil on canvas, 36⅛ x 28¾ in. (91.8 x 73 cm)
The Metropolitan Museum of Art, New York; Gift of George A. Hearn, 1910

(1905) and *The Age of Innocence* (1920); in Adams' novels *Democracy, an American Novel* (1880) and *Esther* (1884); and in almost all of James' works, but perhaps most memorably in *The Portrait of a Lady* (1881) and *The Wings of the Dove* (1902).

When Ezra Pound, T. S. Eliot, and other American modernists led a second generation of expatriate artists to Europe, following in the footsteps of these old-order authors, they were centrally inspired by the life and work of Henry James. For while James' writings are often seen as the final flowering of the classic realist novel, they also broke the ground for the experiments of modernist prose. If James was socially and politically conservative, his explorations in psychology, philosophy, and aesthetics were often

and his mural design for the Boston Public Library. Boston portraitists such as Frank W. Benson, Edmund Tarbell, Lilian Westcott Hale, Joseph De Camp, and their younger colleague William M. Paxton pictorially encapsulated a female world of poetic gentility and pensive contemplation (figs. 29–32). Yet not even Boston was impervious to the impact of the new century: the tunic-like garments worn by Bessie Potter Vonnoh's society subjects mirrored the dress reform movement that sought to increase the freedom and mobility of American women (fig. 33).

The instinct to retreat from the world of crass materialism and vulgar

radically avant-garde. Though his stories remain limited to the rarefied lives of cultivated, leisure-class characters, his plots force readers to confront exquisitely formulated problems of modern morality and philosophy, complex challenges to the old verities.

In James, as in Wharton and Adams, we are always aware that just below the surface of the fictional pictures of a seemingly easy and elegant social world lies a fluid chaos no longer grounded by fixed social or moral standards. Also, though these plots center on dramas of consciousness in a mostly female world, James did not simply retreat before the subject of Gilded Age business; novels such as *The Golden Bowl* (1904) develop some of the first, and most profound, critical analyses of American consumer culture. And though he sought to defend genteel, elite culture from the degradations of an emerging mass culture, the ambivalent James was at the same time deeply fascinated by the public power of the new modes of mass spectacle; he longed to achieve such popular appeal, and so probed with exceptional insight (in works such as *The Bostonians*, 1886) the new cultures of conspicuousness, publicity, and celebrity that would come to dominate twentieth-century life.

Even a seemingly old-fashioned early story like "Daisy Miller" (1879) develops as a provocative anticipation of modern concerns as it outlines the predicaments of its two main characters: Daisy Miller emerges as a Marilyn Monroe–like innocent who becomes a charismatic star as she attempts to live out her private desires in an emerging world of mass publicity and mass spectacle and then finds herself trapped by the power dynamics of celebrity culture; Winterbourne, Daisy's companion, represents the entrapment of one sort of modern male in this expatriate leisure class—a deracinated, intellectual, internal personality paralyzed by self-consciousness to the point where he is incapable of action or emotional involvement with others. Developed as James' self-critical portrait of his own situation as a member of the American old order at the turn of the century, Winterbourne later served as a model for Eliot's paradigmatically modern persona, J. Alfred Prufrock. Once again, the anxious meditations of the old order offered a telling preview of the modern. —P. G.

33. **Bessie Potter Vonnoh**
Day Dreams, 1903
Bronze, 10½ x 21⅛ x 10¼ in. (26.7 x 53.7 x 26 cm)
The Corcoran Gallery of Art, Washington, D.C.; Museum Purchase

commercialism was shared by the American Impressionists Willard Metcalf, Robert Reid, Edward Simmons, J. Alden Weir, and John H. Twachtman (figs. 34, 35, 37). These Impressionists (joined by William Merritt Chase after Twachtman's death in 1902) had united in 1898 with Benson, Tarbell, Childe Hassam, and Thomas Dewing to create a cooperative exhibiting society, The Ten, to combat what they felt were discriminatory hanging practices in the annual exhibitions of the Society of American Artists.[1] Their yearning for detachment from materialism and the ethos of consumerism reached its apex in the work of Dewing (fig. 41). Following the lead of the American expatriate artist James McNeill Whistler, Dewing perfected an art of muted, soft harmonies and simplified, indefinite space that emanated an elusive poetry and evanescent spirituality. Reticent and empty, his compositions counterposed the culture of abundance with an iconography of separation and detachment. His languorous female subjects, distanced from each other and from the world of things by their postures and the emptiness of their surroundings, related only inwardly to their own states of mind.

34. Willard Metcalf
May Night, 1906
Oil on canvas, 39¼ x
36⅜ in. (99.7 x 91.9 cm)
The Corcoran Gallery of
Art, Washington, D.C.;
Museum Purchase,
Gallery Fund

36. Henry Ossawa Tanner
The Good Shepherd,
c. 1902–3
Oil on canvas, 27 x 32 in.
(68.6 x 81.3 cm)
Jane Voorhees Zimmerli
Art Museum, Rutgers,
The State University of
New Jersey, New Brunswick;
In memory of the
deceased members of
the Class of 1954

35. John H. Twachtman
Winter Harmony,
c. 1890–1900
Oil on canvas, 25¾ x
32 in. (85.1 x 100 cm)
National Gallery of Art,
Washington, D.C.; Gift of
the Avalon Foundation

37. J. Alden Weir
Moonlight, c. 1905
Oil on canvas, 24 x 20 in.
(61 x 50.8 cm)
National Gallery of Art,
Washington, D.C.;
Chester Dale Collection

38. **Arthur B. Davies**
*Jewel-Bearing Tree of
Amity,* c. 1912
Oil on canvas, 18¼ x
40⅜ in. (46.4 x 102.6 cm)
Munson-Williams-Proctor
Institute Museum of Art,
Utica, New York

39. **Arthur Mathews**
Masque of Pandora,
c. 1914
Oil on canvas, 52 x 48 in.
(132.1 x 121.9 cm)
The Oakland Museum of
California; Gift of Concours
d'Antiques, and the Art
Guild

40. **Pamela Colman Smith**
The Wave, 1903
Watercolor, 10¼ x 17¾ in.
(26 x 45.1 cm)
Whitney Museum of
American Art, New York;
Gift of Mrs. Sidney N.
Heller 60.42

41. **Thomas Wilmer Dewing**
The Garland, 1899
Oil on canvas, 31½ x
42¼ in. (80 x 107.3 cm)
Collection of Mr. and Mrs.
Peter G. Terian

42. Paul Manship
Flight of Night, 1916
Marble and bronze,
14⅛ in. (35.9 cm) height
Wadsworth Atheneum,
Hartford, Connecticut; Gift
of Philip L. Goodwin

43. Malvina Hoffman
Column of Life, 1917
(cast 1966)
Bronze, 26 x 7 x 7 in.
(66 x 17.8 x 17.8 cm)
Los Angeles County
Museum of Art; Gift of the
B. Gerald Cantor Art
Foundation

44. Maurice Prendergast
The Promenade, 1913
Oil on canvas, 30 x 34 in.
(76.2 x 86.4 cm)
Whitney Museum of
American Art, New York;
Alexander M. Bing Bequest
60.10

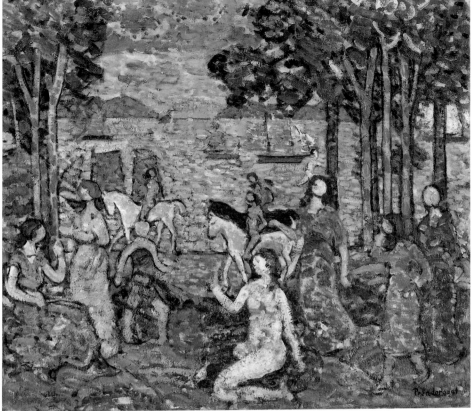

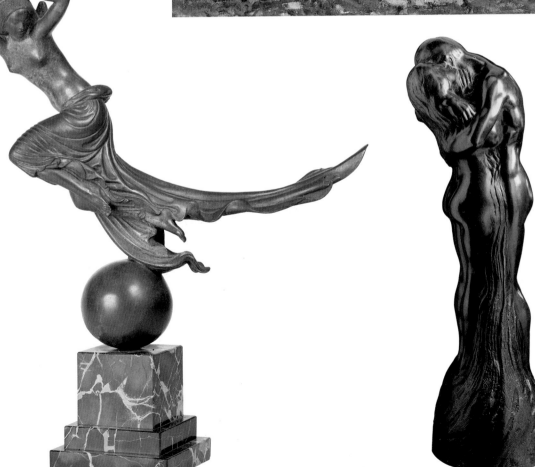

LOUIS COMFORT TIFFANY AND GEORGE OHR

The form, decoration, and sale of objects became a concern of increasing magnitude to many designers and manufacturers in the second half of the nineteenth century, as markets grew more global and highly competitive. The rapid application of mechanization to the production process introduced a wide range of poorly made objects that were either precise and sterile imitations of earlier work or ill-conceived objects with discordant decoration. Many consumers, critics, and manufacturers expressed dissatisfaction with these products, triggering a return to less mechanical techniques of production and aesthetics. Some viewed this approach as an antidote to the evils of an increasingly brutal society dominated by commercial concerns. The principal clientele for this new work, however, were wealthy individuals who had the means to commission objects that were frequently experimental, aesthetically unorthodox, and expensive to produce. Despite this limited audience, and the time it took to filter down to broader markets, this kind of work became one of the most influential forces in the revitalization of design by the end of the century.

Among the Americans who helped shape this late nineteenth-century renaissance, Louis Comfort Tiffany and George Ohr exemplify nearly opposite models of creative innovation and entrepreneurship. Born into a family of considerable affluence and position in New York, and heir to his father's large jewelry and silver firm, Tiffany and Company, Louis quickly established himself as both artist and designer in the United States, although his reputation would be international. An incessant experimenter with materials, aesthetics, and techniques of production, he emerged as the dominant figure in American design by the final decade of the nineteenth century. It was at this time that Tiffany executed a series of stained-glass windows designed by French painters such as Pierre Bonnard and Henri Toulouse-Lautrec that were shown at Siegfried Bing's highly influential retail gallery in Paris, La Maison de l'Art Nouveau. He also developed innovative and expressive new materials such as his patented, iridescent Favrile glass and the rough-textured "Lava" glass and refined an increasingly original design lexicon based on Art Nouveau style.

Like most gifted artists of the time, Tiffany was a talented synthesizer of diverse ornamental vocabularies. Although he was well regarded for historicist designs early in his career, his finest work was deeply indebted to nature, inspired by the sinuous organicism and opulent coloration of plant and animal life (fig. 45). His decorative forms and scenes, though based on close observation of the material world, generally eschewed illustration in favor of a more personal and willful assertion of his own

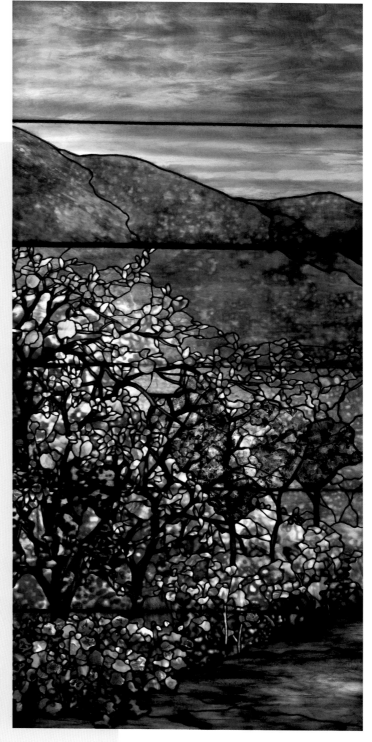

45. **Tiffany Studios, New York**
Sunset and Landscape Window, c. 1900
Leaded Favrile glass,
76 x 37 in. (193 x 94 cm)
Collection of Catherine and David Bellis

In their desire to escape the tyranny of objectivity and rationality, artists from a wide range of disciplines looked back with longing to premodern times. Their search for an antidote to the dehumanizing implications and mechanized processes of the industrial age led them to an interest in mystic and occult phenomena and to the art and refined aestheticism of medieval, oriental, and "primitive" cultures. The elegiac calm and introspective mystery of the figures that populated the biblical narratives of the expatriate artist Henry Ossawa Tanner and the medievalizing canvases of Arthur Mathews and Arthur B. Davies intimated a world far removed from the excessive materialism of the industrial age (figs. 36, 38, 39). The arcadian simplicity and harmony depicted by Maurice Prendergast was likewise remote from the pragmatism and spiritual compromises of modern life (fig. 44). By 1905, the Bostonian painter had evolved a personal kind of Post-Impressionism by combining the saturated palette of the Fauvist painter Henri Matisse with the flat, decorative patterning favored by French Post-Impressionists, particularly Édouard Vuillard. Prendergast's union of foreground and background created a continuous, mosaic-like frieze of spots and dabs of high-keyed colors that recalled medieval tapestries. So too, the gracefully sinuous figures sculpted by Paul Manship and Malvina Hoffman (figs. 42, 43) offered an antidote to the weightiness and moral earnestness of sculpture by Daniel Chester French and Augustus Saint-Gaudens (figs. 6, 8). Hoffman's *Column of Life* was indebted for its forms and sense of introspection to Auguste Rodin, the French sculptor with whom she had studied in Paris. Taking her cue from Rodin's *The Kiss*, Hoffman created sensuous bronze figures that seem almost to melt into each other in a frank evocation of uninhibited sexuality.

fecund imagination. Tiffany's vases, lamps, and decorative windows ranged from highly representational designs to those that conventionalized ornament or were uncompromisingly abstract. His consummate skills as both designer and exploiter of new techniques enabled his workmen to render his designs into metal, enamel, glass, wood, and ceramic (fig. 46).

George Ohr, as both artist and man, was far less of a cosmopolitan than Tiffany, and his relative geographic isolation in Louisiana seems to have left him less subject to the strains of internationalism that often characterized the work of Tiffany. The extravagance and novelty of Ohr's ceramic forms and the exquisiteness of his glazes lay distinctly outside the realm of the most avant-garde taste at the turn of the century. His most individual work, a large

body of traditionally functional vessels such as vases, teapots, and bowls, defied the canons of convention with their arresting, but often totally unserviceable, forms (fig. 47). Ohr decorated their crushed and twisted shapes with nonrepresentational, spontaneous effects achieved with glazes that surpassed in boldness even the most adventurous work produced abroad. —D. O.

Celebration of the idealized, procreative world of nature and womanhood as an alternative to the stress and vulgarity of modern life would become central to the development of modern painting in America. One of the earliest practitioners was Pamela Colman Smith, who drew on Symbolist notions of synesthesia as a gateway to the unconscious to record hermetic, mystical visions. Relying on neither narrative nor the strict imitation of natural appearance, she sought to express a spiritually exultant, pantheistic unity with the world (fig. 40).

46. **Louis Comfort Tiffany**
Jar, 1900
Blown Favrile glass, 9⁷⁄₁₆ x 5¹¹⁄₁₆ in. (24 x 14.5 cm)
Philadelphia Museum of Art; Purchase, The Temple Fund

47. **George Ohr**
Crushed Bowl, c. 1902–7
Scrottled earthenware, 4½ x 7 x 6⅝ in. (11.4 x 17.8 x 16.8 cm)
Collection of Andrew Van Styn

ROMANCE AND REALISM IN ILLUSTRATION

Publishing underwent enormous changes during the first two decades of the twentieth century, enabling illustrated books and magazines to reach new and broader audiences. New halftone printing technologies facilitated reproduction directly from a photographic image and decreased the costs of color illustrations. In fact, as illustrated books and magazines flooded the market, some critics complained that these image-laden publications were infantilizing the general public and leading to illiteracy. Illustrations ornamented the covers and articles of competing weekly magazines, such as *The Saturday Evening Post*, *Collier's*, *Leslie's Weekly*, and *Harper's Weekly*. Book publishers found audiences for repackaged classics, the latest novels, and juvenile literature as long as they were accompanied by illustrations by the leading artists of the day.

48. *Poems of Childhood*, by Eugene Fields, illustrated by Maxfield Parrish
New York: Charles Scribner's Sons, 1904
Frances Mulhall Achilles Library, Whitney Museum of American Art, New York

49. *The Boy's King Arthur*, edited by Sidney Lanier, illustrated by N. C. Wyeth
New York: Charles Scribner's Sons, 1917
Helen Farr Sloan Library, Delaware Art Museum, Wilmington

Publishers catered to a prevailing taste among the American public for the romantic, the pastoral, and the nostalgic, even as the country became increasingly industrialized and urbanized. Magazine covers re-created a small-town America that was rapidly disappearing, or envisioned life in Gilded Age high society. Book publishers helped invent an American West that never was and imagined mythical worlds of adventure and fantasy for children and adults alike. Reflecting this retrospective attitude, the period was also a golden age for handcrafts and book collecting, as gentlemen and captains of industry—from J. P. Morgan in New York City to Henry E. Huntington in San Marino, California—amassed libraries of luxurious editions redolent of an aristocratic past.

Images of a romantic Europe appealed to Americans who looked to the Old World with a mixture of escapism and curiosity. Maxfield Parrish became enormously popular for his storybook fantasies of old Europe such as *The Knave of Hearts* (1925), as well as for photographically based images of pubescent girls perched on swings, which made their way to book covers, posters, puzzles, and millions of covers of candy boxes (fig. 48). Historical fantasy and tales of heroism were a constant in the work of many of Parrish's teachers and peers, including N. C. Wyeth, who illustrated *The Boy's King Arthur* (1917), and Howard Pyle, who wrote and illustrated *The Story of the Grail and the Passing of Arthur* (1910), among other works (figs. 49, 50).

Contemporary life in America received fantastic treatment on another order: a fascination with the upper classes pervaded illustrations of "contemporary life," and among the most popular images of post-Victorian American high life were those by Charles Dana Gibson and Howard Chandler Christy. But Americana was on the covers of all the major magazines, such as the sentimental visions of small-town family life on *Good*

The yearning for psychic wholeness and authenticity of thought and action that was associated with premodern times was not limited to painting and sculpture. Admiration for this earlier era was evidenced in the illustrations of Howard Pyle, N. C. Wyeth, and Maxfield Parrish (figs. 48–50) and in the Orientalism of the modernist choreographers Ruth St. Denis, Ted Shawn, and Isadora Duncan (figs. 54, 56, 57, 76). By adapting the imagery and rhythms of Asian and classical Greek cultures, these dancers found a means of breaking free of traditional balletic restraints while simultaneously investing their compositions with a sense of spontaneity and innocence that was associated with pre-industrial times.

A similar ideology shaped the Arts and Crafts movement. Inspired by the example of John Ruskin and William Morris in England, the leaders of the American Arts and Crafts movement championed handcrafted production and the unity of art and life. They sought to bring the modern individual closer to nature through an emphasis on simplicity and the intrinsic beauty of natural materials. Stylistically, the spare rectilinear simplicity that characterized Arts and Crafts furniture, crafts, and architecture represented a bold modernism (figs. 58, 60, 62–64). Yet, like the choreography of Duncan and St. Denis, it was a modernism clothed in the ethos of a simpler, seemingly more "authentic" age.

The desire to align with more spiritually integrated cultures led to a fascination with the myth of frontier American and Native American peoples.

Housekeeping covers by Jessie Willcox Smith, who also illustrated Louisa May Alcott's *Little Women* in 1915. A decade after the 1890 census report declared the frontier closed, ethnographic history as well as tall tales of the Old West became increasingly popular. Audiences appreciated the "authenticity" of detail—of saddle fittings and cowboy gear—in the illustrations by Frederic Remington, an easterner who traveled west in 1880 and flourished as the illustrator of books on the West and outdoor life; and in the lore of Charles Marion Russell, a Western wrangler and self-taught painter. The most ambitious project of the era was Edward S. Curtis' twenty-volume *The North American Indian; Being a Series of Volumes Picturing and Describing the Indians of the United States, and Alaska* (1907–30). Written, illustrated with photographs, and published by Curtis, with a foreword by Theodore Roosevelt and field research conducted under the patronage of J. P. Morgan, the project involved nearly three decades of photographic work among native cultures. As Curtis sought to capture landscapes and ceremonies that were less and less common in contemporary life, his photographs became highly stylized and filled with artificial poses and costumes. —M. C.

50. **Howard Pyle**
The Story of the Grail and the Passing of Arthur, written and illustrated by Howard Pyle
New York: Charles Scribner's Sons, 1910
Helen Farr Sloan Library, Delaware Art Museum, Wilmington

No longer seen as a threat to white settlement of the West after the surrender at Wounded Knee in 1890, Native Americans acquired a fabled status as an embodiment of harmony and unity. For photographers, they provided a subject matter both mythic and nativist. Although the reality of Indian life was far from romantic, few photographs portrayed the disheartening conditions of reservation life. Most sought instead to recapture an idealized and highly romantic vision of the past grandeur and nobility of an exotic, vanishing culture. The Indians who participated in Buffalo Bill's Wild West Show or as "living exhibitions" in turn-of-the-century expositions and world's fairs offered accessible subjects to photographers such as Frank Rinehart, Joseph Keiley, Gertrude Käsebier, and Karl Moon, who preferred the studio to the reservation (fig. 51). Adam Clark Vroman was unusual in his more ethnographic effort to document the lives, homes, crafts, and ceremonies of the Hopi and Zuni Indians of the Southwest.

The photographer who most consciously merged ethnographic intentions with a romantic desire to portray the Native Americans' heroic past was Edward Curtis. With funding from J. P. Morgan, Curtis undertook the most ambitious photographic survey of Native American tribes ever attempted (figs. 52, 53). His work spanned twenty-three years, from 1907 to 1930, covered approximately eighty tribes,

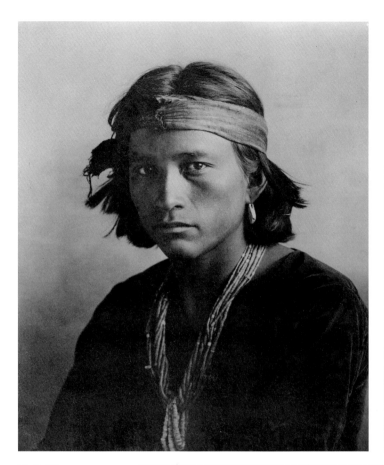

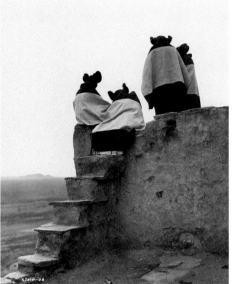

53. **Edward S. Curtis**
Watching the Dancers,
1906
Platinum print, 7⅝ x 6 in.
(19.4 x 15.2 cm)
Amon Carter Museum,
Fort Worth, Texas

51. **Karl Moon**
Biyazh, Navaho Boy,
c. 1905
Gelatin silver print, 9½ x
8 in. (24.1 x 20.3 cm)
Andrew Smith Gallery,
Santa Fe, New Mexico

52. **Edward S. Curtis**
Canyon de Chelly, 1904
Platinum print, 17 x 21 in.
(43.2 x 53.3 cm)
Christopher Cardozo,
Minneapolis

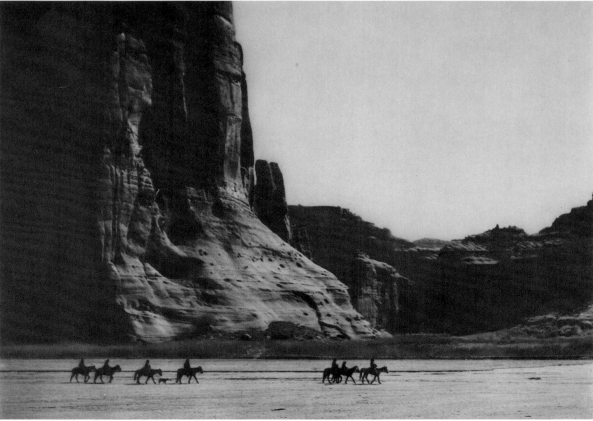

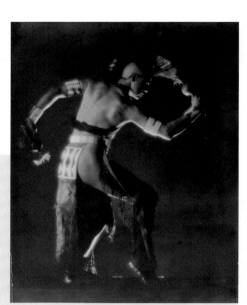

54. *Ted Shawn,* n.d.
Dance Collection, The New York Public Library for the Performing Arts, Astor, Lenox and Tilden Foundations

55. *Loie Fuller,* n.d.

EARLY MODERN DANCE

At the beginning of the twentieth century, a trio of remarkable Americans, Loie Fuller, Isadora Duncan, and Ruth St. Denis, created a modern dance revolution that resonated with feminist ideals of dress reform, of improving physical health education, and of gaining more sexual autonomy and political power.

America had no legacy of classical ballet and no coherent system of modern dance aesthetics in 1900. Fuller, Duncan, and St. Denis began their careers in a rambunctious populist theater that fortunately left them unencumbered with rigid ideas about what forms theatrical dance could take. Loie Fuller abstracted dance by stripping away storyline, character, stage decor, and the strictures of corsets. In 1892, on the stage of the Folies-Bergère in Paris, she danced alone, illuminated by brilliantly hued electric lights that hit the iridescent silk of her costume, streaming color across the fabric. Her voluminous costume swirled into enormous abstract shapes, now revealing, then concealing her body in a moving image that placed dance at the edges of modern abstraction (fig. 55).

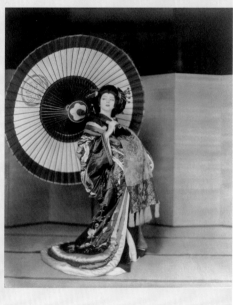

Isadora Duncan arrived in Europe in 1901. In contrast to Fuller, she performed in a simple Grecian tunic that revealed everything (fig. 57). Dancing in bare feet, with bare arms, she created movements inspired by the figures on Greek vases or by the dynamic motions of waves and wind. A heroic soloist with her powerful simple gestures and elegant poses, Duncan invented new movement vocabularies that expressed grand ideas about humankind's liberation through the power of music and dance.

Between 1900 and 1920, an ardent interest in oriental design and the sinuous dances of the East inspired the choreography of Ruth St. Denis (fig. 56). Her early solos, based on religious and mystical themes, added both ethnic variety and a simple solemnity to modern dance. In 1914, she married the dancer Ted Shawn (figs. 54, 76). Together, they founded the Denishawn School in California and trained a new generation of modern dancers, among them Martha Graham. —S. S.

56. *Ruth St. Denis,*
photograph by
Soichi Sunami, n.d.
Gelatin silver print, 9½ x 7¼ in. (24.1 x 18.4 cm)
Dance Collection,
The New York Public Library for the Performing Arts, Astor, Lenox and Tilden Foundations

57. *Isadora Duncan,*
photograph by
Arnold Genthe, n.d.
Gelatin silver print,
13 x 10¼ in. (33 x 26 cm)
George Eastman House, Rochester, New York

LEADING THE SIMPLE LIFE: THE ARTS AND CRAFTS MOVEMENT

The Arts and Crafts movement was the most significant force in design reform at the turn of the century. Originating in late nineteenth-century Britain as a rebellion against an increasingly mechanized and urban society, the movement soon came to America. Its principal goals were the revival of handcraftsmanship, the establishment of working conditions that gave the maker more control over the creative process, the cultivation of an aesthetic of simplicity, and the elevation of decorative arts to the status of fine arts through design unity.

The furniture made by Gustav Stickley's Craftsman Workshops demonstrates how rectilinear forms derived from the structure of the piece replaced the ornate curves of Victorian revival styles (fig. 58). Solid, native woods were used instead of imported veneers, which had been condemned as immoral, since they deceived the eye and were not made of local materials. Decoration beyond the embellishment of construction was abolished. Since the concept of "honesty" was integral to the aesthetic, such construction features as mortise and tenon joints were proudly revealed.

A search for a distinctly "American" style accompanied the movement's idealization of the vernacular, the natural, and the rural. It was manifested in the use of native oak, local clays, and English and Spanish colonial forms (e.g., the tall-case, or "grandfather," clock) and in images of indigenous flora and fauna. Arts and Crafts reformers passionately believed that handmade objects produced from natural materials were morally superior to those made by machine, and that these objects had the power to improve people's lives, bringing joy to both the maker and the user. At their most idealistic, Arts and Crafts advocates vowed to change society through the transformation of work. Because of their labor-intensive methods, however, they were never able to achieve the goal of producing a democratic art for a wide public while upholding the highest standards of craftsmanship.

Art pottery was one of the first industries to respond to the new demand for more individual, handmade objects. A potter such as George Ohr personally designed, threw, manipulated, and glazed his earthenware, but his work was not commercially viable (fig. 47). In contrast, at the successful Grueby Pottery, labor was differentiated: a male architect designed the pots, men threw them, and women (recent graduates from art schools) decorated them according to prescribed patterns. The wares were beautifully made by hand, but at the expense of the ideal that a single person would control the design process from inception to finished product. At Rookwood Pottery in Cincinnati, labor was divided even further—as many as twenty-one individuals worked on each piece. Despite the context of large-scale production, Rookwood did strive for individual expression. The decorators could follow their own inspiration in creating a design; only the shapes (while usually hand-thrown) were predetermined (fig. 59). By making its products in molds, Van Briggle Pottery went further still in sacrificing handwork. As *House and Garden* pointed out in 1903, "Mr. Van Briggle's idea is that it is far more satisfactory to spend unlimited time and thought in carrying out an idea which may be worthy of repetition . . . than to attempt for every vase a new design which must of necessity often be careless and hasty in thought and execution." Teco ware demonstrates

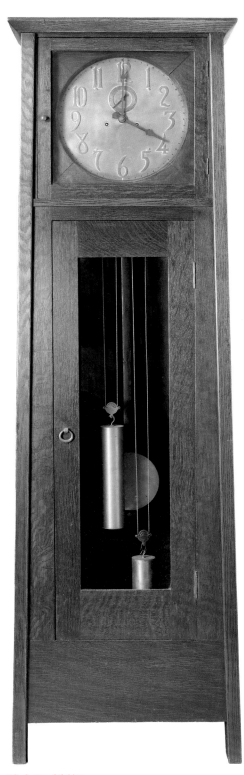

58. Gustav Stickley
Tall-case Clock, 1901
Manufactured by
Craftsman Workshops,
Eastwood, New York
Oak, 71¼ x 21⁵⁄₁₆ x 13⁵⁄₁₆ in.
(181 x 53.8 x 33.8 cm)
Collection of Robert
Kaplan

and resulted in more than 40,000 images, which he assembled into books, the grandest of which was a twenty-volume opus containing text and 1,500 photogravures entitled *The North American Indian*. In his quest to document a time that no longer existed, Curtis paid Native Americans to stage battles and ceremonies, and to change from their Anglicized dress into "traditional" costumes that he carried with him as props. In an effort to create a mood of romantic heroism and connection to nature, he retouched his negatives to remove evidence of the modern world. His single images, marketed in decorative frames and utilizing the orotone printing process to create iridescent, luminous effects—the result of fixing the image on glass and sealing it with a mixture of gold pigment and banana oil—were frequent adornments in Arts and Crafts homes.

how art pottery could flourish even at the largest and most commercial scale; it was a special line of the Gates Pottery, itself part of a huge architectural terracotta company. The financial success of the company's utilitarian wares, such as drain tiles and bricks, afforded William Gates and his staff the freedom to experiment with glazes and clays to create an art line. By using molds to execute designs commissioned from leading architects and sculptors, Teco succeeded in joining the useful and the beautiful, producing objects of "originality and true merit, at a comparatively slight cost."

The vases by Grueby, Van Briggle, Rookwood, and Teco also reveal that the Arts and Crafts movement was not confined to a single style, but drew upon many, chosen on moral as well as aesthetic grounds. Green was favored as the color of nature; Grueby's versions of matte glazes were regarded as the most successful evolution of the glazes introduced by French potteries in the 1890s. Van Briggle's depiction of the legendary siren Lorelei, with her flowing hair integrated into the shape of the vase, is an American expression of the sinuous, organic lines of European Art Nouveau. Another view of nature is seen in the Rookwood vase, influenced by the dreamy landscapes of the Symbolist painters. And the Teco vase reflects still another aesthetic—that of simple geometric forms cleansed of all historical references.

The brothers Charles Sumner Greene and Henry Mather Greene of Pasadena, California, came closest to fulfilling the Arts and Crafts ideal of total design unity by producing custom-made furnishings for houses they designed. In commissions such as the Blacker house (1907–9), the Greenes were responsible not only for the house but also for the furniture, stained glass, and landscaping (fig. 60).

The language of the Greenes was wood—native redwood and pine for beams and shingles, mahogany for furniture. They delighted in structural revelation, in demonstrating how wood could be joined, interlocked, and sculpted. Their furnishings also indicate the deep affinity that Arts and Crafts practitioners felt for the Orient, with its reverence for nature and its uncluttered aesthetic: the proportions of the Blacker house armchair and the double brackets at the knees were indebted to Chinese traditions, as was the recurrent use of hanging lanterns.

While most people could not afford a Greene and Greene house, they could still buy into the Arts and Crafts ideal with a "simple but artistic" bungalow that they could learn how to furnish in a wide variety of ways. Hundreds of Arts and Crafts societies were established throughout America to exhibit and sell craftsmen's work. Many periodicals, among them the *Ladies' Home Journal*, *House Beautiful*, and Gustav Stickley's *The Craftsman*, were founded as part of this movement, and were dedicated to promoting, in the words of the *House Beautiful* motto, "Simplicity, Economy and Appropriateness in the Home."

The Arts and Crafts conviction that decorative arts were equal in value to painting

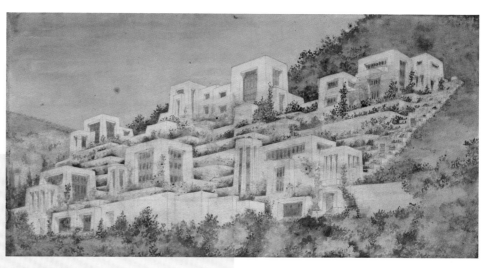

and sculpture greatly benefited women, since it bestowed dignity to crafts and provided an avenue to professionalize traditional women's skills. Unusual when first introduced in the 1840s, training for women in design and art education was widespread by the turn of the century. Nonetheless, a woman still had to contend with the deeply entrenched belief that her place was in the home. Professional opportunities were limited to areas that most closely resembled the domestic sphere and focused on "feminine" qualities of dexterity rather than on "masculine" ones of strength and originality. A sexual division of labor prevailed despite real advances in design education: women were largely confined to decorating (not throwing) pottery, to making jewelry (not large pieces of metalwork), and, of course, to the textile arts of embroidery and weaving.

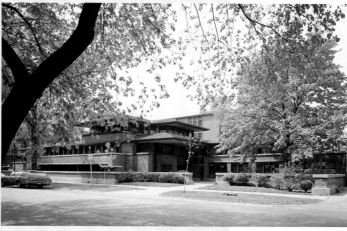

61. **Irving Gill**
Perspective for Casas Grandes, Homer Laughlin Project, c. 1915
Watercolor on paper,
13⅛ x 27⅜ in.
(33.3 x 56.8 cm)
University Art Museum, University of California, Santa Barbara; Architectural Drawing Collection, Irving J. Gill Collection

62. **Frank Lloyd Wright**
Robie House, Chicago, 1907

Although the Arts and Crafts movement did not succeed in attaining all of its goals, many real achievements resulted from the efforts of craftsmen, teachers, critics, and philanthropists who operated in its name. New economic opportunities for women, improved standards of design, and an increased recognition of the importance of individual expression are some of the Arts and Crafts legacies that are still with us today.
—W. K.

THE ARTS AND CRAFTS HOME

As the city of the Gilded Age expanded, the electric streetcar and suburban railway opened up a new way of life for the growing managerial and professional classes. Abandoning increasingly noisy, dangerous, and unhealthy city apartments, many began to realize the dream of a more private and hygienic life on the city's verges. By 1900, the outskirts of America's great cities and small towns were cluttered with eclectic middle-class homes, laid out face to the street, filled with enclosed parlors and bedrooms, and styled after the farmstead, the Queen Anne cottages of the rich, or the historicist brick villas of European resorts.

In the last few years of the nineteenth century, architects began to grasp the richer possibilities inherent in a leafy suburb, a home with few servants, and a clientele more focused on family comforts than on great entertainments. Borrowing ideas from the British Arts and Crafts movement, the ideal of the garden suburb, and such exotic examples as the adobe rancho and the Japanese house, pioneering architects—from

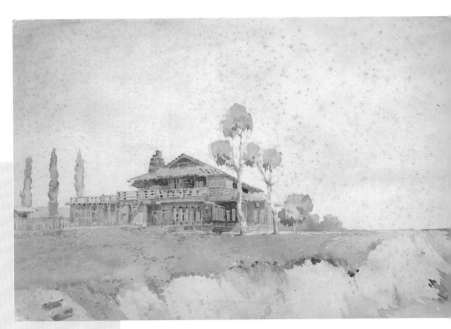

examples as the adobe rancho and the Japanese house, pioneering architects—from Frank Lloyd Wright in Chicago and Frederick G. Scheibler in Pittsburgh to Bernard Maybeck, Greene and Greene, and Irving Gill in California—began a decade of invention and experiment, searching for a domestic architecture that would represent
something unique about Americans' relationship to the land, to self-reliance, and to society.

Much of the driving force behind this movement toward the "simple house" was concerned with the ethics of family living, with health, or with the encouragement of intimacy, quiet, and leisure. Wright spoke of designing houses "for the growth of the soul," as sites for the cultivation of imagination and the development of more liberal manners. Gill used concrete and stripped down his ornamentation not for aesthetic reasons but in order to maximize domestic hygiene and minimize domestic labor (fig. 61). The brothers Charles Sumner Greene and Henry Mather Greene, working largely in the health resorts of Pasadena and Long Beach, oriented houses, doors, and rooms to benefit from the movement of air and light, and to distinguish between meditative and busy spaces (fig. 63). All believed that artistic order was essential to the moral purpose of the simple home, and they effected this order through the unity of design—leaving next to nothing to the whims and tastes of the client, but crafting and fixing every lamp, wall, window, table, and chair around a consistent aesthetic.

"Vista without, vista within," said Wright. Both Wright and the Greenes were first concerned with transparency, breaking down the idea of the room to open up the flow of space inside the house and dissolving the boundaries between architecture and landscape. For them, as for Gill, materials were left undisguised, structure was clear, surface decoration was minimal. The forms themselves—the planes, the lines, and the visible structure of the building—became the ornament: Wright's long walls, roofs, and window courses; the Greenes' great overlapping roof supports; Gill's simple arches and the play of light upon them.

These simple houses, bravely promoted by the progressive ladies' magazines of the day, mark one of the triumphant high points in American art and design and represent a gigantic step toward modernity. Wright's famous Wasmuth portfolio, first published in Germany in 1911, is one of the founding documents of modernism. A compendium of Wright's architectural designs, it allowed later giants such as Ludwig Mies van der Rohe and J. J. P. Oud to see architecture anew. Meanwhile, the work of the Greenes, Maybeck,

PICTORIAL PHOTOGRAPHY

Nowhere was the desire to escape the crass materialism of the present more evident than in Pictorial photography. Invoking an association with painting, the name reflected the division that existed within the burgeoning photographic community at the turn of the century between those who used photography to provide utilitarian records of the external world and those who used it as a vehicle for aesthetic expression. This latter group of Pictorial photographers distinguished their efforts from those of documentary or scientific photographers by minimizing the descriptive accuracy of their work and subverting the mechanical aspects of its production. They found models for the elusive and poetic indefiniteness that suited this purpose in earlier art movements, which had likewise turned their backs on fact and materialism—Symbolism, Impressionism, and British Aestheticism, especially as practiced by Whistler. Like these antecedents, Pictorialists used a dense, softened light to convey the dreamy, poetic indeterminacy of subjective reverie. They avoided the crisp, sharply defining light and casual croppings of documentary photographers in favor of diffused half-lights, which disintegrated form and cloaked subjects in diaphanous atmospheres. There were various ways to achieve the desired soft-focus effect: mechanically throwing the camera lens out of focus, splashing it with water, covering it with gauze, or jiggling the camera. Manipulation could take place in the developing and printing stage as well, especially with platinum and gum-bichromate processes. The matte finishes and hand-coated emulsions of the platinum print allowed for more subtle tonal gradations than was possible with commercially prepared paper and glossy emulsions, while the gum-bichromate print permitted the photographer to alter tone, incorporate color, and blur parts of the image. The resulting suppression of detail and the subdued, smoothly nuanced tones added mystery and uncertainty to images and lent them a quality of withdrawal and detachment from the world. Subscribing to the Symbolist equation of idealized feminine beauty, metaphysical calm, and spiritual timelessness, Pictorialist photographers frequently portrayed women in solitary, contemplative reverie or in mystical communion with nature. Depicting their subjects—usually women and children—engaged in leisure activities or at play in the home or garden, they reformed the intimacies and continuities of daily life into wistfully romantic paeans to an idyllic world removed from the turmoil and dissonance of modern life (figs. 65–67). Their frequent choice of female nudes as a photographic subject had as much to do with equating women with spiritual innocence as it did with the nude's inherent sensuality and underlying eroticism. So too did the ubiquity of images of women passively gazing into clear globes or crystals, a pose that was intended to suggest meditative self-absorption, devoid of reference to the physical world (figs. 68–70).

In the first ten years of the century, the exploitation of softly nuanced, shallow space to express subjective, dreamlike moods was practiced by every major art photographer: Gertrude Käsebier, Alvin Langdon Coburn, Frank Eugene, Imogen Cunningham, Edward Weston, Eva Watson-Schütze, Anne W. Brigman, George Seeley, Joseph Keiley, Clarence H. White, F. Holland Day, Alice Boughton, and Edward Steichen (figs. 71–76). By choosing to eschew rationality and materialism, these Pictorialists aligned themselves with the painters, choreographers, composers, and designers whose formal vocabulary was modern but whose values were those of the pre-industrial past.

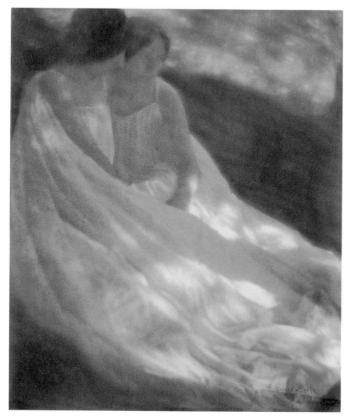

65. **George Seeley**
The Burning of Rome,
1906
Brown pigment gum-bichromate over platinum, mounted on brown paper, 9¹¹⁄₁₆ x 7¾ in. (24.6 x 19.6 cm)
The Metropolitan Museum of Art, New York; The Alfred Stieglitz Collection, 1933

66. **Clarence H. White**
The Orchard, 1902
Platinum print, 9½ x
7½ in. (24 x 19.1 cm)
Gilman Paper Company
Collection, New York

67. **Gertrude Käsebier**
*Blessed Art Thou Among
Women,* 1899
Platinum print, 9½ x
5³⁄₁₆ in. (24.2 x 14.8 cm)
The Clarence H. White
Collection, Princeton
University; Collection
assembled and organized
by Prof. Clarence H. White,
Jr., and given in memory of
Mr. Lewis F. White, Dr.
Maynard P. White, Sr., and
Prof. Clarence H. White Jr.,
the sons of Clarence H.
White, Sr. and Jane Felix
White

68. Anne W. Brigman
The Bubble, c. 1905
Gelatin silver print, 7¹⁄₁₆ x
9⅜ in. (18 x 23.8 cm)
Collection of Michael and
Jane Wilson

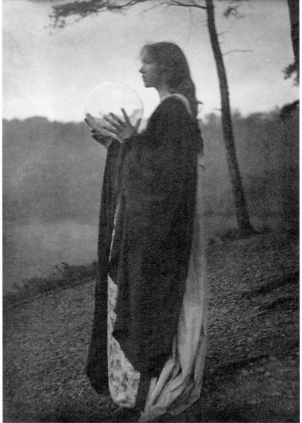

69. Edward Steichen
Little Round Mirror, 1901
(printed 1902)
Gum-bichromate print, 19⅛ x
13¹⁄₁₆ in. (48.6 x 33.2 cm)
The Metropolitan Museum of
Art, New York; Gift of Alfred
Stieglitz, 1933

70. Clarence H. White
The Bubble, 1905
Platinum print, 9⁹⁄₁₆ x
7⅝ in. (24.2 x 19.3 cm)
The Metropolitan Museum
of Art, New York; The
Alfred Stieglitz Collection,
1933

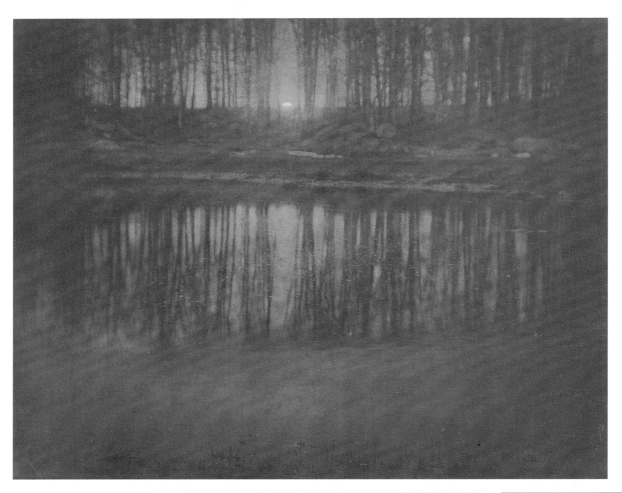

71. **Edward Steichen**
Moonrise—Mamaroneck, New York, 1904
Platinum, cyanotype, and ferroprussiate print, 15¼ x 19 in. (38.7 x 48.2 cm)
The Museum of Modern Art, New York; Gift of the photographer

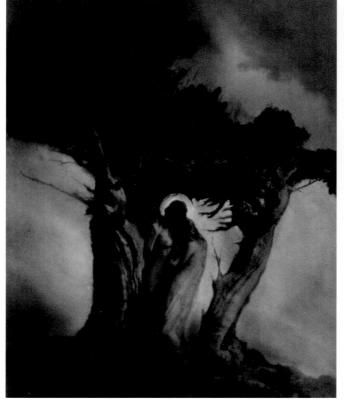

72. **Anne W. Brigman**
Heart of the Storm, c. 1915
Gelatin silver print, 9½ x 7½ in. (24.2 x 19.1 cm)
Collection of Michael and Jane Wilson

73. **George Seeley**
Autumn, c. 1910
Photogravure, 8¼ x 6⅝ in. (21 x 16.8 cm)
Philadelphia Museum of Art; The Estate of Carl Zigrosser

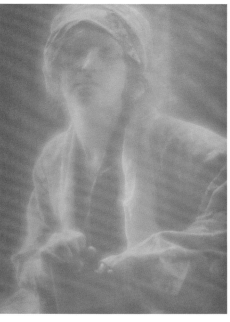

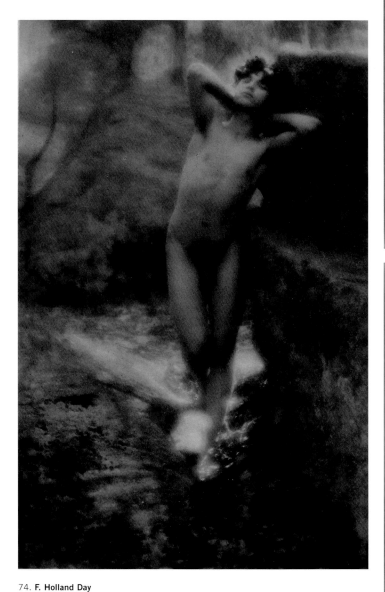

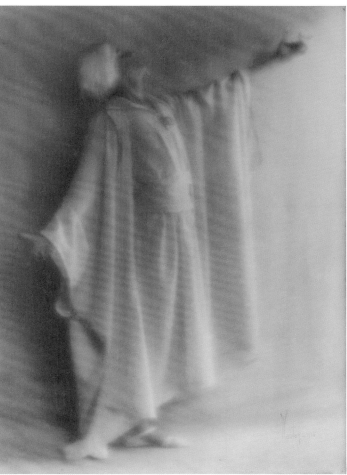

75. **Imogen Cunningham**
Nei-san-Koburi/The Dream,
c. 1910
Platinum print, 8⅝ x
6⅜ in. (22.8 x 16.1 cm)
The J. Paul Getty Museum,
Los Angeles

76. **Edward Weston**
Ted Shawn, 1915
Platinum print, 16 x
11¾ in. (40.7 x 29.9 cm)
Gilman Paper Company
Collection, New York

74. **F. Holland Day**
*Untitled (Nude Youth with
Laurel Wreath Against
Rocks, Standing in
Stream),* 1907
Platinum print, slightly
hand-colored with pencil,
9⅜ x 7⁷⁄₁₆ in. (23.8 x
19.2 cm)
Library of Congress,
Washington, D.C.

THE EMERGENCE OF THE PHOTO-SECESSION

By the early twentieth century, a host of photographic clubs, societies, journals, and exhibitions were serving the professional and amateur photographer. One of the most respected and active figures within these organizations was Alfred Stieglitz. Born in Hoboken, New Jersey, of German-Jewish parents, Stieglitz had taken up photography while studying mechanical engineering at the Technical University in Berlin. He returned to the United States in 1890 with a passionate belief in the aesthetic and expressive possibilities of photography. Six years later, he was instrumental in merging the Society of Amateur Photographers of New York and the New York Camera Club into a new society, the Camera Club of New York. Vice president of the Club and chairman of the publications committee, he transformed the Club's leaflet into a lavish new quarterly, *Camera Notes,* through which he proselytized for the artistic recognition of photography as a fine art.

77. Cover of *Camera Work,* July 1910, design by Edward Steichen
The Metropolitan Museum of Art, New York; The Alfred Stieglitz Collection, 1953

By 1902, Stieglitz's dissatisfaction with the Camera Club's egalitarian exhibition and membership policies had encouraged him to form a new, more elite society called the Photo-Secession, a name he chose in order to invoke spiritual allegiance with European vanguard artists who had seceded from academic institutions. The impetus for the society's formation was a photography exhibition he had been asked to organize for the National Arts Club in New York in March of 1902. Entitled "American Pictorial Photography," the exhibition of 162 photographs by thirty-two contributors had been presented under the nominal aegis of the Photo-Secession. What began as an exhibition strategy became a formal organization several months later with Stieglitz as director and a governing council of twelve other photographers. Membership was by invitation, not application. Despite, or perhaps because of, Stieglitz's exacting standards, the cadre of photographers associated with the Photo-Secession represented the most outstanding photographic talent of the period. The only prominent photographer not a member of the Photo-Secession was F. Holland Day, a wealthy Boston aesthete who, in the early years of the century, posed the single challenge to Stieglitz's position as preeminent promoter of art photography.

Shortly after the National Arts Club exhibition, Stieglitz resigned as editor of *Camera Notes* to found a new quarterly journal, *Camera Work,* over which he had exclusive editorial and publication control. Fifty issues of *Camera Work* appeared between 1903 and 1917. Radically different from all other photographic magazines of the period in focusing on aesthetics rather than on technique, the magazine exemplified the Pictorialist commitment to print quality by reproducing images in photogravure on thin Japan paper, hand-mounted on heavy textured paper. While Edward Steichen's design of the magazine's cover, typography, and layout resembled the Arts and Crafts aesthetic of William Morris (fig. 77), the magazine's content mirrored the Symbolist intellectual proclivities of its editors and contributors. Foremost among these were Charles Caffin and Sadakichi Hartmann (alias Sidney Allan), both of whom championed the superiority of spiritual claims over those of reason and materialism. Their passion for a Symbolist art of subtlety, ineffability, and emotional evocation provided intellectual support for the elusive metaphysics and brooding moodiness of the Pictorialist style.

During its first three years, the Photo-Secession centered its activities on *Camera Work,* the official mouthpiece of the society, and on loan exhibitions of

members' works that Stieglitz circulated in America and Europe. Ironically, none of these exhibitions had come to New York City, which meant that Photo-Secession work had not been seen in its "hometown" since the National Arts Club show of 1902. This changed in 1905 when Steichen suggested that the studio he had just vacated on the top floor of 291 Fifth Avenue be converted, along with two rooms behind it, into headquarters and galleries for the Photo-Secession. After some hesitation, Stieglitz agreed, and The Little Galleries of the Photo-Secession opened to the public on November 24, 1905, in three small galleries designed and decorated by Steichen (fig. 78). Inspired by the spare, simple interior designs of the Vienna Secessionist architect Josef Hoffmann, the galleries encouraged quiet, contemplative viewing. Shunning the lavish red velvet and brocaded walls of most period exhibition spaces, Steichen covered the walls with burlap fabric, subdued in color, and he installed photographs in a single, horizontal row at eye level.

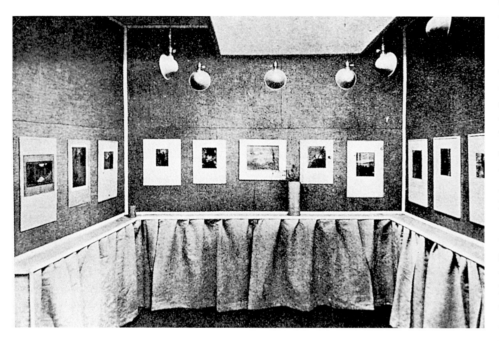

78. *The Little Galleries of the Photo-Secession,* photograph by Alfred Stieglitz As reproduced in *Camera Work*, April 1906

Like *Camera Work*, The Little Galleries featured the work of a limited number of photographers. Even within this select group, only six photographers had one-person shows: Alvin Langdon Coburn, Baron Adolf de Meyer, George Seeley, Paul Strand, Steichen, and Stieglitz. Stylistically, their work was remarkably consistent in subject matter and image treatment. Softly focused, low in tonality, and cropped so as to accommodate large open areas, their photographs offered an idyllic escape from the discordant frenzy of modern life.

The Photo-Secession ended as it began—with an exhibition. The occasion was an international retrospective of Pictorial photography that the Photo-Secession was asked to organize in 1910 for the Albright Art Gallery in Buffalo, New York. Consisting of nearly six hundred photographs by sixty-five artists from four countries, the "International Exhibition of Pictorial Photography" was the largest and most historically comprehensive exhibition of art photography ever assembled up to that time. The museum's decision to purchase fifteen of the exhibited prints and to allocate a room in its galleries for their permanent display vindicated Photo-Secessionist claims that photography had the right to recognition as a fine art. Yet the show also marked the first acknowledgment of what would become an incontrovertible division within the ranks of art photographers between those who favored the Pictorial treatment of subjects and those who advocated "pure," or straight, photography. As early as 1904, the soft-focus, painterly technique of Pictorial photography drew objections from Stieglitz's associate Sadakichi Hartmann for its lack of vigor.[2] After 1910, this view became pervasive as technical precision and overall sharpness, once dismissed as hopelessly inartistic, came to be valued over muted indeterminacy.

This view was eventually adopted by Stieglitz, whose allegiance to Pictorialism was being challenged by his exposure to vanguard painting. After 1910, he mounted no further exhibitions under the rubric Photo-Secession. Those who remained sympathetic to Pictorialist ideals rallied around Clarence White, who, along with

Käsebier, broke with Stieglitz in 1912 over what they viewed as Stieglitz's autocratic and dictatorial manner. White promulgated a more inclusive definition of Pictorial photography in his schools, the first of which he established in Maine in the summer of 1910 and the second in New York City in 1914.[3] Dedicated to furthering the cause of artistic photography, White and various protégés, including Karl Struss and Laura Gilpin, founded in 1916 the Pictorial Photographers of America, an organization open to amateurs and professionals alike, with national chapters, monthly exhibitions, traveling shows, and its own journal.[4] Through these agencies, White and his followers inspired a new generation of photographers to value soft-focus effects and the subtle balancing of light and dark, mass and void. Emphasizing two-dimensional design and formal arrangements, White instilled in his students a concern for the equilibrium between description and abstraction. Convinced of the social utility of art, he encouraged the application of artistic principles to commercial work, a realm anathema to Stieglitz. This acceptance of commercialism, coupled with the experience of applying design concepts to a variety of subjects, primed White's students to answer the needs of the advertiser and the art director in the 1920s.

Modernity and Urban America

Notwithstanding the desire to preserve the past through quiet, genteel subjects, the power of modernity was ultimately overwhelming. In the urban landscape of electricity, steel, and commerce lay an indigenous reflection of American democracy and ingenuity. The city was the expression of the new America—modern, young, and alive. Here, American success was unbeholden to foreign influence. In cities like New York and Chicago, skyscrapers dwarfed streets, while horse-drawn carts shared space with electric streetcars and automobiles, subways and elevated trains transported masses of people, and electric lights illuminated formerly gas-lit streets. These were the symbols of progress and futurity. There was something celebratory and patriotic about making art out of such subjects, and artists turned to them with a newfound pride in America.

Among the first to do so were Alfred Stieglitz, Edward Steichen, and Alvin Langdon Coburn, who saw in the grandeur and authority of capitalist America suitably indigenous subject matter. Already by 1900, they and other Pictorial photographers had turned to images of American technology and engineering prowess—railroad terminals, construction sites, bridges, docks, and the new urban landscape of soaring skyscrapers—as pulse points of American modernity (figs. 79–82). Yet, however drawn they were to tall buildings and electric light, they nevertheless remained committed to transcribing mood and evocative light. Consequently, they treated the city as a site for suggestive and poetic reveries. Theirs was a city of nights and twilights and smoke. Valuing romance and mystery, they aestheticized the often brutal forces of the city by swathing them in atmospheric effects (figs. 83–86). "It is only at twilight," Coburn wrote in 1911, "that the city reveals itself to me in the fulness [sic] of its beauty, when the arc lights on the Avenue click into being."[5] Partly, this reflected their misgivings about the new America. Sadakichi Hartmann, Stieglitz's mentor in these years, wrote in Camera Work in 1903 of the "exuberant, violent strength" of New York, but tempered his celebration with a lament for the city's "mad, useless Materiality."[6] The Flatiron Building, a symbol of the new America, elicited a similar mixture of apprehension and exhilaration from Stieglitz. He described his vision of it on a night covered with snow: "It appeared to be moving toward me like the bow of a monster ocean steamer—a picture of new America still in the making."[7] To

79. **Alfred Stieglitz**
The Aeroplane, c. 1911
Photogravure, 5¾ x 7 in.
(14.6 x 17.8 cm)
Private collection

80. **Alfred Stieglitz**
The City of Ambition,
1910
Photogravure on Japanese
tissue mounted on paper-
board, 13⅜ x 10¼ in.
(34 x 26 cm)
National Gallery of Art,
Washington, D.C.; Alfred
Stieglitz Collection

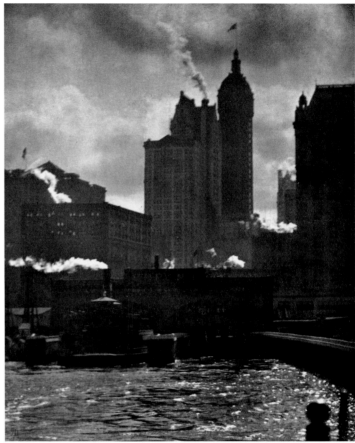

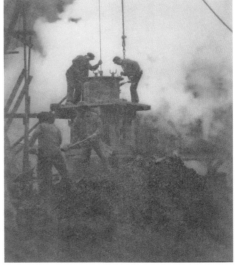

81. **Alvin Langdon Coburn**
*House of a Thousand
Windows,* 1912
Platinum print, 16⅛ x
12⅜ in. (41 x 31.4 cm)
Hallmark Photographic
Collection, a project of
Hallmark Cards, Inc.,
Kansas City, Missouri

82. **Alvin Langdon Coburn**
Tunnel Builders, 1909
Photogravure, 7½ x 6¼ in.
(19.1 x 15.9 cm)
Private collection

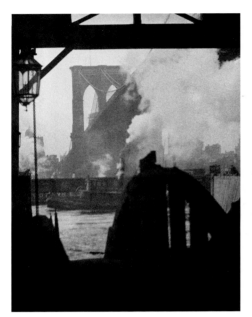

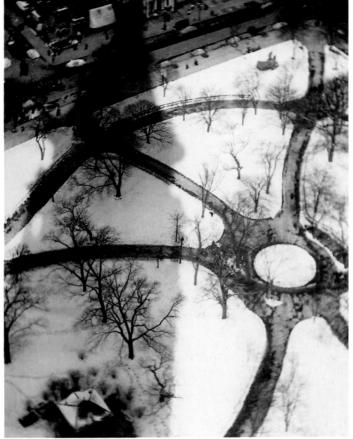

85. **Alvin Langdon Coburn**
The Octopus, 1912
Platinum print, 16¹¹⁄₁₆ x
12¹¹⁄₁₆ in. (42.3 x 32.2 cm)
George Eastman House,
Rochester, New York

86. **Edward Steichen**
Brooklyn Bridge, 1903
(printed 1960s)
Gelatin silver print, 17 x
14 in. (43.2 x 35.6 cm)
LaSalle National Bank
Photography Collection,
Chicago

83. **Karl Struss**
*Brooklyn Bridge from Ferry
Slip, Late Afternoon,* 1912
Platinum print, 4⅞ x
3¹¹⁄₁₆ in. (12.4 x 9.4 cm)
Amon Carter Museum,
Fort Worth, Texas

84. **Edward Steichen**
The Flatiron, 1904
(printed 1905)
Gum bichromate over plat-
inum print, 19⅝ x 15⅜ in.
(49.9 x 38.9 cm)
The Metropolitan Museum
of Art, New York; The
Alfred Stieglitz Collection,
1933

87. *Pennsylvania Railroad Station,* 1914

88. **Daniel H. Burnham** and **Edward H. Bennett**
Proposed Civic Center Plaza, perspective rendered by Jules Guérin, 1908
Graphite and watercolor on paper, 29¾ x 41⅙ in.

(75.5 x 105.5 cm)
The Art Institute of Chicago; On permanent loan to The Art Institute of Chicago from the City of Chicago

REORDERING THE CITY

The thirty years following the Civil War in America were marked by massive growth in industry, commerce, transport, and population. In this turbulent and expansive period, cities exploded into new

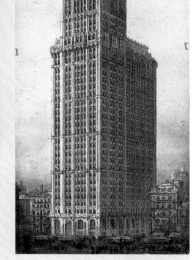

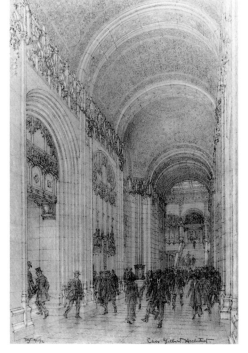

89. **Cass Gilbert**
Woolworth Building, New York, 1910, perspective rendered by T. R. Johnson
Ink and wash on board, approximately 30 x 12 in. (76.2 x 30.5 cm)
The New-York Historical Society

90. **Cass Gilbert**
Woolworth Building Lobby, New York, c. 1911
Ink and wash, approximately 16 x 10 in. (40.6 x 25.4 cm)
The New-York Historical Society

quarters. Streets, waterfronts, and depots descended into architectural disorder as gigantic new structures set themselves beside modest old ones, as existing buildings were chopped up so that ever busier streets could be widened, and as the taste for exuberant eclecticism—from the flamboyant historicisms of the Second Empire style to the severity of Henry Hobson Richardson's neo-Romanesque—mirrored the reckless uncertainty of the time.

For the first fifteen years of the twentieth century, America set about regulating its new wealth and reforming its unruly urban life, reconceiving the city at a new scale and rethinking the city center as a focus of culture, the generator and emblem of John Dewey's "moral democracy." This progressive spirit was evident in such ambitious reworkings of the urban system as Philadelphia's Fairmount Parkway (fig. 91), where institutions of science, learning, and civil arts were to be ranged along a broad civic avenue, or Daniel H. Burnham and Edward H. Bennett's spacious Chicago plan, in which an entire nineteenth-century city was to be reordered along transportation axes (fig. 88). As the city's infrastructure went underground, and layers of transportation rose above, ever more visionary schemes were proposed.

In New York, where the island geography of Manhattan had delayed the arrival of the railroad until the later nineteenth century, two massive projects illustrate the

mitigate their discomfort with this "monster," new America, Stieglitz and his fellow Pictorial photographers humanized it by enveloping it in veils of snow, mist, and haze.

The heyday of this urban soft-focus photography was short-lived, as Stieglitz and other Photo-Secessionists, including second-generation members like Karl Struss, began to turn away from soft-focus techniques to a more geometric, objective style known as straight photography because of its reliance on unmanipulated images (figs. 92, 93). Stieglitz had always resisted overt technical manipulation of images, preferring to rely on atmosphere to mute the harsh realities of modern life. In 1907, he had temporarily abandoned the tonal nuances of Pictorialism to take what he later considered the most important photograph of his career, *The Steerage* (fig. 94). According to his much later account, he took the photograph because of the impact the geometric elements of

re-scaling of the city. McKim, Mead, and White's Pennsylvania Station was the first to realize a "superblock"—a massive metal framework that allowed a single masonry composition to embrace a whole sector of the city in one unified, chaste, and rational architectural scheme (fig. 87). Proposals for Grand Central Terminal were even more ambitious, using the space above the railroad tracks to situate a great aerial avenue, and moving traffic around it four stories above ground level. In the Woolworth Building of 1911, Cass Gilbert (once a draftsman for McKim, Mead, and White, who in turn had served with Richardson) moved the office tower sky-high, taking advantage of new steel-frame structural techniques and of electrically driven systems to generate an unprecedented vertical density (fig. 89). The building's sheer walls arrive at a new formal language that breaks away from the load-bearing constraints of masonry construction. In Gilbert's drawings for this first great skyscraper, one sees the lure of Edison, and the modernity he represented—from the lantern that serves as a beacon of the future to the vivid electric glow of the lobby (fig. 90). —N. O.

91. **Paul Philippe Cret**
Proposed Scheme for the Philadelphia Parkway, 1907
Graphite on paper, 28½ x 21 in. (72.4 x 53.3 cm)
The Architectural Archives of the University of Pennsylvania, Philadelphia

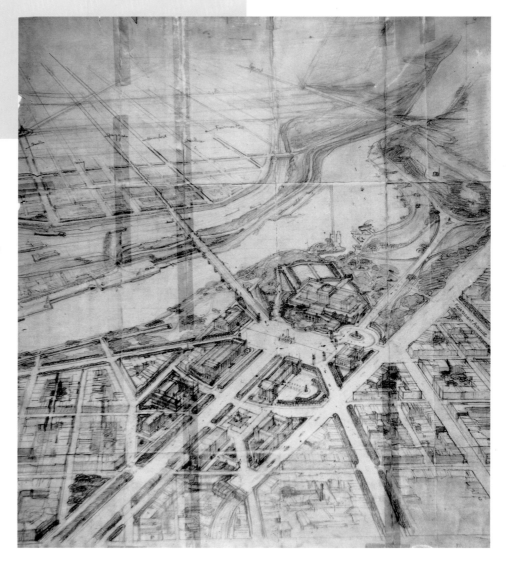

92. Karl Struss
Fifth Avenue, c. 1914
Toned gelatin silver print,
7⅛ x 9⅜ in. (18.1 x
23.8 cm)
Laurence Miller Gallery,
New York

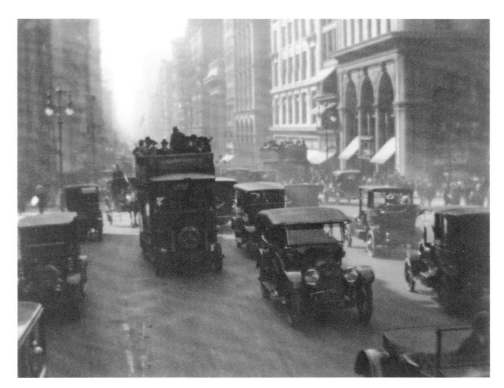

93. Alfred Stieglitz
*From the Back Window—
"291",* 1915
Platinum print, 9⅝ x
7⅝ in. (24.1 x 19.1 cm)
National Gallery of Art,
Washington, D.C.; Alfred
Stieglitz Collection

94. Alfred Stieglitz
The Steerage, 1907
Photogravure, 13¹³⁄₁₆ x
10⁷⁄₁₆ in. (33.5 x 26.5 cm)
Whitney Museum of
American Art, New York;
Gift of an anonymous
donor 77.106

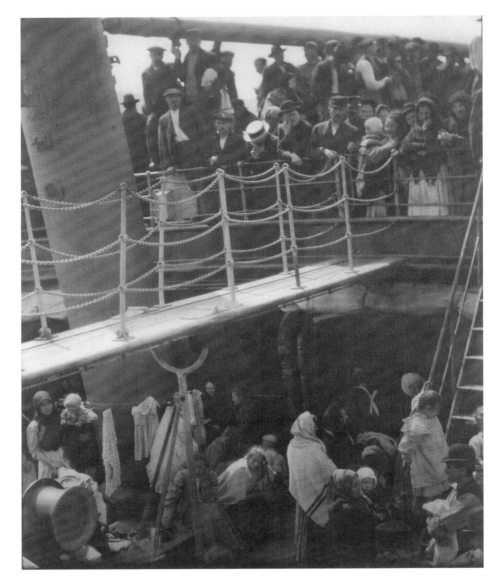

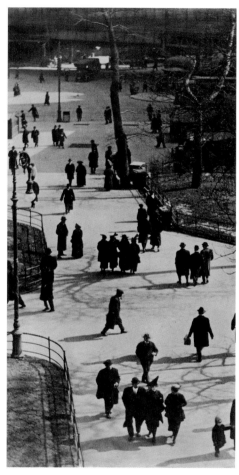

95. **Paul Strand**
Wall Street, New York,
1915 (printed later)
Platinum palladium print,
10⅛ x 12¹³/₁₆ in. (25.7 x
32.2 cm)
Whitney Museum of
American Art, New York;
Gift of Michael E. Hoffman
in honor of Sondra Gilman
91.102.2

96. **Paul Strand** and
Charles Sheeler
Film still from *Manhatta,*
1920
The Museum of Modern
Art, New York/Film Stills
Archive

97. **Paul Strand**
New York, City Hall Park,
1915
Platinum print, 13⅜ x
6½ in. (34 x 16.7 cm)
The J. Paul Getty Museum,
Los Angeles

the scene made on him, but he did not show it publicly until 1911 because of the lukewarm response it received from his co-worker and fellow Pictorialist Joseph Keiley.[8] He included it in the October 1911 issue of *Camera Work*, along with fourteen other photographs, many of which underscored his ambivalence about the "new America still in the making."

By 1912, Photo-Secessionists such as Struss had begun exploiting the tension between the romantic moodiness of Pictorialism and the bold, angular geometry of the urban environment. Yet it was not until Paul Strand's 1914 cityscapes that the transition from classic Pictorialism to modernism began in earnest (figs. 95, 97). What distinguished Strand's photographs from other urban records was their striking fusion of strong formal clarity with an interest in movement and dynamism. By setting the geometry of the city's architectural forms against the organic flux of

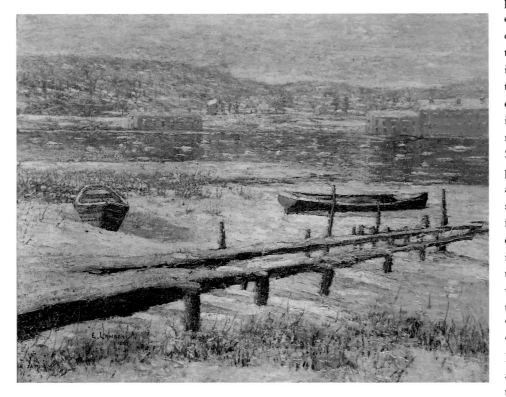

98. **Ernest Lawson**
Winter on the River, 1907
Oil on canvas, 33 x 40 in.
(83.8 x 101.6 cm)
Whitney Museum of
American Art, New York;
Gift of Gertrude Vanderbilt
Whitney 31.280

pedestrians and moving vehicles, Strand expressed the chaos and impermanence of the modern metropolis while simultaneously acknowledging the solidity of its physical structures. His portrayal of those elements he believed were most expressive of the city's spirit would find its fullest realization in *Manhatta,* the nine-minute film he made with Charles Sheeler in 1920 (fig. 96).[9] By then, both photographers were firmly established as highly respected proponents of straight photography. Although the film registered their respect for the powerful physicality of the city's buildings, it retained the romantic humanism of the Pictorialists. Its epic romanticism was due, in part, to the intertitle quotations from Walt Whitman's poems— "Broadway Pageant," "Mannahatta," "Crossing Brooklyn Ferry," and "A Hymn of Praise to New York City"— and, in part, to the cinematic sequences themselves. The film opened with a ferry's arrival in New York and closed with a tranquil image of the sun shimmering on the harbor. In between, misty clouds of steam and smoke softened the geometricized cityscape. Balancing this emotional and, at times, ecstatic vocabulary was the aggressive modernity of the film's unconventional, flattened perspectives, its oblique angles, close-cropped framing, and taut, geometric treatment of rooftop architecture. In its incorporation of these dichotomous impulses, the film bridged Pictorialist urban photography and the crisp, hard-edged style that followed.

Painters and printmakers likewise responded to the economic and technological prowess of their nation by turning their attention to metropolitan America, where that prowess was most evident. While exhilarated by the archetypal modernity of the new America, they, like the Pictorial photographers, continued to shroud the city in gray and muted light so that it assumed the mysterious ambience of the poetic and the charm of the picturesque. Such restraint in the presence of the modern was particularly apparent in the work of Ernest Lawson, Childe Hassam, Theodore Robinson, Guy Wiggins, and Edward Willis Redfield (figs. 98–101).

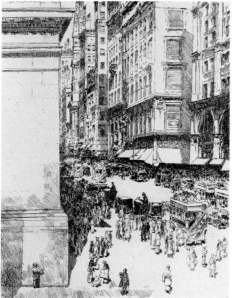

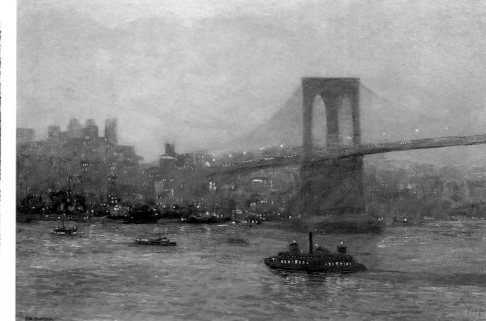

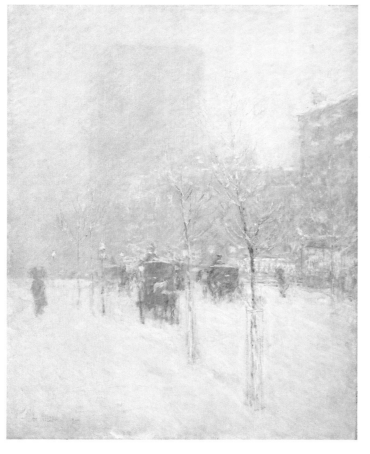

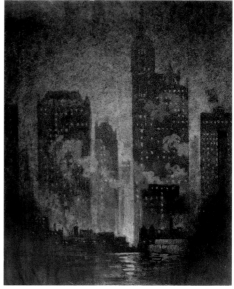

99. **Childe Hassam**
Fifth Avenue, Noon, 1916
Etching, 10⅝ x 7¹¹⁄₁₆ in.
(27 x 19.5 cm)
The Metropolitan Museum
of Art, New York; Gift of
Mrs. Childe Hassam, 1940

100. **Childe Hassam**
*Late Afternoon, New York:
Winter,* 1900
Oil on canvas, 37 x 29 in.
(94 x 73.6 cm)
Brooklyn Museum of Art,
New York; Dick S. Ramsay
Fund

101. **Edward Willis Redfield**
Brooklyn Bridge at Night,
1909
Oil on canvas, 36 x 50 in.
(91.4 x 127 cm)
CIGNA Museum and Art
Collection, Philadelphia

102. **Joseph Pennell**
Cortlandt Street Ferry,
1908
Sandpaper mezzotint,
12¹⁵⁄₁₆ x 9¹³⁄₁₆ in. (32.9 x
24.9 cm)
The Metropolitan Museum
of Art, New York; Harris
Brisbane Dick Fund, 1917

103. George Luks
Roundhouse at High Bridge, 1909–10
Oil on canvas, 30⅜ x
36¼ in. (77.2 x 92.1 cm)
Munson-Williams-Proctor
Institute Museum of Art,
Utica, New York; Museum
Purchase

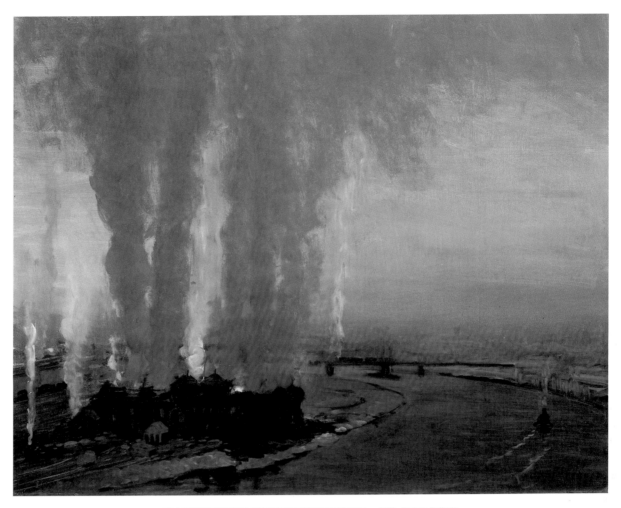

104. George Bellows
*Pennsylvania Station
Excavation,* 1909
Oil on canvas, 31¼ x
38¼ in. (104 x 121.3 cm)
Brooklyn Museum of Art,
New York; A. Augustus
Healy Fund

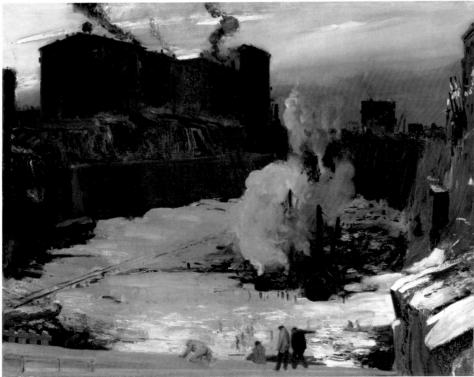

105. Jonas Lie
Path of Gold, c. 1915
Oil on canvas, 34 x 36 in.
(86.4 x 91.4 cm)
High Museum of Art,
Atlanta; J. J. Haverty
Collection

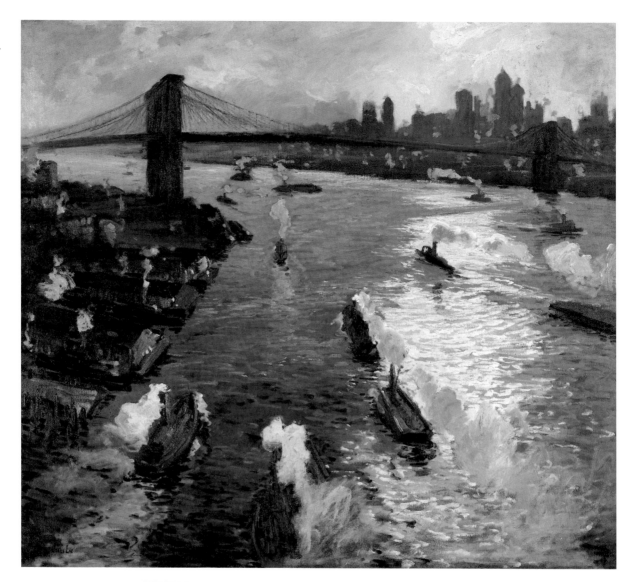

106. B. J. O. Nordfeldt
Calumet River Chicago,
1911
Etching, 8⅞ x 11¾ in.
(22.4 x 29.9 cm)
The Metropolitan Museum
of Art, New York; Gift of
Mrs. B. J. O. Nordfeldt,
1955

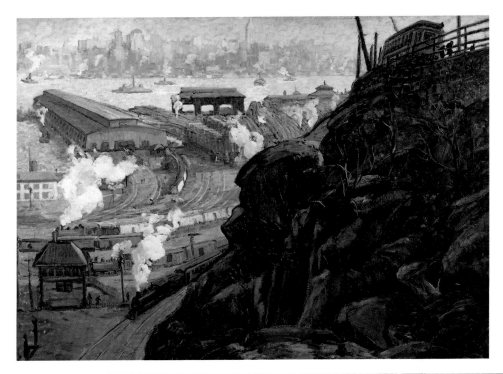

107. **Leon Kroll**
View of Manhattan from the Terminal Yards, Weehawken, New Jersey, 1913
Oil on canvas, 36 x 48 in. (91.4 x 112.9 cm)
Collection of Richard Weimer

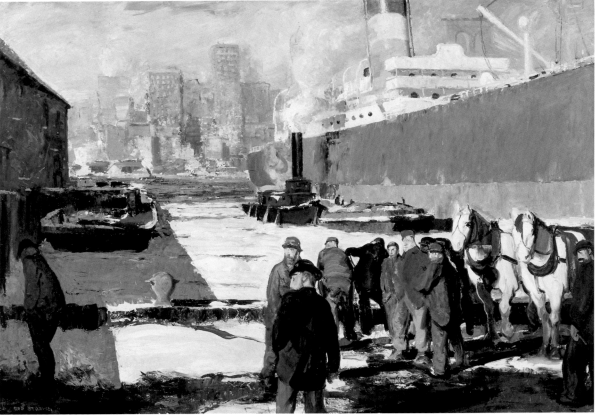

108. **George Bellows**
Men of the Docks, 1912
Oil on canvas, 45 x 63½ in. (114.3 x 161.3 cm)
Maier Museum of Art, Randolph-Macon Woman's College, Lynchburg, Virginia; First Purchase of the Randolph-Macon Art Association, 1920

Hassam, for example, infused his New York street scenes with moody atmospheric effects of mist, snow, fog, and twilight. Even when he enlarged his repertoire to include skyscrapers, construction sites, and bridges, his soft-focus effects and narrow color range neutralized the modernity of these images by encoding them in nature. So too with Redfield, who recast his nighttime panoramas of bridges and skyscrapers as shimmering firmaments.

Joseph Pennell, returning to America in 1904 after a thirty-year absence, was elated by the country's skyscrapers, docks, mills, and bridges—which he considered the "true temples of the present" (fig. 102).[10] Nevertheless, in depicting these emblems of American industry and commerce, he adhered to the essentially Impressionist style of his mentor James McNeill Whistler and generally avoided references to the human dimensions of labor. In defending himself against charges that he lacked social awareness, he claimed that he was "simply an artist searching for the Wonder of Work—not for morals—political economy—stories of sweating—the crimes of ugliness."[11]

Even artists who responded to the energy of the American metropolis with a more dynamic and forceful realism often punctuated their vistas with cloudlike pockets of steam. In the hands of printmakers and painters such as George Bellows, George Luks, Jonas Lie, Gifford Beal, Leon Kroll, and

NATURALIST LITERATURE

In the first two decades of the twentieth century, American writers responded to the breathtakingly swift rise of the ruthless, winner-take-all culture of the Industrial Revolution. Just twenty years earlier, by "lighting out for the territory," Huckleberry Finn could at least *try* to outrun the hypocrisies of what Mark Twain contemptuously called "sivilization": a nation built on corruption, violence, and deceit. By 1901, however, Frank Norris showed that Huck's flight to freedom was merely a hopeless and naive romance. In Norris' *The Octopus* (1901), Huck's West is already caught in the cruel grip of the railroad, a monster whose tentacles encircle and strangle, obliterating the rancher's way of life in the service of the corporate purse. Laissez-faire liberalism and industrialization yielded a damning legacy of unrestrained individualism. Naturalism, like muckraking and Progressivism, grew out of a deeply troubled America torn by class turmoil, nativist xenophobia, and sexual conflict.

Drawing on the gritty, cynical styles of French authors Émile Zola and Honoré de Balzac, the Naturalists viewed life as a relentless struggle and the American myth of rugged individualism as a merciless fantasy. Naturalists stripped away the lies masking squalid and violent realities, lies bred of the corruption of America's religious institutions, factory system, and vapid popular culture. Stephen Crane's *Maggie: A Girl of the Streets* (1893), a story of ruination amid jammed Bowery tenements, presaged Norris' and Theodore Dreiser's economic determinism, spare style, and sometimes treacly sentimentality. Dreiser's *Sister Carrie* (1900; fig. 109) showed that the sunny premise according to which each American was free to succeed was in fact undermined by ruthless social and economic laws that sustained an amoral and hypocritical system. Naturalist America was no open frontier ripe with promise. For Dreiser, America was a machine that split families and degraded human dignity. At its heart lay a great walled city, at once forbidding and magnetically attractive, that seemed to promise wealth and happiness while working mindlessly to exterminate all who drew near with stifling workhouses, foul lodgings, and crowds of isolated souls. Never agents of their own destiny, Naturalism's unclever, trusting protagonists are vulnerable and dependent—pitiable waifs amid superhuman forces, borne along by seducers, vague appetites, and witless chance. Profoundly influenced by Social Darwinist thinkers whose "survival of the fittest" mentality used evolution to rationalize class divisions, Naturalist fiction inspired dread and sympathy, providing a foundation for the kind of social changes in which its practitioners did not always seem to believe. —J. W.

109. *Sister Carrie,* by Theodore Dreiser (first published 1900) New York: Dodge, 1907 Berg Collection of English and American Literature, The New York Public Library, Astor, Lenox and Tilden Foundations

B. J. O. Nordfeldt, the billowing smoke of steam engines and freight trains became metaphors not for poetic reverie but for American power and prosperity (figs. 103–108). With a veiled haze that alluded, but did not succumb, to the pastoral, these paintings exuded a dynamic authority that mediated between urban modernity and rural arcadia. Shunning the softened, close-toned harmonies of Impressionism and the meticulous detailing and glossy finish of Neoclassicism, these painters used broad, vigorous brushstrokes and dark, brooding colors to visualize the grandeur, exuberance, and violent strength of the new America.

ROBERT HENRI AND URBAN REALISM

American technology and engineering expertise were not the only sources of a self-consciously American art. American national identity was also discovered in the commonplace aspects of daily urban life. Pleas for a specifically American and "democratic" art that dealt with the everyday urban world had been voiced in the literary community during the last decade of the nineteenth century. Following the call of literary realists William Dean Howells and Hamlin Garland to reject the escapist fantasies of the Gilded Age and turn for subject matter to daily life, Naturalist writers such as Theodore Dreiser, Stephen Crane, and Frank Norris had crafted the hard realities of urban poverty into powerful works of fiction. Unlike their predecessors, they subscribed to the philosophy of determinism, which held that heredity and environment governed everything; moral choices were nonexistent. The protagonists of their novels, trapped in a physical world over which they have no control, live sordid, grim lives. So candidly did Dreiser treat sexuality and depict the corrupting choices forced upon young girls driven by poverty and material

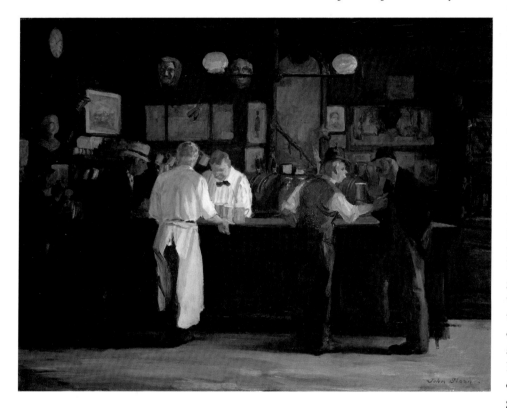

110. **John Sloan**
McSorley's Bar, 1912
Oil on canvas, 26 x 32 in.
(66 x 81.3 cm)
The Detroit Institute of
Arts; Founders Society
Purchase, General
Membership Fund

desire that his novel *Sister Carrie* (1900) was initially suppressed by his publisher.

Around 1900, artists too began to look at the unvarnished facts of vernacular life for subject matter. Like their literary counterparts, they rejected the domesticated interiors and introspective portraits of the genteel tradition. But unlike the writers who emphasized the urgency of struggle and discontent, this new generation of urban realists chronicled an optimistic, democratic world of lighthearted enjoyments and gaiety. Unabashedly extroverted and romantic, they exulted in the dense, agitated, frenetic pace of the city and sought out as subjects those spots where people congregated—streets, parks, beaches, and night spots (figs. 110–16). For these artists, the social and economic inequities of poverty, ethnicity, and age were irrelevant. What mattered to them was immediacy and intensity, not social protest.

A pictorial reaction against the eviscerated and refined themes of genteel society was probably inevitable. Nevertheless, the particular inflection it took in the early years of the century was due primarily to one man—Robert Henri—and to

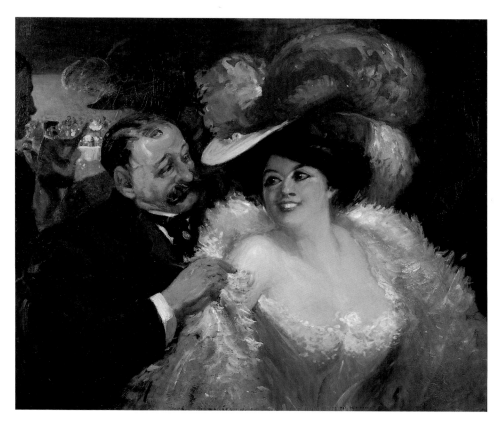

111. George Luks
The Café Francis, c. 1906
Oil on canvas, 36 x 42 in.
(91.4 x 106.7 cm)
The Butler Institute of
American Art, Youngstown,
Ohio

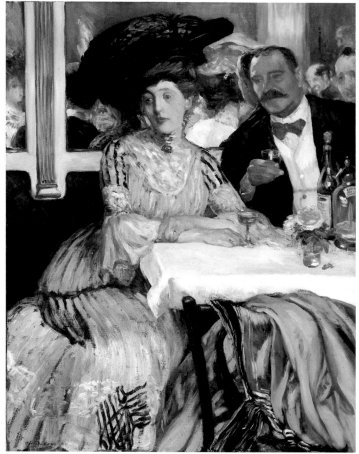

112. William Glackens
At Mouquins, 1905
Oil on canvas, 48⅛ x
36 in. (121.9 x 99.1 cm)
The Art Institute of
Chicago; Friends of
American Art Collection

113. John Sloan
Hell-Hole, 1917
Etching and aquatint,
7⅞ x 9¾ in.
(20 x 24.8 cm)
Whitney Museum of
American Art, New York;
Purchase 31.859

114. **John Sloan**
Picture Shop Window,
1907–8
Oil on canvas, 32 x
25⅛ in. (81.3 x 63.8 cm)
The Newark Museum, New
Jersey; Gift of Mrs. Felix
Fuld, 1925

115. **Maurice Prendergast**
Central Park, 1901, 1901
Watercolor on paper, 15⅟₁₆ x
22⅛ in. (38.3 x 56.2 cm)
Whitney Museum of
American Art, New York;
Purchase 32.42

116. **John Sloan**
The Picnic Grounds,
1906–7
Oil on canvas, 24 x 36 in.
(61 x 91.4 cm)
Whitney Museum of
American Art, New York;
Purchase 41.34

one place—Philadelphia. Before the turn of the century, the Pennsylvania Academy of the Fine Arts in Philadelphia had been the academic platform for Thomas Eakins, one of the few artists of his time to encourage students to "study their own country and to portray its life and types."[12] Although Eakins had been dismissed from the Academy in 1886 for removing the loincloth of a male model in a mixed class of men and women, his influence was still dominant during Henri's years there. Through his study under Eakins' protégé Thomas Anshutz, Henri developed

THE OPEN-AIR SCHOOL IN HOGAN'S ALLEY.

a profound respect for an art of uncompromising truthfulness that reflected the unique qualities of the American experience. In 1888, Henri left Philadelphia for a four-year sojourn in Paris. Unimpressed by the optical surface sensations of Impressionism, he was drawn instead to the work of Hals, Velázquez, and the "Spanish" period of Manet. In their somber palettes and virtuoso contrasts of light and shadow, he found a means of communicating personal feeling and authenticity of experience.

When Henri returned to Philadelphia in 1891 to teach at the Pennsylvania Academy of the Fine Arts, he imparted what he had learned in Europe to a group of young artist-reporters who worked together on the *Philadelphia Press*—William Glackens, Everett Shinn, John Sloan, and George Luks. These artists gathered weekly at the Charcoal Club to sketch informally from life under more adequate lighting than that provided by the Academy. After the Club's demise in 1894, these informal discussions and sketching sessions shifted to Henri's studio on Walnut Street. Charismatic and messianic, Henri persuaded these young disciples to abandon illustration and become artists. Under his guidance, they established a new realism premised on the close observation and ecstatic celebration of the daily lives of ordinary Americans.

117. **George Luks**
The Open-Air School in Hogan's Alley
From *The New York World*, October 18, 1896
Collection of Richard Marschall

118. **William Glackens**
A Spring Morning in Washington Square
Cover of *Collier's*, April 16, 1910
Butler Library, Columbia University in the City of New York

119. **Everett Shinn**
Café Martin, Formerly Delmonico's, c. 1908
Pastel on paper, 17½ x 23½ in. (44.5 x 59.7 cm)
Mint Museum of Art, Charlotte, North Carolina; The Harry and Mary Dalton Collection

In this endeavor, they relied on their talents as newspaper illustrators. Although they composed their paintings from memory in the studio, their experience as artist-reporters determined the style and subject matter of their realism. Newspaper reporting had trained their memories and the quickness of their perceptions and encouraged them to develop a spontaneous, notational style of broad, loose brushstrokes. It had also encouraged them to emphasize topical, human-interest subjects and to portray these relatively ordinary stories as picturesque or sensational. Thus, although they were nurtured by Henri, their commitment to human interest and the "facts of life" had its roots in their journalistic work, just as it had with the Naturalist writers who had begun

their careers working on newspapers. And, as with these writers, journalism ultimately led them to New York, the center of the mass circulation press.

By 1900, when Henri returned from his second European sojourn to teach at the New York School of Art, Glackens, Luks, and Shinn were already in residence in the city. Initially employed by newspapers such as the *New York World* and the *New York Herald* to illustrate news stories or, in Luks' case, to draw comic strips (fig. 117), they had eventually procured more lucrative and less time-demanding assignments illustrating books and popular magazines (figs. 118, 119). Henri's studio once again became the meeting place for these artists, as it had been in Philadelphia. By the time John Sloan arrived in New York in 1904, Henri had gathered around him a robust group of students and friends that included the Philadelphia group, younger artists such as George Bellows, Rockwell Kent, and Glenn Coleman, and various newspaper critics who would later become important champions of Henri's brand of urban realism.

Henri presented a startling contrast to his teaching colleague and founder of the New York School of Art, William Merritt Chase. Although sharing an affinity for rapid, virtuosic paint handling, the two artists differed radically in their attitude toward painting and their choice of subjects. Chase encouraged students to pictorially reflect the qualities cherished by genteel society and epitomized by proper manners, domestic introspection, and idealized femininity. Henri, in contrast, preached that art must express the spirit of its time, that it must give shape to the world around it. Counseling artists to look to their own time and nation for subject matter, he argued that American artists needed an art "that expresses the *spirit* of the people of today."[13] What that meant to Henri was a new kind of subject matter, which incorporated the disorder, frenzy, and uncontrolled energy of the modern city. To him, such subjects circumvented artifice and sentimentality. Their immediacy and intensity were needed to generate an equally immediate and intense art. "Because we are saturated with life, because we are human," Henri wrote, "our strongest motive is life, humanity; and the stronger the motive back of a line, the stronger, and therefore the more beautiful, the line will be. . . . It isn't the subject that counts but what you feel about it."[14]

To facilitate the direct and spontaneous transmission of self into art, Henri favored rapid, spontaneous execution and painterly techniques. He advised painters to work quickly on the entire canvas rather than to labor over its individual parts: "Do it all in one sitting if you can. In one minute if you can."[15] He even forbade the use of small brushes in his class because they fostered an emphasis on delicate detail. The results were loose, painterly brushstrokes that emphasized mass rather than line.

Henri's admonitions accorded with contemporary calls for "masculine" renewal in American society to counter what some saw as the feminization of culture, a trend they feared would sap American vitality. Faced with new technologies, new leisure, and the accelerated pace of modern life, many Americans had become victims of psychiatric and emotional disorders characterized by chronic fatigue and lack of motivation—neurasthenia, it was called. Theodore Roosevelt's insistence on the "strenuous life" and the emphasis, within Henri's circle, on physical manhood and intense passions were part of a pervasive counteroffensive against this debilitating languor that seemed to loom over tired, nerve-shaken Americans.

Henri's protégés heeded his call for "making pictures from life."[16] Enthralled by the density and vitality of the city, they painted everyday things and people with a robust impulsiveness that mirrored the vigor and optimism of America during the Roosevelt years. They sought out painting subjects in unfashionable, ethnic neighborhoods because they believed that such sites offered an authenticity and

121. **Robert Henri**
Eva Green, 1907
Oil on canvas, 24 x
20⅛ in. (61 x 51.1 cm)
Wichita Art Museum,
Kansas; The Roland P.
Murdock Collection

120. **George Bellows**
Paddy Flannigan, 1908
Oil on canvas, 30¼ x
25¼ in. (76.8 x 64.1 cm)
Collection of Erving and
Joyce Wolf

123. **John Sloan**
The Hawk (Yolande in Large Hat), 1910
Oil on canvas,
26�5⁄16 x 32¼ in.
(66.8 x 81.9 cm)
Whitney Museum of
American Art, New York;
50th Anniversary Gift of
the John Sloan Memorial
Foundation 90.15

122. **Robert Henri**
Salome, 1909
Oil on canvas, 77½ x
37 in. (196.9 x 94 cm)
The John and Mable
Ringling Museum of Art,
the State Art Museum of
Florida, Sarasota

124. **John Sloan**
The Haymarket, 1907
Oil on canvas, 26¼ x
32⅛ in. (66.6 x 81.4 cm)
Brooklyn Museum of Art,
New York; Gift of Mrs.
Harry Payne Whitney

125. **Everett Shinn**
Stage Scene, 1906
Oil on canvas, 24⅛ x
29⅜ in. (61.1 x 74.6 cm)
Collection of Daniel and
Rita Fraad

126. George Luks
Cake Walk, 1907
Monotype, 5 x 7 in.
(12.7 x 17.8 cm)
Delaware Art Museum,
Wilmington; Gift of
Helen Farr Sloan

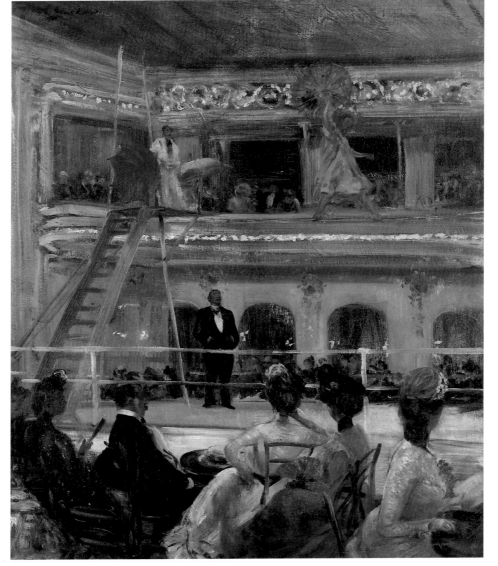

127. William Glackens
*Hammerstein's Roof
Garden,* c. 1901
Oil on canvas, 30 x 25 in.
(76.2 x 63.5 cm)
Whitney Museum of
American Art, New York;
Purchase 53.46

129. **Joseph Stella**
*Immigrant Girl:
Ellis Island,* 1916
Charcoal on paper, 29 x
14⅛ in. (73.7 x 35.9 cm)
Hirshhorn Museum and
Sculpture Garden,
Smithsonian Institution,
Washington, D.C.; The
Joseph H. Hirshhorn
Bequest, 1981

130. **Joseph Stella**
Portrait of an Old Man,
1908
Graphite and colored
pencil on paper, 11¾ x
9¼ in. (29.9 x 23.5 cm)
Sheldon Memorial Art
Gallery, University of
Nebraska, Lincoln;
Howard S. Wilson Memorial

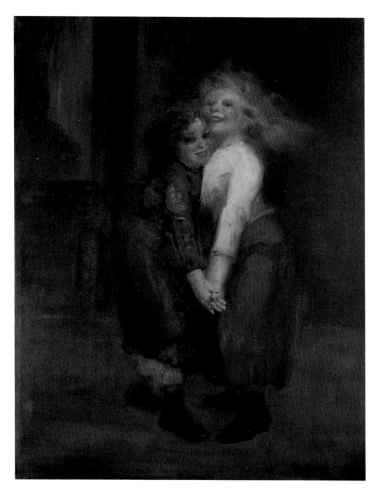

128. **George Luks**
The Spielers, 1905
Oil on canvas, 36¹⁄₁₆ x
26¼ in. (91.6 x 66.7 cm)
Addison Gallery of
American Art, Phillips
Academy, Andover,
Massachusetts; Gift of an
anonymous donor

131. **Augustus Sherman**
Gypsy Family at Ellis Island, c. 1910
Gelatin silver print, 9½ x 6¾ in. (24.1 x 17.1 cm)
William Williams Papers, Manuscripts and Archives Division, The New York Public Library, Astor, Lenox and Tilden Foundations

132. **Arnold Genthe**
The Street of Gamblers (By Day), 1895–1906
Gelatin silver print, 23 x 17 in. (58.4 x 43.2 cm)
California Historical Society, San Francisco

133. **Augustus Sherman**
Women from Guadeloupe, West Indies, at Ellis Island, 1911
Gelatin silver print, 9½ x 7⅛ in. (24.1 x 18.1 cm)
William Williams Papers, Manuscripts and Archives Division, The New York Public Library, Astor, Lenox and Tilden Foundations

134. **Arnold Genthe**
Shop in Chinatown, San Francisco, 1896
Gelatin silver print, 10⅜ x 13⅛ in. (26.3 x 33.3 cm)
The Museum of Modern Art, New York; Gift of Albert M. Bender

vivacity absent from the world of wealth and privilege (figs. 120, 121, 123, 128–30). Their desire to assault cultural codes of restraint, propriety, and the separated spheres of men and women, which had been the hallmark of Victorian culture, also led them to popular culture and to public sites of social pleasure and leisure activities (figs. 122, 124–27). In allowing unsupervised encounters between men and women, popular entertainment satisfied the artists' quest for spontaneity and for freedom from the chafing restraints of Victorianism.

RACE AND AFRICAN AMERICAN SELFHOOD

Faced with the violently restrictive conditions that would later be called the "nadir" of the African American experience, U.S. blacks writing in the first two decades of the twentieth century necessarily defended black selfhood in terms that rendered the meaning of African American identity increasingly complex. In countering the charges of black brutishness and moral inferiority that were marshaled to legitimize the intensified repression that African Americans experienced after the end of Reconstruction, black intellectuals unavoidably engaged in an ethical discourse with far-reaching ramifications for African Americans' social standing.

Thus Booker T. Washington, in his 1901 autobiography *Up from Slavery,* strove to assuage whites' anxieties about "social equality" among the races. He outlined a program for industrial education that would have ensured the continued social inferiority of African Americans and Native Americans alike. At the same time, W. E. B. Du Bois asserted that training in the liberal arts would be beneficial to blacks: educated blacks would be able to morally uplift the African American laboring classes, thus promoting a sense of racial unity. Both positions suggested that bourgeois social values of industry, thrift, and sexual chastity needed to be promulgated among an African American constituency, thereby corroborating the very charges of black moral degradation they were meant to refute.

A primary effect of this development—itself a consequence of the crucial move among anti-lynching and black-suffrage activists of the 1890s to establish an African American claim to the condition of "civilization"—was the differentiation of the African American populace into various social strata, and the solidification of bourgeois mores as the essential element of full-fledged "American" identity. This was manifested in such contemporary works by black authors as Pauline E. Hopkins' "uplift fiction" *Contending Forces: A Romance of Negro Life North and South* (1900) and her three novels serialized in *Colored American Magazine* (1901–3); Du Bois' protest novel, *The Quest of the Silver Fleece* (1911); and James Weldon Johnson's fictional racial "passing" narrative, *The Autobiography of an Ex-Colored Man* (1912). The concept of "passing" also informs the distinctive autobiographical works of the Chinese American Sui Sin Far (Edith Eaton) ("Leaves from the Mental Portfolio of an Eurasian," 1909) and the Santee Sioux Charles Eastman (*Indian Boyhood*, 1902, and *From the Deep Woods to Civilization*, 1916). The ethic of bourgeois citizenship thus joined the nationalism produced by U.S. participation in World War I to define "American" existence across all lines of race and ethnicity. It constitutes one of the lasting sociocultural legacies of this critical period. —P. B. H.

Henri and his fellow urban realists were as fascinated as Symbolist artists by the "exotic" and decadent, but they directed their romantic impulses toward the contemporary world of their own experience, rather than to the past. Their vision of slum life as picturesque and exotic paralleled that in the photographs Augustus Sherman took of arriving immigrants at Ellis Island (figs. 131, 133) and the candid shots Arnold Genthe produced with a concealed camera of urban street life in San Francisco's Chinatown (figs. 132, 134). That Genthe's photographs, albeit invasive, coincided with the passing of a bill forbidding Asian immigration gave them a poignant status as records of a disappearing culture.

The enormous number of immigrants who arrived in America between 1890 and 1914 furnished cities with a turbulent, chaotic energy. The influx of immigrants was augmented by rural and small-town Americans—white as well as black—who likewise made the

135. **Lyonel Feininger**
The Kin-der-Kids Abroad
From *The Chicago Tribune,*
1906

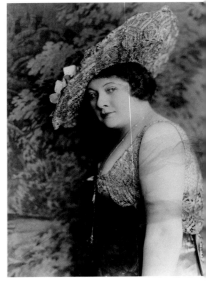

VAUDEVILLE AND THE *FOLLIES*

By 1900, the major form of entertainment in the United States was vaudeville, a kind of variety performance that had developed out of saloon owners' efforts to attract eager and free-spending drinkers with free shows. During the 1870s and 1880s, vaudeville had slowly been cleaned up to appeal to a more respectable and broader clientele. Like the earlier blackface minstrel show, it was open to entertainers from ordinary backgrounds and served a largely working-class audience. But since most of its entertainers did not wear the black mask, it also fostered new themes and specialties. Given a large new European immigrant population, vaudeville was an especially effective venue for ethnic humor (in particular German, Italian, Jewish, and Irish) and became a kind of American microcosm, incorporating many separate parts into a whole.

Vaudeville's heyday lasted a scant fifty years, its symbolic death blow coming in 1932 when New York's Palace Theater, America's premier vaudeville house, succumbed to the new film industry. During its peak, it was a profitable big business, aiming to amuse or distract while making as much money as possible. In the teens, there were some one thousand "big-time" vaudeville theaters and more than four thousand "small-time" ones; at its height of popularity, ten people attended a vaudeville show for every one who patronized all other forms of entertainment. As many as ten to twenty thousand acts competed for bookings. The result was a largely anti-intellectual enterprise that attempted to provide something for everyone. More than any other form of American entertainment, vaudeville influenced morals and attitudes across the country.

By the late teens, however, other amusement forms were beginning to eclipse the popularity of vaudeville. Lavish revues, musical comedies, and even burlesque stole the better vaudevillians, while offering a more sophisticated audience forms of spectacle and surface elegance impossible in vaudeville, whose hallmark was frequent bill changes and specialty acts.

Of the new live entertainment forms in the teens, the revue essentially merged high-class burlesque with vaudeville acts, and added a tenuous story line. The productions were enhanced by spectacular scenery designed by such artists as the Austrian American Joseph Urban and with music composed by the likes of Irving Berlin and George and Ira Gershwin. Urban, who worked for Florenz Ziegfeld, producer of the famous *Follies* (1907–32), abandoned the standard painted scenery of the day for sets that were as innovative as they were artistic. Though simple in line and detail, his scenery incorporated vibrant color and a pointillist technique that created a sense of

136. *Will Rogers,* n.d. Billy Rose Theatre Collection, The New York Public Library for the Performing Arts, Astor, Lenox and Tilden Foundations

137. *Eddie Cantor,* n.d. Billy Rose Theatre Collection, The New York Public Library for the Performing Arts, Astor, Lenox and Tilden Foundations

138. *W. C. Fields,* n.d. Billy Rose Theatre Collection, The New York Public Library for the Performing Arts, Astor, Lenox and Tilden Foundations

139. *Sophie Tucker,* n.d. Billy Rose Theatre Collection, The New York Public Library for the Performing Arts, Astor, Lenox and Tilden Foundations

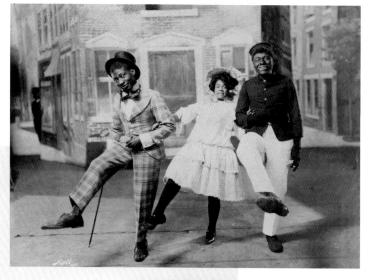

richness. Unlike most of his predecessors, Urban framed his settings with portals and featured multiple platforms to help focus the attention of the audience. Ziegfeld's taste was equally unfailing when it came to identifying extraordinary performers. Among the now famous talents he hired were Will Rogers, Eddie Cantor, W. C. Fields, and Sophie Tucker (figs. 136–39).

Musicals and revues of the teens were in reality an amalgam of elitist European culture and American popular entertainment. The musical stage at this period was in its infancy, though unique experiments were taking place. Victor Herbert excelled in an Americanized form of operetta, and in the late 1890s two early musical-theater works by African Americans were produced—Bob Cole and Billy Johnson's *A Trip to Coontown* and Paul Laurence Dunbar and Will Marion Cook's *The Origin of the Cakewalk; or, Clorindy*. In 1902, the multitalented black artist Bert Williams (who was forced to appear in blackface in the *Follies* as a star of the revue) and his early partner George Walker presented the musical *In Dahomey* on Broadway (fig. 140). Though these early efforts were well received, black artists were rarely seen on Broadway until the 1920s.

Among the significant innovations in musical theater through World War I were those that rejected European styles in favor of an American idiom—especially ragtime, which represented the era's most powerful influence from black music. The composer Jerome Kern and librettist Guy Bolton (and later P. G. Wodehouse) tried to revolutionize the musical stage with small casts, modest sets, and more immediate stories and characters, such as those in *Very Good Eddie* (1915). Yet the popularity of European-inspired operettas continued into the 1920s, until a new generation of composers took the musical in new directions, culminating in Kern's 1927 *Show Boat* (fig. 141), an innovative creation (produced by the indefatigable Ziegfeld) that demonstrated the potential of an integrated concept revolving around a serious subject—a form now commonplace in American musical theater. —D. W.

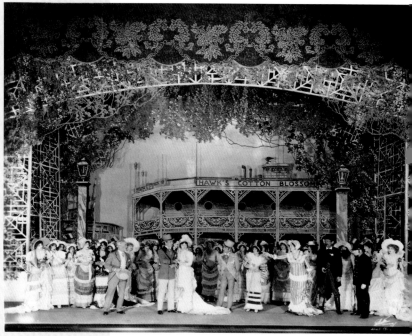

urban pilgrimage in search of economic and social opportunities. Drawn to the promise of opportunity, these new urban arrivals often experienced a reality that was difficult and sordid. As a result, there were as many immigrants desiring repatriation as there were new urbanites who wished to return to the simpler life of the farm—as immortalized in Frank Baum's 1900 book *The Wizard of Oz*. For some, like those pictured in Alfred Stieglitz's photograph *The Steerage* (fig. 94), the dream of American prosperity was shattered when they were deemed health risks by the authorities at Ellis Island and sent home. For others, like those depicted in Lyonel Feininger's *Kin-der-Kids* comic strip (fig. 135), reverse immigration was voluntary—a response to their feelings of alienation in America and nostalgia for familiar traditions and customs.

Vast numbers of immigrants remained, however, and began to find shared experiences in the world of popular entertainment. The cross section of ethnic Americans—from Will Rogers and W. C. Fields to Sophie Tucker, Burns and Allen, and Bert Williams—who performed in the variety acts that toured nationally on the vaudeville circuit introduced the music, humor, and

EARLY FILM: EDISON, BIOGRAPH, AND THE BIRTH OF HOLLYWOOD

At the turn of the century, new technologies transformed daily life in the United States, especially in the cities. Electric streetcars carried people to work and play, and electric lights illuminated streets, places of work and commerce, and most private dwellings. Telephones carried the human voice across distances. And technology provided entertainment, as people listened to the phonograph, screamed on Coney Island's electrically powered thrill rides, gawked at electric advertisement displays, or attended vaudeville theaters, tent shows, or concert halls to see moving pictures. At first, it was the marvel of the motion picture machine itself, rather than any particular motion picture, that drew in audiences. The Vitascope, the Cinématographe, the Animatographic, and other scientifically named devices projected images of entertainers, wonders of nature, or street scenes with people, animals, and machines moving about. The films demonstrated the latest technology of representation—the ability to capture motion.

Once the novelty of pure reproduction of motion passed, attention shifted to the films themselves—some of them focused on current events (such as Biograph's re-creation of a 1904 battle during the Russo-Japanese War) or famous personalities, while travel films of distant places attracted other viewers. American filmmakers also drew on vaudeville routines, comic strips, magic lantern narratives, dance performances, and other sources from a vibrant popular culture in order to pull in audiences. The films were short (rarely longer than five minutes), and exhibitors strung them together in variety programs as part of a vaudeville show or projected them in tent shows, at lecture programs, or even as outdoor advertising. From France, more elaborate films began to arrive around 1903, based on fairy-tale pantomimes with fanciful sets and costumes and magical special-effect disap-

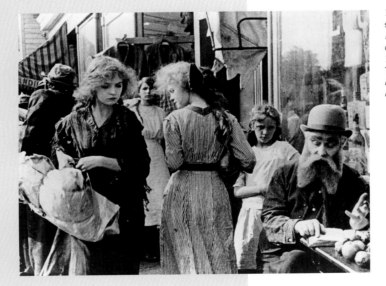

142. Lillian Gish in street scene from *The Musketeers of Pig Alley*, directed by D. W. Griffith, 1912
The Museum of Modern Art, New York/Film Stills Archive

pearances and transformations, often in brightly glowing colored versions. These early movies—such as Georges Méliès' famous *Trip to the Moon* (1902)—offered bursts of visual pleasure, exoticism, fantasy, and fast-paced action. It was a mechanically derived form of entertainment drawing on many sources, but unlike anything ever seen before.

Increasingly, storytelling competed with pure visual stimulation for audience favor. Chase scenes and gags gave audiences new experiences of the way film could string together action in different spaces to convey a single continuous story. The two largest American producers, the Thomas Edison Company and the American Mutoscope and Biograph Company, battled each other in court over their motion picture patents and imitated each other on the screen. But the appearance of a new kind of motion picture

theater changed everything. Entrepreneurs made movies the basis of a cut-rate mechanical version of more expensive vaudeville shows, tailored for working-class audiences with a bit of money and time. By 1907, every city and nearly every town had "nickelodeons," which featured about half an hour of short motion pictures and songs performed to the accompaniment of projected song slides—all for one nickel, the price of a beer. These tiny theaters laid the foundation of the motion picture industry in the United States as a medium of mass entertainment. The entrepreneurs understood that a new audience hungered for visual entertainment and stories told through images—a cheaper, shorter, less formal entertainment.

Although early filmmakers referred to their business as the "theater of the working man," they wanted to expand their mass audiences. But would middle-class patrons accept film as a form of storytelling and entertainment, rather than as a scientific novelty? Class tensions surrounded middle-class desires to regulate and even curtail motion pictures, which had opened up new ways of understanding the modern world for its working-class audiences. Filmmakers began to base films on respected works of literature—for example, on Robert Browning's *Pippa Passes* (D. W. Griffith, 1909) and Shakespeare's *Romeo and Juliet* (Vitagraph, 1908). They also developed stories that were shaped by the criteria the middle class valued: character psychology, moral lessons, and more complex plotting. The standard length of films

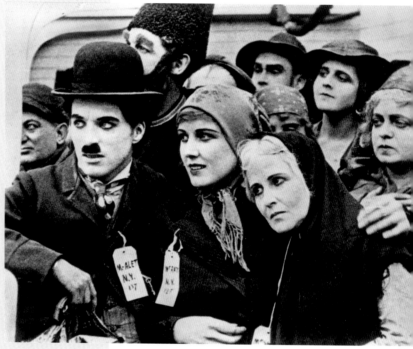

143. Charlie Chaplin in *The Immigrant,* directed by Charlie Chaplin, 1917 The Museum of Modern Art, New York/Film Stills Archive

grew to a single reel, about fifteen minutes. All of these goals presented challenges to American filmmakers, who had decided by 1908 to resolve their patent conflicts and unite in order to reclaim audiences from foreign filmmakers. Directors such as Charlie Chaplin and D. W. Griffith at the Biograph Company (*The Lonely Villa*, 1909, and *The Lonedale Operator*, 1911) experimented with editing to create a new dynamic tempo of modern drama that recast the suspenseful plotting of theatrical melodrama (fig. 142). Having begun as a technological novelty, film was now using its unique control over space and time to tell stories that reflected the accelerated pace and new spaces of modern life. These fast-moving stories retained the working-class audiences' interest, but also drew increasing numbers of middle-class patrons. By 1913, the industry could claim that everyone went to the movies and that a mass audience was being formed.

The year 1914 saw the birth of the film industry as we know it. The fifteen-minute films of the nickelodeon era gave way to feature films of an hour or more. Films were previously marketed with the name of the production house—Biograph, IMP, Vitagraph, Essanay—while actors frequently were not even named in the credits. New movie moguls like Adolph Zukor introduced stars as a way to attract audiences. By 1916, the biggest stars, Mary Pickford and Charlie Chaplin (fig. 143), took home a million dollars a year. Nickelodeons were overshadowed by picture palaces, large theaters designed

dialects of African Americans, Jewish Americans, and eastern European immigrants to a wide audience (figs. 136–39). Like comic strips, whose satire on immigrant and slum life was drawn from an outsider's viewpoint, vaudeville humor often accentuated ethnic stereotypes. Yet its widespread appeal and national circuit made it a pivotal arena for cultural exchange and implicitly celebrated the heterogeneity of American democracy.

The joining of these vaudeville acts with silent film shorts in nickelodeon theaters across America initiated the development of a broad-based national culture. So too did the growing consolidation of mass circulation newspapers and magazines and the national distribution of sheet music. While a substantial portion of popular music looked back nostalgically to rural and small-town America in songs such as "By the Light of the Silvery Moon," "Down by the Old Mill Stream," and "Let Me Call You Sweetheart," much of American popular song began to incorporate the syncopated offbeat rhythms that were being carried up from the South by migrating African Americans. With the introduction of ragtime to Broadway in Irving Berlin's 1914 musical *Watch Your Step* and the widespread enthusiasm for the fox-trot, which relied on ragtime's syncopated beat, the contributions of African Americans began to transform American popular music and performance into an indigenous expression liberated from European models—"the one distinctive American contribution to the musical materials of the world," as Berlin described ragtime (fig. 146).[17] That it was Vernon and Irene Castle, the white glamour couple of dance (fig. 144), who popularized the fox-trot nationwide bespoke the racial hostilities and inequities of the time, which were also reflected in *The Birth of a Nation* (1915), D. W. Griffith's racist film on the Civil War, Reconstruction, and the rise of the Ku Klux Klan. Although it was not until the 1920s that African American dancers, singers, and musicians were widely acknowledged as cultural intermediaries and "race" advocates, their centrality in the construction of a modern American cultural identity was already being recognized in the teens.

with palatial splendor and often seating over a thousand viewers. Even though small theaters continued to exist, the larger theater, with its aura of glamour, replaced "the theater of the working man." These newer houses still offered moderate prices, because they sold many seats; the industry could thus claim to provide "democracy's entertainment"—to draw all classes and submerge different ethnic identities into a vast "universal" audience. In actuality, disparities did exist; African Americans in the South (and often in the North) were segregated in balcony seats, while ethnic audiences lost the sense of local identity and intimacy that the smaller, neighborhood nickelodeon had provided.

Pioneer film companies such as Edison and Biograph faded away, as new entrepreneurs, often Jewish immigrants, organized companies whose corporate descendants, in name at least, still survive: Paramount, Universal, Warner Brothers. These companies began to integrate all areas of the industry, making their profits not only from the production of motion pictures but also from distribution networks across the world and nationwide chains of film theaters with flagship picture palaces. In 1913, film production was scattered over the East Coast (New York, Philadelphia, New Jersey), Chicago, and California. In the next five years, most productions clustered around Los Angeles, and the world began to identify the movies with Hollywood. Business offices, executive decisions, and the management of theaters remained in New York, but the stars and the studios moved to sunny California, where the weather allowed outdoor filming all year long and where labor was cheap because unions were weak. But Hollywood was never just a place. It became an image of a life of glamour and wealth, the energy and excitement captured in both feature films and slapstick comedies shot along the streets of Los Angeles. Hollywood projected a modern life of romance and adventure to the rest of the nation and the world.

Makers of feature films initially used the theater as a model. But the fast-paced action and crazy comedy that had premiered in the nickelodeon proved more enduring and popular than the adaptation of Broadway hits. The close-up, which had been around since the earliest Edison peepshows, became a means both of expressing character psychology and making new stars sources of fascination and eroticism. Productions became spectacular, as directors like D. W. Griffith and Cecil B. De Mille re-created ancient Babylon or Egypt. Actors who exploited the expressiveness of close-ups (Lillian Gish or Mae Marsh in Griffith's films) and the athletic grace of young, lively bodies (Chaplin, Douglas Fairbanks, and Pickford) created new ways to communicate with their audiences. The tempo of American films reflected a machine-driven society, as races with locomotives or jalopies weaving in and out of big-city traffic supplied thrills for comedies and dramas alike. —T. G.

144. Sheet music cover for "The Castle Walk," composed by James Reese Europe and Ford T. Dabney
New York: Joseph W. Stern, 1913
Music Division, The New York Public Library for the Performing Arts, Astor, Lenox and Tilden Foundations

POPULAR MUSIC, RAGTIME, AND EARLY JAZZ

More than 24,000,000 immigrants entered the United States in the late nineteenth and early twentieth centuries. Most disembarked at Ellis Island in New York Harbor, and many stayed in the city; according to the census of 1900, some two-thirds of New York's population had been born abroad. Italians and Jews, in particular, settled there, by the millions, joining the Irish and Germans as major ethnic groups. Blacks were also beginning to be a presence, though the peak of their migration from the rural South was to come later.

Older immigrants tended to remain in ethnic enclaves, but many younger newcomers wanted to be part of a broader American society. For them, the popular arts, especially vaudeville songs and comedy skits caricaturing various ethnic groups, acted as a "sort of abrasive welcoming committee . . . assur[ing] the Swedes, the Germans, the Irish, and then the Jews that to be noticed, even if through the cruel lens of parody, meant to be accepted" (Irving Howe).

New York's music publishers, many of them with offices on Tin Pan Alley (West 28th Street), developed new production and marketing techniques for popular song, offering inexpensive sheet music in easily performed arrangements, attractively packaged with eye-catching front covers, publicized by vaudeville performers. The first Tin Pan Alley songs were heterogeneous in style: some were ethnic dialect songs, others were older-style sentimental ballads, semiclassical "high class" ballads, or songs from operettas and early musical comedies. Jews, who eventually made up 40 percent of the city's population, became increasingly dominant as songwriters and publishers.

Ragtime, a musical style with roots in the black culture of the Southeast, began to have an impact on mainstream urban popular music. Scott Joplin, whose "Maple Leaf Rag" (1899) was the first great commercial success of the genre, came to New York to pursue his career, as did other ragtime musicians; white pianists and composers, such as Joseph Lamb, began writing in ragtime idiom; and the bands of John Philip Sousa and Arthur Pryor often included ragtime pieces in their programs. Joseph Howard's "Hello! Ma Baby" (1899) was one of the first Tin Pan Alley ragtime songs. Irving Berlin's earliest such works were written in 1909, and his "Alexander's Ragtime Band" (fig. 145) sparked a rash of these songs, including Lewis F. Muir's "Hitchy Coo" and "Waiting for

145. Sheet music cover for "Alexander's Ragtime Band," composed by Irving Berlin
New York: Ted Snyder Music Publishing, 1911
Music Division, The New York Public Library for the Performing Arts, Astor, Lenox and Tilden Foundations

146. Sheet music cover for "Watch Your Step," composed by Irving Berlin
New York: Waterson, Berlin, Snyder, 1914
Music Division, The New York Public Library for the Performing Arts, Astor, Lenox and Tilden Foundations

SOCIAL REFORM

Robert Henri's urban protégés celebrated the noise and color of the city without regard for the sordid and impoverished conditions under which many metropolitan inhabitants lived. Even George Luks, who prided himself on his identification with the struggles of the working class, transformed the crowded street scenes of the Lower East Side slums into bustling, exotic pageants devoid of crime, overcrowding, or poverty. The strong passions and flamboyant masculinity he brought to his work exemplified the turn-of-the-century mania for masculine renewal and physical manhood rather than a desire for social reform (fig. 147). He painted his slum scenes and picturesque types with "Guts! Life! Life!"—but he painted them because they were places of teeming humanity and epic adventures, not places of harshness, poverty, and resignation.[18] William Glackens, married to the daughter of a wealthy Hartford silk manufacturer, had from the beginning featured in his work the pleasant, fashionable side of middle-class leisure (fig. 148). After 1911, when he revised his painting style by adopting the bright pastels and feathering brushstroke of Pierre Auguste Renoir, little social commentary remained. Everett Shinn had, by 1900, turned from human-interest street scenes to theater subjects (fig. 149). So involved was he in the theater that he installed a working stage in his studio at Waverly Place and, from 1917 to 1923, worked as a designer and art director in Hollywood. Nor was Henri's involvement in the actualities of lower-class life any greater. He had depicted children and the denizens of unfashionable neighborhoods out of a conviction that they embodied simplicity and a state of innocence (figs. 121, 150). What mattered to him, in the end, was art not life.

the Robert E. Lee." Though these compositions have often been ignored by historians of ragtime, their lively tempi, syncopated rhythmic patterns, and breezy mode, all of which influenced later American popular song, were derived from ragtime.

Narrative-based musicals took on a characteristically American flavor during this period, with George M. Cohan's musical plays, beginning with *Little Johnny Jones* (1904) and *Forty-five Minutes from Broadway* (1906). Irving Berlin's *Watch Your Step* (1914) was the first musical comedy to use syncopated dance rhythms throughout, and its stars, Irene and Vernon Castle, helped popularize social dancing to syncopated music across class lines (figs. 144, 146).

A pattern was taking shape in American popular music that persisted for several decades. Tin Pan Alley exemplified modernist ideology and practice: centered in New York City, it took musical materials from wherever it could find them, fashioned them into commodities (sheet music, piano rolls, and phonograph discs and cylinders), and marketed these nationwide. —C. H.

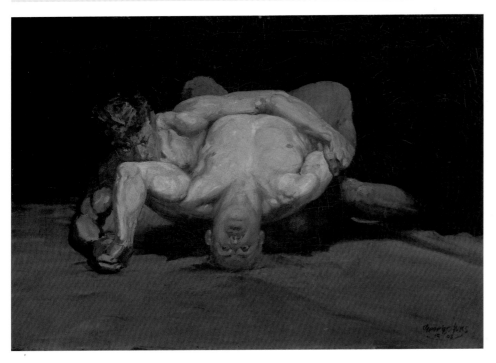

147. **George Luks**
The Wrestlers, 1905
Oil on canvas, 48⅜ x 66⅜ in. (122.9 x 168.6 cm)
Museum of Fine Arts, Boston; The Hayden Collection

John Sloan's work, more than that of any of his colleagues, registered the uneventful, passing moments of everyday urban existence with a life-affirming, voyeuristic detachment—what he called "an innocent poet's eye."[19] He took special delight in the explicit sexuality of working-class women and their freedom from genteel codes of propriety and decorum (fig. 151). Politically left-wing, he reserved his concern for social inequities and class conflict for the illustrations he produced for the radical political journal *The Masses,* of which he was art editor; in his oils, he remained an upbeat portrayer of the charming, smiling side of modern life (fig. 152).

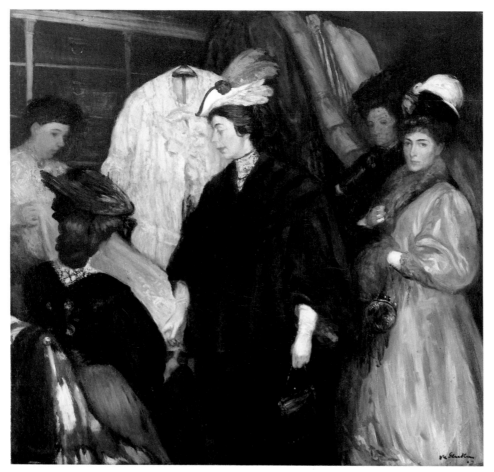

148. **William Glackens**
The Shoppers, 1907
Oil on canvas, 60 x 60 in.
(152.4 x 152.4 cm)
The Chrysler Museum of
Art, Norfolk, Virginia; Gift
of Walter P. Chrysler, Jr.

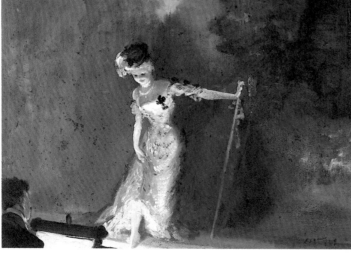

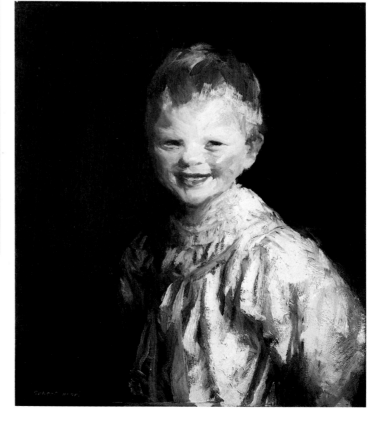

149. **Everett Shinn**
Revue, 1908
Oil on canvas, 18 x 24 in.
(45.7 x 61 cm)
Whitney Museum of
American Art, New York;
Gift of Gertrude Vanderbilt
Whitney 31.346

150. **Robert Henri**
Laughing Child, 1907
Oil on canvas, 24 x 20 in.
(61 x 50.8 cm)
Whitney Museum of
American Art, New York;
Gift of Gertrude Vanderbilt
Whitney 31.240

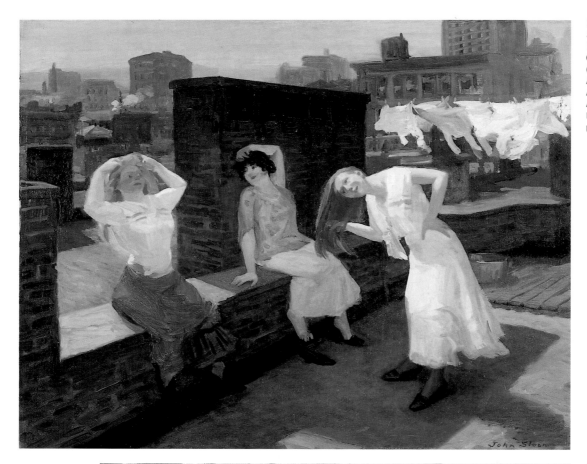

151. **John Sloan**
Sunday, Women Drying Their Hair, 1912
Oil on canvas, 26 x 32 in.
(66 x 81.3 cm)
Addison Gallery of
American Art, Phillips
Academy, Andover,
Massachusetts; Museum
purchase

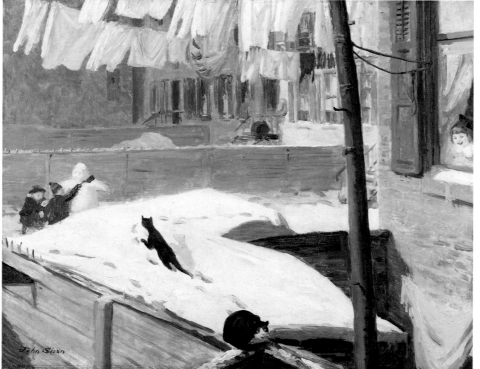

152. **John Sloan**
Backyards, Greenwich Village, 1914
Oil on canvas, 26 x 32 in.
(66 x 81.3 cm)
Whitney Museum of
American Art, New York;
Purchase 36.153

There were other artists and writers, however, who felt obliged to use their art as a tool for social change by calling attention to the ills brought on by immigration-driven overcrowding and industrial expansion. Adherents of Progressivism, the reform movement in politics, they believed that the behavioral and moral character of individuals could be altered by changing their environment. Convinced that knowledge and action were interconnected, they assumed that if people knew the conditions obstructing social justice, they would act in their collective self-interest to remedy them. This view was shared by a group of exposé journalists—pejoratively dubbed muckrakers by Theodore Roosevelt—who documented the abuses of business and government in books and magazine articles, particularly in *McClure's*, *Scribner's*, and *Collier's*. Viewing corruption as a result of privilege and power, writers such as Upton Sinclair, Lincoln Steffens, and Ida Tarbell aimed their investigative reports at those institutions and situations in which American democracy seemed to have failed—the Standard Oil Company, the meatpacking industry, and city government.

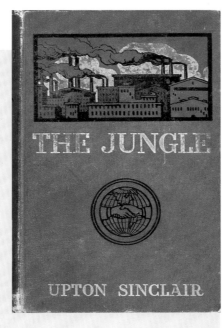

MUCKRAKING AND PROGRESSIVISM

Unlike many of the Naturalist writers, the muckrakers believed in the possibility of change. Jacob Riis' *How the Other Half Lives* (1890) epitomized the reformist spirit at muckraking's heart by exposing the wretched conditions in the Mulberry Street slums of New York. Jane Addams took up the reform mission by founding Hull House Settlement in Chicago, expanding opportunities for the poor, and speaking out for women's rights. Upton Sinclair published *The Jungle* (1906) (fig. 153) in the belief that literature must better humanity. His story of the revolting conditions in the meatpacking stockyards shocked President Theodore Roosevelt and caused an uproar that led to legal reforms. *McClure's* magazine established itself as muckraking's standard-bearer. In its pages, Lincoln Steffens' "The Shame of the Cities" (1902) probed municipal corruption in St. Louis. Ida Tarbell's scathing exposé, *The History of the Standard Oil Company* (1904), showed John D. Rockefeller's corrupt trust as a threat to equal opportunity and contributed to the Supreme Court's breakup of the monopoly in 1911. Ray Stannard Baker was drawn to the ugliness of railways, miner strikes, and lynchings. Muckraking's revelations of corruption in American business, labor, and politics energized Progressivism—the movement to shift responsibility from the individual and the family to the group and the state. Theodore Roosevelt resisted Progressivism; Woodrow Wilson pursued and eventually tainted it with his ambitious wartime policies of statist social control. By the cusp of the 1920s, the nation's reformist convictions were just beginning to be tested, and, in Naturalism and the grisly muckraking exposé, America found expressive forms to suit its ugly troubles. —J. W.

153. *The Jungle,* by Upton Sinclair
New York: Jungle Publishing Company, 1906
The Tamiment Institute Library, New York University

The private charities and public social activism that were identified with the Progressive Era were fueled by the wide division that existed in turn-of-the-century America between a relatively small sector of society in whose hands enormous wealth and power were concentrated and a poor, largely immigrant population that lived in squalid conditions in overcrowded, cold-water tenements with inadequate light, air, privacy, and sanitation facilities. The young girls whom the urban realists portrayed in moments of carefree relaxation spent most of their time working long shifts in airless, ill-lighted, and unsafe factory lofts. In 1911, the fire that took the lives of 146 workers, most of them young Jewish and Italian women, at the Triangle Shirtwaist Factory off Washington Square in lower Manhattan, led to tougher safety standards, but it did little to ameliorate the low wages or long workdays of the majority of sweatshop employees. In response to such conditions, Socialism gained converts and labor union membership grew, especially in the militant Industrial Workers of the World (IWW), which preached social revolt, not reform, and catered to unskilled workers. Increases in racial discrimination and racial violence that had followed the 1896 Supreme Court decision upholding "separate but equal" facilities for blacks and whites gave rise to the founding of the National Association for the Advancement of Colored People (NAACP) in 1909 and the National Urban League in 1910.

Many of the social issues that engaged Progressives were inextricably connected with the arrival in American cities of legions of immigrants in the early years of the century. No longer predominantly from northern and western Europe but from its southern and eastern regions, these new arrivals fueled anxiety about the fate of traditional Anglo-Saxon values and customs—even to the point of worrying Americans like Theodore Roosevelt, who thought that the country was on the road to "race suicide." Such Americans saw the Americanization process, in which ethnic cultures shed their differences and assimilated into American life, as critical to the ideology of the melting pot and the preservation of the country's democratic character.

This was the view of Jacob Riis, an immigrant from Denmark who had taken up photography as an outgrowth of his work as a police reporter for the *New York Tribune*. Brought into direct contact with the wretched conditions of slum life through his reportorial assignments, he had turned to photography as a way to bear witness to the overcrowded and disease-ridden living conditions of the immigrants in New York's Lower East Side. His methods were invasive: he and his assistant

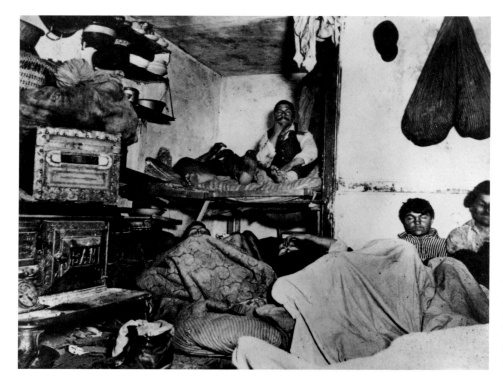

would burst into a tenement unannounced in the dead of night and record its unsuspecting inhabitants with the help of a magnesium flash explosion. Garishly illuminating every speck of dust and crack in the wall, the resulting photographs were as raw as their subjects. Convinced that the conditions of poverty, crime, and congestion under which most immigrants lived had to be changed in order to ensure the perpetuation of American values, Riis used his photographs in articles, books, and lantern-slide lectures in the hope of alarming his audience into taking action (fig. 154). *How the Other Half Lives*, his groundbreaking 1890 book, which pioneered in the use of halftones to reproduce photographs, alerted Police Commissioner Theodore Roosevelt to slum conditions in New York and eventually led to the razing of the Lower East Side's most notorious tenements.[20]

154. Jacob Riis
*Five Cents a Spot,
Unauthorized Lodgings in
a Bayard Street Tenement,*
c. 1890 (printed later)
Gelatin silver print, 8 x
10 in. (20.3 x 25.4 cm)
Howard Greenberg Gallery,
New York

Riis was not alone in using photographs for social purposes. His most notable successor was Lewis W. Hine, who began to photograph immigrants arriving at Ellis Island as early as 1904 in connection with his teaching job at the Ethical Culture School in New York. In keeping with the school's mandate to engender respect for immigrants, Hine engaged his subjects in a dialogue in which they presented themselves as self-contained, dignified, and confident of their ability to meet the challenges of assimilation (figs. 155–57). By 1908, Hine had turned his attention to the fate of immigrants after their arrival in America—a fate inseparable from the inequities surrounding industrial development, since it was primarily non-union immigrants who made up the industrial workforce (figs. 159, 160). Hine's participation, along with the painter Joseph Stella, in the 1908 Pittsburgh Survey, an exhaustive investigation into the life of a prototypical industrial community, inaugurated his full-time commitment to photographing the lives of the

155. **Lewis W. Hine**
Climbing into the Promised Land, Ellis Island, 1908 (printed 1930s)
Gelatin silver print, 13 x 10½ in. (33 x 26.8 cm)
Brooklyn Museum of Art, New York; Gift of Mr. and Mrs. Walter Rosenblum

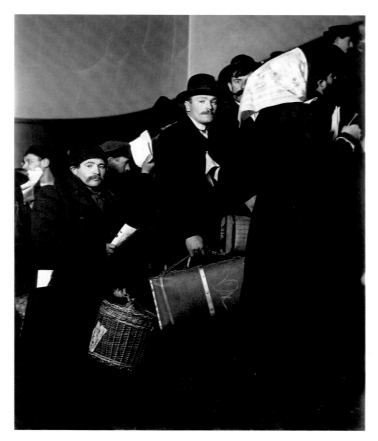

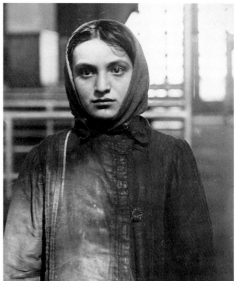

156. **Lewis W. Hine**
Couple on the Lower East Side, New York, c. 1910 (printed 1930s)
Gelatin silver print, 11 x 14 in. (27.9 x 35.6 cm)
Private collection

157. **Lewis W. Hine**
Young Russian Jewess, 1905
Gelatin silver print, 13⅝ x 10½ in. (34.6 x 26.7 cm)
Private collection

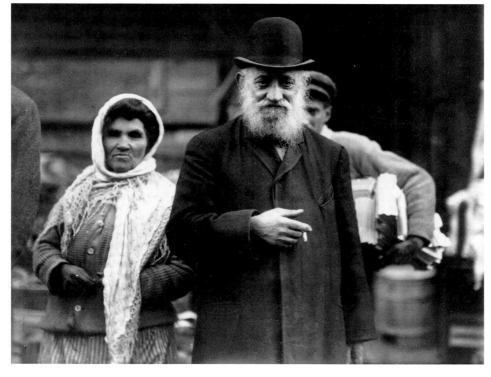

158. Lewis W. Hine
Untitled (Girl in a Cotton Mill), n.d.
Gelatin silver print, 7½ x 9½ in. (19.1 x 24.1 cm)
Collection of Susan Ehrens and Leland Rice

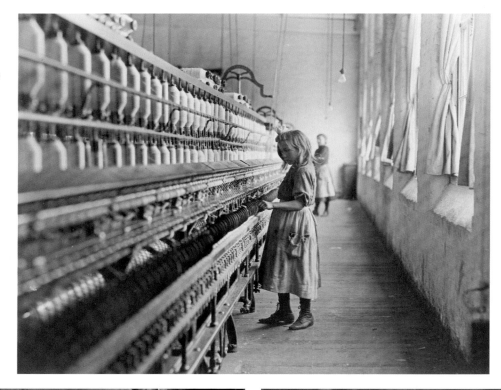

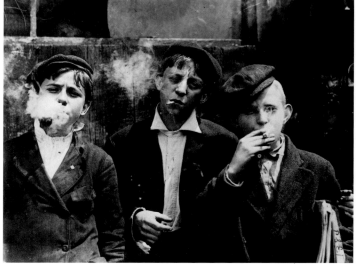

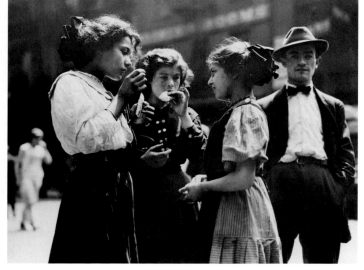

159. Lewis W. Hine
Newsies at Skeeter Branch, St. Louis, Missouri, 11 a.m., May 9, 1910, 1910
Gelatin silver print, 3⅝ x 4⅝ in. (9.2 x 11.8 cm)
The Metropolitan Museum of Art, New York; Gift of Phyllis D. Massar, 1970

160. Lewis W. Hine
Lunchtime, New York, 1915
Gelatin silver print, 10¼ x 13⅜ in. (26 x 34 cm)
Collection of Naomi and Walter Rosenblum

underprivileged and exploited. As staff photographer for the National Child Labor Committee from 1908 to 1918, Hine traveled throughout the country, often resorting to subterfuge to obtain entry into factories and mills in which underage children labored (fig. 158).[21] His photographs, used in slide lectures, photographic brochures, and poster displays for conventions and expositions, reflected his profound sympathy and respect for his subjects and delivered a strong indictment against economic exploitation (figs. 161, 162). Unlike Riis' photographs, which emphasized the degradation of his subjects, Hine's social records passionately affirmed the dignity inherent in all individuals and made a compelling case for the promulgation of laws to protect children in the workforce. Paralleling the efforts of Hine, Jessie Tarbox Beals and others documented the living and working conditions of the poor in the hope that the irrefutable evidence offered by the camera would promote social awareness and encourage legislative reform (figs. 163, 164).

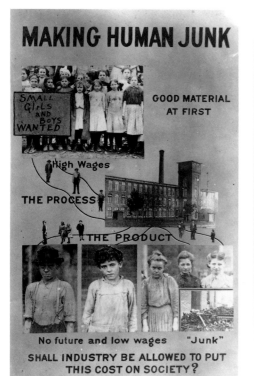

161. **Lewis W. Hine**
Making Human Junk,
c. 1915
Library of Congress,
Washington, D.C.

162. Cover of *What the United States Government Says About Child Labor in Tenements*
Brochure published by the National Child Labor Committee with photographs by Lewis Hine, 1911
The Tamiment Institute Library, New York University

Very different in mood were the candid photographs taken in the fall of 1916 by Hine's former student at Ethical Culture, Paul Strand (figs. 165, 166). Using a right-angled camera so as not to jeopardize the unself-conscious expression of his subjects, Strand captured a quality of strength, nobility, and fortitude in closely cropped, frontal depictions—a compositional type new to American portrait photography. While not intended as agents of social change, Strand's elegiac portraits nevertheless represented a stern censure of the inequities and hardships of urban poverty.

Many people feared that young girls from rural America would succumb to the harsh and impersonal economic realities of the urban environment by voluntarily turning to prostitution or by being tricked or forced into entering the sex trade by "white slave traffickers." Such concerns became a dominant issue for the reformers—and a frequent subject of film (*Traffic in Souls,* 1913), theater (*The Lure;* fig. 167), and art. Even E. J. Bellocq's morally neutral, posed photographs of prostitutes in the Storyville brothels of New Orleans were considered so potentially scandalous that they remained private until fifteen years after his death (fig. 168). Indeed, so passionate was the debate over the fate of young girls forced into an underground network of prostitution rings that when Abastenia St. Leger Eberle's sculpture of a young girl being auctioned into prostitution was reproduced on the cover of *The Survey* in May 1913, the magazine was deluged with letters from subscribers threatening cancellation (fig. 169). Eberle's belief that "the artist has no right to work as an individualist without responsibility to others" ultimately led her to set up a studio on the top floor of a Lower East Side tenement in order to be closer to her subjects.[22]

Although no other artist went so far as Eberle, her colleagues were not immune to the spirit of insurgency and social reform that gripped the nation in these years. By the second decade of the century, artists and intellectuals were caught up in issues ranging from women's suffrage to Socialism, labor agitation, birth control, Freudian analysis, and racial equality. In New York, the bohemian revolt against

163. **Jessie Tarbox Beals**
Room in a Tenement Flat,
1910
Gelatin silver print, 8 x
10 in. (20.3 x 25.4 cm)
Museum of the City of New
York; The Jacob A. Riis
Collection

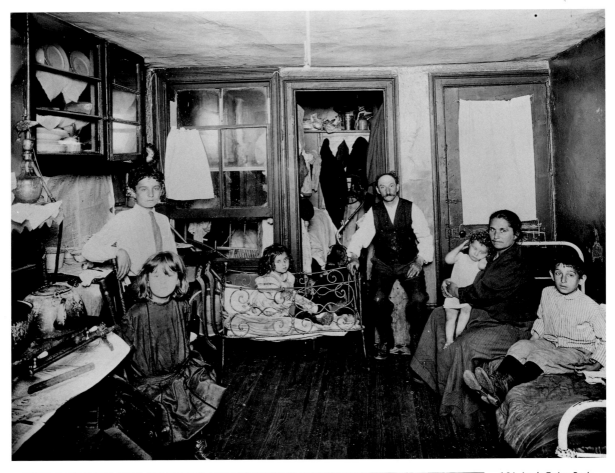

164. **Jessie Tarbox Beals**
*Untitled (Destitute Mother
with Twins),* n.d.
Gelatin silver print, 8 x
10 in. (20.3 x 25.4 cm)
Community Service Society
Photography Archives, Rare
Book and Manuscript
Library, Columbia
University in the City of
New York

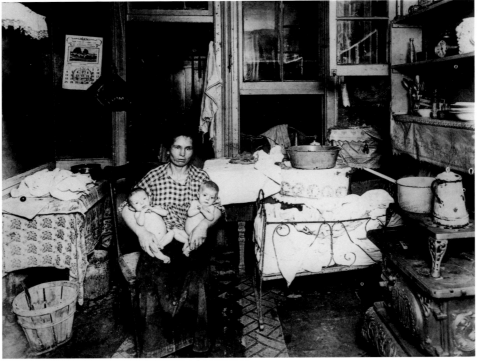

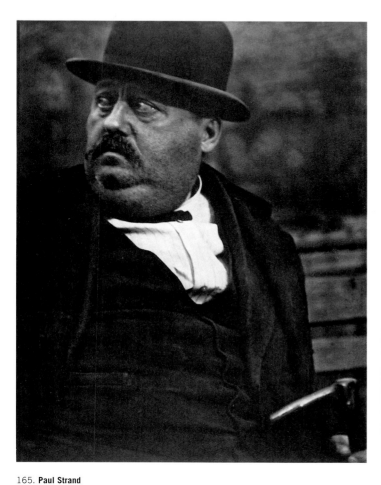

165. **Paul Strand**
Man in Derby Hat, 1916
Platinum print, 10 x 8 in.
(25.4 x 20,3 cm)
Philadelphia Museum of
Art; The Paul Strand
Retrospective Collection,
1915–1975, Gift of the
Estate of Paul Strand

166. **Paul Strand**
Blind Woman, New York,
1916
Gelatin silver print, 13¼ x
10⅟₁₆ in. (33.7 x 25.6 cm)
The Metropolitan Museum
of Art, New York; Alfred
Stieglitz Collection, 1933

167. Program for George
Scarborough's *The Lure,*
Manhattan Opera House,
New York, 1913
Museum of the City of
New York

168. **E. J. Bellocq**
Storyville Portrait,
c. 1911–13 (printed later)
Gelatin silver print, 9⅞ x
7⁹⁄₁₆ in. (25.1 x 20.2 cm)
New Orleans Museum of
Art; Museum purchase,
1977 Acquisition Fund
Drive

169. **Abastenia St. Leger
Eberle**
White Slave, 1913
Bronze, 19¾ x 17 x
10¼ in. (50.2 x 43.2 x
26 cm)
Collection of Gloria and
Larry Silver

entrenched conventions and the advocacy of sexual freedom, feminism, leftist politics, and modern aesthetics took place primarily in Greenwich Village. In an atmosphere of frenzied experimentation, Village denizens flouted establishment rules of dress, sexuality, language, decorum, and domestic partnering. Although much of the revolt remained limited to issues of lifestyle, politics exerted an increasingly strong hold through a network of alliances with art. One of the primary sites of cross-fertilization between art and politics was the Socialist magazine *The Masses,* which flourished under the editorship of Max Eastman from 1912 to 1917.[23] Here, drawings by an art staff that included John Sloan, Art Young, Glenn O. Coleman, Boardman Robinson, and Stuart Davis were used as independent works (fig. 170), equal in importance to political and social texts by the magazine's staff writers John Reed and Floyd Dell. In 1913, with the inauguration of Mabel Dodge's "evenings" at 23 Fifth Avenue in Greenwich Village, an even greater intermingling of cultural and political radicals began to characterize the New York world. Here, on any given evening, the mixed group of Socialists, trade unionists, newspaper reporters, suffragists, poets, psychoanalysts, artists, and writers might include William "Big Bill" Haywood of the IWW; the anarchist Emma Goldman; the writers Hutchins Hapgood, Lincoln Steffens, Carl Van Vechten, John Reed, and Max Eastman; and the artists Marsden Hartley and Charles Demuth. The most public event to emerge from Dodge's gatherings occurred on June 7, 1913, at

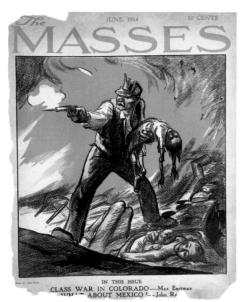

170. **John Sloan**
Miner at Ludlow, Colorado
Cover of *The Masses,*
June 1914
The Tamiment Institute
Library, New York
University

171. Program cover for
*The Pageant of the
Paterson Silk Strike,*
June 7, 1913
The Tamiment Institute
Library, New York
University

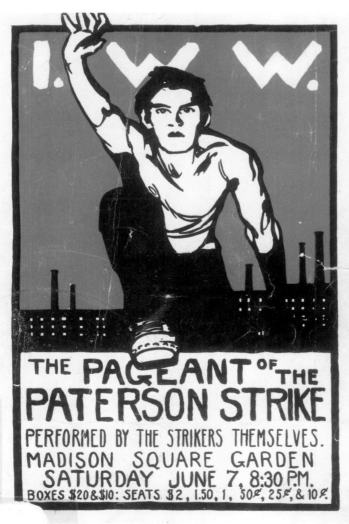

Madison Square Garden, when the group produced a reenactment of the silkworkers strike then taking place under IWW auspices in Paterson, New Jersey (fig. 171). With a script by John Reed, stage sets by Robert Edmond Jones, and a cast of 1,147 of the Paterson strikers, the event united art and politics on a scale never before attempted. But as an economic and political strategy, the pageant failed miserably. Not only did it lose money, but the silkworkers' capitulation to management five months later and the subsequent blacklisting and arrest of thousands of strikers led to a decline in the power of the IWW. For Dodge, the failure was of little consequence; she had already set sail for Europe with John Reed, with whom she had begun an affair. Yet even this personal alliance between political and cultural radicals did not last. By 1917, Dodge had moved permanently to Taos, New Mexico, with her current husband, the painter Maurice Sterne.

THE 1908 MACBETH EXHIBITION AND THE EIGHT

Exhibition opportunities for American artists in the first years of the century were controlled almost exclusively by two rival artist-run institutions: the Society of American Artists and the National Academy of Design, both based in New York. The 1906 merger of these academies held out the promise of an annual national exhibition equal in size and scope to the great Parisian Salons. Yet, despite the greater diversity that this amalgamation theoretically allowed, the work of the urban realists differed so greatly from that of the academicians in style, subject, and mood that a confrontation between the groups was inevitable. It came in 1907, the year of the first combined annual presentation. Robert Henri, a member of the selection jury, became angered by the jury's exclusion of several works by his friends and by its slight to two of his own canvases during the hanging. At an after-dinner meeting at his studio a month later, he laid plans for a secessionist show. The Macbeth Galleries was willing to host it, and on February 4, 1908, the group's "Exhibition of Paintings" opened in Macbeth's two adjoining octagonal rooms. Eight artists were included, each allocated twenty running feet on which to hang canvases: the original Philadelphia rebels—Henri, Sloan, Luks, Glackens, and Shinn—plus Ernest Lawson, Arthur B. Davies, and Maurice Prendergast.

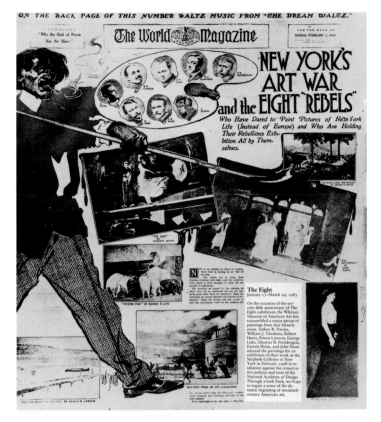

172. "New York's Art War and the Eight 'Rebels,'" *The World Magazine,* February 2, 1908

The original five artists shared a commitment to vernacular themes and spontaneous paint handling. But the addition of Lawson, Prendergast, and Davies obviated all stylistic consistency. Davies was a widely respected but iconoclastic painter of dreamlike, Pre-Raphaelite figures in landscapes (fig. 38). With his soft, muted palette and imaginary subjects more Symbolist and visionary than realist, it was only his opposition to establishment values that made him an apt collaborator. Lawson, a former pupil of John Twachtman and J. Alden Weir, was an Impressionist who had been invited to show with the group by virtue of his friendship with Glackens. His rough-hewn paint handling and brightly colored views of scenes along the Harlem River in upper Manhattan reflected his study of nature under different light conditions, but contained none of the vernacular subject matter of the urban realists (fig. 98). Prendergast, stylistically the most radical member of the exhibiting group and a resident of Boston rather than New York, was likewise welcomed because of his originality and willingness to defy the Academy (fig. 115).

Stylistic diversity aside, Henri and his colleagues, as a result of their experience on newspaper staffs, were sufficiently familiar with the workings of the popular press to know they had to present themselves as a unified group in order to garner press attention. With the marketing help of journalist friends, they portrayed themselves as rebels against authority and exponents of cultural nationalism. Their efforts succeeded. News coverage of the exhibition described it as a "revolt" against the academic practice of depicting America and her people through the veil of imported, European styles. Even such presumably negative sobriquets as "the revolutionary black gang" and "the Apostles of Ugliness" that were leveled at the artists had the salutary effect of piquing the interest of the public, which came to the exhibition in droves (fig. 172). Visitors on opening day numbered three hundred an hour. When the show closed, on February 19, income from the exhibition totaled almost $4,000, and Sloan could legitimately boast, "We've made

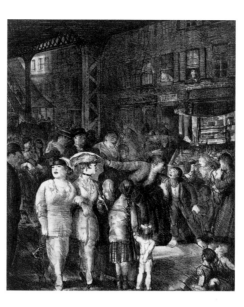

173. **George Bellows**
The Street, 1917
Lithograph, 19 x 15 in.
(48.5 x 38.7 cm)
The Metropolitan Museum
of Art, New York;
Fletcher Fund, 1971

a success—Davies says an *epoch*."[24] The exhibition's subsequent nine-city tour further validated the notion that insurgency could be counted on to succeed in contemporary art as effectively as in contemporary politics.

Despite the lack of stylistic cohesion within the group of artists exhibiting at the Macbeth Galleries, subsequent histories have tended to treat The Eight, as they came to be called, as a cohesive unit. A more accurate and inclusive epithet, "Ashcan artists," took hold in 1916 around a controversy at *The Masses* about whether to underscore the political message of an image with an explanatory caption. In the debate, the illustrator Art Young chastised artists such as Sloan and Stuart Davis for not captioning work that depicted "ash cans and girls hitching up their skirts in Horatio Street."[25]

Henri's promotion of a distinctly American expression gained further momentum two years later, in 1910, when he and Sloan joined with Rockwell Kent, Walt Kuhn, Guy Pène du Bois, and Stuart Davis to organize the five-hundred-work invitational "Exhibition of Independent Artists" to coincide with the National Academy's 1910 spring exhibition. In the spirit of democracy, the entries of the over two hundred artists who submitted work were hung alphabetically. Like the Macbeth presentation, the Independents exhibition was promoted with extensive advance publicity that associ-

174. **George Bellows**
Stag at Sharkey's, 1909
Oil on canvas, 36¼ x
48¼ in. (92.1 x
122.6 cm)
The Cleveland Museum of
Art; Hinman B. Hurlbut
Collection

ated the reputed independence and freedom of the show with a specifically national agenda. Although, as before, the press reaction was generally hostile toward the art for being too frank and vulgar, the use of the term "insurgents" to define the exhibitors linked them with the political activists who were fighting monopolistic business trusts. Again, the public's appetite for change and innovation was shown to be high: the crowd of over 2,500 people who attended the opening was so large that the riot squad had to be summoned to maintain order.

Among the most notable younger artists included in the 1910 Independents exhibition were George Bellows and Rockwell Kent. Seventeen years Henri's junior, Bellows had been emboldened by Henri's class at the New York School of Art to prize direct, immediate experience and to focus on the tangible aspects of urban life. No one conveyed more convincingly the masculine confidence and raw energy of America. His depictions of New York's streets, its waterfronts, and the construction of Pennsylvania Station viscerally captured the monumental

power of these icons of American commercial and engineering success (figs. 104, 108, 173). The compression of violence and titanic force that marks Bellows' urban landscapes also pervaded his boxing pictures, which matched the novels of Frank Norris and Jack London in their brutal, explosive portrayal of violence (fig. 174).

Early American Modernism

ALFRED STIEGLITZ AND 291

In 1908, the year Robert Henri and his "black gang" challenged the power of the National Academy at the Macbeth Galleries, a less public but ultimately more lethal assault on traditional values was launched by Alfred Stieglitz at The Little Galleries of the Photo-Secession. The exhibition of drawings by Auguste Rodin that Stieglitz mounted in January, a month before The Eight exhibition, represented a new chapter for the gallery and for modern art in America. When Stieglitz and Edward Steichen founded The Little Galleries of the Photo-Secession in 1905, their intention was that it not be limited to photography. But since neither had any contacts outside the photography community, the medium dominated exhibitions at the gallery for more than a year. This changed in May of 1906 when Steichen closed up his portrait studio in New York and sailed for France, resolving to paint and photograph noncommercially. Once settled, he began making contacts that would enable him to inform Stieglitz about the latest art developments and recommend nonphotographic art for exhibition in the gallery.

Steichen's task was not difficult. In the years before World War I, Paris was a magnet for everyone interested in advanced art. The American artists in residence when Steichen arrived in 1906 included Patrick Henry Bruce, Arthur B. Carles, John Covert, Charles Demuth, Arthur Dove, Samuel Halpert, Stanton Macdonald-Wright, John Marin, Alfred Maurer, Morgan Russell, Morton Livingston Schamberg, Maurice Sterne, John Storrs, Abraham Walkowitz, and Max Weber. These artists gained peripheral access to the French art world through the American collectors Michael Stein and his wife, Sarah, and Michael's siblings Gertrude and Leo. It was thanks to Sarah Stein that Americans such as Bruce and Weber were among the first pupils in the painting class that Henri Matisse opened in 1907. At the Saturday soirées hosted by Gertrude and Leo Stein at 27 rue de Fleurus, American artists became familiar with the newest developments in Parisian modernism and were introduced to its leading practitioners, Matisse and Pablo Picasso. By 1908, two years after Steichen's arrival in Paris, the ranks of American progressive artists in Paris had grown sufficiently to warrant his founding of the New Society of Younger American Artists for the purpose of exhibiting and promoting members' work. No exhibitions materialized in Europe, but Steichen drew heavily upon this group for the exhibitions he helped arrange for The Little Galleries.

Steichen made full use of these contacts as well as those made on an earlier sojourn in Paris, in 1901–2, when he had taken a series of photographs of Auguste Rodin. Not surprisingly, Rodin was the first artist Steichen chose for an exhibition at The Little Galleries. The French artist's show of figurative watercolors did not open until January 1908, but when it did, the voluptuous sensuality of the work unleashed a torrent of negative response from the conservative art establishment— including a vow from William Merritt Chase never to return to 291. Steichen next recommended an exhibition of Matisse drawings, watercolors, lithographs, and etchings—which Stieglitz mounted in April 1908. Like the Rodin show, it represented a degree of pictorial abstraction and distortion never seen in America before, and it too was greeted with vitriolic tirades.

Shortly after the Matisse exhibition, the three-year lease on the gallery's space expired. When the landlord doubled the rent, several of Stieglitz's supporters rallied to form a rent fund committee, which leased two rooms across the hall, in the adjoining building. Even though the street address for these new quarters was 293 Fifth Avenue, the number 291 remained the informal name by which the gallery was known.

For the next few years, Steichen and Stieglitz worked together to mount exhibitions not only of the work of French artists such as Henri de Toulouse-Lautrec and Henri Rousseau, but of progressive American art as well. The two-person exhibition of John Marin and Alfred Maurer at 291 in 1909 came about after Steichen introduced Stieglitz to the artists during one of Stieglitz's four trips to Paris between 1904 and 1911. In 1910, Steichen helped Stieglitz arrange an exhibition entitled "The Younger American Painters," devoted to the work of nine artists, all of whom, except Marsden Hartley, Steichen knew through the New Society of Younger American Artists.

"The Younger American Painters" preceded by one month the large "Exhibition of Independent Artists," which Henri and his cohorts mounted that April. The Independent show's exclusion of all artists associated with Stieglitz crystallized the current antagonism between realism and abstraction. In 1910, the realists had the upper hand, as Sloan gleefully recorded in his diary: "[Walter Pach] tells me that Stieglitz of Photo Secession is hot under the collar about our show. . . . I imagine he thinks we have stolen his thunder in exhibiting 'independent' artists."[26]

Despite their rivalry, Stieglitz and Henri shared a number of basic beliefs, the most important being a commitment to authenticity and intensity of expression. For both men, this entailed a celebration of the uncorrupted and liberated character of those outside "rational" society. Indeed, Stieglitz echoed Henri in remarking, "Nothing charms me so much as walking among the lower classes. . . . I dislike the superficial and artificial, and I find less of it among the lower classes. That is the reason they are more sympathetic to me as subjects."[27] Their differences lay in fundamentally different worldviews and life experiences. Henri believed that society and the masses were inherently benevolent. He valued the collective over the individual and held that art, because it was democratic, needed to be intelligible and available to all. Stieglitz, in contrast, distrusted the masses and viewed art as a sanctified realm reserved for the enlightened. Whereas Henri held that a beneficent society would nurture individual creativity, Stieglitz put his faith in the potential of the liberated individual to reform society.

The two men embodied opposing American myths. Henri, a quintessential Westerner, stood for the America of the frontier and the small town that had developed independently of European tradition. His father, a gambler turned real estate developer, had fled from Nebraska to Atlantic City with his family because he had killed a business associate in an argument. Once there, the son had changed his name from Robert Henry Cozad to Robert Henri. A nationalist who believed that artists should celebrate the character of their own nation, he favored an indigenous style, free from European influence. Stieglitz, on the other hand, believed in aesthetic expressions that transcended nationalism. The eldest son of affluent German-Jewish immigrants, Stieglitz brought to his American identity a vision of the country as industrial, urban, and a refuge for immigrants seeking freedom and opportunity. His inherent affection for European culture suspended any misgivings about its influence on American art.

For Stieglitz, 1910 was a watershed year. Disenchanted with the Pictorial photography he had selected for the 1910 "International Exhibition of Pictorial Photography" in Buffalo, he shifted his allegiance to the vanguard American art and artists he had shown that March in "The Younger American Painters." Henceforth, 291 served as the meeting place for an artistic community comprising primarily painters and critics. After 1910, only three photography exhibitions were presented there—those of Baron de Meyer (1911), Stieglitz (1913), and Paul Strand (1916). The gallery served an indispensable role in keeping vanguard American artists informed about aesthetic developments in Europe and encouraging returning expatriates to continue the experiments they had begun abroad. Stieglitz's view of the gallery as an elite laboratory for the examination of new art rather than as a business freed him from the usual gallerist's obligation to please the public. He presided over the enterprise as benevolent patron and patriarch, claiming that he never derived financial gain from the gallery; and indeed, he put much of his own money into it and into the financial support of its artists. Arthur Dove was not alone when he later declared, "I do not think I could have existed as a painter without that super-encouragement and the battle he has fought day by day for twenty-five years. He is without a doubt the one who has done the most for art in America."[28]

As Stieglitz's interest in Pictorial photography waned, so did his reliance on Steichen. The growing distance between them was due to the influence of two artists: Marius de Zayas, the Mexican caricaturist, and Max Weber, who had returned to New York in 1908 after a three-year sojourn in Paris more informed about French art and aesthetics than anyone else in America. Stieglitz had responded to Weber's intensity and impoverished condition by arranging for him to live in a room just behind the gallery in 1910. During this year, Weber exerted his most profound influence on the dealer's taste. It was he who persuaded Stieglitz to hold a memorial exhibition of the work of Henri Rousseau and he who encouraged Stieglitz's interest in Native American and pre-Columbian art. Yet, ultimately, his most important contribution to Stieglitz's education lay in his comprehension of Cézanne's distortion of reality for the sake of formal coherence. Under Weber's tutelage, Stieglitz was prepared to appreciate the French artist's work, which Steichen sent to 291 for exhibition in March 1911. Without Weber, Stieglitz's response to Cézanne might well have remained what it had been in the summer of 1907, when he and Steichen dismissed the Frenchman's work as a joke.[29] Weber, intolerant and critical of everyone except Cézanne, Rousseau, and himself, undoubtedly encouraged Stieglitz to question Steichen's success as a photographer and his infallibility as an agent. Weber's influence over Stieglitz came to an abrupt end at the time of his 291 exhibition in January 1911. Disagreeing with Stieglitz about what constituted reasonable prices for his paintings, Weber stormed out of the gallery after a heated exchange of words and thereafter had little to do with Stieglitz.

Following Weber's departure, the role of unofficial adviser fell to de Zayas, whose caricatures Stieglitz had presented at 291 in 1909 and 1910 (and would again in 1913). De Zayas, who had become a close friend of Picasso's during a winter visit to Paris in 1910–11, had encouraged Stieglitz to show the Spaniard's drawings. Although it is questionable whether Stieglitz understood Picasso's work at the time of the April 1911 show, he was a quick and receptive student. When he visited Picasso that summer with de Zayas, he declared him to be more significant than Matisse—an appraisal that helped cool his relationship with Steichen, whose taste did not yet encompass Cubism.

Paradoxically, Stieglitz's elevation of Picasso had been based not on the artist's formal breakup of space but rather on what Stieglitz understood—via de Zayas—to be Picasso's creation of a pictorial equivalent of his emotional response to nature.

For Stieglitz, as for those in his circle, the primacy of feeling and instinct over logic and learned tradition was paramount. Unlike Henri, who had developed within the American tradition of realism, Stieglitz had entered the art field by way of Symbolism and Aestheticism—thus his decision to precede the 1908 Rodin show at 291 with an exhibition of drawings by the American Symbolist Pamela Colman Smith (fig. 40). Smith's work was decidedly less radical than that which Stieglitz soon showcased at the gallery; indeed, his choice of it for the gallery's first non-photographic show indicated that his aesthetic conceptions in 1908 were still firmly rooted in the late nineteenth-century German Romantic tradition of painters like Arnold Böcklin and Franz von Stuck, whose reproductions decorated his home.

Symbolist concerns continued to guide Stieglitz even after his conversion to more vanguard art. So too with *Camera Work*, which had turned its attention to nonphotographic arts in 1908 in accordance with Stieglitz's shift in interest. The critics Sadakichi Hartmann and Charles Caffin, who had followed Stieglitz from *Camera Notes* to *Camera Work*, remained passionate champions of Symbolism's reverence for mystery and vagueness and its elevation of intuition and subjectivity over intellect. Thanks to these critics, the French philosopher Henri Bergson and Belgian Symbolist playwright Maurice Maeterlinck came to enjoy wide currency within the Stieglitz circle. Through Bergson's conception of intuition as the means to transcend outward appearance and attain true reality, and Maeterlinck's proposition that the unconscious was the core of personal being, Stieglitz and his group came to appreciate abstract art. According to Bergson, truly "seeing" required that the intuitive mind reach beyond rational contemplation and empathetically identify an object's spirit or inner essence. This was possible with abstraction precisely because it depended on pure experience rather than on intellectually recognizable subject matter. Functioning outside of reason, abstraction thus offered a means to liberate people from rational ways of perceiving the world.

175. **Alfred H. Maurer**
Flowers, c. 1912
Oil on cardboard, 21¼ x 18 in. (54 x 45.7 cm)
Whitney Museum of American Art, New York
31.300

These attitudes were strengthened by turn-of-the-century scientific discoveries that had cast doubt on the reality of the visible world. The disintegration of the atom, Albert Einstein's theory of relativity, Sigmund Freud's theory of the unconscious, quantum physics—all had undermined the certainty that sense perceptions yielded a true vision of "reality." Artists in America, as elsewhere, responded by turning their attention either to the emotional impact of objects or to the dynamic forces beneath surface appearances that intuition made visible. Once abstraction was given the imprimatur of spirituality by Wassily Kandinsky in his book *On the Spiritual in Art*—a translated excerpt of which appeared in the July 1912 issue of *Camera Work*—the ideological framework for abstraction was complete.

Stieglitz's regard for emotional expression and his belief that art must be experienced without intellectual intervention guided his direction of 291. The commitment to "felt," as opposed to cognitive, experience became the operative principle against which he measured himself and others. His conviction that the experience of art—like that of a sunset or love—was inimical to verbalization led to his notorious unwillingness to explain an artist's work to the public. "You will find," he once said, "as you go through life that if you ask what a thing means, a picture, or music, or whatever, you may learn something about the people you

ask, but as for learning *about* the thing you seek to *know*, you will have to sense it in the end through your own experience. . . . If the artist could describe in words what he does then he would never have created it."[30]

TOWARD AN AMERICAN MODERNISM

American painters took their first steps into nonrepresentational art by means of Fauvism, which had made its public debut in 1905 at the Salon d'Automne in Paris and was enthusiastically supported by the American collectors Leo, Gertrude, Michael, and Sarah Stein. The emotionally expressive color inherent in Fauvism allowed American artists to accommodate a nonrealistic vocabulary without abandoning recognizable imagery. One of the first to do so was Alfred Maurer, who had arrived in Paris in 1897 as a promising figurative painter in the style of Thomas Anshutz, his teacher at the Pennsylvania Academy of the Fine Arts. By 1904, he had become a regular guest at Leo and Gertrude Stein's and was well on his way toward modernism. The still lifes and landscapes he executed through 1914, when he returned to America, were among the first American efforts to adopt Fauvism's loose brushwork and high-keyed palette (fig. 175). One of Maurer's classmates from the Pennsylvania Academy, Arthur B. Carles, went to Paris in 1905, at the moment Fauvism was being launched. Through his studies in Matisse's painting class, Carles crafted a lyrical style characterized by fluid drawing and sensuous color (fig. 177). Similarly atmospheric, all-over color washes prevailed in the scenic watercolors John Marin executed in Europe between 1908 and 1911. By marrying the brilliant color and spontaneous handling of Fauvism with the diaphanous washes and atmospheric space of Cézanne's watercolors, Marin developed a romantic watercolor style whose lightness and fluidity also invoked Chinese painting (figs. 176, 178).

176. **John Marin**
Sunset, Maine Coast,
c. 1919
Watercolor on paper,
16¼ x 19¼ in. (41.3 x
48.9 cm)
Columbus Museum of Art,
Ohio; Gift of Ferdinand
Howald

The Fauvist color and animate, atmospheric surfaces of Marin's watercolors anticipated those Charles Demuth produced on his return to America from Paris in 1914 (fig. 179). Demuth approximated Marin's high-intensity color, all-over compositions, and free, improvisatory handling of the watercolor medium while simultaneously introducing an undercurrent of sensuality, especially in his vaudeville, nightclub, and circus scenes (fig. 180). These figurative works were unusual in joining a modern vocabulary with subject matter from popular culture. Their abstract, rhythmic structure of concentric bands of light emanating from a circular center evoked the intimacy and vitality that made vaudeville America's most popular form of entertainment in the early years of the century.

Scenes of entertainment—but of high society rather than of the masses—attracted the Polish-born Elie Nadelman, who emigrated to America in late 1914 as an already successful sculptor of sleek, abstracted figures within the Greek and

177. **Arthur B. Carles**
Still Life with Compote,
1911
Oil on canvas mounted on
wood, 24⅛ x 25⅛ in.
(61.2 x 63.8 cm)
The Newark Museum, New
Jersey; Bequest of Miss
Cora Louise Hartshorn,
1958

178. **John Marin**
Tyrolean Mountains, 1910
Watercolor on paper,
14½ x 17¾ in. (36.8 x
45.1 cm)
Columbus Museum of Art,
Ohio; Gift of Ferdinand
Howald

179. **Charles Demuth**
Poppies, c. 1915
Watercolor on paper,
17½ x 11⅜ in. (44.5 x
28.9 cm)
Columbus Museum of Art,
Ohio; Gift of Ferdinand
Howald

180. **Charles Demuth**
Acrobats, 1919
Watercolor and pencil
on paper, 13 x 7⅞ in.
(33 x 20 cm)
The Museum of Modern
Art, New York; Gift of
Abby Aldrich Rockefeller

Roman tradition. References to this tradition would remain central to Nadelman throughout his career, as would his essential formalism: "The subject of any work of art," he wrote in *Camera Work* in 1910, "is for me nothing but a pretext for creating significant form. . . ."[31] Nadelman's debt to the clarity, order, and simplicity of classical art and his reliance on gently flowing contours resulted in sculpture that stood poised between the past and the present. This became even more evident after he introduced genre subjects into his repertoire—dancers, society figures, an orchestra conductor, a woman at a piano (fig. 181). Stylized, fluid, and unerringly elegant, these sculptures mirrored the values and activities of the world of wealth and privilege even as they incorporated anecdotal subjects from daily life.

The catalyst for Nadelman's shift to quotidian subjects—as well as his substitution of wood for bronze and marble—was American folk art, which he had begun to collect immediately after coming to America. The formal, unaffected simplicity that Nadelman's work took from folk art aligned it with that of the figurative vanguard sculptors Robert Laurent and William Zorach, who were likewise inspired by the directness of folk art (fig. 183). But whereas they were committed to direct carving, which emphasized the unique qualities of each material and encouraged subject, composition, and surface treatment to emerge during the carving process, Nadelman polychromed his finished sculptures and often produced two or three nearly identical versions of a single piece with the aid of paid assistants. After 1919, Nadelman abandoned this practice of replication, along with his simplified tubular style and genre subjects, and returned to the more classic style and subject matter of his earlier work.

The fanciful, symbolic watercolors of Charles Burchfield, imbued with the haunted fantasies and brooding melancholy of childhood, were worlds removed from the sophistication of Nadelman's elegantly attired men and women and the decadence of Demuth's performers. Burchfield's deployment of high-intensity color and calligraphic line transformed nature into a site of mystery and elemental power (fig. 182). That Burchfield evolved such a style in Salem, Ohio, with no firsthand exposure to modernist tendencies save those he absorbed in his brief study at the Cleveland School of Art, bore witness to how pervasively Fauvist color had infiltrated American art in the early decades of the century.

Georgia O'Keeffe, far more experimental than Burchfield, shared with him the distinction of not having traveled abroad during her formative period. Unlike him, though, she evolved her highly personal vocabulary of form and color through contact with the teachings of the art educator Arthur Wesley Dow and exposure to the examples of modernist art shown at Alfred Stieglitz's gallery, 291. Dow impressed on O'Keeffe—as he had on Max Weber and the Pictorialist photographers Alvin Langdon Coburn and Clarence H. White—the importance of two-dimensional design, which he had derived from his study of Japanese art. By 1915, O'Keeffe was incorporating these principles in a group of charcoal drawings that were Symbolist in mood but abstract in form (fig. 184). A friend and former classmate of O'Keeffe's, Anita Pollitzer, showed the charcoals to Stieglitz, who indicated that he might exhibit them at the gallery. When, in May 1916, O'Keeffe discovered that ten of them had been included in a group show at 291 without her permission,

181. **Elie Nadelman**
Tango, c. 1919
Painted cherry wood and gesso, 3 units, 35⅞ x 26 x 13⅞ in. (91.1 x 66 x 35.2 cm) overall
Whitney Museum of American Art, New York; Purchase, with funds from the Mr. and Mrs. Arthur G. Altschul Purchase Fund, the Joan and Lester Avnet Purchase Fund, the Edgar William and Bernice Chrysler Garbisch Purchase Fund, the Mrs. Robert C. Graham Purchase Fund in honor of John I. H. Baur, the Mrs. Percy Uris Purchase Fund, and the Henry Schnakenberg Purchase Fund in honor of Juliana Force 88.1a–c

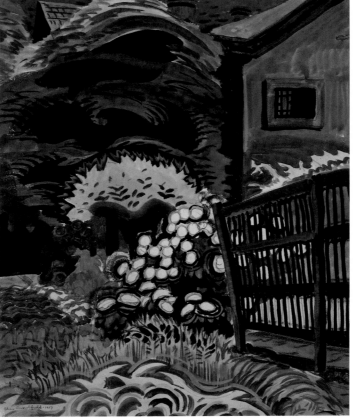

182. **Charles Burchfield**
Noontide in Late May,
1917
Watercolor and gouache
on paper, 22 x 17⁵⁄₁₆ in.
(55.9 x 45.6 cm)
Whitney Museum of
American Art, New York;
Purchase 31.408

183. **Robert Laurent**
The Flame, c. 1917
Wood, 20⅝ x 7½ x 7½ in.
(52.4 x 19.1 x 19.1 cm)
overall
Whitney Museum of
American Art, New York;
Gift of Bartlett Arkell
42.1a–b

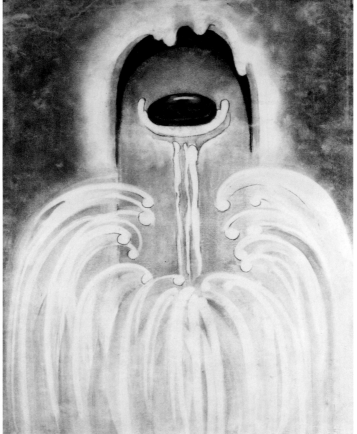

184. **Georgia O'Keeffe**
Special No. 2, 1915
Charcoal on paper, 23¾ x
18¼ in. (60.3 x 46.4 cm)
National Gallery of Art,
Washington, D.C.; The
Alfred Stieglitz Collection,
Gift of The Georgia
O'Keeffe Foundation

she demanded their removal. The ensuing confrontation sparked a sexual and emotional relationship between dealer and artist whose immediate effect was to prompt a new, more expressive phase in O'Keeffe's art. For the next three years, she worked exclusively in watercolor, relying on a vocabulary of abstract organic forms, luminous color washes, high-keyed color, and flowing rhythms to rapturously celebrate the vital forces of nature and give form to her inner emotional states—what she described as "the intangible thing in myself" (fig. 185).[32]

By elevating color over subject and allowing it to exercise compositional authority, these artists and others—among them Rockwell Kent, William Zorach, Marguerite Thompson (Zorach), and Manierre Dawson—aimed to communicate emotional experience (figs. 186–89). Their model for nonrepresentational expression was music. Following the 1912 publication in *Camera Work* of Kandinsky's essay on the spiritual quality of music and its relationship to color, music came to be accepted as the paradigm for visual abstraction. O'Keeffe, Marsden Hartley, Max Weber, and Arthur Dove in particular invoked music to support their subordination of subject matter to formal values and emotional expression. For

185. **Georgia O'Keeffe**
Morning Sky, 1916
Watercolor on paper, 8⅞ x 12 in. (22.5 x 30.5 cm)
Whitney Museum of American Art, New York; Purchase, with funds from The Lauder Foundation— Leonard and Evelyn Lauder Fund, Gilbert and Ann Maurer and the Drawing Committee 94.69

186. **William Zorach**
Woods in Autumn, 1913
Oil on canvas, 29 x 23¾ in. (73.7 x 60.3 cm)
Whitney Museum of American Art, New York; Gift of an anonymous donor 71.221

187. **Marguerite Thompson (Zorach)**
Deer in the Forest, 1914
Gouache on paperboard, 10 x 8 in. (25.4 x 20.3 cm)
Private collection; courtesy Tom Veilleux Gallery, Farmington, Maine

188. **Rockwell Kent**
Pastoral, 1914
Oil on canvas, 33 x
43½ in. (83.8 x 110.5 cm)
Columbus Museum of Art,
Ohio; Gift of Ferdinand
Howald

189. **Manierre Dawson**
Prognostic, 1910
Oil on canvas, 33¾ x
35¾ in. (85.7 x 90.8 cm)
Milwaukee Art Museum

most artists, the analogy between music and painting was indirect: they usually gave their works musical titles simply to indicate an intention to depict abstract emotional states independent of attachment to objects. Rarely were paintings visual translations of specific musical compositions. Yet, whatever the impetus, the parallel between music and art was so commonplace by 1913 that American critics could write of "color music" when describing abstract painting and declare the new art movement the "Academy of Music." [33]

CLASSICISM AND EXOTICISM IN TURN-OF-THE-CENTURY MUSIC

The interest in and growth of support for classical music in the United States in the early decades of this century reflect intersections of art and commerce in fascinating and characteristically American ways. It was then that the idea of a universal musical tradition established itself as the standard for the present as well as the past. Like the majority of western Europeans, Americans looked back on the nineteenth century as a golden age of classical music, albeit one that had to be imported (primarily from Germany) to its shores. Inside the new Boston Symphony Hall, built in 1900 (for an orchestra founded in 1881), Beethoven's name was enshrined in a plaque front and center above the stage. To bring the glories of this Germanic tradition to an ever larger public was the mission of five American orchestras founded between 1891 and 1900. And in 1902, the widely successful Aeolian Piano Company listed many classical composers among its over eight thousand selections on piano rolls that supplied 75,000 player pianos.

In the early 1900s, the patterns of a transatlantic culture trade established themselves through travel and technology. Then as now, American audiences and American invention proved irresistible to Europeans. From over there to over here came waves of virtuoso musicians, among them the pianists Artur Rubinstein and Sergei Rachmaninoff, the Irish tenor John McCormack, who became a U.S. citizen in 1918, and the conductors Arturo Toscanini and Leopold Stokowski. By 1920, the great Italian tenor Enrico Caruso had become a millionaire from sales of the American recordings he had been making since 1902. Other famous foreign singers included the sopranos Johanna Gadski, Alma Gluck, and Geraldine Farrar. Only occasionally did American-born musicians reach comparable celebrity. Through sound recordings, piano rolls, and national tours, virtuoso dazzle and operatic glamour were disseminated into the mainstream of American musical life.

The success of European classical music as a cultural commodity proved to be both a blessing and a curse for new music. On the one hand, the émigré composer Victor Herbert successfully adapted Viennese operetta to the American stage; *Babes in Toyland* (1903) and *Naughty Marietta* (1910) were later made into sound films (fig. 190). On the other hand, even the unprecedented support for new American operas

190. Poster for Fred R. Hamlin and Julian Mitchell, *Babes in Toyland,* 1903
Billy Rose Theatre Collection, The New York Public Library for the Performing Arts, Astor, Lenox and Tilden Foundations

THE ARMORY SHOW

The 1910 Independents show, organized by Robert Henri and his realist colleagues, had attempted to address the lack of exhibition opportunities and patronage that American artists faced in the first decade of the century. In 1911, another Independents show, organized by Henri's student Rockwell Kent, enjoyed only limited success, because of Kent's stipulation that none of the participating artists submit paintings to the National Academy that year—a restriction that resulted in the absence from the show of Henri, Sloan, Glackens, Lawson, and Shinn. In late 1911, three artists who exhibited together at the Madison Gallery—Jerome Myers, Walt Kuhn, and Elmer L. MacRae—began discussing the possibility of an exhibition of American art even more ambitious than either the 1910 or the 1911 show. Conversations continued throughout the winter in Myers' studio with the director of the Madison Gallery, the painter Henry Fitch Taylor, and other invited artists. By January 1912, a committee of twenty-five artists, calling itself the Association of American Painters and Sculptors, had been formed. Most of the Association's original members were affiliated either with the National Academy or with Henri. The relatively conservative tone of the group was indicated by its choice of J. Alden Weir as president and Gutzon

Borglum as vice president. For about a year, the group tried without success to find an exhibition site and funding for the venture. Finally, faced with the resignation of Weir and what seemed an insoluble financial dilemma, the group persuaded Arthur B. Davies to accept the presidency. Well connected socially and adept at raising funds, Davies was sufficiently allied with both conservatives and realists to satisfy both factions. Unbeknownst to the conservatives, he harbored sympathies for vanguard art and knew more about recent developments than did most of his peers. He subscribed to various European art journals, was a frequent visitor to 291, and had been the single purchaser of two of Max Weber's paintings from the artist's 1909 show at the Haas Gallery.

offered by New York's Metropolitan Opera between 1910 and 1920 failed to secure a place for this genre.

Issues of national identity in music centered on questions of what could make American classical music different or characteristically New World. In one of the first books about American classical composers, Rupert Hughes lamented the snobbery of those "who despise everything contemporary or native." A more positive approach came, ironically, from a European composer, Antonín Dvořák, during his stay here from 1892 to 1895. He challenged American composers to incorporate into their concert works indigenous and therefore nationally authentic folk music from Native American and African American song; this challenge bore fruit in an enormously popular collection of spirituals arranged for concert voice and piano, *Jubilee Songs of the United States of America* (1916), by one of his pupils, the African American composer Henry Thacker Burleigh. Others resisted Dvořák, such as John Knowles Paine and Amy Beach, who espoused the ideal of music as a pan-national language, best realized through a style emulating German traditions. Edward MacDowell, arguably the most successful composer of his generation, quarreled with Dvořák's approach to art as contrived, but he nevertheless wrote the *Indian Suite for Orchestra* (1897), inaugurating a wave of "Indianist" compositions by such composers as Charles Wakefield Cadman (*Four American Indian Songs*, 1909) and Arthur Farwell (*Navajo War Dance No. 2, for Piano*, 1904); Farwell proclaimed that "the German masterpieces [were] unapproachable, especially from another land and race," and used the pioneering musical anthropology of Alice Fletcher for inspiration. Perhaps because the frontier was closed, "Indianist" compositions captured a nostalgia for the pre-industrial past and the wide-open spaces of mythic individualist freedom.

Ironically, the Indian could also serve as a symbol of the exotic "other"—as a source of Impressionist color that washed away nineteenth-century Romantic nationalism. Occasionally, Cadman looked to the Far East, not just the American West, for inspiration, as did Charles Tomlinson Griffes. *The Pleasure Dome of Kubla Khan* (1917) is still an admired work, as is his extraordinary *Sonata for Piano* (1918). Griffes' modernism, forged in relative isolation, would prove prophetic for a new postwar generation of American classical music pioneers. —J. T.

Until Davies became president, the Association envisioned its show as larger than the previous Independents exhibitions, but similarly national in focus, with a handful of European artists included for publicity value. And indeed, with the final list numbering over one thousand American works chosen by Glackens, the exhibition fulfilled the Association's goal of providing a comprehensive cross section of American contemporary art. Davies was convinced, however, that American aesthetic provincialism had to be broken, and he pushed his colleagues to include more contemporary European art in the exhibition. His success attested as much to the Association's ignorance about the potential impact of European art as to the arrogance and authoritarianism of which Davies was later accused by disgruntled Association members.

It was not until the fall of 1912, after Davies saw the catalog of a large international survey of modern art being held in Cologne, that his dream of what would become the Armory Show took concrete form. He sent this catalog of the "Sonderbund" exhibition to Walt Kuhn, secretary of the Association, with a note suggesting that the Association's show be similarly inclusive. Kuhn agreed and sailed immediately for Europe, arriving in Cologne on the last day of the show. After arranging to borrow a large group of the exhibited paintings, he traveled to The Hague, Munich, and Berlin, where he contracted to borrow more pictures, including "a roomful" by Odilon Redon. Joined by Davies in Paris, the two of them, accompanied by Walter Pach, an expatriate American artist and critic, spent the next few weeks visiting artists and dealers and making arrangements to borrow even more works for the show. Davies and Kuhn returned to America via London, where they selected still more works from a large survey of modern art organized by the critic Roger Fry for the Grafton Gallery. Pach remained behind as

the Association's European agent to supervise the assembly and shipping of the loans.

Within the space of several weeks, Davies and Kuhn had selected over four hundred European art works that admirably showed the evolution of modern art since the Romantic period. They had included works by the earlier French masters Delacroix, Ingres, Corot, and Courbet to provide historical perspective on the art of the present. The present was well represented by large concentrations of Impressionism, Post-Impressionism, Neo-Impressionism, and Fauvism, along with extensive selections of the work of Cézanne, the Cubists, and, owing probably to Davies' Symbolist leanings, Redon, Puvis de Chavannes, and the Nabis. German Expressionism, which Davies and Kuhn considered merely an adaptation of Fauvism, was represented by only two canvases—an Ernst Kirchner landscape and Wassily Kandinsky's *Improvisation No. 27* (1912). The English and Russian moderns were absent altogether, as were the Italian Futurists, who were excluded because they had insisted on being exhibited as a group. Thus the story of modern art that Davies told was predominantly French—a viewpoint that would persist in America for decades.

191. Installation view of the "International Exhibition of Modern Art," New York, 1913 Walt Kuhn, Kuhn Family Papers, and Armory Show Records, Archives of American Art, Smithsonian Institution, Washington, D.C.

192. Catalog cover for the "International Exhibition of Modern Art," 1913 Frances Mulhall Achilles Library at the Whitney Museum of American Art, New York

NEW YORK

1913

International Exhibition of Modern Art

Association of American Painters and Sculptors, Inc.

February Seventeenth to March Fifteenth

Catalogue 2⁵ Cents

The "International Exhibition of Modern Art," as it was officially called, opened with a gala reception on February 17, 1913, at the armory of the New York National Guard's Sixty-ninth Regiment, at 26th Street and Lexington Avenue. The problem of turning the cavernous room into functional galleries was solved at the last minute by dividing the space into a maze of octagonal rooms, which were decorated with greenery and capped by a dome of cloth streamers (fig. 191). The Association's motto for the show, "The New Spirit," and its emblem, the pine tree flag of Revolutionary Massachusetts, aptly described the spirit of rebellion and independence in which the show was undertaken (fig. 192). That the exhibition far exceeded the organizers' dreams—and perhaps their desires—was due not to the vast array of American work, which outnumbered the European inclusions by a ratio of three to one, but to the new and controversial art that constituted the European section.

At first, press coverage was laudatory and attendance disappointing. Not until the first vitriolic reviews appeared did the show become a success. At times, there were so many viewers crowding in front of Marcel Duchamp's *Nude Descending a Staircase, No. 2* (fig. 193), which had been singled out by the press for special abuse, that the picture could not be seen. Lambasted as an "explosion in a shingle factory" and lampooned as "The Rude Descending a Staircase (Rush Hour at the Subway)" (fig. 194) and "a

195. **Arthur G. Dove**
Plant Forms, c. 1912
Pastel on canvas, 17¼ x
23⅞ in. (43.8 x 60.6 cm)
Whitney Museum of
American Art, New York;
Purchase, with funds from
Mr. and Mrs. Roy R.
Neuberger 51.20

196. **Arthur G. Dove**
Abstraction, Number 2,
c. 1911
Chalk and graphite on
paper, 21¼ x 17¹³⁄₁₆ in.
(54 x 45.2 cm)
Whitney Museum of
American Art, New York;
Purchase 61.50

THE IMPACT OF CUBISM AND FUTURISM

Notwithstanding Stieglitz's exhibition of Picasso's work at 291 in 1911, it was not until after the Armory Show that Cubist geometry decisively influenced American modernism. The early, analytic stage of Cubism, with its monochromatic color, angular lines, and faceted analysis of three-dimensional form, had made little impression on this country's artists. What appealed to them was the geometric simplification of objects that characterized the next stage, Synthetic Cubism. By joining its compressed space, closed shapes, and crisply demarcated forms with the high-keyed, expressive color of Fauvism, American artists forged a unique synthesis of two dominant European styles.

The combination of Fauvism and Cubism had been announced in 1912 with Arthur Dove's series of pastels entitled *The Ten Commandments*. Using a vocabulary of interpenetrating forms, repeated shapes, and overall color and textural similarities, Dove found a means of describing the flux and movement of life. His expanding and contracting forms suggested nature's pulsating growth and explosive energy and, by extension, the life forces and pantheistic interconnectedness of everything (figs. 195, 196). Dove described the essence or inner character of objects by means of color and form—what he called the "condition of light" and "force lines" of an object. As he later wrote, "I would like to take wind and water and sand as a motif and work with them, but it has to be simplified in most cases to color and force lines and substances, just as music has done with sound."[35]

Like many American artists, Dove evolved his modernist vocabulary after he returned from Europe and encountered Alfred Stieglitz. For Marsden Hartley, the trajectory was reversed. Hartley had met Stieglitz in 1909 when he brought his high-keyed, Neo-Impressionist Maine landscapes to the dealer's attention. As a member of Stieglitz's coterie, he had quickly absorbed the Fauvist and Analytical Cubist styles that Stieglitz exhibited at 291. In 1912, the dealer established a fund to send Hartley to Europe. After spending one year in Paris, he moved to Berlin, where he began a powerful group of symbolic paintings that combined expressive, modulated brushwork and Fauve colors with the tightly knit, collage format of Synthetic Cubism (fig. 198). In Berlin on the eve of World War I, Hartley was entranced by the city's military environment and incorporated its pageantry and visual excitement into his paintings. He transformed the stripes and designs of German imperial flags and military emblems into an overall design of overlapping and interlocking flat patterns. After war broke out in 1914, the German officer whom Hartley loved was killed. The artist created symbolic portraits of his lost

THEATER IN THE TEENS

The famous 1913 Armory Show in New York City was more than a defining moment for the visual arts in America: its modernist influences also inspired a generation of American set designers, sending them scurrying to Europe to study firsthand revolutionary changes in theater. The impact on the American stage was immense, yet slow to develop. Indeed, for the twenty years or so following the Armory Show, the American theater was a hybrid of new American modernism and vestiges of the traditional past. Even playwriting innovators like Eugene O'Neill, though determined to find new ways to express American concerns and themes, often continued to reflect the kind of melodramatic dramaturgy and surface realism associated with the work of the producer, director, and playwright David Belasco during the last quarter of the nineteenth century.

Designers who returned from European expeditions began to revolt against such Belascan pictorial realism and decorative distractions through simplification of design, beginning with Robert Edmond Jones' spare and visually stunning design in 1915 for Anatole France's *The Man Who Married a Dumb Wife*. The "new stagecraft" (adapted from European models), typified by the designs of artists such as Lee Simonson, Norman Bel Geddes, Cleon Throckmorton, and Jones, subsequently contributed to an innovative era in American theater. Without a doubt, the teens became the period of gestation for the modern American theater in many ways. The decade witnessed the establishment of unions (especially Actors' Equity); the emergence of the Little Theatre movement, a concrete reaction to the commercialization of the theater; the early work of O'Neill, which for some marks the beginning of a real American theater—or at least the international recognition of an American dramatic idiom; the formation of crucial early institutional theater groups, such as the Washington Square Players (which would evolve into the Theatre Guild) and the Provincetown Players, both precursors of the group phenomenon that became a major characteristic of the theater of the twenties and thirties. —D. W.

Lippmann's assessment of a world "bursting with new ideas, new plans, and new hopes. The world was never so young as it is today, so impatient with old and crusty things."[34] Bourgeois mores and conventional codes of respectability were challenged by the growing acceptance of birth control, psychoanalysis, women's suffrage, and anarchism. Sigmund Freud's ideas on free association and dream interpretation, which he had promulgated on his 1909 American lecture tour, were so ubiquitous after 1913 that they became the basis of games at Greenwich Village parties. The exchange of ideas flourished in the pages of the new "little magazines" that sprang up: *The Smart Set* (1913–22), *The New Republic* (1914–present), *The Little Review* (1914–29), *291* (1915–16), *Poetry* (1912–present), *The Seven Arts* (1916–17), *The Soil* (1916–17), and *Others* (1915–19).

The inauguration of several salons in the wake of the Armory Show gave the vanguard community a degree of cohesion and camaraderie it had not previously known. Mabel Dodge's salon offered the widest mixture of American politics and literature, while that of Walter and Louise Arensberg was more international and centered on art. The Arensbergs' conversion to modern art at the Armory Show had precipitated their move from Boston to New York in 1913. Two years later, Marcel Duchamp arrived in America and took up residence in an apartment above theirs on the Upper West Side. The Arensbergs' late-night gatherings hosted artists who had fled war-torn Europe—Duchamp, Francis Picabia, Jean Crotti, Albert Gleizes, Mina Loy, Elsa von Freytag-Loringhoven, and Edgard Varèse—and numerous Americans, including Charles Sheeler, Joseph Stella, Morton Livingston Schamberg, John Covert, Marius de Zayas, Wallace Stevens, William Carlos Williams, and Katherine Dreier. With Duchamp as the guiding force, the Arensbergs' apartment would become the center of proto-Dada activity in New York.

MODERNIST POETRY IN CHICAGO

For a few years after 1912, a modest town house on Chicago's North Side was the nerve center of modern poetry in the English language. Here Harriet Monroe, friend of both the city's culture-hungry industrialists and its bohemian writers and artists, edited *Poetry: A Magazine of Verse*. It was the first American magazine devoted solely to poetry—the established literary quarterlies used verse mainly for filler—and it was founded to promote a new spirit in art and letters.

Monroe was no avant-gardist—her own verse ran to watery Keatsian colors—but she was passionate about poetry as a calling and a cause. When the Chicago publisher and booster Hobart Chatfield-Taylor suggested that the Windy City needed a poetry magazine to highlight its genteel side, Monroe got more than a hundred prominent citizens to pledge fifty dollars apiece. Nest egg in hand, she set to work in the public library, reading every scrap of English verse published in the preceding five years. And then she wrote to the poets she liked. Among them was a one-man revolution named Ezra Pound.

From his bully pulpit in London, Pound put Monroe in touch with the people who mattered in modern poetry—beginning with the Imagist circle to which he belonged. Pound, Richard Aldington, Hilda Doolittle ("H. D."), T. E. Hulme, and F. S. Flint were calling for a hard, economical, tersely visual—that is, imagistic—verse that would do battle with the long-windedness and sentimentality then ruling the reviews. *Poetry* magazine became Imagism's first showcase.

One result of Pound's collaboration was a wide cosmopolitanism that Monroe could not have managed alone. Another was that two energetic avant-gardes coexisted in *Poetry* without really making friends: the Imagists and the "Chicago School" poets who were the objects of Monroe's real love and loyalty—Vachel Lindsay, Edgar Lee Masters, Carl Sandburg, and many lesser lights. These American writers and artists had come to Chicago not to practice an exacting art of reduction such as the Imagists called for but to liberate themselves from the stifling commercial culture of their hometowns. Their work tended toward the loose-limbed, the colloquial, and the visionary—quite the opposite of the Imagist recipe.

Lindsay wandered the country, trading his ethereal verses for bread and preaching a gospel of beauty; in Chicago, he developed a bombastic, oratorical style that celebrated homegrown visionaries like William Jennings Bryan. Masters worked in a restrained, ironic, epitaphic mode, telling the stories of small-town saints and sinners in *Spoon River Anthology* (1915). And Sandburg became the bard of working Americans, slinging a loose, prosy line that made plenty of room for native talk and lore. Less careful as artists than the Imagists and their descendants, Lindsay, Masters, and Sandburg are spiritual ancestors of the Beats and all the other vision-hungry, vagabonding looseners of the American necktie.

Pound never reconciled himself to sharing pages with the likes of these, and by 1913 he had found other venues. *Poetry* would go on in glory, publishing work by Marianne Moore, William Carlos Williams, Amy Lowell, William Butler Yeats, and countless others. In short, Harriet Monroe's brave little magazine, which still exists, invented the poetry world we inhabit today. —J. S.

193. **Marcel Duchamp**
Nude Descending a Staircase, No. 2, 1912
Oil on canvas, 58 x 35 in.
(147.3 x 88.9 cm)
Philadelphia Museum of
Art; Louise and Walter
Arensberg Collection

194. *The Rude Descending a Staircase (Rush Hour at the Subway)*
From *The New York Evening Sun,* March 20, 1913

SEEING NEW YORK WITH A CUBIST

The Rude Descending a Staircase
(Rush Hour at the Subway)

staircase descending a nude," the painting catapulted Duchamp into national prominence—a position, paradoxically, he did not enjoy in France. The public came to jeer or to be shocked, but it came in droves. Before the show closed on March 15, an estimated 75,000 people had seen it.

From New York, the show—minus work by American artists not members of the Association—traveled to the Art Institute of Chicago, where it generated an even greater scandal and a more frenzied response. Fortunately for attendance, the show coincided with an Illinois state commission investigating vice in Chicago, and the report that some of the exhibited paintings were immoral and suggestive only heightened an already feverish reaction to the exhibition. Students at the Art Institute, incited by teachers who toured the galleries denouncing the exhibits, hanged Constantin Brancusi, Pach, and Matisse in effigy. The derision of Matisse was encouraged by the observation that one of his nudes had six toes. All these protests and controversies, however, had the effect of ensuring the show's success. Not so in Boston, the exhibition's next stop. Here the response was tepid—surprisingly so, since space constraints had limited the presentation to the vanguard European works. With few denunciations and no scandal to incite public curiosity, the show suffered a declining attendance over its three-week run.

Despite its cool reception in Boston, the impact of the Armory Show was tremendous. Conceived with the intention of celebrating the strength of American art, it had inadvertently exposed most of it as provincial and *retardataire*. But in offering a crash course in modern art, the Armory Show had also closed the gap between American and European standards of reference. The American public might not rush to embrace abstract art—which it equated with European art—but a foothold for it had been established, and America would never again be ignorant of its existence. This foothold was secured by the post-Armory Show opening in New York of a host of galleries sympathetic to modern art—the Carroll Galleries, the Daniel Gallery, the Modern Gallery, the People's Art Guild, and the Washington Square Gallery—and the emergence of new collectors eager to immerse themselves in the art of the present—Arthur Jerome Eddy, Louise and Walter Arensberg, John Quinn, Katherine Dreier, and Duncan Phillips.

The years after the Armory Show coincided with a mood of euphoria that swept the art community. Mabel Dodge's description of the time as one in which nothing seemed impossible to the human spirit was echoed by the critic Walter

197. **Marsden Hartley**
Painting, Number 5,
1914–15
Oil on canvas, 39½ x
31¾ in. (100.3 x 80.6 cm)
Whitney Museum of
American Art, New York;
Gift of an anonymous donor
58.65

198. Marsden Hartley
Forms Abstracted, 1913
Oil on canvas, 39½ x
31¾ in. (100.3 x 80.6 cm)
Whitney Museum of
American Art, New York;
Gift of Mr. and Mrs. Hudson
D. Walker and exchange
52.37

199. Marsden Hartley
Provincetown, 1916
Oil on board, 24⅛ x 20 in.
(61.3 x 50.9 cm)
The Art Institute of
Chicago; The Alfred
Stieglitz Collection

friend by juxtaposing decorative patterns of flags and emblems with the Iron Cross, the feathered helmets, spurs, and tassels of the Kaiser's Royal Guards, and his friend's initials, age, and regiment number (fig. 197).

As the war continued, it became increasingly difficult to send money from America to Germany, and Hartley was forced to return home in late 1915. Confronted with the intense anti-German sentiment in America, he was obliged to disavow his emotional connection with the German military environment that had so effectively fueled his creative energies. For the first few years after his return, Hartley experimented with a group of abstract Synthetic Cubist works whose crisply demarcated forms and flat, iconic treatment attained a degree of rigid frontality that would not be equaled by another American artist for several decades (fig. 199).

200. **Morgan Russell**
Synchromy in Blue Violet,
1913
Oil on canvas, 21¾ x
15 in. (55.2 x 38.1 cm)
Curtis Galleries,
Minneapolis

While Hartley was in Berlin producing his German military paintings, two other American artists, Morgan Russell and Stanton Macdonald-Wright, were in Paris formulating an optically based system of painting anchored in the potential of color to affect the perception of space. Calling themselves Synchromists, meaning "with color," they publicly announced their program of building three-dimensional form with color in exhibitions in Munich and Paris in June and November of 1913. They insisted, moreover, that their abstract, chromatic experiments preceded those of Robert Delaunay and František Kupka, European progenitors of what was dubbed Orphism. Although Russell and Macdonald-Wright chose to ignore the crucial influence the Orphists exerted on them, the claim that they independently arrived at a system for using color to create volume was legitimate. Both artists exploited value contrasts to produce color rhythms through receding or advancing space. Yet, despite their shared program, they turned out discernibly different work, Russell's color segments being opaque and Macdonald-Wright's being diaphanous and fluid (figs. 200, 201). The Synchromists' union of color with solid, geometric form was emulated by many artists, the most gifted of whom was Patrick Henry Bruce. A student of both Matisse and Delaunay, Bruce juxtaposed thickly painted, geometric color planes to suggest the abstract dynamism of modern life (fig. 202).

Oscar Bluemner's reduction of landscape motifs to bold color planes (fig. 203) has often been linked with Synchromism. But whereas the Synchromists dealt with the optical properties of color, Bluemner was attracted to its mystical symbolism and emotive properties. Trained as an architect, he organized his landscape motifs into architectonic "color planes," as he called them, which he believed

201. **Stanton Macdonald-Wright**
"Oriental": Synchromy in Blue-Green, 1918
Oil on canvas, 36 x 50 in.
(91.4 x 127 cm)
Whitney Museum of American Art, New York;
Purchase 52.8

202. **Patrick Henry Bruce**
Composition II, 1916
Oil on canvas, 38¼ x
51 in. (97.2 x 129.5 cm)
Yale University Art Gallery,
New Haven; Gift of
Collection Société Anonyme

produced emotional sentiments in the viewer that paralleled his own. "Colors," he once said, "are visible creative forces." "When you 'FEEL' colors, you will understand the 'WHY' of their forms."[36]

A similarly expressionist intensity informed the work of John Marin, one of the first artists to abstractly pictorialize the frenzied flux and energy of the city. Returning to America in 1911 after a prolonged European stay, Marin found in the city's architectural and engineering structures a manifestation of the nation's explosive growth and romantic promise. For him, the whole city was alive—buildings as well as people. He wanted to express in his work what he perceived as omnipresent spatial tensions and balances. "As my body exerts a downward pressure on the floor," he observed, "the floor in turn exerts an upward pressure on my body."[37] Using watercolor and the fragmented geometries of Cubism, he began in 1912 to explode and expressionistically tilt the city's architecture in order to describe the kinetic tensions of dynamic forces against one another in space (fig. 204).

203. **Oscar Bluemner**
Space Motive, a New Jersey Valley, c. 1917–18
Oil on canvas, 30½ x 40½ in. (77.5 x 102.9 cm)
Whitney Museum of American Art, New York; Purchase, with funds from Mrs. Muriel D. Palitz 78.2

204. **John Marin**
Brooklyn Bridge, c. 1912
Watercolor and charcoal on paper, 18⅝ x 15⅝ in. (47.3 x 39.7 cm)
The Metropolitan Museum of Art, New York; The Alfred Stieglitz Collection, 1949

For other vanguard artists, it took the arrival of European colleagues to direct their attention to the splendor of the country's technology. The first European painter to extol America's technological dynamism was Francis Picabia, who had visited New York in conjunction with the Armory Show and been widely quoted in newspapers. He urged American artists to seize the dynamic vitality of New York as subject matter—an enthusiasm reinforced by the exhibition of his New York-inspired paintings at 291 two days after the close of the Armory Show. Picabia's ebullient comments about America as the country of the future and his advocacy of New York as the paradigm of modernity were echoed by other Euro-peans who fled to this country following the outbreak of World War I.

Marcel Duchamp declared upon his arrival in 1915 that American skyscrapers were more beautiful than anything France had to offer; two years later, he defended the exhibition of his ready-made urinal *Fountain* (1917) as art, contending that "the only works of art America has given are her plumbing and her bridges" (fig. 205).[38] To the Cubist painter Albert Gleizes, who also arrived in 1915, skyscrapers were "works of art. . . .creations in iron and stone which equal the

most admired old world creations. . . . The genius who built the Brooklyn Bridge is to be classed alongside the genius who built Notre Dame de Paris."[39]

These artists were warmly received in American art circles, and their affirmative declarations encouraged American artists to turn their gaze toward the beauty and dynamism of the urban world. When they did so, they utilized a vocabulary more akin to Futurism than to Cubism. Although both styles fragmented images, Cubism presented objects as if observed by a single individual from multiple viewpoints, whereas Futurism emphasized the movement of objects themselves. Paradoxically, although no actual Futurist art had been seen in America because of the Futurists' exclusion from the Armory Show, press reaction had elevated it to a position of prominence by labeling the show's vanguard inclusions, almost without exception, "futuristic art" and by calling Cubism "static Futurism" or a "subset of Futurism."[40] The impression that the entire modernist impulse was Futurist in conception was reinforced by the show's inclusion of several Futurist-inspired works, in particular Duchamp's *Nude Descending a Staircase, No. 2,* which dominated journalistic commentary (fig. 193). Not surprisingly, when Americans began to depict what was new in modern life—speed, dyna-mism, and the visual energy of the urban and technological environment—they chose a Futurist vocabulary of interpenetrating, repeated forms.

205. **Marcel Duchamp**
Fountain, 1917, photograph by Alfred Stieglitz
From *The Blind Man,* May 1917
Philadelphia Museum of Art; Louise and Walter Arensberg Collection

Fountain by R. Mutt.

Photograph by Alfred Stieglitz

THE EXHIBIT REFUSED BY THE INDEPENDENTS

Excluding Marin, the artists who most effectively used this vocabulary to portray the cacophony and turbulence of the city were immigrants: Max Weber and Abraham Walkowitz, both from Russia, and Joseph Stella, from Italy. By 1915, Weber had progressed from the high-keyed, figurative Cubism of his 1910–12 period to a series of kaleidoscopic evocations of the kinetic sensations of New York, in which flat, richly ornamented surfaces were juxtaposed with fluid, transparent space (fig. 206). The result was a unique synthesis of decoration and movement. In his sculpture, Weber relied on angularity and distortion to suggest motion—as did his contemporary Alice Morgan Wright (figs. 207, 208).

Abraham Walkowitz likewise took Futurism as his point of departure after the Armory Show. Prior to 1913, he had painted figurative images in a style that owed as much to his interest in children's drawings as to the Fauvist art he had seen during his 1906–7 year abroad. His post-1913 skyscraper studies, with buildings effaced in tangles of lines and tilted precariously against one another, captured the spectacle of a city engulfed in a restless web of frenzy and confusion (fig. 209).

Stella, an Italian by birth, had seen examples of his countrymen's Futurist work while in Europe in 1912. Yet what precipitated his adoption of Futurism was a nighttime visit in September 1913 to Coney Island, the New York amusement park. Stella was struck by its dazzling array of lights, surging crowds, and motorized rides. He combined vignettes of actual and imagined scenes in a churning

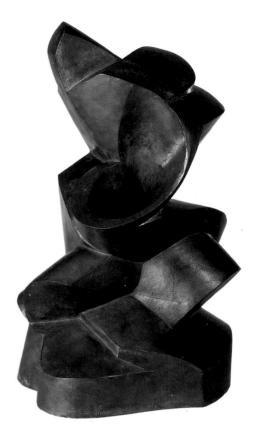

206. **Max Weber**
Chinese Restaurant, 1915
Oil on canvas, 40 x 48 in.
(101.6 x 121.9 cm)
Whitney Museum of
American Art, New York;
Purchase 31.382

207. **Alice Morgan Wright**
Wind Figure, 1916
Bronze, 10⅝ x 5 x 3¼ in.
(27 x 12.7 x 8.3 cm)
Hirshhorn Museum and
Sculpture Garden,
Smithsonian Institution,
Washington, D.C.; Gift of
Elinor W. Fleming, 1983

208. **Max Weber**
Spiral Rhythm, 1915
(enlarged and cast
1958–59)
Bronze, 24⅛ x 14¼ x
14⅞ in. (61.3 x 36.2 x
37.8 cm)
Hirshhorn Museum and
Sculpture Garden,
Smithsonian Institution,
Washington, D.C.; Gift of
Joseph H. Hirshhorn, 1966

209. **Abraham Walkowitz**
New York, 1917
Watercolor, ink, and
graphite on paper, 30⅝ x
21¾ in. (77.8 x 55.2 cm)
Whitney Museum of
American Art, New York;
Gift of the artist in memory
of Juliana Force 51.35

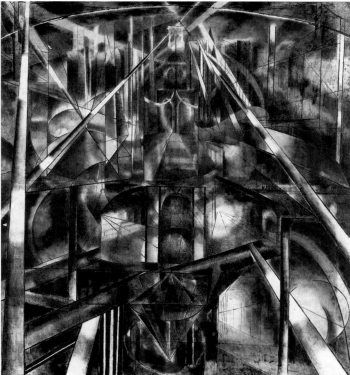

210. **Joseph Stella**
Battle of Lights, Coney Island, Mardi Gras, 1913–14
Oil on canvas, 76⅞ x 84⅝ in. (195.2 x 215 cm)
Yale University Art Gallery, New Haven; Bequest of Dorothea Dreier to the Collection Société Anonyme

211. **Joseph Stella**
Brooklyn Bridge, 1919–20
Oil on canvas, 84 x 76 in. (213.4 x 193 cm)
Yale University Art Gallery, New Haven; Gift of Collection Société Anonyme

arabesque of surface patterns that resonated with the motion, glitter, and brassy mechanical sound of the carnival environment. The result, *Battle of Lights, Coney Island, Mardi Gras* (fig. 210), was the first American work to merge a machine subject with a style that encapsulated machinery's dynamism and speed.

Stella next celebrated the machine as a symbol both of divinity and of American culture. His vehicle was the Brooklyn Bridge, in whose union of the majestic and the monstrous he saw a metaphor of modern life—its contradictory conditions of exuberance and imprisonment: "It impressed me as the shrine containing all the efforts of the new civilization of AMERICA—the eloquent meeting of all forces arising in a superb assertion of their powers, in APOTHEOSIS. . . . Many nights I stood on the bridge . . . [feeling] deeply moved, as if on the threshold of a new religion or in the presence of new DIVINITY."[41] Stella brought to the subject not only an immigrant's desire to celebrate the wealth and grandeur of the New World but also a poet's wish to wrest mystical significance from everyday reality (fig. 211). In creating a vision of spiritual redemption out of twentieth-century technological icons, Stella followed the American poet Walt Whitman, who had glorified the dynamism, vitality, and energy of the native environment and hailed the machine as an American cultural symbol. Throughout his career, Stella continued to use the Brooklyn Bridge to create a contemporary myth that reconciled the machine and the human spirit (fig. 212).

212. **Joseph Stella**
*The Brooklyn Bridge:
Variation on an Old Theme,*
1939
Oil on canvas, 70 x 42 in.
(177.8 x 106.7 cm)
Whitney Museum of
American Art, New York;
Purchase 42.15

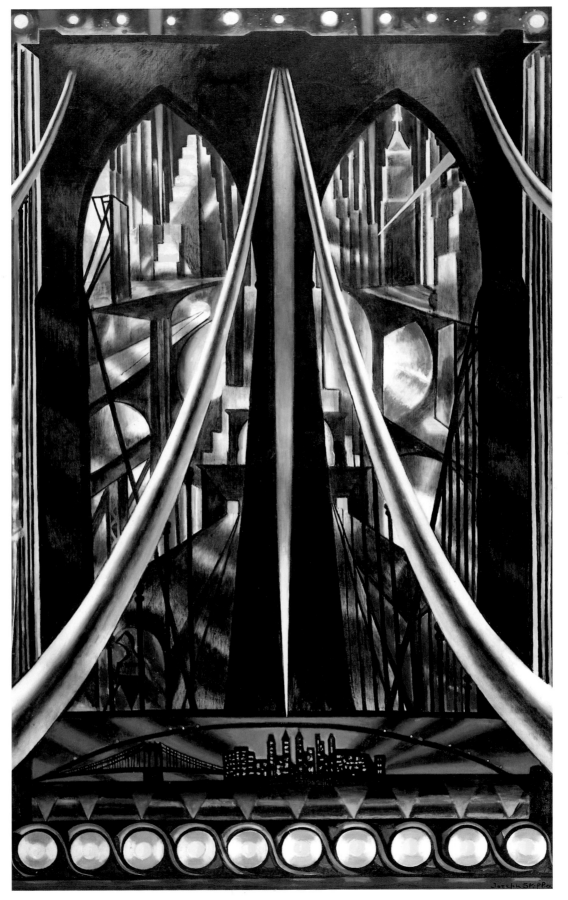

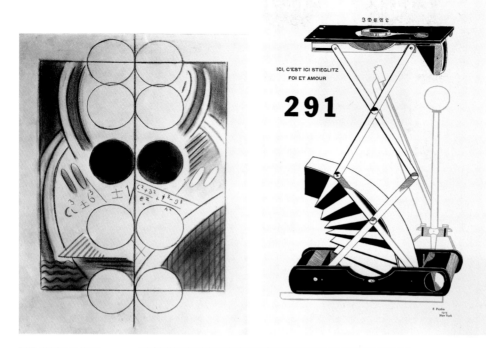

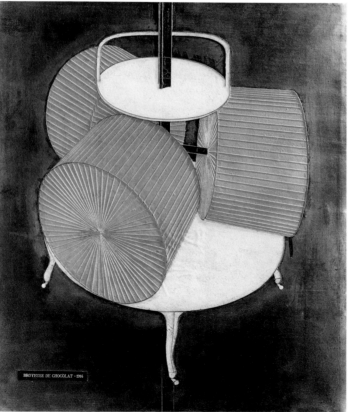

213. **Marius de Zayas**
Alfred Stieglitz, c. 1912
Charcoal on paper, 24¼ x
18⁹⁄₁₆ in. (61.6 x 46.5 cm)
The Metropolitan Museum
of Art, New York; The
Alfred Stieglitz Collection,
1949

214. **Francis Picabia**
*Ici, c'est ici Stieglitz/Foi et
amour (Here, This Is
Stieglitz/Faith and Love)*
Cover of *291*, July–August
1915

215. **Marcel Duchamp**
Chocolate Grinder, No. 2,
1914
Oil, thread, and pencil on
canvas, 25¾ x 21⅜ in.
(64.4 x 54.3 cm)
Philadelphia Museum of
Art; Louise and Walter
Arensberg Collection

DADA

Stella's desire to construct a transcendent and rhapsodic mysticism out of the materials of the machine environment was not shared by his associates in the Arensberg circle, who were far less ambivalent about the machine, which they embraced without qualm as "the soul of the modern world."[42] As Marius de Zayas' associate Paul Haviland ecstatically proclaimed in 1915, "We are living in the age of the machine. Man made the machine in his own image."[43] Picabia, upon returning to New York in April of that year, declared his intention to bring the machine into his studio. He made good his boast that summer with a series of "portrait" drawings in which isolated technological objects, rendered in a style that recalled the mail-order catalog illustrations and newspaper ads on which some of the images were based, represented specific people. The best-known of these object portraits, as they were called, was *Here, This Is Stieglitz*, which allegorically represented the photographer and dealer as a folding camera (fig. 214). Picabia's use of objects to symbolize a person's psychic and physical characteristics was not unprecedented. Already in 1912, de Zayas had created abstract caricatures of art world personalities by means of complex diagrams of algebraic formulas and geometric shapes (fig. 213). And in March 1915, four months before Picabia's machinist drawings were published in de Zayas' and Paul Haviland's experimental magazine *291* and ten months before they were exhibited in New York at de Zayas' Modern Gallery, Marcel Duchamp's two *Chocolate Grinder* paintings had gone on view at the Carroll Galleries (fig. 215). In these paintings, which were studies for the "Bachelor Apparatus" of Duchamp's masterpiece, *The Bride Stripped Bare by Her Bachelors, Even (The Large Glass)*, Duchamp announced a conceptual fusion of the sexual and the mechanical—a fusion that was appropriated by Picabia and others, including Man Ray, in his photograph of an egg beater, entitled *Man*, and that of a light reflector and clothesline assembly, entitled *Woman* (fig. 216). In the *Chocolate Grinder* paintings, Duchamp isolated clearly defined, simplified forms on blank backgrounds to create a purified, precise art

without debt to past styles. In *The Large Glass,* he went even further (fig. 217). On two panes of glass, joined together to form a freestanding, transparent field, he applied a variety of mechanistic images to form two "machines"—the Bride in the upper panel, the Bachelors in the lower. Thematically, the work addressed the myth of sexuality: the Bachelor Machine was to receive from the Bride "love gasoline," which would mix with his secretions to produce union. Since Duchamp refused to complete *The Large Glass,* however, the work asserted not union but its impossibility—hence, sexual failure and frustration.

Picabia's and Duchamp's reliance on an impersonal, linear execution to render machinist imagery encouraged Morton Livingston Schamberg to persevere with his own series of machine paintings, which he showed in a group exhibition in April 1916 at the Bourgeois Gallery. Schamberg had begun to incorporate machinist subject matter into his art as early as 1912, but only on seeing Duchamp's and Picabia's work did he relinquish the painterly, textured surfaces he had retained from his student days under William Merritt Chase at the Pennsylvania Academy. Inspired by their example, he adopted a crisp, immaculate painting style in which distilled images of actual machines were presented on monochromatic backgrounds (figs. 218, 219). In contrast to the work of Duchamp and Picabia, with its cryptic humor and self-conscious desire to remove personal gesture from art, Schamberg's machine paintings remained within aesthetically conventional bounds. Far from subverting art, his strong, lucid color and flat, precisely rendered geometric planes exuded a calm rationality and timeless order. Only once, in 1917, confronted with the mechanistic death and destruction of World War I, did Schamberg give vent to cynicism. The work was entitled *God,* an assemblage created in collaboration with Baroness Elsa von Freytag-Loringhoven (fig. 220).

A cast-iron plumbing trap set in a wooden miter box, *God* presents unaltered artifacts as art, a practice derived from Duchamp. Although the Cubists had earlier

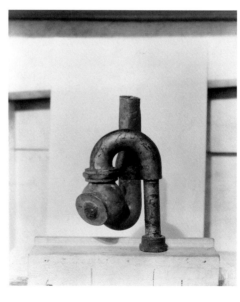

218. **Morton Livingston Schamberg**
Mechanical Abstraction, 1916
Oil on canvas, 30 x 20¼ in. (76.2 x 51.4 cm)
Philadelphia Museum of Art; Louise and Walter Arensberg Collection

219. **Morton Livingston Schamberg**
Telephone, 1916
Oil on canvas, 24 x 20 in. (61 x 50.8 cm)
Columbus Museum of Art, Ohio; Gift of Ferdinand Howald

220. **Morton Livingston Schamberg** and **Baroness Elsa von Freytag-Loringhoven**
God, 1917
Photograph by Morton Livingston Schamberg
Gelatin silver print, 9¼ x 7⅜ in. (23.5 x 18.8 cm)
The Museum of Fine Arts, Houston; Museum purchase, with funds provided by the Brown Foundation Accessions Endowment Fund

incorporated fragments of everyday reality into their collages, it was not until Duchamp that commercially produced, utilitarian objects were endowed with artistic status by the artist's act of selection and titling. Moreover, not only were Duchamp's objects unaltered, they were new—not worn or abandoned like the materials used in Cubist-derived collages. Their pristine, glistening surfaces stood for the products of an industrialized society. Their very newness imparted anonymity, an impersonal detachment impossible to achieve with used objects. Dislocated from their familiar contexts and assigned cryptic or ironic titles, Duchamp's readymades, as he called them, were powerfully enigmatic. The first readymade Duchamp selected in America, a shovel to which he affixed the title *In Advance of the Broken Arm* (1915), hung from the ceiling of his studio. *Fountain* (1917), his most notorious readymade, was an ordinary white bathroom urinal, which he submitted as sculpture to the 1917 Independents exhibition under the pseudonym R. Mutt (fig. 205).

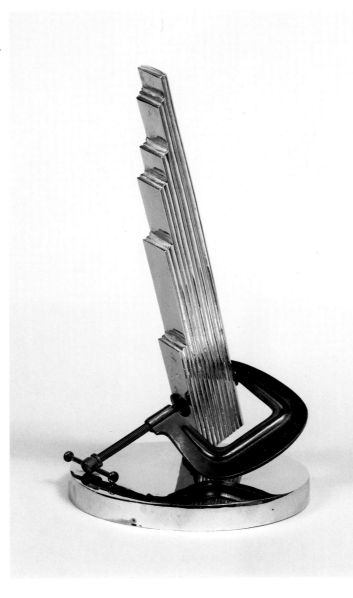

221. **Man Ray**
New York, 1917 (1966 edition)
Chromed and painted bronze, 17 x 9⅜ x 9⅜ in. (43.2 x 23.7 x 23.7 cm)
Whitney Museum of American Art, New York; Purchase, with funds from the Modern Painting and Sculpture Committee 96.174

Apart from Duchamp, the artist who most consistently created poetic images by combining ready-made objects with words was Man Ray. In 1915, after working in a relatively representational, Cubist style for seven years in Ridgefield, New Jersey, Man Ray moved to a studio in Manhattan. Although he later attributed his shift in subject matter from nature to man-made products to his new locale, it is more likely that his almost daily contact with Duchamp provided the impetus. From 1917 to 1921, Man Ray specialized in found-object sculptures whose components he altered or manipulated by combining them with other objects and adding provocative titles. Some, like *New York* (fig. 221), an assembly of wood strips fastened by a C-clamp, seem purposefully designed; in others, his juxtaposition of disparate artifacts registers as a random grouping. In neither case, however, did Man Ray feel the compunction to preserve the uniqueness of his objects, and many of his works, including *New York,* were replicated in multiple versions.

Man Ray's delight in playful bad manners extended to his involvement in the magazines produced by members of the Arensberg circle: *Ridgefield Gazook, Rongwrong, The Blind Man, 391, 291, New York Dada,* and *TNT*. Only in painting did Man Ray adhere to established, albeit vanguard, conventions. His reduction of objects to simplified, geometric shapes (figs. 222–27)—like that in the work of Walter Arensberg's first cousin John Covert (fig. 228)—derived from the flat, planar

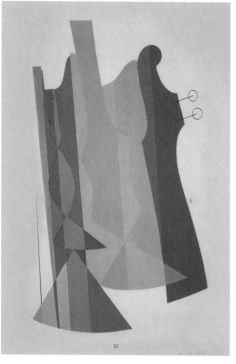

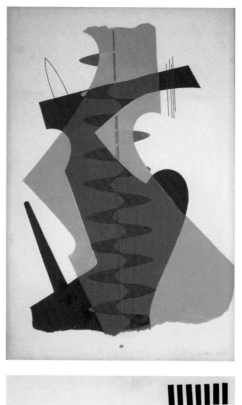

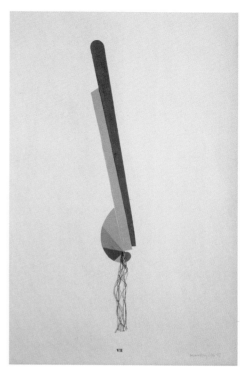

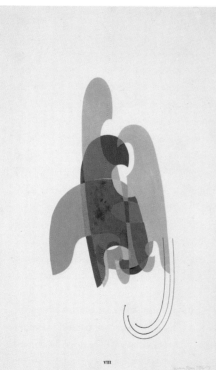

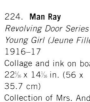

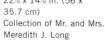

Left to right, top to bottom:

222. Man Ray
*Revolving Door Series III:
Orchestra,* 1916–17
Collage and ink on board,
22⅟₁₆ x 14⅟₁₆ in. (56 x
35.7 cm)
Private collection

223. Man Ray
*Revolving Door Series IV:
The Meeting,* 1916–17
Collage and ink on board,
22⅟₁₆ x 14⅟₁₆ in. (56 x
35.7 cm)
Collection of Richard S.
Zeisler

224. Man Ray
*Revolving Door Series VII:
Young Girl (Jeune Fille),*
1916–17
Collage and ink on board,
22⅟₁₆ x 14⅟₁₆ in. (56 x
35.7 cm)
Collection of Mrs. Andrew
P. Fuller

225. Man Ray
*Revolving Door Series VIII:
The Shadows,* 1916–17
Collage and ink on board,
22⅟₁₆ x 14⅟₁₆ in. (56 x
35.7 cm)
Collection of Mr. and Mrs.
Meredith J. Long

226. Man Ray
*Revolving Door Series IX:
Concrete Mixer,* 1916–17
Collage and ink on board,
22⅟₁₆ x 14⅟₁₆ in. (56 x
35.7 cm)
Collection of Mr. and Mrs.
Meredith J. Long

227. Man Ray
*Revolving Door Series X:
Dragonfly,* 1916–17
Collage and ink on board,
22⅟₁₆ x 14⅟₁₆ in. (56 x
35.7 cm)
Collection of Mr. and Mrs.
Meredith J. Long

216. **Man Ray**
Woman, 1918
Gelatin silver print, 17¼ x
13¼ in. (43.7 x 33.5 cm)
Gilman Paper Company
Collection, New York

217. **Marcel Duchamp**
*The Bride Stripped Bare by
Her Bachelors, Even (The
Large Glass),* c. 1915–23
Oil, varnish, lead foil, lead
wire, and dust on two glass
panels, 109¼ x 69¼ in.
(277.5 x 175.9 cm)
Philadelphia Museum of
Art; Bequest of
Katherine S. Dreier

without debt to past styles. In *The Large Glass,* he went even further (fig. 217). On two panes of glass, joined together to form a freestanding, transparent field, he applied a variety of mechanistic images to form two "machines"—the Bride in the upper panel, the Bachelors in the lower. Thematically, the work addressed the myth of sexuality: the Bachelor Machine was to receive from the Bride "love gasoline," which would mix with his secretions to produce union. Since Duchamp refused to complete *The Large Glass,* however, the work asserted not union but its impossibility —hence, sexual failure and frustration.

Picabia's and Duchamp's reliance on an impersonal, linear execution to render machinist imagery encouraged Morton Livingston Schamberg to persevere with his own series of machine paintings, which he showed in a group exhibition in April 1916 at the Bourgeois Gallery. Schamberg had begun to incorporate machinist subject matter into his art as early as 1912, but only on seeing Duchamp's and Picabia's work did he relinquish the painterly, textured surfaces he had retained from his student days under William Merritt Chase at the Pennsylvania Academy. Inspired by their example, he adopted a crisp, immaculate painting style in which distilled images of actual machines were presented on monochromatic backgrounds (figs. 218, 219). In contrast to the work of Duchamp and Picabia, with its cryptic humor and self-conscious desire to remove personal gesture from art, Schamberg's machine paintings remained within aesthetically conventional bounds. Far from subverting art, his strong, lucid color and flat, precisely rendered geometric planes exuded a calm rationality and timeless order. Only once, in 1917, confronted with the mechanistic death and destruction of World War I, did Schamberg give vent to cynicism. The work was entitled *God,* an assemblage created in collaboration with Baroness Elsa von Freytag-Loringhoven (fig. 220).

A cast-iron plumbing trap set in a wooden miter box, *God* presents unaltered artifacts as art, a practice derived from Duchamp. Although the Cubists had earlier

Left to right, top to bottom:

222. **Man Ray**
Revolving Door Series III: Orchestra, 1916–17
Collage and ink on board, 22⅟₁₆ x 14⅟₁₆ in. (56 x 35.7 cm)
Private collection

223. **Man Ray**
Revolving Door Series IV: The Meeting, 1916–17
Collage and ink on board, 22⅟₁₆ x 14⅟₁₆ in. (56 x 35.7 cm)
Collection of Richard S. Zeisler

224. **Man Ray**
Revolving Door Series VII: Young Girl (Jeune Fille), 1916–17
Collage and ink on board, 22⅟₁₆ x 14⅟₁₆ in. (56 x 35.7 cm)
Collection of Mrs. Andrew P. Fuller

225. **Man Ray**
Revolving Door Series VIII: The Shadows, 1916–17
Collage and ink on board, 22⅟₁₆ x 14⅟₁₆ in. (56 x 35.7 cm)
Collection of Mr. and Mrs. Meredith J. Long

226. **Man Ray**
Revolving Door Series IX: Concrete Mixer, 1916–17
Collage and ink on board, 22⅟₁₆ x 14⅟₁₆ in. (56 x 35.7 cm)
Collection of Mr. and Mrs. Meredith J. Long

227. **Man Ray**
Revolving Door Series X: Dragonfly, 1916–17
Collage and ink on board, 22⅟₁₆ x 14⅟₁₆ in. (56 x 35.7 cm)
Collection of Mr. and Mrs. Meredith J. Long

Cubism brought to America by Picabia, Duchamp, and Albert Gleizes. Ultimately, however, even this mode proved too restrictive, and in 1917 Man Ray abandoned painting almost entirely in favor of photography and found-object sculpture.

Man Ray's and Duchamp's artistic irreverence and mischievous desire to challenge normative aesthetic taste were associated with what came to be called New York Dada, whose parent movement had been born in Zurich in 1916 in response to the atrocities of World War I. "The beginnings of Dada," as Tristan Tzara, one of its founders, remarked, "were not the beginnings of art, but of disgust."[44] Revolted by the senseless carnage of a war waged in the name of reason, European Dadaists sought to remove the veneer of rationalism and expose the fundamental irrationality of human behavior. But their nihilistic stridency was completely absent from New York Dada. Distanced from the war and comfortable in the private world of affluence that the Arensbergs provided, American Dadaists initially took little interest in the Zurich group. Not until 1920, when Picabia and Duchamp returned from visits to Europe, where they met Tzara, was there any concentrated collaboration between the Americans and the Europeans.

228. **John Covert**
Resurrection, 1916
Oil on board, 25¼ x 27 in.
(64.1 x 68.6 cm)
Whitney Museum of
American Art, New York;
Gift of Charles Simon
64.18

Even then, the definition of what constituted New York Dada was so vague and inclusive as to implicate not only all the art executed by members of the Arensberg circle but all art that either exhibited whimsical irrationality or jolted viewers out of self-satisfied assumptions. The first public symposium in America on Dada, for example, yielded a general definition that focused on humor. The symposium took place in April 1921 in conjunction with a group exhibition of alleged Dada works by European artists such as Paul Klee and Kurt Schwitters at the Société Anonyme, the modern art museum founded by Katherine Dreier, Duchamp, and Man Ray. At the symposium, Joseph Stella declared that Dada meant "having a good time. . . . [I]t is a movement that does away with everything that has always been taken seriously. To poke fun at, to break down, to laugh at, that is Dadaism."[45] Marsden Hartley echoed the sentiment, lauding Dada for its freedom, humor, and ability "to deliver art from the clutches of its worshippers."[46] Much of Dada's irreverence and wit derived from an enthusiasm among its artists for scurrilous innuendos and sexual allusions, for word games, and for the appropriation of traditionally non-art materials into art. This latter practice was so identified with New York Dada that any work created in this manner was likely to be categorized as Dada or, in later years, as Neo-Dada (figs. 229, 230).

As an "official" movement in America, Dada was short-lived. The 1921 symposium coincided with the sole issue of America's only Dada magazine, *New York Dada.* By that time, Gleizes had been back in Paris for two years, where he was

joined in June 1921 by Duchamp and in July by Man Ray. By then, European Dada was already being absorbed by what would become its Parisian successor, Surrealism. The demise of New York Dada was more definitive. Morton Schamberg died prematurely in the flu epidemic of 1918, the Arensbergs moved to California in 1921, and John Covert decided in 1923 to terminate his art career and take a job in the family-owned Crucible Company. These events marked the end of an era.

CUBISM AND AMERICAN PHOTOGRAPHY

Cubism's geometric simplification of forms and balance between description and abstraction had an impact on photographers as well as on painters. Paul Strand, Charles Sheeler, and Morton Schamberg—"*the* Trinity of Photography," as Stieglitz reportedly called them—were the first to adapt Cubism's formal language to the medium.[47] Strand later described his photographs from this period as an

229. **Arthur G. Dove**
The Critic, 1925
Collage of paper, newspaper, fabric, cord, and broken glass, 19 ¾ x 13¼ x 4¾ in. (50.2 x 33.7 x 12.1 cm)
Whitney Museum of American Art, New York; Purchase, with funds from the Historic Art Association of the Whitney Museum of American Art, Mr. and Mrs. Morton L. Janklow, the Howard and Jean Lipman Foundation, Inc., and Hannelore Schulhof 76.9

attempt to "find out what this abstract idea was all about and to discover the principles behind it. . . . I did not have any idea of imitating painting or competing with it but was trying to find out what its values might be to someone who wanted to photograph the real world."[48]

In the summer of 1916, in his studio in Twin Lakes, Connecticut, Strand embarked on a series of still lifes and abstract studies in which he brought his camera so close to his subjects that he stripped them of their utilitarian functions and traditional associations; they became formal designs of light and dark shapes (figs. 231, 233). For Strand, the imperative was philosophical as well as artistic. He believed that photography "finds its raison d'être, like all media, in the complete uniqueness of means. . . . [T]his objectivity is of the very essence of photography, its contribution and at the same time its limitation." Criticizing print manipulation as "merely the expression of an impotent desire to paint," Strand admonished photographers to use the photographic medium with honesty.[49] He felt that photography must eliminate extraneous subject matter as well as emotional expression, which was the province of painting, in order to portray the subject objectively.

Strand's cityscape photographs had been premiered in a one-artist show at 291 in March 1916 (figs. 95, 97), and his abstract still lifes had been included in the October 1916 issue of *Camera Work.* Following the candid street photographs he made that fall (figs. 165, 166), Strand's work was again featured in *Camera Work*—in the magazine's final issue, of June 1917. Here Stieglitz departed from his practice of reproducing gravures on Japanese tissue paper and instead printed directly on the

magazine page, a decision he attributed not to economy but to the desire to emphasize the spirit of the photographs' "brutal directness."[50]

Over the next three years, Strand endeavored to reconcile the expressive ambitions he had inherited from Pictorialism with the modernist urge for objectivity. This synthesis became increasingly important to him as he grew more wary of the dehumanizing potential of technology. He came to see the camera as a machine over which spiritual control needed to be exercised. In his 1922 essay "Photography and the New God," he lauded Stieglitz for producing photographs that subjugated the machine to expressive purpose.[51] Stieglitz's photographs, Strand argued, pointed to a future in which a modern machine—the camera—would integrate "science and expression" into "a true religious impulse."[52]

230. **Joseph Stella**
Prestidigitator, c. 1916
Oil and wire on glass,
13⅜ x 8½ in. (33.8 x 21.6 cm)
Whitney Museum of American Art, New York; Daisy V. Shapiro Bequest 85.29

Between 1914 and 1917, while Strand was applying the lessons of vanguard painting to the medium of photography, Morton Schamberg and Charles Sheeler, living in Pennsylvania, were pursuing parallel investigations. Friends since their student days at the Pennsylvania Academy of the Fine Arts, both had turned to photography around 1910 as a means of supporting themselves while painting. In 1914, Sheeler began a series of interior views of the weekend house he shared with Schamberg in Doylestown (fig. 232), and exteriors of the barns that dotted the surrounding countryside of Bucks County. Tightly cropped, his images functioned both as descriptions of the real world and as self-contained, two-dimensional abstractions. Schamberg, too, in a group of cityscapes he made in 1916–17 from the windows of his downtown Philadelphia studio, achieved an equally high degree of formal abstraction. Both artists were stimulated by their participation in the Arensberg circle—Schamberg as an occasional visitor to the Arensberg apartment, Sheeler as a more frequent guest, especially after 1917 when his employment as a photographer for Marius de Zayas' Modern Gallery brought him more often to New York.

An entirely different translation of geometric principles into photography was made by the former Pictorialist Alvin Langdon Coburn, who had moved to London and come under the influence of Vorticism, the English equivalent of Futurism led by the painter Wyndham Lewis and the American poet Ezra Pound. Coburn's experiments, called Vortographs, lasted only four months, from October 1916 to January 1917 (fig. 234). Inspired by Vorticism's rejection of romanticism and sentimentality and its advocacy of geometric, nonrepresentational art, Coburn developed a photographic equivalent of hard-edged, faceted abstraction. He did so by clamping

231. **Paul Strand**
Wire Wheel, 1917
Platinum print from
enlarged negative, 12⅝ x
10¼ in. (32.1 x 25.2 cm)
The Metropolitan Museum
of Art, New York;
The Alfred Stieglitz
Collection, 1949

232. **Charles Sheeler**
*Doylestown House:
Stairwell,* c. 1917
Gelatin silver print, 9⅛ x
6½ in. (23.2 x 16.5 cm)
Museum of Fine Arts,
Boston; The Lane
Collection

233. **Paul Strand**
Porch Shadows, 1916
Satista print, 13¼ x 9⁹⁄₁₆ in.
(33.7 x 23.4 cm)
The Art Institute of
Chicago; The Alfred
Stieglitz Collection

three shaving mirrors together in a hollow triangular arrangement through which he photographed crystal and pieces of wood placed on a glass tabletop. Split into sharp diagonals that appeared to shift and dissolve, Coburn's kaleidoscopic images conveyed both the beauty of pure structure and the cosmic metaphysics that increasingly occupied him.

WAR AND THE AMERICAN ART WORLD

The war that engulfed Europe in August 1914 was, for most Americans, something to be waited out. Though horrified by the devastation wrought by twentieth-century weapons technology—machine guns and massed artillery—Americans firmly resisted military engagement for over two years. Indeed, President Woodrow Wilson won a second term in 1916 on the slogan "He kept us out of war."

234. Alvin Langdon Coburn
Vortograph, 1917
Gelatin silver print, 8¹¹⁄₁₆ x
10⅝ in. (22.1 x 27 cm)
The Art Institute of
Chicago; Harold L. Stuart
Endowment

The art world seemed particularly immune to the political and military conflicts raging in Europe. Although the outbreak of hostilities had curtailed European travel and sent all but a few Americans home, critics and artists remained focused on giving American art a stature equal to that enjoyed by European art. In 1916, Willard Huntington Wright, the brother of Stanton Macdonald-Wright and the art columnist for *Forum*, persuaded the magazine to sponsor an authoritative assembly of advanced American painting, the "Forum Exhibition of Modern American Painters." In an attempt to advance the public's understanding of abstraction, Wright secured the help of a five-person committee of sponsors whose job it was to certify the quality of the exhibited work and help explain it to the public. To abet this mission, he published an exhibition catalog, which included his introductory essay and explanatory statements from each of the seventeen participating artists. Wright's argument for abstraction—that formal qualities rather than subject matter were the basis of all great art—failed to convince the American public, and he gave up art criticism shortly thereafter to write detective fiction under the pseudonym S. S. Van Dine.

An equally ambitious undertaking was attempted by the realists, who opened a gargantuan Independents exhibition of over 2,500 paintings and sculptures by artists from around the country at the Grand Central Palace on April 10, 1917. The expectation had been that the size and breadth of the exhibition would refuel the country's enthusiasm for American art and for the realist agenda. Sadly for the realists, the public's attention was consumed by a controversy among the organizers over whether to accept Duchamp's *Fountain* as an art work—even though the jury-free premise of the show promised exhibition space to all artists who paid the entry fee. Even without the controversy, there was little chance of success: four days before the opening, America declared war on Germany. In the ensuing months, the art world changed. In July, the postmaster general, in response to antiwar material published in *The Masses*, charged the journal with subversion under the terms of the espionage act; unable to distribute copies, the magazine folded eight months later. *The Seven Arts*, a literary magazine edited by James Oppenheim, Waldo Frank, and Van Wyck Brooks, was likewise forced to cease publication in 1917, after its subsidy was withdrawn over its antiwar attitudes. That same year, Stieglitz closed his gallery and, with only thirty-six remaining subscribers, suspended publication of *Camera Work*.

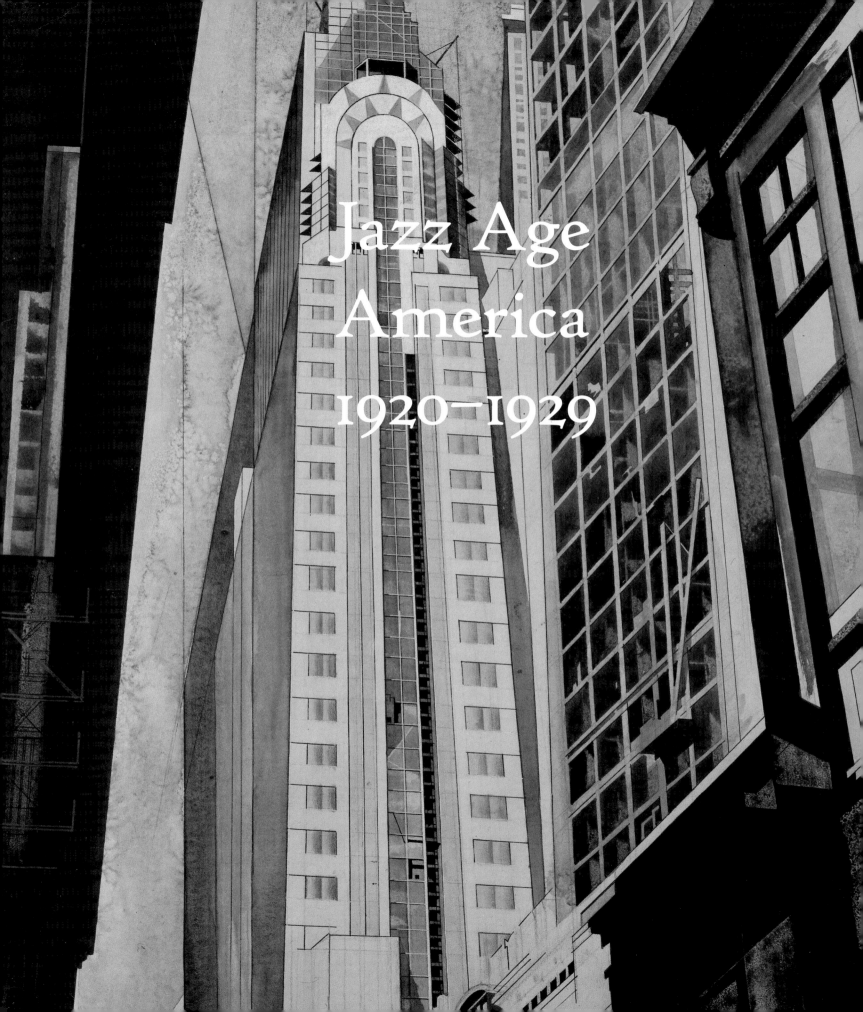

Jazz Age

America

1920–1929

The Culture of Prosperity

Every age contains contradictions, but none more so than the twenties. Thrust to the forefront of international politics by its participation in World War I, the nation turned inward, becoming more isolationist than ever before in its history. Labor strikes, terrorist bombings, and growing paranoia about the spread of Communism gave rise to the "Red scare" of 1919–20, passage of legislation restricting immigration from southern and eastern Europe, and the resurgence of the Ku Klux Klan. It was an era, on the one hand, of unparalleled social freedom and material prosperity and, on the other, of political conservatism and religious fundamentalism. An era whose soaring stock market and introduction of installment buying transformed America into a nation of consumers also saw passage of the Eighteenth Amendment, which prohibited the consumption and sale of liquor, as well as the conviction of John Scopes for teaching evolution. Women,

NEW STYLES OF SOCIAL DANCE

Between 1900 and 1930, American social dance achieved worldwide dominance with an epidemic of popular dance crazes. As women gained more freedom outside the home and an emerging middle class blurred traditional class distinctions, American dancing loosened and became more casual. As popular music began to be driven more by the beat than by melody, complex syncopations and polyrhythms invaded the movement. In the 1910s, newer, black-derived "jazz" dances began to be performed by young people at parties or dance halls where breaking rules became the new tradition. Created in African American communities, these dances spread to the American mainstream, then moved to Europe and the world.

The influence of African American aesthetics on dance was demonstrated early on by the rising popularity of the cakewalk. It had begun fifty years earlier as the slave's parody of the manners of the whites at their formal balls, and by 1900 it was both a ballroom and a stage dance. Combining the high-kneed strut step of the original black dance with the walking (or traveling) steps of the European schottisches and galops, the dance was set to the 2/4 or 4/4 time of early ragtime jazz. It spread like wildfire. Sheet music from the years 1890–1910 indicates the widespread appeal. Cakewalk exhibition dance teams played vaudeville and Europe, and in 1904 the dance was validated by European aristocracy when the Prince of Wales learned it from Bert Williams and George Walker, African American musical theater producers as well as a performing comedy team.

Between 1907 and 1914, there arrived a rash of rollicking "animal dances" with names like turkey trot, eagle rock, and grizzly bear. Eccentric animal gestures were grafted onto easy one-step or two-step couple dances. In 1912, the tango was introduced. Latin-inspired, it was a smoother, more elegant couple dance made popular in America (like the fox-trot) by Vernon and Irene Castle, a sophisticated, young husband-and-wife team. They were adored as superstars. Irene's dress and hair styles determined what young women wore, and Vernon came to personify the insouciant sophisticate (fig. 144).

The Charleston, which had been developing in black communities for many years, was introduced to large numbers of white audiences in Noble Sissle and Eubie Blake's 1922 revue *Runnin' Wild*. Immediately picked up by movies and newsreels, it became an overnight dance fad (fig. 236). It fit the emancipated American woman who bobbed her hair and wore knee-length dresses. Beloved by most, banned by some moralists, the wild dance and rubber-legging flapper became cherished icons of the age. Then, in 1924, the Charleston hit Paris, and all Europe fell in love with it. —S. S.

235. **John Held, Jr.**
Rhapsody, 1927
Manufactured by Stehli Silks
Printed crepe de chine silk, 40 x 72 in. (101.6 x 182.9 cm)
The Newark Museum, New Jersey; Purchase, 1927

236. Sheet music cover for "The Charleston," 1923

238. **Coles Phillips**
Cover of *Life*, April 7,
1927
New York Society Library

237. **John Held, Jr.**
Cover of *McClure's*, August
1927

239. **J. C. Leyendecker**
*Couple Descending a
Staircase (Advertisement
for Arrow Shirt Company)*,
c. 1930
Oil on canvas mounted on
wood panel, 50 x 32½ in.
(127 x 82.6 cm)
Private collection; courtesy
Illustration House,
New York

having won the vote in 1920, were pressed to leave the workplace and resume the job of homemaker. The electorate voted Warren G. Harding in as president in 1920 on a "return to normalcy" platform, while riotously challenging the assumptions and behavioral guidelines of the past.

Outwardly, Americans seemed intoxicated by their new freedoms and exuberant in their indulgent pursuit of pleasure and wealth. It was a period of excess in which youth and liberation dominated maturity and sobriety. The pleasure-seeking mood of the period was nowhere captured as succinctly as in the illustrations of John Held, Jr., which appeared on magazine covers, in cartoons, and on fabric designs (figs. 235, 237). Like the Gibson girl a generation earlier, Held's American flapper embodied the morals, mores, and mood of the Roaring Twenties. With a sophisticated wit and irreverence, Held conveyed the high spirits and carefree disregard of convention that characterized the nation's youth. With her short skirts, bobbed hair, and boyish physique, the flapper epitomized America's absorption with material comfort and pleasure over politics and spiritual concerns.

JAZZ AGE CINEMA

Cinema was maturing as an art form; not surprisingly, it was also growing as a business. How to attract audiences week after week was an often asked question, which the Hollywood studios answered by increasing sexual themes, elevating visual design, and emphasizing the achievements of film technologies.

Film themes and styles evolved quickly after World War I. While some actresses (Theda Bara) saw their careers tumble and others (Lillian Gish and Mary Pickford) continued successfully, a new group of performers, including Colleen Moore, Joan Crawford, and the "It" girl, Clara Bow, emerged that represented America's more liberal views on sexual behavior and the feminine ideal. Cecil B. De Mille's films countered America's most recent wave of puritanism, which carried in Prohibition, and extolled the virtues of the forthcoming Jazz Age. Films increasingly treated scandalous themes, while the private lives of performers became the subject of newspaper articles and a headache for Hollywood moguls. To help deal with this volatile situation, Will H. Hays, President Harding's campaign manager, U.S. postmaster general, Presbyterian elder, and Republican, was appointed the first president of the Motion Picture Producers and Distributors of America (now the Motion Picture Association of America)—known informally as the Hays Office. Though Hays' power over motion picture stories and visuals increased by the decade's end, his initial responsibility was to keep the press from magnifying the tales of Hollywood and to keep at bay the threats of censorship being provoked by exaggerated newspaper accounts.

In the meantime, images of exotic locations and people grew in popularity, and movie theaters themselves were being transformed—from the dark halls of the preceding decade to the grand movie palaces that featured simulated ancient architecture, such as Grauman's Chinese Theater in Hollywood and the Roxy Theatre in New York (fig. 243). Studios found great success using exotica both in the theaters and in the films, with sets that suggested exotic lands but were more often designed, constructed, and photographed in Los Angeles. In many instances, the films took the format of the male adventure film, which became a Hollywood staple featuring a cast of robust men: Rudolph Valentino in *The Sheik* (George Melford, 1921; fig. 242), John Barrymore in *Robin Hood* (Allan Dwan, 1922) and *The Thief of Bagdad* (Raoul Walsh, 1924), and Ramon Novarro and Francis X. Bushman in *Ben-Hur* (Fred Niblo, 1926).

In real life, the public's fascination with foreign culture and history was spurred by Howard Carter's discovery of the intact ancient Egyptian tomb of Tutankhamen in the Valley of the Kings, Thebes, in November 1922. Archaeological and anthropological explorations of distant lands extended to film with the emergence of a new genre, the documentary. Robert J. Flaherty's *Nanook of the North* (1922) is considered the first of

240. Joan Crawford in *Our Dancing Daughters*, directed by Harry Beaumont, 1928
Billy Rose Theatre Collection, The New York Public Library for the Performing Arts, Astor, Lenox and Tilden Foundations

241. *Nanook of the North,*
directed by Robert J.
Flaherty, 1922
The Museum of Modern
Art, New York/Film Stills
Archive

this genre. Less an anthropological record than a skillfully contrived narrative, *Nanook* traced the lives of an Eskimo family in northern Canada and became both a critical and a popular success when it premiered at the Roxy Theatre (fig. 241). Similar and more spectacular works followed, such as *Grass* (Merian C. Cooper and Ernest B. Schoedsack, 1925), which chronicled the migration of the 50,000-member Bakhtiari tribe across the icy rivers and snowy mountains of Persia. The human figure set against expansive mountain ranges, harsh deserts, or Arctic tundra became a staple documentary format—man versus the natural world.

The vast landscape also formed the backdrop for several other film genres of the 1920s: comedies, westerns, and war films. Silent comedians often depended on the difference between their physical appearance and their surroundings in order to create visual humor. Small and wiry (Charlie Chaplin, Buster Keaton, Harold Lloyd), these comedians tended to be seen as lone figures challenged by an oversized world—witness Lloyd hanging from a clock at the top of a skyscraper (*Safety Last*, Fred C. Newmeyer and Sam Taylor, 1923; fig. 244) or Chaplin's "Tramp" in the Alaskan wilderness (*The Gold Rush*, Chaplin, 1925). Similarly, the western often contrasted the lone cowboy against the unending mysteries of the plains or mountains. The western was also crucial in the development of another film genre, the action film. The use of train tracks, horses, and cars, traveling cameras, and fast-paced action became a Hollywood trademark, soon followed by spectacular special effects (*Noah's Ark*, Michael Curtiz, 1928). Such visual devices were employed successfully in war films like *The Big Parade* (King Vidor, 1925), *Lilac Time* (George Fitzmaurice, 1928), and *Wings* (William A. Wellman, 1927), which received the first Academy Award for best picture.

242. Rudolph Valentino
and Agnes Ayres in *The
Sheik,* directed by George
Melford, 1921
Photofest, New York

Technical achievements were beginning to play an important role as Hollywood sought new ways to attract audiences. By the mid-1920s, box office receipts were down slightly as a result of competition from the increasingly popular sound entertainment, radio. On August 20, 1920, one of America's first radio stations, 8MK, broadcast a program called "Tonight's Dreamer" in Detroit. Radio listenership grew so quickly that within two years there were over five hundred radio stations across the United States. Not willing to see the film industry take a backseat to radio, Warner Brothers decided to produce the first sound motion picture, *Don Juan* (Alan Crosland), which premiered on August 6, 1926. Musical accompaniment was produced by means of a series of 16-inch audio discs, which played in synchro-

nization with the moving image—a sound process developed by AT&T called Vitaphone. The premiere of *Don Juan* was important for a second reason: no live vaudeville acts preceded the film, as they usually did at a major motion picture premiere. Instead, there were short sound films featuring the violinist Mischa Elman and the Metropolitan Opera stars Giovanni Martinelli and Marion Talley. The next year brought the first feature film to employ spoken dialogue, *The Jazz Singer* (Crosland, 1927); though more noted for Al Jolson's performance, it became the first commercially successful sound film by running eight or more weeks in towns that traditionally held films for only one week (fig. 245). And, finally, the first all-talking feature film, *Lights of New York* (Bryan Foy), premiered on July 6, 1928, in New York City.

While studios were hastily gearing up for sound motion pictures, the silent film was simultaneously reaching its zenith in works such as *Sunrise* (F. W. Murnau, 1927), *Wings*, and *The Wind* (Victor Seastrom, 1928). However, sound film eclipsed silent cinema's advancements, even though everything on a set that generated sound—cameras, costumes, moving sets—had to become "silent on the set," except of course the person speaking. Sound also created difficulties for many actors known for their physical appearance and expressiveness, not their voice. Some chose to retire from the film business after making only a few sound pictures (Clara Bow, Pola Negri, Mary Pickford), while others tried but could not technically master the new medium (John Gilbert's voice was thought to be too high) and were forced to end their careers early. But still others made the transition with great success, including Ruth Chatterton and Greta Garbo. Sound, which the studios originally deemed a fad ("canned theater"), was here to stay as audience attendance at sound pictures increased far beyond that at the studio moguls' beloved silents. The film era that began in silence ended with motion pictures becoming the most popular sound medium in the country and a catalyst for that musically defined decade—the Jazz Age, the Roaring Twenties. —M. Y.

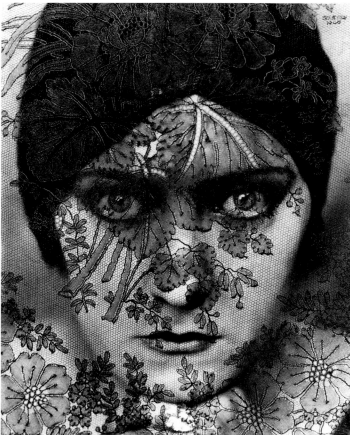

246. Karl Struss
Gloria Swanson in the Lion's Den—Fantasy Sequence from Male and Female, 1919
Gelatin silver print, 6⅞ x 8¹⁵⁄₁₆ in. (17.5 x 22.7 cm)
Amon Carter Museum, Fort Worth, Texas

247. Edward Steichen
Gloria Swanson, 1924 (printed 1965)
Gelatin silver print, 13⅝ x 10⅝ in. (34.6 x 27 cm)
Amon Carter Museum, Fort Worth, Texas

What Held did for the youth of the Jazz Age, Coles Phillips and J. C. Leyendecker did for their more sophisticated, older counterparts (figs. 238, 239). Even before the war, Leyendecker's "Arrow Collar Man" had come to epitomize the elegant and glamorous lifestyle of the privileged upper class. By the twenties, his portraits of the world of wealth and ennui mirrored the generation F. Scott Fitzgerald described as "dedicated more than the last to the fear of poverty and the worship of success; grown up to find all Gods dead, all wars fought, all faiths in man shaken."[53]

The unbridled opulence of the twenties found expression in an art of decoration and adornment. As if not fully reconciled to the tremendous changes wrought by new technologies and advances in communication, artists sheathed the most blatant examples of modernity in an envelope of history. Thanks, in part, to the discovery of King Tutankhamen's tomb in 1922 and the ensuing Egyptomania that swept the world, the twenties witnessed a wholesale revival of interest in the linear ornament and lyricism of archaic and exotic cultures. In film, this exoticism was manifested in the rage that directors such as Cecil B. De Mille and D. W. Griffith showed for exotic cultures and locales and in the cinematic roles played by Rudolph Valentino, Douglas Fairbanks, and Gloria Swanson (figs. 242, 246, 247); in architecture, in a surge of ornamentation that reached its crescendo in New York's Chrysler Building and the era's movie palaces (figs. 248, 249, 253, 254); and in the decorative arts, in Art Nouveau's heir, the streamlined style known as Art Deco.

In the pictorial arts, Art Deco's precisely organized patterns, which easily mixed modern and ancient references as they moved from the repetitive, streamlined imagery of the machine to the seminaturalistic curves of bodies, were a bridge between art that identified with more tranquil and ordered times and art that sought to create something self-consciously modern by celebrating the materials and inventions of the modern world. In America, the movement found its most eloquent expression in the work

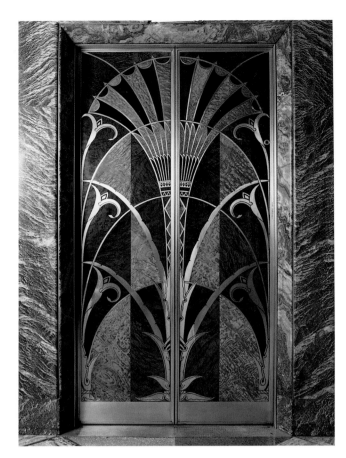

of Florine Stettheimer and Paul Manship. Stettheimer was one of three unmarried sisters who presided with their mother over a salon that included Carl Van Vechten, Virgil Thomson, DuBose Heyward, Gaston Lachaise, Elie Nadelman, Marguerite and William Zorach, and Marcel Duchamp. Highly artificed and stylized, her art exulted in surface excess and linear ornament. Her figures are sinuous and androgynous, her settings unabashedly decorative and dense (fig. 263). Her fancifully carved and painted frames, her artificial, brilliant color, and her blatant indulgence in ornamental linearity corresponded to the era's continuing involvement with Art Nouveau. Until 1929, Stettheimer had been a private artist, her subjects limited to her family, friends, and the world of her own experience. After the stock market crash, she turned outward; in an expression of patriotism, she began a series of four paintings, which she worked on intermittently until her death in 1944, that celebrated specifically American themes: Broadway, Wall Street, Fifth Avenue, and the art world (fig. 264).

A similar refinement of design and linear ornament marked the sculpture of Paul Manship (fig. 266). But in contrast to Stettheimer, who died without ever having been fully recognized as an important artist, Manship enjoyed public acclaim all his life—from his first, sold-out exhibition in 1913 to his commissions to create bronze gates for the Bronx Zoo (1933), the Prometheus Fountain for Rockefeller Center (1934), and, two years before his death, the Sphere and Sundial for the 1964 New York World's Fair. His ambition to give visual form to mythological subjects and his stylistic synthesis of modernist classicality and sinuous linearity encapsulated the spirit of his times and made him the unofficial patron saint of Art Deco.

Johan Hagemeyer, in the photographs he took of San Francisco between 1920 and 1922, also bridged the past and the present. Using shadow as a compositional device, he joined the illusory, soft-focus aesthetic of the preceding decade with the geometric formalism of the decade to come (fig. 265). Although financial pressures forced him to open a commercial studio in Carmel, California, in 1923 and focus exclusively on commercial portraiture, Hagemeyer's early appreciation of spatial harmony helped set the aesthetic course for the next generation of West Coast photographers.

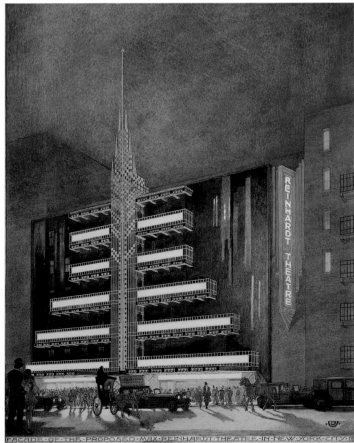

248. **William Van Alen**
Elevator Doors for the Chrysler Building, 1927–30
Manufactured by the Tyler Company
Metyl-wood veneers

249. **Joseph Urban**
Front Elevation for Reinhardt Theatre, 1928
Gouache, gold leaf, and pencil on paper, 16¾ x 13⅝ in. (43 x 35 cm)
Rare Book and Manuscript Collection, Butler Library, Columbia University in the City of New York

SKYSCRAPERS IN THE BOOM YEARS

Thanks to an economic boom that doubled the volume of office space in New York and Chicago, the skyscraper grew in the 1920s at an incredible speed. Since its function was to sell or rent office space, profit became the critical factor in how one was built. As the skyscraper became a symbol of power and progress, its height testified to that power and to technical

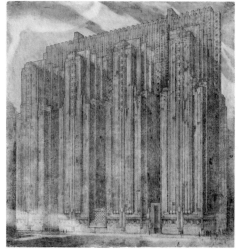

achievement. These towering symbols of transatlantic modernity were welcomed throughout the world as a vision—sometimes dystopian, sometimes optimistic—of the city to come. In America, Raymond Hood looked forward to a city of towers in which nothing but the skyscraper prevailed. Local zoning laws varied the shape of the skyscraper from city to city. But the New York law of 1916 requiring buildings above a certain height (usually 100 or 125 feet) to step back as they rose, in order to allow more light below, produced the most widely imitated forms (figs. 279, 280).

European modernists, already inspired by the new height and scale of the American vertical city, played a critical role in reshaping the American skyscraper. Proposals made for the widely publicized Chicago Tribune competition of 1922 by Eliel Saarinen (from Finland), Walter Gropius (from Germany), and Adolf Loos (from Austria) revolutionized the image of the tall building (fig. 250). Although the winning entry was a nostalgic Gothic revival building designed by John Mead Howells and Raymond Hood, more adventurous American architects were quick to follow the Europeans' lead.

Saarinen himself stayed in the United States and extended his Tribune proposal into an elaborate urban scheme, while Frank Lloyd Wright's unbuilt project for the National Life Insurance Company (1924–25) was clearly intended as a criticism of the Tribune Building, which hid its steel frame under a heavy stone facade. Wright's tower, built of cantilevered slabs resting on interior columns, was to have had a skin of glass blocks framed in copper and glass—a textured reflective surface without and light open space within (fig. 251). Using a more abstract approach, Joseph Urban designed the New School for Social Research (1929–31) in New York as an alternative to the fussy and monochromatic tall building. With an emphasis on horizontality, a complex play of rectangles, and the stark contrast between black frame and white center, this seven-story building both fits into its town house context and upsets it with its clarity of form and sense of rational composition (figs. 252, 256). In a series of designs for city department stores, Urban integrated a sense of high style, intense color, and luxury with a modern vocabulary of slick

250. **Eliel Saarinen**
Chicago Lake Front Development with Tower, 1923
Graphite on tracing paper, 11⅝ x 8⁵⁄₁₆ in. (29.8 x 21.6 cm)
Cranbrook Art Museum, Bloomfield Hills, Michigan

251. **Frank Lloyd Wright**
National Life Insurance Company Office Building, Chicago, 1924, perspective rendered by unknown draftsman
Pen and ink with wash and colored pencil over graphite on linen, on japanese paper, 38¾ x 34¹³⁄₁₆ in. (98.4 x 88.5 cm)
Centre Canadien d'Architecture/Canadian Center for Architecture, Montreal

252. **Joseph Urban**
Street Elevation for New School for Social Research, New York, 1930
Graphite and ink with wash on board, 20⁵⁄₁₆ x 14¹³⁄₁₆ in. (52 x 38 cm)
Rare Book and Manuscript Collection, Butler Library, Columbia University in the City of New York

254. Gordon H. Coster
*The Chrysler Building,
New York City,* 1929
Gelatin silver print,
brown-toned, 13⁷⁄₁₆ x
10⁷⁄₁₆ in. (34.1 x 26.5 cm)
Centre Canadien
d'Architecture/Canadian
Centre for Architecture,
Montreal

253. Earle Horter
*The Chrysler Building
Under Construction,* 1931
Ink and watercolor on
paper, 20½ x 14¹¹⁄₁₆ in.
(52.1 x 37.3 cm)
Whitney Museum of
American Art, New York;
Purchase, with funds from
Mrs. William A. Marsteller
78.17

255. Edward Steichen
*Fortieth Street, Sunday
Night,* 1925
Gelatin silver print, 16½ x
13¼ in. (41.9 x 33.7 cm)
The Museum of Modern
Art, New York; Gift of the
photographer

256. **Joseph Urban**
Perspective for Auditorium, New School for Social Research, New York, 1930
Graphite and ink with wash on board, 12½ x 16 in. (32 x 41 cm)
Rare Book and Manuscript Collection, Butler Library, Columbia University in the City of New York

surfaces and reflective steel (fig. 257).

The first persuasively modern, functionalist skyscraper—Philadelphia's PSFS headquarters (1929–33)—was designed by the American George Howe and the recent Swiss immigrant William Lescaze (fig. 258). More than its predecessors, this thirty-two-story building, described by its owner as "ultra-practical," was as innovative in its interior systems as in its exterior form. Rejecting symmetry, the architects marked the building's varying functions and sectors (public services on the main floor, offices on the other levels, escalator, service core) by designing them with different materials and different fenestration. Howe and Lescaze's pioneering experiment in explicit rationalism was among the last of the prewar skyscrapers. For nearly twenty years thereafter, the oversupply of office space, the Depression economy, World War II, and the postwar focus on housing prevented commercial building on this scale. By the late 1940s, advances in technology (including fluorescent lighting and air conditioning) and changes in architectural ideology inspired a totally different kind of office tower, and the rich variety of formal experiment would be replaced by the economics of standardization. —N. O.

257. **Joseph Urban**
Proposal for Kauffman Store Renovation, Pittsburgh, 1928
Gouache, pencil, and ink on board, 18⁵⁄₁₆ x 19⅛ in. (47 x 49 cm)
Rare Book and Manuscript Collection, Butler Library, Columbia University in the City of New York

258. **George Howe** and **William Lescaze**
Two Alternatives for Philadelphia Savings Fund Society, 1931
Pencil on paper, 21½ x 16½ in. (54.6 x 41.9 cm)
Collection of Marc Dessauce

259. **Viktor Schreckengost**
"Jazz" Punch Bowl, 1931
Manufactured by Cowan
Pottery Studio, Rocky
River, Ohio
Glazed porcelain, 11¾ x
16⅜ in. (29.8 x 41.6 cm)
Cooper-Hewitt, National
Design Museum, Smith-
sonian Institution, New
York; Gift of Mrs. Homer D.
Kripke

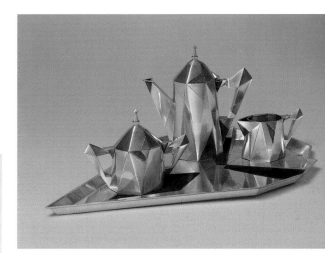

JAZZ AGE STYLING

By the 1920s, the automobile, airplane, high-
speed train, and ocean liner had dramatically
altered people's conception of distance. Instan-
taneous forms of communication—telephone,
radio, and film—were radically changing
their experience of time and proximity to
world events.

In Europe, avant-garde artists thought
the future must be a machine age. The
old world order had been shattered by
World War I; designers believed they had a
critical role to play in building a new one.
Working from the shared belief that the
machine would establish a new structure
for society, different groups of designers
chose different directions. While some
rejected the past absolutely and abhorred
all decoration, such a purely functionalist
aesthetic was seldom embraced in Amer-
ica. Instead, designers here opted to cele-
brate modern life—its speed, dynamism,
and technology—through decorative im-
agery, rather than through pure geometric
form. They translated avant-garde styles
such as Cubism, Suprematism, and De
Stijl into more commercial and decorative
designs.

Viktor Schreckengost's "Jazz" punch
bowl (fig. 259), for example—with its
allusions to speakeasies, music, and cock-
tail glasses—embodies the nervous energy
of the city in the twenties and a glamorous nightlife made possible by electric light. The
zigzag lines suggest lightning bolts, an apt image to represent the energy of a new age.

The Gorham Company designer Erik Magnussen used prismlike surfaces of colored
silver to create his "Cubic" coffee service (fig. 260). A 1927 *New York Times* article
stated that the service had "been poetically named 'The Lights and Shadows of Man-
hattan' because of its suggestion of metropolitan architecture and the play of light over
its variegated surfaces."

Manhattan's stepped-back skyscraper was the building type that most captured
designers' imaginations. It embodied civic pride, industrial prowess, and a complete
break with the past. Designers created scaled-down versions in decorative objects for
the home; for example Paul Frankl produced a line of skyscraper furniture (fig. 261),

260. **Erik Magnussen**
*"Cubic" Pattern Coffee
Service,* 1927
Manufactured by Gorham
Manufacturing Company,
Providence, Rhode Island
Silver with patinated,
oxidized, and gilt decora-
tion, 9½ in. (24.1 cm)
height of coffeepot
Museum of Art, Rhode
Island School of Design,
Providence; Gift of Textron,
Inc.

261. **Paul Theodore Frankl**
Skyscraper Bookcases,
late 1920s
California redwood with
nickel-plated steel trim,
90 in. (228.6 cm) height
Cincinnati Art Museum;
Gift of the estate of Mrs.
James M. Hutton II

described by *Good Furniture* magazine in 1927 as being "as American and as New Yorkish as Fifth Avenue itself."

These kinds of designs were derided by the avant-garde as "modernistic." Purists of the modern movement such as Le Corbusier and Marcel Breuer wanted to invent a universal language of form. In contrast, American Jazz Age designs were inspired by *images* of machines or of skyscraper technology, not by the ideals of standardized abstract forms engendered by the machine. The zigzag lines, geometric shapes, and rounded surfaces were borrowed from the avant-garde but certainly were not of it.

These objects were intended for members of the middle and upper classes who embraced the machine age and its innovations. However, not everyone wanted to live with recurrent images of dynamic motion. During the 1920s, many designers updated older styles, especially Neoclassical ones, to create a more "moderate" modernism based on continuity with the past. The chair that the architect Eliel Saarinen designed for his own dining room evoked a classical vocabulary in its tapered legs and back, which suggest a fluted column (fig. 262). Geometric precision and the abstraction of eighteenth-century motifs made the chair a modern statement, although not one likely to find favor with purists advocating what became known as the International Style.

International Style designers also despised the exotic, expensive materials adored by the practitioners of alternative forms of modernism. Greenheart, mahogany, and ebony woods, ivory, shagreen, and silk were only a few of the rare and expensive materials used in the creation of luxury objects during the 1920s.

The influence of Europe on American design during this period can hardly be overestimated. Even the responses to the American urban landscape were often articulated by immigrants (Magnussen was Danish; Frankl, Austrian) and many of the best designers trained abroad. The early 1920s saw a reluctance to acknowledge any uniquely American contribution to modern design aesthetics; the United States did not participate in the hugely influential 1925 Exposition Internationale des Arts Décoratifs et Industriels Modernes in Paris (the term "Art Deco" is a contraction of the exhibition's title), because the government declared that "American manufacturers and craftsmen had almost nothing to exhibit in the modern spirit." By the end of the decade, though, the modern was trumpeted in magazines and furnishings showrooms.

In 1920s America, the "modern" in decorative arts could take many forms—it could be manifested as a miniaturized version of a skyscraper, a geometric abstraction of classical styles, an eclectic interpretation of Cubism, a response to machine technology, or a highly stylized rendering of animal shapes. All were inspired by a progressive, optimistic spirit, and none were yet restrained by the antidecorative passions of functionalism. —W. K.

262. **Eliel Saarinen**
Dining Room of Saarinen House, c. 1930
Cranbrook Archives,
Bloomfield Hills, Michigan

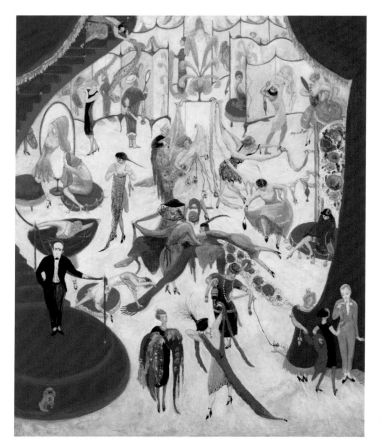

263. **Florine Stettheimer**
Spring Sale at Bendel's,
1921
Oil on canvas, 50 x 40 in.
(127 x 101.6 cm)
Philadelphia Museum of
Art; Given by Miss Ettie
Stettheimer

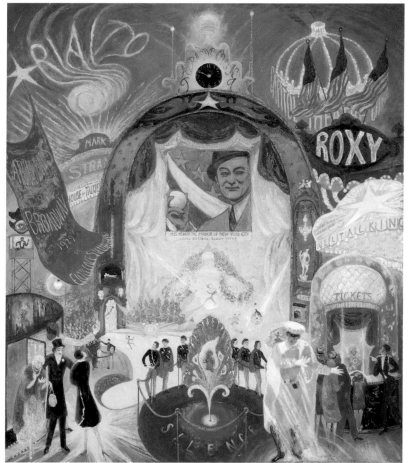

264. **Florine Stettheimer**
The Cathedrals of Broadway,
1929
Oil on canvas, 60⅛ x
50⅛ in. (152.7 x
127.3 cm)
The Metropolitan Museum
of Art, New York; Gift of
Ettie Stettheimer, 1953

265. **Johan Hagemeyer**
Pedestrians, 1920
Gelatin silver print, 9⅝ x
7⅝ in. (24.4 x 19.4 cm)
Center for Creative
Photography, University of
Arizona, Tucson

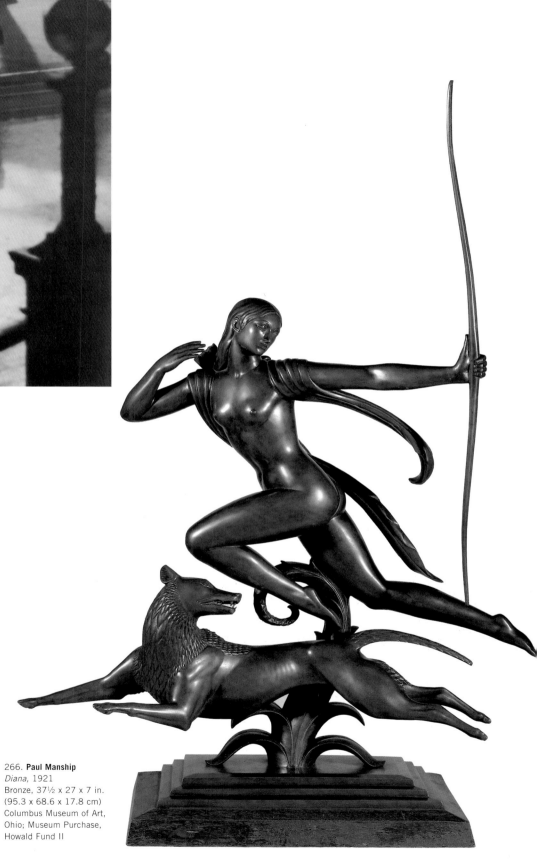

266. **Paul Manship**
Diana, 1921
Bronze, 37½ x 27 x 7 in.
(95.3 x 68.6 x 17.8 cm)
Columbus Museum of Art,
Ohio; Museum Purchase,
Howald Fund II

Precisionism and the Machine Age

Precisionism was the American version of the classicizing impulse or "call to order" that swept Europe after World War I. The carnage and brutality of the war had shattered the idealistic dreams for social-spiritual renewal that had prevailed in the early twentieth century. This disillusionment engendered a two-pronged reaction among artists: on the one hand, a pessimistic desire to retreat from the present into a world of absurd irrationality and, on the other, a tendency to look to the future and a new world order based on rationality and science. Confident of humanity's ability to impose order on the world, those in the latter group chose modern machinery and industrial forms as their model for the precision, logic, and purity they desired in society and their art.

Of the various manifestations of these classicizing movements, French Purism cast the most significant spell on American painting in the 1920s. This was due to the steady stream of pilgrimages to Paris that American artists made throughout the decade and to the widespread dissemination of the movement's theoretical pronouncements. These came to America through the 1918 book-length manifesto *Après le Cubisme*, written by the movement's founders Charles-Édouard Jeanneret (Le Corbusier) and Amédée Ozenfant, and through their journal *L'Esprit Nouveau*, which enjoyed wide currency in the American art community. Indebted to Cubism, the work of Ozenfant and Le Corbusier replaced Cubist chaos, flux, and illegibility with order, balance, and clarity by utilizing flat, hard-edged planes, muted colors, and simplified geometric shapes executed in a dry, mechanical manner. By presenting everyday objects in a style that paralleled the mathematical harmony of the machine, the Purists achieved an art of order, stark monumentality, and atemporality. Paradoxically, although they considered the machine an analogue to eternal, classical principles and the visual source for modern art, they continued to rely for subject matter on traditional Cubist still-life themes.

The analogous American style, Precisionism, likewise took the flat, hard-edged vocabulary of Cubism as its point of departure. Charles Demuth and Preston Dickinson were among the first artists to fashion a lucid, geometrical art based on machine and architectural imagery. Already in the winter of 1917, while in Bermuda with Marsden Hartley, Demuth had begun setting the biomorphic forms of trees and branches within a subtly shifting structure of ruler-drawn lines and planes that crisscrossed his centralized forms (fig. 267). By 1919, in a group of temperas, he had joined pale color and diaphanous light effects with flatter forms that extended to the perimeters of the canvas. Intersecting diagonals functioned as rays of light that lent a soft, diffused radiance to his compositions while simultaneously reinforcing their geometry. By 1918, Dickinson too was reducing architectural scenes to sharply cut, angled masses, executed in discordant colors (fig. 269). Yet his style, like that of Demuth, remained allied with the delicately fragmented and decorative Cubism he had learned in Paris in the teens.

Not surprisingly, given that all unacademic American art in the twenties was called Cubism, the austere, sharply delineated style known now as Precisionism was initially labeled Cubist.[54] The terms "New Classicists" and "Immaculate School," which the dealer Charles Daniel had proposed as a way to suggest the style's emphasis on order, stability, and impersonal execution, were widely used until 1946, when the art historian Milton Brown coined the label Cubist-Realist. Finally, in 1960, "Precisionism" came into currency and is now generally accepted as a term to describe art from the twenties and thirties with simplified, hard-edged forms, impersonal paint handling, and geometric structure. Theoretically, any subject can be considered Precisionist as long as it adheres to these criteria. Under this definition, for example, Charles Sheeler's still-life paintings of Shaker objects and early American furniture from his Pennsylvania farmhouse are considered

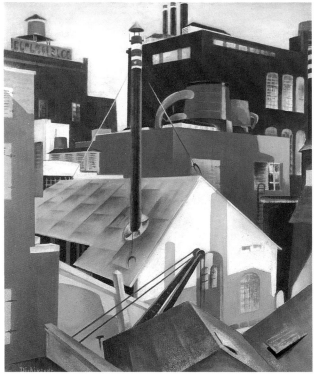

267. **Charles Demuth**
Trees and Barns: Bermuda,
1917
Watercolor over pencil on
paper, 9½ x 13⁷⁄₁₆ in.
(24.1 x 34.1 cm)
Williams College Museum
of Art, Williamstown,
Massachusetts; Bequest of
Susan Watts Street

268. **Charles Sheeler**
Interior, 1926
Oil on canvas, 33 x 22 in.
(83.8 x 55.9 cm)
Whitney Museum of
American Art, New York;
Gift of Gertrude Vanderbilt
Whitney 31.344

269. **Preston Dickinson**
Industry, c. 1923
Oil on canvas, 30 x
24¼ in. (76.2 x 61.6 cm)
Whitney Museum of
American Art, New York;
Gift of Gertrude Vanderbilt
Whitney 31.173

Precisionist (fig. 268). While this broad-based definition is occasionally invoked, the term "Precisionism" is most useful when applied to works that conjoin geometric simplification with architectural and machinist subjects.

For Precisionist artists, architecture offered a ready-made subject with which to explore the abstract arrangement of flat, simplified shapes without forfeiting recognizability. This distillation likewise allowed them to express stability and permanence (fig. 270). In the hands of Niles Spencer, for example, the flat, geometric shapes of buildings became the constituent blocks of a classical art—ordered, quiet, and timeless (fig. 272). Uniting hard-edged, tightly interlocking forms with subtly textured paint and warm, earth colors, Spencer asserted the abstract structure and flatness of the canvas surface while simultaneously endowing it with a gentle reticence and richness.

270. **Howard Cook**
Skyscraper, 1929
Woodcut, 17⅞ x 8⅝ in.
(45.4 x 21.9 cm) irregular
Whitney Museum of
American Art, New York;
Purchase, with funds from
The Lauder Foundation,
Leonard and Evelyn Lauder
Fund 96.68.45

Sheeler, too, in his photographs of rural Pennsylvania barns, sought to "reduce natural forms to the borderline of abstraction, retaining only those forms which [he] believed to be indispensable to the design of the picture."[55] His conviction that artists should base their designs on nature's underlying structure, along with his penchant for formal clarity, had led him, as early as 1914, to reject soft-focus, impressionist photography in favor of unmanipulated architectural images. By 1917, he was translating these ideas into drawings (fig. 271). Following his move to New York in 1919, Sheeler turned to the city's skyscrapers. For him, these monuments of American engineering offered the same honesty of structure and absence of superfluities that he had found in vernacular rural architecture. While making the film *Manhatta* with Paul Strand in 1920, he seized upon the skyscraper as the urban counterpart to the barns of Bucks County and began to take still photographs of them.

Sheeler's photographs of the complex arrangements of rooftops, building forms, and shadows became the basis for the series of crystalline, hard-edged paintings that he executed between 1920 and 1922 (fig. 273). Unlike the prewar, expressively fragmented urban images of John Marin, Joseph Stella, and Max Weber, which reveled in the city's accelerated tempo, multiplicity of perceptions, and anthropomorphic vitality, Sheeler's images were coolly austere, intellectually precise, and static. In paring away ornament to expose underlying geometries, Sheeler turned skyscrapers into truly functionalist forms. Like the photographs on which they are based, these paintings, in their treatment of shadows as solid, their elimination of detail, and their close-cropped compositions, provide an unprecedented degree of dramatic abstraction.

To a generation disillusioned by emotional excess, the city's impersonal rationalism promised a cool and intelligent realm of disciplined human emotions. It caught the imagination of those who were excited by the cult of progress and belief in the new. This romance with the city as an environment of order and rationalism differed radically from the robust human vitality with which the Ashcan artists described the urban experience.

The American artist who first saw an occasion for optimism in the disciplined order and detachment of the city was Louis Lozowick, the only American to have contact with the Constructivists, a group of Russian artists who worked in the

271. **Charles Sheeler**
Bucks County Barn, 1923
Tempera and crayon on
paper, 19⅝ x 26 in.
(49.8 x 66 cm)
Whitney Museum of
American Art, New York;
Gift of Gertrude Vanderbilt
Whitney 31.468

272. **Niles Spencer**
City Walls, 1921
Oil on canvas, 39⅜ x
28¾ in. (100 x 73 cm)
The Museum of Modern
Art, New York; Given
anonymously (by exchange)

273. **Charles Sheeler**
Church Street El, 1920
Oil on canvas, 16⅛ x
19⅛ in. (40.6 x 48.5 cm)
The Cleveland Museum of
Art; Mr. and Mrs. William
H. Marlatt Fund

275. **Louis Lozowick**
Minneapolis, 1925
Lithograph, 11⅝ x 8⁹⁄₁₆ in.
(29.5 x 22.7 cm)
Whitney Museum of
American Art, New York;
Gift of the Dain Gallery
72.51

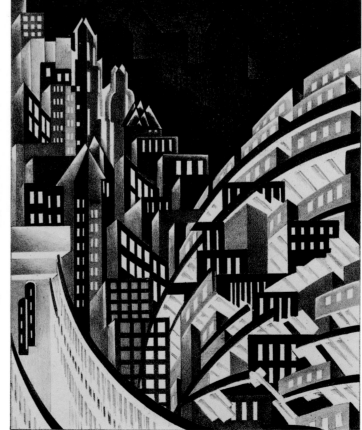

274. **Louis Lozowick**
Pittsburgh, 1922–23
Oil on canvas, 30 x 17 in.
(76.2 x 43.2 cm)
Whitney Museum of
American Art, New York;
Gift of Louise and Joe
Wissert 83.50

276. **Louis Lozowick**
New York, c. 1925
Lithograph, 15⅛ x
11⅜ in. (38.4 x 28.9 cm)
Whitney Museum of
American Art, New York;
Purchase, with funds from
the John I. H. Baur
Purchase Fund 77.12

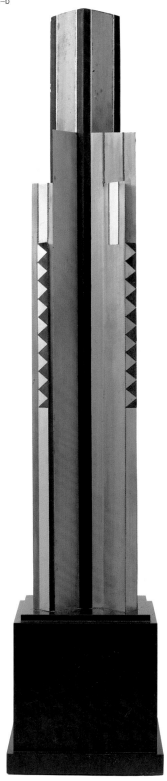

277. **John Storrs**
Forms in Space, c. 1924
Aluminum, brass, copper,
and wood on marble base,
28½ x 5⅝ x 5⁵⁄₁₆ in.
(72.4 x 14.3 x 13.5 cm)
Whitney Museum of
American Art, New York;
Gift of Charles Simon
84.37a–b

1920s. To Constructivists such as El Lissitzky and Aleksandr Rodchenko, the promise of the future lay in a society whose parts were efficiently organized, well articulated, and equal. They saw in the rational operation of the machine a model not only for an aesthetic but for a morality free of sentiment and caprice. Living in Berlin between 1920 and 1924, Lozowick had met the Constructivists and been influenced by their identification of America with "gigantic engineering feats and colossal mechanical constructions."[56] Inspired by their belief in the inherent beauty and necessity of industrial order, Lozowick came to view the urban environment as a source for pure artistic form and as a positive force in shaping rational society: "The dominant trend in America today, beneath all the apparent chaos and confusion is towards order and organization which find their outward sign and symbol in the rigid geometry of the American city."[57]

While still in Europe, Lozowick executed a series of paintings of nine American cities he had visited, presenting the salient feature of each site: New York's skyscrapers, Pittsburgh's steel mills, Minneapolis' grain elevators, and Seattle's lumberyards. Using the intrinsically mathematical patterns and geometric forms of the city as a scaffolding, he joined carefully demarcated forms, flattened space, and controlled execution with diagonal thrusts, dramatically exaggerated upward-tilted perspective, and overlapping forms to exploit the drama of scale and create a dynamic and monumental urban landscape (figs. 274–76).

John Storrs and Hugh Ferriss extended Lozowick's urban optimism into more visionary directions—Storrs in stylized sculptured equivalents of streamlined towers and Ferriss in charcoal drawings of real and idealized urban structures (figs. 277–80). Ferriss' dramatic chiaroscuro renderings exaggerate the monumentality and romance of the city by suppressing detail in favor of simplified, sculptural mass and by enveloping buildings in a luminous mist. Commissioned throughout the twenties by architectural firms to illustrate new building projects, he was thrust into the limelight as a prophet of urban utopia by the publication in 1929 of his visionary city plans in *The Metropolis of Tomorrow*.

Ferriss' utopian vision of the city was not universally shared. Georgia O'Keeffe responded to the mechanized urban landscape with the same ambivalence and estrangement that had characterized Pictorial photographers in the first decade of the century. Influenced perhaps by Stieglitz, with whom she began living in New York City in 1918, she pastoralized the city by bathing it in light and the poetry of evening (fig. 281). Using similar means, George Ault exploited the mystery of night to cloak New York City with an enigmatic, but claustrophobic, silence that mirrored his vision of skyscrapers as "tombstones of capitalism" and the city as "the inferno without the fire" (fig. 282).[58]

Notwithstanding these isolated misgivings, the equation of America with the machine and technology—an equation made before the war by Marcel Duchamp, Francis Picabia, and Albert Gleizes—pervaded the general consciousness in the 1920s. Dazzled by the prosperity of postwar America and by the proliferation of new gadgets and machines, Americans raised industry into a national religion. The widespread availability of radios, telephones, and automobiles transformed public life by making communication faster and distances shorter. At the same time, domestic machines—irons, sewing machines, vacuum cleaners, toasters, washing machines, refrigerators—converted the American household into an efficient, hygienic, mechanized environment. So pervasive was the impact of mechanization on the lives of ordinary citizens that people began speaking of their era as the "machine age." Businessmen and engineers became the cultural heroes of the 1920s, symbols of a new world of innovation founded on technology and scientific management. Henry Ford proclaimed industry as the "New Messiah," and President

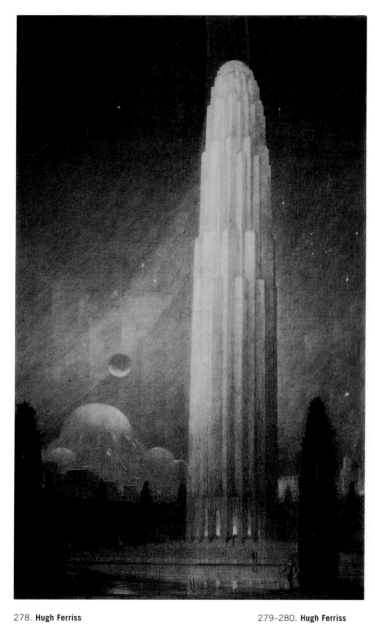

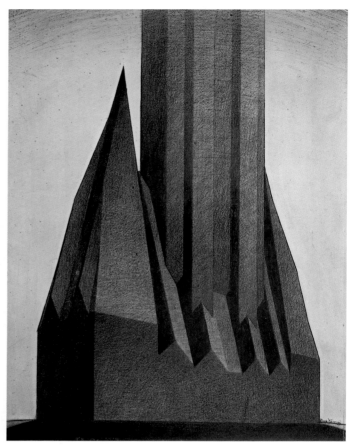

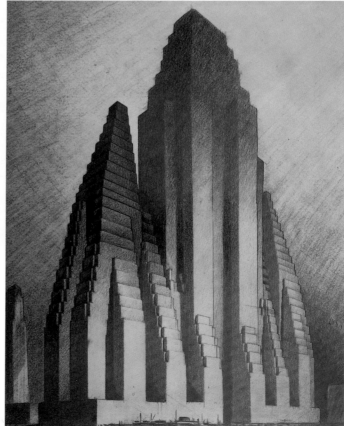

278. Hugh Ferriss
Philosophy, 1928
Charcoal on paper, 38 x
22 in. (96.5 x 55.9 cm)
Avery Architectural and
Fine Arts Library, Columbia
University in the City of
New York

279–280. Hugh Ferriss
*Study for Maximum Mass
Permitted by the 1916
New York Zoning Law,
Stage 4,* 1922
Crayon and ink on board,
26³⁄₁₆ x 20 in.
(66.5 x 50.8 cm)
Cooper-Hewitt, National
Design Museum,
Smithsonian Institution,
New York; Gift of Mrs.
Hugh Ferriss

281. **Georgia O'Keeffe**
The Shelton with Sunspots, 1926
Oil on canvas, 49 x 31 in.
(123.2 x 76.8 cm)
The Art Institute of
Chicago; Gift of Leigh B.
Block

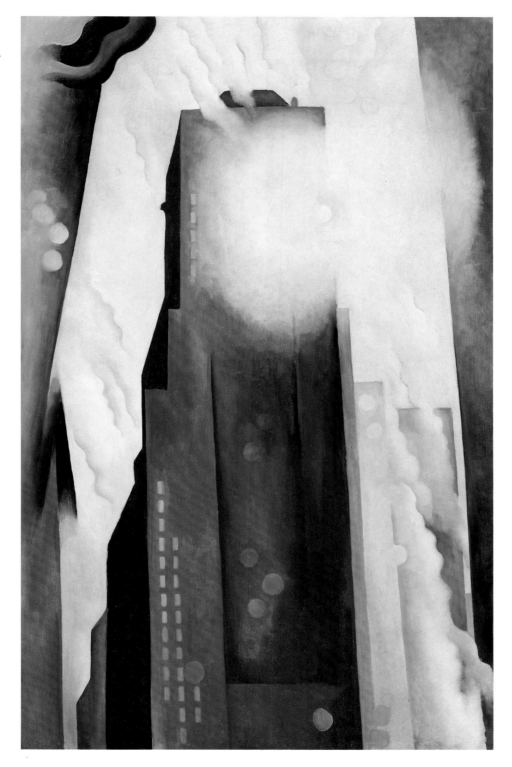

Calvin Coolidge declared, "The man who builds a factory builds a temple. The man who works there worships there."[59] Bruce Barton's book *The Man Nobody Knows* (1925), which epitomized the secularization of religion and the religiosity of business, was the country's best-selling nonfiction title in 1925 and 1926—an indication that many Americans identified the triumvirate of science, industry, and technology with prosperity and hope. Barton described Jesus as the founder of a modern enterprise who had "picked up twelve men from the bottom ranks of business and forged them into an organization that conquered the world."[60]

Behind the artists' celebration of the machine lay the machinist work of Marcel Duchamp and Morton Schamberg. In his *Chocolate Grinder* paintings and in *The Large Glass* (figs. 215, 217), Duchamp had replicated the machinelike craftsmanship and impersonal detachment of the machine by employing mechanical drawing and sleek materials such as glass and metal. His work provided a point of departure for Schamberg's equally lucid, diagrammatic images of isolated, precisely rendered machines.

Charles Demuth had been particularly receptive to Duchamp's fastidious execution, but it was Schamberg's plumbing fixture mechanomorph, *God* (fig. 220), that more closely matched his own cryptic commentary on the correlation of industry and religion. In *Incense of a New Church*, Demuth equated incense with the billowing, stylized smoke that swirls menacingly around the cathedral-like forms of the Lukens Steel yards near his home in Lancaster, Pennsylvania (fig. 283). A large chalice in the painting's foreground cements the religious-industrial symbolism: the transubstantiation of Christian communion is now enacted in the industrial arena. The incandescent fires, colossal machinery, and dark and brooding interiors of factories seemed to lend themselves to religious association. The awesome and frightening power of the machine was celebrated by the painters Joseph Stella and Louis Lozowick and the photographers William Rittase, Margaret Bourke-White, Ira Martin, and Lewis W. Hine (figs. 284–88).

282. **George Ault**
Sullivan Street Abstraction, 1924
Oil on canvas, 24¼ x 20 in. (61.6 x 50.8 cm)
Walker Art Center, Minneapolis; Art Center Acquisition Fund, 1961

Charles Sheeler's reverence for industrial subjects was more restrained but no less strongly felt. His conversion occurred in 1927, when he was hired by a Philadelphia advertising agency, N. W. Ayer and Company, to photographically document the newly opened Ford Motor Company plant on the Rouge River, which had been built to produce the Model A. Designed by Albert Kahn, the plant occupied over eleven hundred acres and included twenty-three main buildings, ninety-three miles of railroad track, and 75,000 employees. The advertising campaign launched to herald the plant was meticulously orchestrated to create a glamorous image for Ford by promoting the aesthetic side of industry. For Sheeler, the six weeks he spent at River Rouge, as the plant was informally called, marked a turning point in his career. Convinced that every age manifests itself by some external evidence, he came to view factory architecture as the modern equivalent of the religious architecture of the past and factories themselves as "our substitute for religious expression."[61] Like those of vernacular architecture and skyscrapers, the forms of the huge River Rouge complex were beautiful to him because they "had been designed with their eventual utility in view."[62] They fulfilled the requirement of great art: the parts worked perfectly together to achieve a consummate whole.

In the thirty-two photographs Sheeler made of River Rouge, he joined the aesthetic of a mechanical instrument—the camera—with a machine subject (fig. 289). Sheeler's desire for an art that would mechanically express the mechanical age found even fuller expression in the River Rouge drawings and paintings he executed three years later (fig. 290). For these works, he used an opaque projector to translate his photographs onto the canvas surface. This allowed him to predetermine his compositions and eliminate the vagaries of spontaneous expression, bringing him closer to his goal of reproducing the inherent beauty of his subjects with as "little personal interference as possible."[63] By transforming the art-making process into a machinelike set of operations, Sheeler endowed his compositions with a silent stillness. His subjects seem suspended in a vacuum, undisturbed by variations in light and atmosphere. Removed from history and time, they exude something of a newly secularized spiritualism. Sheeler's factories are idealized landscapes, exemplars of universal values of harmony, purity, and order. Absent from them is the harsh reality of the assembly line and the temporality of the human presence. To achieve this effect, Sheeler ignored the part of River Rouge that produced cars and concentrated instead on the part that transformed raw materials into steel. He created an experience of the technological sublime by aestheticizing industry, thereby rendering a vision of the utopian world order sought by European artists.

The year 1927 marked the beginning of Precisionism's maturity. The sublimity of Sheeler's River Rouge photographs was echoed that same year in Demuth's most powerful late work, *My Egypt* (fig. 291). In this hieratic painting, Demuth dispensed with the whimsy and delicacy of his earlier architectural depictions in favor of a powerful synthesis of form and content. His equation of American industry with Egyptian pyramids confirmed industry's position at the pinnacle of American achievement, just as Sheeler's painting *Classic*

283. **Charles Demuth**
Incense of a New Church, 1921
Oil on canvas, 26 x 20⅛ in. (66 x 51.1 cm)
Columbus Museum of Art, Ohio; Gift of Ferdinand Howald

284. **Joseph Stella**
The Quencher (Night Fires), c. 1919
Pastel on paper, 22½ x 29 in. (57.2 x 73.7 cm)
Milwaukee Art Museum; Gift of Friends of Art

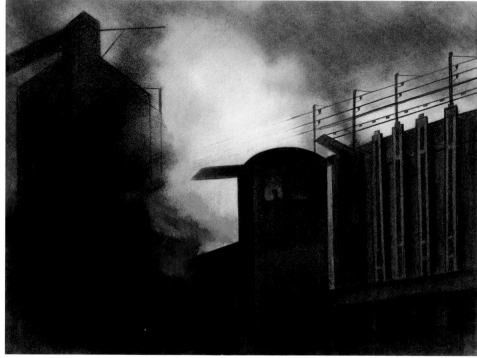

287. **Margaret Bourke-White**
Electric Furnace, Ludlum Steel Co., Dunkirk, New York, c. 1928–29
Gelatin silver print, 12¾ x 10 in. (32.4 x 25.4 cm)
The Museum of Modern Art, New York; Gift of the photographer

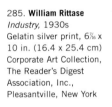

285. **William Rittase**
Industry, 1930s
Gelatin silver print, 6⁷⁄₁₆ x 10 in. (16.4 x 25.4 cm)
Corporate Art Collection, The Reader's Digest Association, Inc., Pleasantville, New York

286. **Margaret Bourke-White**
Chrysler Corporation, 1929
Gelatin silver print, 13⅛ x 9½ in. (33.3 x 24.1 cm)
Bourke-White Collection, Department of Special Collections, Syracuse University Library

288. **Lewis W. Hine**
Powerhouse Mechanic, 1925 (printed 1940)
Gelatin silver print, 13½ x 10½ in. (34.4 x 26.7 cm)
Brooklyn Museum of Art, New York; Gift of Mr. and Mrs. Walter Rosenblum

289. **Charles Sheeler**
Industry, center panel of triptych, 1932
Gelatin silver print, 7⅞ x 6⅜ in. (20.1 x 16.2 cm)
The Art Institute of Chicago; Gift of Jean and Julien Levy

290. **Charles Sheeler**
River Rouge Plant, 1932
Oil on canvas, 20 x 24⅛ in. (50.8 x 61.3 cm)
Whitney Museum of American Art, New York; Purchase 32.43

Landscape would later identify industry as the American equivalent of the Greek classical past (fig. 292).

The year 1927 also saw Elsie Driggs draw upon a childhood memory of Pittsburgh to paint the city's steel mills. Like Sheeler, Driggs found an aesthetic beauty—an "inevitable rightness," she called it—in these forms, which unite function and felicitous proportion.[64] Out of her memory of Pittsburgh, she created an image of industry at once threatening and powerfully seductive (fig. 293).

The exaltation of the machine and industry reached its apotheosis in the landmark 1927 "Machine Age Exposition," held at Steinway Hall in New York under the auspices of *The Little Review,* the literary magazine edited by Jane Heap. International in scope, it modeled itself on the Purist Pavilion arranged by Le Corbusier for the Exposition Internationale des Arts Décoratifs et Industriels Modernes, held in Paris two years earlier. The New York exhibition juxtaposed paintings and constructions with actual machines and photographs of factories, grain elevators, and power plants. All were installed by Duchamp, in galleries decorated with hand tools hung on chains from the ceiling. Calling the machine "the religious expression of today" and engineers "the great new race of men," the organizers identified artists of the first rank as those who were transforming the reality of the age—the machine—into dynamic beauty by pictorially rendering the pure form and design of indigenous American architecture, that is, of smokestacks, factories, and gas tanks.[65] Although international in scope, the show's identification of America with the machine was made explicit in Lozowick's catalog essay, "The Americanization of Art," in which he equated the history of engineering feats with the history of America.

Sheeler, Demuth, Lozowick, Duchamp, and the photographer Ralph Steiner were among the artists selected by the organizers to be on the artists' board. All were deemed to have used the order, calculation, and efficiency of modern technology to transcribe the new American landscape (figs. 294, 295). Fittingly, Paul Strand was absent from the roster. Already in 1922, in his essay "Photography and the New God," he had argued that humanity was faced with the alternative of "being ground under the heel of the new God" or of "controlling the heel."[66]

291. Charles Demuth
My Egypt, 1927
Oil on board, 35¾ x 30 in.
(90.8 x 76.2 cm)
Whitney Museum of
American Art, New York;
Purchase, with funds from
Gertrude Vanderbilt
Whitney 31.172

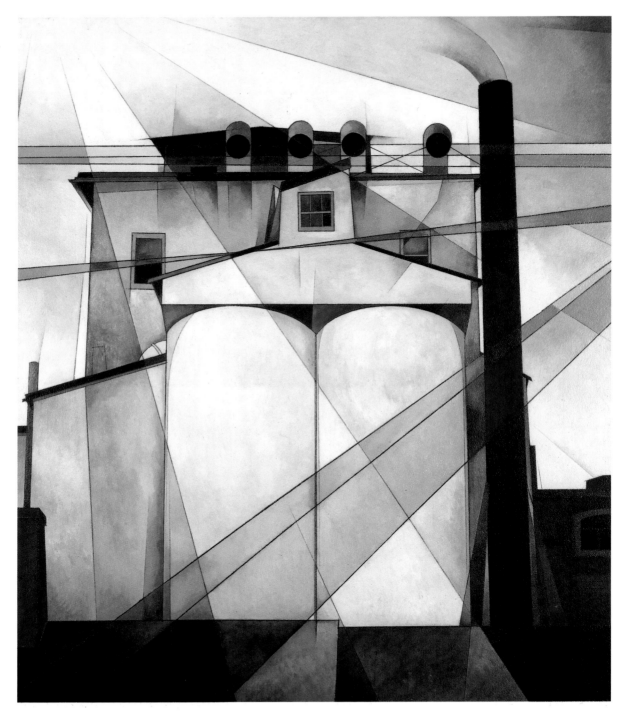

292. **Charles Sheeler**
Classic Landscape, 1931
Oil on canvas, 24¾ x
32¼ in. (63.5 x 81.9 cm)
Mr. and Mrs. Barney A.
Ebsworth Foundation

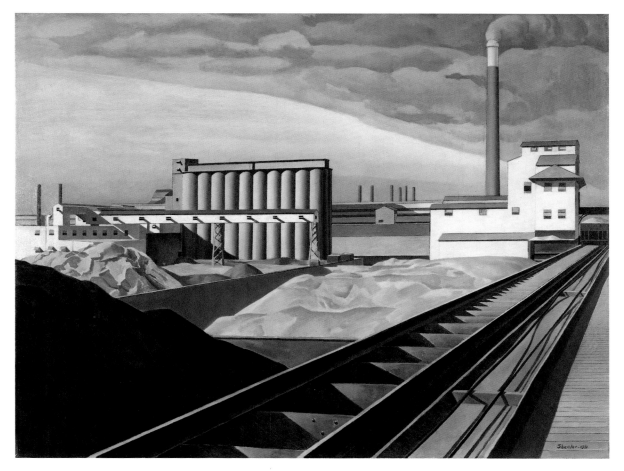

293. **Elsie Driggs**
Pittsburgh, 1927
Oil on canvas, 34¼ x
40 in. (87 x 101.6 cm)
Whitney Museum of
American Art, New York;
Gift of Gertrude Vanderbilt
Whitney 31.177

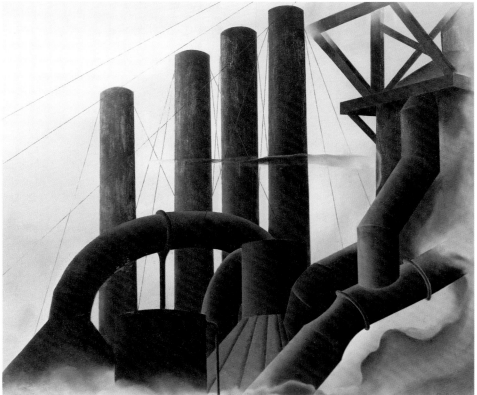

294. **Louis Lozowick**
Machine Ornament,
c. 1925–27
India ink on paper, 15 x
9 in. (38.1 x 22.9 cm)
Whitney Museum of
American Art, New York;
Purchase, with funds from
the Neysa McMein
Purchase Award and
Barbara Babcock Millhouse
82.24

295. **Louis Lozowick**
Crane, 1928
Lithograph, 12¼ x 8⅜ in.
(31.1 x 21.3 cm)
Whitney Museum of
American Art, New York;
Purchase 31.770

A year later, in photographs of his recently acquired Akeley movie camera and other tools in the Akeley store, he had successfully fused objective and subjective expression (fig. 296). By 1925, though, his growing uneasiness over the psychological and spiritual fragmentation induced by the machine environment had led him to abandon urban-industrial themes for nature. Nevertheless, his earlier machinist work inspired photographers such as Ralph Steiner and Paul Outerbridge, Jr., to include machine imagery among their subjects. They stopped short of adopting Strand's technique of long (thirty-minute) exposures to yield high contrasts of light and dark, but they did emulate his close framing of subjects, which accentuated the clear-cut geometry and abstract beauty of machine forms (figs. 297, 298).

Strand's concern with the dehumanizing potential of technology was dismissed by American intellectuals such as Walter Lippmann, Matthew Josephson, and Herbert Croly, who saw in the rational control of society by a disinterested managerial elite a remedy to social and political problems. Like European utopians, they regarded industry as a model for efficient and forward-looking social engineering. Aligned against these proponents of technological optimism were other intellectuals, among them Lewis Mumford and Waldo Frank, who warned that the scientific management of industry upon which the assembly line was based would destroy workers' pride and autonomy. Indeed, the wholesale adoption of Frederick Taylor's efficiency studies to factory management was already regimenting workers' movements to an insufferable degree. Fear over the robotization of humans underlay much of the cinematic comedy of Buster Keaton and Harold Lloyd (fig. 244); it would reach its apogee in Charlie Chaplin's *Modern Times* (1936), in which Chaplin's tramp is transmogrified into an automaton. Even Elmer Rice's expressionist play *The Adding Machine* (1923) and the Theatre Guild's New York production of *R.U.R.* (1923), written by the Czech playwright Karel Čapek, which added the word "robot" to the English language, evinced a pervasive concern that the machine was a menace to be opposed, circumvented, or outwitted. Eugene O'Neill's *Dynamo* (1929), devoid of both humor and hope, offered an even more pessimistic view: the protagonist deifies the machine, science, and materialism only to find them, in the end, failed substitutes for the old God, unable to provide answers to the meaning of life (fig. 299)

Notwithstanding these doomsayers, the desire to celebrate the materials and inventions of the modern world with clarity and impersonal elegance still exerted a hold on artists such as Sheeler into the 1930s (fig. 301)—and attracted new converts. Ralston Crawford, a second-generation Precisionist, saw the architectonic structures of industry as emblematic not only of an eminently assured and stable civilization but of utopian social possibilities as well (figs. 302, 303). Although sharing with Precisionism a subject matter and stylistic insistence on an ordered pictorial discipline purged of spontaneity and emotional excess, Crawford was temperamentally allied with the industrial designers of the thirties who believed,

296. **Paul Strand**
Double Akeley, New York,
1922
Gelatin silver print, 9¹¹⁄₁₆ x
7¾ in. (24.6 x 19.7 cm)
San Francisco Museum of
Modern Art; The Helen
Crocker Russell and
William H. and Ethel W.
Crocker Family Funds,
Purchase

297. **Paul Outerbridge, Jr.**
Marmon Crankshaft, 1923
Platinum print, 4⁹⁄₁₆ x
3¹¹⁄₁₆ in. (11.6 x 9.3 cm)
The Baltimore Museum of
Art; Purchase with
exchange funds from the
Edward Joseph Gallagher
III Memorial Collection;
and Partial Gift of George
H. Dalsheimer, Baltimore

298. **Ralph Steiner**
Untitled (Power Switches),
c. 1928
Gelatin silver print, 7⅝ x
9⁹⁄₁₆ in. (19.4 x 24.3 cm)
The Art Institute of
Chicago; Gift of Jean Levy
and the Estate of Julien
Levy

as he did, that technology "represented the liberation of the world from poverty."[67] *Overseas Highway*, his dramatic 1939 image of a causeway speeding into space, would catch the imagination of a nation emerging from the doldrums of the Depression and make him a national celebrity (fig. 304).

By 1932, a group of California photographers had joined the Precisionist effort by promoting the sharply focused aesthetic associated with machine technology. The group's mentor was Edward Weston, who in 1922 had begun to turn from the Pictorialist work that had made him famous to the precision and objectivity of straight photography. Traveling to New York that summer, Weston stopped in Ohio to visit his sister. There, the sight of the hard, metallic architecture of the American Rolling Mill Company (Armco) factory inspired photographs of clarity and sharp detail (fig. 305). His encounter with Stieglitz and Sheeler in New York intensified his commitment to this style. Although Weston would not turn

THE MATURING OF AMERICAN DRAMA

The twenties, a complex decade for the American theater, have been termed the Theatrical Twenties. During these years, approximately 2,500 works were staged in New York; however, some 70 percent failed. Nevertheless, the opportunity for such prodigious production was a stimulant, especially for playwrights. The best writing to date in the United States appears in this decade: the early plays of Eugene O'Neill, the comedies of George S. Kaufman (in numerous collaborations), the expressionistic plays of Elmer Rice (such as *The Adding Machine*, 1923), George Kelly's comedies, the plays of wit and style of Philip Barry and S. N. Behrman, dramas by Sidney Howard, Maxwell Anderson, and Robert Sherwood.

Although not the first significant American playwright or the dominant writer of the decade, O'Neill nonetheless represented the maturing of American drama. During the 1920s, he wrote twenty plays and earned Pulitzer Prizes for three: *Beyond the Horizon* (1920; written in 1918), *Anna Christie* (1922; written 1920), and *Strange Interlude* (1928; written 1926–27) (fig. 300). Though ultimately O'Neill's forte was a kind of modified realism, much of his work in the early twenties challenged accepted dramaturgical techniques, especially in its use of nonverbal resources (song, pantomime, masks, dance, scenic effects, novel sound effects) (fig. 299). Two early efforts, *The Emperor Jones* (1920) and *The Hairy Ape* (1921), are frequently categorized as expressionistic. In fact, O'Neill is considered by some critics as the greatest expressionistic dramatist of any country, boldly exploring taboo subjects, using visual symbolism, rejecting verisimilitude, and creating dramas dominated by serious, often somber themes, ranging from insanity and murder to suicide and death.

Yet despite the noble and artistically innovative efforts of O'Neill and others, the dominant theater of the time, like the decade itself, was characterized by escape. Most theatergoers sought a lighter fare, not the work of new writers of depth and sensitivity. It is not surprising that the early twenties mark the apogee of the musical revue, that operettas were the rage, and that a kind of "smiling through the tears" comic sentimentality dominated the theatrical landscape. The hit of the early twenties was not an O'Neill play but Anne Nichols' mawkish comic romance between a Jewish boy and an Irish colleen, *Abie's Irish Rose*. Excoriated by the critics when it opened in 1922, the play nonetheless ran for over five years, setting a record for longevity, and making its author a millionaire. —D. W.

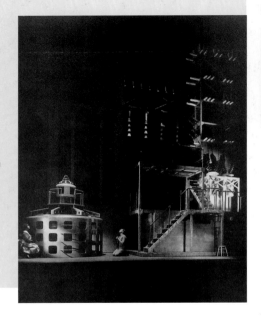

299. *Dynamo,* by Eugene O'Neill, set by Lee Simonson, 1929

300. Window card for Eugene O'Neill, *Strange Interlude,* John Golden Theatre, New York, 1928 Museum of the City of New York

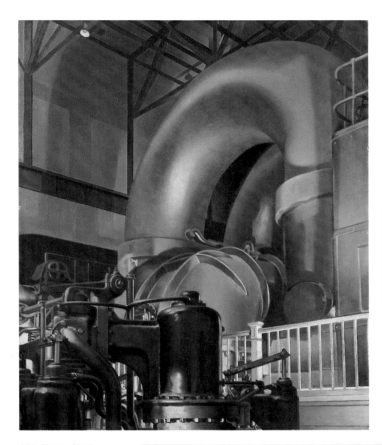

301. **Charles Sheeler**
Steam Turbine, 1939
Oil on canvas, 22 x 18 in.
(55.9 x 45.7 cm)
The Butler Institute of
American Art, Youngstown,
Ohio

302. **Ralston Crawford**
*Steel Foundry, Coatesville,
Pennsylvania,* 1936–37
Oil on canvas, 32 x 40 in.
(81.3 x 101.6 cm)
Whitney Museum of
American Art, New York;
Purchase 37.10

303. **Ralston Crawford**
Grain Elevators, Buffalo,
c. 1938
Gelatin silver print, 6¼ x
9⅜ in. (15.9 x 23.8 cm)
Private collection

his attention again to industrial subjects for almost twenty years, his work provided a model for a community of photographers who included Ansel Adams, Willard Van Dyke, Imogen Cunningham, Sonya Noskowiak, Alma Lavenson, and Brett Weston. Calling themselves f/64 after the smallest aperture then available on cameras, they espoused the simple and unmanipulated presentation of subjects (figs. 306–309). Because they favored a resolutely purist application of photography, they printed by contact rather than by enlarging and chose glossy paper over matte finishes in order to accentuate tonal contrasts and wealth of detail. By means of long exposure times, they perfected an art of sharply defined, simplified images that maximized detail across all areas of the picture surface while allowing for the greatest depth of focus.

304. **Ralston Crawford**
Overseas Highway, 1939
Oil on canvas, 28 x 45 in.
(71.1 x 114.3 cm)
Curtis Galleries,
Minneapolis

305. **Edward Weston**
Armco Steel, 1922
Platinum print, 9⁹⁄₁₆ x
7⅝ in. (24.4 x 19.3 cm)
The J. Paul Getty Museum,
Los Angeles

306. **Willard Van Dyke**
Cement Works, Monolith,
California, 1931
Gelatin silver print, 9⅝ x
7⅜ in. (24.5 x 18.7 cm)
CNF Transportation Inc.,
Palo Alto, California

308. **Alma Lavenson**
Standard Oil Tanks, 1931
Gelatin silver print, 9½ x
7⅝ in. (24.1 x 19.4 cm)
Collection of Susan Ehrens
and Leland Rice

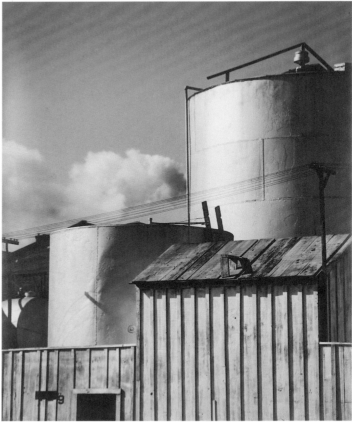

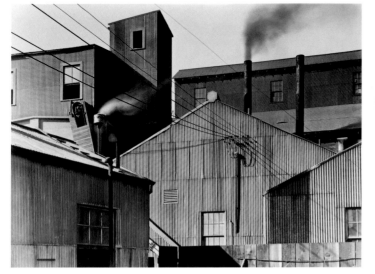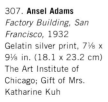

307. **Ansel Adams**
*Factory Building, San
Francisco,* 1932
Gelatin silver print, 7⅛ x
9⅛ in. (18.1 x 23.2 cm)
The Art Institute of
Chicago; Gift of Mrs.
Katharine Kuh

309. **Sonya Noskowiak**
*Untitled (Pipes and Metal
Braces),* 1930
Gelatin silver print, 7¼ x
9¹¹⁄₁₆ in. (18.4 x 24.6 cm)
Center for Creative
Photography, University of
Arizona, Tucson

Consumer Culture and the Search for National Identity

Discussions about America and the machine age took place against the backdrop of nationalism in the 1920s, as American intellectuals and artists sought to identify what was uniquely American and what constituted the quintessential American experience. Although earlier generations had made similar efforts, the search assumed particular urgency after World War I. Politically, the desire to hold fast to what was American took regressively isolationist form: the Red scare, passage of restrictive immigration and tariff laws, rejection of U.S. membership in the League of Nations, and the rise of the Ku Klux Klan. Artistically, the nationalist agenda found a highly productive outlet in the search for indigenous subjects and forms of expression. At the turn of the century, Robert Henri and the Ashcan artists had advocated a nationalist art independent of European influence. In the 1920s, the American poet William Carlos Williams reformulated the call for national expression by admonishing artists to derive not only their subjects but also their viewpoints from their own period and place. "It is the degree of understanding about, and not situations themselves, which is of prime importance," Williams wrote in *Contact*, the literature magazine he and Robert McAlmon published from December 1920 through June 1923.[68]

The willingness of artists to disentangle themselves from European influence and find inspiration in the American environment was indebted to the country's emergence after World War I as a global power. America's rampant prosperity was in marked contrast to Europe's shattered hopes and war losses. "New York is the place," Duchamp and Gleizes exclaimed. "Europe is finished."[69] "America is just as God-damned good as Europe," wrote Henry McBride, while Malcolm Cowley declared, "We have just fallen heir to the proud position of world supremacy."[70]

Even writers and artists who went to Paris did so as much out of a desire to take advantage of an unprecedented exchange rate (twenty francs to the dollar) as to escape what they saw as the vacuous materialism of America. Once there, they remained American in their choice of material and viewpoint and resisted the Europeanization that had

THE JAZZ AGE IN LITERATURE

In a letter to his editor, Maxwell Perkins, F. Scott Fitzgerald took credit for naming the Jazz Age; but as his 1931 essay "Echoes of the Jazz Age" makes clear, it was not jazz he was interested in. What he had in mind was more the excessive nervous energy of the time, whose chief symbol was the automobile. In his essay, speed as well as the liberating convenience of a private space for petting and other intimacies resonate as central values. When Dorothy Parker met Zelda Fitzgerald for the first time, Zelda was astride the hood of a taxi, and Scott was perched on its roof. No wonder, then, that the automobile became such a central feature in *The Great Gatsby* (fig. 310), where cars function not only as stylish emblems of wealth and glamour, mobility, brute force, and sleek efficiency but also as crucial plot elements in the tragic destruction consequent on that wealth and glamour.

The twenties were dominated by other mechanical inventions as well, like the cinema and the radio. Even the poetry of E. E. Cummings, flitting across the page like a typesetter's nightmare, relies on the technology of the typewriter, on the idea of poetry as typed and the poet as typist, as a way of distancing itself from nostalgia and sentiment. And it is that instability between form and sentiment that makes Cummings a quintessentially modern poet:

> her:hands
> will play on,mE as
> dea d tunes OR s-crap p-y lea Ves flut te rin g
> from Hideous trees or
> Maybe Mandolins.

The verbal experimentation so important in Cummings' poetry is only another aspect of the witticisms and wisecracks that characterized the creative intellectual and literary coterie that gathered at the Algonquin Round Table: Robert Benchley, Alexander Woolcott, Heywood Broun, George Kaufman, Marc Connelly, and, especially, Dorothy Parker—all of them active as writers for new, urban, sophisticated magazines like *Vanity Fair* or *The New Yorker*, and all of them verbally competitive, endlessly fascinated by the sudden and paradoxical insight produced by wordplay (as when Parker described some essays as having "all the depth and glitter of a worn dime"). Similarly, the desire for verbal experimentation carried over into many *New Yorker* stories which are nothing but straight dialogue, trying to capture the nuances of social and dramatic situations through the faithful recording of the minute details of direct speech. Dorothy Parker was to revive the monologue as a literary form in short pieces such as "The Waltz" (1935) and "The Telephone Call" (1928) that show the protagonist trapped not only by circumstances but by the machinelike progression of the linguistic form itself.

Another major symbol of this period is the flapper, the young girl with bobbed hair and short skirts, brazenly direct in conversation, frank in her morality, and claiming for herself a degree of freedom unheard of by previous generations. She may have been created by Fitzgerald, but the flapper portrait was perfected by Anita Loos in *Gentlemen Prefer Blondes* (fig. 311), while the illustrations of John Held, Jr. (figs. 235, 237), gave

her immortality. Fitzgerald and his wife, Zelda, came to symbolize the style of the Jazz Age; but as he himself realized, all his stories "had a touch of disaster in them—the lovely young creatures in my novels went to ruin, the diamond mountains of my short stories blew up."

The myths and legends that surround the decade clearly are inherent in labels like "the Roaring Twenties" and "the Jazz Age," which tend to obscure the fact that the sophisticated literature of the time was profoundly critical of American life. For all the frivolity of the flappers and the bathtub gin and "the filling stations full of money," this was also the period that produced major works of modernism by Ernest Hemingway and Fitzgerald, Ezra Pound and T. S. Eliot, John Dos Passos and William Carlos Williams. —P. O.

310. *The Great Gatsby,* by F. Scott Fitzgerald New York: Charles Scribner's Sons, 1925

311. *Gentlemen Prefer Blondes: The Illuminating Diary of a Professional Lady,* by Anita Loos New York: Boni-Liveright, 1925 Glen Horowitz Bookseller, New York

engulfed their predecessors. Inspired by the postwar European romance with America, they saw their nation and themselves with fresh eyes. This was particularly true for African Americans, who found in the European approbation of jazz and African American performers a source of pride in their identity as black Americans and a confirmation of their contribution to American culture.

With their own countries devastated by the war, Europeans turned eagerly to American popular culture and consumer goods. American cinema, jazz, comic books, detective stories, and consumer products flooded the European market. Expatriate Americans came to value especially this aspect of the American experience. *Broom,* one of the short-lived expatriate magazines published in the twenties, lauded America's consumer products, advertisements, and billboards as unique expressions of American culture. *Broom*'s editor, Matthew Josephson, declared that "advertisements contain the fables of this people" and that poetry was to be found in the testimonials for canned soup and motor cars rather than in the rose garden.[71] Louis Lozowick, also in *Broom,* praised American-dominated advertising and typography as integral parts of modern expression.

Gerald Murphy, the exemplar of expatriate America, translated these ideas into sixteen paintings that rendered everyday American products in the flat, legible style of advertising. The scion of the Mark Cross fortune, Murphy had moved to Paris in the fall of 1921 and settled into a glamorous social life of hedonism and abandon with other expatriate Americans: the composer Cole Porter and the writers Archibald MacLeish, Ernest Hemingway, John Dos Passos, and F. Scott Fitzgerald; the latter based the character of Dick Diver in *Tender Is the Night* (1934) on Murphy. Enthralled by the art he saw in Paris, Murphy studied painting for a few months with Natalia Goncharova, an émigré Russian Constructivist. By 1924, he had created his first painting—a bold, hard-edged depiction of three American exports then being eagerly consumed by the French public: a Gillette safety razor, a Parker Duofold fountain pen, and a box of Three Stars matches (fig. 315). Stylistically, Murphy's smoothly painted, fastidiously demarcated forms set against a background structure of abstract shapes resembled Purist art, especially that of Fernand Léger. And, indeed, Murphy was a good friend of Léger's and had his first one-person

312. Sheet music cover for "Yes Sir! That's My Baby," composed by Gus Kahn and Walter Donaldson
New York: Irving Berlin, 1925
Music Division, The New York Public Library for the Performing Arts, Astor, Lenox and Tilden Foundations

313. Sheet music for "Ain't We Got Fun," composed by Richard Whiting, Raymond Egan, and Gus Kahn
New York: Jerome Remick & Co., 1921
Music Division, The New York Public Library for the Performing Arts, Astor, Lenox and Tilden Foundations

THE GOLDEN AGE OF TIN PAN ALLEY

The decade of the 1920s is sometimes called the golden age of Tin Pan Alley song, not only because the boom economy brought record profits to the music business but, more important, because so many twenties songs found a permanent place in the repertory.

Two veteran songwriters, Irving Berlin and Jerome Kern, and the younger Cole Porter, George Gershwin, and Richard Rodgers wrote many of these classic songs, but scores of other composers and lyricists turned out songs scarcely less excellent (figs. 312–14).

Tin Pan Alley had developed a highly efficient and profitable system for publishing songs in sheet music form and marketing them all over the country before World War I. Around 1920, publishers began to profit from sales of phonograph records, which approached and then surpassed those of sheet music; music could not be recorded without permission from the copyright holder (the publisher), who received a percentage of the sales of all "mechanical reproductions" of these songs. And after commercial radio began in the early 1920s, these publishers found ways to retain control over and benefit from the broadcast of their compositions. With the help of these new electronic media, Tin Pan Alley songs could be disseminated even more widely than before.

The music was still performed live as well—on the vaudeville stage, in restaurants, hotel dining rooms, cabarets, tea rooms, dance halls, and silent-film theaters, and at home by amateurs. Some songs were written for the stage, though only one musical comedy, Kern and Hammerstein's *Show Boat* (1927) achieved lasting success.

While still exhibiting some stylistic variety, popular songs of the 1920s moved closer to a common musical language. Harmonies became more complex and sophisticated, partly because some of the younger men, Gershwin and Porter, for instance, were trained in classical music, and partly because Berlin, Kern, and other older songwriters had always been innovative harmonists. Virtually all songs were now written in verse-chorus form, and as the decade waned the verse became shorter and then optional, leaving the thirty-two-bar chorus as the gist of the song. —C. H.

314. Sheet music cover for "I Wanna Be Loved by You," composed by Bert Kalmar, Herbert Stothart, and Harry Ruby
New York: T. B. Harms, 1928
Music Division, The New York Public Library for the Performing Arts, Astor, Lenox and Tilden Foundations

exhibition at the Bernheim-Jeune Gallery, where Léger and other Purists showed their work.

Yet Murphy's schematic rendering of objects and his magnification of them to colossal scale represented a unique union of the style of advertising with machine-made products. His close-up enlargements paralleled those in magazine advertisements and on billboards. The effect, as Léger noted, was similar to viewing an object on a movie screen.[72] Before 1929, when he abandoned painting for personal

MODERNIST POETRY—WILLIAMS AND STEVENS

By the 1920s, the term "modernism" covered a variety of innovative approaches to post-romantic poetry as writers sought new contexts and forms of expression. Ezra Pound's dictum "Make it new" often led to obscurity, but one of the paradoxes of the modernist movement is that some of its greatest poetry took as its subject the ordinary, the everyday, the common-place.

"No ideas but in things," wrote the poet William Carlos Williams. For him, a glimpse out of a window at a red wheel-barrow in the rain was enough to evoke a small masterpiece. Plums left out on a kitchen table, a road passing close to a hospital, a funeral, a cloud, a flower, the approach of winter—each became the ker-nel of a poem. For Williams, the discovery of the commonplace was the key that opened the world of his poetry. He is probably the only American poet who could write, in "K. McB.," of a woman he admired as "You exquisite chunk of mud . . . especially in April!"

More complex was the work of Williams' friend and fellow poet Wallace Stevens, whose imaginative journey took more complicated turns, but who began with the same ordinary objects and commonplace events. "Thirteen Ways of Looking at a Blackbird," one of Stevens' most remarkable poems, published in a 1923 collection, used an unre-markable blackbird as its point of departure. In the same collection, he self-consciously titled a poem describing two tubs of blue flowers "Banal Sojourn." The poem, despite its ordinary beginnings, was neither a sojourn nor banal. As he later wrote in "Esthé-tique du Mal," "The greatest poverty is not to live / In a physical world. . . ." —A. C.

315. **Gerald Murphy**
Razor, 1924
Oil on canvas, 32⅝ x
36½ in. (82.9 x 92.7 cm)
Dallas Museum of Art;
Foundation for the Arts
Collection, gift of the artist

reasons, Murphy created a handful of masterpieces, among them *Watch*, a totally flat, centralized series of techno-logical blueprints seen simultaneously, and *Cocktail*, a collage-like presentation of various objects, arranged frontally and in profile, from his parents' cocktail tray (figs. 316, 317). Although painted in Europe, they were, as he said of his life there, "all somehow an American experience."[73]

The same year Murphy began painting, Charles Demuth began a series of eight emblematic "posters" of American artists, which, like Murphy's paintings, were executed in a flat, bold style that replicated advertisements. For Demuth, as for Murphy, the decision to pay homage to America through a style viewed as sin-gularly American was an affirmation of his national identity. Demuth retained this poster style but applied it to a poem in *The Figure 5 in Gold*, one of his best-known works (fig. 318). Paying indirect tribute to the poem's author, William Carlos

316. **Gerald Murphy**
Watch, 1924–25
Oil on canvas, 78½ x 78⅞
in. (199.4 x 200.3 cm)
Dallas Museum of Art;
Foundation for the Arts
Collection, gift of the artist

317. **Gerald Murphy**
Cocktail, 1927
Oil on canvas, 29⅛₆ x 29⅞
in. (73.8 x 75.9 cm)
Whitney Museum of
American Art, New York;
Purchase, with funds from
Evelyn and Leonard A.
Lauder, Thomas H. Lee
and the Modern Painting
and Sculpture Committee
95.188

Williams, the painting visually rendered the scene Williams had memorialized in his poem "The Great Figure": the clanging and howling of a fire engine, emblazoned with a golden 5, on its way to a fire. Demuth's use of ray lines and receding images of the number 5 to convey the insistent forward movement of the fire truck encapsulated the speed and ruthless modernity that Europeans identified with America.

The union of the modern and the vernacular found expression as well in the work of Stuart Davis. Unlike Murphy and Demuth, Davis started his career as a realist, steeped in the ideology of art espoused by Robert Henri and the Ashcan artists. Davis felt the impact of Henri's ideas as a child: his father, Edward Wyatt Davis, was the art editor who had befriended and hired Henri's protégés as illustrators for the *Philadelphia Press;* Davis, as a sixteen-year-old, had quit high school and left home to study at Henri's art school in New York. For his first ten years as a painter, from 1910 to 1920, Davis was allied with Henri and Sloan, whom he considered mentors. Even after 1920, when the influence of the modern art he had seen in the Armory Show superseded his allegiance to realism, he retained a commitment to recording life around him. He would claim all his life that the originating impulse for his art was the contemporary American scene. "I paint what I see in America," he declared. "I paint the American scene."[74]

The America Davis saw was vastly different from that of Henri and Sloan. For him, what epitomized contemporary life were jazz, radio, movies, and consumer products. He first described this world in a series of paintings of Lucky Strike cigarette packages (fig. 319). Painted to resemble collages, these works applied the vocabulary of Synthetic Cubism to the world of product promotion and mass-produced packaging. Exuberant about having successfully encapsulated what he considered the American experience, Davis boasted that these paintings were "really original American work."[75] His quest for a nativist art was joined by an equally aggressive desire to

318. **Charles Demuth**
The Figure 5 in Gold,
1928
Oil on cardboard, 36 x
29¾ in. (91.4 x 75.6 cm)
The Metropolitan Museum
of Art, New York; Alfred
Stieglitz Collection, 1949

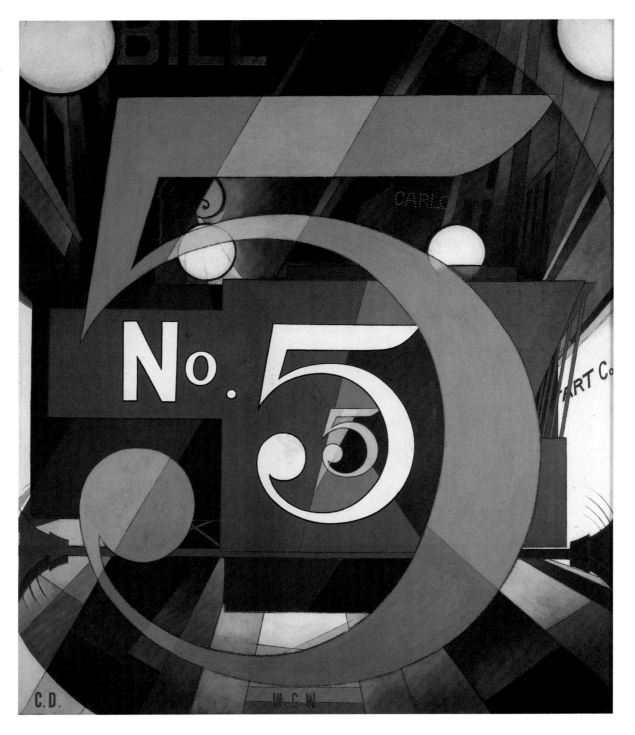

create a new type of pictorial space. This he did by suppressing the illusion of three-dimensional space through flattening and overlapping shapes. He continued this practice—with the addition of painted grids, stripes, dashes, and stippled dots to provide visual energy—in a group of still-life compositions of everyday household products (fig. 320). Such a bold, irreverent presentation of consumer products would not appear again in American art until the advent of Pop Art in the 1960s.

A similar approach guided Davis in his New York street scenes. As in his depictions of mass-produced objects, he reduced architectural subjects to geometric, boldly colored shapes. But now, instead of presenting them in overlaying planes, he concentrated on their recession, which allowed him to manipulate flat design while describing a specific locale (fig. 321). Like Demuth in his paintings of Lancaster, Pennsylvania, and Patrick Henry Bruce in his abstracted still-life arrangements (figs. 322, 325), Davis evoked three-dimensional space without forfeiting the two-dimensional pictorial plane. Bruce pushed isometric projection to an almost hallucinatory and unsettling degree by presenting his geometric solids from many conflicting vantage points while pictorially insisting that they share a common surface plane.

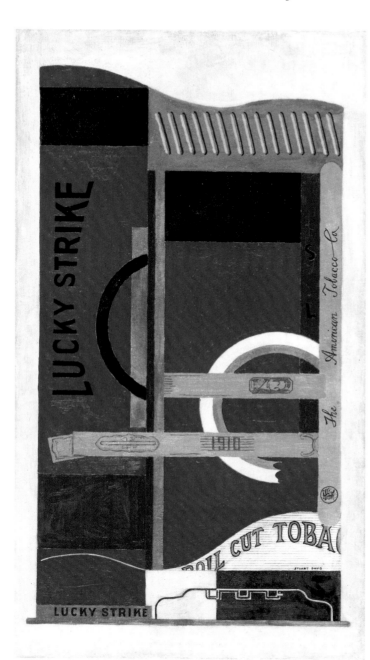

The fascination these painters felt for the graphic language of advertising was shared by photographers, most particularly by Ralph Steiner, who had participated in the "Machine Age Exposition" as exhibitor and member of the artists' board. In marked contrast to the documentary photographers of the 1930s who would record images of billboards, posters, and hand-painted signs in order to celebrate individuals and regional cultures outside the mainstream, Steiner was attracted to billboards because of their bold, geometric patterns and their association with commerce and consumption (figs. 323, 324). His respect for angular design and flat, abstract patterning had been nurtured by his study at the Clarence White School. Along with his fellow students Paul Outerbridge, Jr., and Anton Bruehl, he had been guided by White's associate, the painter Max Weber, to privilege structural principles over subject matter and to emphasize the spaces between objects as much as the objects themselves. This training made them ideally suited for employment in the growing world of commercial advertising photography, where refined, formal arrangements that balanced description and abstraction were highly prized (figs. 326–29). Although drawings by innovative commercial designers such as Raymond Loewy competed with photographic images for the public's attention throughout the twenties, photography's association with modernity, coupled with the public's faith in its veracity, ultimately led to the photographic domination of advertising.

The most famous and highly paid advertising photographer of the period was Edward Steichen, who had turned to advertising after the war. Under a lucrative contract with the J. Walter Thompson agency from 1923 to 1942, he was instrumental in shifting advertising photography from Pictorialism to sharp-focus representation. Citing "the meticulous detail, the biting precision" of straight photography, he

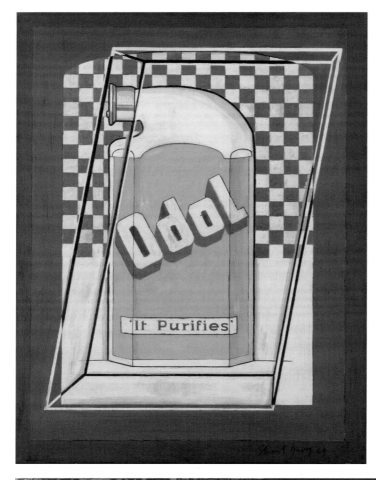

320. **Stuart Davis**
Odol, 1924
Oil on canvas board, 24 x
18 in. (61 x 45.6 cm)
The Museum of Modern
Art, New York; Purchase
©Estate of Stuart Davis/
V.A.G.A., N.Y.

321. **Stuart Davis**
House and Street, 1931
Oil on canvas, 26 x
42¼ in. (66 x 107.3 cm)
Whitney Museum of
American Art, New York;
Purchase 41.3
©Estate of Stuart Davis/
V.A.G.A., N.Y.

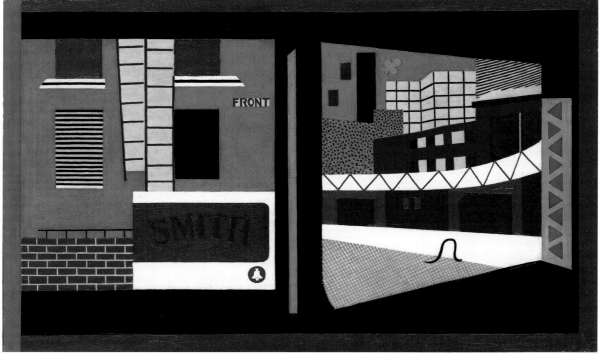

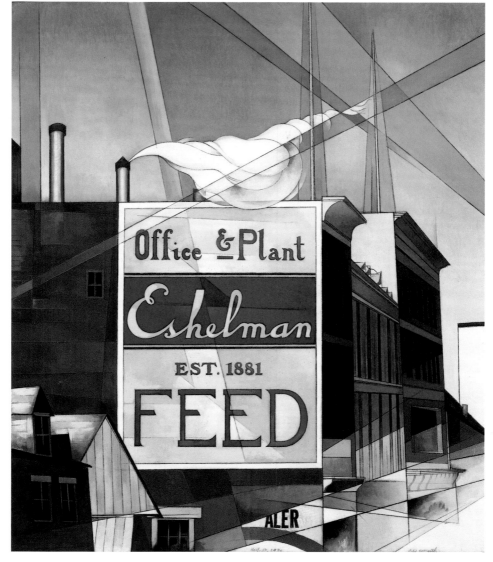

324. **Ralph Steiner**
Lollipop, 1922
Gelatin silver print, 4⅞ x
3⁵⁄₁₆ in. (12.4 x 10 cm)
Collection of Therese and
Murray Weiss

325. **Patrick Henry Bruce**
Painting, c. 1921–22
Oil on canvas, 35 x
45¾ in. (88.9 x 116.2 cm)
Whitney Museum of
American Art, New York;
Gift of an anonymous donor
54.20

326. **Ralph Steiner**
Typewriter Keys, 1921–22
Gelatin silver print, 8 x
6 in. (20.3 x 15.2 cm)
Collection of Naomi and
Walter Rosenblum

328. **Paul Outerbridge, Jr.**
Telephone, Study of Form,
1923
Platinum print, 4⅝ x
3¹¹⁄₁₆ in. (11.7 x 9.3 cm)
Library of Congress,
Washington, D.C.

327. **Anton Bruehl**
*Top Hats (Weber and
Heilbroner Advertisement),*
c. 1929
Gelatin silver print, 14 x
10⅞ in. (35.6 x 27.6 cm)
Center for Creative
Photography, University of
Arizona, Tucson

329. **Paul Outerbridge, Jr.**
*Advertisement for George
P. Ide Co.,* 1922
Platinum print, 4½ x
3⅜ in. (11.4 x 8.4 cm)
The Museum of Fine Arts,
Houston; Museum pur-
chase with funds provided
by Target Stores, Inc.

argued that its "conviction of truth and reality" made it the most potent advertising style (figs. 330, 331).[76] Unlike photographers who chafed at the restrictions of commercial photography, Steichen reveled in the challenge of working on a tight deadline to create images that were as compelling on the pages of mass-circulation magazines as on a gallery wall. This further separated him from Strand and Stieglitz, with their self-conscious precocity and animosity to commercial photography and mass reproduction.

The same year that Steichen began to work for J. Walter Thompson, he also replaced Baron Adolf de Meyer as the photographic editor in chief of Condé Nast's *Vogue* and *Vanity Fair*. Within a year, he had revolutionized fashion photography by supplanting the ornate, atmospheric backgrounds and romantic mood of Pictorialism with straight-edged, geometric patterns and strong contrasts of light and shadow (fig. 332). By eliminating backlighting and relying on simple, plain backgrounds, he achieved a polished and glamorous look that accorded with the self-reliant femininity of the new woman. The style would dominate fashion photography until the early 1940s, when it was replaced with the more informal, spontaneous, exuberant style promulgated by Alexey Brodovitch at *Harper's Bazaar*.

A wide range of fine-art photographers and artists followed Steichen into advertising and fashion. Among those who did, almost to the exclusion of painting, was Charles Sheeler. Sheeler had earned a living since his student days by photographing architecture and works of art for private collectors and galleries. After his principal patron, Marius de Zayas, went out of business in 1923, Sheeler was encouraged by Steichen to join the staff of Condé Nast. From 1923 to 1931, Sheeler focused his artistic energies almost entirely on producing fashion photographs and celebrity portraits for *Vogue* and *Vanity Fair* and product photographs for freelance advertising clients (figs. 333, 334). The most important of these clients was N. W. Ayer and Company, through whom he received the commission to document the Ford Motor Company's River Rouge plant. Not until 1932 would Sheeler leave Manhattan and give up advertising photography to resume painting.

330. **Edward Steichen**
Douglass Lighter, 1928
Gelatin silver print, 9⅟₁₆ x
7½ in. (24 x 19.1 cm)
George Eastman House,
Rochester, New York

331. **Edward Steichen**
*Matches and Matchboxes:
1926 Fabric Design for
Stehli Silks,* c. 1926
(printed later)
Gelatin silver print, 13½ x
10 in. (34.3 x 25.4 cm)
Hallmark Photographic
Collection, a project of
Hallmark Cards, Inc.,
Kansas City, Missouri

As demographics shifted from the farm to the city and America became, for the first time in its history, a nation of urban dwellers, artists consciously rejected the small town and its values. In literature, Edgar Lee Masters' *Spoon River Anthology* (1915), Sherwood Anderson's *Winesburg, Ohio* (1919), Sinclair Lewis' *Main Street* (1920), and Thomas Wolfe's *Look Homeward, Angel* (1929) depicted the American small town as a place of thwarted ambition, sexual frustration, and spiritual vacuity (fig. 335). This same mood of frustration and sullen endurance found expression in the work of Charles Burchfield following his move from Salem, Ohio, to Buffalo, New York, in 1921. An acknowledged admirer of Sherwood Anderson's writings, Burchfield, in his work of the 1920s and 1930s, elicited from the vernacular architecture of small-town America a mood of desolation and melancholy analogous to that which Lewis and Anderson documented in their fiction (fig. 336).

332. **Edward Steichen**
*Art Deco Gown,
Photographed in the
Apartment of Nina Price,*
1925
Gelatin silver print, 10 x
8 in. (25.4 x 20.3 cm)
The Condé Nast
Publications, Inc., New
York; courtesy *Vogue*

333. **Charles Sheeler**
L. C. Smith Typewriter,
1924–28
Gelatin silver print, 11¼ x
15⅞ in. (28.6 x 40.3 cm)
Museum of Fine Arts,
Boston; The Lane
Collection

334. **Charles Sheeler**
*Frances Hope Modeling a
Chanel Sheared Lambskin
Coat over Tweed Dress,
Holding Binoculars,* 1927
Gelatin silver print, 10 x
8 in. (25.4 x 20.3 cm)
The Condé Nast
Publications, Inc., New
York; courtesy *Vogue*

Artists like Burchfield, who sought to embody the American experience by portraying everyday life, were known collectively as American Scene painters. Many had studied with Robert Henri or John Sloan and had thoroughly assimilated their belief that realism was the rendering not simply of superficial details but of a whole attitude toward life and humanity. In the case of Henri's students Edward Hopper and Guy Pène du Bois, this meant loneliness and isolation. No painter described melancholy more poignantly or felt it more deeply than Hopper. The sadness that pervades his work derived from his sense of loss over values and a way of life that had been abandoned (figs. 337, 338). The past endures in Hopper's paintings, but without vitality or purpose. An ardent political conservative who would loathe Franklin D. Roosevelt and the New Deal, Hopper identified with an American past that had been rendered obsolete; his genius was to transform it into universal and timeless themes.

Hopper transmuted scenes and motifs from everyday life into epic statements about the human condition. He crystallized archetypal feelings and transcribed them with such clarity that they triggered in viewers latent or half-forgotten experiences and emotions. In the presence of Hopper's work, these dimly remembered sensations return as revelations—manifestations of Ralph Waldo Emerson's remark, often quoted by Hopper, "In every work of genius we recognize our own rejected thoughts; they come back to us with a certain alienated majesty."[77]

For Hopper, art was reality filtered through the artist's emotions and subconscious perceptions. In transcribing his intimate impressions of the world onto canvas, he used notes, recollections, and one primary model—his wife. What he portrayed was the unassailable condition of contemporary, urban life: loneliness, alienation, and the unbridgeable distances that separate people from their environment and from each other (figs. 339, 340).

Hopper responded intensely to theater and cinema, the two luxuries he allowed himself in an otherwise frugal existence. As his work developed, he increasingly

337. Edward Hopper
Railroad Sunset, 1929
Oil on canvas, 28¼ x
47¾ in. (71.8 x 121.3 cm)
Whitney Museum of
American Art, New York;
Josephine N. Hopper
Bequest 70.1170

338. Edward Hopper
Lighthouse Hill, 1927
Oil on canvas, 28¼ x
39½ in. (71.8 x 100.3 cm)
Dallas Museum of Art; Gift
of Mr. and Mrs. Maurice
Purnell

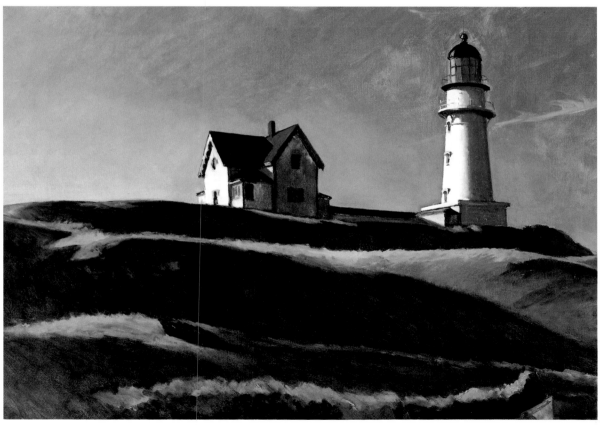

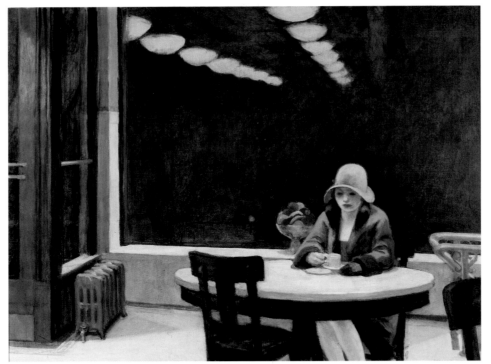

339. **Edward Hopper**
Automat, 1927
Oil on canvas, 28⅛ x
36 in. (71.5 x 91.5 cm)
Des Moines Art Center,
Iowa; Purchased with
funds from the Edmundson
Art Foundation, Inc.,
Des Moines Art Center
Permanent Collections

340. **Edward Hopper**
Chop Suey, 1929
Oil on canvas, 32 x 38 in.
(81.3 x 96.5 cm)
Collection of Mr. and Mrs.
Barney A. Ebsworth

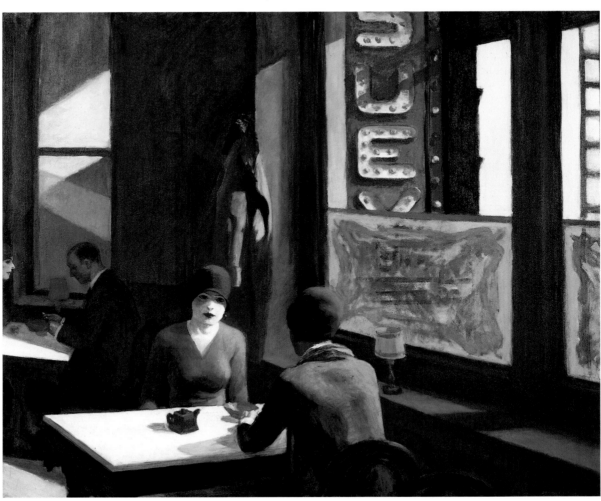

exploited the framing and lighting conventions of cinema, using light as a compositional element and purveyor of mood and cropping his scenes off-center. As a result, his canvases often register as a frozen moment in a cinematic sequence. The voyeuristic desire to know what comes next heightens the painting's psychological hold—and exacerbates awareness of the estrangement and isolation that has been fixed, forever, in time.

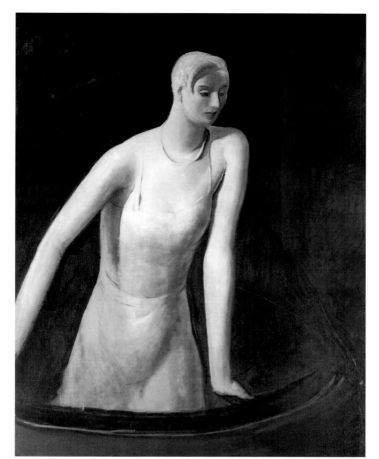

341. **Guy Pène du Bois**
Opera Box, 1926
Oil on canvas, 57½ x 45¼ in. (146.1 x 114.9 cm)
Whitney Museum of American Art, New York; Purchase 31.184

342. **Guy Pène du Bois**
Mr. and Mrs. Chester Dale Dine Out, 1924
Oil on canvas, 30 x 40 in. (76.2 x 100.6 cm)
The Metropolitan Museum of Art, New York; Gift of Chester Dale, 1963

Guy Pène du Bois shared with Edward Hopper a narrative of inaction, which he achieved by depicting frozen moments of stillness that precede incident. The son of a music critic, he spent his early years in Paris. Forced back to America in 1906 by his father's illness, he participated in the Armory Show as an art critic and member of the publicity committee. Eighteen years after leaving, he returned to Paris, where he worked as a painter and critic until the stock market crash again forced his repatriation. Even while in Europe, however, he painted American subjects: the sophisticated American urbanite, the flapper, the American abroad (figs. 341, 342). Fascinated by the world of privilege, du Bois documented the decadent complacency and self-imposed isolation of cosmopolitan men and women within the public arena. By treating figures and the space around them with equivalent solidity and inertia, he created an impassive immobility that answered his desire for order and harmony. Purged of anecdotal detail, his compositions strike a balance between the idealized forms of abstraction and the particularities of realism.

The monumental, tubular figures and smoothly brushed forms in du Bois' work were shared in the twenties by other realists who likewise treated the human figure as volumetric and stylized. George Bellows, in his 1924 boxing picture of Jack Dempsey and Luis Angel Firpo, abandoned the raw physicality of paint and boxers that he had stressed earlier (fig. 174) in favor of smoothly painted, generalized forms (figs. 343). So too Thomas Hart Benton, whose works in the 1920s used the muscular, rounded forms of Michelangelo to describe vernacular scenes of everyday life (fig. 344).

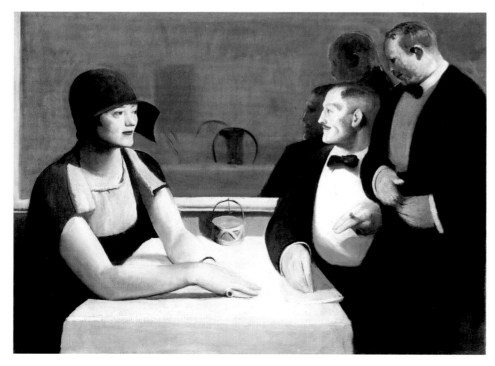

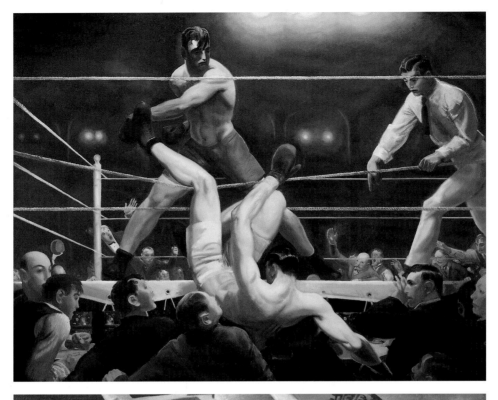

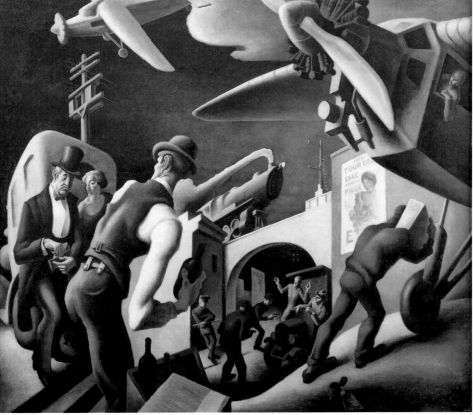

JAZZ

In the annals of American popular culture, the 1920s are the Jazz Age—a sobriquet that calls to mind a curious mixture of youthful rebellion, libidinal energy, and offhand cynicism set to a syncopated musical sound track. Yet the cultural and aesthetic meanings of the new idiom, jazz, were by no means clear-cut. For its critics, it was chief among the poisonous manifestations of modernity; for its admirers, it held the heady suggestion of new social freedoms; and for African Americans, it offered economic opportunity and a new arena for the expression of cultural identity.

Jazz had emerged early in the century in New Orleans as an ingenious synthesis of black rural folk traditions and urban dance entertainment. By the 1920s, the New Orleans natives Joe "King" Oliver, Sidney Bechet, and Louis Armstrong followed the Great Migration to the North, establishing their reputations as improvising virtuosos in Harlem and on Chicago's South Side through their penchant for pungent timbres and hard-swinging rhythms (fig. 345). Much of this musical energy remained within the bounds of the black community. Recording companies had discovered in the new urban black enclaves a ready market for what they termed "race records"—a series of recordings targeted specifically at the tastes of a transplanted minority. Transplanted African American consumers, homesick for the South, could savor the down-home blues of rural performers like Blind Lemon Jefferson and Charley Patton, or veterans of black vaudeville like Bessie Smith (fig. 346) and Ma Rainey; or they could explore the possibilities of a new urban identity through the jazz created in New York and Chicago by Armstrong and others.

Jazz first entered the white-dominated commercial mainstream as part of the revolution in social dance that swept the country in the first decades of the century. By the 1920s, as dancing in commercial venues acquired respectability, ballrooms like the Roseland in New York opened their doors to middle-class couples eager to try out the latest steps. Dances such as the Charleston, and the highly syncopated music that accompanied it, bore the clear imprint of black culture—an obvious factor in the wave of indignant disapproval that marked jazz as a source of controversy.

In fact, many of the musicians who rose to prominence in the early phase of the dancing boom, among them the bandleader and impresario James Reese Europe, were African American (fig. 348). Europe's campaign to demonstrate the special qualifications of African Americans to play the new musical styles culminated in several highly publicized concerts at Carnegie Hall and helped establish dance music as one of the few skilled fields open to black talent. Still, white Americans tended to throw the spotlight on musicians of their own race. New York heard its first jazz from the all-white

345. *Louis Armstrong,* 1944

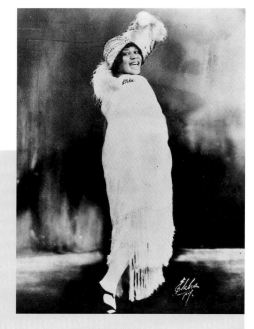

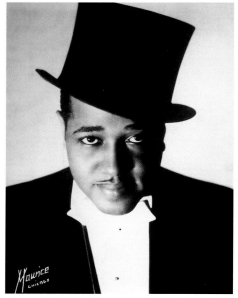

Original Dixieland Jazz Band, while "the King of Jazz" in the 1920s was the portly, Denver-born violinist Paul Whiteman, best known today for having commissioned George Gershwin's genre-stretching composition *Rhapsody in Blue* in 1924.

Jazz was, of course, integral to the Harlem Renaissance—even if as "mere" dance music it lacked the official cachet of literature, painting, and art music composition. White aficionados of black culture flocked to Harlem nightspots such as the Cotton Club, which opened for business on Lenox Avenue in 1922. As its very name suggests, the Cotton Club offered an idea of blackness that was filtered through hackneyed plantation images from the nineteenth-century minstrel show. But the elaborate floor shows, catering to a twentieth-century preference for frank expressions of sexuality, relocated the landscape to a sensual, imaginary Africa. A key element was the imaginative and evocative music of the house band, led by Edward Kennedy "Duke" Ellington. By decade's end, Ellington had forged a new public image for African American music, both sophisticated and down-to-earth (fig. 347). —S. D.

348. *The James Reese Europe Orchestra,* 1914

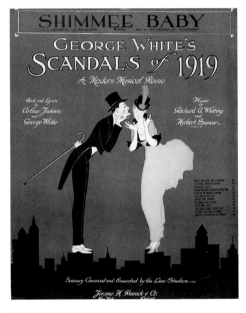

349. Sheet music for "I'm Just Wild about Harry," from *Shuffle Along,* by Noble Sissle and Eubie Blake
New York: M. Witmark and Sons, 1921
Music Division, The New York Public Library for the Performing Arts, Astor, Lenox and Tilden Foundations

350. Sheet music for "Shimmee Baby," composed by Arthur Jackson, from *George White's Scandals of 1919*
New York: Jerome Remick, 1919
Music Division, The New York Public Library for the Performing Arts, Astor, Lenox and Tilden Foundations

BLACK AND WHITE POPULAR MUSIC IN THE JAZZ AGE

Shortly after World War I ended, Prohibition became the law (but not the practice) of the land, producing bathtub gin, bootlegging, and thousands of nightclubs called speakeasies, many of which provided musical entertainment. Here gangsters, performers, and socialites found themselves in unprecedentedly close quarters. Harlem became the "Nightclub Capital of the World," and white New Yorkers flocked to the Cotton Club, featuring the suave, smooth, and inspired Duke Ellington orchestra, and to Connie's Inn, where the ebullient stride pianist Fats Waller rewrote musical history.

White patronage of black jazz clubs might be slumming, but slumming was becoming an elite art. The brash, brilliant George Gershwin and the author and photographer Carl Van Vechten were frequent guests at Harlem's parties and clubs, and Europe's foremost composers and musicians visited as well. Abroad, jazz was considered "the classical American music." The term "jazz" was used loosely in the 1920s to encompass everything from Tin Pan Alley pop to the music of Eubie Blake, Louis Armstrong, and Ellington, but it always meant a loosened beat and black sources, acknowledged or otherwise. Various American women's groups and magazines lobbied against jazz as a "voodoo" art, but America in the 1920s was still a cultural parvenu, acutely sensitive to European taste and approval. When Ellington made his first trip to Europe, he was amazed to discover that he was better known there than at home. The European belief that America's greatest contribution to the world's culture lay in its black popular music would open minds, and doors, at home.

The 1921 premiere of the all-black revue *Shuffle Along*, with music by Noble Sissle and Eubie Blake, was a mainstream triumph (fig. 349). The blues had originated in the Deep South in the decades after the Civil War, but gained widespread attention in 1921 when the Harlem cabaret artist Mamie Smith cut "Crazy Blues" for Okeh records and found herself with a hit. Columbia Records signed Bessie Smith in 1923; by 1928, she had recorded 180 songs for the label. Over the next five years, Gershwin, Jerome Kern, Richard Rodgers and Lorenz Hart, Dorothy Fields and Jimmy McHugh,

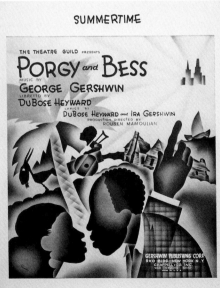

351. Window card for Marc Connelly, *The Green Pastures,* Broadway Theatre, New York, 1930
Billy Rose Theatre Collection, The New York Public Library for the Performing Arts, Astor, Lenox and Tilden Foundations

352. Sheet music cover for "Summertime," from *Porgy and Bess,* by George Gershwin and DuBose Heyward
New York: George Gershwin Publishing Corp., 1935
Music Division, The New York Public Library for the Performing Arts, Astor, Lenox and Tilden Foundations

HARLEM RENAISSANCE

The search for American cultural identity that engulfed the nation in the 1920s had its counterpart in the African American community. The Harlem Renaissance, as it was called, occurred against the backdrop of a massive migration to the North of African Americans seeking jobs in Northern industry during and after World War I, when immigration restriction curtailed the influx of foreign labor. The concentration of African Americans in cities like New York and Chicago engendered a new sense of power, opportunity, and desire for self-determination.

This rise in ethnic consciousness did not, however, temper the period's extreme racial violence, which postwar employment competition had fueled. What became the Harlem Renaissance began as an attempt to cultivate racial tolerance by promoting the cultural accomplishments of African Americans. Already in the teens, African American music and dance had been important elements in the construction of American cultural identity. After the war, they became synonymous with it, as jazz and the Charleston pervaded every home and dance floor in America. Beginning in 1921 with *Shuffle Along* (fig. 349), the first musical revue written and performed by African Americans, black performers became widely popular on Broadway and in Harlem and in Chicago's South Side nightclubs. Audiences at New York cabarets like the Cotton Club and Connie's Inn were still exclusively white and plays about African American life—like *Porgy* (1927) and *Green Pastures* (1930)—were still written by whites for white audiences. But far more African American performing artists were being granted cultural positions of respect than ever before (figs. 351, 352).

Alain Locke was the guiding spirit of the Harlem Renaissance, along with his colleague Charles Johnson, editor of the Urban League's newly founded magazine, *Opportunity*. Their dream of a new generation of ethnically proud African American artists was enshrined at a dinner they held in Harlem in March 1924 to introduce the white publishing world to new African American talent. The evening's guest speaker was W. E. B. Du Bois, whose 1903 book *The Souls of Black Folk* had helped launch the crusade for African Americans' political and social rights. Du Bois remained the leading intellectual spokesperson in the African American community throughout the twenties, thanks to his editorship of *The Crisis*, the journal of the NAACP that he had helped found in 1910. But it was Locke, the master of ceremonies at the Harlem dinner, who shepherded what was then called the New Negro movement—a movement based on the belief that racial advancement depended on the recognition of African American aesthetic contributions, rather than on political or economic action.

and other Tin Pan Alley composers put out two hundred songs with "Blues" in the title.

The success of the blues alerted the recording and radio industries not only to white interest in black music but to the unsuspected dimensions of the black market. Columbia had gone into receivership just months before Bessie Smith made her first record, but "Down-Hearted Blues" sold 780,000 copies in its first year and almost single-handedly recouped Columbia's fortunes. All the big record companies put out "race" records; by the mid-1920s, their retail sales were ten times the 1909 figure. Although no black had a major network radio show until ABC sponsored Fats Waller's "Rhythm Club" in the early 1930s, and although recording sessions were segregated, Okeh put out a record of the hits from *Shuffle Along*; by 1930, over two hundred black women vocalists had been signed by record companies, and, starting in 1927, Duke Ellington's music was broadcast live from the Cotton Club.

The new media had met black music, and the conjunction proved historic for both parties. White musicologists had long despaired of capturing the complex slides, slurs, and blues notes of black music in Western modes of transcription, but with radio and records, black music could simply be reproduced and transmitted. Once the new sound media made black music available, millions of people in America and Europe could discover for themselves that black music was not just an African American sound. As the black journalist J. A. Rogers put it in 1925, "Jazz has absorbed the national spirit, the tremendous spirit of go and nervousness, lack of conventionality and boisterous good nature characteristic of the American, white or black." The music expressed, in James Weldon Johnson's words, "not only the soul of [the black] race, but the soul of America." —A. D.

353. **Winold Reiss**
Cover of *Survey Graphic*,
March 1925
The Estate of Winold
Reiss, courtesy Shepherd
Gallery, New York

354. *Home to Harlem,* by
Claude McKay, cover art by
Aaron Douglas
New York: Harper &
Brothers, 1928
Yale Collection of American
Literature, Beinecke Rare
Book and Manuscript
Library, Yale University,
New Haven

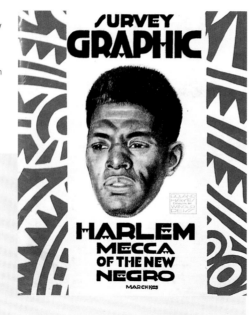

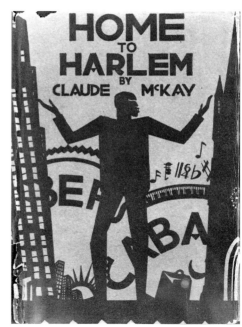

LITERATURE OF THE HARLEM RENAISSANCE

As the 1920s began, few people in Europe—or the United States, for that matter—studied the work of American authors. Far fewer people even knew that there was such a thing as African American literature. By 1914, only a handful of black writers, headed by W. E. B. Du Bois, James Weldon Johnson, Paul Laurence Dunbar, and Charles Chesnutt, had achieved anything resembling national visibility. By the 1930s, the Harlem Renaissance, based in Manhattan, the first self-conscious black literary movement in U.S. history, had produced twenty-six novels, ten volumes of poetry, five Broadway plays, and a flood of stories and essays.

The Harlem Renaissance was the product of the migration between 1910 and 1930 of several million Southern blacks eager to find jobs in big-city Northern and Midwestern industry. In 1890, one in seventy people in Manhattan was a Negro; in 1930, one in nine. James Weldon Johnson thought that New York attracted the more artistically inclined migrants because, in the teens and twenties, it was becoming the national headquarters not of American industry but of the nation's popular arts. A predicted real estate boom that failed to materialize left landlords in upper Manhattan hungry for tenants; though charged exorbitant rents, blacks moved in, founding what Johnson called "Black Manhattan" and the writer Alain Locke described as a "race capital."

Two distinct generations of black artists were at work in the Harlem Renaissance: the older, more traditionally minded group led by Du Bois and Johnson, and a younger, less overtly political group that included Langston Hughes, Countee Cullen, Jean Toomer, Nella Larsen, Claude McKay, Zora Neale Hurston, and Wallace Thurman. Like their white peers, the younger writers, some of whom collaborated on a short-lived magazine called *Fire!*, liked to shock their elders by their personal and literary daring. Hughes, Cullen, McKay, and Thurman were all gay, though none was altogether out of the closet; few of them entered stable marriages or partnerships, and even fewer had children. They audaciously proclaimed themselves, in the words of Langston Hughes, "black like that old mule, / Black, and don't give a damn!"

Whatever their differences, the younger and older leaders of the Harlem Renaissance agreed on the fundamentals of their project. All of them believed that establishing black artistic credentials would further economic and political civil rights. As Johnson put it, "A people that has produced great art and literature has never been looked upon as distinctly inferior." Although the Harlem Renaissance is sometimes faulted today for its prioritizing of artistic achievement, it was an important and necessary experiment, one that African Americans had never before had the cultural access and clout to make.

The writing of the Harlem Renaissance was both race-proud and integrationist. Johnson sometimes used the term "Aframerican" to describe black Americans; the

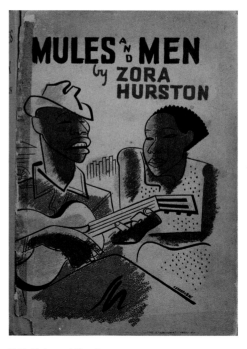

355. *Mules and Men,* by
Zora Neale Hurston, cover
art by Miguel Covarrubias
Philadelphia: J. B.
Lippincott, 1935
Fales Library/Special
Collections, New York
University

The New Negro movement, or Negro Renaissance, was officially launched in 1925 with two publications. The first was a direct result of the Harlem dinner: a special edition in March of *Survey Graphic* devoted to African American artists and entitled "Harlem: Mecca of the New Negro" (fig. 353). Guided by Locke, the magazine's editors situated Harlem at the center of the new African American renaissance. Although other cities could boast large African American communities, the identification of Harlem as the "race capital" of black America was not inappropriate.

Not only did Harlem contain more African Americans per square mile than any other place on earth, it represented the largest concentration of African American artistic and intellectual talent to be found anywhere. *Survey Graphic*'s choice of a single locale as representative of a more widespread reality echoed its strategy in 1910, when the editors selected Pittsburgh as the quintessential industrial city. Unlike Pittsburgh, however, Harlem was more than a place: it functioned as a "state of mind," a symbol of the promise and hopes of black America.[78]

The second publication that launched the Harlem Renaissance was a hardcover anthology of prose and

obliteration of even the possibility of a hyphen signaled a bold claim that blacks were not newcomers or immigrants, not "foundlings," in Locke's phrase, but "conscious . . . collaborators" in the creation of America. In a pioneering series of books and articles, the historians Carter G. Woodson, who inaugurated "Negro History Week" in 1926, and Arthur A. Schomburg, who amassed the treasure trove of material now housed in New York's Schomburg Center, revealed just how extensive the black contribution had been.

James Weldon Johnson, author of *God's Trombones* (fig. 369), published a pathbreaking anthology, *The Book of American Negro Poetry* (1922), some of whose selections dated from the eighteenth century. Zora Neale Hurston, a trained anthropologist as well as a novelist, explored black Southern folklore in *Mules and Men* (1935; fig. 355). Countee Cullen dramatized the legacy of black religion in his masterpiece, *The Black Christ and Other Poems* (1929). Yet Cullen also declared his passionate allegiance to John Keats, and Claude McKay, Wallace Thurman, and Nella Larsen riffed on T. S. Eliot's *The Waste Land* in their own work. Writing, as the critic William Stanley Braithwaite urged them to do, as if no "white man ever attempted to dissect the soul of the Negro," did not mean renouncing white influences. Why should they be any less interested in white art than whites were in black?

Personal ties between black and white writers were sometimes close. Jean Toomer, writing his lyrical outburst of a novel, *Cane* (1923), told a friend, the white novelist Waldo Frank, "I cannot think of myself as being separated from you in the dual task of creating an American literature"; Toomer also found inspiration in the poetry of another white friend, Hart Crane. Yet the black writers did not see themselves as part of the much publicized "Lost Generation," the major white literary movement of the day. In Wallace Thurman's brilliant, often bleak novel *Infants of the Spring* (1932), a *roman à clef* of the Harlem Renaissance, a young white man, fearing an "eclipse" of his own literary powers, nonetheless believes that his black friend, a writer who is the novel's hero, has "something to fight and contend for," a "new store of energy" to tap. If the characteristic note of the Lost Generation was a highly stylized, exultant despair, the spirit of the Harlem Renaissance was one of complex, shaded, many-faceted celebration. The African American writers had been not lost but found, and in that hard-won moment of expression and recognition, American culture was changed forever. —A. D.

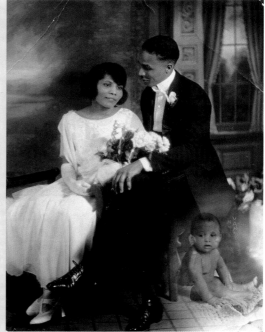

356. **Winold Reiss**
Title page of *The New Negro: An Interpretation*, edited by Alain Locke
New York: Albert and Charles Boni, 1925
The Schomburg Center for Research in Black Culture, The New York Public Library, Astor, Lenox and Tilden Foundations

357. **James VanDerZee**
Wedding Day, 1925
Gelatin silver print, 8 x 6 in. (20.3 x 15.2 cm)
Collection of Donna M. VanDerZee; courtesy Howard Greenberg Gallery, New York

poetry, *The New Negro: An Interpretation* (1925; fig. 356), which Locke assembled several months after *Survey Graphic*'s Harlem issue. In his contributing essays, Locke urged African American artists to acknowledge their African heritage and draw upon African art for inspiration. Locke was not alone in proposing Africa as a symbol of pride and accomplishment for black Americans. The most flamboyant spokesperson was Marcus Garvey, the leader of the Universal Negro Improvement Association (UNIA), whose mission to raise money to send black Americans back to Africa ultimately landed him in prison for mail fraud. Garvey's militant separatism was distasteful to Locke, but his celebration of Africa appealed to countless artists, among them James VanDerZee, the most successful of Harlem's commercial photographers, who functioned as the official recorder of UNIA (fig. 357).

When *The New Negro* and *Survey Graphic*'s Harlem issue were published, literature, music, and photography were vocational options for African Americans—

358. **Unknown**
Three Members of the Northeasterners Inc. Strolling on Seventh Avenue in Harlem, 1927
Gelatin silver print, 9¼ x 7 in. (23.5 x 17.8 cm)
Photographs and Prints Division, The Schomburg Center for Research in Black Culture, The New York Public Library, Astor, Lenox and Tilden Foundations

359. **James VanDerZee**
Couple in Raccoon Coats, 1932
Gelatin silver print, 8 x 10 in. (20.3 x 25.4 cm)
CNF Transportation Inc., Palo Alto, California

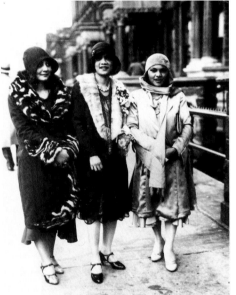

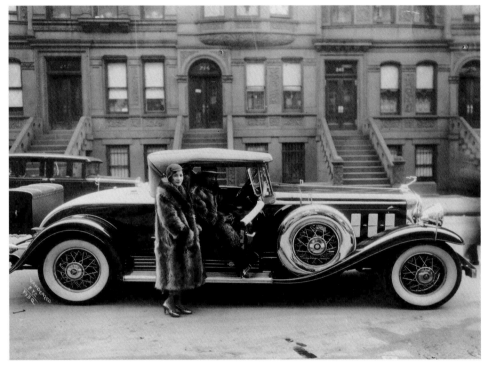

360. **James VanDerZee**
Marcus Garvey in a Regalia, 1924
Gelatin silver print, 5¹⁵⁄₁₆ x 10 in. (15.2 x 25.6 cm)
Collection of Donna M. VanDerZee; courtesy Howard Greenberg Gallery, New York

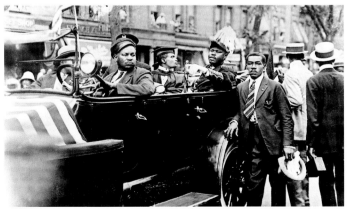

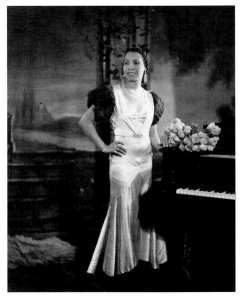

361. **James VanDerZee**
Satin and Fur, 1932
Gelatin silver print, 10 x 8 in. (25.4 x 20.3 cm)
Collection of Donna M. VanDerZee; courtesy Howard Greenberg Gallery, New York

362. Winold Reiss
Portrait of Langston Hughes, c. 1925
Pastel on board, 30¹⁄₁₆ x 21⅝ in. (76.3 x 54.9 cm)
National Portrait Gallery, Smithsonian Institution, Washington, D.C.; Gift of W. Tjark Reiss in memory of his father, Winold Reiss

363. Miguel Covarrubias
The Lindy Hop, 1936–37
Lithograph, 13 x 9½ in. (33 x 24.1 cm)
Collection of Leonard and Syril Rubin

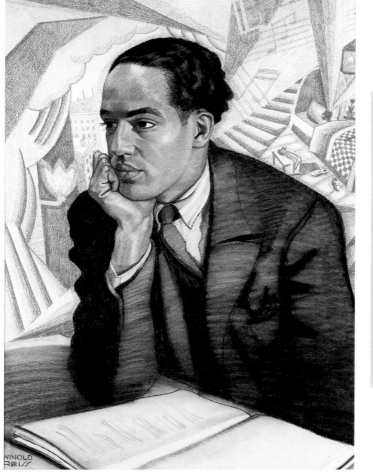

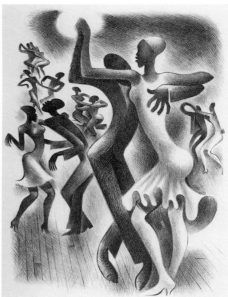

but not painting and sculpture. The burgeoning African American middle class had given rise to a generation of African American photographers—VanDerZee and Prentice Hall Polk among them—who recorded the social fabric of their communities and helped convey the image of urban black America as prosperous and glamorous (figs. 357–61). Painters and illustrators were far more rare, with the result that the earliest graphic artists to depict contemporary African American life were foreigners: the German-born Winold Reiss (fig. 362) and the Mexican-born caricaturist Miguel Covarrubias (fig. 363). The one exception was Aaron Douglas, who made his Harlem debut with the between-chapter illustrations for *The New Negro*. The most sought-after graphic artist in the African American community, he designed covers for the magazines *Opportunity* and *The Crisis*, and book jackets for almost every major African American writer of the period: Langston Hughes, James Weldon Johnson, Claude McKay, Countee Cullen, and Jean Toomer (figs. 354, 364, 366, 367, 369). Douglas' work used Art Deco stylization, Cubist-inspired rays of transparent light, and the silhouetted, bold forms of Egyptian art to portray subjects related to African American history and life.

Other African American artists laid an even more direct claim to the African sculptural tradition. Meta Warrick Fuller, who had worked in Paris under Auguste Rodin prior to 1905, created a memorial to the newly awakened consciousness of ancestral roots within the African diaspora in her sculpture *The Awakening of Ethiopia* (fig. 368). Likewise, Augusta Savage and Nancy Elizabeth Prophet enlisted African subjects in order to generate racial pride and race consciousness (fig. 365).

364. **Aaron Douglas**
Cover of *Opportunity*,
February 1926
Yale Collection of American
Literature, Beinecke Rare
Book and Manuscript
Library, New Haven

365. **Nancy Elizabeth Prophet**
Congolais, 1931
Wood, 17⅛ x 6¾ x 8⅟₁₆ in.
(43.5 x 17.1 x 20.5 cm)
Whitney Museum of
American Art, New York;
Purchase 32.83

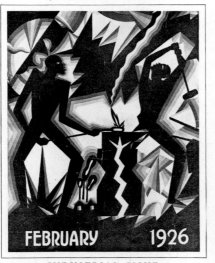

OPPORTUNITY
JOURNAL OF NEGRO LIFE

FEBRUARY 1926

INDUSTRIAL ISSUE

366. **Aaron Douglas**
Cover of *The Crisis*,
May 1928
The Schomburg Center for
Research in Black Culture,
The New York Public
Library, Astor, Lenox and
Tilden Foundations

367. *The Weary Blues*, by
Langston Hughes, cover art
by Miguel Covarrubias
New York: Alfred A. Knopf,
1947 (facsimile of original
1926 edition)
Fales Library/Special
Collections, New York
University

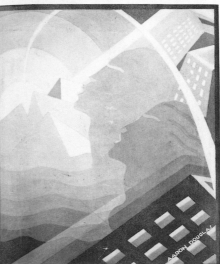

THE CRISIS

MAY, 1928 15 Cents a Copy

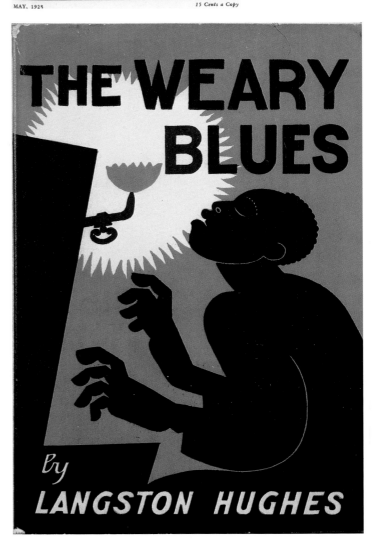

THE WEARY BLUES
By LANGSTON HUGHES

368. **Meta Warrick Fuller**
The Awakening of Ethiopia, c. 1914
Bronze, 67 x 16 x 20 in. (170.2 x 40.6 x 50.8 cm)
Art and Artifacts Division, The Schomburg Center for Research in Black Culture, The New York Public Library, Astor, Lenox and Tilden Foundations

369. *God's Trombones: Seven Negro Sermons in Verse,* by James Weldon Johnson, illustrated by Aaron Douglas
New York: Viking Press, 1927
Berg Collection of English and American Literature, The New York Public Library, Astor, Lenox and Tilden Foundations

370. **Augusta Savage**
Lift Every Voice and Sing, New York World's Fair, 1939
Plaster with black paint, 192 in. (487.7 cm) height
Destroyed, c. 1940

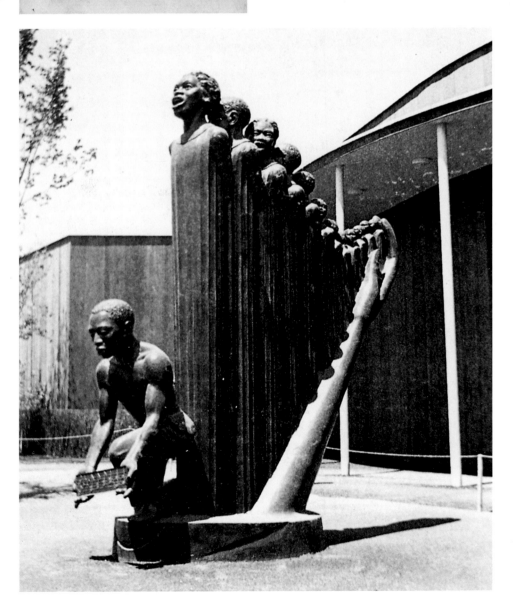

Savage, whose portrait bust of a Harlem youth had won her a scholarship to study abroad from 1929 to 1932, was one of the first artists to consistently treat black physiognomy (fig. 371). Her output was small, for she taught full-time at the Savage School of Arts and Crafts in Harlem; after 1937, she directed the Harlem Community Art Center. Her largest and most public sculpture was *Lift Every Voice and Sing,* the sixteen-foot-high memorial to the African American contributions to American music (fig. 370), which she created for the 1939 New York World's Fair. Taking her theme from the lyrics of James Weldon Johnson's poem of that title, Savage paid tribute not only to Negro spirituals and hymns but to the pride and faith of a new generation of African Americans. The sculpture, cast in plaster and finished to resemble black basalt, was demolished after the fair closed, along with most of the fair's buildings. It survives only in photographs and in the many metal replicas sold at the fair as souvenirs.

It was a widely held presumption in the twenties that the African American sensibility differed from that of white America. The attempt to define this sensibility, or "spiritual soul," led to considerations of African Americans as mystical, exotic, and spontaneous—as epitomizing a degree of freedom, expressiveness, and sensuality that had been lost in white culture. Such conceits were central to the novels of Jean Toomer, Claude McKay, and Countee Cullen, to the myth of John Henry, and, most explicitly, to the career of Josephine Baker (fig. 372). Even the academic, figurative sculptures of Richmond Barthé, who claimed that he was simply portraying the rhythm and spontaneous imagination endemic to his "people," were charged with an expressive sexuality that observers now link with the era's proclivity for primitivizing African Americans (fig. 373).

White patronage and white support of African American art more often than not drew upon similar assumptions. Eugene O'Neill's *Emperor Jones* (1920) and Carl Van Vechten's *Nigger Heaven* (1926) represented the most abrasive examples of such postulations, but the concepts underlying these works were shared by white philanthropists such as Albert Barnes, who collected African art because he believed it mirrored primitive natures, unburdened by education, and Charlotte Mason, the Park Avenue patron from whom Langston Hughes ultimately parted because she wanted him to write about mystical, mysterious experiences associated with the "Dark Continent." One of the few white philanthropic agencies free of such taint was the Harmon Foundation, which served between 1926 and 1935 as the primary patron for African American visual artists through its annual prizes and traveling

exhibitions, which introduced the work of African American artists to a national audience.

Not all African Americans agreed that their spiritual essence could be found by returning to African roots. As Langston Hughes asserted when he broke from Charlotte Mason, "I was only an American Negro—who loved the surface of Africa and the rhythms of Africa—but I was not Africa. I was Chicago and Kansas City and Broadway and Harlem."[79] Augusta Savage echoed a similar sentiment in rejecting Locke's directive that African American artists study the ancestral arts of Africa: "For the last 300 years [African Americans] have had the same cultural background, the same system, the same standard of beauty as white Americans. . . . It is impossible to go back to primitive art for our models."[80] Savage's ultimate rejection of the strategies of the Harlem Renaissance leadership was so intense as to generate later speculation that she was the one who arranged the theft of her portrait bust of W. E. B. Du Bois from the Harlem branch of the New York Public Library.

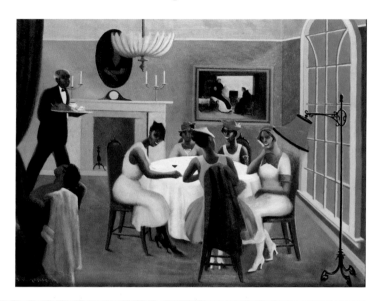

374. **Archibald Motley, Jr.**
Cocktails, c. 1926
Oil on canvas, 32 x 40 in.
(81.3 x 101.6 cm)
Collection of Mr. John P. Axelrod; courtesy Michael Rosenfeld Gallery, New York

375. **Archibald Motley, Jr.**
Blues, 1929
Oil on canvas, 36 x 42 in.
(91.4 x 106.7 cm)
Collection of Archie Motley and Valerie Gerrard Browne

The Chicago painter Archibald Motley, Jr., likewise shunned the Harlem Renaissance leaders because he felt that their assessment of what constituted an African American was doctrinaire and that they denied their unique American heritage in favor of a vague myth to which they had little connection. Far from being antidotes to modernity, the African Americans whom Motley depicted were urban, progressive, and young. His paintings, which often featured people of mixed racial ancestry, presented a far more complex picture of African Americans and their experience—one that accorded with the speed, restlessness, and dynamism of modern life (figs. 374, 375).

The stock market crash in 1929 brought an abrupt end to the optimism and promise of the Harlem Renaissance. The sordid socioeconomic realities that had existed all along became unbearably evident as white culture turned its energies in other directions. "We were no longer in vogue, anyway, we Negroes," Hughes remarked. "Sophisticated New Yorkers turned to Noël Coward."[81] The passage of the Twenty-first Amendment in 1933, which repealed Prohibition, severely diminished white patronage of Harlem's nightclubs and cabarets, as well as the sense of rebirth in Harlem's literary and artistic community. Even Alain Locke acknowledged that "the rosy enthusiasm and hopes of 1925" had been "cruelly deceptive mirages."[82]

ABSTRACT NATURE PAINTING AND PHOTOGRAPHY

Even though the number of artists working abstractly in the twenties diminished, American abstraction flourished as those who continued to pursue a course outside realism developed mature and powerful personal styles. Support for their efforts came from the new patrons and galleries that had emerged after the Armory Show and from Katherine Dreier's Société Anonyme, established in 1920 by Dreier, Marcel Duchamp, and Man Ray to sponsor exhibitions, lectures, and symposia on modern art. Alfred Stieglitz, in contrast, remained relatively inactive as a dealer after the close of 291 in 1917, save for three exhibitions of his own work and that of Georgia O'Keeffe that he mounted at the Anderson Galleries. In March 1925, he came out of retirement with a group show entitled "Seven Americans." Nine months later, he opened a new gallery, The Intimate Gallery, to support the work of American artists he deemed to be committed to America and the creation of a national culture. The Gallery—or Room, as it was called— was located in a small corner space, twenty-six by twenty feet, in the Anderson Galleries Building on the corner of Park Avenue and 57th Street. Unlike 291, which had been international and expansive in scope, The Intimate Gallery was exclusively American and focused on only seven artists: John Marin, O'Keeffe, Arthur Dove, Marsden Hartley, Paul Strand, Stieglitz, and "X"—an open slot occupied intermittently by Gaston Lachaise, Oscar Bluemner, Peggy Bacon, Francis Picabia, and Charles Demuth, who all received one-artist exhibitions at the gallery during its four-year existence.

376. **Alfred Stieglitz**
Equivalent, 1926
Gelatin silver print, 4¾ x
3¾ in. (11.6 x 9.2 cm)
National Gallery of Art,
Washington, D.C.; Alfred
Stieglitz Collection

Stieglitz referred to the gallery as an "American Room," a designation that mirrored the contemporaneous call for a national form of expression. However, in contrast to those artists and intellectuals who identified America with commercialism, popular culture, and machine technology, Stieglitz and the members of his circle—which now included writers such as Waldo Frank, Paul Rosenfeld, Sherwood Anderson, and Van Wyck Brooks—considered the locus of national identity to be the land. Convinced that mechanization was psychologically damaging, they turned to nature as the agent of spiritual wholeness. The contest over which aspect of the American experience would define national identity had been waged in America since the 1780s and 1790s, when Alexander Hamilton and Thomas Jefferson debated over whether America's future was urban or agrarian. On one side were those who saw the essence of America as industrial, commercial, technological, and urban; on the other were those who linked American values and imperatives to nature and agriculture. Stieglitz, for whom nature was a site for spiritual introspection, not surprisingly championed artists whose primary subject matter was landscape. Still committed to the principles—though not the style—of Symbolism and British Aestheticism, he measured all artists by their emotional connection to nature and by the intensity with which they communicated their experiences.

During the years of 291, Stieglitz had made relatively few photographs. After meeting Georgia O'Keeffe in 1917, however, he enthusiastically returned to the medium. By the fall of 1922, he had begun a series of cloud photographs that would occupy him for the next eight years and encompass almost four hundred images. Drawing inspiration from the Symbolist notion of correspondence, he sought to create pictorial equivalents of his innermost, subjective feelings. So convinced was he of the artist's power to transform the objective facts of the world into a

377. **Joseph Stella**
Nativity, 1919–20
Pastel on paper, 37 x
19⅛ in. (94 x 48.6 cm)
Whitney Museum of
American Art, New York;
Purchase 31.469

communicable poetry of personal expression that he unabashedly announced his ambition: "To put down my philosophy of life . . . to record something so completely that those who see [the picture] will relive an equivalent of what has been expressed."[83] A year before he began his "equivalents," as he termed them, Stieglitz had claimed the search for Truth to be his obsession.[84] In his equivalents, which he once called "documents of eternal relationship," he aimed to reveal the profound and changeable relationship between himself and the world.[85] That he chose sky and cloud as his subjects, traditional symbols of infinity and transcendence, was not a coincidence (fig. 376).

Stieglitz was not alone in retaining fin de siècle Symbolism as the aesthetic framework within which to depict abstract emotional states. Convinced that art should express intangible ruminations and inner mysteries, Joseph Stella and Agnes Pelton summoned sound and color to evoke the passion, drama, and mystery of their personal visions and poetic reveries (figs. 377, 378). Symbolist notions of synesthesia, a quasi-mystical belief in the subjective interaction of all sensory perception, similarly directed O'Keeffe and Arthur Dove in works such as *Music—Pink and Blue II* and *Fog Horns* (figs. 379, 380).

Nature, for artists such as Dove, O'Keeffe, John Marin, Rockwell Kent, and Oscar Bluemner, embodied a pantheistic sublime. Luminous, pared-down organic shapes, often radiating outward in halos of modulated color, functioned for these artists as pictorial equivalents of the universal rhythm or life force they felt permeated all things (figs. 381, 383). They distilled nature to its essence in order to translate its mystic immanence into powerful, abstract form. This transcendental connection with nature was particularly evident in Dove's work, which abounded in affirmations of his love and empathetic feelings for the earth. As O'Keeffe said in comparing Dove to Marin, "Dove is the only American painter who is of the earth . . . Marin is not of the earth. He walks over the earth, but Dove is of it."[86]

Abstractionists in the twenties, reflecting the era's penchant for streamlining, replaced the weightless fragmentation and buoyancy of their prewar work with simplified, elemental compositions. No one epitomized this shift more emphatically than O'Keeffe. Her move to New York in 1918 from Canyon, Texas, where she had been teaching school, and her ensuing relationship with Stieglitz (whom she married in 1924) expanded her social world and aesthetic vision. Her work, once delicate and atmospheric, became condensed and monumental—a change linked to her shift from watercolor to oil and to her adaptation of the close-up techniques favored by modernist photographers (fig. 382). Influenced, on the one hand, by the clarity of straight photography and, on the other, by her own conviction that "it is only by selection, by elimination, by emphasis that we get at the real meaning of things," O'Keeffe expunged all pictorial equivocation in favor of explicit forms with precise edges and smooth paint handling.[87] Following photographic models, she tightly cropped

378. **Agnes Pelton**
Sea Change, 1931
Oil on canvas, 20 x
28³⁄₁₆ in. (50.8 x 71.6 cm)
Whitney Museum of
American Art, New York;
Promised gift of Irvin and
Lois E. Cohen P.2.97

379. **Georgia O'Keeffe**
Music—Pink and Blue II,
1919
Oil on canvas, 35 x
29⅛ in. (88.9 x 74 cm)
Whitney Museum of
American Art, New York;
Gift of Emily Fisher
Landau in honor of Tom
Armstrong 91.90

380. **Arthur G. Dove**
Fog Horns, 1929
Oil on canvas, 18 x 26 in.
(45.7 x 66 cm)
Colorado Springs Fine Arts
Center, Colorado

382. **Georgia O'Keeffe**
Black Spot No. 2, 1919
Oil on canvas, 24 x 16 in.
(61 x 40.6 cm)
Private collection

381. **Oscar Bluemner**
Last Evening of the Year,
c. 1929
Oil on wood, 14 x 10 in.
(35.6 x 25.4 cm)
Whitney Museum of
American Art, New York;
Gift of Juliana Force
31.115

383. **Rockwell Kent**
The Trapper, 1921
Oil on canvas, 34 x 44 in.
(86.4 x 111.8 cm)
Whitney Museum of
American Art, New York;
Purchase 31.115

her images so that they filled the entire canvas; thrust to the front of the picture plane and isolated from their identifying contexts, they announced an unprecedented abstraction and monumentality. The resulting formal rigor allowed O'Keeffe to indulge in a voluptuously sensual color vocabulary and paint handling without risk of becoming banal or decorative. This was particularly important in her post-1924 flower paintings, in which detailed, smoothly executed depictions of botanical subjects became metaphors of the organic, pulsating, life-giving rhythms of nature (fig. 384).

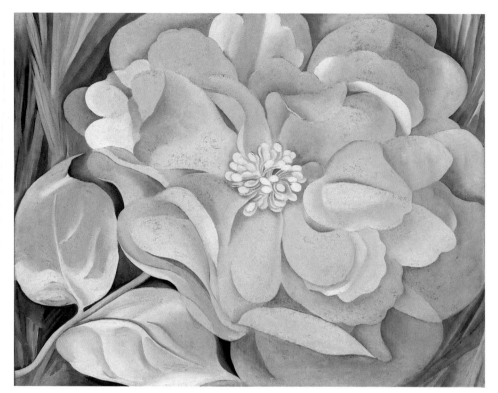

384. **Georgia O'Keeffe**
The White Calico Flower,
1931
Oil on canvas, 30 x 36 in.
(76.2 x 91.4 cm)
Whitney Museum of
American Art, New York;
Purchase 32.26

Not surprisingly, given photography's centrality to Stieglitz's circle, there was an active cross-fertilization between painters and photographers. O'Keeffe's willingness to explore flower themes with an insistent clarity of detail may well have owed something to the decontextualized floral photographs taken by Charles Sheeler and Edward Steichen that were reproduced in *Vanity Fair* in 1920 and 1923. Photography's tightly cropped, close-up techniques influenced not only O'Keeffe but Rebecca Salsbury Strand (later James) as well (fig. 385). Similarly, the firm, clear outlines and the rigorous simplification of form achieved by the West Coast painter Henrietta Shore (fig. 386) recalled the photographs of Edward Weston, whom she met in 1927. Pared down to essentials and flattened on the picture plane, her compositionally austere and luminous paintings shared with Weston's photographs an elemental, iconic grandeur.

Yet the influence was reciprocal rather than unidirectional. Indeed, Weston had begun his close-up photographs of shells (fig. 387) only after seeing Shore's paintings of similar subjects in 1927. More significantly, his decision in 1922 to abandon Pictorialism and dedicate himself to straight photography had been strengthened when, on a visit to New York that year, he saw O'Keeffe's painting of a single green apple on a black tray. Following Weston's return to California in late 1926, after a three-year sojourn in Mexico, this experience remained in his mind as he began his close-up photographs of vegetables (fig. 388). He added shells to his repertoire and, following his 1929 visit to the Point Lobos nature preserve, rocks, trees, and kelp. In his Pictorialist work, Weston had sought to evoke universals by obscuring details (fig. 76). In this new work, he attempted to convey the silent clarity of objective truth through monumentality and microscopic precision. "To see the *Thing Itself* is essential: the quintessence revealed direct without the fog of impressionism," he would write.[88] His desire for an "absolute, impersonal recognition" was shared by Imogen Cunningham, who had likewise discarded her earlier Pictorialist leanings (fig. 75) in favor of simplified, highly detailed records of the abstract forms of nature (figs. 389, 390).[89] Cunningham, a former member of the Photo-Secession, had shown her magnified flower photographs to Stieglitz. That he chose not to exhibit them at The Intimate Gallery may have been due to his fear that they would be perceived as influences on O'Keeffe's flower painting. Stieglitz's own photographs, deeply

385. **Rebecca Strand**
Moon and Clouds, c. 1935
Pastel and gouache on
board, 22 x 28 in.
(55.9 x 71.1 cm)
Barbara Mathes Gallery,
New York

386. **Henrietta Shore**
Two Worlds, c. 1921
Oil on canvas, 30 x 26 in.
(76.2 x 66 cm)
Nora Eccles Harrison
Museum of Art, Logan,
Utah; Gift of the Marie
Eccles Caine Foundation
for the Nora Eccles
Harrison Museum
Permanent Collection

387. **Edward Weston**
Two Shells, 1927
Gelatin silver print, 9½ x
7¼ in. (24 x 18.4 cm)
The J. Paul Getty Museum,
Los Angeles

388. **Edward Weston**
Pepper No. 35, 1930
Gelatin silver print, 9½ x
7⅝ in. (24.1 x 19.4 cm)
Jane Corkin Gallery,
Toronto

389. **Imogen Cunningham**
Two Callas, c. 1929
Gelatin silver print, 11¹³⁄₁₆ x
8⅞ in. (30 x 22.5 cm)
The Bokelberg Collection;
courtesy Hans P. Kraus Jr.
Fine Photographs, New
York

390. **Imogen Cunningham**
Magnolia Blossom, 1925
Gelatin silver print, 9³⁄₁₆ x
11⅝ in. (23.3 x 29.5 cm)
San Francisco Museum of
Modern Art; The Henry
Swift Collection, Gift of
Florence Alston Swift

indebted to O'Keeffe's subject matter and to her ambition to give form to emotions, he willingly installed in proximity to her paintings.

For Stieglitz, O'Keeffe's paintings represented an expression of sensual, unaffected nature that accorded with the almost messianic preoccupation in his circle to liberate the emotional and instinctual life from materialist values and constraints. Fueled by the widely accepted theories of Sigmund Freud and the sexologist Havelock Ellis, critics saw art in sexual terms. O'Keeffe's flower paintings were particularly prone to sexual interpretation, despite her vehement claims that she magnified the scale of the flower images only to ensure that people would notice them. Ironically, it was Stieglitz himself who helped promulgate the view that O'Keeffe's work was the pure expression of Womanhood—understood as Nature and Womb. He had introduced her to the public through photographs, many of which were intensely erotic (fig. 391), and then transferred this sexual identity to her paintings through the pamphlets he published in conjunction with her exhibitions. These publications credited her work with such things as revealing "the intimacies of love's juncture, with the purity and the absence of shame that lovers feel in their meeting."[90] O'Keeffe's was not the only work interpreted in exaggeratedly sexual terms. Henrietta Shore's abstractions were similarly explained as manifestations of subliminal eroticism. And Marsden Hartley, whose overheated essay on O'Keeffe initiated the sexual exegesis of her work, was himself the object of florid literary allusions by the critic Paul Rosenfeld, who wrote of the "stiffish bananas, globular pomegranates, and luscious figs as a bursting pod is crammed with seed" in Hartley's still lifes and of the "coupling organs" in his New Mexico mountains "fitting into each other," like "breasts and wombs of clay."[91]

391. **Alfred Stieglitz**
Georgia O'Keeffe: A Portrait—Hand and Breasts, 1919
Palladium print, 7⅝ x 9¼ in. (19.3 x 23.6 cm)
National Gallery of Art, Washington, D.C.; Alfred Stieglitz Collection

As an expression of American life, the cult of virility was highly esteemed in Stieglitz's milieu. Dove, Marin, and Hartley—notwithstanding the latter's homosexuality—were praised for what Rosenfeld called the "male vitality" of their work.[92] Indeed, this emphasis on pictorial masculinity may have accounted for Demuth's absence from the roster of artists officially identified with The Intimate Gallery. Although his work was included in "Seven Americans" and awarded three shows at the gallery, the suspicion voiced by Strand and Rosenfeld about the "delicate niceness" and "almost female refinement in his wash" may have caused Stieglitz to withhold full endorsement.[93] And, in fact, the delicately modulated, pale color and diaphanous light effects in Demuth's floral watercolors of the twenties did exude a fragile elegance and emotional reserve at odds with the pictorial masculinity of other members of Stieglitz's coterie (fig. 392).

However much the work of O'Keeffe, Hartley, Dove, and Marin lent itself to sexual interpretation, no other artist so frankly canonized sexuality and the vitality of Eros as the French-born Gaston Lachaise. *Standing Woman*, the life-size sculpture shown in his 1927 exhibition at The Intimate Gallery, personified the female principle and the awesome power, mystery, and majesty of women. Liberated from gravity and the sensations and weightiness of the body, the sculpture epitomized Lachaise's transmutation of flesh into spirit. Like most of his work, it was a devotional offering to his wife, Isabel Nagel, the Canadian American whom he fell in love with in France and followed to America in 1906. In contrast to most Western artists, Lachaise depicted women as neither chaste nor seductive, but rather as goddesses whose elusive inward divinity and fecundity merited

reverential worship (fig. 393). His presentation of the human body in heroic and spiritual terms aligned his work with Indian religious sculptures and Paleolithic and Mesopotamic fertility images, while simultaneously endearing him to an intellectual world that was rebelling against the Puritan denial of flesh. With a unique blend of expressionist passion and classical idealism, he created modern incarnations of the Great Mother of abundance, sexuality, and creation.

The new sexual freedom that prevailed in postwar American society made nude portraiture even more acceptable than it had been in the Pictorialist period. There remained some artists, such as Sheeler and Cunningham, who refrained from using the body as anything but a subject with which to explore abstract arrangements of shape and texture (figs. 395, 396). But others, such as Man Ray, reveled in the frank display of hitherto restricted subjects (fig. 397). So too did Stieglitz in the over five hundred photographs he took of O'Keeffe from 1917 to 1933 (fig. 391). Stieglitz's dream had been to document the entire life of an individual—from birth to death. His cumulative suite of O'Keeffe images, which record the full range of her emotional, sexual, and physical life, approximated this dream. Stieglitz took most of the photographs indoors, in soft natural light, with relatively long exposures. Their unequivocal truthfulness and precision set a standard that influenced Paul Strand (in his photographs of his wife-to-be, Rebecca Salsbury) and Edward Weston. Although Weston had already taken nude photographs of his companion and fellow photographer Tina Modotti, which Stieglitz singled out for praise in 1922, he was affected by the simplification and degree of detail Stieglitz achieved in his photographs of O'Keeffe. Stieglitz's use of small apertures, close-up framing, exposure times that lasted as long as three to four minutes, and attention to the entire picture surface were lessons that Weston carried with him (figs. 398–400).

392. **Charles Demuth**
Red Gladioli, 1928
Watercolor on paper, 20 x 14 in. (50.8 x 35.6 cm)
Whitney Museum of American Art, New York; Promised gift of Mr. and Mrs. Laurance S. Rockefeller in honor of Tom Armstrong P.1.87

A changed mood marked the work of these nature painters and photographers at the end of the decade. Faced with the social and economic disruptions of the Depression, they deepened their commitment to expressing the imperturbability of nature and its cycles. Hartley's art, always informed by a powerful muscular tension and persuasive primordial intensity, became even more compositionally solid and sculptural. Unlike the other members of Stieglitz's gallery, Hartley had spent most of the twenties in Europe, intermittently moving from place to place in search of a subject that would prove as psychologically fulfilling as the prewar Berlin military environment had been. His inability to find such a subject, coupled with his seeming ingratitude to Stieglitz, ultimately led to an estrangement between dealer and painter in 1938. By then, Hartley was back in his native Maine and was claiming the region's severity and rugged simplicity as his personal subject. The strength and expressive physicality of his paint handling, which had sustained the quality of his work through fallow periods, combined now with a greater sense of weight and density. Convinced that one's entire physical being—"the whole body, the whole flesh"—must be put into action when painting, Hartley abandoned elegance and refinement in favor of raw immediacy, deliberately simplifying form for the sake of emotional expression.[94] "[Painting]

393. Gaston Lachaise
Draped Seated Nude,
1932–34
Graphite on paper, 24⅛ x
19 in. (61.3 x 48.3 cm)
Whitney Museum of
American Art, New York;
Purchase, with funds from
an anonymous donor
87.52

394. Gaston Lachaise
Standing Woman,
1912–27
Bronze, 69½ x 26¹⁵⁄₁₆ x
17 in. (176.5 x 68.4 x
43.2 cm)
Whitney Museum of
American Art, New York;
Purchase 36.91

395. Imogen Cunningham
Untitled (Two Sisters),
1928
Gelatin silver print, 8¼ x
10¼ in. (21 x 26 cm)
Collection of Susan Ehrens
and Leland Rice

396. Charles Sheeler
Nude No. 6, 1918–19
Gelatin silver print, 5 x
7⅜ in. (12.7 x 18.7 cm)
Museum of Fine Arts,
Boston; The Lane
Collection

397. Man Ray
La Prière, 1930
Gelatin silver print, 9½ x
7⅞ in. (24 x 17.5 cm)
The Saint Louis Art
Museum; Eliza McMillan
Purchase Fund

398. **Edward Weston**
Nude on Azotea, 1924
Gelatin silver print, 7⁵⁄₁₆ x
9¼ in. (18.6 x 23.5 cm)
Center for Creative
Photography, University of
Arizona, Tucson

399. **Edward Weston**
Nude (18N), 1923
Gelatin silver print, 7½ x
9½ in. (19.1 x 24.1 cm)
Museum of Fine Arts,
Boston; The Lane
Collection

400. **Edward Weston**
Neil, Nude, 1925
Palladium print, 9¼ x
7³⁄₁₆ in. (23.5 x 18.2 cm)
The Art Institute of
Chicago; Gift of Anne
d'Harnoncourt in honor of
Hugh Edwards

is a medium for passion," Hartley once wrote.[95] "[It] is essentially a paroxysm of intelligence coupled with orgiastic deliverance."[96] Works such as *Rising Wave, Indian Point, Georgetown, Maine* and *Robin Hood Cove, Georgetown, Maine* supported his contention that a painting's success derived from a union of emotional intensity and formal principles (figs. 401, 402).

Although Hartley was a native of Maine, it was Marin who first identified his work with the state. Marin's decision in 1914 to establish a summer residence in Maine led to a change in his work, as he replaced the stenographic effects and lyrical effusions of his earlier urban depictions with a more tactile and weightier handling of the watercolor medium and a greater emphasis on architectonic structure (figs. 403, 405). The addition of oil to his repertoire of materials in 1925 allowed him to utilize the physical properties of paint rather than fragmentary graphic notations for expressive effect (fig. 404). The impact of his work became increasingly dependent on the use of broad planes of color and rough textures. Marin's emphasis on direct rather than mediated experience and his use of landscape as a springboard for interior revelation exemplified the centrality of personal expression in the Stieglitz circle. "Seems to me," Marin once said, "that the true artist must perforce go from time to time to the elemental big forms—Sky, Sea, Mountain, Plain—and those things pertaining thereto, to sort of re-true himself up, to recharge the battery. For these big forms have everything. But to express these, you have to love these, to be part of these in sympathy."[97] Such claims endeared Marin to Stieglitz and those who viewed American materialism, industry, and popular culture as inimical to spiritual values and the formation of a true national aesthetic.

401. **Marsden Hartley**
Rising Wave, Indian Point, Georgetown, Maine,
1937–38
Oil on board, 22 x 28 in. (55.9 x 71.1 cm)
The Baltimore Museum of Art; Edward Joseph Gallagher III Memorial Collection

402. **Marsden Hartley**
Robin Hood Cove, Georgetown, Maine, 1938
Oil on board, 21¾ x 25⅞ in. (55.2 x 65.7 cm)
Whitney Museum of American Art, New York; 50th Anniversary Gift of Ione Walker in memory of her husband, Hudson D. Walker 87.63

By 1929, O'Keeffe was spending summers in New Mexico and winters in New York. In New Mexico, she was living in a landscape whose austere grandeur subjugated the individual to nature; she was also removed from the emotional intensity of daily life with Stieglitz. Her work, as a result, lost its ecstatic, unabashedly rapturous quality, but gained a greater monumentality and iconic power (fig. 411). In *Summer Days* (fig. 409), for example, she paid homage to the eternal cycle of birth and death—symbolized by the flower and skull—and to the renewable forces of nature that she

403. **John Marin**
Region of Brooklyn Bridge Fantasy, 1932
Watercolor on paper, 17 x 22⅛ in. (43.2 x 56.2 cm)
Whitney Museum of American Art, New York; Purchase 49.8

404. **John Marin**
Wave on Rock, 1937
Oil on canvas, 22¾ x 30 in. (57.8 x 76.2 cm)
Whitney Museum of American Art, New York; Purchase, with funds from Charles Simon and the Painting and Sculpture Committee 81.18

405. **John Marin**
White Horses—Sea Movement off Deer Isle, Maine, 1926
Watercolor on paper, 15¼ x 19¾ in. (38.7 x 50.2 cm)
Whitney Museum of American Art, New York; Gift of an anonymous donor 54.61

406. Arthur G. Dove
Sand Barge, 1930
Oil on cardboard, 30 x 40
in. (76.2 x 101.6 cm)
The Phillips Collection,
Washington, D.C.;
Acquired 1931

407. Oscar Bluemner
A Situation in Yellow,
1933
Oil on canvas, 36 x
50½ in. (91.4 x
128.3 cm)
Whitney Museum of
American Art, New York;
Gift of Nancy and Harry
L. Koenigsberg 67.66

408. Paul Strand
*Ranchos de Taos Church,
New Mexico,* 1931
Gelatin silver print, 4⅝ x
5⅞ in. (11.8 x 14.9 cm)
National Gallery of Art,
Washington, D.C.;
Southwestern Bell
Corporation Paul Strand
Collection

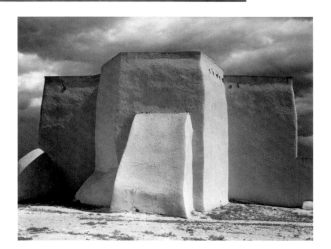

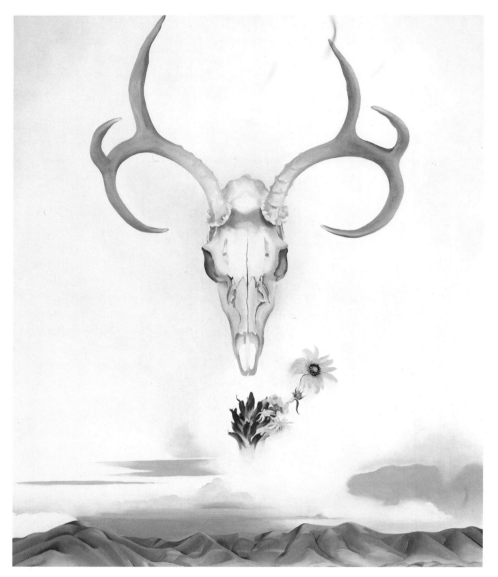

409. **Georgia O'Keeffe**
Summer Days, 1936
Oil on canvas, 36 x 30 in.
(91.4 x 76.2 cm)
Whitney Museum of
American Art, New York;
Gift of Calvin Klein
94.171

410. **Arthur G. Dove**
Ferry Boat Wreck, 1931
Oil on canvas, 18 x 30 in.
(45.7 x 76.2 cm)
Whitney Museum of
American Art, New York;
Purchase, with funds from
Mr. and Mrs. Roy R.
Neuberger 56.21

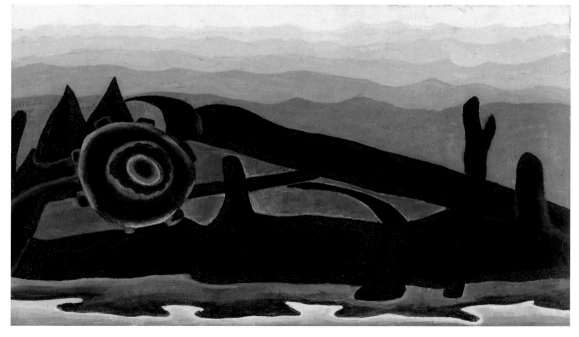

submitted would "always be there as it is now after all man's destruction is finished."[98] Dove's work, too, assumed a greater weight and severity as he deepened his sense of oneness with nature and his faith in its perfection and continuity. In his desire to exclude all that was momentary or transitory, he simplified form—as did Oscar Bluemner—into large shapes delineated by discrete, rich areas of color (figs. 406, 407, 410).

A similarly exultant awe in the presence of nature pervaded the photographs of members of f/64, who replaced close-up views with majestic open landscapes that recorded the beauty and power of land and sky (figs. 412–14). Edward Weston shifted his attention to expansive views of Point Lobos, and Paul Strand began in 1929 to investigate the relationship between man-made structures and the landscape (fig. 408). By 1930, Ansel Adams, today the most famous American landscape photographer, had relinquished hopes for a music career and committed his energies exclusively to photography. Spiritually attuned to the American wilderness, he photographically interpreted the natural scene with an unexcelled level of grace and majesty (fig. 415). He saw nature photography as an almost religious crusade. "There is a deeper thing to express," he once wrote, "[than] the shallow fashions of surface."[99] Nearly scientific in his control of exposure and development, he brought to his work a technique even more meticulous than that he had earlier admired in Strand's photographs. In Adams' hands, the land and the individual's relationship to it became an occasion for national pride and a sanctified embodiment of the Sublime.

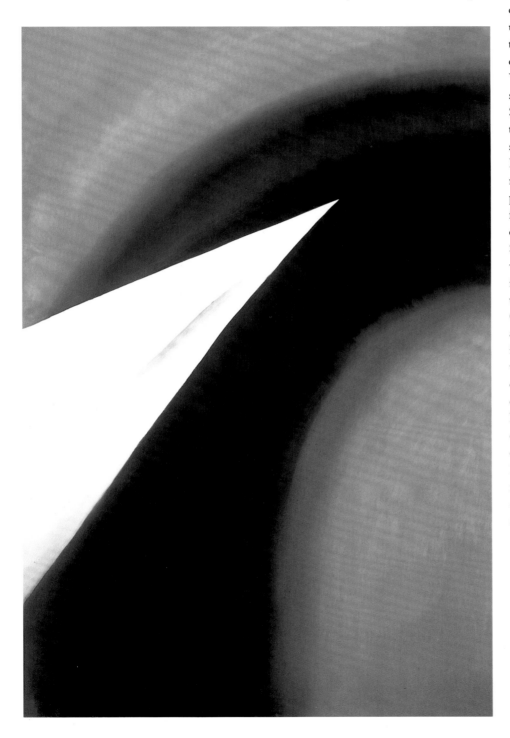

412. **Laura Gilpin**
Bryce Canyon, No. 2,
1930
Platinum print, 9¹¹⁄₁₆ x
7⅝ in. (24.6 x 19.4 cm)
Amon Carter Museum, Fort
Worth, Texas; Bequest of
Laura Gilpin

413. **Edward Weston**
Red Rock Canyon, 1937
Gelatin silver print, 7⅝ x
9³⁄₁₆ in. (19.4 x 24.3 cm)
Museum of Fine Arts,
Boston; The Lane
Collection

414. **Brett Weston**
Sand Dune, 1933
Gelatin silver print, 7½ x
9½ in. (19.1 x 24.1 cm)
Collection of Kathy and
Ron Perisho

415. **Ansel Adams**
*Bridal Veil Fall, Yosemite
Valley,* c. 1927
Gelatin silver print, 9⅝ x
7¹¹⁄₁₆ in. (24.5 x 19.5 cm)
The Art Institute of
Chicago; Gift of Arnold
Gilbert

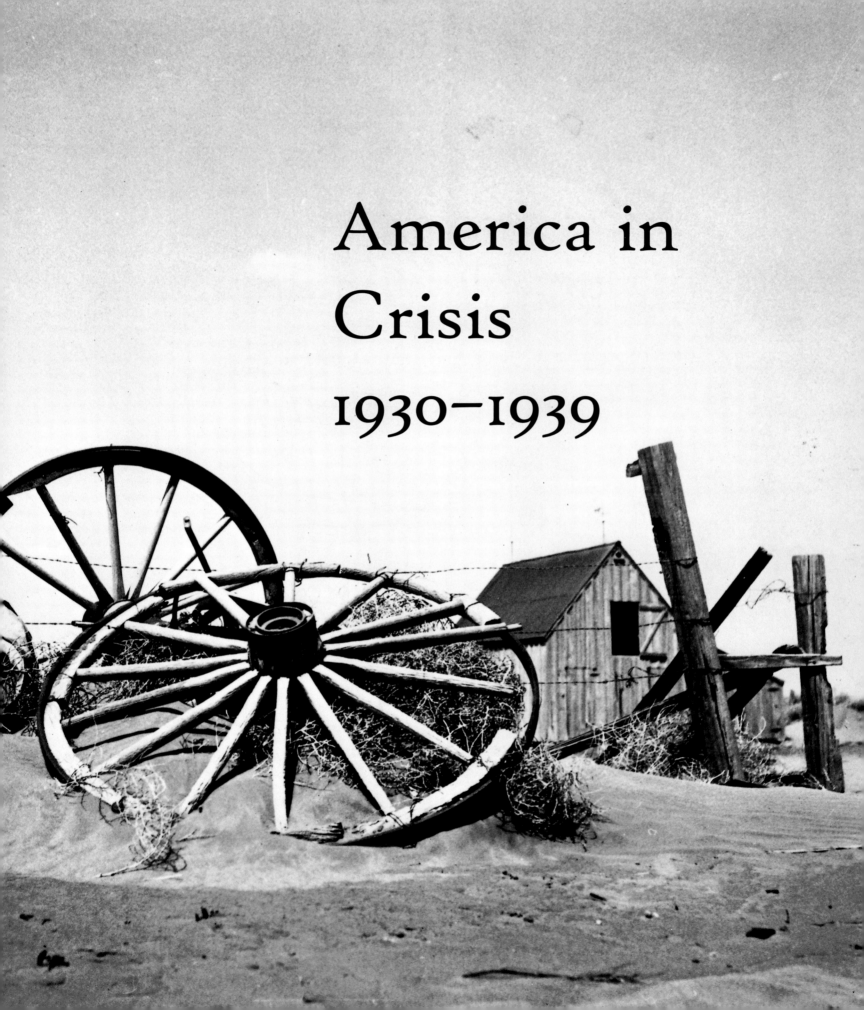

America in
Crisis

1930–1939

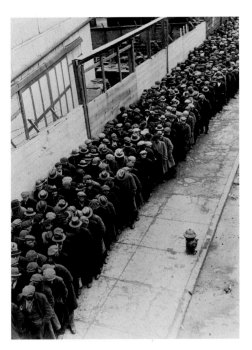

On October 29, 1929, the Wall Street stock market crashed, and along with it went the prosperity and euphoria of the Jazz Age. Herbert Hoover, elected president in a landslide the preceding November, looked to private enterprise for solutions to what he hoped would be a temporary "depression," as he called it. Sadly, the situation over the next three years worsened as businesses and industries that had overexpanded during the 1920s went into bankruptcy. Every week, 100,000 new workers joined the ranks of the unemployed; banks foreclosed on defaulted mortgages and ultimately closed themselves. By the fall of 1932, over one-quarter of the labor force was unemployed. As the ranks of the destitute and homeless grew in urban centers, families took refuge in makeshift shacks, dubbed Hoovervilles, put together from salvaged bits of wood, tar paper, cardboard, and tin. Unemployed men queued up for bread and daily rations at soup kitchens or sold apples on consignment on street corners (fig. 416). The economic catastrophe was exacerbated by devastating droughts in the Midwest that eroded soil and transformed once fertile farmlands into arid dust bowls (fig. 417). Powerless against the drought and the competition from large-scale, mechanized farms, thousands of small farmers and sharecroppers, unable to pay rent or meet mortgage payments, began to wander the countryside in search of work. In the spring of 1932, seventeen thousand veterans marched on Washington, D.C., demanding an advance on the bonus payment due them for their

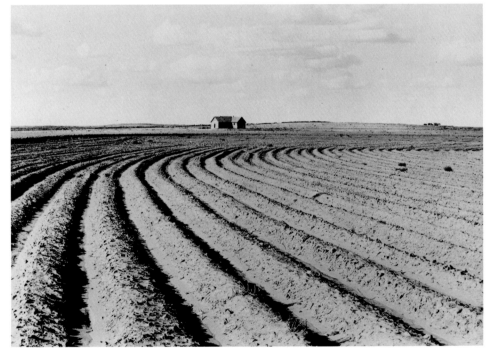

417. **Dorothea Lange**
*Abandoned Farmhouse on
Large Mechanized Cotton
Farm, Texas*, 1938
Gelatin silver print, 7⅜ x
9½ in. (18.7 x 24.2 cm)
Center for Creative
Photography, University
of Arizona, Tucson

service in World War I. Calling themselves the Bonus Expeditionary Force and vowing to stay until their bonuses were awarded, they were routed several months later at their makeshift camp across the Anacostia River by federal troops under the command of General Douglas MacArthur. Although privately ambivalent, Hoover defended MacArthur's action; it was one of his last acts as president. In the presidential election that fall, the country voted for change. Franklin Delano Roosevelt was sworn in as the thirty-second president of the United States in January 1933, reassuring the nation that "the only thing we have to fear is fear itself."

Rediscovering America

FEDERAL SUPPORT OF THE ARTS

The new administration's most pressing task was to provide relief. In his first one hundred days in office, Roosevelt prevailed on Congress to enact a flood of legislation and created a host of new agencies to promote recovery and regulate the economy. Desiring, as he said, to "preserve not only the bodies of the unemployed from destitution, but also their self-respect, their self-reliance, and courage and determination," he proposed to augment direct relief with work relief through a public works program.[100] The idea to employ artists within the new Civil Works Administration (CWA) was suggested by George Biddle, an artist himself and former Groton and Harvard University classmate of Roosevelt's. Biddle's suggestion that American artists do for the social ideals of the Roosevelt administration what Mexican muralists had done for the Mexican revolution received a ready endorsement from Roosevelt and from Edward Bruce, an artist who doubled as a lawyer for the Treasury Department (fig. 419). In December 1933, owing in part to Bruce's effective lobbying efforts, over one million dollars of the CWA's money was allocated for the creation of the Public Works of Art Project (PWAP) to employ needy artists, at hourly wages, to create murals, sculptures, prints, and paintings that would embellish public buildings. With Bruce as national director, the PWAP divided the country into sixteen regions, each with its own chairperson. Mindful that the federal government was its patron, the PWAP designated the "American Scene" as appropriate subject matter. Although it discouraged art that was abstract, controversial, or "foreign" in theme, the PWAP in practice gave artists relatively wide aesthetic latitude. Only a limited number of controversies over content erupted; the most publicized was over three of the twenty-five murals commissioned for San Francisco's Coit Tower memorial to volunteer firemen—those by Victor Arnautoff (fig. 420), Bernard Zakheim, and Clifford White—which were attacked for containing Communist propaganda, such as the motto "Workers of the World Unite" and the hammer-and-sickle emblem. An equally vehement but less public protest was lodged by the secretary of the navy against Paul Cadmus' *The Fleet's In!* for its licentious portrayal of sailors (fig. 421). The censure of the work, however, did not dampen Cadmus' enthusiasm for the subject, which he continued to explore throughout the decade (fig. 418).

In June 1934, the PWAP was liquidated along with its parent agency, the Civil Works Administration. Although in existence for only six months, it nevertheless established that government had the same obligation to artists that it had to all productive and useful members of society. For the first time in the country's history, artists were officially viewed as performing a valuable service to the community. There was, as one PWAP artist remarked, "hope and a feeling of being included in the life of my time."[101] This inclusion, however, implied an obligation: an acceptance of the imperative that art go beyond mere aestheticism and connect with the social and political issues of the day.

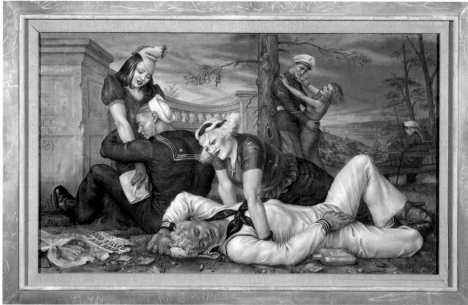

418. **Paul Cadmus**
Sailors and Floosies, 1938
Oil and tempera on panel,
25 x 39½ in. (63.5 x 100.3 cm)
Whitney Museum of American Art, New York; Gift of Malcom S. Forbes
64.42a–b

African Americans likewise celebrated individuals and events from their historical past. Jacob Lawrence did so by means of a unique format. Impressed by contemporary Mexican murals, particularly those of Diego Rivera, as well as by the combination of image and text in photo-essay books, he began to paint stories using multiple panels, each accompanied by a narrative caption. His earliest narratives focused on individual African American heroes and heroines: the abolitionists Frederick Douglass and Harriet Tubman, and the slave turned revolutionary

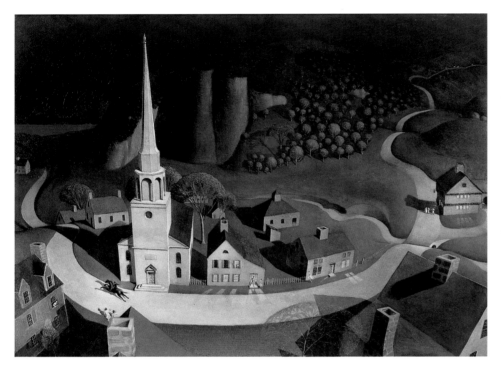

446. **Grant Wood**
Midnight Ride of Paul Revere, 1931
Oil on board, 30 x 40 in. (76.2 x 101.6 cm)
The Metropolitan Museum of Art, New York; Arthur Hoppock Hearn Fund, 1950
©Estate of Grant Wood/V.A.G.A., N.Y.

Toussaint L'Ouverture, who established Haiti as the first independent black-ruled republic in the New World. By means of exaggerated perspective, flat shapes, and primary colors, Lawrence transformed these historical figures into iconic symbols of perseverance and triumph over social and political adversity. In 1940, he turned from individual sagas to a collective one, *The Migration of the Negro.* In sixty panels, which he worked on simultaneously in order to ensure that color intensity and hue remained constant throughout, he described the migration between 1916 and 1930 of more than one million African Americans across the Mason-Dixon line to find work and to escape the discrimination and violence that were rampant in the South. As in his previous series, Lawrence adopted the cadenced pace and rhythm of folktales to create a visual analogue to the African American oral tradition (figs. 453–55).

African American history was likewise the theme of Aaron Douglas' four-mural cycle *Aspects of Negro Life,* executed under PWAP sponsorship for the Harlem branch of the New York Public Library (fig. 456). Using the same vocabulary he had employed in his earlier graphics—silhouetted figures overlaid with diagonal and concentric bands of chromatically gradated color—Douglas depicted what he considered the four defining moments of African American history: in Africa, in the American South during slavery and Reconstruction, in the post-Reconstruction years, and in industrial America.

Hale Woodruff was the third member of the trio of African American mural painters in the 1930s who found subject matter in the African American struggle for freedom. In *The Amistad Mutiny Murals,* the three-panel series he created for Talladega College in Alabama, Woodruff commemorated the story of the fifty-four Africans bound for slavery aboard the Spanish ship *Amistad* who successfully overthrew their captors and regained their liberty (fig. 457). Focused on three episodes— the mutiny, the ensuing trial in New Haven, Connecticut, and the repatriation to Africa—the mural testified to the heroism of revolution and the triumph of democracy. Taking a cue from the Mexican muralists, Woodruff created a dramatic tension between motion and equilibrium by balancing high-keyed colors and densely overlapping forms with a hieratic, pyramidal composition.

447. **Gutzon Borglum**
Mount Rushmore National Memorial, 1927–41
U.S. National Park Service, Keystone, South Dakota

448. Poster for *Abe Lincoln in Illinois,* by Robert E. Sherwood
Plymouth Theatre, New York, 1938
Billy Rose Theatre Collection, The New York Public Library for the Performing Arts, Astor, Lenox and Tilden Foundations

449. **Marsden Hartley**
Young Worshipper of the Truth, 1940
Oil on panel, 28 x 22 in. (71.1 x 55.9 cm)
Sheldon Memorial Art Gallery, University of Nebraska, Lincoln; Nebraska Art Association Collection, Nelle Cochrane Woods Memorial

nostalgia for the simplicity and self-sufficiency associated with rural life. As Dorothy Gale exclaimed upon returning to Kansas after her adventures in the Land of Oz, "Isn't it funny? This is the place I was looking for all the time. And I never knew it! This is the most beautiful place in the whole wide world! . . . Oh, Auntie Em, there's *no* place like home."[110]

Behind the renewed reverence for rural and small-town America lay an allegiance to the ideals of community, hard work, and self-reliance as the source of

445. Doris Humphrey in *The Shakers*, 1931, photograph by Soichi Sunami
Gelatin silver print
Dance Collection, The New York Public Library for the Performing Arts, Astor, Lenox and Tilden Foundations

national strength. Even though the frontier had been officially pronounced closed in 1893, it remained a paradigm of these values, which seemed threatened by industrialization and urbanization. This theme was central to James Truslow Adams' 1931 best-selling book, *The Epic of America*, which popularized the phrase the "American Dream." The optimistic—and somewhat innocent—desire to discover redemptive myths, symbols, and images in rural and small-town America also marked King Vidor's film *Our Daily Bread* (1934), Martha Graham's dance *Frontier* (1935) and Doris Humphrey's *The Shakers* (fig. 445), and what was known in literary circles as the Agrarian movement. This movement coalesced in 1930 when twelve conservative Southern writers—among them Robert Penn Warren, Donald Davidson, Allen Tate, and John Crowe Ransom, all of whom had contributed in the twenties to a short-lived literary magazine, *The Fugitive* (1922–25)— produced a manifesto, *I'll Take My Stand*. In it, they argued in favor of Southern regionalism and defended its land-based culture against industrial capitalism, which they deemed profoundly destructive to the American ideals of unity, wholeness, balance, and integration.

In keeping with the desire to connect the past to the present, Americans developed a mania for historical heroes and events associated with the principles of democracy and freedom. In *Midnight Ride of Paul Revere*, Grant Wood amalgamated myth, fiction, and childhood fantasy to engender a sense of national identity out of historical fact (fig. 446). The nation also turned to famous presidents as personifications of the American system. Fittingly, Gutzon Borglum's sculptural monument to four American presidents—Washington, Jefferson, Lincoln, and Theodore Roosevelt—begun in 1927, was dedicated in 1939 at Mount Rushmore in South Dakota (fig. 447), though it was only completed two years later. The era was particularly fascinated with Abraham Lincoln as a symbol of democratic and racial unity—witness Robert E. Sherwood's play *Abe Lincoln in Illinois* (fig. 448); E. P. Conkle's play *Prologue to Glory* (1937); John Ford's film *Young Mr. Lincoln* (1939); and Marsden Hartley's painting *Young Worshipper of the Truth* (fig. 449).

In response to the widely publicized lynchings and racial tensions of the period, the memory of the abolitionist John Brown was invoked by artists, writers, and playwrights more times than in any other decade since his hanging in 1859. For the poet Stephen Vincent Benét (*John Brown's Body*, 1928), the painter Horace Pippin (*John Brown Going to His Hanging*, fig. 450), and playwrights Michael Blankfort and Michael Gold (in their play *Battle Hymn*, fig. 451), Brown was a messianic agent of revolutionary reform. For John Steuart Curry, who harbored strong antiwar sentiments, Brown's fanatical fury and righteous rage were more problematic. "I portray John Brown," he wrote, "as a bloodthirsty, godfearing fanatic," a dangerous do-gooder who "brought on the Civil War."[111] It was John Brown as "the meteor of the war" whom Curry depicted in his mural cycle for the Kansas statehouse, *The Tragic Prelude* (fig. 452).[112]

442. Joe Jones
American Farm, 1936
Oil and tempera on
canvas, 30 x 40 in.
(76.2 x 101.6 cm)
Whitney Museum of
American Art, New York;
Purchase 36.144

443. John Steuart Curry
The Tornado, 1932
Lithograph, 9⁹⁄₁₆ x 14⅛ in.
(25.2 x 35.9 cm)
Whitney Museum of
American Art, New York;
Purchase 32.97

444. Thomas Hart Benton
Cradling Wheat, 1939
Lithograph, 9¹³⁄₁₆ x 12 in.
(24.6 x 30.5 cm)
Philadelphia Museum of
Art; Carl and Laura
Zigrosser Collection,
Lola Downin Peck Fund
©T.H. Benton and R.P.
Benton Testamentary
Trusts/V.A.G.A., N.Y.

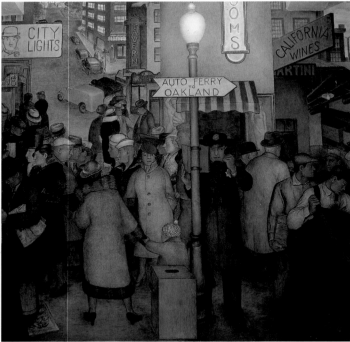

420. **Victor Arnautoff**
City Life, 1934 (detail)
Fresco, 120 in.
(304.8 cm) height
Coit Tower, San Francisco

419. **Edward Bruce**
Industry, 1932
Oil on canvas, 28 x 36 in.
(71.1 x 91.4 cm)
Whitney Museum of
American Art, New York;
Exchange 34.4

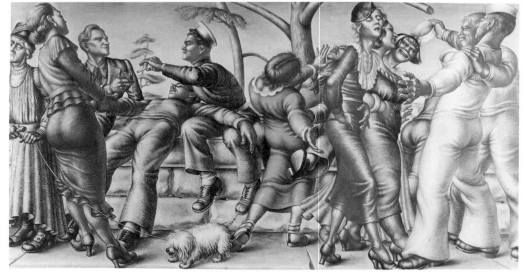

421. **Paul Cadmus**
The Fleet's In!, 1934
Oil on canvas, 30 x 60 in.
(76.2 x 152.4 cm)
U.S. Naval Historical
Center, Washington, D.C.

THE ARCHITECTURE OF A NEW DEMOCRACY

Even before America's entry into World War I, the reforms of the Progressive Era and the country's growing presence in international affairs had dramatically enlarged federal government. The city of Washington, a ramshackle town quite out of scale with the grandiose parks and plan dreamed up for it by Pierre L'Enfant and A. J. Downing in the nineteenth century, gradually began to reflect government's increasing presence in American life. Europeans trained in the Beaux-Arts tradition set the stage, with architecture such as Paul Cret's Pan American Union Building (1912–13). Associating classical forms with the monumental requirements of a national city, American architects working in the capital continued to borrow from this traditionalist architectural vocabulary and set a Washington style that persisted through the massive government building boom of the New Deal and the wartime era. Harking back to the simplified classicism of the early republic and drawing on the rage for "colonial revival," the style that resulted was as distinctively American in its expression of government as the skyscraper city was representative of business: a plainspoken monumentalism in which vast public lawns and avenues, assembly points for parade and protest, fronted directly on the great facades and portals of government in an ambiguous expression of power and accessibility.

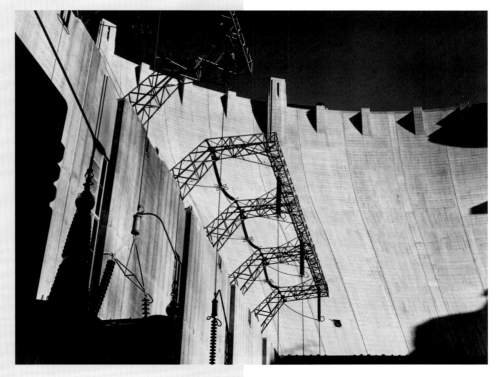

422. **Charles Sheeler**
View of Boulder Dam,
1939
Gelatin silver print, 7⅜ x 9⁷⁄₁₆ in. (18.7 x 24 cm)
Museum of Fine Arts, Boston; The Lane Collection

At the same time, New Deal public projects—the new towns and plants of the Tennessee Valley Authority, the bridges and roadways of Robert Moses' New York, the PWAP libraries and post offices of countless campuses and small towns—cast the symbols and monuments of a reforming national government across the nation. But it was the great engineering projects of the time, such as the Boulder, Hoover, and Grand Coulee Dams, San Francisco's Golden Gate Bridge, and New York's George Washington Bridge, that most captured the public imagination (figs. 422–25). Celebrated in Woody Guthrie's folk songs and in the photography of illustrated weeklies, they became at once emblems of a recovering society, promises for the future, and sources for a postwar approach to architecture and design in which the looks and techniques of civil engineering projects of the 1930s would find their way into the simplest rural kitchen or suburban yard. —N. O.

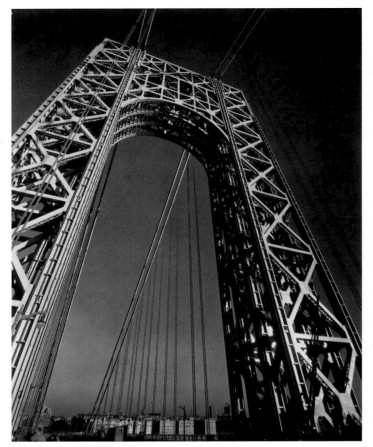

423. **Edward Steichen**
George Washington Bridge,
1931
Gelatin silver print, 9⁹/₁₆ x
7½ in. (24.5 x 19.2 cm)
George Eastman House,
Rochester, New York

424. **Peter Stackpole**
Tower Construction Begins,
San Francisco—Bay
Bridge, 1934
Gelatin silver print, 9⅛ x
6⅛ in. (23.2 x 15.4 cm)
San Francisco Museum of
Modern Art; The Henry
Swift Collection, Gift of
Florence Alston Smith

425. **Margaret Bourke-**
White
Fort Peck Dam, Montana,
1936
Gelatin silver print, 13 x
10½ in. (33 x 26.7 cm)
The Metropolitan Museum
of Art, New York; Ford
Motor Company Collection,
Gift of the Ford Motor
Company and John C.
Waddell, 1987

426. **Grant Wood**
Study for *Breaking the Prairie*, 1935–39
Colored pencil, chalk, and graphite on paper, triptych, 22¾ x 80¼ in. (57.8 x 203.8 cm) overall
Whitney Museum of American Art, New York; Gift of Mr. and Mrs. George D. Stoddard
81.33.2a–c
©Estate of Grant Wood/V.A.G.A., N.Y.

427. **Ethel Magafan**
Wheat Threshing, 1937
Egg tempera on panel, 17½ x 34⅞ in. (44.5 x 88.6 cm)
Wichita Art Museum, Kansas; Art Purchase Fund, Friends of the Wichita Art Museum

The dream of a socially meaningful art lay behind the second federally funded arts program of the Depression era, the Section of Painting and Sculpture. Begun in October 1934, only four months after the demise of the PWAP, and lasting until 1943, the Section was administered by the former PWAP director Edward Bruce, again through the Treasury Department. The Section's mission was not to provide work relief but to employ artists of merit to execute murals and sculptures for newly constructed federal buildings. Bruce envisioned the agency as an instrument for the creation of a national art that would embody the values, aspirations, and achievements of the American people. He considered the public to be the artist's patron and stressed the community's involvement in the selection process. Like public murals of the past, Section murals were to be uplifting and inspiring—to provide visual testimony to the enduring aspects of the American way of life. They were to exude, in Bruce's words, "the same feeling I get when I smell a fresh ear of corn"; they were to make Americans "feel comfortable about America."[102] To achieve these goals, the Section insisted that subject matter be uniquely American and symbolize the values of work and community through images of daily life or historical events. Eleven hundred murals were commissioned by the Section during its existence; permanently affixed to the walls of post office and justice buildings across the country, they became synonymous in people's minds with government-sponsored art during the Depression.

The Section nevertheless did not have a monopoly on public murals. Some were commissioned through the relatively small and short-lived Treasury Relief Art Project (TRAP) and some through the later WPA/FAP. Yet, whatever the funding source, all murals had to be approved by representatives of the local community or sponsoring institution. They thus reflected the interests and aspirations of their various constituencies; they were barometers of popular taste and declarations of the nation's self-worth in the face of economic collapse and social disorder. Given this function, it is not surprising that the most common theme was an idealized past or present in which individuals labored together for a common good (figs. 426, 427). This was what most effectively answered the need for continuity, self-esteem, and faith in America.

Although the coalition of artists known as the Regionalists played a minor role in the creation of federally funded murals, their art symbolized the widespread effort to find renewal and affirmation in the frontier and the collective national past. As

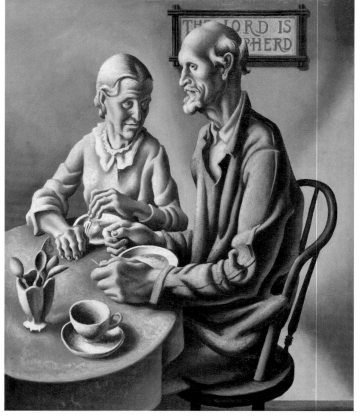

428. Thomas Hart Benton
The Ballad of the Jealous Lover of Lone Green Valley, 1934
Oil and tempera on canvas, transferred to aluminum panel, 42½ x 53¼ in. (107.3 x 135.2 cm)
Spencer Museum of Art, University of Kansas, Lawrence; Purchase, Elizabeth M. Watkins Fund
©T.H. Benton and R.P. Benton Testamentary Trusts/V.A.G.A., N.Y.

429. Thomas Hart Benton
The Lord Is My Shepherd, 1926
Tempera on canvas, 33¼ x 27⅜ in. (84.5 x 69.5 cm)
Whitney Museum of American Art, New York; Purchase 31.100
©T.H. Benton and R.P. Benton Testamentary Trusts/V.A.G.A., N.Y.

Thomas Hart Benton asserted, "I wanted to show that the peoples' behaviors, their *action* on the opening land, was the primary reality of American life."[103] Each of the three leading Regionalists was identified with a Midwestern state: Benton with Missouri, John Steuart Curry with Kansas, and Grant Wood with Iowa. All three trumpeted the cause of an American art distinct from European standards, and all three based their concept of artistic nationalism on the values, history, and patterns of behavior of agrarian America.

Benton, whose father and great-uncle (after whom he was named) had been congressmen from Missouri, saw art as an agent of social change, a means to restore the values and democratic traditions of the American republic. He condemned neither the machine nor urbanism; rather, he sought to align these aspects of the modern world with the values of hard work, individualism, and community associated with the American rural experience (figs. 428, 429). The dramatic, bombastic possibilities of mural painting suited Benton's personality, and it was with murals that he established his reputation as an artist. In his mural commission for the third-floor boardroom of the New School for Social Research in New York, he used his characteristically dynamic style to announce the essential ideas he would address throughout the decade. Restless, undulating rhythms endowed the panels of *America Today* with a baroque energy that he enhanced by overlapping forms and intertwining foreground and background elements in a manner that approximated the fast pace, zip pans, and moving panoramas of film (figs. 430, 431). Benton believed that the self-reliance and individualism associated with the frontier, if transferred to an urban, industrial setting, would bring about a harmonious,

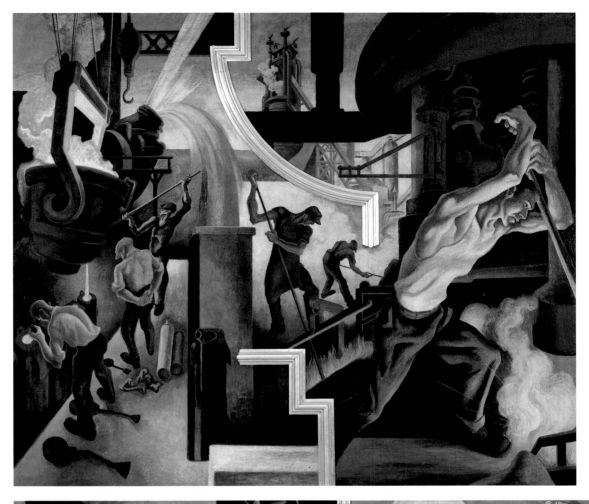

430. **Thomas Hart Benton**
Steel, from the *America Today* murals, 1930
Distemper and egg tempera on gessoed linen with oil glaze, 92 x 117 in. (233.7 x 297.2 cm)
The Equitable Life Assurance Society of the U.S., New York
©T.H. Benton and R.P. Benton Testamentary Trusts/V.A.G.A., N.Y.

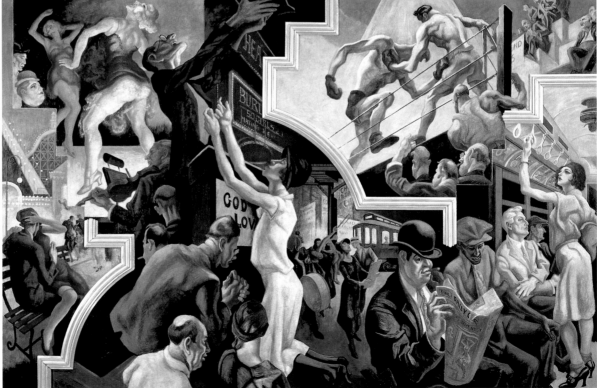

431. **Thomas Hart Benton**
City Activities with Subway, from the *America Today* murals, 1930
Distemper and egg tempera on gessoed linen with oil glaze, 92 x 134½ in. (233.7 x 341.6 cm)
The Equitable Life Assurance Society of the U.S., New York
©T.H. Benton and R.P. Benton Testamentary Trusts/V.A.G.A., N.Y.

fulfilled life. In *America Today,* he depicted such an idealistic workplace, where skilled industrial laborers work autonomously within an overall community.

America Today also celebrated the essentially democractic nature of modern American leisure—the cabarets, movie palaces, dance halls, and public spaces, where separation of sexes, classes, and ethnic and religious groups was relaxed. This notion was developed more fully in Benton's next mural series, *The Arts of Life in America,* which the Whitney Museum commissioned in 1932. Focusing the mural on popular arts rather than on industry, Benton submitted that Americans could discover regenerative spiritual and communal values by embracing indigenous folk culture. Writing of his fourth and last mural project of the 1930s, *A Social History of the State of Missouri,* executed for the Missouri State Capitol in 1935–36, Benton asserted that the folk heroes and popular arts of Missouri were, to him, "beautiful. They are part of the life and legend of Missouri as I know it." Such tales and songs were "the chronicle of the people's mind" (fig. 432).[104]

In December 1934, *Time* magazine ran an article on Regionalism, announcing that an authentic American art movement located in the Midwest was replacing incomprehensible, foreign-based art styles. The magazine reproduced Benton's self-portrait on the cover, a decision that implicitly elevated Benton's role to that of group spokesman. The conservative critic Thomas Craven reinforced this position by championing Benton, but his support ultimately damaged the artist's reputation; it linked him in people's minds with Craven's anti-Semitic, rabidly isolationist brand of cultural nationalism and laid the seeds for Benton's later ostracism from the mainstream art world. Benton's attack on Marxism in 1935, coupled with his public diatribes against foreign-based abstraction, blinded people to the promise of regeneration and social reform in his paintings. Unfortunately for Benton, popular opinion turned against him with the onset of World War II and the shift from a nationalist to an internationalist cultural outlook. After the war, in an art world

432. **Thomas Hart Benton**
St. Louis and Kansas City, south wall, from *A Social History of the State of Missouri,* 1935–36
Egg tempera and oil on linen mounted on panel, 170 in. (431.8 cm) height
House of Representatives Lounge, State Capitol Building, Jefferson City, Missouri
©T.H. Benton and R.P. Benton Testamentary Trusts/V.A.G.A., N.Y.

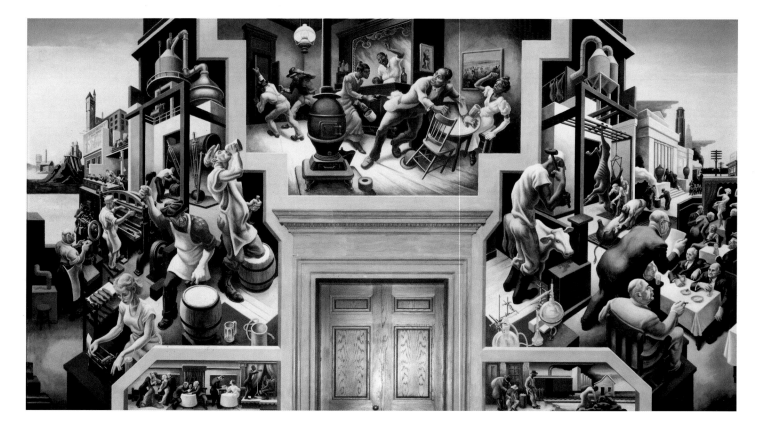

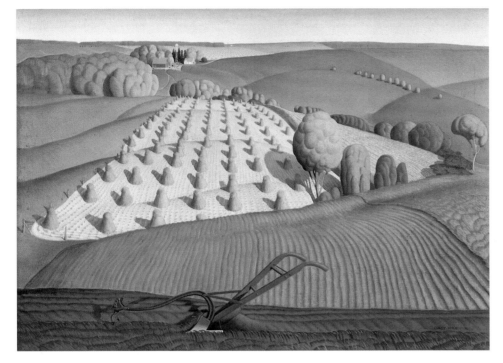

that repudiated both the masses and representational art, Benton found himself marginalized as the leading representative of a value system and aesthetic whose ideology seemed at once dangerous and irrelevant.

Grant Wood, identified in the 1934 *Time* article as the "chief philosopher and greatest teacher of representational U.S. art," was also a vehement proponent of cultural nationalism.[105] Convinced that "a work which does not make contact with the public is lost," Wood urged artists to adopt a narrative style and create art based on what was unique to the American experience.[106] In his own art, he drew on American legends and myths in the belief that they united people and gave them a sense of shared experience. Using a combination of Old Master techniques and Art Deco stylization replete with descriptive details, decorative patterns, and impersonal, crisp paint handling, Wood portrayed a rural America that was fast passing. Against a backdrop of bountiful farmlands that spoke reassuringly of harmony and prosperity, he fashioned a world without fragmentation or isolation in which people worked collectively for the common good (figs. 433, 434). As in *American Gothic* (fig. 435), he exploited national stereotypes to create believable fables of American resilience and strength, thereby rekindling people's pride in who they were and where they had come from. Wood was not above casting aspersions, however. Smarting from criticism leveled at one of his works by several members of the Daughters of the American Revolution, he used the bicentennial of George Washington's birthday to sardonically contrast Washington's heroism—as exemplified in Emanuel Leutze's 1851 painting *Washington Crossing the Delaware*—with the narrow moralism of those who sought to embalm the past in Washington's name (fig. 436).

John Steuart Curry, the third member of the Regionalist triumvirate identified by *Time,* was less ideological than either Benton or Wood. His first major Regionalist painting, *Baptism in Kansas,* launched him as the rural equivalent of the earlier

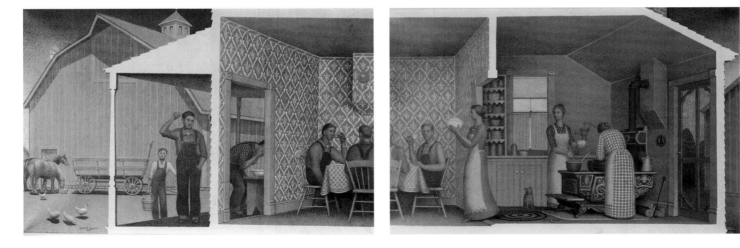

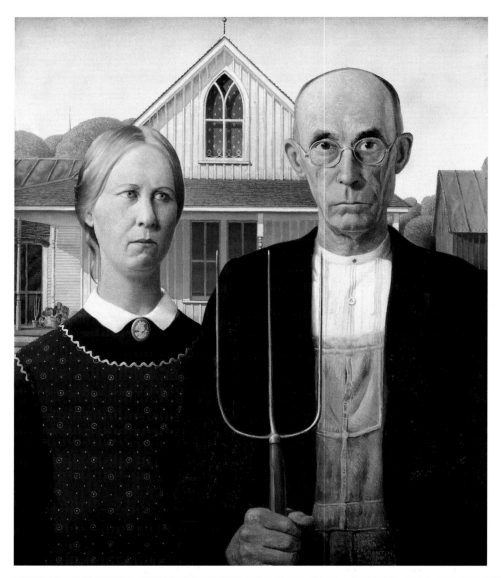

435. **Grant Wood**
American Gothic, 1930
Oil on board, 29⅞ x
24⅞ in. (74.3 x
62.4 cm)
The Art Institute of
Chicago; Friends of
American Art Collection
©Estate of Grant
Wood/V.A.G.A., N.Y.

436. **Grant Wood**
Daughters of Revolution,
1932
Oil on masonite,
20 x 40 in. (50.8 x
101.6 cm)
Cincinnati Art Museum;
The Edwin and Virginia
Irwin Memorial
©Estate of Grant
Wood/V.A.G.A., N.Y.

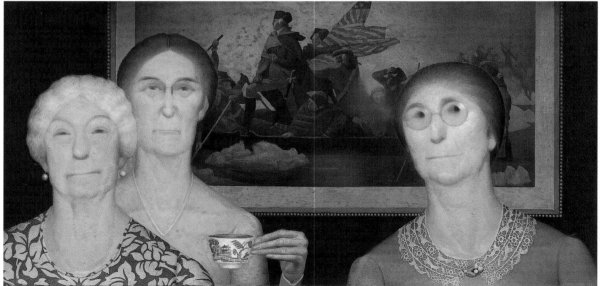

generation of Ashcan painters (fig. 437). Although he lived on the East Coast from 1919 to 1936, Curry's vision was rooted in the everyday experiences and landscape of rural America (fig. 438). Like Benton, Curry believed that human interactions with the land and the struggle against the forces of nature were the fundamental American experiences. He returned repeatedly to themes of violence and to the adversarial contest between the individual and nature—the onset of lightning storms, tornadoes, and the aftermath of floods (fig. 443). Like his Regionalist colleagues, Curry was lauded during his lifetime for mirroring, as one critic wrote, "our contemporary will to believe in ourselves, to believe in our own resources and in our native beauty."[107]

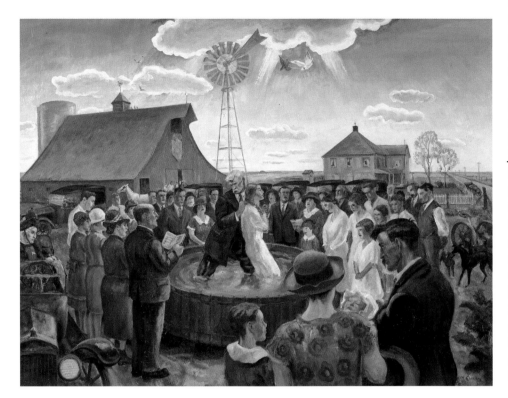

437. **John Steuart Curry**
Baptism in Kansas, 1928
Oil on canvas, 40 x 50 in.
(101.6 x 127 cm)
Whitney Museum of
American Art, New York;
Gift of Gertrude Vanderbilt
Whitney 31.159

Not all Regionalist depictions idealized the rural and small-town experience. For some, like the Texas Regionalists Alexandre Hogue and Jerry Bywaters, the hardships of wresting a living from land devastated by the drought overrode all other issues (figs. 439–41). Even Joe Jones, painting in New York, remained haunted by memories of the parched, bleached soil of his native Missouri (fig. 442). Nor were Benton or Curry oblivious to the hardships of rural life. Works such as Benton's *Departure of the Joads* (1939), commissioned to promote the film *The Grapes of Wrath,* bear witness to the artist's sympathy for those forced to live on desolate, unproductive land.

This work and other images by Regionalist artists were widely dispersed during the Depression through prints (figs. 443, 444). In 1934, Reeves Lewenthal established the Associated American Artists (AAA) with the goal of producing and marketing large editions (between 100 and 250) of etchings and lithographs by famous artists to a broad public. Skirting the gallery system, the AAA sold the prints for five dollars in department stores across the country, thereby promoting art as a popular product and challenging its status as a luxury item. The strategy gave artists a quick and easy source of money while simultaneously creating a democratic art, accessible to the public.

THE USABLE PAST

Images of rural America were inextricably linked with the quest for a "usable past," for those elements of American tradition that formed a continuum from the past to the present which could guide the nation in revitalizing itself.[108] More than ever before, Americans needed to know, as the novelist John Dos Passos asserted, "what kind of firm ground other men, belonging to generations before us, have found to stand on."[109]

As the country sought to rekindle faith in itself, it looked back to a seemingly more innocent and uncomplicated time in which individuals still commanded their own destinies. For the first thirty years of the century, as the country's demographics shifted from the farm and small town to the city, rural regions had been treated with ambivalence or derision. What emerged in the 1930s was a pronounced

438. John Steuart Curry
Kansas Cornfield, 1933
Oil on canvas, 60⅜ x
38½ in. (153.4 x 97.8 cm)
Wichita Art Museum,
Kansas; The Roland P.
Murdock Collection

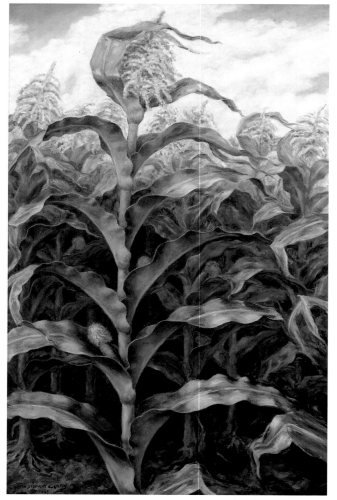

439. Alexandre Hogue
Drouth Stricken Area, 1934
Oil on canvas, 30 x
42¼ in. (76.2 x 107.3 cm)
Dallas Museum of Art;
Dallas Art Association
Purchase

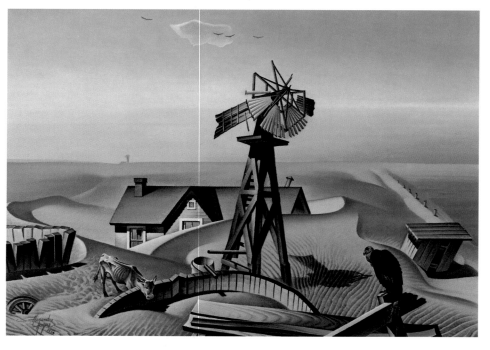

440. **Jerry Bywaters**
Share Cropper, 1937
Oil on masonite, 29¼ x
23½ in. (74.3 x 59.7 cm)
Dallas Museum of Art;
Allied Arts Civic Prize,
Eighth Annual Dallas Allied
Arts Exhibition, 1937

441. **Alexandre Hogue**
*Erosions No. 2: Mother
Earth Laid Bare,* 1938
Oil on canvas, 40 x 56 in.
(101.6 x 142.2 cm)
The Philbrook Museum of
Art, Tulsa, Oklahoma

450. **Horace Pippin**
John Brown Going to His Hanging, 1942
Oil on canvas, 24⅛ x 30¼ in. (61.3 x 76.8 cm)
Museum of American Art of the Pennsylvania Academy of the Fine Arts, Philadelphia; John Lambert Fund

451. Poster for *Battle Hymn*, by Michael Blankfort and Michael Gold
Federal Theatre Project, Experimental Theatre, 1936
George Mason University, Fairfax, Virginia

452. **John Steuart Curry**
John Brown, 1939, from *The Tragic Prelude*, 1937–40
Oil on canvas, 69 x 45 in. (175.3 x 114.3 cm)
The Metropolitan Museum of Art, New York; Arthur Hoppock Hearn Fund, 1950

453. **Jacob Lawrence**
The Migration of the Negro, panel 1, *During the world war there was a Great Migration North by southern Negroes*, 1940–41
Tempera on masonite, 12 x 18 in. (30.5 x 45.7 cm)
The Phillips Collection, Washington, D.C.; Acquired 1942

454. **Jacob Lawrence**
The Migration of the Negro, panel 59, *In the North the Negro had freedom to vote*, 1940–41
Tempera on masonite, 18 x 12 in. (45.7 x 30.5 cm)
The Phillips Collection, Washington, D.C.; Acquired 1942

455. **Jacob Lawrence**
The Migration of the Negro, panel 50, *Race riots were numerous. White workers were hostile toward the migrants who had been hired to break strikes*, 1940–41
Tempera on gesso on board, 18 x 12 in. (45.7 x 30.5 cm)
The Museum of Modern Art, New York; Gift of Mrs. David M. Levy

456. **Aaron Douglas**
*Aspects of Negro Life:
Slavery Through
Reconstruction,* 1934
Oil on canvas, 60 x 139 in.
(152.4 x 353.1 cm)
Art and Artifacts Division,
The Schomburg Center for
Research in Black Culture,
The New York Public
Library, Astor, Lenox and
Tilden Foundations

457. **Hale Woodruff**
*The Mutiny Aboard the
Amistad, 1839,* panel 1
from *The Amistad Mutiny
Murals,* 1939
Oil on canvas, 72 x 120 in.
(182.9 x 304.8 cm)
Savery Library, Talladega
College, Alabama

458. **Richmond Barthé**
Stevedore, 1937
Bronze, 30½ x 16½ x
2½ in. (77.5 x 41.9 x
6.3 cm)
Collection of John P.
Axelrod; courtesy
Michael Rosenfeld
Gallery, New York

THE PATTERNS OF EVERYDAY AMERICAN LIFE

The Depression was a crisis of values as much as of institutions. Faced with the trauma of social and economic collapse, artists and intellectuals cried out for the recovery of what was quintessentially American in the present and in the past, as if the rediscovery of commonalities could give meaning and worth to the nation and reassure Americans of their ability to endure and triumph. This call for indigenous American subjects and styles as a means of affirming national values was, in itself, not new. But in contrast to earlier decades, national identity was now seen almost exclusively as residing in the values and patterns of everyday life. With the collapse of industry and business, artists turned to "the people" as the source of national strength (fig. 458). More interested in public than in private experience, they shunned the romantic individualism that had prevailed in earlier decades in favor of collective experience shared by all Americans. The heroes of the age were not the glamorous or affluent, but the common people. By 1933, F. Scott Fitzgerald's book *The Great Gatsby* was out of print.

The search for the essential America led to a massive national inventory, much of it undertaken under the aegis of the Works Progress Administration (WPA), the work relief program Roosevelt created in May 1935. Although most of the five billion dollars allocated to the program was used for construction projects, two arts programs received funding through it. The first was the Treasury Relief Art Project (TRAP), administered through the Treasury Department, which provided murals and sculpture for extant federal buildings. The second was Federal Project Number One, the most ambitious cultural program of its kind anywhere. Federal One consisted of four cultural units, each with a separate director and regional administrators: the Federal Art Project (FAP), under the directorship of Holger Cahill; the Federal Writers' Project (FWP), under Henry Alsberg; the Federal Theatre Project (FTP), under Hallie Flanagan; and the Federal Music Project (FMP), under Nikolai Sokoloff.

Central to many of the initiatives of these programs was the archival desire to itemize all aspects of American life past and present and to counter the nation's confusion and uncertainty with the weighty accumulation of unembellished facts. A generation that had heard President Hoover proclaim in 1930, "The Depression is over," had understandably lost its trust in words.[113] The era's longing for factual authenticity led to a preponderance of documentary literature, eyewitness reporting, personal testimonials in advertising and pulp novels, and greater naturalism in fiction. As a character in Ernest Hemingway's *A Farewell to Arms* (1929) observed, "There were many words that you could not stand to hear and finally only the names of places had dignity."[114]

The camera and radio, with their ability to convey direct unmediated experience, emerged as the decade's central instruments of communication. So thorough was the acceptance of radio as a purveyor of truth that mass panic ensued when Orson Welles' Mercury Theatre broadcast a live radio dramatization of H. G. Wells' story of a Martian invasion, *The War of the Worlds.* The decade likewise saw the proliferation of photo-books and the founding of photo-magazines—*Life* in 1936 and *Look* in 1937. "The March of Time," which eventually developed into newsreels, began on radio in 1931 and on film in 1935 as a form of fictionalized documentary that employed actors to reenact public events. This became the model for the Federal Theatre Project's most successful and groundbreaking genre, the Living Newspapers. Taking their stories, dialogue, and characters from the real world and weaving newspaper

459. *Iowa: A Guide to the Hawkeye State,* from the Federal Writers' Project, *American Guide Series* New York: Viking Press, 1938 Manuscripts and Archives Division, The New York Public Library, Astor, Lenox and Tilden Foundations

FEDERAL WRITERS' PROJECT: THE *AMERICAN GUIDE SERIES*

In 1935, when President Franklin Roosevelt created a Federal Writers' Project (FWP) within the Works Progress Administration (WPA), his goal was to stretch a safety net of government labor under writers and other ink-stained professionals shaken by the Depression. One newspaper fumed that the "shovel-leaners" of the WPA projects were being augmented by a brand-new battalion of "pencil leaners."

Far from leaning on their pencils, the FWP's eventual roster of 6,700 writers—which included such luminaries and soon-to-be-luminaries as Conrad Aiken, John Cheever, Saul Bellow, Zora Neale Hurston, Richard Wright, Ralph Ellison, and Kenneth Rexroth—created a cultural inventory whose depth and breadth are stunning. Oral histories, folklore compendia, ethnic studies, historical records—a total of 276 books, 701 pamphlets, and 340 other writings were born under the eye of the FWP's director Henry Alsberg, a writer with impeccable Greenwich Village bohemian connections.

The FWP's most visible project was the *American Guide Series* (figs. 459–61). These travel guidebooks to the forty-eight states (plus the territories of Alaska and Puerto Rico) and several major cities, regions, and interstate highways were researched and published between 1935 and the FWP's demise in 1943. (Many were reprinted by state historical societies and other publishers in the 1980s.) Collating and editing a tidal flow of data from FWP writers and passionate amateurs, editors at the state level and others under Alsberg's supervision in Washington crafted a mile-by-mile picture of America that did more than support the newly emerging national habit of automobile vacationing.

The *American Guides* were prefaced with long and carefully written essays that explored each state's character and traditions in depth; then came highway itineraries so detailed and quirky that they still give the impression of having missed nothing. By paying dogged attention to the smallest facts and local traditions—a failed grist mill, a ghost story associated with a lake, the site of an annual African American picnic or of recent labor strife—the *American Guides* revealed a teeming, contradictory micro-America that did not jibe with the national myths of progress, Protestant rectitude, and melting-pot uniformity that even the Depression had failed to undermine. The *Guides'* landscape is haunted by eccentricity, failure, the melancholy of vanished towns, and the unmeltable ethnicity of streets and neighborhoods. Though limited in their understanding of communities of color, and touched by the celebratory cultural-nationalist rhetoric of their day, the *Guides* remain powerful prophecies of the stranger-than-ever mosaic that America has become in our time. —J. S.

460. Poster for *U.S. One: From Maine to Florida,* 1938, from the Federal Writers' Project, *American Guide Series* Records of the Work Projects Administration, National Archives, Washington, D.C.

461. *California: A Guide to the Golden State,* from the Federal Writers' Project, *American Guide Series* New York: Hastings House, 1939 Manuscripts and Archives Division, The New York Public Library, Astor, Lenox and Tilden Foundations

stories, congressional speeches, sociological studies, and court records into the scripts, the Living Newspapers initiated a new form of theatrical documentary. By means of film sequences and slide projections of factual data in the form of charts, maps, and newspaper headlines, along with an off-stage announcer who introduced new characters and established time and place, the Living Newspapers spoke to America's preference for facts over fiction and illusion.

The urge to gather factual evidence also governed the production of the *American Guide Series*, compiled by members of the Federal Writers' Project on every state and major city in the country (figs. 459–61). Intended to stimulate business by encouraging people to "see America first," the guides assembled facts on local customs, politics, geography, landmarks, history, literature, and folklore from every community in America. These detailed and comprehensive portraits of America's past and present introduced Americans to their own cultural diversity. Operating under similar guidelines, other members of the Federal Writers' Project fanned out across the South to collect the oral histories of tenant farmers, sharecroppers, cotton mill workers, and former slaves. The transcribed results—*These Are Our Lives* (1939), *A Treasury of American Folklore* (1944), and *Lay My Burden Down: A Folk History of Slavery* (fig. 463) —were contemporary epics that provided Americans with faithful records of the disenfranchised while simultaneously assembling a national folklore. Inventories were undertaken in other WPA divisions as well. John A. Lomax, working first with the Federal Music Project and later with the Library of Congress, traveled throughout the country recording regional folk songs, ballads, and spirituals. The talents of FAP artists and photographers were lent to the Historical American Buildings Survey, the Historical Records Survey, and the Index of American Design to amass comprehensive archives of American buildings and design. The resulting photographs and meticulously executed drawings affirmed the importance of local traditions and indigenous culture in the construction of national identity (fig. 462).

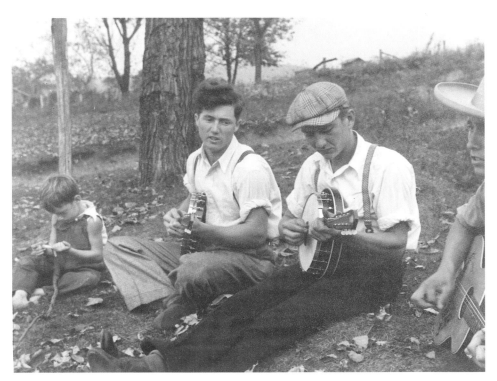

462. **Ben Shahn**
Musgrove Brothers, Westmoreland Country, Pennsylvania, 1935
Gelatin silver print, 10½ x 13½ in. (26.7 x 34.3 cm)
Collection of Susan Ehrens and Leland Rice
©Estate of Ben Shahn/V.A.G.A., N.Y.

463. *Lay My Burden Down: A Folk History of Slavery,* edited by B. A. Botkin
Chicago: University of Chicago Press, 1945
Manuscripts and Archives Division, The New York Public Library, Astor, Lenox and Tilden Foundations

LAY MY BURDEN DOWN

B. A. Botkin

In their own fascinating anecdotes and folk tales, former Negro slaves tell what slavery and emancipation meant to each of them.'

CULTURAL DEMOCRACY AND THE WPA

The need to find employment for writers and visual and performing artists had motivated the launching of Federal One. "Hell! They've got to eat just like other people," the relief administrator Harry Hopkins had said to skeptics who objected to the federal government's hiring of artists.[115] Yet for Federal One administrators, relief was secondary to the dream of an art-conscious America. Galvanized by a vision of cultural democracy, federally funded theater companies, symphony orchestras, choral groups, dance bands, and chamber ensembles toured the country, bringing classical and contemporary music, dance, and theater to small and middle-sized American towns. Exhibitions and art classes were offered in WPA-funded art centers nationwide, and murals and easel paintings were dispersed to post offices, hospitals, schools, housing units, and courthouses throughout the land. For the first time in the nation's history, art was a part of everyday life.

With the widespread employment of artists came hopes for a renaissance for American art. The WPA's Federal Art Project, with a budget far larger than that allocated to other cultural projects, became the locus of such ambitions. Holger Cahill, the FAP director, encouraged volume of production out of a conviction that masterpieces arose from collective foundations. With the

MUSIC IN THE 1930S: A USABLE PAST

Loss and home, two defining themes for Depression culture, had powerful resonances in American music from the 1930s through World War II. Economic collapse and social chaos engendered a search for sustaining traditions: perhaps hope could be reclaimed by celebrations of American identity. American composers came home in the sense that many abandoned the modernist experimentation of the 1920s for fresh musical styles, reaching out to mass audiences in what Aaron Copland called the ideal of "accessibility."

Folk music was one important link between new music and new audiences. A country that in the early 1900s thought it possessed no folk music worthy of the name, the United States began to discover and to honor living folk musics among its rural and culturally marginalized populations. During the 1930s, John A. Lomax (famous as the "ballad hunter") and his son Alan crisscrossed the country many times, recording a prodigious inventory of song types and traditions—blues, hollers, English ballads, and cowboy songs. Aided by WPA programs in the arts (such as the Federal Theatre Project and the Federal Music Project), the Lomaxes made field recordings that became the basis of a revitalized Archive of American Folk Song at the Library of Congress. They and colleagues such as the ethnomusicologist Charles Seeger and his wife, Ruth, a composer and folk song arranger, stood at the center of the "urban folk revival" that made Woody Guthrie (fig. 464), Huddie "Leadbelly" Ledbetter, and Charles' son, Pete Seeger, into legends. The Seegers redefined regional vernacular art as national treasures and helped classically trained composers discover the musical vitality of "people's music."

Outstanding legacies from this period include a number of American classics, among them Aaron Copland's ballets *Billy the Kid* (Eugene Loring, choreographer, fig. 598), *Rodeo* (Agnes de Mille, choreographer, fig. 597), and *Appalachian Spring* (Martha Graham, choreographer, fig. 599). Copland's luminous orchestrations and reinventions of fiddle tunes, cowboy songs, and Shaker melodies ("Tis the Gift to Be Simple") pervade our aural landscape even today. Virgil Thomson, steeped in Midwestern Protestant hymnody, created two classic film scores, *The Plow That Broke the Plains* (1936) and *The River* (1937), both commissioned by Roosevelt's Farm Security Administration and directed by Pare Lorentz. The scores use hymn tunes, fiddle tunes, and blues to evoke an American sound. And Roy Harris, who in 1940 called folk music cultural "big business," subtitled his choral Symphony no. 4 "Folksong."

Thus American composers moved away from the "conceptual Americanism" of the 1920s, which advocated support for native composition, whatever the style, to a "compositional Americanism" in the 1930s, in which the integration of concert music with folk and popular culture—each revitalizing the other—became an important ideal. Musical memory and reclaimed tradition became cultural bridges to the future, repairing the loss of faith during the Depression and reinforcing cultural unity during wartime. —J. T.

464. *Woody Guthrie*, n.d.

COLONIAL REVIVAL: IDEALIZING THE PAST

Alongside the many "modern" styles that characterized the 1920s and 1930s, traditional styles flourished as well. Reacting against a constantly changing world, many Americans surrounded themselves with objects that were either made two centuries earlier or made to look as if they had been (fig. 465). Fearful of the machine age's disruptive influences and of new technologies that would unleash forces beyond human control, people sought solace in the American past. The seventeenth and eighteenth centuries were perceived as a pre-industrial idyll, before the advent of factories, anonymous cities, and the invasion of non-English-speaking immigrants threatened "traditional" American values.

Objects made before or just after the American Revolution were assigned the virtues of simplicity, self-sufficiency, purity, and integrity. Access to these objects could be obtained in many ways. A wealthy person could buy antiques, a middle-class person could buy reproductions, and anyone with an automobile and some leisure time could visit the past by taking a trip to Greenfield Village or Colonial Williamsburg.

Greenfield Village was an assemblage of old buildings (many, like Thomas Edison's laboratory, associated with the achievements of American heroes) that Henry Ford purchased in the late 1920s, brought to Dearborn, Michigan, and furnished with American antiques. Dedicated in 1929, the village was opened to the public about four years later. The sleepy and decaying town of Williamsburg, formerly the capital of Virginia, captured the imagination of John D. Rockefeller in 1926. Determined to restore it to its former glory, he proceeded throughout the 1930s to renovate its colonial buildings, demolish Victorian ones, and re-create those, like the Governor's Palace, that no longer existed. Thus, in an ironic turn of events, the funding for these paeans to an idealized, rural American past came from two people who helped transform the country into an industrial economy: Ford's cars created a newly mobile society; Rockefeller's oil monopoly provided its fuel.

America's new industrial wealth also provided Henry Francis du Pont, an heir to the family chemical and textile fortune, with the means to amass in his home outside Wilmington, Delaware, what became the country's largest collection of American decorative arts. From the 1920s to 1951 (when the collection was opened to the public as the Henry Francis du Pont Winterthur Museum), du Pont assembled his objects into two hundred period settings, buying historic interiors and building fragments in an attempt to recapture the lost world of America in the years between 1640 and 1840.

The new interest in the American past intensified in the 1930s. To a country mired in its worst economic depression, the eighteenth century seemed an especially comforting time. One WPA program—the Index of American Design—was created to document examples of folk and vernacular objects. About four hundred artists were hired to make

465. **Florence Kawa**
Textile, designed for the Works Progress Administration Handcraft Project, Milwaukee, c. 1940
Block-printed cloth, 64 x 44 in. (162.6 x 111.8 cm)
Franklin D. Roosevelt Library, National Archives, Washington, D.C.

exception of murals, which required approval of the sponsoring institution, Cahill allowed artists the freedom to explore any subject or style they desired as long as their work was professional. By affording artists the opportunity to paint full-time, he made it possible for members of a generation who might have been forced to take up other professions to develop their craft instead. Not the least of the contributions of the WPA was the camaraderie and sense of community it gave to artists who shared the experience of working for the same employer and standing in line together for a paycheck. As Barnett Newman later said, "I paid a severe price for not being on the project with the other guys; in their eyes I wasn't a painter; I didn't have the label."[116]

drawings of quilts, furniture, ceramics, ships' figureheads, and other artifacts (fig. 466).

Wallace Nutting embodies the almost messianic zeal with which many Americans embraced their material culture. A former Congregational minister, Nutting found a new religion in the Colonial Revival. He participated in all its manifestations: he was an important collector of seventeenth- and eighteenth-century furniture; he established a company that made reproductions of more than a thousand furniture forms from his collection; operated the Wallace Nutting Chain of Colonial Homes (which he restored, furnished with antiques, and opened to the public); and took sentimental photographs of staged colonial interiors that were marketed throughout the country. He proselytized for the cause in over twenty books, in which the perceived strength and character of the Colonial era are re-created through devoted imitation. —W. K.

466. *Magnus Fossum Copying the 1770 Coverlet "Boston Town Pattern" for the Index of American Design,* February 1940 Records of the Work Projects Administration, National Archives, Washington, D.C.

Conflicts between FAP officials and the art community over jobs, work conditions, and relief requirements existed from the beginning, but they intensified in 1936 following congressional cuts in WPA allocations. Strikes and sit-ins accelerated in the spring of 1937 in response to the 25 percent reduction in WPA funds. With the congressional election of 1938, the balance in Congress began to shift in favor of anti-New Deal conservatives, who saw Federal One as wasteful, inefficient, and too closely allied with leftist politics. The House Committee on Un-American Activities, established that year under the chairmanship of the Texas Democrat Martin Dies, charged Federal One with Communist infiltration, especially in its theater and writing divisions. With the ascension of the conservatives in 1939, this charge, although largely unsubstantiated, hastened the already declining fortunes of Federal One. That year, Congress eliminated the Federal Theatre Project entirely and placed the remaining three units of Federal One under the administration of Colonel Francis Harrington, who, unlike the agency's previous director, Harry Hopkins, had little sympathy for the federal government's employment of artists he regarded as otherwise unemployable. The 1939 relief act reduced WPA funding even more severely, limited employment on the payroll to eighteen months, and required loyalty oaths of all employees. In New York City, where 45 percent of FAP workers lived, the situation was made even more egregious by the appointment of Colonel Brehon Somervell as the city's WPA director. When Congress passed a bill in 1940 excluding Communists from WPA rolls, Somervell moved to ferret out anything that smacked of Communism, especially within the mural division. By 1941, with the onset of war, what remained of Federal One was directed toward the production of war propaganda and training aids. In 1943, as defense plants and the draft diminished the ranks of the unemployed, Roosevelt ordered all projects phased out.

FSA AND RURAL DOCUMENTARY PHOTOGRAPHY

A visual record of rural America was undertaken in the 1930s through the Information Division of the Resettlement Administration (RA), incorporated in 1937 into the newly created Farm Security Administration (FSA). Farmers were particularly hard hit during the Depression. Driven from their lands by devastating dust storms and drought, competition from mechanized agricultural practices, and the country's overall economic collapse, thousands of families headed West looking for work. The Resettlement Administration had been established in 1935 under Rexford Tugwell to assist these farmers with low-cost loans, land renewal projects, and resettlement. To counter anticipated hostility to the socialist aspects of the program, Tugwell created the Historical Section to document the nature of rural life, the necessity for federal assistance, and, ultimately, the success of RA policies. Tugwell appointed Roy Stryker, one of his former students and a colleague in the economics department at Columbia University, to head the Historical Section.

Stryker's mandate from Tugwell was to "introduce America to Americans," to document an aspect of American life that had been ignored or downplayed in order to generate awareness of it and provoke change.[117] As one RA photographer later remarked, "It was our job to document the problems of the Depression so that we could justify the New Deal legislation that was designed to alleviate them."[118] In this spirit, Pare Lorentz produced his two FSA documentary films, *The Plow That Broke the Plains* (fig. 469), which attributed the Dust Bowl to poor land use, and *The River* (fig. 468), which documented how unwise land use exacerbated the massive flooding of the Mississippi River.

Yet, as with Lorentz in his films, neither Tugwell nor Stryker felt it sufficient to show the causes of rural poverty; what had to be shown was the human consequences—and in a way that did not ridicule the afflicted, abuse their privacy, or present them as clichés. As Tugwell cautioned Stryker, "A man may have holes in his shoes, and you may see the holes when you take the picture. But maybe your sense of the human being will teach you there's a lot more to that man than the holes in his shoes, and you ought to try and get that idea across."[119]

Shortly after his appointment, Stryker saw a group of photographs by Dorothea Lange that did precisely what he envisioned. The photographs were part of a report prepared on California migrant workers by the agricultural economist Paul Taylor, who had been hired by the California State Emergency Relief Administration to help determine the most effective aid program for the enormous number of migrants pouring into California looking for work. Taylor, recognizing the importance of photographs in securing federal aid, had added Lange to the payroll. His final report, recommending that camps be built for migrant workers, included fifty-seven of Lange's photographs. These became models of the kind of photography Stryker wanted produced by the RA and FSA.

To achieve his goal of amassing a pictorial record of America, Stryker hired photographers of the first rank. This was what differentiated RA and FSA photographs from those produced during the Depression by other federal agencies, such as the Civilian Conservation Corps (CCC) and the National Youth Administration (NYA), which were likewise charged with collecting documentary evidence of rural life. Typically, the photographs taken under the auspices of these agencies were uncontroversial images that stressed recovery, stability, and well-being, and ignored all hint of crisis and breakdown (fig. 470). Although the FSA file contained many similarly affirming images, the majority focused on real problems and real situations.

Socially responsive documentary photography was not limited to the FSA. Photographers moved in and out of the unit, and some of the era's foremost

CINEMATIC DOCUMENTARIES FOR THE PEOPLE

While some Hollywood filmmakers addressed social issues, others responded to the Depression with Shirley Temple musicals, believing that audiences simply needed cheering up. But films made outside the studio system provided stark images of economic crisis and suggested radical solutions. Although these films never gained a large audience, they helped inaugurate an alternative tradition of film production. Eventually, Franklin Roosevelt's administration also produced films, using the medium to argue for reform programs, and thereby initiating a controversial relationship between government and media.

The roots of thirties documentaries lie largely with a small group of filmmakers associated with the Film and Photo League, a leftist political organization, and organizations that grew out of it, such as Nykino and Frontier Films. Politically committed filmmakers took their cameras out into the city streets and union halls. They used innovative techniques they had seen in classic Soviet films such as Sergei Eisenstein's *The Battleship Potemkin* (1925), Vsevolod Pudovkin's *Mother* (1926), and Dziga Vertov's *The Man with a Camera* (1929), with their aggressive editing styles, powerful emotional appeal, and raw, unglamorous approach to reality. Documentaries of strikes and demonstrations like the Bonus March contrasted sharply with newsreels shown in most theaters in terms of how they treated the same material. A number of these filmmakers were distinguished still photographers, such as Ralph Steiner and Paul Strand, whose film *Redes/The Waves* (1936), shot in Mexico, showed fishermen struggling against exploitation. Some documentaries, including Jay Leyda's *A Bronx Morning* (1931) and Conrad Freiberg's journey through Chicago, *Halsted Street* (1932), portrayed the inequalities and poverty of life in urban neighborhoods. *Pie in the Sky* (1934), a collaboration among Irving Lerner, Elia Kazan, Ralph Steiner, and Molly Day Thatcher, combined staged scenes and documentary footage, partly set in a junkyard, to create a satirical vision of the false promises of religion in capitalist society. Although most of these films reached only small audiences, the filmmakers longed to attract larger ones with productions such as *The World Today*, which adapted techniques employed in more mainstream newsreel films. Tom Brandon set up a national system of distribution known as Garrison films, which made prints available to union halls, political organizations, and college film societies across the country. Leo Hurwitz,

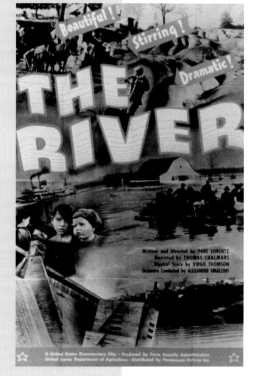

467. *The City,* directed by Ralph Steiner and Willard Van Dyke, 1939
The Museum of Modern Art, New York/Film Stills Archive

468. Poster for *The River,* directed by Pare Lorentz for the Farm Security Administration, 1938
Records of the Farmers Home Administration, National Archives, Washington, D.C.

Ben Maddow, Strand, and others produced a feature film, *Native Land* (1942), combining documentary and staged scenes with a strong argument for the unionization of workers. *Native Land* was shown in New York City and by political groups nationwide, but was never released to a wide audience.

The Roosevelt administration recognized the need for visual records of the Depression. Roy Stryker's Farm Security Administration (FSA) sent photographers throughout the country to capture images of the devastation in the Dust Bowl and the plight of American farmers. Such images made the crisis vivid to the public and were used to demonstrate the value of government policies. The film critic Pare Lorentz was hired to make films with the same mandate: inform and persuade. Although considerably less radical politically, Lorentz employed filmmakers from Nykino (including Steiner, Strand, and Hurwitz) to work on *The Plow That Broke the Plains*, a documentary whose striking images, dramatic editing, and powerful narration and musical score (by Virgil Thomson) explained the ecological disaster of the Dust Bowl and the government's response (fig. 469). The film gained wide exposure, being screened by national theater chains as a short subject along with Hollywood features. However, when this commercial use of film as propaganda for specific governmental policies was attacked by Republican politicians, the documentary was shorn of its original ending, which showed the government's proposed Greenbelt towns, designed to relieve the depressed conditions of farmers and urban slum dwellers.

Lorentz continued to work closely with Willard Van Dyke and Steiner on films that were visually powerful and had a driving rhythm born of the coordination of editing, musical score, and poetic narration. One such work is *The River*, which describes the system of federal dams to control flooding (fig. 468). The more politically radical filmmakers, however, felt that Van Dyke and Steiner had abandoned their revolutionary ardor, because their films expressed confidence in the federal government's ability to solve ecological and economic problems. The film Steiner and Van Dyke made for the 1939 New York World's Fair, *The City*, uses dynamic editing and carefully captured images of daily life to feel the pulse of the metropolis (fig. 467). Although less politically critical than Freiberg's *Halsted Street*, it also gained great popularity. The most interesting of Van Dyke's films, *Valley Town* (1940), deals rather facilely with workers losing factory jobs because of new technology. But it also uses songs by Marc Blitzstein in conjunction with strongly evocative editing to create an innovative interior monologue for the film's characters.

Whether radically critical or conceived as part of government reform policy, the documentaries of the thirties offered a vision of the Depression that had been excluded from Hollywood films. Moreover, the filmmakers' use of novel techniques and their attempt to set up alternative means of distribution and exhibition paved the way for later underground and experimental films. —T. G.

469. *The Plow That Broke the Plains,* directed by Pare Lorentz for the Farm Security Administration, 1936
The Museum of Modern Art, New York/Film Stills Archive

practitioners—Margaret Bourke-White (fig. 472), Doris Ulmann (fig. 475), and Lewis W. Hine, for example—never worked for it. Of the photographers Stryker initially hired for the agency, only Russell Lee remained with it until its demise. Walker Evans, Dorothea Lange, and Arthur Rothstein (fig. 473), all part of Stryker's original group, left between 1937 and 1940; others, such as Jack Delano, John Vachon, Gordon Parks, and Marion Post Wolcott (figs. 476–78), did not join until after 1937. Ben Shahn, an artist hired in the RA's Special Skills Division to make posters

470. **Wilfred J. Mead**
Civilian Conservation Corps Enrollee Wielding Sledgehammer, c. 1940
Records of the Civilian Conservation Corps, National Archives, Washington, D.C.

explaining what was being done for impoverished rural farmers (fig. 474), was an unofficial member of the photography section. Conceptually helpful to Stryker in formulating his goals for the agency, Shahn only occasionally submitted material to FSA files; his primary contributions of this nature were pictures he took surreptitiously with a right-angled view camera in Pulaski County, Arkansas, in 1935 (fig. 471).

FSA depictions of the plight of sharecroppers, tenant farmers, and Dust Bowl migrants compelled America to confront the disjunction between its ideals and its realities. The most famous of the many images that revealed these disjunctions was Bourke-White's photograph of African American flood victims waiting for food outside a relief agency in Louisville, Kentucky, underneath a billboard from the "American Way of Life" propaganda campaign of the National Association of Manufacturers (fig. 479). The dichotomy between the daily struggle faced by impoverished Americans and the implicit prosperity of big business produced pathos and visual irony— as in Dorothea Lange's photograph of two men with suitcases walking alongside a billboard advertising the benefits of travel on the Southern Pacific Railroad (fig. 480).

Such images made the anguish and suffering of those most burdened by the Depression real to millions of Americans. Lange, in particular, sought to use

471. **Ben Shahn**
Cotton Pickers, 1935
Gelatin silver print, 7⅜ x 8¾ in. (18.8 x 22.3 cm)
Gilman Paper Company Collection, New York
©Estate of Ben Shahn/V.A.G.A., N.Y.

her photographs as tools to effect social change. As in her famous *Migrant Mother,* taken in a migrant pea-pickers camp in California, she presented the universal in the guise of the particular (fig. 481). Even when Lange combined her images with commentary and the words of her subjects, as she and Paul Taylor did in the documentary book *An American Exodus* (1939), her subjects appeared not as individuals but as generic types (fig. 482). But it is precisely for this reason that they functioned

472. **Margaret Bourke-White**
Augusta, Georgia ("The Lord Jesus Is Coming Today"), 1937
Gelatin silver print, 13⅜ x 9⅞ in. (34 x 25.1 cm)
Bourke-White Collection, Department of Special Collections, Syracuse University Library, New York

473. **Arthur Rothstein**
Farmer and Sons, Dust Storm, Cimarron, Oklahoma, 1936
Gelatin silver print, 7½ x 7³⁄₁₆ in. (19.1 x 19.2 cm)
George Eastman House, Rochester, New York

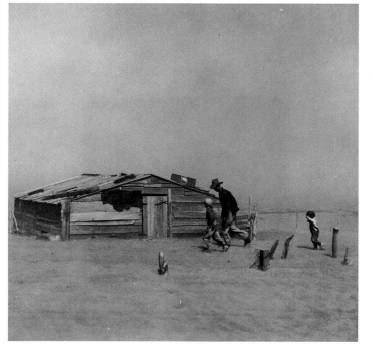

474. **Ben Shahn**
Years of Dust, 1937
Poster
Franklin D. Roosevelt Library, National Archives, Washington, D.C.
©Estate of Ben Shahn/V.A.G.A., N.Y.

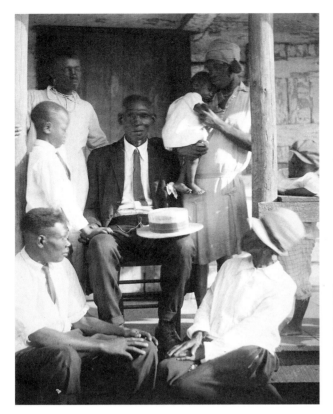

475. **Doris Ulmann**
*The Preacher's Family,
South Carolina*, c. 1930
Platinum print, 8 x 6 in.
(20.3 x 17.8 cm)
The Chrysler Museum of
Art, Norfolk, Virginia;
Museum purchase

476. **Gordon Parks**
*Black Children and White
Doll,* 1942 (printed later)
Gelatin silver print, 15⅜ x
19⅛ in. (39.1 x 48.6 cm)
Collection of the artist

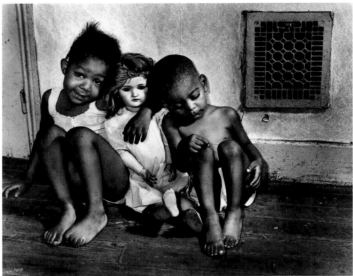

477. **Gordon Parks**
*American Gothic,
Washington, D.C.,* 1942
(printed later)
Gelatin silver print,
12⅞ x 9⅜ in.
(32.7 x 23.8 cm)
Collection of the artist

478. **Marion Post Wolcott**
*Two Young Couples in a
Juke Joint, near
Moorehaven, Florida*, 1939
(printed 1982)
Gelatin silver print, 11¹⁵⁄₁₆ x
8⅞ in. (30.3 x 22.6 cm)
Center for Creative
Photography, University of
Arizona, Tucson

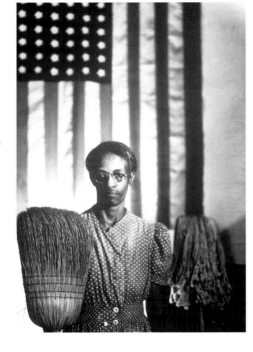

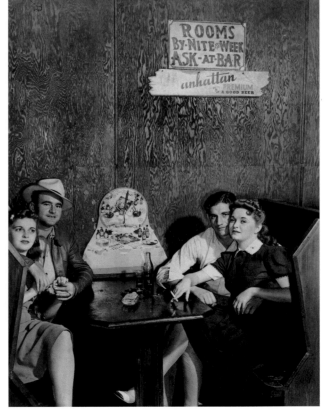

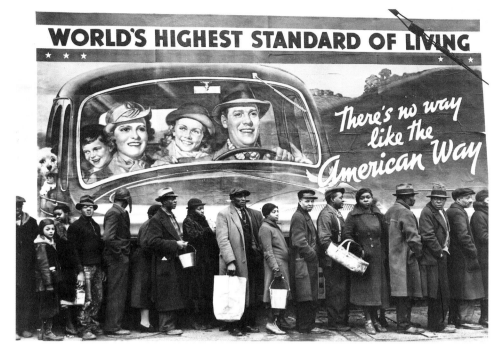

479. **Margaret Bourke-White**
The Louisville Flood, 1937
Gelatin silver print, 9¹¹⁄₁₆ x
13⅜ in. (24.6 x 34 cm)
Whitney Museum of
American Art, New York;
Gift of Sean Callahan
92.58

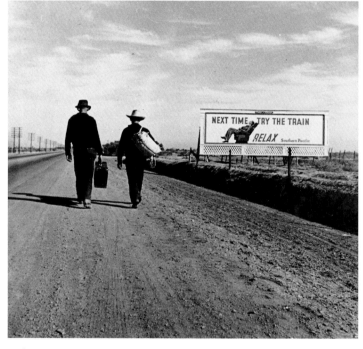

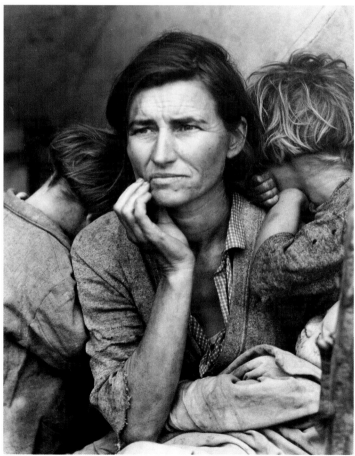

480. **Dorothea Lange**
*On the Road Toward Los
Angeles*, 1937
Gelatin silver print, 7⅜ x
7⅜ in. (18.7 x 18.7 cm)
CNF Transportation Inc.,
Palo Alto, California

481. **Dorothea Lange**
*Migrant Mother, Nipomo,
California*, 1936
Gelatin silver print, 9⅛ x
7 in. (23.2 x 17.8 cm)
Collection of Susie
Tompkins Buell

"IF YOU DIE, YOU'RE DEAD—THAT'S ALL."

Texas Panhandle, 1938

482. *An American Exodus: A Record of Human Erosion,* text by Paul Schuster Taylor, photographs by Dorothea Lange
New York: Reynal & Hitchcock, 1939
Frances Mulhall Achilles Library, Whitney Museum of American Art, New York

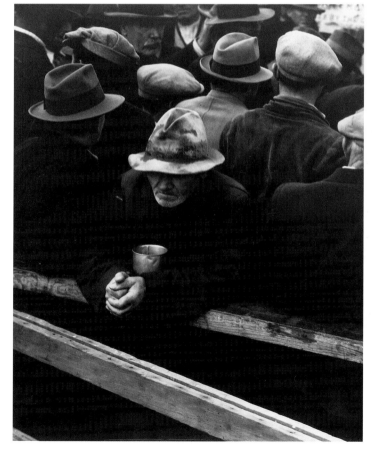

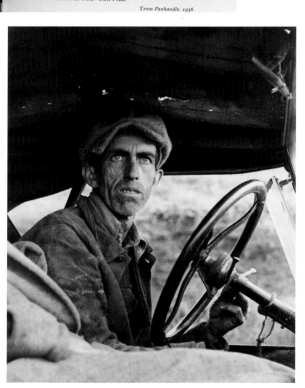

483. **Dorothea Lange**
The White Angel Breadline, San Francisco, 1933, 1933
Gelatin silver print, 13¼ x 10⅜ in. (33.7 x 26.4 cm)
Collection of Susie Tompkins Buell

484. **Dorothea Lange**
Ditched, Stalled, and Stranded, San Joaquin Valley, February, 1936, 1936
Gelatin silver print, 9⅜ x 7⅜ in. (23.8 x 18.7 cm)
Collection of Susan Ehrens and Leland Rice

so compellingly as human documents and elicited complex emotional responses (figs. 483, 484). The captions accompanying Lange's photographs inevitably shaped their meaning, as they did for all RA/FSA photographs. Photographers sent captions along with field reports to the FSA, but they were often changed in the editing process by Stryker or the publisher. Although Stryker considered Lange's captioning exemplary, the two often disagreed about where and in what form—and with what captions—her photographs would appear. Ultimately, the conflict led to Lange's dismissal from the agency in 1939.

The tension between the supposed authenticity of the photograph and its accompanying text was nowhere so pronounced as in *You Have Seen Their Faces*, the photo-essay book produced in 1937 by Bourke-White and the novelist Erskine Caldwell. Juxtaposing Bourke-White's photographs with fictionalized quotations that Caldwell felt expressed the sentiments of the individuals portrayed, the book delivered an impassioned indictment of Southern tenant farming. Although probably the decade's most influential protest against this tenancy practice, the book was nevertheless accused by some of sensationalizing the

PHOTO-ESSAYS

A powerful new form of communication—the photo-documentary essay—defined the mood of the 1930s and established photographic publishing traditions that continue to this day. Combining photographs and textual narration, the photo-documentary essay linked a closely related series of pictures to tell a "true-life story." Whether appearing as a captioned human-interest piece, hard-hitting exposé, academic report, or photographic meditation on a specific American locale, the photo-essay came to dominate photographic publishing in books and magazines by the mid-thirties.

This kind of photographic narrative was not, however, entirely new. Jacob Riis' pioneering publication, *How the Other Half Lives* (1890), had brought new social awareness of urban poverty through words and pictures, and articles in European photographic weeklies of the 1920s had introduced the picture-narrative format. But it was in the thirties that photo-essays became widespread, and they formed the basis for a plethora of new magazines and books. Technological advances that facilitated cheap, mass-produced reproductions were of course significant. But, more important, diverse audiences had developed an appetite for both the perceived truth of photographs and the drama of stories told through sequenced images. In some cases, such as Lewis W. Hine's *Men at Work* (1932), the extended photo-essay provided, from one remarkable picture to the next, a vision of America at work—and a more layered examination than the optimistic photographs of America's industrial development that were common at the time. Later in the decade, complex social documents proliferated in response to the tremendous challenges of the Depression. The photo-essay, along with movie house newsreels, provided some of the most informative and compelling portraits of Americans grappling with the realities of the era; it even seemed to promise a means of understanding seemingly incomprehensible social conditions.

To describe the current American scene, publishers commissioned photographers to crisscross the country and detail local social and geographic conditions. Significant support for photo-documentary essays came from new pictorial magazines—notably *Life* magazine, which announced its interest in "eye-witness reports" at its founding in 1936. Behind much of the sociological and photographic fieldwork of photographers and writers was enormous U.S. government patronage; the Farm Security Administration

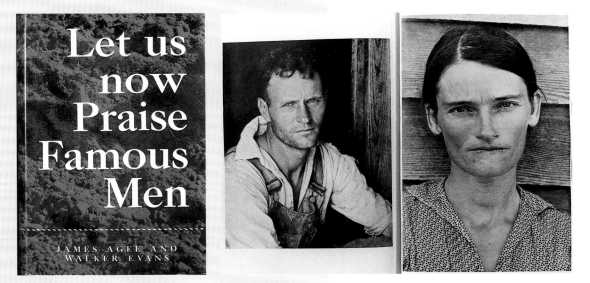

485. *Let Us Now Praise Famous Men,* text by James Agee, photographs by Walker Evans Boston: Houghton Mifflin, 1941 Frances Mulhall Achilles Library, Whitney Museum of American Art, New York

486. *Changing New York,*
text by Elizabeth
McCausland, photographs
by Berenice Abbott
New York: E. P. Dutton,
1939
Frances Mulhall Achilles
Library, Whitney Museum
of American Art, New York

supported work by Walker Evans and Dorothea Lange, among others, and disseminated free prints for purchase or publication.

This extraordinary patronage gave a sense of purpose, and in some cases unprecedented freedom, to photographers intent on delivering an aesthetic or social message through words and pictures. Some photographers, such as Arthur Rothstein, became masters of the magazine picture assignment. Others demanded and eventually received considerable autonomy. Walker Evans declared that his photographs for Carleton Beals' *The Crime of Cuba* (1933) were an independent indictment of the Machado regime. As the decade continued, some of the most important photographers increasingly insisted on the right to communicate their personal artistic visions and often politicized points of view. In 1935, Margaret Bourke-White persuaded *Fortune* to depart from its accustomed celebration of business to run her extensive coverage of the Dust Bowl. In the late 1930s, Walker Evans and the writer James Agee took a project commissioned by *Fortune* for a never-published article about tenant farmers and presented it as a book, *Let Us Now Praise Famous Men*, published in 1941 (fig. 485). The photographer and writer asserted in the preface that the photographs were "not illustrative" of the text, but "coequal, mutually independent, and fully collaborative."

This collaborative approach was also explored in a number of still-influential photographic books. *An American Exodus* (1939), created by Dorothea Lange and her husband, the agricultural economist Paul Taylor, chronicled the travels of dispossessed Dust Bowl farmers with documentary photographs, quotations from the farmers, and captions by the authors (fig. 482). Berenice Abbott's *Changing New York* provided a visual record of the architecture of New York City in the 1930s, enhanced with descriptive text by Elizabeth McCausland, the distinguished photography critic and advocate of the photo-essay (fig. 486). Interpreting the visual layers of past and present in a moment of massive urban development, the book presented such varied subjects as the lower Manhattan skyline, the Grand Opera House, Central Park Plaza, and small storefronts across the city. Erskine Caldwell, the celebrated author of *Tobacco Road* (1932), teamed up with Margaret Bourke-White to travel around the country and produce a documentary survey of Southern life, interviewing and photographing sharecroppers, members of chain gangs, and revivalists in *Say, Is This the U.S.A.* (1941; fig. 593). Richard Wright and Edwin Rosskam's *12 Million Black Voices* examined the deplorable conditions in which African Americans continued to live and work generations after slavery was abolished (fig. 487). Like the best of these photo-textual documents, it identified, through captions and diverse photographs, a poetry in people's looks, language, and history, just as it revealed the era's underlying belief that information can and should persuade and transform the public. —M. C.

487. *12 Million Black
Voices: A Folk History of the
Negro in the United States,*
by Richard Wright, photographs selected by Edwin
Rosskam, photograph on left
by Jack Delano, photograph
on right by Carl Mydans
New York: Viking Press,
1941
Frances Mulhall Achilles
Library, Whitney Museum of
American Art, New York

pathos of the farmers and thereby stripping them of dignity. Walker Evans, among Bourke-White's fiercest detractors, criticized her not only for her melodramatic camera angles and lighting but also for exploiting the plight of her subjects in order to maximize the propaganda impact.

Evans, in contrast, was scrupulous about preserving the dignity and self-respect of his portrait subjects. The task of documentary photography, as he saw it, was not to transform the actual but "to perceive the aesthetic reality within the actual world."[120] In his own photographs, he distilled beauty from even the humblest and most weathered of subjects. His ability to convey photographically the dignity, mystery, and profound sadness of even the simplest things—animate and inanimate—informed the photographs he took for *Let Us Now Praise Famous Men,* his 1936 collaboration with James Agee (fig. 485). Begun with a commission from *Fortune* to record the personal lives of three tenant families in Hale County, Alabama, Agee's manuscript was rejected by both *Fortune* and Harper and Brothers (which had contracted for it) and not published until 1941. The lukewarm reception the book received at that time has since been supplanted by almost universal acclaim. Agee's text, which drew its title from chapter 44 of Ecclesiasticus, gave full scope to the dignity of the powerless, the inevitability of their suffering, and the potential for their redemption. These expressions were well served by Evans' photographs, which communicated a profound reverence for the world as it is, along with an equally profound despair at irremediable suffering. His work did not propagandize his subjects' abominable poverty, but neither did it temper their grief.

The reverence and stillness that inflected Evans' portraits permeated his photographs of torn posters, weather-beaten buildings, vernacular architecture, Model A Fords, and domestic interiors (figs. 488, 490–92). Muted and quiescent, his work exudes respect for the process of survival and the endurance of the past. These same subjects drew the attention of other documentary photographers, as if the recording of weathered and handmade artifacts expressed appreciation for cultural life outside the urban and industrial mainstream. Nostalgia for a way of life nearly extinguished by mass-production culture was particularly evident in the work of Doris Ulmann. Using a soft-focus lens and extended exposures, Ulmann transformed her subjects into icons of pre-modern simplicity and valor (figs. 475, 493).

The America these documentary photographers emphasized was generally one of forlorn, homeless, poverty-stricken people. Yet however poignant and heartbreaking, these photographs also chronicled strength, courage, and perseverance. There is an innocence about them, a belief in America and the American dream—a faith in the nation and its ultimate ability to triumph over adversity (fig. 489). It is the coexistence of these dichotomies—suffering and dignity, exploitation and inner strength—that endowed RA/FSA photographs with their power. Stryker, years later, identified this conjunction as central to RA/FSA photographs: "You could look at the people and see fear and sadness and desperation. But you saw something else, too. A determination that not even the Depression could kill.

490. Walker Evans
Torn Movie Poster, Truro, Massachusetts, 1930
Gelatin silver print, 6¼ x 4�- / ⁻ in. (15.8 x 10.6 cm)
The Art Institute of Chicago; Gift of Mrs. James Ward Thorne

491. Walker Evans
Negro Church, 1936
Gelatin silver print, 5⁷/₁₆ x 3⁷/₁₆ in. (13.8 x 8.7 cm)
Whitney Museum of American Art, New York; Purchase, with funds from the Photography Committee 97.68

492. Walker Evans
Joe's Auto Graveyard, Pennsylvania, c. 1936
Gelatin silver print, 8¼ x 13 in. (21 x 33 cm)
Collection of Dr. and Mrs. Barry S. Ramer

The photographers saw it—documented it."[121] What had started out as a report on the immediate impact of severe economic depression had ended as a celebration of American resiliency and values.

This mythology of the fortitude and indestructibility of "the people" was exemplified in Carl Sandburg's poem "The People, Yes" (1936) and in John Steinbeck's novel *The Grapes of Wrath*. "We ain't gonna die out," Ma Joad declared toward the end of the book. "People is goin' on—changin' a little, maybe, but goin' right on." The redemptive certainty of her utterance was made even more affirmative in the 1940 movie version (fig. 494): "We're the people that live. They can't wipe us out. They can't lick us. We'll go on forever, Pa, cause we're the people."[122] Like *The Grapes of Wrath*, FSA photography ultimately projected perseverance and hope.

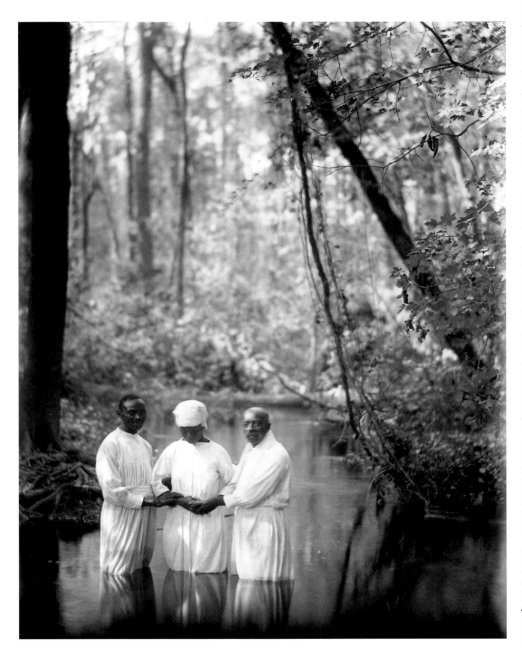

The shift from national self-scrutiny to national celebration was pervasive. In a spirit of discovery, writers had taken to the road in the early 1930s in the hope of understanding their country and the traditions of American life. They had begun on a note of insecurity and uncertainty: "We don't know / We aren't sure," Archibald MacLeish had lamented in the opening passages of *Land of the Free* (fig. 495).[123] Similar doubts about America had been expressed in Sherwood Anderson's *Puzzled America* (1935), Edmund Wilson's *The American Jitters* (1932), and Theodore Dreiser's *Tragic America* (1931). In the end, the search reaffirmed faith in the nation and inspired reverence for things felt to be quintessentially American. From Thornton Wilder's *Our Town* (1938) to Sherwood Anderson's *Home Town* (1940), the subject became not failure but hope, not criticism but praise.[124] Just as *Life* magazine had announced its intent in 1937 to document life in the United States so that readers could "take stock of some of the abiding things which are magnificently *right* about America," so too did writers and photographers find in the strength, dignity, and endurance of the average American assurance against the insecurities wrought by the Depression.[125] "Oh my America—my new-found-land," MacLeish exulted. "How blest am I in this discovering thee!"[126]

494. Left: *The Grapes of Wrath,* by John Steinbeck New York: Viking Press, 1939
Berg Collection of English and American Literature, The New York Public Library, Astor, Lenox and Tilden Foundations

Right: Henry Fonda, Jane Darwell, and Dorris Bowdon in *The Grapes of Wrath,* directed by John Ford, 1940
The Museum of Modern Art, New York/Film Stills Archive

495. *Land of the Free,* by Archibald MacLeish, photograph by Dorothea Lange New York: Harcourt Brace, 1938
Frances Mulhall Achilles Library, Whitney Museum of American Art, New York

We told ourselves we were free because we were free.
We were free because we were that kind.
We were Americans.
All you needed for freedom was being American.
All you needed for freedom was grit in your craw
And the gall to get out on a limb and crow before sunup.
Those that hadn't it hadn't it.
"Have the elder races halted?
Do they droop and end their lessons wearied over there beyond the seas?
We take up the task eternal and the burden and the lesson —
Pioneers O Pioneers."

We told ourselves we were free because we said so.

We were free because of the Battle of Bunker Hill
And the constitution adopted at Philadelphia

THE URBAN AMERICAN SCENE

The desire to reaffirm faith in America by depicting daily life was as widespread among urban painters as among rural ones. But the urban American Scene painters did not satisfy their longing for stability by turning to the American past; they found stability in the everyday life of the present. The New York neighborhood of 14th Street around Union Square, where these artists had studios, furnished many of them with a name—the 14th Street School—and a subject matter: shoppers, office workers, and salesgirls. The unofficial leader of the group was Kenneth Hayes Miller, an instructor at the Art Students League since 1911, who looked to the order and simplicity of classical and Renaissance art as a model for painting his vernacular subjects. Unlike his Ashcan predecessors, Miller emphasized formal qualities over personalized responses to subject matter and aimed for idealized generalizations over individualized depictions. Tubular and weighty, his forms are evenly painted, carefully modeled, and generally frontal (fig. 496). Using a classical mode, Miller created images of matronly shoppers that affirmed the optimism, promise, and success of commercial urban America. His middle-class matrons promote the image of women as patient, stable, and nurturing. Icons of domesticity and consumption, they personified the back-to-the-home movement and its stereotype of the homemaker as skilled professional that had emerged in the twenties out of the prosperity and postwar desire for normalcy. Miller's depiction of the 14th Street neighborhood as crowded and thriving avoided all reference to poverty or ethnicity. Instead, his idealized figures proposed an optimistic vision of a homogeneous urban community whose commercial rituals bespoke the fundamental well-being of American society.

Under Miller's guidance, his students took their compositional cues from Renaissance and Baroque artists and their subject matter from street life—even though this life was far removed from their own. Edward Laning came from a distinguished Illinois family, Isabel Bishop was married to a prominent neurologist, and Reginald Marsh, the scion of well-to-do artist parents, enjoyed the benefits of prep school and Yale University.

496. **Kenneth Hayes Miller**
Shopper, 1928
Oil on canvas, 41 x 33 in.
(104.1 x 83.8 cm)
Whitney Museum of
American Art, New York;
Purchase 31.305

497. **Yasuo Kuniyoshi**
Café, 1937
Oil on canvas, 16 x
12⅛ in. (40.6 x 30.8 cm)
Whitney Museum of
American Art, New York;
Purchase 37.40
©Estate of Yasuo
Kuniyoshi/V.A.G.A., N.Y.

Among Miller's students, Bishop was unique in depicting intimate exchanges between young, female office workers (fig. 498). Using an all-over, close-valued palette, and a mottled background of repeating horizontals, she created a fluid, weblike surface that linked foreground, background, and figure. Luminous and soft, her work entices the viewer to draw close, to witness the fleeting private moments that Bishop, from the sanctuary of her studio, froze in time.

As women renewed their covenant with femininity in the post-flapper era, the siren assumed her place as female role model alongside Bishop's office worker and Miller's housewife. A pervasive stereotype in thirties film, the siren's everyday counterpart played a central part in Reginald Marsh's paintings (figs. 499, 500). In recasting the voluptuous movie queen in a common-place role, Marsh revealed his own ambivalence toward her earthy vulgarity. Like Willem de Kooning several decades later, he saw her as an object both of desire and of sexual danger, her overt sexuality at once irresistibly alluring yet frightening.

Marsh's work recorded his exhilaration in the vibrancy and energetic pace of city life. Every part of his densely cluttered, multifigured paintings abounded with a vitality and visual turbulence that had far more in common with Thomas Hart Benton than with the classical realism of his urban peers. Much of this stemmed from Marsh's characteristic technique of applying choppy, calligraphic brushwork onto a background of patchy, thinly applied tempera (a medium to which he was introduced by Benton). The effect is of a continual surface flickering, which causes the eyes to move without rest from place to place across the painting. The sense of agitated and accelerated movement that resulted was heightened by Marsh's asymmetrically framed scenes and avoidance of an obvious focal point. Echoing movie conventions, both devices suggest the sequential unfolding of episodes across the canvas surface.

Like that of many Miller students, the art of Japanese-born Yasuo Kuniyoshi was essentially graphic, with brushwork that allowed for varying textures, ranging from heavy, rich impastos to delicate, transparent glazes. Women were Kuniyoshi's chief subject, but in contrast to Marsh's confident, self-possessed females, Kuniyoshi's women are always alone, pensive and brooding, in varying states of undress, smoking or holding newspapers. Voluptuously sexual in their weariness and languor, they exude a tragic vulnerability, as if despondent about having ceded their independence to an undisclosed other for whom they passively wait (fig. 497).

Very different are Walt Kuhn's brooding, richly textured paintings of acrobats, clowns, and showgirls. Strident, high-keyed color and expressive paint handling create psychologically complex portraits whose rigid, hieratic pose and frontal gaze reinforce the figures' volumetric solidity. Set against monochromatic backgrounds, Kuhn's portrait subjects are at once commanding, sad, and impassive. Most of his models came from the world of theater; all underwent transformation in his studio as he attired them in circus costumes from his collection (fig. 501).

498. **Isabel Bishop**
Lunch Hour, 1939
Oil and tempera on panel,
27 x 17½ in. (68.6 x
44.5 cm)
Collection of Mr. and Mrs.
John Whitney Payson

499. Reginald Marsh
Hudson Bay Fur Company,
1932
Egg tempera on muslin
mounted on board,
30 x 40 in. (76.2 x
101.6 cm)
Columbus Museum of Art,
Ohio; Museum Purchase,
Howald Fund

500. Reginald Marsh
Twenty Cent Movie, 1936
Egg tempera on board,
30 x 40 in. (76.2 x
101.6 cm)
Whitney Museum of
American Art, New York;
Purchase 37.43

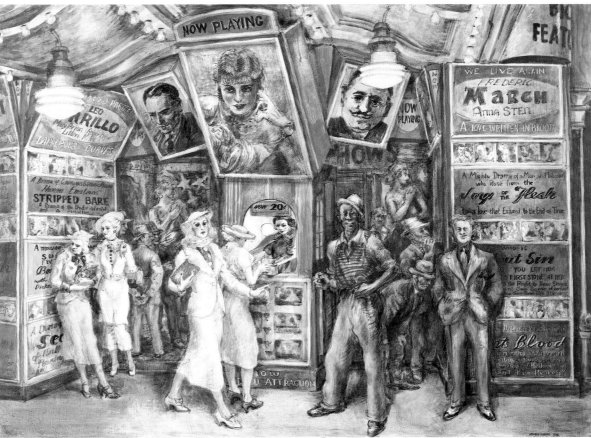

501. **Walt Kuhn**
Plumes, 1931
Oil on canvas, 40 x
30⅛ in. (101.5 x 76.5 cm)
The Phillips Collection,
Washington, D.C.; Acquired
1936

502. **Archibald Motley, Jr.**
Black Belt, 1934
Oil on canvas, 31⅞ x
39¼ in. (81 x 99.7 cm)
Hampton University
Museum, Virginia

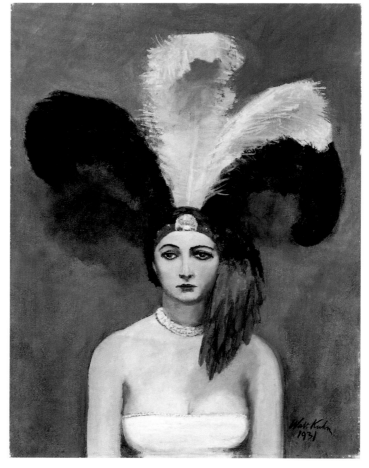

503. **William H. Johnson**
Café, c. 1939–40
Oil on paperboard, 36½ x
28⅜ in. (92.7 x 72.2 cm)
National Museum of
American Art, Smithsonian
Institution, Washington,
D.C.; Gift of the Harmon
Foundation

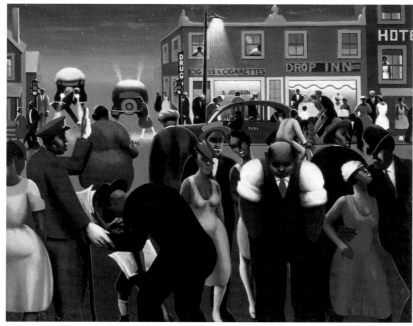

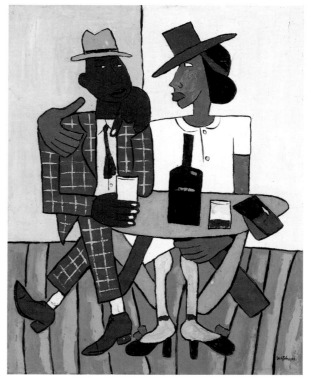

Kuhn emphasized the tawdry aspect of urban entertainment; others exulted in its exuberant disregard of hard times. Indeed, from the lindy hop and the swing bands of Benny Goodman and Tommy Dorsey to the musicals and screwball comedies of Hollywood, American popular entertainment offered the public temporary respite from the difficult realities of the present. Nightclubs and dance halls continued to thrive after the repeal of Prohibition. Although white patronage of clubs in Harlem and Chicago's South Side declined, African Americans kept flocking to them to drink and dance. Archibald Motley, Jr., recorded this world, as did William H. Johnson following his return from Europe in 1938 (figs. 502, 503). Desiring to "paint his own people" in a style that fused the geometric severity and patterning of African art with the primitivism of folk expression, Johnson evolved a painting technique characterized by angularity,

BIG BAND SOUND

In late 1935, during Benny Goodman's landmark engagement at the Palomar Ballroom in Los Angeles, a bemused reporter for *Metronome* wondered out loud whether he was "attending a dance in a ballroom or some new and weird type of orchestral recital. . . . The dancers literally swarmed to the platform and though they came to dance they stood around to listen and applaud." When Goodman opened at the Paramount Theatre in New York in early 1937, the tens of thousands who packed the first day's shows disconcerted the management by shouting, whistling, and dancing in the aisles. These and other displays of youthful enthusiasm were unmistakable signs of the revolution in popular culture that has come to be known as the swing era.

In its musical essentials, the typical swing arrangement was deceptively simple. A rhythm section of piano, string bass, drums, and acoustic guitar set out a steady foundation beat for the dancers, strong enough to resonate in the cavernous spaces of the major ballrooms (the Savoy Ballroom in Harlem took up an entire city block), yet subtle and supple enough to inspire the whole band. Choirs of saxophones, trombones, and trumpets harmonized short, bluesy fragments called riffs, often tossing them back and forth in call-and-response fashion. Soloists took turns displaying their prodigious capacity for rhythmic and melodic invention. The music could be informal and demotic, as in the "head arrangements" collectively conceived by bands such as Count Basie's orchestra from Kansas City, or elegant and intricate, as in the compositions of the inimitable Duke Ellington (fig. 504). Swing was welcome everywhere, from tobacco warehouses in the South (where two flatbed trucks parked together often served as an impromptu stage) to New York's venerable Carnegie Hall.

Despite the furor over its emergence in 1935, swing itself was nothing new. The word "swing" had been in use among musicians for some time, referring to the relaxed, four-beats-to-the-bar rhythmic style preferred by lindy hoppers at the Savoy (fig. 505). What *was* new was the integration of this music into American mass-market entertainment—bands were heard on nationwide radio broadcasts, on records at the local corner café, and in live performances in ballrooms and former vaudeville theaters. Once-anonymous bandleaders now rivaled movie stars in popularity. Their bands offered a comprehensive package of entertainment: dance music, popular song (as performed by singers and instrumentalists), comedy and variety, as well as the exacting discipline of jazz improvisation.

All of this had an indelible effect on the culture at large. The music of the swing bands smoothly integrated African American aesthetic values into a new image of national identity. According to the historian David Stowe, swing was the "preeminent musical expression of the New Deal: a cultural form of 'the people,' accessible, inclusive, distinctively democratic, and thus distinctively American." Its irresistible rhythms became the sound track for America's recovery from the Depression. —S. D.

504. *Duke Ellington and His Orchestra*, n.d.

pictorial flatness, and strong, bold color. The unequivocal celebration of urban life did not, however, consume the total attention even of Miller's students. Marsh's work, for example, expressed an ambivalence about the alienation and loss of identity engendered by the city's dazzling overload of sensations and by its homogenizing consumer culture. Yet, like Bishop in occasional canvases (fig. 513), Marsh remained an observer rather than a critic, even when he turned more overtly to scenes of poverty and social dislocation (fig. 509). To him, the plight of the underprivileged was inevitable, a condition that obviated the value of protest art.

This was true as well of the Soyer brothers—Isaac, Moses, and Raphael—who chose to address the economic realities of Depression America by painting the pathos of ordinary people. "Yes, paint America, but with your eyes open," Moses Soyer asserted. "Do not glorify Main Street. Paint it as it is—mean, dirty, avaricious."[128] Among the last wave of eastern European Jews to come to America before the passage of restrictive immigration legislation in the twenties, all three brothers specialized in figures that were psychologically isolated, melancholy, and bored. Unlike the majority of their American Scene colleagues, they documented the depressing mood of the period, depicting individuals who were passive rather than

DEPRESSION-ERA SOCIAL DANCE

As attitudes about "night life" shifted during the first twenty years of the century, a dance fever gripped America. "Steppin' out" became respectable, and ballroom dance contests flourished. Dance competitions had always been part of American social dance, and in the 1920s "dance marathons" became popular. The dance marathon had egalitarian appeal. Anyone could enter, but only the strong would win. A dance marathon was exciting, cheap entertainment that lasted twenty-four hours a day, seven days a week. It was estimated that by 1929 dance marathons had taken place in most American cities.

By 1929, dance marathons had turned into variety shows, or "walkathons," with professional contenders, emcees, and vaudeville acts. During their peak popularity in the 1930s, they were dramatic paradigms for getting through the Depression: you may be broke, but you remain upright and endure. Walkathon contestants had to walk the floor (usually photographed as exhausted dancers holding each other up) for forty-five minutes, with a fifteen-minute break each hour, twenty-four hours, seven days a week.

It was during a regular dance contest in 1928 that the "lindy hop" was named by Shorty Snowden in honor of Charles Lindbergh's bold "hop" across the Atlantic the year before. Appropriately, Snowden was a dancer at Harlem's Savoy Ballroom, where the dance reached its most extraordinary levels of perfection. Overlapping with the Charleston, the lindy (also called swing, jitterbug, jive) contained Charleston-like ingredients—the oppositional flinging of the limbs, the wild, unfettered quality, the upbeat tempos, and the side-by-side dancing of partners.

The lindy's most notable feature was the "breakaway," when partners split apart or held on to each other with one hand. At the Savoy Ballroom, spectacular maneuvers were added. In the mid-1930s, dancers started doing heart-stopping aerial throws that sent the woman orbiting around her partner. Thus the lindy hop continued to celebrate flight—with fragile human physicality—recognizing in movement a technology that altered the twentieth century. Initially through movies, music, and newsreels, and then through the dancing of American GI's in World War II, the lindy was taken to the world. —S. S.

505. *Lindy Hoppers,* n.d. Dance Collection, The New York Public Library for the Performing Arts, Astor, Lenox and Tilden Foundations

purposeful, who endured rather than protested (figs. 510–12). Such passivity was even more profoundly portrayed in Edward Hopper's work, which continued in the 1930s to register a resigned sadness for those aspects of urban and rural America rendered obsolete by industrialization and mass culture (figs. 514, 515).

Within the photography community, the task of creating documents that would speak to contemporary urban social realities fell to members of the New York City-based Photo League. The Photo League was one of two offshoots of the Workers Film and Photo League, which had been established in 1930 for the purpose of creating photographic records of the "class struggle" and assuring the flow of illustrations to radical publications. In 1936, the group split into two separate entities: Frontier Films and the Photo League. The Photo League, under the leadership of Sid Grossman and Sol Libsohn, retained the parent group's vision of photography as an agent of social change, but replaced its sectarian, Communist outlook with a broader, more humanistic approach. The League ran a school, organized exhibitions, published a newsletter called *Photo Notes*, and sponsored lectures and symposia. Open every evening and every weekend to amateurs and professionals alike, the League functioned as a place for photographers to meet and share information. In addition to Grossman and Libsohn, members included Walter Rosenblum (fig. 506), Dan Weiner, David Robbins, Ruth Orkin, Arthur Leipzig, and Aaron Siskind, all of whom favored a straightforward documentary style and a socially responsive subject matter. Within these guidelines, however, the group accommodated a wide range of styles. The premium it placed on social responsibility led to a number of collective, documentary projects that combined word and image to engender social awareness (figs. 507, 508, 519). The largest of these projects was "Harlem Document," produced between 1937 and 1940 by a team of eight photographers headed by Aaron Siskind in collaboration with Michael Carter, the editor of *Photo Notes*.

The "Harlem Document" ended just as the Photo League came under an FBI investigation arising out of Grossman's purported association with Communists. Most of the League's members were, in fact, politically left of center and some were even members of the Communist Party, but neither Grossman nor the organization was openly involved in politics. Nevertheless, in 1947, after seven years of investigation, the attorney general concluded that the League was a subversive Communist front organization. With newspapers and magazines unwilling to review League exhibitions or publicize its events, and photographers afraid of being blacklisted, membership declined and the League finally disbanded in 1951.

The Photo League, even in its heyday, did not include all the photographers dealing with the urban environment. Indeed, RA/FSA photographers documented city residents almost as frequently as country ones (figs. 516, 517, 520). Other photographers, whether working under the auspices of the Federal Art Project like Berenice Abbott, or working independently like Margaret Bourke-White and Alfred Stieglitz, favored architectural subjects, which lent themselves to an emphasis on formal problems over social issues. For them, New York was the apotheosis of modern urbanism, a meeting place of the past and the present. Abbott's project to document the changing appearance of New York engaged her from 1929 to 1939 and encompassed over three hundred images (figs. 486, 518). For Stieglitz, no longer able to handle a camera easily, those years marked the decline of his active photographic life. In 1937, at age seventy-three, he stopped taking pictures.[129]

506. **Walter Rosenblum**
Pitt Street, Three Children on Swings, 1938
Gelatin silver print, 7½ x 9½ in. (19.1 x 24.1 cm)
Collection of Naomi and Walter Rosenblum

507. **Aaron Siskind**
Untitled, from the series *Harlem Document,* 1939
Gelatin silver print, 13⅜ x 10⅜ in. (34 x 26.4 cm)
Whitney Museum of American Art, New York; Gift of Alice and Leo Yamin 92.48

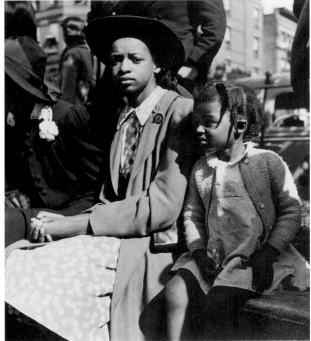

508. **Aaron Siskind**
Parade Watchers, 1940
Gelatin silver print, 7⅜ x 6⅜ in. (18.8 x 16.2 cm)
George Eastman House, Rochester, New York

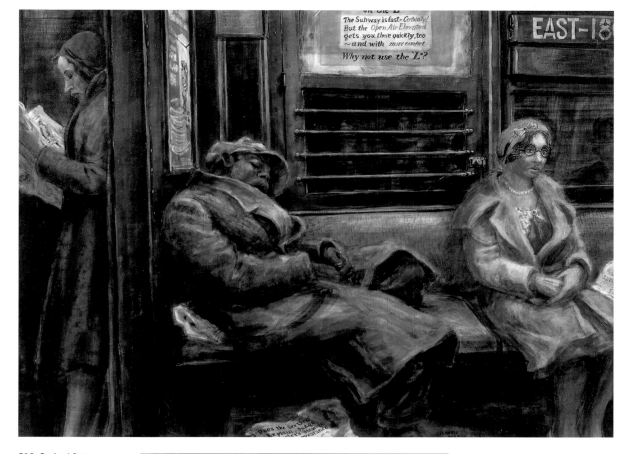

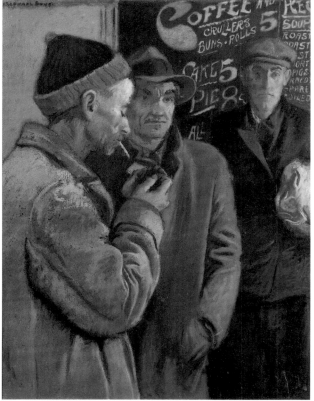

511. Raphael Soyer
The Mission, c. 1935
Lithograph, 12⅛ x 17¹¹⁄₁₆ in.
(30.8 x 44.9 cm)
Whitney Museum of
American Art, New York;
Purchase 36.59

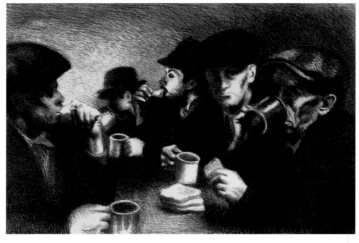

512. Isaac Soyer
Employment Agency, 1937
Oil on canvas, 34¼ x
45 in. (87 x 114.3 cm)
Whitney Museum of
American Art, New York;
Purchase 37.44

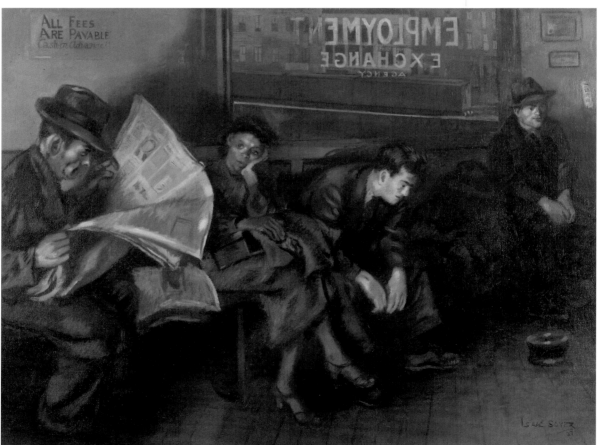

513. **Isabel Bishop**
Waiting, 1937–38
Oil and tempera on panel,
29 x 22¼ in. (73.7 x
56.5 cm)
The Newark Museum, New
Jersey; Purchase 1944,
The Arthur F. Egner
Memorial Fund

514. **Edward Hopper**
New York Movie, 1939
Oil on canvas, 32¼ x
40⅛ in. (81.9 x
101.9 cm)
The Museum of Modern
Art, New York; Given
anonymously

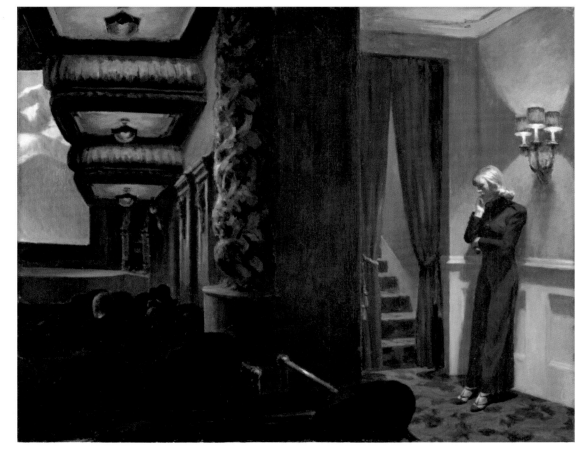

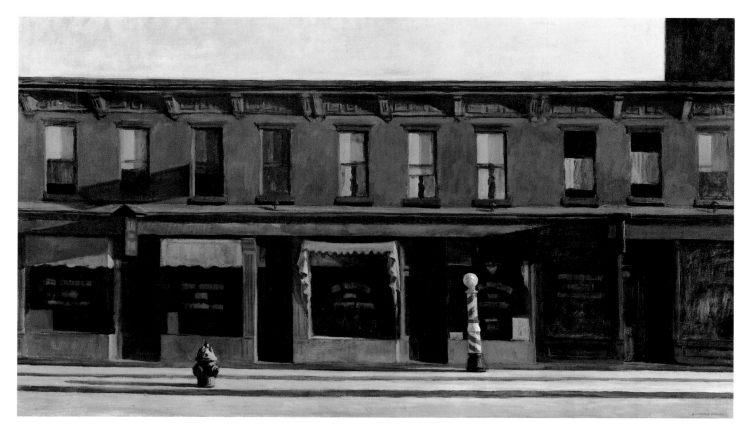

515. **Edward Hopper**
Early Sunday Morning,
1930
Oil on canvas, 35³⁄₁₆ x
60¼ in. (89.4 x 153 cm)
Whitney Museum of
American Art, New York;
Purchase, with funds from
Gertrude Vanderbilt
Whitney 31.426

516. **Walker Evans**
Girl in Fulton Street,
New York, 1929
Gelatin silver print, 7½ x
5¼ in. (18.8 x 13.2 cm)
The Museum of Modern
Art, New York; Purchase

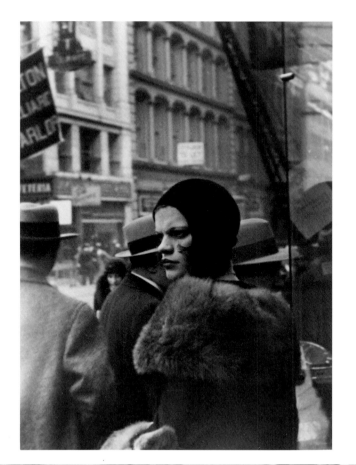

517. **Walker Evans**
Couple in Car, Ossining,
New York, 1932, 1932
(printed 1974)
Gelatin silver print, 6⁷⁄₁₆ x
9¾ in. (16.3 x 24.8 cm)
Center for Creative
Photography, University
of Arizona, Tucson

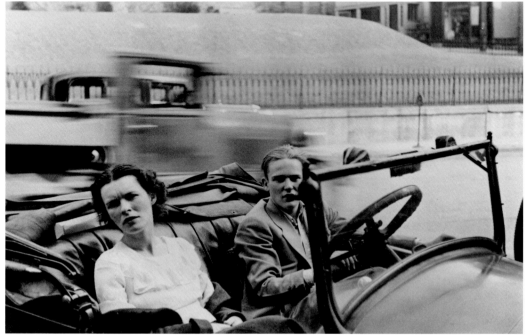

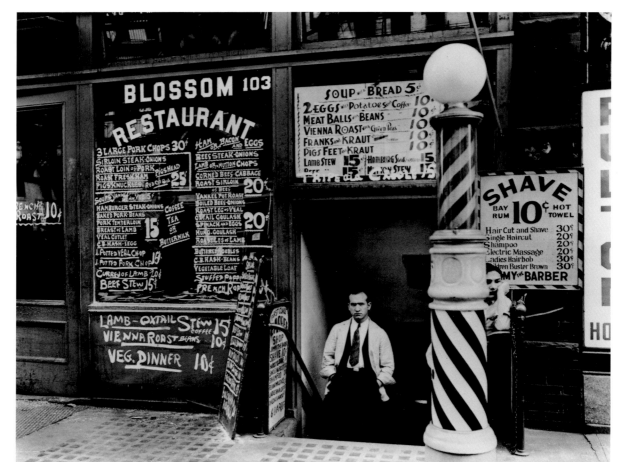

518. **Berenice Abbott**
Blossom Restaurant, 103 Bowery, Manhattan, October 24, 1935, from the Federal Art Project series *Changing New York,* 1935
Gelatin silver print, 8 x 10 in. (20.3 x 25.4 cm)
Museum of the City of New York

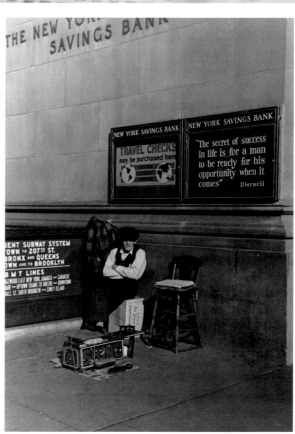

519. **Arnold Eagle** and **David Robbins**
Untitled, from the Federal Art Project series *One-Third of a Nation,* 1938
Records of the Work Projects Administration, National Archives, Washington, D.C.

520. **Arthur Rothstein**
Bootblack, Corner of 14th Street and 8th Avenue, New York City, 1937
Library of Congress, Washington, D.C.

CHOREOGRAPHY IN FILM

The years between 1930 and 1945 constituted a golden age of dance on film. But then it was also a golden age of dancers: John Bubbles and Bill Robinson, arguably the most elegant tap dancers of their era; the power hoofers Ruby Keeler and Eleanor Powell; the brothers Fayard and Harold Nicholas, whose flash act featured flying acrobatics that landed them in toothpick-straight splits; and a host of vaudevillians and musical-comedy stars, among them the ardent and open-armed Gene Kelly and the impeccable stylist and comedian Donald O'Connor.

It was also a period of vivid, sometimes dazzling partnerships: Fred Astaire and Ginger Rogers (fig. 521), Bill Robinson and Shirley Temple, O'Connor and Peggy Ryan. And it was a time when ballet was so venerated that the Disney Studios used ballet dancers as the models for the dancing ostriches and hippos cavorting on pointe in its 1940 animated film *Fantasia*. The model for this Disney sequence was George Balanchine's dreamlike "Water Nymph Ballet," starring Vera Zorina, in *The Goldwyn Follies* (1938). Balanchine also directed and choreographed the glamorous and poignant ballets in the 1939 movie *On Your Toes*, based on the Broadway show. He proved to be a wonderful director of ballet on film—sensitive to faces in close-up as well as to bodies at middle distance, and he used the technical resources of the sound stage and editing room to capture emotion and choreographic form alike.

For most of America, however, Busby Berkeley (at Warner Brothers) and Astaire (especially in partnership with Rogers at RKO Studios) represented the great poles of movie dancing in this period. Both frequently worked in the genre of the "backstager"— a musical whose pretext for dance numbers was the onstage performances of show people. (Astaire would dance their offstage impulses as well.)

Although Berkeley came from a theatrical family and had choreographed twenty-one Broadway musicals before he arrived in Hollywood to make his first one for film, he had never studied dance. He got his start as a dance director in the army during World War I, when, as the conductor of parade formations, he worked out "trick" drills to relieve his boredom with the standard routines. Collaborating with the art director Richard Day on the 1930 movie translation of the Ziegfeld show *Whoopee!*, Berkeley seems to have arrived at the practice that influenced everything else he would do for Hollywood—that is, to use only a single camera for dance numbers and to plan every shot in advance rather than, as was customary, to film a dance number from several directions and splice together excerpts afterward. He choreographed for the camera: his dance continuity was located in the lens rather than in the movements of the bodies it regarded (fig. 522). The camera's motion, its self-reflexive conversations between close-ups and long shots, its vertiginous perspectives—notably the Berkeley "top shot," peering down on the synchronized formations of the chorus from high overhead—constituted the choreography proper of his dances.

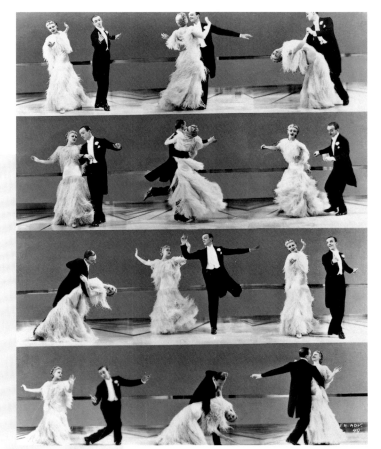

521. Fred Astaire and Ginger Rogers in dance sequence from *Top Hat*, directed by Mark Sandrich, choreographed by Fred Astaire, 1935
The Museum of Modern Art, New York/Film Stills Archive

Fred Astaire, in contrast, had studied several kinds of theatrical dancing intensively since childhood and arrived in Hollywood as a Broadway star, recently cut loose from his first dancing partner, his sister, Adele, who left the act to get married. By the time Astaire established himself at RKO in the early thirties, he was also an experienced stage choreographer. Although the nine pictures he made with Ginger Rogers for that studio contain dance numbers for large groups, his contributions were restricted to the duets he danced with Rogers—which he worked out with his assistant, Hermes Pan—and his solos. A famous Astaire quip goes, "Either the camera dances, or I do." At RKO, where he had freedom and rehearsal time, he and his team produced a group of dance films that are still without equal. Astaire, who enjoyed a superstar's control over the production of his films, insisted that the dancers be presented full figure and, if possible, the dances be shot continuously from beginning to end. His duets and solos were rhythmically sophisticated, rigorously rehearsed, and timed to the musical sound track down to a frame. Even though the actual movement is derived from ballroom, tap, and jazz, the theme-and-variation structure of the choreography gives it a timeless, classic quality. Astaire's duets with Rogers have never been rivaled for their sweep and romance; and his duets with other partners, such as Rita Hayworth, Judy Garland, and Lucille Bremer, are almost as fine.

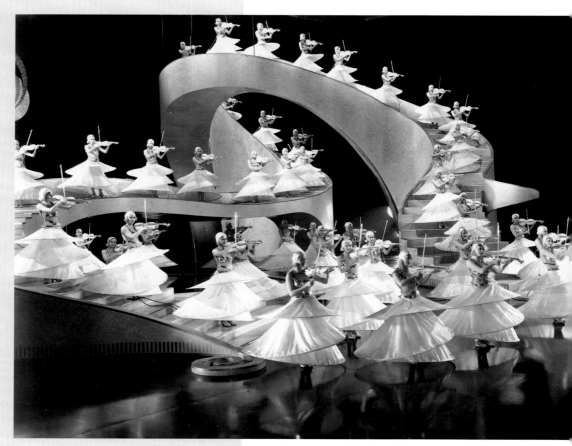

522. *Gold Diggers of 1933,* directed by Mervyn LeRoy, choreographed by Busby Berkeley, 1933
The Museum of Modern Art, New York/Film Stills Archive

With America's entrance into World War II, movie musicals became more literal and realistic; the growing fascination with Freudian analysis encouraged more Surrealism by way of "dream ballets" and fancy camera work. The musical's hero was no longer a high-class performer, but rather the ordinary man in the street who happened to dance like Gene Kelly—muscular, gregarious, athletic. And so the indoor magic and elegance of the 1930s became, in the 1940s, an outdoor and outgoing brio, a different kind of grace. —M. A.

THIRTIES GENRE FILMS

The coming of sound to American movies in the late 1920s
marked a cultural as well as a technological transformation. In
1929, for example, the gangster for the first time surpassed the
cowboy as a subject for Hollywood moviemakers. Sound accompa-
nied and abetted the triumph of metropolitan life as the primary
subject for the new popular movie genres of the 1930s.

Sound mattered to the gangster genre for urban and ethnic
accents—the so-called gashouse lingo of "dese," "dem," and
"dose"—and for roaring auto engines, police sirens, and machine-
gun rat-tat-tat. It mattered in comedy for the wild verbal riffs of
vaudeville and stage comics like the Marx
Brothers and for the rapid romantic patter
of the new screwball genre. It mattered, of
course, for musicals, which overcame ini-
tial audience indifference when Warner
Brothers hit on the Broadway-show form-
ula in 1933 with *42nd Street*. Sound also
brought the animated short—from Mickey
Mouse to Betty Boop to Bugs Bunny—to
new heights of popularity. The only signifi-
cant 1930s genre for which sound may
have been less than essential was the
horror film, although it did give us Bela
Lugosi's unforgettable and highly imitable
Transylvanian accent.

The legendary lawlessness of the
Prohibition era sparked Hollywood's
appetite for urban ethnic gangsters on the
model of Chicago's Al Capone—and

523. James Cagney and
Mae Clarke in *The Public
Enemy,* directed by William
A. Wellman, 1931
The Museum of Modern
Art, New York/Film Stills
Archive

524. Clark Gable and
Claudette Colbert in *It
Happened One Night,*
directed by Frank Capra,
1934
The Museum of Modern
Art, New York/Film Stills
Archive

brought stardom to performers who also stemmed from city streets. Edward G. Robinson
portrayed Rico Bandello in *Little Caesar* (1930), James Cagney played Tom Powers in
The Public Enemy (fig. 523), and Paul Muni was Tony Camonte in *Scarface* (1932)—
the three works that remain the classic gangster films from the early Depression years.
Critics and moralists have debated ever since whether such doomed figures, who ride
high but are brought low, caution against a criminal life or represent tragic heroes with
whom spectators instinctively identify.

Other forms of urban ethnic life found their way into early sound comedies through
such verbal comic performers as the Marx Brothers (Groucho, Harpo, Chico, and Zeppo),
Eddie Cantor, and George Burns and Gracie Allen. Their racy, often vulgar humor was
reined in as the 1930s decade went on, to be supplanted by screwball comedies that
often featured wealthy characters acting zany and forging cross-class romances. Frank
Capra's *It Happened One Night* (fig. 524) was an Academy Award–winning prototype, with

ts story of a runaway heiress being tamed by—and taming—a worldly newspaperman.

Musicals went through similar changes. This genre most dependent on sound zoomed in popularity in 1933–34 when Warner Brothers fused Depression-era stories with Busby Berkeley dance spectacles that liberated the musical from stage conventions. Following *42nd Street* came, in quick order, *Gold Diggers of 1933* (fig. 522) and *Footlight Parade* (both 1933) and *Dames* (1934). In mid-decade, like screwball comedy, the genre took on a more leisure-class aura in RKO musicals like *Top Hat* (fig. 521) and *Swing Time* (1937), featuring the incomparable dancing partnership of Fred Astaire and Ginger Rogers.

Sound was instrumental in Walt Disney's success when the animator fully integrated music and sound effects into *Steamboat Willie* (fig. 525), the third cartoon he made with his new character Mickey Mouse. Cartoons (along with newsreels and other short subjects) were part of every feature film presentation during the 1930s. Between major studios and independent producers, more than one hundred were created every year. Disney also pioneered with color cartoons—his *Flowers and Trees* (1932) was the first work of any type released in the three-color Technicolor process—and in feature-length animated films, beginning with *Snow White and the Seven Dwarfs* in 1937.

If all the principal genres discussed so far—even animation to a surprising extent—drew their élan from the contemporary urban swirl, horror films were the anomaly among popular 1930s genres. Almost uniformly, they were set among the Old World upper crust, often in the preceding century. Universal Studios established its domination of the decade's horror cycle with two 1931 classics adapted from nineteenth-century fiction—*Dracula*, from the 1897 Bram Stoker novel, with Lugosi as the vampire count, and *Frankenstein*, from Mary Shelley's 1818 novel, featuring Boris Karloff as the sewn-together monster. Later the studio practiced the art of the sequel with such works as *The Bride of Frankenstein* (1935), *Dracula's Daughter* (1936), and *Son of Frankenstein* (1939).
—R. S.

525. *Steamboat Willie*, directed by Walt Disney and Ub Iwerks, 1928 The Museum of Modern Art, New York/Film Stills Archive

LITERARY RESPONSES TO CATASTROPHE

A man narrowly escapes death when a beam falls from a construction site. Rocked by life's randomness, he abandons family, home, and name to seek a way to live with the irrationality and haphazardness of reality. With this anecdote, Sam Spade, Dashiell Hammett's archetypal tough guy, captures the spirit of his age. How must America cope with the sudden collapse of its defining and most trustworthy structures? Hammett's *The Maltese Falcon* (1930) opened a decade that was reeling from the onset of the worst economic catastrophe in the nation's history, a decade that would end in renewed international warfare, the deadliest of all time. In sixty-three days—from the crash of the Wall Street stock market on October 29, 1929, to January 1, 1930—the world and America's way of looking at it changed. Billions of dollars in investments had been wiped out. Small-government do-nothing-ism could hardly serve the new realities. Unemployed millions found competing explanations; more rarely, hints at solutions were found in literature. The two broad trends in 1930s literary innovation responded to the collapse of the American dream in markedly different ways.

Proletarian fiction evolved from the nineteenth-century American fascination with socialist and communal alternatives to industrialization's steamroller effect on individual liberty. Social experiments like Brook Farm and John Humphrey Noyes' Oneida Community grew from the belief that unbridled competition diminishes quality of life. Such idealism was transformed by the rise of industrial labor and the influence of Soviet cultural exports, which saw history as class struggle and art as a weapon. James T. Farrell's Studs Lonigan trilogy—*Young Lonigan: A Boyhood on the Chicago Streets* (1932), *The Young Manhood of Studs Lonigan* (1934), and *Judgment Day* (1935)—harnessed the enduring power of naturalism to a radical class consciousness (fig. 526). Although Farrell's fiction transcends proletarian formula, it epitomizes his belief that the tragedy of class warfare and capitalism's "false consciousness" could be overcome only through education and collectivist political action. The radical left, all

526. *Studs Lonigan,*
by James T. Farrell
New York: Random House,
1932–35
The Tamiment Institute
Library, New York
University

527. *Native Son,*
by Richard Wright
New York: Harper &
Brothers, 1940
Berg Collection of English
and American Literature,
The New York Public
Library, Astor, Lenox and
Tilden Foundations

528. *The Disinherited,* by
Jack Conroy
New York: Covici, Friede,
1934
The Lilly Library, Indiana
University, Bloomington

Social Realism

The social and economic problems of the 1930s engendered a moral imperative among artists and intellectuals to create a socially responsible art that communicated through a language understandable to "the people." The result covered a wide spectrum of subject matter and styles, including both Regionalism and Urban Scene painting. Yet some artists were not content either to glorify the way of life of the past or to record what they saw around them. For these so-called Social Realists, art was a weapon, as the Mexican muralist Diego Rivera had called it.[130]

but vanquished by the tinkering of Progressivism a generation earlier, spoke energetically in the pages of thoughtful journals like *New Masses, Partisan Review, Modern Quarterly, Criterion, Science and Society, Dynamo,* and *Dialectics.* Yet, despite its influence on writers like Farrell, John Dos Passos, and John Steinbeck, proletarianism in its pure form failed to capture the popular imagination.

The chief alternative to this often humorless and tragic proletarian fiction catered to America's stubbornly resilient myth of the gritty and triumphant individual. Uncomfortable with calls to collectivist action grounded in foreign ideas, Americans embraced the spare, new tough-guy fiction of Hammett, Ernest Hemingway, James M. Cain, Horace McCoy, and Raymond Chandler. Also known as "hard-boiled" writing, this bluntly realistic subgenre responded to the nation's confusion and despair in a new vernacular, stripped of all ornament and indicative of its heroes' disillusionment with bromides like "honor" or "glory" or "pity." Hammett's Spade, Chandler's Philip Marlowe, and Hemingway's Harry Morgan embodied the tough-guy posture of uncomplaining self-control in a crime-infested world run amok. The implicit ideology was a familiar American one: individual strength can withstand anything, and tragedy is the result of weakness. The popularity and pliancy of the premise can be seen in Thornton Wilder's *Our Town* (1938) and Margaret Mitchell's *Gone with the Wind* (1937), with their optimistic message that personal fortitude can overcome all obstacles, in Zora Neale Hurston's *Their Eyes Were Watching God* (1937), whose protagonist survives anguish to tell her story, and in *Native Son* (fig. 527), where Richard Wright's Bigger Thomas rebels against fate and achieves his own voice.

Most writing fell somewhere between programmatic collectivism and vigilante individualism. Even Chandler's tough guy is a hapless romantic struggling for self-worth against social forces beyond his control. Such figures are the sympathetic focus of Dos Passos' self-consciously audacious mosaic of American cultural bewilderment. His *U.S.A.* trilogy—*42nd Parallel* (1930), *1919* (1932), and *The Big Money* (1936)—rejects the ruthless collective *and* the laissez-faire millionaires in an almost overwhelming, modernist profusion of skewering prose-poem "biographies"; "newsreel" collages of headlines, popular song lyrics, and catch phrases; and quasi-autobiographical "camera eye" observations. William Faulkner's unconventional Yoknapatawpha County novels assert that individuals can master their modern future through honest reappraisals of their secret pasts. In *Of Mice and Men* (1937) and *The Grapes of Wrath* (1939), John Steinbeck recorded the anxieties and hopes of a nation that was learning the limits of individualism. Wary of the future, repelled by the struggles of the past, and drawn to a dream of a gentle, humane retreat, his simple, ordinary outcasts—laborers, primitives, half-wits, escapees, and misfits—try to help one another lead lives of meaning in a suddenly unfamiliar and cruel world. —J. W.

Like the photographers of the Farm Security Administration, these artists, filmmakers, and writers were motivated by the desire to effect social change. Conrad Freiberg's film *Halsted Street* examined the poverty and inequities of everyday urban life; Paul Strand's *Native Land* (1942) documented the struggle of American workers to organize against union-busting corporations. In literature, a proliferation of proletarian novels featured the poor, the unemployed, and the victims of racial injustice, from James T. Farrell's Studs Lonigan trilogy to Jack Conroy's *The Disinherited*, Langston Hughes' *Scottsboro Limited*, and Richard Wright's *Native Son* (figs. 526–29). In theater, the commitment to social reform fell to the Group Theatre, founded in 1931 by Harold Clurman, Cheryl Crawford, and Lee Strasberg, and to the Federal Theatre Project's Living Newspapers

529. *Scottsboro Limited: Four Poems and a Play in Verse*, by Langston Hughes, illustrated by Prentiss Taylor
New York: Golden Stair Press, 1932
Fales Library/Special Collections, New York University

530. Poster for *It Can't Happen Here,* by Sinclair Lewis
Lafayette Theatre, Detroit, c. 1936
Library of Congress, Washington, D.C.

THEATER IN THE 1930S

The economic prosperity and the prevailing hedonism of the United States in the 1920s were brought to an abrupt halt by the stock market crash of October 1929. The Great Depression soon arrived, and stayed for most of the 1930s. Thousands upon thousands were out of work, and breadlines appeared everywhere—even in Times Square. Productions of plays on Broadway fell from an all-time high of 264 in 1928 to a low of 69 in 1940, and many actors deserted Broadway for Hollywood. Yet the decade proved to be a time of artistic growth and change.

Among the many national programs designed to relieve unemployment was the Federal Theatre Project (FTP), headed by Hallie Flanagan, established in 1935. At its peak, it employed ten thousand people, operated theaters in forty states, published a magazine, and sponsored a play and research bureau. It mounted 1,200 productions nationwide, including plays by the Americans Maxwell Anderson, Thornton Wilder, and Sidney Howard, as well as by Europeans including Anton Chekhov, Leo Tolstoy, Henrik Ibsen, and George Bernard Shaw. On October 12, 1936, the FTP opened simultaneous productions in twenty-one theaters in seventeen states of an adaptation of Sinclair Lewis' novel *It Can't Happen Here* (fig. 530). But its most stunning contribution to the art of theater was its invention of the Living Newspapers. Each "edition" presented a particular socioeconomic problem, suggested solutions, and encouraged public action, by means of short scenes, singing and speaking choruses, soliloquies, pantomime, projected photographs and cartoons, dramatic lighting effects, and fast-paced action. *One-Third of a Nation,* on housing problems, was its most famous production (fig. 531). In late 1937, Orson Welles undertook an FTP production of Marc Blitzstein's *The Cradle Will Rock*, a radical anti-establishment musical. After apprehensive federal administrators withdrew funding, Welles and John Houseman assumed the role of producers, forming a partnership that later yielded the Mercury Theatre. When fearful civic authorities padlocked the Maxine Elliott Theatre on opening night, the producers, the author, the cast, and a loyal audience walked twenty blocks to the old Venice Theatre, where a bare-bones performance was mounted. Two days later, the Maxine Elliott was unlocked and the play went on to enjoy an extended run.

A number of FTP productions adopted a revisionist approach to older theatrical works. Houseman headed the FTP's Negro Unit, housed in Harlem's New Lafayette Theatre. In 1936, he engaged the young Orson Welles to direct a production of *Macbeth*. Set in Haiti, with an all-black cast, it became known as "the voodoo Macbeth." It ran for twelve weeks in Harlem and then moved downtown for two more months.

The Mercury Theatre again created a sensation in November 1937 with its Welles-directed version of *Julius Caesar*, presented in modern dress and with the title character clearly a Fascist dictator. But the Mercury made its greatest impact on public consciousness on October 30, 1938, with its radio dramatization of H. G. Wells' *War of the Worlds*. Directed and narrated by Welles, the Halloween Eve broadcast terrified listeners, who were convinced that the end of the world was at hand.

Somewhat similar to the Mercury were a number of short-lived "proletarian" theaters that were critical of the established order, including the Workers Laboratory

531. Poster for *One-Third of a Nation,* by Arthur Arent
Adelphi Theatre, New York, 1938
Billy Rose Theatre Collection, The New York Public Library for the Performing Arts, Astor, Lenox and Tilden Foundations

(fig. 531), which documented social problems for the audience and then called for specific actions to solve them. Dealing with such topics as housing, health care, natural resources, and labor unions, they aimed to affect public policy by pointing to the discrepancies between public ideals and public realities. *Power,* a plea for the public ownership of utilities, contributed to the agency's demise by introducing into the script unauthorized quotations from the *Congressional Record* on Senate opposition to the plan. These quotations ridiculed senators, providing additional ammunition for those in Congress who wished to dissolve the Federal Theatre Project. On the eve of congressional fiscal allocations in July 1937, administrators of the FTP withdrew funding from Marc Blitzstein's pro-union labor opera, *The Cradle Will Rock*, on the grounds that it was too controversial.

Theatre (founded in 1930 and reorganized in 1934 as the Theatre of Action) and the Theatre Collective (founded in 1932). The latter became the New Theatre League in 1935 and presented the first production of Clifford Odets' *Waiting for Lefty*, which ended with actors and audience shouting "Strike! Strike!" (fig. 532). The most remarkable of these labor-oriented productions was *Pins and Needles* (1936), put on by the International Ladies' Garment Workers' Union. A light satire on the relations between capital and labor, it held the stage for four years, toured widely, and played a command performance at the White House.

The most successful, long-lasting, and influential of these anti-establishment theater organizations, however, was the Group Theatre. It lasted from 1931 to 1940, produced twenty-three plays, and nurtured a group of theater artists who would wield incalculable influence for many years. Its founders (Harold Clurman, Cheryl Crawford, and Lee Strasberg) chose the name to indicate a nonhierarchical structure in which all participants were equal and were equally devoted to producing plays "related to American life." After the success of their first production, Paul Green's *House of Connelly* (1931), the Group Theatre went on to produce plays by Maxwell Anderson, John Howard Lawson, Sidney Kingsley, Robert Ardrey, William Saroyan, and Clifford Odets. Odets was nurtured within the group, which produced five of his plays, most notably *Awake and Sing* (1935) and *Golden Boy* (1937).

The Theatre Guild, founded in 1919 as the successor to the Washington Square Players, maintained a constant management team, an ongoing production team, a largely stable cadre of actors, and a nationwide subscription audience. It produced most of the plays of Eugene O'Neill and fifteen by George Bernard Shaw and introduced works by Sidney Howard, S. N. Behrman, Robert E. Sherwood, Maxwell Anderson, and Philip Barry. In 1934, rebelling against the tight control the Theatre Guild exercised over various facets of production, five playwrights (Anderson, Behrman, Howard, Sherwood, and Elmer Rice) formed the Playwrights' Company. It had two great successes in 1938—Sherwood's *Abe Lincoln in Illinois* (fig. 448), with innovative scenery by Jo Mielziner, and Anderson and Kurt Weill's *Knickerbocker Holiday*.

Even the commercial theater of Broadway, though chiefly concerned with revues, musicals, and star attractions, was affected by the currents of social consciousness. Among the significant Broadway productions that explored serious issues were Jack Kirkland's long-running adaptation of Erskine Caldwell's *Tobacco Road* (1932), which presented the plight of tenant farmers in the rural South; John Steinbeck's own dramatization of his short novel *Of Mice and Men* (1937), which looked at the lives of Western ranch hands; Maxwell Anderson's *Winterset* (1935), which dealt with the infamous Sacco and Vanzetti case; and his *Key Largo* (1939), which offered a trenchant discussion of Marxist thought.

Finally, the 1930s welcomed the unique talent of Thornton Wilder, whose serene *Our Town* (1938) won the Pulitzer Prize and has since become perhaps the most read and produced play of the twentieth century. —V. R.

Before the stock market crash of 1929, only a few artists had engaged in radical politics. They gathered around *New Masses*, a magazine founded in 1926. At its inception, two factions shaped its content: a literary contingent of writers, including Waldo Frank, Lewis Mumford, Sherwood Anderson, and Van Wyck Brooks; and a political group of artists and intellectuals associated with the defunct magazines *The Masses* (1911–17) and *The Liberator* (1918–24). In its first two years, *New*

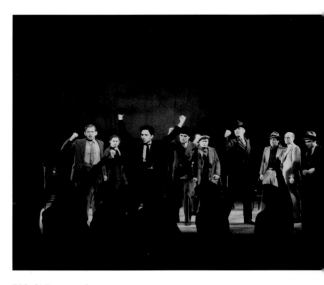

532. Strike scene from *Waiting for Lefty,* by Clifford Odets, 1935 Billy Rose Theatre Collection, The New York Public Library for the Performing Arts, Astor, Lenox and Tilden Foundations

Masses presented a mixture of political commentary, literature, and art. Revolutionary but nonpartisan, its editors viewed artistic innovation as analogous to radical politics and encouraged experimental and abstract art along with socially critical illustrations (fig. 533). In 1928, with the appointment of Michael Gold as editor in chief and Hugo Gellert as art editor, the political faction won control of the magazine. Gold transformed it into an exclusively political journal concerned with the cause of the proletarian worker, the redistribution of wealth, and the class struggle. Its covers and cartoon illustrations, predominantly by Gellert and William Gropper, became more overt in their social and political criticism (figs. 534, 535). Intended to be didactic and easily understood—as well as proletarian—the illustrations typically were spare and deliberately unsophisticated in style and subject. With a minimum of detail and background setting, they often presented a simple, unambiguous conflict: between Fascism and Communism, workers and capitalists, or Soviet productivity and American unemployment. Prints and illustrated pamphlets, which were inexpensive to produce and easy to circulate widely, became a principal tool through which these and other radical artists reached an audience beyond *New Masses* subscribers (fig. 537).

To further disseminate their radical political ideas, a group of *New Masses* staff members founded an artists' and writers' club in October 1929. Named the John Reed Club, after the journalist and founder of the American Communist Party, the Club held art exhibitions, established an art school, and provided a meeting place where members and nonmembers could discuss current artistic and political issues. The Club, which eventually included thirty branches in major cities across the country, flourished until 1935, when the Soviet Union initiated its Popular Front, a strategy designed to enlist Western democracies in the struggle against Fascism in Italy and Germany. Before the Popular Front, the Communists did not differentiate between capitalists and Fascists; both were enemies. Writers and artists were urged to adopt an overtly proletarian viewpoint in order to assist in the class struggle. After the launching of the Popular Front at the Communist Party World Congress in 1935, the Communists sought alliances with democratic countries in the struggle against war and Fascism. During this period, the John Reed Clubs were disbanded as being too narrowly sectarian.

533. **Louis Lozowick**
Cover of *New Masses,*
August 1928

534. **Hugo Gellert**
Cover of *New Masses,*
July 1931
Special Collections,
University of Wisconsin
Library, Madison

535. **William Gropper**
Free Speech, from *New Masses,* August, 1927
William Gropper Papers,
Archives of American Art,
Smithsonian Institution,
Washington, D.C.

Even before the Popular Front, in the summer of 1933, a group of Club members had organized an artists' trade union, which became known as the Artists' Union soon after the establishment of the Public Works of Art Project.[131] With the creation of the Federal Art Project in 1935, the union became the de facto bargaining agent for artists employed by the federal government, lobbying for higher wages, reduced relief requirements, and better working conditions. Although nominally apolitical, the union had been organized by Communist Party members, who continued to dominate its leadership. The Artists' Union followed the example of other militant labor unions, including among its tactics mass picketing, strikes, and sit-ins. Anticipated reductions in WPA employment in fall 1936 and spring 1937 met with a combative union response—a sit-in in December 1936 during which 12 were wounded and 210 arrested was followed by an all-night sit-in in June 1937 in WPA offices in New York and Washington. These demonstrations furthered solidarity among union members, but they also strengthened congressional critics, who claimed that the arts were frivolous and the federal projects a hotbed of Communist infiltration. When Congress allocated money for the WPA in 1937, substantially less funding was voted for the Federal Art Project than for other work relief initiatives. In an attempt to bolster its political leverage, the Artists' Union merged with the newly formed CIO in January 1938. Four years later, with the erosion of federal patronage and a growing number of injunctions against employing Communists on the project, the United American Artists, as it was called under its CIO charter, dissolved.

Discussion about the necessity for social commentary in art, which had arisen at the Artists' Union's Wednesday night meetings, was given a more public hearing in November 1934 with the launching of *Art Front*, the union's official periodical (fig. 538). Although its primary function was to publicize union activities, the magazine soon became a forum for debate about the use of art for social ends, and the role of art and artists in society. In its first year, when Stuart Davis was editor and the magazine was an eight-page oversize tabloid sold at Artists' Union demonstrations, *Art Front* printed a series of heated exchanges between Davis and the Regionalists Thomas Hart Benton and John Steuart Curry. Davis attacked Benton and Curry for what he considered their reactionary social attitudes and *retardataire* painting styles; Benton

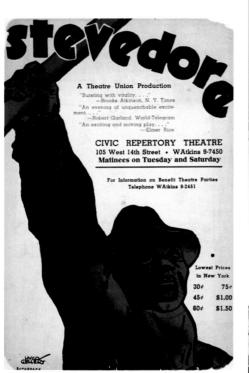

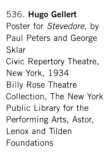

536. **Hugo Gellert**
Poster for *Stevedore,* by Paul Peters and George Sklar
Civic Repertory Theatre, New York, 1934
Billy Rose Theatre Collection, The New York Public Library for the Performing Arts, Astor, Lenox and Tilden Foundations

537. *Comrade Gulliver: An Illustrated Account of Travel into That Strange Country, the United States of America,* by Hugo Gellert
New York: G. P. Putnam's Sons, 1935
Frances Mulhall Achilles Library, Whitney Museum of American Art, New York

538. **William Gropper**
Cover of *Art Front,*
June–July 1937
Art Front Papers, Archives of American Art, Smithsonian Institution, Washington, D.C.

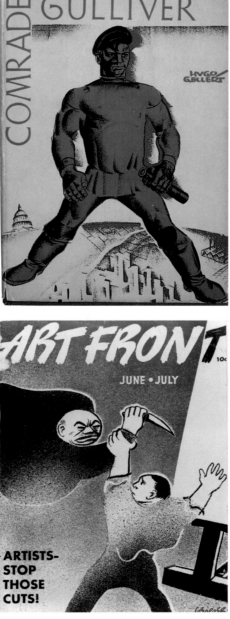

retaliated by inveighing against abstraction as alien, decadent, and subversive of American traditions and values. Even after December 1935, when *Art Front* expanded the number of its pages, improved the quality of its reproductions, and assumed the smaller format of most other art magazines, it remained the era's most important polemical journal dealing with art and politics and the social utility of art. In its pages, Social Realists railed against abstractionists for their lack of political commitment, while modernists dismissed Regionalists and Social Realists as being

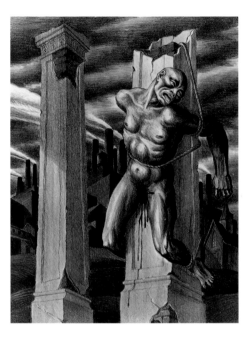

539. **Harry Sternberg**
Southern Holiday, 1935
Lithograph, 21¾ x 15¾ in.
(55.2 x 40 cm)
Whitney Museum of
American Art, New York;
Purchase, with funds from
The Lauder Foundation,
Leonard and Evelyn Lauder
Fund 96.68.292

both aesthetically irrelevant and propagandists. The question of how to reconcile socialist humanism with modernist aesthetics was answered with often obtuse and convoluted formulations by modernists such as Davis and Balcomb Greene. Davis' argument was the most compelling: that modern art was inherently opposed to Fascism—and thus inherently political—because it celebrated the most progressive aspect of American democracy—freedom of expression.

In December 1937, *Art Front* inexplicably and without warning ceased publication. It may have been eclipsed by the publication program of the American Artists' Congress, a broad-based organization of progressive artists formed under the mandate of the Popular Front to fight against the threat of war and Fascism. The Congress held its first public session over a three-day period in 1936 with some 360 artist delegates and guests listening to thirty-four speeches by such figures as Lewis Mumford, Margaret Bourke-White, Stuart Davis, the art historian Meyer Schapiro, and the Mexican muralists José Clemente Orozco and David Alfaro Siqueiros. Within a year, the Congress had instituted an active program of symposiums, lectures, and exhibitions—among which were thirty print exhibitions, each with the same one hundred prints, held simultaneously in cities across America. The Congress raised funds for the Loyalist forces fighting General Franco's army in Spain, lobbied to boycott exhibitions held in Nazi Germany and Fascist Italy, and defended WPA art projects.

The Communist Party's emphasis on united political action began to falter after the 1936–38 Moscow trials against Soviet intellectuals. The Soviet-German nonaggression pact of August 1939 and the Soviet Union's invasion of Finland that December destroyed all semblance of unity within the American Artists' Congress as members split over support of the Soviet Union. In April 1940, the Congress' governing board issued a statement, later approved by the whole Congress, exonerating the Soviet Union for the Finnish invasion and portraying the relief effort to assist Finland as an anti-Communist plot. This public position signaled the takeover of the Congress by the Communist Party and led to the resignation of thirty Congress members, including Stuart Davis, who had been Congress secretary and one of the organization's founders. Shortly afterward, the dissident group, led by Meyer Schapiro, formed the Federation of Modern Painters and Sculptors, a non-political organization dedicated to promoting the welfare of American artists. The American Artists' Congress continued, but the Popular Front period of collaboration among leftists against war and Fascism was over.

Even in its heyday, the American Artists' Congress did not hold a monopoly on social commentary; racial injustice and the abuses of industry galvanized the attention of artists from a wide aesthetic and political spectrum. When the NAACP launched its campaign against lynching in 1935, artists such as John Steuart Curry, Thomas Hart Benton, Reginald Marsh, Paul Cadmus, Harry Sternberg, and Philip

Guston created prints and drawings and participated in the exhibition organized on that theme by the John Reed Club to coincide with congressional hearings on antilynching legislation (figs. 539–41). Artists felt equally compelled to address the confrontation between strikers and company police. While the work of some artists implicated both strikers and police in fomenting violence, Philip Evergood's *American Tragedy* was unmitigatedly partisan (fig. 542). Basing his painting on an unprovoked police attack on picketing workers at the South Chicago plant of

540. **Philip Guston**
Drawing for *Conspirators*,
1930
Graphite, ink, colored pencil, and crayon on paper, 22½ x 14½ in. (57.2 x 36.8 cm) irregular
Whitney Museum of American Art, New York; Purchase, with funds from The Hearst Corporation and The Norman and Rosita Winston Foundation, Inc. 82.20

Republic Steel on Memorial Day, 1937, Evergood utilized strident color and deliberately heavy lines to create an epic portrayal of the brutality of the police and the heroism of the workers.

Unlike Evergood, Ben Shahn looked not to the present but to the recent past—the trial and execution of Nicola Sacco and Bartolomeo Vanzetti —to represent the shortcomings of American democracy. Accused of robbing and murdering a shoe factory paymaster and his guard in Massachusetts on April 15, 1920, the two Italian-American anarchists had been found guilty and sentenced to death by presiding Judge Webster Thayer despite witnesses who swore that the accused were miles from the scene of the crime. Worldwide protests followed the verdict, which was considered to have been based on the defendants' anarchist political beliefs rather than on their criminal guilt. A second trial and subsequent petition to Massachusetts Governor Alvan T. Fuller for a stay of execution failed to save the two men. Fuller's decision followed the conclusion of a three-member committee, headed by Harvard University's president, Abbott Lawrence Lowell, that the charges of bias were unwarranted and therefore clemency was ill advised.

In August 1927, Sacco and Vanzetti were electrocuted. Four years later, in 1931, Shahn began a series of twenty-three small gouaches and two temperas, which he entitled *The Passion of Sacco and Vanzetti* to suggest a connection between the persecution and martyrdom of the two men and the persecution and martyrdom of Christ (figs. 543, 544). In the largest tempera, he painted the three Lowell committee members standing in hypocritical mourning over the caskets of Sacco and Vanzetti, holding lilies, symbols of death and resurrection.

541. Paul Cadmus
To the Lynching!, 1935
Graphite and watercolor
on paper, 20½ x 15¾ in.
(52.1 x 40 cm)
Whitney Museum of
American Art, New York;
Purchase 36.32

542 . Philip Evergood
American Tragedy, 1937
Oil on canvas, 29½ x
39½ in. (74.9 x 100.3 cm)
Private collection

543. Ben Shahn
*Bartolomeo Vanzetti and
Nicola Sacco,* from the
series *The Passion of Sacco
and Vanzetti,* 1931–32
Tempera on paper over
board, 10½ x 14½ in.
(26.7 x 36.8 cm)
The Museum of Modern
Art, New York; Gift of Abby
Aldrich Rockefeller
©Estate of Ben
Shahn/V.A.G.A., N.Y.

547. **Alexander Calder**
Little Ball with Counterweight, c. 1931
Painted sheet metal, wire, and wood, 63¾ x 12½ x 12½ in. (161.9 x 31.8 x 31.8 cm)
Whitney Museum of American Art, New York; Promised 50th Anniversary Gift of Mr. and Mrs. Leonard J. Horwich
P.9.79

548. **Paul Kelpe**
Untitled, c. 1938
Oil on canvas, 98¾ x 90½ in. (250.8 x 229.9 cm)
Brooklyn Museum of Art, New York; On loan from the New York City Housing Authority

549. **Alice Trumbull Mason**
Brown Shapes White, 1941
Oil on wood, 23⅚ x 31¾ in. (60.8 x 80.7 cm)
Philadelphia Museum of Art; A. E. Gallatin Collection
©Estate of Alice Trumbull Mason/V.A.G.A., N.Y.

and begin weekly meetings of what would be called the American Abstract Artists (AAA). By the time they opened their first exhibition in vacant offices in the Squibb Building on Fifth Avenue, in April 1937, the group numbered thirty-nine members. The Squibb Gallery exhibition was accompanied by a portfolio of lithographs; thereafter the group's annual exhibitions were accompanied by a yearbook containing essays and illustrations of members' current work.

Although membership included artists who worked in painterly and expressionist styles, the American Abstract Artists had a reputation for being a predominantly hard-edged, geometricist organization. This was due in part to the three primary leaders of the group: Balcomb Greene and Carl Holty, who alternated as chairman, and George L. K. Morris, who served as the group's de facto spokesman through his articles in the annual catalogues and his column "Art Chronicle" in *Partisan Review*. All three favored a disciplined, planar Cubist vocabulary that emulated the vanguard styles then predominant in Paris.

546. **George L. K. Morris**
Nautical Composition,
1937–42
Oil on canvas, 51 x 35 in.
(129.5 x 88.9 cm)
Whitney Museum of
American Art, New York;
Purchase 43.11

This bias toward French art was shared by most abstract American artists. It was to France that vanguard artists went to study: Stuart Davis in 1928–29; John Ferren in 1929–39; George L. K. Morris in 1929–30; Alexander Calder in 1926–33; Carl Holty in 1928–35; and Charles Biederman in 1936–37. Once there, they generally established contact with the leading French artists' alliance, Abstraction-Création Non-Figuratif (commonly known as Abstraction-Création), which operated from 1931 to 1936. As its name implied, Abstraction-Création included two "nonfigurative" approaches: abstraction from nature and the creation of pure forms invented independently of nature. Most characteristic of the group was a stylistic amalgam of geometric Cubism and abstract Surrealism. That thirty-three American artists were members of the group attested to their success in emulating this hybrid style in which geometric and biomorphic forms floated in a flat Cubist space (figs. 545, 546, 548–51). This predominantly rational and ordered style was featured in the Parisian group's annual exhibitions and in its journal, *Abstraction-Création*. Along with *Cahiers d'Art* (begun in Paris in 1926), *Abstraction-Création*—and its post-1936 continuation, *Plastique*—kept even artists who remained in America abreast of evolving tendencies in European art. So ubiquitous and pivotal were these magazines to American aesthetic developments that Gorky once defended himself against the accusation that he pillaged French art by asserting, "We all steal. You steal from *Cahiers d'Art,* I steal from *Cahiers d'Art.* The only difference is I steal better than you because I know French and you don't!"[133]

Paradoxically, the two best-known American abstractionists, Alexander Calder and Stuart Davis, declined to join the group. In 1927–28, in his Eggbeater series, Davis had used an eggbeater, an electric fan, and a rubber glove nailed to a table to create an abstract composition of interlocking flat and curved shapes (fig. 552). Floating on an unbounded background and painted with a quirky palette quite unlike the classic tonalities of European Synthetic Cubism, Davis' composition set the format for American geometric abstraction in the 1930s.

Unlike Davis, who had little personal contact with European modernists, Calder enjoyed their respect and affection. From 1926 to 1931, he delighted audiences

The American Abstract Art Community

A small number of artists responded to the turmoil and disequilibrium of the thirties with a utopian vision of universal harmony. Against the chaos of the present, they posited a geometric, nonobjective art of order and stability based on reason and devoid of references to the real world. Geometric abstraction offered a vehicle for expressing immutable certainties, and thus provided a sense of assurance, security, and truth. Precisely because it eliminated allusions to external reality, abstraction obliterated reminders of the social, political, economic, and racial differences that divided people. Not surprisingly, it attracted a large number of women—Gertrude Greene, Esphyr Slobodkina, Rosalind Bengelsdorf, Charmion Von Weigand, Irene Rice Pereira, Suzi Freylinghuysen—and foreign-born Americans—Fritz Glarner, Josef Albers, Arshile Gorky, Carl Holty, László Moholy-Nagy, Ilya Bolotowsky, John Graham—who were excluded from the rampant masculine nationalism of the 1930s. Geometric abstraction's vision of a utopian future made perfect through science and technology added to its appeal. As Rosalind Bengelsdorf wrote, "It is the era of science and the machine. . . . So-called abstract painting is the expression in art of this age. The abstract painter coordinates his emotional temptations with his reason: the reason of this age." [132]

545. **John Ferren**
Composition on Green,
1936
Oil on canvas, 29 x 39½ in.
(73.7 x 100.3 cm)
Whitney Museum of
American Art, New York;
Purchase, with funds from
the Friends of the Whitney
Museum of American Art
78.54

Not everyone agreed with this assessment of abstract art's social utility. Leftists chastised it for being irrelevant and escapist and conservatives for being elitist and unintelligible. Despite these accusations, a small group of artists committed themselves to abstract art during the 1930s. Excluded from all but a handful of galleries, and denied exhibition opportunities at both the Whitney Museum and The Museum of Modern Art, American geometric abstractionists banded together to find venues for their work. Preliminary discussions on the subject among Rosalind Bengelsdorf, Byron Browne, Albert Swinden, and Ibram Lassaw began informally in Lassaw's studio in 1935 and were continued in January 1936 with a larger group of artists. They set their sights on the Municipal Art Gallery, run by the Federal Art Project. Upon discovering that the gallery required a minimum of twenty-five exhibitors, the group—which now included Burgoyne Diller, Harry Holtzman, and Gertrude and Balcomb Greene—set about gathering the requisite number of abstract artists into a cooperative exhibiting society. In the meantime, Holtzman, acting independently, rented a studio, collected work from all the abstract artists he knew, and called a general meeting that November. Holtzman's vision was of an intellectual forum where practical and philosophical issues could be discussed. At the first meeting, however, disagreements erupted when Arshile Gorky presumptuously assumed an instructional role; the second meeting ended with Gorky storming out, followed by his friend Willem de Kooning. Although in the face of conflicting goals Holtzman abandoned his plan for a discussion group, the meeting encouraged artists who had attended to form an organization to introduce abstract work to the public. On January 8, 1937, at Albert Swinden's studio, twenty-two artists voted to organize

544. Ben Shahn
The Passion of Sacco and Vanzetti, from the series *The Passion of Sacco and Vanzetti,* 1931–32
Tempera on canvas, 84½ x 48 in. (214.6 x 121.9 cm)
Whitney Museum of American Art, New York; Gift of Edith and Milton Lowenthal in memory of Juliana Force 49.22
©Estate of Ben Shahn/V.A.G.A., N.Y.

550. **Ad Reinhardt**
Untitled, 1938
Gouache on cardboard,
10 x 8 in. (25.4 x
20.3 cm)
Whitney Museum of
American Art, New York;
Gift of an anonymous
donor 79.54

551. **Charles Biederman**
*Painting, New York,
January 1936*, 1936
Oil on canvas, 51¼ x
38¼ in. (130.2 x
97.2 cm)
Whitney Museum of
American Art, New York;
50th Anniversary Gift of
the John I. H. Baur
Purchase Fund and the
Wilfred P. and Rose J.
Cohen Purchase Fund
80.17

552. **Stuart Davis**
Egg Beater No. 1, 1927
Oil on canvas, 29⅛ x
36 in. (74 x 91.4 cm)
Whitney Museum of
American Art, New York;
Gift of Gertrude Vanderbilt
Whitney 31.169
©Estate of Stuart
Davis/V.A.G.A., N.Y.

553. **Alexander Calder**
Calderberry Bush, 1932
Painted steel rod, wire,
wood, and sheet alu-
minum, dimensions vari-
able, with base: 88½ x
33 x 47½ in. (224.8 x
83.8 x 120.7 cm)
Whitney Museum of
American Art, New York;
Purchase, with funds from
the Mrs. Percy Uris
Purchase Fund 86.49a–b

abroad with performances of his *Circus* ensemble, which included tiny animals and performers constructed from wire and found objects. Calder abruptly terminated his circus theme in December 1930, following a visit to Mondrian's studio. What impressed him were not the Dutch artist's paintings, which he had previously seen on exhibition, but his studio—an austere, geometric environment that Mondrian had designed according to the principles of dynamic equilibrium by tacking variously sized sheets of colored cardboard onto white walls. This visit, which Calder later credited with having "started things," precipitated his shift from figurative sculpture to severe, open wire constructions.[134] Under the influence of the Spanish painter Joan Miró, Calder soon introduced more biomorphic, associative, and playful imagery. By 1932, he had synthesized the influence of Miró and Mondrian into his own characteristic vocabulary: a palette restricted to primary colors, plus black and white; and a compositional structure consisting of flat, cut-out shapes of painted sheet metal balanced along a supporting rod. Moreover, he now applied the motion of his *Circus* performances to abstract constructions. But instead of hand cranks or motors, Calder called upon a system of weights and balances to create mobility. The results were compositions in constant flux, as different shapes and densities created a succession of spatial configurations. Dependent on air currents and touch, their movement was random, their compositions unfixed. Initially, Calder's "mobiles," as they were dubbed by Marcel Duchamp, relied primarily on a standing structure to support the moving elements (figs. 547, 553). After 1935, he began to suspend his mobiles from the ceiling. Their imagery was abstract, but also cosmic. The idea of unconnected bodies of different sizes and densities floating in space sprang from an underlying sense of form that Calder identified with the "system of the Universe."[135] At first, the allusions were to planets and moons in the solar system. Eventually, they came to suggest the rhythms and changing relationships in time and space of objects in the natural world.

Of paramount importance to those abstractionists who remained in America were several New York institutions devoted to the collection and exhibition of progressive European art. Katherine Dreier, whose Société Anonyme had vacated its permanent quarters on East 47th Street in 1924, focused her energies in the 1930s on arranging lectures and only occasionally on organizing temporary exhibitions for other institutions. Although none of these exhibitions matched the ambition of the three-hundred-work "International Exhibition of Modern Art" she had organized for the Brooklyn Museum in November 1926, Dreier's expansion of the Société Anonyme's collection during the 1930s more than compensated for her curtailed exhibition program. The Société Anonyme's mission to present a historical overview of early twentieth-century art was furthered in 1929 with the founding of The Museum of Modern Art, whose ambitious exhibition and acquisition program provided artists with a firsthand account of the most significant movements in modern European art. In contrast to the collection of Société Anonyme and The Museum of Modern Art, that

assembled by A. E. Gallatin and installed in a study room of New York University in December 1927 focused on post-Cubist geometric abstraction. Gallatin's Gallery of Living Art, as it was called (until 1933, when it was renamed Museum of Living Art), provided an informal meeting place where students and artists could study the development of modern art from Cubism to De Stijl and Constuctivism.

Familiar with these collections and with journals such as *Cahiers d'Art*, the majority of American geometric abstractionists worked in a Synthetic Cubist vocabulary of closed, flat shapes throughout much of the thirties. Under the influence of Picasso's late 1920s studio interiors, and the work of Joan Miró—shown in New York in 1930 and 1932—and through direct contact with Fernand Léger, who visited New York in 1931, 1936, and 1938, the exclusive grip of Cubist angularity relaxed and became tempered by biomorphism. The result was a style in which curved, self-contained forms were set within a geometric framework of lines and planes or splayed across the entire canvas surface to create an all-over dispersion of attention (figs. 554–57). The conflation of geometric and biomorphic imagery was seen in sculpture as well—particularly in the work of Ibram Lassaw, who replaced the monolithic solidity of cast metal with open-space constructions obtained by welding (fig. 561).

By the late 1930s and early 1940s, this amalgamation of the biomorphic and the geometric began to give way, on the one hand, to more open, gestural configurations by artists such as Gorky and Charles Howard (figs. 558–60) and, on the other, to a more severe, rectilinear approach derived from Constructivism and De Stijl. One of the first painters to defect to De Stijl was Burgoyne Diller. As early as 1934, inspired by De Stijl works reproduced in art magazines and the Piet Mondrian paintings acquired by the Société Anonyme and the Gallery of Living Art, Diller began to create an art of elemental rectangles of pure primary colors (fig. 565). By the time Mondrian arrived in America in 1940, other artists—Gertrude Greene, Ilya Bolotowsky, Albert Swinden, Charles Biederman, and Harry Holtzman—had adopted the visual language of De Stijl, or Neoplasticism, as Mondrian called it (figs. 566, 567). Neoplasticism depended on the asymmetrical opposition of horizontal and vertical relationships and on the use of primary colors—formal qualities its artists considered paradigms of a universal harmony of nonequal but equivalent forces. American Neoplastic artists accepted these premises, but took greater liberties with color, forgoing the primary colors insisted upon by their

554. **Ilya Bolotowsky**
Sketch for *Mural, Williamsburg Housing Project, New York*, c. 1936
Gouache and ink on board, 16¼ x 29½ in. (41.3 x 74.9 cm)
Whitney Museum of American Art, New York;
50th Anniversary Gift of the Edward R. Downe, Jr., Purchase Fund, Mr. and Mrs. William A. Marsteller, and the National Endowment for the Arts 80.4
©Estate of Ilya Bolotowsky/V.A.G.A., N.Y.

555. **Willem de Kooning**
Untitled, c. 1937
Gouache and graphite on paper, 6¾ x 13¾ in. (17.1 x 34.9 cm)
Whitney Museum of American Art, New York;
Purchase, with funds from Frances and Sydney Lewis 77.34

556. **Rosalind Bengelsdorf**
Sketch for *Mural, Central Nurses Home, Welfare Island*, 1938
Casein and tempera on board, 5⅝ x 16½ in. (14.3 x 41.9 cm)
Whitney Museum of American Art, New York;
Gift of the artist 77.114

557. **Arshile Gorky**
Organization, 1933–36
Oil on canvas, 49¾ x
60 in. (126.4 x 152.4 cm)
National Gallery of Art,
Washington, D.C.; Ailsa
Mellon Bruce Fund

558. **Arshile Gorky**
Painting, 1936–37
Oil on canvas, 38 x 48 in.
(96.5 x 121.9 cm)
Whitney Museum of
American Art, New York;
Purchase 37.39

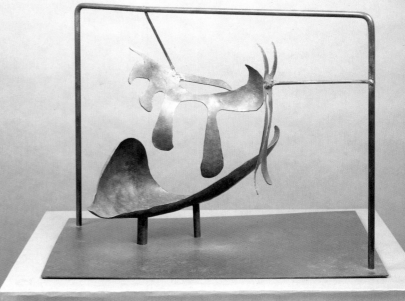

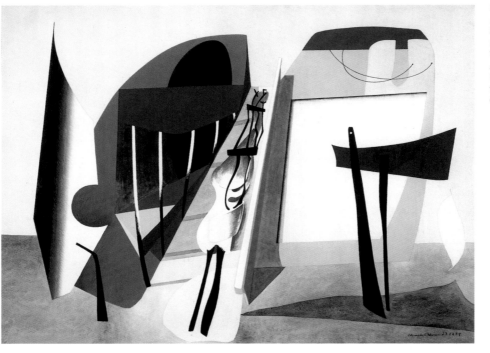

559. **Arshile Gorky**
*Nighttime, Enigma and
Nostalgia,* c. 1931–32
Ink on paper, 24 x 31 in.
(61 x 78.7 cm)
Whitney Museum of
American Art, New York;
50th Anniversary Gift of
Mr. and Mrs. Edwin A.
Bergman 80.54

560. **Charles Houghton
Howard**
Hare Corner, 1939
Gouache and graphite on
paper, 26⅝ x 35⅞ in.
(67.6 x 91.1 cm)
Whitney Museum of
American Art, New York;
Purchase, with funds from
the Katherine Schmidt
Shubert Purchase Fund
93.66

561. **Ibram Lassaw**
Sculpture in Steel, 1938
Steel, 18⅝ x 23⅜ x 15 in.
(47.3 x 59.8 x 38.1 cm)
Whitney Museum of
American Art, New York;
Purchase, with funds from
the Painting and Sculpture
Committee 86.11

European counterparts in favor of more inventive color harmonies. Americans also adhered to the Neoplastic insistence that art was not an imitation of nature but a reality in itself. This view accounted for the upsurge in the construction of wall reliefs by American artists in the early 1930s; since applied elements were more "concrete" than painted ones, they avoided the problem of illusionism.

By the mid-1930s, Wassily Kandinsky's postwar abstractions had engendered a third strain of abstraction in America. On view at the Plaza Hotel in the collection the German-born Hilla Rebay was assembling for Solomon Guggenheim, Kandinsky's work featured seemingly weightless, hard-edged circles and lines deployed against open fields of color. This vocabulary and the spiritual imperatives behind it became the model for painters such as Rolph Scarlett and Rudolf Bauer (figs. 570, 571). For them, as for Rebay, art drew its subject matter from the spiritual realm, not the world of concrete realities. For many American artists—particularly leftists—who were sensitive to charges that abstract art was irrelevant to social reform,

BIOMORPHISM AND ORGANICISM IN DESIGN

Beginning in the mid-1930s, a new design vocabulary entered the American marketplace through a small group of designs for furniture, ceramics, and textiles that were alternately designated biomorphic or organic. These new products were designed without the use of a compass, T-square, or rule, the traditional drafting tools that produced geometric forms.

American designers and manufacturers who explored biomorphism during the Depression and afterward were not simply rejecting the reigning modernist canon, based on functionalism, which had emerged in Europe immediately after World War I. During the 1920s and 1930s, the Dadaists and Surrealists had electrified many in the international community with images inspired by their interest in the subconscious. Three-dimensional biomorphic objects began to appear in the marketplace by the mid-1930s, with the result that furnishings by Gilbert Rohde and Isamu Noguchi and ceramics by Eva Zeisel were described as being zoomorphic or anthropomorphic (figs. 563, 564). Other objects were far more abstract, however, and many of these were interpreted as containing encoded subconscious or psychological messages that reflected a desire to infuse ordinary objects with a more emotive and personal character.

In contrast, Charles Eames' designs for chairs and other living room furniture during the early 1940s explored an ideal of organic wholeness based on new techniques for laminating and bending plywood shells into compound curves that partly grew out of his work for the U.S. Navy, producing molded wood stretchers and splints. By 1946, when Eames' furniture designs began to be mass-produced by Herman Miller, Inc., they established a new American standard for using a minimal amount of materials to achieve forms of maximum utility, lightness, and sculptural effect (fig. 562). —D. O.

564. **Eva Zeisel**
"Museum" Dinner Service, c. 1942–45
Manufactured by Shenango Pottery, New Castle, Pennsylvania, for Castleton China Company, New York
Glazed porcelain, 10 in. (25.4 cm) height of coffeepot
The Museum of Modern Art, New York; Gift of the manufacturer

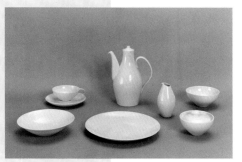

562. **Charles and Ray Eames**
Eames Molded Plywood Chairs, c. 1946
Manufactured by Molded Plywood Division, Evans Products Company, Venice, California

Plywood, calf-skin upholstery, and metal, 27⅝ x 22¼ x 25⅝ in. (70.2 x 56.5 x 65.1 cm)
Herman Miller, Inc., Zeeland, Michigan

563. **Isamu Noguchi**
Table for A. Conger Goodyear, 1939
Rosewood and glass, 30 x 84 in. (76.2 x 213.4 cm)
Private collection; courtesy The Isamu Noguchi Foundation, Long Island City, New York

565. Burgoyne Diller
First Theme, 1938
Oil on canvas, 30⅟₁₆ x
30⅟₁₆ in. (76.4 x 76.4 cm)
Whitney Museum of
American Art, New York;
Purchase, with funds from
Emily Fisher Landau
85.44
©Estate of Burgoyne
Diller/V.A.G.A., N.Y.

566. Albert Swinden
Sketch for *Mural,*
Williamsburg Housing
Project, c. 1936
Gouache on board, 8 x
11 in. (20.3 x 27.9 cm)
Whitney Museum of
American Art, New York;
Purchase, with funds from
the John I. H. Baur
Purchase Fund and the
M. Anthony Fisher
Purchase Fund 81.1

567. Charles Biederman
#16, 9/1938, 1938
Oil on wood, 29 x 10½ in.
(73.7 x 26.7 cm)
Whitney Museum of
American Art, New York;
Purchase, with funds from
the Painting and Sculpture
Committee 93.13

DOMESTIC ARCHITECTURE: TOWARD A NEW GEOMETRY

The late 1920s and 1930s were rich in architectural experimentation. Single-family houses for the middle and upper classes became the primary laboratory for the invention of new forms based on abstraction. Developing a unique language and geometry for each project, and experimenting with materials, modular planning, and construction, architects saw these modernist villas as essentially rational compositions in the landscape. Rejecting conventional notions of what a house should look like, they abandoned the traditional divisions of wall, window, door, and room, letting the arrangement of living spaces, different levels, and even basic forms be dictated by the site, the view, or the habits of the client.

The American Frank Lloyd Wright and the Austrian immigrants Rudolph M. Schindler and Richard Neutra were among the foremost proponents of this new geometry. In the summer house that he built in 1928–29 on a Catalina Island hillside, Schindler swiveled the structure and organized the sections into single open units, each on its own level, in order to respect the site and allow each living space to face both bay and ocean (fig. 569). Fascinated by American construction techniques, especially machine-made components and steel framing, Neutra in 1927–29 designed an angled steel-and-glass "health house" for Dr. Richard Lovell in Los Angeles. The building is considered the first steel-frame house in America, and its basic geometries, developed to emphasize the configuration of the site, were repeated in Neutra's intensely landscaped terraces, walls, and gardens.

Wright, for his part, conceived one of the icons of American architecture in 1935. The almost oriental composition of Fallingwater, built over a waterfall, is based on a series of overlapping cantilevered trays, between which lie the interior spaces of the house (fig. 568). The architect here left the landscape entirely alone, and floated Fallingwater in it like a ship at anchor, its complex cubic sculpture reflecting the structural geometries of the little valley around the house. Borrowing from abstract painting and sculpture, abandoning ornament, and blurring the boundary between interior and outdoors, wall and window, these three architects created a new architectural diversity in the quest for "better living." —N. O.

568. **Frank Lloyd Wright**
Perspective elevation for *Fallingwater, Bear Run, Pennsylvania,* 1935–36, rendered by Taliesin Fellowship
Graphite and colored pencil on tracing paper laid down on japanese paper, 18½ x 32⅛ in. (47 x 81.5 cm)
Centre Canadien d'Architecture/Canadian Center for Architecture, Montreal

569. **Rudolph M. Schindler**
Perspective elevation for *Summer Residence for Charles H. Wolfe, Avalon, Catalina Island, California,* 1928–29
Graphite, ink, colored pencil, and watercolor on linen, 32⅜ x 17⅝ in. (82.5 x 46 cm)
Architectural Drawing Collection, University Art Museum, University of California, Santa Barbara

Rebay's position that art was unconnected to life and that its sole function was to nourish humanity's spiritual dimension seemed heretical. Seven members of the American Abstract Artists published a virulent refutation of her pronouncements in the October 1937 issue of *Art Front*.

A year later, a group of New Mexico-based artists—Emil Bisttram (fig. 572), Ed Garman, and Raymond Jonson (fig. 573)—who also considered spirituality central to art, founded the Transcendental Painting Group. Rejecting all involvement with economic, political, or social concerns, the group pledged to carry painting "beyond the appearance of the physical world, through new concepts of space, color, light and design, to imaginative realms that are idealistic and spiritual."[136] Influenced by theosophy, the spiritual philosophy founded in New York in 1875 by Madame Blavatsky, the Transcendental painters employed a non-objective vocabulary to convey the intangible world of the spirit.

570. **Rolph Scarlett**
Composition, 1939
Oil on canvas, 42 x 40 in. (106.7 x 101.6 cm)
Solomon R. Guggenheim Museum, New York; Bequest, Solomon R. Guggenheim, 1949

Yet geometric abstraction was malleable enough as a style to accommodate the pursuit of social as well as spiritual goals. Socially oriented abstractionists envisioned a future where artists worked with architects, city planners, and industrial designers to create an efficient, utopian world. Like the urban optimists of the late 1920s, they saw technology as an ally. But now it was the materials and forms of technology that were admired, not its rationality and order. Dreams of this technologically advanced future were brought closer to reality in 1937, when László Moholy-Nagy arrived in America to direct a design school in Chicago. Here, at what was called the New Bauhaus, and at the Design Laboratory in New York, which opened with financial support from the WPA/FAP, students were taught to use art and technology to enhance society by designing graphics and objects of everyday use. After two years, the New Bauhaus closed and Moholy-Nagy opened his own school, known initially as the School of Design and later as the Institute of Design. Steeped in the Bauhaus principles of applying art to life, he incorporated into his work new technologies, new materials, and new attitudes toward motion (fig. 575). His interest in the properties of light and transparency led him to experiment with photograms, a camera-less photographic process that involved arranging translucent or opaque objects on a sheet of photographic paper and exposing them briefly to light (fig. 576). The result was the reverse of ordinary vision: the more light a given area received, the darker it became. Man Ray had evolved the same process in Paris with what he called rayography, a designation that referred both to light and to his name. In the mid-1930s, a number of artists, including Theodore Roszak and Gyorgy Kepes, Moholy-Nagy's fellow refugee from Nazi Germany, turned to similar methods to produce photographs that emphasized tonal relationships and pictorial structure over subject matter (figs. 577, 578).

571. **Rudolf Bauer**
Space, 1932
Ink, watercolor, conté, and
graphite on paper, 16 x
19 in. (40.6 x 48.3 cm)
Solomon R. Guggenheim
Museum, New York; Gift,
Solomon R. Guggenheim,
1941

572. **Emil Bisttram**
Two Cells at Play, c. 1942
Oil on canvas, 36 x 27 in.
(91.4 x 68.6 cm)
SBC Communications,
Inc., San Antonio, Texas

573. **Raymond Jonson**
City Perspectives, 1933
Oil on canvas, 48 x 38 in.
(121.9 x 96.5 cm)
Private collection

574. Theodore Roszak
Bi-Polar in Red, 1940
Metal, plastic, and wood,
54½ x 8⅝ x 8⅝ in.
(137.8 x 21.9 x
21.9 cm) overall
Whitney Museum of
American Art, New York;
Purchase, with funds from
the Burroughs Wellcome
Purchase Fund and the
National Endowment for
the Arts 79.6a–c

575. László Moholy-Nagy
Space Modulator,
1938–40
Oil on canvas on board,
47 x 47 in. (119.4 x
119.4 cm)
Whitney Museum of
American Art, New York;
Gift of Mrs. Sibyl
Moholy-Nagy 55.31

By the time Moholy-Nagy arrived in America, the union of art and technology was already securely established by industrial designers such as Raymond Loewy, Henry Dreyfuss, and Norman Bel Geddes, who had been charged in the wake of the financial crash of 1929 with redesigning American packaging and products in order to improve sales (figs. 584–87). Their use of streamlined, aerodynamic styling lent a look of progress and modernity to a wide range of consumer products that were photographed for advertising use by Anton Bruehl, William Rittase, and Margaret Bourke-White (figs. 579–82). The optimistic future of speed and mobility promised by the organic, rounded edges and smooth surfaces of these designs found its sculptural equivalent in the art of Theodore Roszak (fig. 574). Unlike abstract, urban sculpture of the 1920s, which emulated the geometric, angular forms of skyscrapers, Roszak's constructions imitated the futuristic machines and fantastic rocketships operated in outer space by the widely popular science fiction comic strip heroes Buck Rogers and Flash Gordon.

The most ambitious projection into the future occurred in conjunction with the New York World's Fair, which opened on April 30, 1939. At its most basic, the fair's goal was economic. By heralding the benefits and products of modern industrial living, fair organizers hoped to stimulate the country's economy. Intent on duplicating the huge financial success of Chicago's 1933 "Century of Progress" exposition, they chose "Building the World of Tomorrow" as their motto and hired industrial designers—Loewy, Dreyfuss, Bel Geddes, and Walter Dorwin Teague, among others—to plan and design the fair's exhibits. Experienced in transforming everyday objects into aerodynamically streamlined emblems of speed and futurity,

576. **László Moholy-Nagy**
Untitled, 1939
Gelatin silver print
(photogram), 19⅞ x
15⅞ in. (50.6 x 40.3 cm)
The Cleveland Museum of
Art; Andrew R. and Martha
Holden Jennings Fund

577. **Gyorgy Kepes**
*Untitled (Photograph for
Direction Magazine),* 1939
Photomontage with painted
watercolor, toned gelatin
silver print, 13⅝ x
10⅝ in. (34.6 x 27 cm)
Collection of Leland Rice

578. **Theodore Roszak**
Untitled, 1937–41
Gelatin silver print
(photogram), 9⅞₁₆ x 8 in.
(25.3 x 20.3 cm)
San Francisco Museum of
Modern Art; Purchase

579. **Anton Bruehl**
The Queen Mary, 1932
Gelatin silver print, 9⅝ x
7⅝ in. (24.4 x 19.3 cm)
The Metropolitan Museum
of Art, New York; Ford
Motor Company Collection,
Gift of the Ford Motor
Company and John C.
Waddell, 1987

580. **William Rittase**
Untitled, 1930s
Gelatin silver print, 7⅞ x
9⅝ in. (20 x 24.5 cm)
The Minneapolis Institute
of the Arts

581. **Margaret Bourke-
White**
Detail of a La Salle,
c. 1933
Gelatin silver print, 10 x
13 in. (25.4 x 33 cm)
Bourke-White Collection,
Department of Special
Collections, Syracuse
University Library,
New York

582. **Margaret Bourke-
White**
Brazilian Clipper, n.d.
Gelatin silver print, 13¼ x
9¼ in. (33.7 x 23.5 cm)
The Museum of Modern
Art, New York; Gift of the
photographer

these designers built an ordered, utopian city based on rational planning and scientific invention.

Two structures, in particular, symbolized the "usable future" promised by the fair: the Trylon, a 610-foot triangular tower, and the Perisphere, a 180-foot globe within which was housed Democracity (fig. 583). Designed by Dreyfuss, Democracity's six-minute automated performance introduced visitors, who were stationed on two moving ring-shaped balconies, to a vision of twenty-four hours in the life of a perfectly planned community of the future. In Bel Geddes' Futurama, designed for General Motors, visitors experienced a fifteen-minute simulated ride in the America of 1960, replete with high-speed highways, utopian communities, and model industries. The eruption of war in Europe four months after the fair opened challenged these dreams of saving humanity through science and technology. Attendance dropped in the wake of war, and even the fair's glistening white buildings were ultimately abandoned. The steel armatures of the Trylon and Perisphere, once emblems of hope and promise, were dismantled and turned into scrap metal for the armaments industry.

INDUSTRIAL DESIGN: STREAMLINED MODERNE

"Streamlining has taken the modern world by storm," declared Harold Van Doran in 1940. "We live in a maelstrom of streamlined trains, refrigerators, and furnaces; streamlined bathing beauties, soda crackers, and facial massages." A leading industrial designer, Van Doran explained how the defining aesthetic of the 1930s was drawn from an aerodynamic principle—that a teardrop shape reduces resistance to the air or water through which it moves and thus increases its speed (fig. 584). "The real field of true streamlining is transportation, especially the airplane [where] it is functional. . . . It has been borrowed in many forms by industry for application to static objects, where its employment is due largely to popular fancy."

Many factors contributed to the dominance of streamlining. The revolution in mass production had enabled the introduction of almost innumerable quantities of goods. And as new technologies such as electricity became commonplace, machines moved from the workplace into the home and became part of the everyday life of the middle class. What would make these new products not only palatable but even desirable to a population experiencing ambivalence about the wrenching changes of the twentieth century? The qualities of speed, power, and dynamism inherent in new modes of transportation and communication would have to be brought into a domestic setting and translated into a vocabulary better suited to the somber social conditions of the 1930s than were the machine styles of the exuberant preceding decade.

Industrial design was a new profession whose mission was to "style manufactured articles"; streamlining became its idiom. The goal of "design for appearance" fit this new field's celebrated protagonists, whose backgrounds were more oriented toward the creation of effective packaging than of product. Norman Bel Geddes and Henry Dreyfuss had been theater set designers; Walter Dorwin Teague worked for advertising agencies; Raymond Loewy had produced fashion illustration. A quintessential American development (although popular in Europe as well), streamlining was the ultimate expression of machine *imagery*—not, to the horror of International Style supporters, of machine *form*. Its characteristic horizontal, parallel lines suggested

583. **Arthur Hammond**
Semi-Lunar, Perisphere at 1939 New York World's Fair, n.d.
Gelatin silver print, 13½ x 10¼ in. (34.2 x 25.8 cm)
Brooklyn Museum of Art, New York; Gift of the artist

584. **Raymond Loewy**
Plasticene model of *S-1
Locomotive, Designed for
the Pennsylvania Railroad
Company,* 1936
Cooper-Hewitt, National
Design Museum,
Smithsonian Institution,
New York; Gift of the
Pennsylvania Railroad
through Samuel M.
Vauclain

motion, the teardrop shape conveyed efficiency, and its smooth surfaces implied rationality. It seemed uniquely suited not only to the temper of the times but also to new materials—for example, Bakelite (a plastic first used for consumer goods around 1932) was more effectively produced in curved molds.

The Depression intensified people's need to feel mastery over the new forces unleashed by technology, and streamlining satisfied that need by providing a comforting metaphor for speed, control, and progress. Egmont Arens and Theodore C. Brookhardt believed so profoundly in the efficacy of streamlining that they applied the concept to such unlikely forms as a meat slicer (fig. 586). Kem Weber's work epitomized the way design was used to shape as well as to celebrate the new tempo of modern life. His 1934 "Zephyr" clock (fig. 585), for example, with its horizontal lines and rounded corners that complement the digital clock face (a recent innovation), was advertised as providing "*exact* time at a glance. No hands pointing uncertainly . . . streamlined for instant perception." Zephyr, the Greek god of winds and move- ment, also lent his name to the new streamlined train introduced by the Burlington Railroad line in 1934.

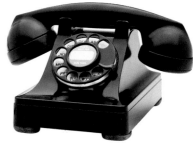

Surface styling, however, was not the only concern. The great pioneers of industrial design were also concerned with functional- ism, while Henry Dreyfuss was the most passionate about ergonomics. Scrutinizing how an object could be most effectively engineered (what he called "design from the inside out") and adhering to his maxim that "the most efficient machine is the one that is built around a person," he succeeded in changing the fundamental design of modern forms of transportation—trains, tractors, airplanes— as well as appliances such as toasters, vacuum cleaners, and refrigerators. Perhaps his most celebrated work was the series of telephones he designed for Bell Laboratories (fig. 587), which embodied his aspiration to make people "safer, more comfortable, more eager to purchase, more efficient—or just plain happier."

These and other industrial designers such as Gilbert Rohde and Russell Wright strove to improve the ordinary person's standard of living. But their paramount concern was to increase profits for the companies that employed them. During the Depression this was a daunting task, since workers in a country with high unemployment were disinclined to spend money. The notion of "planned obsolescence," first introduced in 1927 in the car industry, quickly spread to appliance companies when the need to cre- ate demand intensified as economic conditions worsened. Annual style changes became an essential part of marketing strategy and streamlining was the vehicle by which cus- tomers became convinced that they *had* to have the most up-to-date products. Making the consumer "more eager to purchase" was the ultimate objective. —W. K.

585. **Kem Weber**
*"Zephyr" Digital Clock,
Model No. 304-P40,* 1934
Manufactured by Lawson
Time, Inc., Los Angeles
Lacquered copper, chrome-
plated brass, and plastic,
3¾ x 8¼ x 3¾ in. (9.5 x
20.9 x 9.5 cm)
Collection of John Waddell

586. **Egmont Arens**
and **Theodore C. Brookhardt**
*"Streamliner" Meat Slicer,
Model No. 410,* 1941
Hobart Manufacturing Co.,
Troy, Ohio
Aluminum, steel, and
rubber, 13½ x 21 x 15 in.
(34.3 x 53.3 x 38.1 cm)
Collection of John Waddell

587. **Henry Dreyfuss**
*Telephone, Model No.
302,* 1937
Manufactured by Western
Electric Co., New York, for
Bell Telephone Company
Metal housing
Cooper-Hewitt, National
Design Museum,
Smithsonian Institution,
New York; The Decorative
Arts Association
Acquisitions Fund

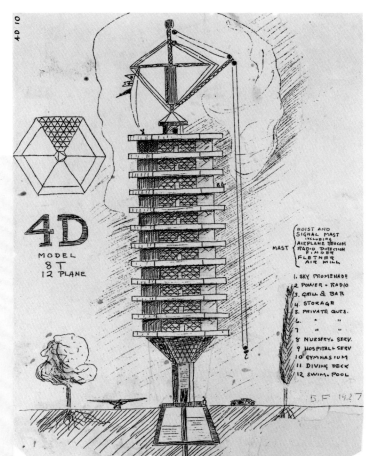

ARCHITECTURE: THE STREAMLINED FUTURE

America in the 1930s was in love with speed, and these years are often referred to as the "streamlined decade." Associated with the speed and movement of modern transportation and communication, streamlining became a metaphor for a modern, optimistic, and mobile America, reshaping the image, the forms, and even the typologies of architecture. For a brief period, sheet metal and glass—the materials of cars, trains, steamships, and planes—became the symbols of a new architecture, and the machine-made component its basic unit.

The roots of streamlining can be seen in utopian projects in the late 1920s and early 1930s. They were strongly linked to the new possibilities of transport and technology. Buckminster Fuller's early work, in particular, enlarged the concept of engineering to challenge our notions of habitat. In 1927, he conceived his futuristic 4-D Towers (fig. 588). Factory-made residential or office towers, equipped with air-rotor mills and transportable by airship, they were designed to maximize space, technology, and energy efficiencies. More pragmatically, Frank Lloyd Wright in 1932 developed a proposal in copper and glass for "wayside markets." The drive-in market, designed to sit beside the highway, included a gas station that could serve both airplanes and automobiles. A harbinger of the shopping mall, this scheme was later incorporated into a larger anti-urban proposition called Broadacre (a utopian world where everyone, including children, would own one acre of land, and where every family would own cars).

Real buildings began to take on streamlined forms in the mid-1930s. The interior columns of Wright's Johnson Wax building (fig. 589) expand as they ascend, while the

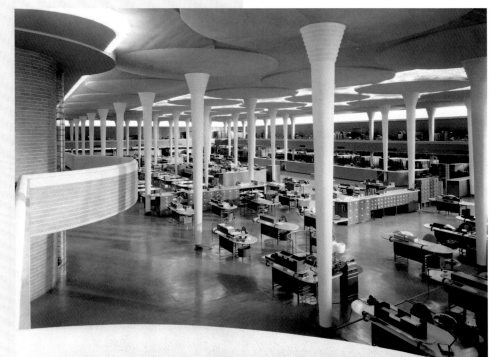

589. **Frank Lloyd Wright**
Interior view of *Johnson Wax Administration Building*, 1938–39

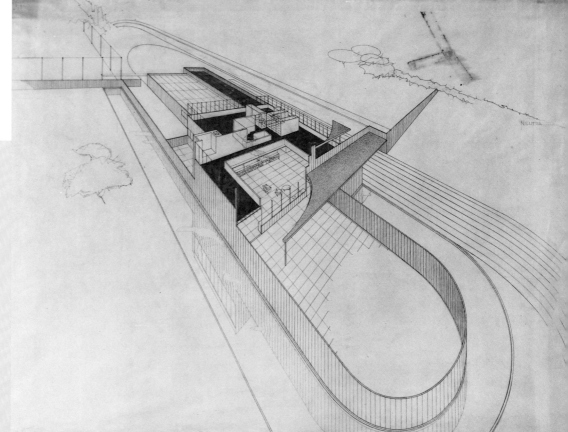

exterior follows the sinuous forms of a road or racing track. The house that Richard Neutra designed for Josef von Sternberg (fig. 590), with its aerodynamic steel wall surrounded by a curved road for the car, was perhaps the most astounding example of streamline architecture. Both structures reject angles and cubic forms entirely.

If the Chicago World's Fair of 1933, with its accent on transportation, efficiency, and speed, opened the door to streamlining, the New York World's Fair of 1939 saw streamlining reach its peak. Many pavilions adopted the approach, as in the curved forms, uninterrupted surfaces, and aerodynamic lines of the Ford pavilion of Albert Kahn and the Aviation Building by William Lescaze, originally conceived to be clad in sheets of aluminum, like an airplane (fig. 591). With the World's Fair, however, it became obvious that streamlining was now more a style than a concept of design, applied to buildings without any direct or symbolic connection to movement. Ironically, this ended up by producing not sleekness but what one critic called an "artificial swelling of volumes."

Nevertheless, the streamlined style helped prepare Americans for the functionalist aesthetics of the postwar era and vividly expressed a new national passion for "progress." —N. O.

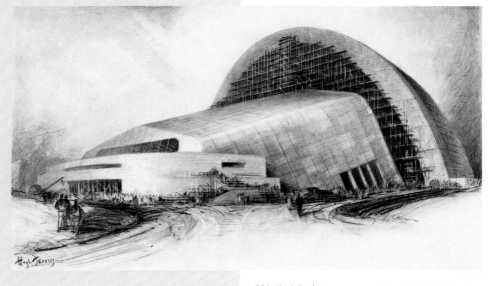

War and
Its Aftermath
1940–1949

America Confronts War

While America struggled with economic upheaval in the thirties, Europe was engulfed by political crisis. In 1936, Adolf Hitler defied the Treaty of Versailles by sending troops into Germany's demilitarized Rhineland, and an army under General Francisco Franco rebelled against the republic of Spain. Two years later, Hitler's Third Reich annexed Austria and Czechoslovakia. Following Hitler's invasion of Poland on September 1, 1939, France and Great Britain declared war on Germany, and World War II began.

COMMUNITY AND CONTINUITY IN HOLLYWOOD FILM: FORD AND CAPRA

When John Ford received his second consecutive Academy Award as best director for his 1941 film *How Green Was My Valley*, the accolade capped a remarkable period when two film directors—Ford and Frank Capra—dominated movie industry honors as no other pair of filmmakers has ever done.

The films of these two directors were notable for their cultural content. As Hollywood moviemakers took on a more confident public role during the Depression years, Capra and Ford more than most others aimed to address historical and social concerns. Neither man, moreover, derived his authority from membership in the traditional Protestant American elite. Ford, born Sean Aloysius O'Feeney, was of Irish descent. Capra came to the United States at age six from a village in Sicily. Both were Catholics.

Perhaps their status as outsiders who worked in a powerful but often controversial new industry stimulated their interest in the relationship between leaders and the community. Although their approaches differ, similar questions recur in their work. Where do leaders come from? How do those whom they lead recognize and acknowledge them? These were not solely problems of political theory. The nation's democratic structures were challenged in those years by the severity of the economic crisis and the rise of Fascist dictatorships overseas. Critics and spectators alike understood the relevance of Ford's and Capra's movie stories.

Capra first gained wide recognition with a screwball comedy, *It Happened One Night* (fig. 524), winner of five Academy Awards, including best picture and best director. Later works—including the two others for which he won best-director honors, *Mr. Deeds Goes to Town* (fig. 592) and *You Can't Take It with You* (1938)— more directly addressed contemporary issues of class and power relations. In Capra's films, leaders are unpretentious visionaries who rise from small-town origins. A hallmark of his films is a crisis moment when this figure is defeated and humiliated. Popular support is required to save the day—for Capra, leadership depended upon strong roots in the community.

Ford's first award for best director came in 1935 with *The Informer*, an adaptation of the novel by the Irish author Liam O'Flaherty (1925). Other awards also honored adaptations—of John Steinbeck's epic of Oklahoma migrants in the Depression, *The Grapes of Wrath* (fig. 494), and *How Green Was My Valley*, from the 1939 Welsh novel by Richard Llewellyn. But Ford was even more strongly identified with historical themes. In films like *Drums Along the Mohawk* and *Young Mr. Lincoln* (both 1939), he depicted, respectively, the American Revolution in western New York and the youthful emergence of the future Civil War president. In these two works and in *Stagecoach*, also made in 1939, Ford treated the formation of leaders and democratic communities during the European settlement of the American West, but the theme resonated clearly into the politically troubled present. —R. S.

With democracy threatened on all sides, the search for American roots transmuted into an adamant defense of indigenous American values. Across the country, artists left behind images of the dispossessed to celebrate those native values most endangered by war in Europe—freedom, democracy, and community. William Zorach's *Future Generation*, for example, placed the family at the center of the nation's heritage (fig. 595). The Hollywood film directors John Ford and Frank Capra supplied audiences with idealized visions of past and present American life (fig. 592), while songwriters composed emblematic ballads about America and its people. Kate Smith premiered Irving Berlin's "God Bless America" in a radio broadcast in 1938. A year later, Paul Robeson recorded Earl Robinson's *Ballad for*

592. *Mr. Deeds Goes to Town,* directed by Frank Capra, 1936
The Museum of Modern Art, New York/Film Stills Archive

Americans, a choral tribute to the brotherhood of the common people; and Woody Guthrie set aside songs of social protest to compose "This Land Is Your Land" (originally titled "God Blessed America for Me"). In 1938, Martha Graham broke the traditional silence of dance to register a patriotic appeal for American democracy with her episodic, narrated ballet *American Document,* which featured an onstage narrator who concluded the dance by reciting the closing lines of the Gettysburg Address: "government of the people, by the people, and for the people shall not perish from the earth." The American Ballet Caravan drew upon the frontier's mythic association with personal freedom and self-reliance to produce Lew Christensen's *Pocahontas* (1936) and *Filling Station* (fig. 596). In scores for Eugene Loring's ballet *Billy the Kid* (fig. 598) and Agnes de Mille's *Rodeo* (fig. 597), Aaron Copland freely integrated American folk songs into classical compositions. His 1944 *Appalachian Spring,* whose sweeping orchestrations evoked prairie skies and pioneer vistas, provided the musical accompaniment for Martha Graham's ballet of the same name (fig. 599). Roy Harris, Samuel Barber, and Virgil Thomson emulated Copland by infusing American themes and popular music into their classical music compositions. Their celebrations of the innocence and vitality of the American past reached a climax in the Richard Rodgers and Oscar Hammerstein II Broadway musical *Oklahoma!* (fig. 600).

593. *Say, Is this the U.S.A.,* text by Erskine Caldwell, photographs by Margaret Bourke-White New York: Duell, Sloan and Pearce, 1941 Frances Mulhall Achilles Library, Whitney Museum of American Art, New York

594. **Jack Delano**
Prelude to Afternoon Meal, Carroll County, Georgia, 1941
Gelatin silver print, 10½ x 13 in. (26.7 x 33 cm)
Roy E. Stryker Collection, Photographic Archives, University of Louisville Special Collections, Kentucky

595. **William Zorach**
Future Generation, 1942–47
Marble, 40 x 19⅜ x 14½ in. (101.6 x 48.7 x 36.8 cm)
Whitney Museum of American Art, New York; Purchase and exchange 51.32

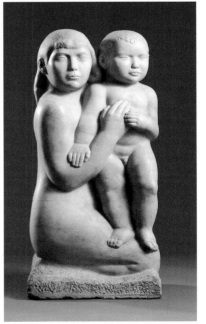

596. Lew Christensen supporting Marie-Jeanne in *Filling Station*, choreographed by Lew Christensen, 1938, photograph by George Platt Lynes Gelatin silver print Dance Collection, The New York Public Library for the Performing Arts, Astor, Lenox and Tilden Foundations

CELEBRATING AMERICA IN DANCE

The term "Americana" in theatrical dancing of the 1930s and 1940s specifically refers to ballets and concert dances whose scenarios draw on American history, myths, and themes. Indeed, discussions of such works often end up speaking of everything in the productions but the choreography: the stories, the characters, the costumes, the scenery, the American folk tunes in the scores. In dance, of course, the score is a crucial component, and the examples of the genre that have survived as masterpieces today contain first-rate commissioned scores by American composers. Three of those ballets had the benefit of music by Aaron Copland: *Billy the Kid*, choreographed by Eugene Loring (fig. 598); *Rodeo*, by Agnes de Mille (fig. 597); and *Appalachian Spring*, by Martha Graham (fig. 599). All of them feature rural, frontier settings, with *Billy the Kid* and *Rodeo* taking place in the Old West and *Appalachian Spring*—a dance depicting the trepidation of a young bride starting life with her husband on an isolated homestead—set in an unspecified wilderness. Equal to these in quality is *Fancy Free* (1944), with a score by Leonard Bernstein and choreography by Jerome Robbins. An urban story, however, of three sailors on shore leave, chasing girls around Times Square, it was something of a departure for the genre—unromantic, unsentimental, contemporary, and humorous without crossing the line into caricature. Of the four works mentioned, only *Rodeo* includes actual American folk dancing (a square dance to a caller, arguably the best part of the ballet).

Although many kinds of theatrical dances were created in the United States during the interwar years, Americana dances are remembered with a special fondness primarily for their working-class milieus and implicitly leftist political content. In modern dance especially, the political dimension of the choreography, fortified by folk music and song, lent a sense of community to artists whose hardscrabble existences gave them little hope for material gain. Most of the overtly political works, frequently derived from anecdotes of abuses suffered by minorities or labor unionists, vanished, although some elliptically political pieces, such as Graham's 1938 *American Document*, contained formal invention that is still admired. The history of American modern dance in general, too, is inseparable from the Federal Dance Project, a New Deal program that lasted from 1936 to 1939. Among the choreographers it supported were Doris Humphrey, Ruth Page, Senia Gluck-Sandor (an early mentor of Jerome Robbins), and Helen Tamiris, who would go on to choreograph for Broadway.

In the ballet world, Americana was valued both for its patriotic aspect and for its box office appeal. Lincoln Kirstein, the visionary patron who brought George Balanchine to America, wanted to establish a native ballet tradition, and to that end he encouraged

597. *Rodeo,* choreographed by Agnes de Mille, 1942, photograph by Roger Wood Gelatin silver print, Dance Collection, The New York Public Library for the Performing Arts, Astor, Lenox and Tilden Foundations

598. *Billy the Kid,* choreographed by Eugene Loring, 1938, photograph by George Platt Lynes Gelatin silver print Dance Collection, The New York Public Library for the Performing Arts, Astor, Lenox and Tilden Foundations

the founding of several companies during the 1930s and the development of Americana repertory for them. Among the works Kirstein commissioned or helped develop were *Alma Mater* (1934), a Balanchine ballet about a Yale football player; *Harlequin for President* (1936; Loring), about the American electoral process; the historical *Pocahontas* (1936; Lew Christensen); and *Filling Station* (fig. 596), as well as *Billy the Kid*. (*Filling Station*, with a stylish score by Virgil Thomson, is, like *Billy the Kid*, still in repertory today.) Eventually, Kirstein's companies—the American Ballet, Ballet Caravan, and Ballet Society—led to the founding in the late 1940s of the New York City Ballet.

By the mid-1940s, nationalist themes were seen as a means to ensure financial success. In 1934, Léonide Massine had choreographed *Union Pacific*, a ballet about the building of the railroad line, for the Ballet Russe de Monte Carlo; it toured the United States extensively. But Massine balked at being ordered by the company's management in the early 1940s to turn from the making of symphonic works to the fashioning of one-act Americana pieces in order to increase box office receipts. Yet the commercial success of the Broadway show *Oklahoma!*, with dances by de Mille (fig. 600), did not extend to concert modern dancers, some of whose finest Americana dances disappeared from view because their companies folded. Fortunately, thanks to film and dance notation, such gems as Doris Humphrey's suite *The Shakers* (fig. 445), inspired by the religious sect that believed in ecstatic dancing as an avenue to spiritual purification, survives in performances by small companies and college dance departments. —M. A.

599. *Appalachian Spring,* choreographed by Martha Graham, 1944, photograph by Arnold Eagle Gelatin silver print, 7¼ x 9¼ in. (18.4 x 23.5 cm) Music Division, The New York Public Library for the Performing Arts, Astor, Lenox and Tilden Foundations

Even the documentary photo-book, the thirties tool for social change, turned to praising the American Way—most notably in Oliver La Farge and Helen Post's *As Long as the Grass Shall Grow* (1940) and in Margaret Bourke-White and Erskine Caldwell's *Say, Is this the U.S.A.* (fig. 593). By this time, the Farm Security Administration (FSA) had shifted its emphasis to more neutral records of rural America. In a 1940 memo, Roy Stryker admonished Jack Delano to "emphasize the idea of abundance—the 'horn of plenty'. . . . I know your damned photographer's soul writhes, but to hell with it. Do you think I give a damn about a photographer's soul with Hitler at our doorstep?"[137] In 1942, with Congress battling over appropriations, Stryker's photo unit was transferred to the government's propaganda agency, the Office of War Information (OWI). At the OWI, photographs of hard times gave way to those "of men, women and children who appear as if they really believed in the U.S." (fig. 594).[138] Disenchanted with the agency's dictates, Stryker resigned in October 1943 and joined the Standard Oil Company of New Jersey, where he assembled a massive photographic record of homefront America. The photographs were part of a public relations campaign to improve the company's image, which had been tarnished by accusations that it had aggravated the American rubber shortage in the early years of the war.

This lauding of American values

AMERICAN MUSICALS

The American musical stage took little note of World War II, except for Irving Berlin's *This Is the Army* (1942), which, after a decent run on Broadway, toured the war fronts. Musical Broadway, for the most part, busied itself with celebrating American communal values and, in the process, brought this uniquely American art form to a point of perfection.

It was during the dark days of 1943 that *Oklahoma!* opened in New York. It eventually broke every production record, playing for more than five years on Broadway, and ten years on the road (fig. 600). This unprecedented popularity affirmed that the production, with its scene and subject matter far removed from the usual sophisticated Broadway musical, had somehow captured the spirit of American optimism, which had been sorely tried by the Depression and the war. But the artistic accomplishments of *Oklahoma!* were even greater and set a pattern in Broadway musicals for many years to come.

It was Theresa Helburn of the Theatre Guild who persuaded Richard Rodgers to musicalize Lynn Riggs' play *Green Grow the Lilacs* (1931), which the Guild had produced some years before. Rodgers brought in Oscar Hammerstein II for the book and lyrics. Agnes de Mille, dancer and choreographer, was later added to the team. Together, these three artists achieved the unprecedented feat of making all the elements—dialogue, song, and dance—integral to the story, the unfolding of the action, and the revelation of character. The same three artists joined forces to create *Carousel* (1945), based on Ferenc Molnár's Liliom story. The musical made use of the song soliloquy and probed the psychology of the characters, even in the dance numbers. A new era had begun for the American musical.

Jerome Robbins transformed ballet-derived dance into theater dance. Early in 1944, he had choreographed *Fancy Free* for the American Ballet Theatre, to an original score by Leonard Bernstein, the young conductor of the New York Philharmonic. The ballet was an instant success, and the two found themselves famous. They decided to make the material into a Broadway musical, recruiting the young Betty Comden and Adolph Green to write the book and lyrics. In the end, the musical had all-new songs, along with all-new music. Only the original concept of three sailors on twenty-four-hour leave in New York City remained. It was now called *On the Town*, and the wartime-driven *carpe diem* theme was instantly appealing. Bernstein's classically structured music used the American idioms of ragtime, blues, and jazz, as George Gershwin had done. For the six plot-advancing dances, Bernstein wrote what were essentially symphonic suites, and Robbins choreographed dances that were organic to the characters and the story and undetachable from the whole. It was a seamless and joyous production and a smashing success because it caught the precise mood of the public.

600. Playbill for Richard Rodgers and Oscar Hammerstein II's *Oklahoma!,* St. James Theatre, New York, 1943 Billy Rose Theatre Collection, The New York Public Library for the Performing Arts, Astor, Lenox and Tilden Foundations

accorded with a fierce isolationism that permeated almost all of American society. Indeed, resistance to involvement in European affairs was the one issue on which most conservatives and progressives agreed. Not until Germany invaded the Soviet Union in June 1941 did the Communist-controlled American Artists' Congress call for American participation in the war. Until then, one of the most outspoken interventionists had been *Life* magazine's publisher, Henry Luce, whose February 1941 article "The American Century" had urged Americans to enter the war in order to ensure the country's position as "the most powerful and vital nation in the world."[139]

In 1949, there appeared another musical with a wartime background. By then, the war was just a vivid memory, and some phases of it could be looked at with a bit of nostalgia and a dash of amusement. So Rodgers and Hammerstein (now their own producers) devised *South Pacific* from James Michener's book about his wartime experiences. It was basically a star vehicle for Mary Martin and the opera star Ezio Pinza, but all the performers sang: in solos, duets, and various combinations of choruses. The director Joshua Logan dispensed with a choreographer and staged the dance movement of the USO show and the character choruses such as "There Is Nothing Like a Dame" himself. The story line concerns a group of natives on a Pacific isle, Navy Seabees, nurses, and a planter exile. Hammerstein produced a beautiful song against racial bigotry, "Carefully Taught." "Some Enchanted Evening" became a hit song, and Mary Martin's "I'm Gonna Wash That Man Right Out of My Hair" became a legend. Much of the appeal of the show lay in Martin's cockeyed optimism. *South Pacific* ran for 1,925 performances, won the Pulitzer Prize, toured widely, and was made into a film in 1958.

Annie Get Your Gun (1946) was also a star vehicle—this time for Ethel Merman. Its chief attraction was its powerful score, composed by Irving Berlin, who also wrote the lyrics. Like *Oklahoma!*, it drew on indigenous American material: the rivalry between sharpshooters Annie Oakley and Frank Butler in Buffalo Bill's Wild West Show. Merman's brash American persona in this typically American setting, singing "There's No Business Like Show Business," made the show wildly successful—1,147 performances on Broadway, a London production, and a road company.

Even Shakespeare was transformed into the musical idiom. *Kiss Me Kate* (1948), with music and lyrics by Cole Porter, had a double story line: a production of *Taming of the Shrew* and the lives and relationships of a company of actors playing in it, making it a kind of backstage, onstage duality. The songs and dances were integral to the action, and in a number like "Too Darn Hot" song and dance proceeded simultaneously. The clever book and songs, among them "Another Opening, Another Show" and "Brush Up Your Shakespeare," led to a run of 1,077 performances and the Tony Award for best musical that year. —V. R.

Even the film industry, despite its sizable number of Jewish-American producers, was initially silent on the issue of intervention, even to the point of capitulating when the Nazis demanded the dismissal of all "non-Aryan" employees from American production facilities in Germany. Only isolated films such as Anatole Litvak's *Confessions of a Nazi Spy* (1939) and Charlie Chaplin's *The Great Dictator* (1940) addressed the Fascist threat. That changed in August 1940 when Germany banned all American films from areas under its control. The wave of American propaganda films that followed so alarmed congressional isolationists that one of them, the Republican senator Gerald Nye, initiated hearings into Hollywood's partisan politics.

All such anti-interventionist activities ceased after the surprise Japanese attack on the American naval base at Pearl Harbor on December 7, 1941, and America's entry into the war. Still, with many Americans in favor of an early negotiated peace, propagandists mobilized to build up support for the war. Ten days after Pearl Harbor, Luce wrote to President Roosevelt, offering *Life*'s services "in the days to come—far beyond strict compliance with whatever rules may be laid down for us by the necessities of war."[140] *Life*'s subsequent in-depth stories on the conflict, as many as two or three each issue, delivered weekly reminders of the war to American homes—and contributed to the huge increase in the magazine's circulation.

Luce's most conspicuous artistic allies in the battle against American complacency were the Regionalists. Alarmed that the nation's aversion to war would dampen its readiness to fight, Grant Wood admonished artists in 1941 to awaken the public to what it stood to lose. "Here, it seems to me, is where artists come in," he asserted. "It is time for us to admit we believe in the value of the goals we mean, in general, when we say 'the American way of life.'"[141] Even before America's entry into the war, Wood produced a number of posters for Bundles for Britain, a relief agency that shipped American clothing and medical supplies to England. Although

Wood died prematurely of liver cancer in February 1942, only two months after Pearl Harbor, his practice of lauding everyday American life to remind the country of what it was fighting for—made explicit in the posthumous use of one of his paintings on the cover of *The Saturday Evening Post*—became the model for wartime propaganda (fig. 601).

Wood was not the only Regionalist to put his art in the service of propaganda.

FOR WHAT ARE WE FIGHTING? By DR. FELIX MORLEY

John Steuart Curry, for example, produced war bond advertisements featuring heroic images of the American farm family to exhort Americans to buy bonds. The strategy to rally the nation's pride by recalling the country's unique traditions of freedom and democracy was especially apparent in the poster series "This Is America: Keep It Free!" (figs. 603, 604) and "This Is America: For This We Fight." No images, however, so caught the American imagination or were so widely distributed as Norman Rockwell's *Four Freedoms*, based on Roosevelt's 1941 State of the Union address. Commissioned by *The Saturday Evening Post*, the paintings were reproduced as posters and released in an edition of four million by the Treasury Department as part of its war bond campaign (fig. 605).

Some propaganda, such as Ben Shahn's war posters (fig. 602) and Thomas Hart Benton's eight-part painting series *The Year of Peril* (fig. 606), sought to persuade through fear.[142] *The Year of Peril,* begun by Benton within days after Pearl Harbor, was intended to fuel the public's resolve to fight for the preservation of democratic principles by stressing the realities of a possible Fascist victory. By gruesomely describing what the Fascists might do to America in an invasion, Benton sought to stimulate complacent citizens—the "naïve isolationists of the middle west," as he termed them—to participate wholeheartedly in the war effort.[143] Abbott Laboratories, a major pharmaceutical firm, purchased and reproduced the paintings in a booklet with a foreword by the poet Archibald MacLeish, then chief of the Office of Facts and Figures (OFF) and head of the Library of Congress. Copies of the booklet, along with reproductions of the paintings on stamps, stickers, and posters, were distributed worldwide by the OFF and its successor, the OWI. Paramount Pictures featured the 1942 New York exhibition of the paintings in newsreels across the country, making them among the most famous fine-art propaganda efforts of World War II.

The brutality of Benton's images matched that of David Smith's 1936 war etchings and figurative bronze reliefs entitled *Medals for Dishonor* (1937–40). Inspired, in part, by the New York exhibition of Picasso's anti-Fascist etchings and his mural *Guernica*, which memorialized the destruction of the Spanish city bombed by Franco's Nazi collaborators, Smith's aggressive and violent commentaries struck at social corruption as much as at war and Fascism. After America's entry into the war, Smith worried that his nightmarish images of human cruelty and barbarism, which he obtained by uniting eroticism with bestiality, would be interpreted as anti-interventionist. Asked to exhibit the *Medals* in 1942, he presented eleven out of the original fifteen under a new title: *Axis Devastation*.

603. *This is America . . .
a nation with more homes,
more motor cars, more
telephones—more com-
forts than any nation on
earth. . . . Keep it Free!,*
1942
Poster
National Museum of
American History,
Smithsonian Institution,
Washington, D.C.; Gift of
the Sheldon-Claire
Company, Chicago

...a nation with more homes, more motor
cars, more telephones–more comforts than
any nation on earth. Where free workers
and free enterprise are building a better
world for all people ⋆ *This is your America*

...Keep it Free!

604. *This is America . . .
where the family is a
sacred institution. . . .
Keep it Free!,* 1942
Poster
National Museum of
American History,
Smithsonian Institution,
Washington, D.C.; Gift of
the Sheldon-Claire
Company, Chicago

...where the family is a sacred
institution. Where children love,
honor and respect their parents
...where a man's home is his
castle ⋆ *This is your America*

...Keep it Free!

605. **Norman Rockwell**
Freedom from Want, 1943
Poster for the Office of
War Information,
Library of Congress,
Washington, D.C.

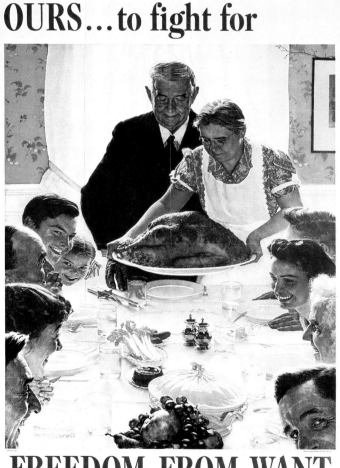

OURS...to fight for

FREEDOM FROM WANT

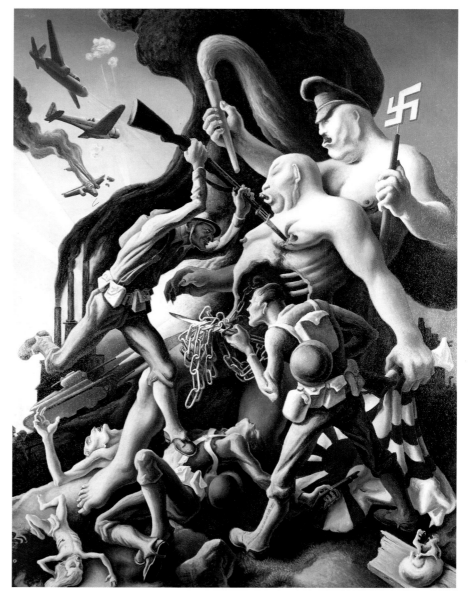

606. **Thomas Hart Benton**
Exterminate! from the series *The Year of Peril,* 1942
Egg tempera and oil on canvas, 98½ x 74½ in. (250.2 x 189.2 cm)
State Historical Society of Missouri, Columbia
©T.H. Benton and R.P. Benton Testamentary Trusts/V.A.G.A., N.Y.

607. **David Smith**
Aryan Fold, 1943
Ink on paper, 19⅝ x 25¼ in. (49.9 x 64.1 cm)
Collection of Candida and Rebecca Smith
©Estate of David Smith/V.A.G.A., N.Y.

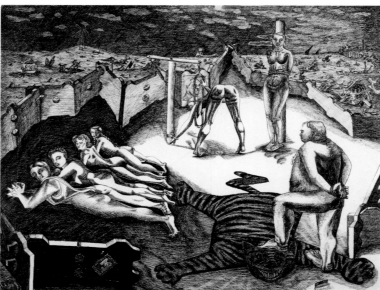

Other artists responded more systematically to the task of creating defense and war-related propaganda. By January 1942, so many art associations had mobilized for this purpose that the federal government asked them to consolidate into one organization. Twenty-three art societies did so under the rubric Artists for Victory. With an eventual membership of over ten thousand, the group became the chief liaison between artists and the government. Their most public activity was sponsoring open, competitive exhibitions, the first and largest of which was held at

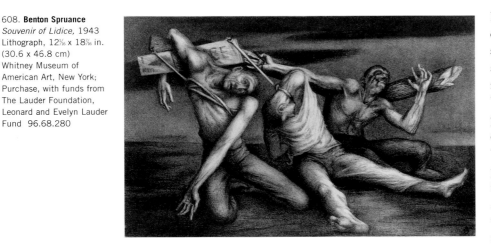

608. **Benton Spruance**
Souvenir of Lidice, 1943
Lithograph, 12⅜ x 18⅜ in.
(30.6 x 46.8 cm)
Whitney Museum of American Art, New York; Purchase, with funds from The Lauder Foundation, Leonard and Evelyn Lauder Fund 96.68.280

The Metropolitan Museum of Art in December 1942. With no restrictions on subject matter and the prospect of $52,000 in prizes, only a minority of the show's participants explored themes related to war. Consequently, Artists for Victory narrowed the scope of its next project: a nationwide print competition on the theme "America and the War." The final one hundred selections were presented in October 1943 in twenty-six identical exhibitions across the country. Among the most successful of the works were Henry Simon's depiction of the three Axis leaders (Adolf Hitler, Benito Mussolini, and Emperor Hirohito) and

Benton Spruance's Christian allegory of villagers in German-occupied Czechoslovakia yoked and nailed to crosses (fig. 608). Artists for Victory sponsored other competitions and exhibitions, but none equaled the drama of "Road to Victory," the exhibition Edward Steichen organized for The Museum of Modern Art in 1942. Drawing on photomontage techniques, Steichen enlarged to mural size 150 photographs, which he had selected from the files of Time-Life, the Associated Press, and the FSA. Hung alongside text panels written by Carl Sandburg, they formed a collective portrait of the nation at war.

The film industry responded to the war with a zeal that owed as much to financial considerations as to nationalism. In addition to the pro-American "Victory" newsreels produced for overseas distribution, seventy films with war themes were released within six months of Pearl Harbor. With the OWI empowered to control the overseas distribution of films, Hollywood generally heeded the agency's mandate to emphasize democratic unity and the positive aspects of American life. Of the nearly seventeen hundred scripts submitted to the OWI for review during the war years, the agency requested—and received—changes in 70 percent of them.

No such editorial review was needed for the short documentary training films Frank Capra made for American Army troops or for his convincing seven-part documentary *Why We Fight* (1942–45), which used stock footage to illustrate the necessity of American involvement in the war. Equally persuasive was John Ford's seventeen-minute *The Battle of Midway* (1942), made during the decisive naval engagement in the Pacific. Ford's raw, blurred footage, the result of using a hand-held camera, was the cinematic counterpart to the haunting war photographs of Robert Capa (fig. 609). The ultimate war film, however, was probably *Casablanca* (1942), Hollywood's paean to the nobility of personal sacrifice for a higher cause. Humphrey Bogart's parting words to Ingrid Bergman—in the face of war, "the problems of three little people don't amount to a hill of beans"—went a long way toward helping the nation bear the hardships of the conflict.

For the first twenty months after the United States entered the war, the government censored all photographs that depicted dead or wounded Americans. News agencies were permitted to publish only reassuring views of military personnel. The order was rescinded in September 1943, after surveys suggested that the absence of pictorial records of American casualties had led to public complacency. Even then, *Life* accompanied its first photograph of Americans killed in the war—George Strock's depiction of three American soldiers lying dead on New Guinea's Buna Beach (fig. 610)—with a full-page editorial assertion that "the love of peace has no meaning or stamina unless it is based on a knowledge of war's terror. . . . Dead men have indeed died in vain if live men refuse to look at them."[144] What followed was the most visually chronicled war in history.

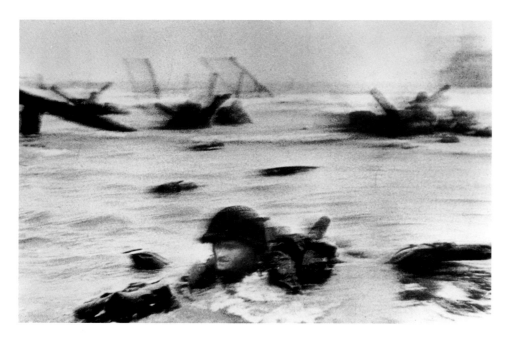

609. **Robert Capa**
D Day, Omaha Beach, Normandy, France, June 6, 1944, 1944
Gelatin silver print, 11 x 13⅝ in. (27.9 x 35.4 cm)
International Center of Photography, New York

Whereas reportage of previous wars had relied on the written word, World War II was inscribed in images. With the development of more compact and portable cameras, faster film, more powerful lenses, and vastly accelerated shutter speeds, the camera's capacity to capture the drama of war far excelled that of other media (figs. 609–13). Indeed, apart from a few exceptions, such as the veteran illustrator Kerr Eby (fig. 617), most artists recorded the war in retrospect. Jacob Lawrence, for example, produced his fourteen-panel *War Series* almost a year after his discharge from the Coast Guard in 1945 (fig. 618). In this series, he departed from his habit of conjoining text and image to create a narrative cycle and relied only on images. The result is less a narrative cycle than a sequence of self-contained canvases, bound together by mood and subject.

Most war photographers worked for one of the three wire services or for *Life* magazine. Voluntarily risking their lives by going into combat alongside soldiers and sailors, they sought to record not merely the events of the war but their human significance as well. Photographers such as Robert Capa and W. Eugene Smith (figs. 609, 613) believed that pictures were worthwhile only if they distilled the meaning and emotions that underlay events, if they communicated not only what happened but what it meant to the participants. Smith's photographs in the Pacific and Capa's in Europe and North Africa attested to the complexity and suffering of the war—to what Smith called "the brutal corrupting viciousness of [war's] doing to the minds and bodies of men."[145] This was far less true of the photographs produced under the auspices of the Naval Aviation Photographic Unit, which documented the activities of naval aircraft carriers for recruitment purposes. Limited by their distance from the enemy, the unit's photographers emphasized the panorama of the war, rather than its human significance, but did so with such beauty and technical precision that many of their images were among the most frequently reproduced of the war.[146]

Perhaps the most famous images from the war were those that recorded victory—from Joe Rosenthal's picture of five marines raising the American flag atop Iwo Jima's Mount Suribachi to Alfred Eisenstaedt's depiction of the mass euphoria

610. George Strock
American Casualties on Beach, New Guinea, 1942
Gelatin silver print, 13½ x 10¼ in. (34.4 x 26.1 cm)
The Metropolitan Museum of Art, New York; Gift of Photography in the Fine Arts, 1959

611. George Rodger
Landing in Italy
Cover of *Life,* March 27, 1944
Life Magazine/Time Inc., New York

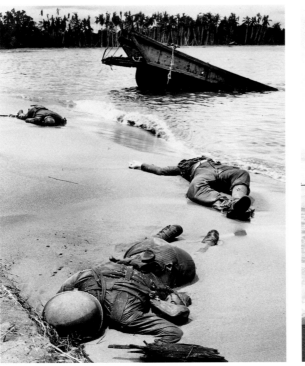

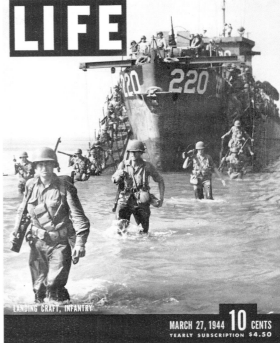

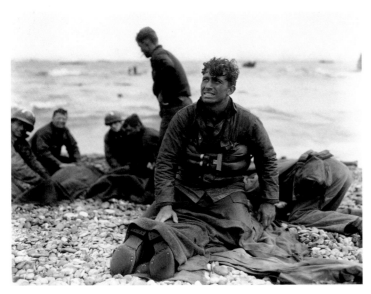

612. Walter Rosenblum
D Day Rescue, 1944
Gelatin silver print, 7 x 8¾ in. (17.8 x 22.2 cm)
Collection of Naomi and Walter Rosenblum

613. W. Eugene Smith
Marines Under Fire, Saipan, 1943
(printed later)
Gelatin silver print, 13¼ x 10⅜ in. (33.7 x 26.2 cm)
International Center of Photography, New York

614. Joe Rosenthal
Old Glory Goes Up on Mount Suribachi, Iwo Jima, 1945
Gelatin silver print, 9¼ x 7⅝ in. (23.5 x 19.4 cm)
George Eastman House, Rochester, New York

615. Alfred Eisenstaedt
VJ Day, Times Square, New York City, 1945
Gelatin silver print, 14 x 11 in. (35.6 x 27.9 cm)
Life Magazine/Time Inc., New York

616. "Atrocities," photographs by Margaret Bourke-White and George Rodger, page spread from *Life*, May 7, 1945
Life Magazine/Time Inc., New York

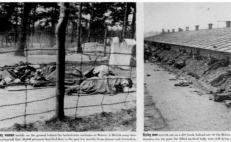

ATROCITIES

CAPTURE OF THE GERMAN CONCENTRATION CAMPS PILES UP EVIDENCE OF BARBARISM THAT REACHES THE LOW POINT OF HUMAN DEGRADATION

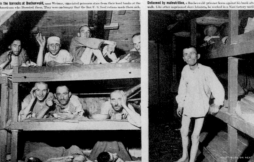

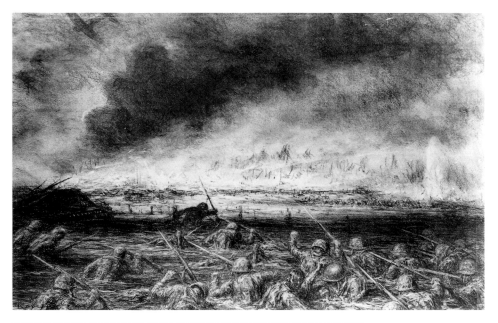

617. **Kerr Eby**
D Day, Tarawa, 1944
Charcoal on paper, 25 x
38 in. (63.5 x 96.5 cm)
Navy Art Collection, Naval
Historical Center,
Washington, D.C.

618. **Jacob Lawrence**
War Series: Victory, 1947
Egg tempera on board,
20 x 16 in. (50.8 x
40.6 cm)
Whitney Museum of
American Art, New York;
Gift of Mr. and Mrs. Roy R.
Neuberger 51.19

that swept America following Japan's surrender (figs. 614, 615).[147] Equally emblematic were the chilling photographs Margaret Bourke-White and George Rodger took in the closing days of the war as they traveled along the Rhine River with General Patton's Third Army, recording the fall of the Third Reich. Their images of the dead and dying at the Buchenwald concentration camp and the labor camp at Erla, which the Nazis destroyed after their surrender, brought home, as no written word could, the horrors of the Nazi regime (fig. 616).

Geometric Abstraction and the Ideology of Formalism

The war touched all facets of American life, but not all types of art. Indeed, before the war and in its early years, geometric abstractionists preserved the Synthetic Cubist vocabulary they had practiced in the thirties despite ongoing charges that the style lacked social conscience. Leftist attacks on the elitism of their work abated somewhat around 1938, as mounting criticism of the Soviet Union began to dampen dreams of a new social order grounded in Marxism. Increasingly, as Soviet policies came under more fire, fewer and fewer artists heeded the leftist call for art that would actively provoke social change. The resignation of seventeen members of the American Artists' Congress in 1940 over the organization's failure to condemn the Soviet invasion of Finland and this splinter group's subsequent formation of the Federation of Modern Painters and Sculptors signaled the art world's growing disaffection with the alliance between art and politics. The Nazis' exploitation of Aryan myths had meanwhile contaminated the Regionalists' use of cultural nationalism; with abstract art the target of Fascist repression throughout Europe, the argument that abstraction could play a political role as a symbol of freedom became more plausible.

619. **Gertrude Greene**
Space Construction, 1942,
1942
Painted board and wood,
36 x 24 in. (91.4 x 61 cm)
Whitney Museum of
American Art, New York;
Gift of Balcomb Greene
62.16

The proposition that abstraction was inherently political found powerful allies in Leon Trotsky, the Soviet leader exiled in Mexico, and André Breton, the French Surrealist poet. In a joint statement, published in *Partisan Review* in 1938, they argued that true, free, and independent art need not be explicitly political, because, by its very nature, such art was critical and hence politically subversive.[148]

The autonomy of art received a more elaborate formulation in *Partisan Review* the following year from a then unknown writer, Clement Greenberg. Entitled "Avant-Garde and Kitsch," Greenberg's article changed the terms of the debate by asserting that vanguard art was indeed inherently critical—but of itself, not of politics. He began his argument by attacking mass culture—kitsch, as he called it—both for its perilous link with mass politics and because it encouraged conformity and thus masked the authenticity of the individual. He submitted that the true artist must fight the

620. **Alexander Calder**
Hanging Spider, c. 1940
Painted sheet metal and
wire, 49½ x 35½ in.
(125.7 x 90.2 cm)
Whitney Museum of
American Art, New York;
Mrs. John B. Putnam
Bequest 84.41

influence of kitsch by turning attention "in upon the medium of his own craft."[149] A year later, in his 1940 essay "Towards a Newer Laocoon," he proposed that differences between the arts arose from differences in the nature of their media. To achieve quality, he suggested, each medium must disassociate itself from the others and exploit its intrinsic properties. For painters, this meant rejecting narrative content and three-dimensionality (which were more properly the domain of literature and sculpture) and accepting the physical, or plastic character of painting—that is, its flat two-dimensionality.

Greenberg's concept of purity in art has been attacked in recent decades, but it was immensely influential and widely held at the time. Similar ideas had been propounded by the German-born painter Hans Hofmann, who had arrived in New York in 1932 to teach at the Art Students League. One year later, he opened his own school.[150] Central to his curriculum was the importance of spiritual expression and the two-dimensionality of painting. Like Greenberg, Hofmann held that each medium had its own exclusive essence and laws. Since the essence of painting was the picture plane, it was incumbent upon artists to stress it. For Hofmann, this did not entail eliminating pictorial depth; indeed, he argued that painting's vitality depended on the tension between the two-dimensional and the three-dimensional, a tension he felt could be achieved by exploiting the properties of color to optically advance or recede in relation to the picture surface. The resulting "push-pull" dynamic ensured that pictorial space was not static or inert but filled with movement.

Greenberg's arguments also had been anticipated by the Russian-born painter and theoretician John Graham. Arguing in his 1937 book *Systems and Dialectics of Art* that nonillusionistic, "pure" painting was the evolutionary culmination of art historical styles, he urged artists to translate the objects in nature into flat, closed forms, since these most successfully resisted pictorial illusionism.

From these perspectives, geometric abstraction was superior to other painting styles because it was more "advanced." By emphasizing formal issues over literary and social concerns, it answered the desire for an art that was politically subversive yet not propagandistic. That the order and balance implicit in the hard-edged, generally rectilinear compositions of such artists as Gertrude Greene, Theodore Roszak, and Carl Holty—and in the hanging mobiles that Alexander Calder began after his return to America from Europe in 1933—offered an antidote to the political convulsions of the time only furthered geometric abstraction's appeal (figs. 619–22).

For these and other members of the American Abstract Artists (AAA), the increasingly widespread endorsement of aesthetic purity was accompanied by a change in their critical fortunes as the charges of imitation that had greeted their first exhibitions began to yield to approbation. Greenberg publicly applauded geometric abstraction in 1940 and two years later acclaimed the AAA's annual as telling "us most about the probable future of abstract art in this country."[151] In 1943, Samuel Kootz, whose 1930 book *Modern American Painters* had established him as an adversary of Regionalism, singled out the work of the geometric abstractionist Byron Browne as exemplifying the new form of American cultural expression that combined American intensity, aggression, and optimism with internationalism.

626. **O. Louis Guglielmi**
Terror in Brooklyn, 1941
Oil on canvas mounted on
board, 34 x 30 in.
(86.4 x 76.2 cm)
Whitney Museum of
American Art, New York;
Purchase 42.5

624. **Philip Evergood**
Lily and the Sparrows,
1939
Oil on board, 30 x 24 in.
(76.2 x 61 cm)
Whitney Museum of
American Art, New York;
Purchase 41.42

625. **Man Ray**
La Fortune, 1938
Oil on canvas, 24 x 29 in.
(61 x 73.7 cm)
Whitney Museum of
American Art, New York;
Purchase, with funds from
the Simon Foundation Inc.
72.129

Gallery. Surrealism received an even more significant institutional endorsement in The Museum of Modern Art's 1936 exhibition "Fantastic Art: Dada and Surrealism," museum director Alfred H. Barr, Jr., predicting that it would supersede geometric abstraction.

Although these exhibitions exposed American audiences to the full spectrum of Surrealism, the movement was initially equated almost exclusively in this country with Dalí's veristic Surrealism, thanks to the Spaniard's multiple and well-publicized visits to the United States. The waves of controversy surrounding his "Dream of Venus" pavilion at the 1939 New York World's Fair, his window displays at the Bonwit Teller department store that year, and his 1941–42 retrospective at The Museum of Modern Art ensured his hold on the American imagination. Not surprisingly, when American artists in the late 1930s began to search for a way to describe the disequilibrium of a world in crisis, they turned to Dalí's symbolically loaded images and crisp, illusionistic style. Doing so allowed them to retain their allegiance to realism, but also incorporate into their work more discordant juxtapositions than empirical observation allowed.

623. **Peter Blume**
Light of the World, 1932
Oil on board, 18 x 20¼ in.
(45.7 x 51.4 cm)
Whitney Museum of
American Art, New York;
Purchase 33.5

Among the first American artists to portray everyday life with an undercurrent of irrationality and psychological disquiet was Peter Blume. Already in his work from the early 1930s, Blume had turned his attention to the dangers of technology. In *Light of the World* (fig. 623), he depicted three figures and a ventriloquist's dummy gathered fearfully around a large, multicolored glass light—an enigmatic, but ominous warning of humanity's helplessness in the face of omnipotent technology. Within a few years, artists such as Philip Evergood and O. Louis Guglielmi had joined Blume in using Surrealist techniques to describe psychological states of entrapment and isolation (figs. 624, 626). Man Ray, too, in an uncharacteristically pessimistic mood, portrayed in *La Fortune* a bleak, desolate future in which people figured not at all (fig. 625). Like the Spanish-born Federico Castellon and the Los Angeles artist Helen Lundeberg, these American Surrealists borrowed the movement's technique of displacement and dissociation but ignored its engagement with the unconscious (figs. 627, 628).

Even Joseph Cornell, one of the first American artists to be associated with Surrealism, openly disavowed the Surrealists' dream theories and their focus on the unconscious. Cornell's assemblages of natural and man-made objects inside shallow, small-scaled, wooden boxes were precipitated by a Max Ernst collage he had seen in one of the French artist's pictorial novels. Cornell's subsequent juxtapositions of unrelated objects conjured up a dream world of stillness and nostalgia. Only occasionally, as in his 1943 *Habitat Group for a Shooting Gallery,* would topicality enter into his hermetic sphere (fig. 629). Here, bullet-shattered glass, wounded

With the addition to the AAA's membership of the refugee artists Piet Mondrian, Fernand Léger, Fritz Glarner, and Amédée Ozenfant, the organization seemed to be ascendant.

The AAA felt confident enough of its position to picket The Museum of Modern Art in April 1940 for its indifference to contemporary American abstraction. In a broadside entitled "How Modern Is The Museum of Modern Art?"—designed by Ad Reinhardt and distributed outside the museum—the AAA challenged what it felt were the institution's conservative policies. That same year, in place of its annual yearbook, the AAA issued a twelve-page pamphlet called *The Art Critics—! How Do They Serve the Public? What Do They Say? How Much Do They Know? Let's Look at the Record.* Written primarily by Reinhardt and Balcomb Greene, the pamphlet's excerpts of negative reviews of abstract art were calculated to convert critics by pointing out their misstatements and contradictions. The ploy worked, and even *New York Times* critic Edward Alden Jewell acknowledged that modern abstraction was "not just a flash in the pan. . . . It appears to have come to stay."[152] This state of grace was to be short-lived. Already by 1944, a new art was emerging that united the demand for a modern pictorial structure with a content that addressed the needs of a world in crisis.

PREWAR SURREALISM

<div style="margin-left:auto"></div>

Surrealism in America

The new art that cut short the preeminence of American geometric abstraction took its inspiration from European Surrealism. The arrival of Surrealism had been formally proclaimed in 1924 by its French poet spokesman André Breton. Born out of a mistrust of reason and logic—a consequence of the traumas of World War I—Surrealism was allied with the irrational, the marvelous, and the truths of the unconscious mind. It differed from most art movements in that its impetus was not visual but literary and political. Even after artists joined the Surrealist ranks, the goal of the movement remained extra-aesthetic: to liberate consciousness for the sake of social revolution. At first it was allied with the Communist Party; in the mid-1930s, those ties broke over issues of artistic freedom, but Surrealism retained its social mission. Indeed, the 1938 Breton-Trotsky statement in *Partisan Review* was an attempt to preserve the connection between social revolution and art by identifying reform with the unfettered creative process.

Under Breton's leadership, European Surrealism was highly organized. Its members maintained a headquarters, held daily meetings, organized exhibitions, and published periodicals, books, and manifestos. In an attempt to bypass reason and unlock the unconscious mind, Surrealists emulated the Freudian psychoanalytic technique of free association—whose pictorial equivalent was automatism or automatic writing. Their object was to externalize the latent images in the unconscious in order to achieve self-knowledge and, through it, psychic liberation. In automatism, the unconscious dictated the creation of images without the intervention of the conscious, rational mind. Under this system, artists improvised abstract, biomorphic images that they later transformed into "art." Automatism dominated European Surrealism until 1929, when Salvador Dalí burst onto the scene and Breton shifted his allegiance to Dalí's figurative, dream-inspired iconography rendered in a fastidious, academically realistic style.

Americans were introduced to Surrealism in the winter of 1931 in the exhibition "Newer Super Realism," which opened at the Wadsworth Atheneum in Hartford, Connecticut, and subsequently traveled in a slightly altered form to the Julien Levy Gallery in New York. The next few years saw nearly annual shows of Joan Miró's and André Masson's work at the Pierre Matisse Gallery as well as that of Max Ernst, René Magritte, Yves Tanguy, Giorgio de Chirico, and Dalí, all at the Levy

621. Carl Holty
Orange and Gold, 1942
Oil on masonite, 54 x 40 in.
(137.2 x 101.6 cm)
Whitney Museum of
American Art, New York;
Purchase 63.76

622. Alexander Calder
Constellation, 1941
Painted wood and wire,
51 x 46½ x 10 in.
(129.5 x 118.1 x 25.4 cm)
Whitney Museum of
American Art, New York;
Promised gift of Dr. and
Mrs. B. Scott Severns
P.3.81

627. **Federico Castellon**
The Dark Figure, 1938
Oil on canvas, 17 x
26⅛ in. (43.2 x 66.4 cm)
Whitney Museum of
American Art, New York;
Purchase 42.3

628. **Helen Lundeberg**
*Plant and Animal
Analogies,* 1934–35
Oil on Celotex, 24 x 30 in.
(61 x 76.2 cm)
The Buck Collection;
courtesy Tobey C. Moss
Gallery, Los Angeles

629. **Joseph Cornell**
*Habitat Group for a
Shooting Gallery,* 1943
Mixed-media box construc-
tion, wood, paper, and
glass, 15½ x 11⅛ x
4¼ in. (39.4 x 28.3 x
10.8 cm)
Des Moines Art Center,
Iowa; Purchased with
funds from the Coffin Fine
Arts Trust, Nathan Emory
Coffin Collection of the
Des Moines Art Center

630. **Frederick Sommer**
Coyotes, 1945 (printed later)
Gelatin silver print, 7⅝ x 9½ in. (19.3 x 24.2 cm)
Collection of Leland Rice

631. **Edmund Teske**
Jane Lawrence, 1945
Gelatin silver print, 6⅜ x 5 in. (16.2 x 12.7 cm)
Collection of Susan Ehrens and Leland Rice

632. **Clarence John Laughlin**
The Eye That Never Sleeps, 1946
Gelatin silver print, 14 x 11 in. (35.6 x 27.9 cm)
Robert Miller Gallery, New York

birds, and a background splashed with blood-red combined to suggest the war and its effect on innocent victims.

The Surrealist proclivity to rearrange the objects of the real world in order to produce startling, disquieting conjunctions was shared by photographers. By manipulating photographs through double exposure and photomontage—which Breton likened to automatism—they broke down fixed notions of reality. The California-based Edmund Teske often combined montage techniques with chemical manipulation (fig. 631), while Frederick Sommer used both montage and subject matter suggestive of decay and putrescence (fig. 630). For Clarence John Laughlin, montage was sufficient to create images of what he called "the psychological substructure of confusion, want, and fear," which he felt was the "symbolic reality of our time" (fig. 632).[153]

633. **Arshile Gorky**
The Artist and His Mother,
c. 1926–36
Oil on canvas, 60 x 50 in.
(152.4 x 127 cm)
Whitney Museum of
American Art, New York;
Gift of Julien Levy for Maro
and Natasha Gorky in
memory of their father
50.17

EUROPEAN SURREALISTS AND THE EMERGING AMERICAN VANGUARD

Because travel to Europe grew less and less appealing as the Continent drifted toward war in the 1930s, American artists derived their ideas about Surrealism despite little firsthand contact with the movement's practitioners. This situation changed following the Nazi occupation of Paris on June 14, 1940, when masses of artists fled from the city that had served as the art world's capital for more than a century. With Great Britain under Nazi siege and France under Nazi control—directly in the north and indirectly in the south through the puppet Vichy government —the majority of evacuees fled, whenever possible, to the United States. By March 1942, they had established a critical mass large enough to warrant the Pierre Matisse Gallery's exhibition "Artists in Exile," followed three years later by a show of thirty-three émigré artists at the Whitney Museum of American Art in response to what its director called the "unprecedented circumstances of the times." Although the expatriate group was far from homogeneous, the Surrealist contingent—Pavel Tchelitchew, Salvador Dalí, Max Ernst, Eugene Berman, André Masson, André Breton, Roberto Matta, Gordon Onslow-Ford, Wolfgang Paalen, Kurt Seligmann, and Yves Tanguy —was sufficiently large to perpetuate the aesthetic dominance it had enjoyed in Paris between the wars.

The arrival in New York of leading European artists and the return of American expatriates shifted the geographic center of the art world to the United States. This raised the question, however, of what America would do with its newly

634. **Willem de Kooning**
Queen of Hearts, 1943–46
Oil and charcoal on fiber-
board, 46⅛ x 27⅝ in.
(117 x 70 cm)
Hirshhorn Museum and
Sculpture Garden,
Smithsonian Institution,
Washington, D.C.; Gift of
Joseph H. Hirshhorn
Foundation, 1966

acquired position. In a letter to *The New York Times* in 1941, art dealer Sam Kootz exhorted the New York art community to create a new kind of painting equal to its recently elevated status: "The probability is that the future of painting lies in America," he wrote, "and all you have to do, boys and girls, is get a new approach, do some delving for a change—God knows you've [had] time to rest."[154]

Given that geometric abstraction was still tainted in some circles by accusations that it too closely imitated European styles, Kootz's lament that not even one

635. **John Graham**
Two Sisters (Les Mamelles d'outre-mer), 1944
Oil, enamel, graphite, charcoal, and casein on board, 47⅞ x 48 in. (121.4 x 121.8 cm)
The Museum of Modern Art, New York; Alexander M. Bing Fund

painter had attempted to experiment or realize a new painting style seemed all too true. In reality, small bands of artists outside the established matrix had already begun to formulate a significant new style. Among these was a coterie around John Graham, whose annual trips to Paris had kept American vanguard artists apprised of new developments in French art. One of the central ideas that Graham passed on to them was the need for painting to forgo pictorial illusionism in favor of the two-dimensionality of the picture plane; another was his belief that the unconscious was the wellspring of creativity. Like the Surrealists, Graham disdained rationalism, believing that the purpose of art was "to re-establish a lost contact with the unconscious."[155] An advocate of psychologist Carl Jung's theories, he instructed his American colleagues that the unconscious was "the storehouse of power and of all knowledge, past and future."[156] Jung held, and Graham agreed, that the mind contained an inherited substratum (the collective unconscious), which surfaced in archetypes—archaic symbols shared by all humankind that recurred in myth, dream, and fantasy. In his 1937 essay "Primitive Art and Picasso," Graham credited children, primitive peoples, and geniuses—he singled out Picasso—with having direct access to this collective unconscious. He extolled all three groups for their capacity to tap into the primordial memories of the past and bring the wisdom of the unconscious to consciousness. Graham challenged artists to fuse the imagery of the unconscious with the two-dimensional qualities of painting—a union he felt had been uniquely accomplished by Picasso.

The Americans most directly affected by Graham's proselytizing were Arshile Gorky and Willem de Kooning, both of whom were immigrants like Graham. De Kooning had jumped ship without papers from a steamer in 1926; Graham, born Ivan Dabrowsky, and Gorky, born Vosdanig Adoian, had come through Ellis Island in 1920 and assumed not only new names but also invented histories.[157] All three artists served an aesthetic apprenticeship to Picasso's biomorphic still lifes, and all three used the Spaniard's portraits as a point of departure for their mature work. Gorky's breakthrough came in a double portrait of himself as an eight-year-old boy with his mother, who had died in his arms of starvation in an Armenian refugee

636. Yves Tanguy
The Wish, 1949
Oil on canvas, 36 x 28 in.
(91.4 x 71.1 cm)
Whitney Museum of
American Art, New York;
Kay Sage Tanguy Bequest
63.46

637. Pavel Tchelitchew
Anatomical Painting, 1946
Oil on canvas, 56 x 46 in.
(142.2 x 116.8 cm)
Whitney Museum of
American Art, New York;
Gift of Lincoln Kirstein
62.26

camp in World War I (fig. 633). Based on a 1912 photograph taken six years before his mother's death, the portrait presaged Gorky's mature work by fusing biomorphic abstraction and brushy paint handling with the poetry of memory and present experience. Whereas Gorky's fealty to Picasso's portraits was brief, de Kooning's remained intact for three decades. In the late 1930s and early 1940s, de Kooning united the anatomical distortions of Picasso's figures with the linear arabesques, rhythmically inflected contours, and glossy surfaces of Gorky's work; the result

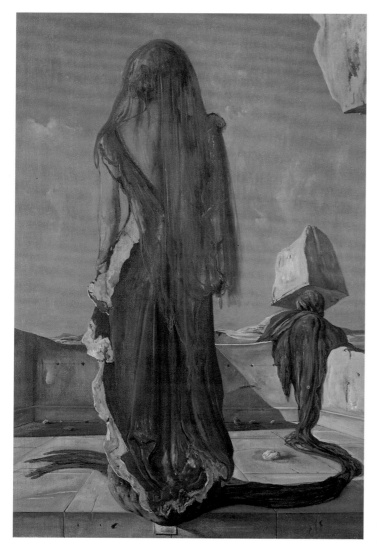

638. **Eugene Berman**
Nike, 1943
Oil on canvas, 58⅜ x 38⅜ in. (148.2 x 97.3 cm)
Hirshhorn Museum and Sculpture Garden, Smithsonian Institution, Washington, D.C.; Gift of Joseph H. Hirshhorn, 1972

was a uniquely haunting, figurative modernism (fig. 634). The third member of the triumvirate, Graham, resumed painting in 1939, after a six-year hiatus. Despite his sharp break with modernism and his consequent denunciation of Picasso as a charlatan, he produced a group of symbolic portraits whose demonic intensity and distortions of glance recalled the Spaniard's work (fig. 635). With their eyes widely askew and their features disassociated, Graham's esoteric goddesses exude bewilderment, eroticism, and malice—a portent of the duality of seduction and threat that would mark de Kooning's figure paintings of the 1950s.

Graham shifted his focus after 1940 to the promotion of primitive art, but his ideas concerning the unconscious left a lasting residue on younger artists that readied them for the arrival of the European Surrealists. These young Americans were attracted neither to the veristic Surrealism of Dalí's colleague Yves Tanguy (fig. 636) nor to the melancholic, introspective New Romanticism of Pavel Tchelitchew and Eugene Berman (figs. 637, 638)—all three of whom became American citizens. Instead, artists such as Robert Motherwell, William Baziotes, and Jackson Pollock found the key to a painting style they could legitimately claim as their own in the abstract Surrealism of Roberto Matta, Gordon Onslow-Ford, Kurt Seligmann, and Wolfgang Paalen. Closer in age to the emergent Americans and more accessible than Breton (who refused to learn English), these Surrealist émigrés directed American attention away from the dream-inspired figuration favored by Breton and American realists toward the automatism that had prevailed in the early phase of Surrealism.

Fluent in French, Robert Motherwell inaugurated an interchange between the two groups by studying privately with Seligmann in 1940, a year after the Swiss artist's relocation to New York. In January and February 1941, he and other younger American artists received a more comprehensive report on Surrealism in four lectures given by the British-born Onslow-Ford at the New School for Social Research. Accompanied by exhibitions arranged by the dealer Howard Putzel, Onslow-Ford's lectures shifted Surrealism from Freud's interpretation of the human psyche to Jung's, which dictated that artists delve into their inner selves and unlock the primordial knowledge of the collective unconscious. Prophetically, he ended his lecture series by accurately predicting that a new form of Surrealism would emerge in the United States under the combined forces of Surrealist émigrés and younger American artists. Onslow-Ford went to Mexico soon thereafter to join Paalen, and his subsequent influence on the emergent Americans was limited primarily to reproductions of his work in Paalen's magazine, *Dyn.* With his departure, the Surrealist American dialogue became relatively

639. **Alfonso Ossorio**
Red Star, 1944
Watercolor and ink on
paper, 13½ x 19¾ in.
(34.3 x 50.2 cm)
Whitney Museum of
American Art, New York;
Gift of the artist 69.153

640. **Gerome Kamrowski**
Emotional Seasons, 1942
Verso: gouache, ink, and
watercolor on wood, 22 x
30 in. (55.9 x 76.2 cm)
Whitney Museum of
American Art, New York;
Purchase, with funds from
Charles Simon 78.69a–b

641. **Robert Motherwell**
Three Figures Shot, 1944
Colored ink on paper,
11⅜ x 14½ in. (28.9 x
36.8 cm)
Whitney Museum of
American Art, New York;
Purchase, with funds from
the Burroughs Wellcome
Purchase Fund and the
National Endowment for
the Arts 81.31

642. Arshile Gorky
The Liver Is the Cock's Comb, 1944
Oil on canvas, 93½ x 155 in. (237.5 x 393.7 cm)
Albright-Knox Art Gallery, Buffalo, New York; Gift of Seymour H. Knox, 1952

643. Arshile Gorky
The Betrothal, II, 1947
Oil on canvas, 50¾ x 38 in. (128.9 x 96.5 cm)
Whitney Museum of American Art, New York; Purchase 50.3

644. **Marcel Duchamp**
Installation view of "First Papers of Surrealism" exhibition, Coordinating Council of French Relief Societies, New York, 1942 Philadelphia Museum of Art; Louise and Walter Arensberg Archives

645. Installation view of the Surrealist room, designed by Frederick Kiesler, in Peggy Guggenheim's Art of This Century gallery, 1942

dormant until it was rekindled by Motherwell. He and Matta had visited Onslow-Ford and Paalen in Mexico for six months in 1941. In the winter of 1942–43, Matta, with Motherwell's assistance, set up classes in his studio for William Baziotes, Jackson Pollock, Peter Busa, Gerome Kamrowski, and Motherwell himself. Matta hoped to challenge Breton's leadership of Surrealism by forming a splinter group that would lead Surrealism back to automatism. Matta's dream failed, but the Americans exposed to his working methods learned to use automatism to convey uncensored experience (figs. 639–41).

Paradoxically, given his absence from Matta's teaching sessions, Gorky was the artist most affected by the Chilean's use of fluid space and morphological transformations. Shortly after the two met in 1941, Matta had suggested to Gorky that he dilute his paints with turpentine to achieve a more fluid and explosive gesture. The results were aqueous, spontaneous veils of thin paint with which Gorky portrayed a hybrid iconography of landscape and figural forms. Always inspired by nature, and thus resistant to pure automatism, he systematically preplanned his paintings in detailed drawings, often using a traditional grid method to transfer these line studies to canvas. Prompted by Matta's erotic imagery and by the loosely painted biomorphic forms of Kandinsky and Miró, Gorky infused his work with a sensuous biomorphism emblematic of fertility and eroticism. *The Liver Is the Cock's Comb* (fig. 642), for example, does not refer simply to sex, as its title might imply—the liver being an ancient symbol of the soul or passions of an artist and the "cock" a slang word for penis—but to the bucolic and fertile environment of childhood and the sensuality Gorky associated with his father's garden, the Garden of Wish Fulfillment, as he called it. In Gorky's hands, landscape became an erogenous realm, the conjunction of nature and the erotic life. His sumptuous affirmation of fecundity and union ended abruptly in 1946 with a string of tragedies: a fire that destroyed much of his work, cancer, sexual impotence, a broken neck from an auto accident, and the disintegration of his marriage. From then until his suicide on July 21, 1948, Gorky's work became increasingly anxious, tense, and aggressive—as

646. **Man Ray**
Cover of *View*, 1943
Frances Mulhall Achilles
Library, Whitney Museum
of American Art, New York

SURREALISM AND AMERICAN PUBLISHING

Thanks to the dislocations caused by World War II, American publishers joined the avant-garde. Although transatlantic interchanges had prompted some alternative publishing efforts in the United States in previous decades, they were rare until the war created a flood of European exiles, primarily from the Surrealist group, who inspired American artists and publishers to move away from traditional book and magazine formats. Following the Surrealist fascination with hallucinatory, dreamlike states of mind, artists and editors relaxed the conventional close correlation between pictures and words. The printed page became an open field for artists' collages, fragmented prose and poetry, and unexpected juxtapositions of image and text.

The earlier arrival of Herbert Bayer from Germany and Herbert Matter from Switzerland helped introduce the strategies of Surrealism to American graphic advertising design in the 1930s. However, it was the presence of the international leaders of the Surrealist movement—André Breton, André Masson, Roberto Matta, Marcel Duchamp, Max Ernst, and Wifredo Lam—as well as the return of American expatriates Man Ray and Dorothea Tanning that spurred American fine-art and literary publishing to fully explore Surrealist thinking. As a literary, philosophical, and artistic movement that depended on the printed page as a primary form of expression, Surrealism was ideally suited to transform the look and approach of the most vanguard magazines, catalogs, and books. This transformation was accomplished with significant patronage from Americans, among them Peggy Guggenheim, the heiress and art collector who was married to Max Ernst in the early 1940s and who helped finance André Breton's stay in New York City; the art dealer Julien Levy, who backed a number of experimental catalogs and exhibitions; and the magazine editor Charles Henri Ford, whose journal *View* provided an important platform for the Surrealist movement in America (fig. 646).

The magazine format was ideal for the wide-ranging interests of the Surrealists. Under Ford's editorship, *View* (1940–47) ran numerous articles on or by Surrealist authors and artists, and produced special issues devoted to the work of Man Ray and Marcel Duchamp. Independently, the Surrealist leader André Breton spearheaded *VVV* (1942–44), the first purely Surrealist magazine published in the United States. With

647, 648. **Marcel Duchamp**
Left to right: Front and back covers of *First Papers of Surrealism* (exhibition catalog)
New York: Coordinating Council of French Relief Societies, 1942
Frances Mulhall Achilles Library, Whitney Museum of American Art, New York

in *The Betrothal, II,* where shapes appear pinched and pulled beyond endurance (fig. 643).

By the end of 1942, Surrealism's presence in New York was pervasive. Already in September 1940, the Surrealist journal *View* had appeared as a six-page tabloid, edited by Charles Henri Ford; by 1943, it had become a full-scale commercial magazine. It was joined in June 1942 by *VVV,* the four-issue Surrealist magazine edited by the American sculptor David Hare with the help of Breton, Ernst, and Duchamp. Four months later, on October 14, 1942, a survey exhibition of émigré work assembled by Breton to benefit the Coordinating Council of French Relief Societies opened at the council's headquarters in the Whitelaw Reid Mansion on Madison Avenue. Called "First Papers of Surrealism," the exhibition included the work of nearly fifty artists, among them several Americans—Calder, Motherwell, Baziotes, and Hare.[158] The catalog cover designed by Duchamp—a trompe l'oeil photograph of a barn in which five bullet holes seem to punch through both the wall and the cover (fig. 647)—obliquely alluded to the war, as did the title of the exhibition, which referred to the immigration papers of many of the participating artists. Although Breton

Marcel Duchamp and Max Ernst as advisers, and the American artist David Hare as editor, *VVV* encompassed poetry, art, anthropology, sociology, and psychology. Though European in outlook, *VVV* explored new territories in the American landscape and culture, publishing, for example, Berenice Abbott's pictures of Hopi Kachina dolls and Frederick Sommer's remarkable series of horizonless photographs of the Sonoran Desert.

The Surrealist emphasis on collaborative projects between artists and poets soon altered literary book publishing. *Young Cherry Trees Secured Against Hares* (1946), a volume of poetry by André Breton, included a collaged cover by Marcel Duchamp in which a photograph of Breton was superimposed on a screened image of the Statue of Liberty and loose line drawings by Arshile Gorky. Man Ray, an American who was a leading figure in Surrealism in 1930s Paris and moved to Los Angeles during the war, created a similar sense of indirect play between words and images in his *Alphabet for Adults* (1948), an alphabetical guessing game in which multiple associations are suggested by each letter. Similarly, the collaged cover by Joseph Cornell for Charles Henri Ford's *ABC's* (1940) takes the familiar form of the childhood primer to suggest primal or mysterious reveries for adults (fig. 650). The design of even simple exhibition catalogs was transformed. The catalog for one of the first exhibitions to intermingle work by émigrés and American artists, *First Papers of Surrealism,* featured a cover by Marcel Duchamp riddled with trompe l'oeil bullet holes (fig. 647).

Toward the end of the decade, the émigré influence on artists and bookmaking extended from commercial design to fine-press publications. European traditions were disseminated by the English printmaker Stanley William Hayter, whose graphics studio nourished artists such as Louise Bourgeois. A book by Bourgeois, *He Disappeared into Complete Silence* (1947), specially printed at the Gemor Press, in New York City, explored a Surrealist view of urban life and architecture. On a more popular level, the Surrealist style merged with the documentary in Weegee's *Naked City* (fig. 649). *Naked City* was, on the one hand, a collection of a newspaper reporter's true crime photographs and, on the other, an assemblage of distorted and even staged images that brought together the most unlikely conjunctions of urban life. This fabulist narrative, like others to follow, owed much to the groundbreaking ideas of the Surrealists in America. —M. C.

"Through his sense of timing, Weegee turns the commonplaces of a great city into extraordinary psychological documents."—Nancy Newhall, Acting Curator of Photography, Museum of Modern Art

649. *Naked City,* by Weegee (Arthur Fellig) New York: Essential Books, 1945 Frances Mulhall Achilles Library, Whitney Museum of American Art, New York

650. *ABC's,* text by Charles Henri Ford, illustrations by Joseph Cornell Prairie City, Illinois: The Press of James Decker, 1940 Frances Mulhall Achilles Library, Whitney Museum of American Art, New York

installed the exhibition, the show's hallmark became Duchamp's mile-long maze of string looped across the ceilings and in front of the pictures (fig. 644).[159]

On October 20, 1942, six days after the "First Papers of Surrealism" opened, Peggy Guggenheim inaugurated her museum-gallery, Art of This Century, in two former tailor shops on the seventh floor of 28-30 West 57th Street. Art of This Century was physically divided into four areas—three fixed installations presenting Guggenheim's collection and one gallery for changing exhibitions of new art—each designed in a different style by Frederick Kiesler. The Surrealist room, in which pictures projected at various angles from curved walls, was the most notorious (fig. 645). On opening night, wishing to show her impartiality to abstract and Surrealist art, Guggenheim wore one earring designed by Tanguy and one by Calder. By commissioning Breton to edit the gallery's first catalog, however, she revealed the fundamentally Surrealist bias that would guide her choice of younger American artists for inclusion in her gallery.

An Art of Dislocation and Myth

The entry of the United States into World War II presented American artists with several choices: to use their art to celebrate American values, to remain detached from world affairs and pursue pure abstraction, or to bear witness to the unsettling realities of the time. As we have seen, composers, choreographers, filmmakers, singers, and photographers who chose the first course registered a prosperous and contented America grounded in family and community. Even Dorothea Lange, who documented the wartime internment of 110,000 Japanese Americans in "relocation camps," retained her faith in the essential myth of America. Her younger colleague Helen Levitt—a close friend of Walker Evans and Ben Shahn—followed in this tradition, portraying in her photographs a profound sympathy for the poetry and vitality of the everyday (figs. 652–54). In contrast to her documentary antecedents, who typically presented individuals as generic types ill at ease with their environments, Levitt created lyrical and commemorative descriptions of urban working-class neighborhoods and children at play that feature open, exuberant interactions between individuals often unaware they were being observed.

For other artists, however, the war elicited feelings of dislocation and anxiety. Sobering and difficult as the 1930s had been, the decade had harbored a sense of optimism and hope. Few

651. **Morris Graves**
In the Night, 1943
Tempera on paper mounted on cardboard, 24¼ x 36¾ in. (61.6 x 93.3 cm)
Whitney Museum of American Art, New York; Gift of Mrs. Robert M. Benjamin 84.74

Americans doubted that the country would survive the calamities of the present as it had those of the past. With the war, however, existence itself was thrown into question. Economic devastation paled in comparison with the death and destruction chronicled daily on the radio and in magazines, newsreels, and newspapers.[160]

Many artists responded to these conditions by creating an art that expressed the vulnerability and uncertainty they now perceived as inherent to the human condition. The Northwest Coast painter Morris Graves, for example, inducted into military service in April 1942 after unsuccessful petitions for deferment as a conscientious objector, funneled his anguish into dark, foreboding portraits of ravaged,

652. **Helen Levitt**
Street Drawing, 1940
Gelatin silver print, 10⅞ x
7⁵⁄₁₆ in. (27.6 x 18.6 cm)
Whitney Museum of
American Art, New York;
Gift of Lilyan S. and Toby
Miller 94.167

653. **Helen Levitt**
Untitled, New York, 1942
(printed later)
Gelatin silver print, 14 x
10 in. (35.6 x 25.4 cm)
Laurence Miller Gallery,
New York

654. **Helen Levitt**
New York, c. 1940
Gelatin silver print, 6⅝ x
9¾ in. (16.8 x 24.8 cm)
The Museum of Modern
Art, New York; Gift of
Edward Steichen

655. Jared French
State Park, 1946
Egg tempera on board,
23½ x 23½ in. (59.7 x
59.7 cm)
Whitney Museum of
American Art, New York;
Gift of Mr. and Mrs. R. H.
Donnelley Erdman 65.78

656. Jacob Lawrence
Tombstones, 1942
Gouache on paper, 28¾ x
20½ in. (73 x 52.1 cm)
Whitney Museum of
American Art, New York;
Purchase 43.14

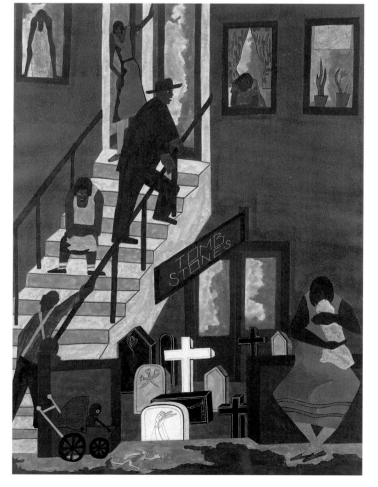

657. **Edward Hopper**
Nighthawks, 1942
Oil on canvas, 30 x 60 in.
(84.1 x 152.4 cm)
The Art Institute of
Chicago; Friends of
American Art Collection

658. **Edward Hopper**
Summertime, 1943
Oil on canvas, 29⅛ x
44 in. (74 x 111.8 cm)
Delaware Art Museum,
Wilmington; Gift of Dora
Sexton Brown

659. Ruth Orkin
*Mother and Daughter at
Penn Station*, 1947
Gelatin silver print, 11¼ x
7½ in. (28.6 x 19.1 cm)
Ruth Orkin Photo Archive,
New York

660. Esther Bubley
*Girl Sitting Alone in the
Sea Grill, a Bar and
Restaurant, Waiting for a
Pick-up, Washington, D.C.,*
1943 (printed later)
Gelatin silver print, 10⅜ x
10⅜ in. (26.3 x 26.3 cm)
The Art Institute of
Chicago; Restricted gift of
Lucia Woods Lindley and
Daniel A. Lindley, Jr.

661. Esther Bubley
*Women Gossiping in a
Drugstore over Cokes,
Washington, D.C.,* 1943
(printed later)
Gelatin silver print, 10½ x
10¼ in. (27.1 x 26.2 cm)
Kathleen Ewing Gallery,
Washington, D.C.

662. Walker Evans
Subway Portrait, 1938–41
(printed c. 1965)
Gelatin silver print, 6⅞ x
10⅛ in. (17.5 x 25.5 cm)
The J. Paul Getty Museum,
Los Angeles

663. Lisette Model
Fashion Show, Hotel Pierre, New York, 1940–46
Gelatin silver print, 13⅝ x 16⅝ in. (34.6 x 42.3 cm)
National Gallery of Canada, Ottawa; Gift of the Estate of Lisette Model, 1990, through Joseph G. Blum, New York, and the American Friends of Canada

664. Lisette Model
Albert-Alberta, Hubert's Forty-second Street Flea Circus, New York, 1945
Gelatin silver print, 13⅜ x 9¼ in. (34 x 23.5 cm)
Whitney Museum of American Art, New York; Gift of the Estate of Lisette Model 95.210

665. Weegee (Arthur Fellig)
Shorty, the Bowery Cherub, Welcomed the New Year, Sammy's on the Bowery, 1943
Gelatin silver print, 13½ x 10⅝ in. (34.4 x 26.9 cm)
Center for Creative Photography, University of Arizona, Tucson

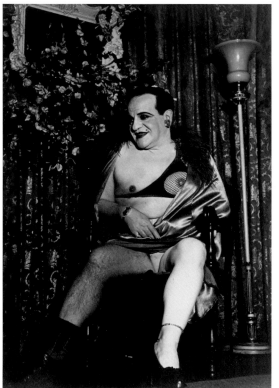

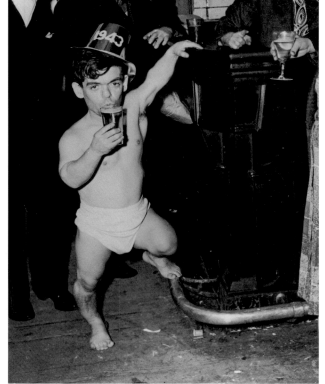

desolate landscapes (fig. 651). Older generation realists Edward Hopper, Jared French, and Jacob Lawrence perfected the chilling evocations of existential solitude that characterized their earlier paintings (figs. 655–58). Their pictorial descriptions of uncertainty, loneliness, and guarded passivity were echoed in photographs. Esther Bubley, Ruth Orkin, and Walker Evans, among other photographers, registered an America where people were isolated and detached from each other even when sharing communal space. Gone were the heroism and fortitude that had

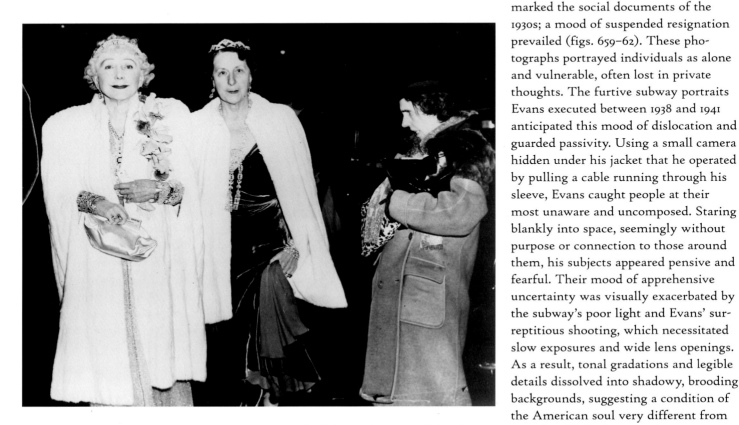

666. **Weegee
(Arthur Fellig)**
The Critic, c. 1943
Gelatin silver print, 10½ x
12½ in. (26.7 x 31.8 cm)
Whitney Museum of
American Art, New York;
Gift of Denise Rich
96.90.2

marked the social documents of the 1930s; a mood of suspended resignation prevailed (figs. 659–62). These photographs portrayed individuals as alone and vulnerable, often lost in private thoughts. The furtive subway portraits Evans executed between 1938 and 1941 anticipated this mood of dislocation and guarded passivity. Using a small camera hidden under his jacket that he operated by pulling a cable running through his sleeve, Evans caught people at their most unaware and uncomposed. Staring blankly into space, seemingly without purpose or connection to those around them, his subjects appeared pensive and fearful. Their mood of apprehensive uncertainty was visually exacerbated by the subway's poor light and Evans' surreptitious shooting, which necessitated slow exposures and wide lens openings. As a result, tonal gradations and legible details dissolved into shadowy, brooding backgrounds, suggesting a condition of the American soul very different from that which Evans had recorded in his portrait and still-life photographs of the 1930s (figs. 490–92).

A similar unease informed the work of Esther Bubley, whom Roy Stryker hired in 1943 as an OWI photographer to document how wartime rubber and oil shortages had decreased automobile travel in favor of bus and train transportation. Assigned to travel by Greyhound bus through the southern United States for six weeks, Bubley digressed from the standard OWI format by featuring individuals who were bored, distracted, and isolated. Shot from below with a flash, her work paralleled the claustrophobic environments, sharp tonal contrasts, and disorienting, unbalanced camera work of Hollywood film noir.

Photography's changed sensibility was even more palpable in the work of Weegee and Lisette Model. Documentary photographers of the 1930s had introduced America to the economically disenfranchised. Weegee and Model redirected the nation's gaze to subcultures of dwarfs, transvestites, derelicts, and vacuous socialites. By the time Model abandoned her working career in the early 1950s in favor of teaching, she had produced an impressive portrait gallery of social eccentrics and those whom society had relegated to the margins (figs. 663, 664). Her grainy prints and motion-blurred negatives had a traumatized, claustrophobic quality that foreshadowed the alienated mood of the succeeding generation of photographers, in particular Diane Arbus, her foremost pupil. The equally raw, raunchy

photographs Weegee took for tabloid newspapers—such as that of Sammy's Bar on New York's Bowery (fig. 665)—shared with Model's a frame of mind and occasionally a subject matter (fig. 666). More so than Model, Weegee purposefully sought out the dark and sordid. Born Arthur Fellig, Weegee changed his name to a phonetic approximation of the Ouija board in homage to his purported ability to anticipate disaster. In reality, his prescience owed more to diligence than to psychic acuity. He spent his nights listening to a shortwave radio tuned to the police band or haunting police stations, waiting for breaking stories about murders, accidents, or fires. Working at point-blank range with a flash, he captured the bleak and seedy underbelly of urban life with a voyeuristic, pitiless vision, exposing the naked emotions of people at their most distressed and vulnerable. Indoors, he used infrared film so that he could shoot in near-total darkness, thereby concealing his presence. The technique stripped away the pretensions and presumed elegance of his subjects by capturing them in illicit or disturbed private moments, while the film exaggerated their facial flaws.

Vanguard painters wishing to express the unsettling realities of the contemporary world seemed to have fewer options. Regionalism and American Scene painting were unacceptable, given their stylistic conservatism and parochial, nationalist agenda. America's participation in a global war that nearly all citizens sanctioned had brought an end to isolationism. News reports of the war reminded Americans daily that they were part of an international community. In the early days of the war, the universality of geometric abstraction made it an appealing vehicle for the expression of this new internationalism—an appeal furthered by the style's two-dimensionality and avoidance of narrative and political content. Ultimately, however, in the face of war, geometric abstraction appeared overly sterile, its emphasis on formal considerations irrelevant. With the utopian, rational goals on which it depended discredited by contemporary disclosures of human evil, the style was no longer viable. By 1942, Motherwell was openly faulting Piet Mondrian's work as too restricted and scientific to "express the felt quality of reality." The proposition that "2 + 2 = 4" was unsatisfying, Motherwell argued, in a time "when men were ravenous for the *human*."[161]

A new artistic language was clearly needed to convey the existence of powerful irrational forces in the human psyche. This new art had to be global, apolitical, and expressive of the horror and fear that engulfed the world. Experience with Surrealism had taught American artists that they could use automatism to tap into the unconscious. However, having been thoroughly indoctrinated during the 1930s in the social responsibility of art, they rejected the expression of personal dreams and hermetic states of mind. They wanted to communicate shared experiences, not reveal the workings of their individual psyches. The collective unconscious and its memory bank of primordial symbols offered a possible solution. By harnessing this storehouse of collective experience, they could express the uncertainty of their time without forfeiting universality. In this endeavor, archaic myths and primitive art offered important precedents; artists turned to them as models.

In 1943, the Federation of Modern Painters and Sculptors was given an opportunity to stake out this new aesthetic territory in public. In the catalog for its third annual exhibition, held that June at the Wildenstein Gallery, New York, the Federation acknowledged, "Today America is faced with the responsibility either to salvage and develop, or to frustrate western creative capacity. . . . In years to come the world will ask how this nation met its opportunity."[162] To answer this challenge, several Federation members included paintings which drew on classical myth for subject matter. When Edward Alden Jewell, reviewing the show for *The New York*

GRAHAM AND BALANCHINE

Choreographers Martha Graham and George Balanchine produced some of their finest works during the 1940s. It was during this time that Martha Graham introduced her famous literary and ritualistic dance-dramas based on ancient Greek myth. Graham often danced the leading roles in these works and continued to expand her dance technique. In contrast to the weighted and counterbalanced look of her 1930s movements, that of the 1940s featured a lighter attack and more complex, spiraling body shapes. At the same time, she began to incorporate male dancers (including Erick Hawkins and Merce Cunningham) into her company, and by extension, began to introduce romantic dialogues. Such works include *Letter to the World* (1940), based on the poems of Emily Dickinson, and *Deaths and Entrances* (1943), which evokes the writings of the Brontë sisters. Among her finest dances of the 1940s are the earliest, *El Penitente* (1940), a passion play set in a Mexican village, and the latest, *Diversion of Angels* (1948), a plotless meditation on the manifestations of love. The second half of the decade witnessed Graham's collaboration with the sculptor Isamu Noguchi. Following *Appalachian Spring* (fig. 599), inspired by America's pioneer era, Graham's collaborative pieces with Noguchi were performed on symbol-strewn sets that suggested the tragic worlds of Aeschylus, Sophocles, and other ancient Greek writers: *Cave of the Heart* (1946), about Medea and Jason; *Errand into the Maze* (1947), the story of Ariadne and the Minotaur; and *Night Journey* (1947), the tragedy of Oedipus and Jocasta.

In contrast to Martha Graham, George Balanchine was pouring his efforts into Broadway shows at the beginning of the 1940s, among them *Keep Off the Grass*, *Louisiana Purchase*, and *Cabin in the Sky*, all from 1940; *The Lady Comes Across* (1942); and *Song of Norway* (1944)—and also working as an itinerant choreographer for the theater, the circus, and various one-time-only galas. Yet he remained devoted to classical dance. In 1941, for example, he produced *Concerto Barocco* to Bach's *Double Violin Concerto in D Minor*—a magisterial dance marked by jazzlike syncopation and stately passion, choreographed for two ballerinas, a small female corps de ballet, and a cavalier in the central adagio.

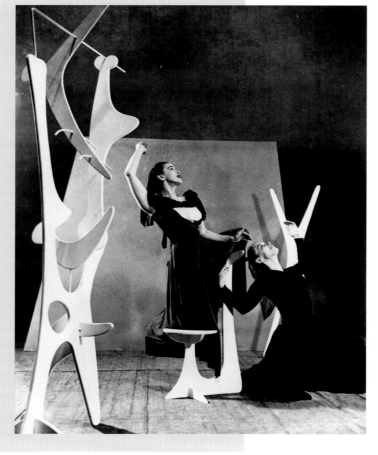

667. Martha Graham and May O'Donnell in *Herodiade,* choreographed by Martha Graham, 1944 Gelatin silver print, 9½ x 7½ in. (24.1 x 19 cm) Dance Collection, The New York Public Library for the Performing Arts, Astor, Lenox and Tilden Foundations

Times, confessed bewilderment at these works, particularly Adolph Gottlieb's *Rape of Persephone* and Mark Rothko's *The Syrian Bull,* the two artists rejoined with a full-page letter, which Jewell published in his Sunday column the following week. Assisted in drafting the letter by Barnett Newman (who remained anonymous because he was not a Federation member), the artists declared their aesthetic ideology: "There is no such thing as good painting about nothing. We assert that the subject is crucial and only that subject matter is *valid which is tragic and timeless.* That is why we profess spiritual kinship with primitive and archaic art."[163] Gottlieb elaborated in a radio broadcast later that month: "If we profess a kinship to the art of primitive man, it is because the feelings they expressed have a particular pertinence today. In times of violence, personal predilections for niceties of color and form seem irrelevant. All primitive expression reveals the constant awareness of powerful forces, the immediate presence of terror and fear, a recognition and acceptance of the brutality of the natural world as well as the external insecurity of life."[164]

Rothko, Gottlieb, and Newman spoke for a wider group of young, emergent artists that included Jackson Pollock, Clyfford Still, William Baziotes, and Richard Pousette-Dart, all of whom were seeking a subject matter that could express the terror and insecurity of contemporary existence. This "small band of Myth Makers," as Rothko later dubbed them, embraced archaic symbols, myths, and artifacts not for their formal qualities, as early twentieth-century artists had done, but for their ability to communicate basic psychological needs. "If there are resemblances between archaic forms and our own symbols," Rothko wrote, "it is not because we are consciously derived from them but rather because we are concerned with similar states of consciousness and relationship to the world."[165]

In the art and myths of ancient Greece, Egypt, Oceania, and the indigenous cultures of the Americas, these artists found expressions of primal fears and motivations that mirrored their own terror and anxiety. Their desire to address the frightening and imponderable mysteries of life led them, in particular, to Greco-Roman myth and literature. In predatory tales such as those of Oedipus and Agamemnon lay a compelling model for the expression of the human inability to ward off the destructive forces of fate. "Greek tragedy," as Newman explained, "constantly revolves around the sense of hopelessness: that no matter how heroically one may act, no matter how innocent or moral that action may seem, it inevitably leads to tragic failure because of our inability to understand or control the social result. . . ."[166] The goal, however, was not to illustrate specific moments in the stories, but to recast what Rothko called "the Spirit of Myth" in a mode at once timeless and modern.[167] The Myth Makers' determination to communicate themes of sacrifice and violence in a modern vocabulary was shared by choreographers, particularly Martha Graham, whose *Herodiade* (fig. 667), *Cave of the Heart* (fig. 668), and *Night Journey* (1947)—with their sets by Isamu Noguchi—were

In 1946, Balanchine founded Ballet Society (renamed the New York City Ballet in 1948). Beginning in that year, Balanchine created three landmark ballets: *Le Palais de Cristal* (later slightly revised as *Symphony in C*), to Georges Bizet's *Symphony No. 1*; *Night Shadow* (later renamed *La Sonnambula*), a haunting ghost story set to a score by Vittorio Rieti (who also wrote the scenario); and *The Four Temperaments*, to a score he had commissioned from Paul Hindemith. In *The Four Temperaments*, Balanchine extended the classical vocabulary in which he had been trained in Russia so that the movements simultaneously suggest moods or "temperaments" and elements of an urban landscape. Balanchine ended the decade with *Symphonie Concertante* (1947); *Firebird* (1949), choreographed to Stravinsky's 1945 *Third Suite for Reduced Orchestra;* and *Bourrée Fantasque* (1949), to music by Emmanuel Chabrier. —M. A.

668. Martha Graham in *Cave of the Heart,* choreographed by Martha Graham, 1946, photograph by Bennet & Pleasant Gelatin silver print, 9½ x 7½ in. (24.1 x 19 cm) Dance Collection, The New York Public Library for the Performing Arts, Astor, Lenox and Tilden Foundations

669. David Hare
Magician's Game, 1944
(cast 1946)
Bronze, 40¼ x 18½ x
25¼ in. (102.2 x 47 x
64.1 cm)
The Museum of Modern
Art, New York; Given
anonymously

670. Louise Bourgeois
Quarantania, 1941
Seven wooden pine ele-
ments on a wooden base,
84¾ x 31¼ x 29¼ in.
(215.3 x 79.4 x 74.3 cm)
Whitney Museum of
American Art, New York;
Gift of an anonymous
donor 77.80
©Louise
Bourgeois/V.A.G.A., N.Y.

671. Isamu Noguchi
Humpty Dumpty, 1946
Ribbon slate, 58¾ in.
(149.2 cm) height
Whitney Museum of
American Art, New York;
Purchase 47.7

Jungian-influenced investigations of myth and the psychology of the unconscious. In these latter two works, Graham brought to the stage the protagonists of Greek tragedy, Medea and Jocasta, whose actions led to sacrifice, violence, and destruction of the family.

An infatuation with the archaic and mythic was at the same time emerging among sculptors, particularly Isamu Noguchi, Louise Bourgeois, and David Hare. Wishing to endow their sculptures with a mythic dimension while simultaneously circumventing explicitly figurative imagery, they turned to vertical, totemic forms. Noguchi had learned the power of the simple shape from Constantin Brancusi, under whom he had apprenticed in Paris in the late 1920s. Noguchi's standing personages, composed of smooth stone planes slotted into one another at right angles (fig. 671), were modern equivalents of archaic Greek kouroi. Mysterious and silent, their interlocking shapes emitted an aura of magic and ritual. While they shared a powerful eroticism with Bourgeois' abstract pole sculptures, they remained more within the Western sculptural tradition than did her hand-painted, wooden totems (fig. 670). Bourgeois' work, roughly crafted rather than smooth, allied more directly with primitive art. The third sculptor, David Hare, was more closely involved with the French Surrealists than any other American artist with the exception of

672. **Mark Rothko**
Entombment, I, 1946
Gouache on paper, 20⅜ x 25¾ in. (51.8 x 65.4 cm)
Whitney Museum of American Art, New York; Purchase 47.10

Man Ray. A cousin of the Surrealist painter Kay Sage, he exhibited photographs in the "First Papers of Surrealism" and edited the Surrealist magazine *VVV*. By late 1942, he had channeled his explorations of myth and the imagery of the unconscious into quasi-figurative sculptures (fig. 669).

The urgency painters felt to convey the anxiety and uncertainty of their time was matched by their determination to preserve the two-dimensionality of the picture plane. The argument advanced by Clement Greenberg and others that a painting's "advanced" status depended on eliminating allusions to three-dimensional space had been exclusively formal; it only concerned painting's physical properties. In the hands of the Myth Makers, flat, nonillusionistic space assumed a moral urgency as well. Rothko and Gottlieb announced this conflation of pictorial and moral veracity in their 1943 mission statement to *The New York Times:* "We favor the simple expression of the complex thought," the two artists asserted. "We are for the large shape because it has the impact of the unequivocal. We wish to reassert the picture plane. We are for flat forms because they destroy illusion and reveal truth."[168] It was not until 1947 that they fully succeeded in simplifying their forms and marrying mythic content to a flat picture space. Until then, they contented themselves with the overlapping linear patterns yielded by automatism.

Coupling automatism with archetypal subject matter allowed Rothko to express at once the terror and the exhilarating promise of life. Using watercolor or thinly applied layers of oil paint, he created luminous fields of muted, ineffable

673. Adolph Gottlieb
Vigil, 1948
Oil on canvas, 36 x 48 in.
(91.4 x 121.9 cm)
Whitney Museum of
American Art, New York;
Purchase 49.2
©Adolph and Esther
Gottlieb Foundation/
V.A.G.A., N.Y.

674. Adolph Gottlieb
Voyager's Return, 1946
Watercolor and gouache on
paper, 25½ x 19⅝ in.
(64.8 x 49.8 cm)
Whitney Museum of
American Art, New York;
Gift of Mr. and Mrs.
Samuel M. Kootz 51.38
©Adolph and Esther
Gottlieb Foundation/
V.A.G.A., N.Y.

color into which he situated automatis-tically derived calligraphic figures (fig. 672). His technique of freely brushing multiple layers of turpentine-thinned oil paint was derived from Milton Avery, a mentor to him and Gottlieb in the thirties. Other Americans had concentrated on color in their paintings, but Avery's use of it to evoke subtle emotions was unique. His soft, lyrical color, and commitment to both formal issues and content was an important precedent for these younger artists, especially Rothko. But whereas Avery portrayed his immediate environment—landscapes, still lifes, scenes of daily life—with repose and harmony, Rothko permeated his art with intimations of a pantheistic world where men, animals, and plants merged into a "single tragic idea."[169] These metamorphic images, culled from biology and anthropology, harked back to prehistory, to the unicel-lular origins of life. After 1947, Rothko would purge his work of these imagi-nary beings and retain only their strati-fied, architectonic rectangles of color.

Gottlieb, meanwhile, was drawing obliquely on the imagery of African, Oceanic, and Native American art to approximate in his art the terror, self-consciousness, and awe that primitive man felt "before the void."[170] Although arrived at through free association, Gottlieb's pictographs, as he called his paintings from the 1940s, were populated by figures that recalled the Northwest Coast Indian art he had seen in New York's American Museum of Natural History and in the large-scale survey exhibition of Native American art at The Museum of Modern Art in 1941. Inspired by the emblematic sim-plicity and all-over patterning of this art, Gottlieb invented a private, subjec-tive vocabulary of recognizable and abstract cabalistic writing and image-symbols, which he deployed within rectilinear compartments on his canvas (figs. 673, 674). This compartmentalized structure, which he likened to Italian medieval panel painting and fresco cycles, allowed him to present his ideograms as simultaneously isolated and part of the whole—symbolic of humanity's metaphysical condition.

Northwest Coast Indian art and, to a lesser extent, that of the Pueblo Indians were widely collected and discussed by American artists in the 1940s. Barnett

675. **Richard Pousette-Dart**
Within the Room, 1942
Oil on canvas, 36 x 60 in.
(91.4 x 152.4 cm)
Whitney Museum of
American Art, New York;
Promised 50th Anniversary
Gift of the artist P.4.79

676. **Lee Mullican**
Thistles near the Sun,
1948
Oil on canvas, 47 x 40 in.
(119.4 x 101.6 cm)
Private collection

Newman, for example, organized exhibitions of it, and Gottlieb amassed a sizable collection, purchased in large part from John Graham's newly opened Primitive Art Gallery. The status of this art as an indigenous heritage that flourished, as Newman asserted, "without benefit of European history" gave it advantages over other so-called primitive art traditions.[171] Artists who championed it felt more than a simple nationalist desire to declare aesthetic independence from Europe; with questions of life, death, and faith at stake, they saw Native American art as a model of the Oneness to which they aspired in the midst of crisis. Richard Pousette-Dart claimed that his work "came from some spirit or force in America, not Europe," that it had an "inner vibration comparable to American Indian art."[172] He overpainted his canvases, sometimes with thirty or forty layers, in order to achieve a richly impastoed, enigmatic interplay of organic and geometric forms and suggest the mystical state of consciousness he associated with Native American culture (fig. 675). By 1950, a San Francisco group calling itself Dynaton (composed of Lee Mullican and the repatriated Surrealists Gordon Onslow-Ford and Wolfgang Paalen) would likewise conjoin the cosmic "vibrations" of Native American art with the Surrealist interest in the unconscious and automatism (fig. 676).

677. **Steve Wheeler**
Laughing Boy Rolling,
1946
Oil on canvas, 36 x 45 in.
(91.4 x 114.3 cm)
Whitney Museum of
American Art, New York;
Purchase 47.3

The New York group known as the Indian Space painters drew more directly on the imagery of Northwest Coast, Inuit, Pueblo, and Inca art to create arrangements of flat, hard-edged forms that spread across the picture surface in an all-over design. The progenitors of the style—Steve Wheeler, Peter Busa, and Robert Barrell—had studied with Hans Hofmann and absorbed his high-keyed palette and his predilection for completely two-dimensional space. Combining this nonillusionistic pictorial space with a careful study of the indigenous art of the Americas resulted in a flat, ideographic style composed of recognizable objects and decorative patterns whose design eliminated the distinction between "background" and "figure." Termed Indian Space by Howard Daum, a younger member of the group, it made its debut at the Galerie Neuf in a 1946 exhibition entitled "Semeiology or 8 and a Totem Pole." Wheeler refused to participate in the exhibition, not wanting his pictographs, as he called them, to be allied with Indian Space painting (fig. 677). Nevertheless, the pronounced stylistic similarity between his paintings and those of Indian Space members led to the inclusion of his work in almost all of the six issues of the group's magazine, *Iconograph,* which Galerie Neuf's owner, Kenneth Beaudoin, published between spring 1946 and fall 1947. In 1947, attempting to dispel the link between his art and that of Native Americans, Wheeler produced a limited-edition book, *Hello Steve,* comprising thirteen photo-silkscreen facsimiles of his pictographs and an essay ascribed to "Adam Gates," a pseudonym.

Jackson Pollock, though equally interested in Native American art, cautioned against looking for explicit references to it in his paintings. If they existed, he

stated, it was "the result of early memories and enthusiasms."[173] More critical to his art were Picasso and Miró. Indeed, for Pollock, Picasso's art offered a compelling example of how to fuse images of violent anguish with a modern pictorial structure. What impressed Pollock in particular was Picasso's incorporation into his etchings and his mural *Guernica* (1937) of images of Greek mythological beings, specifically the Minotaur, a half-man, half-bull creature symbolizing irrationality. *Guernica*'s extended installation at The Museum of Modern Art following its benefit showing at the Valentin Gallery in 1939 made it an accessible standard against which Pollock would measure his own work. By 1942, he had meshed Picasso's imagery and forceful paint handling with Surrealist automatism to create a unique fusion of expressionism and Cubist rectilinear formality. He achieved this style by drawing on a wide range of influences: the dynamic compositional rhythms of his Art Students League teacher, Thomas Hart Benton; the mythic iconography of the Mexican muralists, particularly José Clemente Orozco, whose *Prometheus* frescoes he saw as an eighteen-year-old at California's Pomona College; and his therapeutic experiences with two successive Jungian psychoanalysts from 1939 through 1942.

678. **Jackson Pollock**
Male and Female, c. 1942
Oil on canvas, 73¼ x
48⅞ in. (186 x 124 cm)
Philadelphia Museum of
Art; Gift of Mr. and Mrs.
H. Gates Lloyd

By the time he left Jungian therapy, Pollock had merged an expressionist vocabulary of open, linear arabesques with a mythic imagery of androgynous animal-human figures oscillating between figuration and abstraction. The loose rectilinear compartments into which he subdivided his pictures established their two-dimensionality while simultaneously restraining the intensity of his expressionist imagery. In this way, he could suggest both order and disorder, construction and destruction (fig. 678). By 1943, he was distributing partially closed shapes and open, calligraphic "handwriting" across the picture surface in a manner that eliminated hierarchy and a fixed focal point. While not yielding to specific interpretations, the paintings' mythic imagery and turbulent, explosive gesture alluded to sexuality, power, sacrifice, and bestial irrationality. Pollock's first one-artist exhibition at Peggy Guggenheim's Art of This Century gallery, in November 1943, thrust him into the spotlight as the prophet of a new kind of abstract painting. By his second show, in the spring of 1945, he was being heralded as "the strongest painter of his generation and perhaps the greatest one to appear since Miró."[174]

Postwar Anxiety and Subjectivity

On May 7, 1945, Germany surrendered to Allied forces, bringing to an end an unparalleled display of human barbarism. Three months later, the United States dropped the world's first two atomic bombs on Hiroshima and Nagasaki, Japan. Although the bombs led to Japan's surrender on August 14, they forced a chilling victory. Peace had been won at the cost of innocence and security. The bomb's potential for total world destruction brought home the basic fragility and contingency of human life as well as the impotence of reason to provide the meaning of existence. "We now know the terror to expect," Barnett Newman wrote. "Hiroshima showed it to us. . . . The terror has indeed become as real as life."[175]

The terror and anxiety did not end with the declaration of peace. The Soviet Union, a United States ally in World War II, became the new enemy as fear of Communist expansion thrust the democratic countries of the West into a Cold War. The 1948 Soviet blockade of West Berlin ended in the West's first Cold War victory, but the discovery that the Soviet Union possessed the atomic bomb intensified America's already heightened sense of anxiety and apprehension. With the House Committee on Un-American Activities fomenting a hysteria that Communists had infiltrated every walk of American life, trust in the veracity of observed reality yielded to doubt and uncertainty. Fear was all the greater because the enemy seemed imperceptible, concealed within the fabric of American life.

It was against the backdrop of these realities that American postwar anxiety emerged. The barbarism of Nazi concentration camps and the susceptibility of the masses to political manipulation had shattered faith in human morality and contaminated the belief in collective political reform. In response, most Americans turned their attention from public matters to their own inner lives. Concern with personal fulfillment and individual happiness supplanted the preceding decade's search for collective improvement. This shift in focus from the collective to the individual was reflected in popular music as individual vocalists and solo instrumentalists replaced well-drilled big bands. During the war, swing-band orchestras had lost members to the draft, while a prolonged strike by the American musicians union in 1942–44 had proscribed instrumental—but not vocal—musicians from recording. By the end of the war, the big-band era was over and single vocalists dominated the music industry—from Bing Crosby, Dinah Shore, and Nat King Cole to Frank Sinatra, whose songs of love and heartbreak made him the first idol of the new teenage consumer group, the bobby-soxers.

Much of this music mirrored the desires of an audience ready to relax after the hardships and sacrifices of the Depression and the war. Yet a disturbing malaise ran beneath the surface of the nation's domestic prosperity and international preeminence.

LITERARY RESPONSES TO WAR

Most of the fiction and nonfiction published during or shortly after World War II was the result of direct reportage. Ernest Hemingway wrote articles for *Collier's* magazine about the Allies' invasion of France in 1944 and edited the best-selling anthology *Men at War* (1942), although his finest writing about combat, based on his experiences in World War I, was fictionalized in *In Our Time* (1925) and *A Farewell to Arms* (1929). John Hersey worked as a correspondent throughout World War II and published his first book, *Men in Bataan*, in 1942. He followed it with a description of a battle on Guadalcanal, *Into the Valley* (1943), and a fictionalized account of the American occupation of Italy in his Pulitzer Prize-winning novel, *A Bell for Adano* (1944). Hersey's *Hiroshima*, a powerful investigative report, was first published in an issue of *The New Yorker* in August 1946, one year after the atomic bomb devastated that city. His *The Wall* (1950) described the Nazis' extermination of the Jews in the Warsaw ghetto. Norman Mailer joined the U.S. Army in 1944 and fought in the invasion of Luzon. His highly acclaimed first novel, *The Naked and the Dead* (1948), portrayed the different backgrounds of the Americans who went into combat, and suggested how their different ideologies shaped their responses to war.

Later novelists took longer to deal with the trauma of war experiences, but they produced the most innovative fiction about World War II. Joseph Heller, who served in the Air Force, satirized the bureaucracy of warfare in *Catch-22* (1961). Kurt Vonnegut, Jr., who witnessed the firebombing of Dresden, described the inferno and its crippling aftermath in *Slaughterhouse Five* (1969). Incorporating black humor, these two novels are compelling accounts of the almost unimaginably disruptive and destructive powers of modern warfare. —A. C.

Many Americans found themselves beset by an ineffable sense of insecurity and absence of purpose. Even *Life* magazine concluded in 1948, "The modern individual is out of touch with the inner realities of life and is somehow 'lost.' He suffers from philosophical and spiritual confusions."[176] Novelists such as Carson McCullers and Saul Bellow and playwrights such as Arthur Miller and Tennessee Williams expressed this psychic disquiet in writings marked by inner conflict and alienation (fig. 689). Film noir, with its themes of disillusionment and its mood of entrapment and apprehension, likewise emphasized fear and paranoia. Exploiting techniques developed during the war to compensate for low budgets and restrictions against location shooting, film noir featured shadowy, low-key lighting, strange camera angles, and sharp tonal contrasts. The ensnaring claustrophobic close-ups and deep-focus shots in films such as *The Big Sleep* (1946), *Double Indemnity* (1944), *All About Eve* (1950), and *Sunset Boulevard* (1950) produced a disorienting, unbalanced quality that mirrored a world in which moral certainties had given way to a crisis of faith.

Photography, too, betrayed the widespread sense of uncertainty and apprehension postwar Americans felt despite their outward happiness and affluence. Ted Croner, Louis Faurer, Dan Weiner, David Vestal (fig. 680), and Robert Frank (figs. 682, 683) took photographs that avoided sharp delineations and clear tonal gradations in favor of ambiguous, often blurry images suggesting the process of dissolution or transformation. In contrast to the direct, objective quality of thirties documentary photography, these photographs, often taken on the run, in low light or rain, were dark and menacing rather than celebratory. Their raw analysis of American life as existentially adrift would become closely identified with Robert Frank after the 1959 publication of his book *The Americans*. Yet Frank's involvement with American subject matter was limited in the forties. He arrived in New York from Switzerland in March 1947, went to work for *Harper's Bazaar*, and left in January 1948, following the close of the magazine's in-house photography studio. Not until 1953, when he returned to the United States after a five-year tour of South America and Europe, would he truly claim American subject matter as his own. Even then, his gaze remained that of an outsider, detached and reserved.

In contrast, Louis Faurer, Frank's friend and colleague from *Harper's Bazaar*, produced work that was more poetic and intimate (figs. 679, 684). Ted Croner, too,

THE BIG SINGERS

America's involvement in World War II coincided with the peak of the swing era, and the music of the big bands of Glenn Miller, Benny Goodman, Harry James, and others became indelibly associated with the triumphs and tragedies of the "Good War."

Swing mellowed during the war years, as Americans experiencing separation and loss responded to sentiments of romance and nostalgia. Many bands added string sections, and ballads on the order of Irving Berlin's "White Christmas," Sammy Fain's "I'll Be Seeing You," and Jule Styne's "I'll Walk Alone" soon outnumbered novelty songs, up-tempo pieces for jitterbugs, and jingoistic war songs. Singers began to receive as much attention as the bands themselves. Frank Sinatra, who had sung with Harry James and Tommy Dorsey in the early 1940s, launched his solo career with sensational engagements at New York's Paramount Theatre in 1943–44. Other singers also left big bands, and younger ones started off on their own. Perry Como, Dick Haymes, Doris Day, Dinah Shore, Jo Stafford, and Frankie Carle were among the most popular, as were a handful of black singers—Ella Fitzgerald, Lena Horne, Billie Holiday—who sang the same Tin Pan Alley repertoire, though with the distinctive vocal timbres and ornamentation of African American music. And there was Bing Crosby, who had maintained a solo career throughout the big-band era. Swing hung on, driven increasingly by nostalgia, but by 1945 big bands had largely given way to big singers, who dominated mainstream popular music for a decade.

The mainstay of the singers' repertoire continued to be ballads. Improved sound technology made it possible for singers to project intimate, subtly nuanced vocal styles against sizable orchestras, on recordings and in live performance. Axel Stordahl's lush, semisymphonic arrangements for Sinatra's Columbia recordings became models for other arrangers.

By mid-century, music in the United States was becoming more segregated. American composers of "art" music, drawn to the techniques and ideology of European high modernism, dismissed the notion, cherished by the generation of George Gershwin and Duke Ellington, that a common ground existed between popular and classical music. "Popular" music itself was increasingly produced and marketed for discrete groups: Tin Pan Alley music for urban and suburban whites, and others aspiring to their status and culture; country-western music for rural and working-class whites; rhythm and blues for blacks. The national consensus brought about by the war was beginning to fall apart. — C. H.

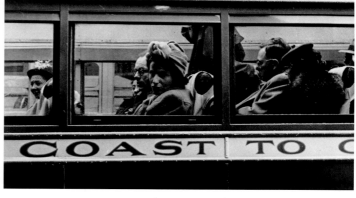

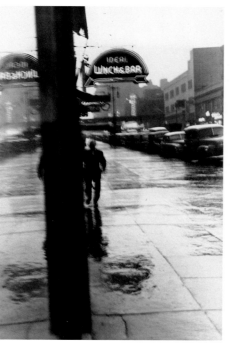

679. **Louis Faurer**
New York City, 1950
(printed 1991)
Gelatin silver print, 11⅜ x
7⅞ in. (28.9 x 20 cm)
Addison Gallery of
American Art, Phillips
Academy, Andover,
Massachusetts;
Gift of Deborah Bell
©Louis Faurer/V.A.G.A.,
N.Y.

680. **David Vestal**
*East 86th Street, New
York,* 1949 (printed later)
Gelatin silver print, 14 x
10 in. (35.6 x 25.4 cm)
Robert Mann Gallery,
New York

681. **Esther Bubley**
*Greyhound Bus Passengers
(Coast to Coast),* 1947
Gelatin silver print, 7½ x
12⅝ in. (19 x 32.1 cm)
CNF Transportation Inc.,
Palo Alto, California

682. **Robert Frank**
Doll/New York City, 1949
Gelatin silver developed-
out print, 13¹³⁄₁₆ x 8⁷⁄₁₆ in.
(35.1 x 31.4 cm)
National Gallery of Art,
Washington, D.C.; Robert
Frank Collection, Gift
(Partial and Promised) of
Robert Frank, in Honor of
the 50th Anniversary of
the National Gallery of Art

683. **Robert Frank**
Central Park South, 1948
Gelatin silver developed-
out print, 13¼ x 10⅜ in.
(33.7 x 26.2 cm)
National Gallery of Art,
Washington, D.C.; Robert
Frank Collection, Gift of
Robert Frank

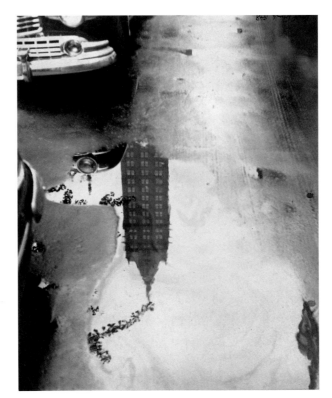

684. **Louis Faurer**
*Staten Island Ferry, New
York City,* 1946 (printed
1980)
Gelatin silver print, 8½ x
8⅜ in. (21.6 x 21.3 cm)
Addison Gallery of American
Art, Phillips Academy,
Andover, Massachusetts;
Gift of Robert Feldman (PA
1954) in memory of Beth
Lisa Feldman, by exchange
©Louis Faurer/V.A.G.A., N.Y.

685. **Ted Croner**
Home of the Brave, 1948
(printed later)
Gelatin silver print, 20 x
16 in. (50.8 x 40.6 cm)
Howard Greenberg Gallery,
New York

686. **Aaron Siskind**
N.Y. 7, 1950
Gelatin silver print,
9⅝ x 13 in. (24.4 x
33 cm)
Whitney Museum of
American Art, New
York; Purchase, with
funds from the
Photography
Committee 96.63

687. **Aaron Siskind**
Chicago, 1948
Gelatin silver print,
19 x 13⅜ in. (48.3 x
34 cm)
Collection of Susan
Ehrens and Leland
Rice

688. **Aaron Siskind**
Chicago, 1949
Gelatin silver print,
14 x 17¹³⁄₁₆ in. (35.6 x
45.3 cm)
The Museum of Modern
Art, New York; Gift of
Robert and Joyce
Menschel

THEATER IN THE 1940S

American theater of the 1940s presented more than the laughter and confidence of the musical stage. Drama of the decade explored a more contemplative, questioning, and abrasive side of life; in the process, American drama came of age, finding its full stature and making a bid for world renown.

Eugene O'Neill was already an international figure, having won the Nobel Prize in literature in 1936, the only American playwright ever to do so. The bulk of his output was behind him by 1940, and only one of his plays reached Broadway during the next decade: *The Iceman Cometh* (1946). *A Moon for the Misbegotten* (1947) closed before reaching New York. He had also completed his autobiographical masterpiece, *Long Day's Journey into Night*, in 1941. At his request, it was not produced until after his death in 1953. Most of his energies in the late 1930s and the 1940s were spent on a multiplay cycle he called "A Tale of Possessors Self-Dispossessed." It was to cover several generations of an American family, whose members would, by their own hands, wreak their own destruction. Before his death, he destroyed most of these plays. Only one survived whole and was finally produced in 1958: *A Touch of the Poet*. Another was reconstituted from fragments and presented as *More Stately Mansions* in 1962.

O'Neill's enduring reputation is based primarily on the realism of these later plays, with their searching investigation of failed hopes, of greed and self-delusion, of the dark forces that impede the individual's search for self and for God. He raised serious questions about the loss of personal integrity in a world full of greed and despair. He seemed always to be asking, "What does it profit a man if he gains the whole world but loses his own soul?"

When Tennessee Williams' *A Streetcar Named Desire* opened on Broadway in 1947, one reviewer called Williams "the Eugene O'Neill of the present period," and the play enjoyed a run of 855 performances. But Williams was not another O'Neill, except in the power and effectiveness of his writing. Whatever their specific narrative, his plays focus on the sensitive misfit battered by an unfeeling world, the loss of a gracious past to an abrasive present, the valor of endurance in the face of loss, the importance of illusion and dreams in an unfriendly world. In 1940, the first of his plays optioned for Broadway production, *Battle of Angels*, failed on the road and was not seen in New York until 1957, having been rewritten as *Orpheus Descending*. But his next produced play, *The Glass Menagerie* (1945), ran for 561 performances, won the Drama Critics Circle Award, and went on to become perhaps the best known and loved of his works. Its stage effectiveness was due in no small part to Jo Mielziner's evocative design, which lent grace and flow to this drama of loss and endurance. The third of Williams' plays to appear in New York was *Summer and Smoke* (1948), which played only one hundred performances. Its multiple setting lent it the aura of a morality play, but its statement is clearly that one does not live by spirit alone, that full humanity is attained only when the sensual self is also realized.

The third great questioner in these years was Arthur Miller, another new voice in American theater. His most famous play, *Death of a Salesman*, opened in 1949 and ran for 742 performances (fig. 689). Like *The Glass Menagerie*, it is a kind of memory

689. Poster for *Death of a Salesman,* by Arthur Miller, 1949
Billy Rose Theatre Collection, The New York Public Library for the Performing Arts, Astor, Lenox and Tilden Foundations

achieved a lyrical record of light and moving objects by working at night in low-light situations with slow shutter speeds and allowing long periods for developing (fig. 685). The subjectivity of these photographs was pushed in more abstract directions by Aaron Siskind, who had left the Photo League and social commentary in 1941 to turn his attention to close-up documents showing the texture and expressive possibilities of natural and inanimate objects—torn posters, tree trunks, driftwood, graffiti, peeling paint (figs. 686–88). His emphasis on the gestural mark linked his work with that of postwar painters, particularly Franz Kline, of whose artistic circle he was a member. Like Alfred Stieglitz earlier, Siskind considered his portraits of objective phenomena to be equivalents of his private feelings—to express, as he said, not "what the world looks like" but "what we feel about the world and what we want the world to mean."[177]

play, its action moving between past and present, and the movement supported by the unique set design of Jo Mielziner. Miller called it "the tragedy of the common man" and later wrote a closely argued essay in support of his thesis. The play is a convoluted family drama centering on the character of Willy Loman, the traveling salesman, who misreads the society of success that surrounds him—he is convinced that to be "well-liked" is the key to success. His son Biff calls him "a man who didn't know who he was," as a kind of eulogy after his suicide. The play is a bitter but moving indictment of the false ideals generated by a consumer society. It won both the Pulitzer Prize and the Drama Critics Circle Award and continues to be played worldwide. —V. R.

Postwar realist painting also reflected the general mood of discomfort and disquiet, whether the work was by younger artists like Andrew Wyeth—who painted *Winter 1946* while grieving over his father's sudden death (possibly suicide) in a train accident (fig. 691)—or by more established figures such as Yasuo Kuniyoshi and Ben Shahn. For Kuniyoshi, the war years had been especially difficult. Following Pearl Harbor, he was classified an "enemy alien" by the American government and put under house arrest. Although eventually allowed to leave his studio residence, he was forbidden air travel for the duration of the war and had to carry an identity card at all times. Even traveling between Manhattan and his country house in Woodstock, New York, required government permission. Despite these affronts, Kuniyoshi spent the war years propagandizing for the Allied cause. In the war's aftermath, however, he became preoccupied with what he called "destruction, lifelessness, hovering between life and death, loneliness" (fig. 692).[178] His disappointment in the postwar world was shared by Ben Shahn, who depicted the rubble of bombed cities to comment on physical, social, and cultural devastation. Yet, unlike Kuniyoshi, Shahn introduced a modicum of hope for reconstruction in images of children playing amid his desolate, ravaged landscapes (fig. 690).

690. **Ben Shahn**
Reconstruction, 1945
Tempera on board, 26 x 39 in. (66 x 99.1 cm)
Whitney Museum of American Art, New York; Purchase 46.4
©Estate of Ben Shahn/V.A.G.A., N.Y.

691. Andrew Wyeth
Winter 1946, 1946
Tempera on board, 31⅜ x
48 in. (79.7 x 121.9 cm)
North Carolina Museum of
Art, Raleigh; Purchased
with funds from the State
of North Carolina

692. Yasuo Kuniyoshi
Deliverance, 1947
Oil on canvas, 40 x 30 in.
(101.6 x 76.2 cm)
Whitney Museum of
American Art, New York;
Purchase 48.7
©Estate of Yasuo
Kuniyoshi/V.A.G.A., N.Y.

FILM NOIR, AVANT-GARDE, AND INDEPENDENT CINEMA

In the history of American movies, the 1940s is a divided decade. During wartime, American movie attendance soared, and the film industry enjoyed remarkable success. With the postwar years, however, came disruption: the film industry was beset by ideological attacks and an anti-Communist blacklist, by a court-ordered breakup of the studio system, and by a rapid fall in attendance even before television became ubiquitous in the nation's homes.

The decade opened on a high note, with Orson Welles' *Citizen Kane* (1941), the work widely acknowledged as the most important film produced in American commercial cinema (fig. 693). The first feature film from the *enfant terrible* of theater and radio, *Citizen Kane* was recognized at once as a work that restored artfulness to American movies. In the 1930s, Hollywood's exacting technological standards had been in a sense self-effacing, designed to absorb spectators into a fictional world with a style that did not call attention to itself. Welles made style visible. The film's narrative fragmentation, its striking use of deep space and low and high camera angles, its long takes and use of sound and lighting to effect scene changes, represented a unified and comprehensive assertion of technique as art, storytelling through constructed images. The theme itself was equally audacious; with a working title of "American," *Citizen Kane* probed the private motives behind the public career of a media baron modeled, despite protestations to the contrary, on the life of the newspaper publisher William Randolph Hearst.

693. Orson Welles in *Citizen Kane,* directed by Orson Welles, 1941 The Museum of Modern Art, New York/Film Stills Archive

Within a few years, however, critics were lamenting the absence of the prewar kind of movie that just told stories and entertained, blaming *Citizen Kane* for the change. It is certainly true that stylization became more prominent in American movies as the 1940s went on. Nowhere is this more apparent than in a film movement of the war and postwar periods that has come retrospectively to be known as film noir (a name first applied by French critics in the 1950s). Film noir is recognizable more by narrative structure and visual style than by generic conventions. Although most of the classic film noir works can be categorized as urban crime films, the movement's distinctive features can be found in a number of genres.

The most striking aspect of film noir visual style was its dark and claustrophobic look. The use of key lighting from sources within the frame cast strong shadows and emphasized concealment. This somber and menacing sense of place was matched by the standard noir story. It frequently involved a man's desire for a dangerous woman, which led him toward lawlessness and guilt. Often these events were narrated in flashback in an atmosphere of foreboding and psychological distress as the narrator looked back at what went wrong. A classic work that exhibited these features, and which many critics consider the movement's progenitor, was Billy Wilder's *Double Indemnity* (1944).

Several sources for film noir have been identified. One was the hard-boiled crime novel of the 1930s—*Double Indemnity*, for example, was adapted from a 1936 novel

New American Abstraction

By 1947, as the immediate shock of the war began to subside, American abstractionists had started searching for new ways to address what Adolph Gottlieb called "the neurosis" of the age.[179] Their explorations produced two different results. One, known as Gesture, or Action painting, sprang from spontaneous, calligraphic brushwork; the other, called Chromatic Abstraction, or Color Field painting, depended on large, simple expanses of color. Both approaches celebrated subjective, private experience, and both sought to synthesize and transmute anxiety and exhilaration. By the end of the decade, with "the main premises of Western art [having] at last migrated to the United States," as Greenberg boasted, the two styles of painting were being grouped together under the rubric "Abstract Expressionism" and heralded nationally and internationally as the dominant style of the age.[180]

Although different in appearance, the two styles were not so rigidly defined as to discourage artists from sharing aspects of both or from working together within the new support structures that emerged after the European émigrés returned home. New galleries opened—Betty Parsons, Samuel Kootz, Sidney Janis, and Charles Egan—to take

by James M. Cain and the script was co-written by the crime novelist Raymond Chandler. Another was the presence in Hollywood of German émigré directors, who brought a dark expressionist style and firsthand experience of Fascism to their film work. Among those who directed significant film noir works in this group were Wilder, Fritz Lang, Otto Preminger, Edgar G. Ulmer, and Robert Siodmak. Finally, film noir stories seemed fueled by postwar anxieties: the sense of displacement felt by veterans, fear of nuclear war, conflicts between individual desires and an emerging conservative social order.

Central to this last concern was the representation of women in film noir. The need for workers during the war had given many women income, mobility, and status for the first time. Much postwar rhetoric was devoted to the subordination of women and the reestablishment of patriarchal family structures. Film noir narratives played into these concerns with portraits of *femmes fatales*, alluring women who draw men into transgressions, such as the characters portrayed by Barbara Stanwyck in *Double Indemnity*, Jane Greer in *Out of the Past* (fig. 694), and Rita Hayworth in *The Lady from Shanghai* (1948). This last work, a classic film noir, was directed by and also starred Orson Welles.

Abstract and experimental works have played a larger role in American film culture than many histories of the medium have acknowledged. Avant-garde filmmakers have also been closely linked to other arts and arts institutions. Art galleries such as the Julien Levy Gallery in New York were spaces where avant-garde screenings were held between the world wars. In 1946, the San Francisco Museum of Art launched its Art in Cinema series, one of the first comprehensive retrospectives of experimental filmmaking in Europe and the United States.

During and after World War II, there was a sense of new beginnings in avant-garde film, largely thanks to the films and manifestos that Maya Deren began to produce in 1943. A poet and writer on dance, Deren met and married the Czech filmmaker Alexander Hammid in Los Angeles that year, and the couple decided to make an experimental film. The resulting work, *Meshes of the Afternoon* (fig. 695), a fourteen-minute silent film (sound was later added), was one of the most famous of all avant-garde film projects. Deren performs as a woman who enters an apartment and falls asleep. The film's images then represent her disorienting and violent dreams, in scenes of distinct beauty and mystery. Moving to New York, Deren made *At Land* (1944), *A Study in Choreography for Camera* (1945), and *Ritual in Transfigured Time* (1945–46), while writing and speaking out for a new avant-garde film movement.

Along with Deren, several other experimental filmmakers began making live-action works whose representation of sexual anxiety and transgression bore striking affinities to motifs in the commercial film noir movement. These included *The Potted Psalm* (1946), by the San Francisco-based Sidney Peterson and James Broughton, and

694. Robert Mitchum and Jane Greer in *Out of the Past,* directed by Jacques Tourneur, 1947
The Museum of Modern Art, New York/Film Stills Archive

the place of Art of This Century, which closed in 1947, and new artist-run magazines—*Tiger's Eye* (1947–49) and *Possibilities* (1947–48)—were started after the demise of *View* in 1947. In the fall of 1948, William Baziotes, David Hare, Robert Motherwell, Mark Rothko, and Clyfford Still founded a school in a loft on 8th Street in New York's Greenwich Village, which offered classes and hosted weekly Friday evening lectures for the public.[181] Called Subjects of the Artist by its founders, the school emphasized the content of art over technique and stylistic analyses. When it closed, less than a year later, its public lectures were continued in the loft by New York University art students and faculty who had assumed the lease.[182] Soon thereafter, in the fall of 1949, another group founded a private, informal society of artists in

Fireworks (1947), a symbolically homoerotic film made in southern California by the seventeen-year-old Kenneth Anger (who had started making films at age eleven and had seven previous completed works).

In New York, Willard Maas used a magnifying glass to explore the human body in the seven-minute film *Geography of the Body* (1943), with a sound-track commentary spoken by the poet George Barker. Maas' wife, Marie Menken, who was working in Isamu Noguchi's studio, made a film observing and interpreting the forms of his sculpture, *Visual Variations on Noguchi* (1945). In Los Angeles, the brothers James and John Whitney photographed paper cutouts for a series of short animated films with sound, *Film Exercises 1–5* (1943–45), which were experiments in sound and visual synchronization.

By mid-decade, avant-garde film was achieving critical mass and institutional recognition: in 1946, Maya Deren was awarded a fellowship from the John Simon Guggenheim Memorial Foundation, and the Whitney brothers won a similar grant the following year. Amos and Marcia Vogel in 1947 established the Cinema 16 film society in New York, which programmed avant-garde works along with documentaries and other independent films, and helped shape the American alternative film culture into the 1960s. —R. S.

695. Maya Deren in
Meshes of the Afternoon,
directed by Maya Deren,
1943
The Museum of Modern
Art, New York/Film Stills
Archive

the same area. Known as the Club, or the Eighth Street Club, it was governed by a voting committee that nominated and approved new members and arranged programs. As it evolved into a more formal program of lectures and panels, the Club came increasingly to be identified with the gestural branch of Abstract Expressionism.[183]

GESTURAL EXPRESSIONISM

Looking back years later, Willem de Kooning credited Jackson Pollock with having launched the new form of painting known as Abstract Expressionism. "Every so often," de Kooning wrote, "a painter has to destroy painting. Cézanne did it, Picasso did it with cubism. Then Pollock did it. He busted our idea of a picture all to hell. Then there could be new paintings again."[184] The Pollock paintings to which de Kooning referred were a series of "poured" abstractions that Pollock created in 1947 by dripping, flinging, and pouring paint from sticks and hardened brushes onto canvases tacked to the floor of his studio. The process itself was not new. Until Pollock, however, no artist had so powerfully used the technique to create an all-over network of lines that did not define images but rather declared themselves simply as line and movement. The result was a sensation of pure energy. Viewers experienced the paintings viscerally; their eyes instinctively traced the arabesques of paint as they curved back on themselves before reaching the edges

of the canvas. The effect was of movement without beginning or end—a quality that made the paintings metaphors of cosmic creation.

Pollock arrived at his compositions spontaneously, through the process of painting itself. Although he claimed he never relinquished control over decision-making, he extended Surrealist automatism to its logical conclusion by making his unconscious the primary source of his art. "When I am *in* my painting," he wrote, "I'm not aware of what I'm doing. It is only after a sort of 'get acquainted' period

696. **Jackson Pollock**
Number 27, 1950
Oil on canvas, 49 x 106 in.
(124.5 x 269.2 cm)
Whitney Museum of
American Art, New York;
Purchase 53.12

that I see what I have been about. I have no fears about making changes, destroying the image, etc., because the painting has a life of its own. I try to let it come through."[185] The unpremeditated, gestural quality of this undertaking became a cornerstone of the Pollock myth. In an age of anonymity and conformity, his work stood for autonomy and freedom.

This mythologizing highlighted Pollock's spontaneity and freedom, but it blinded observers to his central aesthetic ambition: to synthesize metaphysical oppositions—order and chaos, reason and passion, heaven and hell. Guided by Carl Jung's precept that humanity's psychological and physical health depended on acknowledging the brutal and demonic forces of the unconscious, Pollock created a visual language that coupled images of primordial passion with those of spiritual harmony. The tangled, tormented skeins of paint and lack of focal point in his work bespoke entrapment and anxiety; the lyrical grace and unconstricted energy of his calligraphic arabesques suggested freedom and ecstasy (fig. 696). Uniting these oppositions into a single language provided a model for society's reconciliation of anxiety and powerlessness with enchantment, mystery, and exultation.

Pollock had "broken the ice," as de Kooning put it, by releasing line from its traditional role of describing form, and allowing it to carry the burden of composition and emotional expression. The language proved so rich, malleable, and open-ended that it attracted a host of other artists, including Bradley Walker Tomlin, Lee Krasner, de Kooning, Mark Tobey, Robert Motherwell, and Franz Kline (figs. 697–702). Dubbed Gesture or Action painting because of its emphasis on direct, unpremeditated gesture, the style was interpreted as a manifestation of existentialism, the French philosophy whose proponents' work appeared in

697. Bradley Walker Tomlin
Number 2—1950, 1950
Oil on canvas, 54 x 42 in.
(137.2 x 106.7 cm)
Whitney Museum of
American Art, New York;
Gift of Mr. and Mrs. David
Rockefeller in honor of
John I. H. Baur 81.8

698. Lee Krasner
White Squares, c. 1948
Oil on canvas, 24 x 30 in.
(61 x 76.2 cm)
Whitney Museum of
American Art, New York;
Gift of Mr. and Mrs. B. H.
Friedman 75.1

English translation after the war. According to existentialism, particularly as described by Jean-Paul Sartre, meaning and morality were matters of individual responsibility, involving a self-conscious, active encounter with the world. "Man must create his own essence," Sartre wrote; "it is in throwing himself into the world, in suffering in it, in struggling with it, that—little by little—he defines himself."[186] Those who engaged in the process of self-definition won their freedom, but they paid a price: alienation and anxiety.

Existentialist precepts did not, in fact, directly influence the Gesture painters; rather, "it was in the air," as de Kooning asserted. "We felt it without knowing too much about it. We were in touch with the mood."[187] De Kooning himself was the artist whose work most profoundly exemplified the anxiety and risk associated with existentialism. In his black-and-white abstractions, unveiled in April 1948, three months after Pollock exhibited his drip paintings, de Kooning used line to create loosely biomorphic, unbounded shapes that collided and spilled into one another within a tightly packed shallow space (fig. 699). Heavily reworked over the course of many sessions, de Kooning's abstractions were dense and impacted— a quality he achieved by covering his canvas with multiple layers of painted shapes, using heavy, industrial enamels, and superimposing sheets of newspaper onto the wet paint to prolong its drying time. De Kooning's images were indeterminate and seemingly unfixed, as if in a perpetual state of redefinition, which inspired observers to interpret them as metaphors of the modern existential condition. If humanity's fate was to be continually engaged in the task of "becoming," then the turbulent, improvisatory brushstrokes and spatial ambiguity in de Kooning's paintings embodied the anxious struggle for self-definition.

De Kooning's densely agitated, visually shifting forms mirrored the experience

699. **Willem de Kooning**
Attic, 1949
Oil, enamel, and newspaper transfer on canvas, 61⅞ x 81 in. (157.2 x 205.7 cm) The Muriel Kallis Steinberg Newman Collection, Jointly owned by The Metropolitan Museum of Art and Muriel Kallis Newman, in honor of her son, Glenn David Steinberg, 1982

of flux and dislocation in the modern metropolis—the "no environment," as he called it. He wanted to incorporate the city's fragmented, disorienting ambiguity into his art, "to see how far one could go . . . with anxiousness and dedication to fright maybe, or ecstasy," as he once said.[188] Yet, like the early twentieth-century Ashcan painters, he recorded the urban experience through figuration. He tore apart, transposed, and intermixed anatomical parts until they became abstract, but he never yielded his biomorphic vocabulary of figure and landscape to the geometric angularities of the city.

Prior to de Kooning, the Pacific Northwest Coast painter Mark Tobey had painted the frenetic rhythms of the urban environment in a thin calligraphic style he called "white writing," characterized by delicate, densely meshed lines which he distributed across the canvas in an all-over style. The effect was at once exciting and disturbing—"Hell under a lacy design," as he once described it.[189] Over time, Tobey's layered mazes of white calligraphy came to symbolize less the webs that entangled people than what he believed to be the divine presence flowing through all matter. By 1948, abstracted and spontaneous line had become the exclusive means with which he described the universal Oneness central to the Bahai faith he had practiced since 1918 (fig. 700).

That same year, Robert Motherwell began his series *Elegy to the Spanish Republic* (fig. 701). Inspired by the Fascists' execution of the Spanish poet Federico García Lorca in the Spanish Civil War, the paintings were for Motherwell pictorial metaphors of "abandonment, desperation, and helplessness."[190] Using friezelike sequences of alternating black stripes and ovals over a white background, Motherwell posited the thematic opposition between the life force and the death instinct— between construction and destruction—that would occupy him for the rest of his career. Bent on capturing the vitality of the moment yet disinclined to relinquish order and control, he evolved a two-part painting process. He first methodically established the contours and placement of the painting's large, elemental black shapes; only later, as he filled them in with paint, did he dispense with control and abandon himself to the free application of loose, gestural brushwork.

Franz Kline achieved his elemental black forms, similar to Motherwell's, with a more improvisatory method. As Kline noted, "I don't decide in advance that I'm

700. **Mark Tobey**
Universal Field, 1949
Tempera and pastel on cardboard, 28 x 44 in. (71.1 x 111.8 cm)
Whitney Museum of American Art, New York; Purchase 50.24

701. **Robert Motherwell**
At Five in the Afternoon, 1950, from the series *Elegy to the Spanish Republic*
Oil on masonite, 36 x 48 in. (91.4 x 121.9 cm)
Collection of Josephine Morris; courtesy Los Angeles County Museum of Art

going to paint a definite experience, but in the act of painting, it becomes a genuine experience for me."[191] Initially a realistic figure painter, Kline converted to bold calligraphic abstractions suddenly, in 1950, after he projected onto canvas small-scale brush drawings he had improvised on newsprint and the pages from telephone books. He executed his subsequent black-and-white compositions in a broad gestural style, using black enamel paint and six- to eight-inch-wide house painters' brushes, to boldly convey the expansive force and exuberance of the urban industrial landscape of New York and Wilkes-Barre, Pennsylvania, the coal mining town where he grew up (fig. 702). "Hell," he once remarked, "half the world wanted to be like Thoreau at Walden worrying about the noise of traffic on the way to Boston; the other half use up their lives being part of that noise. I like the second half."[192]

702. **Franz Kline**
Chief, 1950
Oil on canvas, 58⅜ x
73½ in. (148.3 x
186.7 cm)
The Museum of Modern
Art, New York; Gift of Mr.
and Mrs. David M. Solinger

Postwar sculptors also used calligraphic gesture and tactile surfaces to convey their personal responses to the world. Most chose to work in metal, a medium that "possesses little art history," as David Smith observed. "What associations it does possess are those of this century: power, structure, movement, progress, suspension, brutality."[193] This new generation of sculptors freed itself from the exclusive grip that bronze casting held on metal sculpture by taking up welding. The process allowed them to circumvent the dense, monolithic solidity intrinsic to casting in favor of open structures assembled from sinuously curved rods or paper-thin sheets of metal.

David Smith was America's greatest practitioner of this technique. Constrained during the war by job responsibilities and the difficulty of obtaining metal, Smith occupied himself with drawings (fig. 607) and small-scaled sculpture that explored themes of violence and bestiality similar to those in his etchings and *Medals for Dishonor.* With the end of the war, he expanded the scale of his work and incorporated new materials, including welded iron, steel, and utilitarian objects—divorced from their function and used exclusively for shape (fig. 703). Despite the increasing abstraction of these sculptures, they retained a brutal and menacing imagery that alluded to primordial, archetypal myths. Gradually, in works such as *Helmholtzian Landscape* (fig. 705), elements of landscape replaced cannons, grotesque birds, and human specters. By 1950, with *Star Cage* (fig. 704), Smith's evocations of the atrocities of war had given way to an iconography of earth and sky. In much of this work, Smith used his early training as a painter to challenge traditional sculptural practices. He colored the composite parts of his work, often with brushy applications of paint, and introduced line as an essential part of his vocabulary. At first, he used line simply as an open, linear structure or scaffolding in which to "cage" his pictographic forms. By the late 1940s, line functioned almost as pure, spontaneously derived drawing.

Other sculptors extended Smith's methods, achieving textured, disquieting surfaces by using oxyacetylene welding torches to melt and manipulate metal alloys.

704. David Smith
Star Cage, 1950
Various metals, welded
and painted, 44⅞ x 51¼
x 25¾ in. (114 x 130.2 x
65.4 cm)
Frederick R. Weisman Art
Museum, University of
Minnesota, Minneapolis;
John Rood Sculpture
Collection Fund
©Estate of David
Smith/V.A.G.A., N.Y.

703. David Smith
Cockfight—Variation, 1945
Steel, 34¼ x 16¾ x 9½ in.
(87 x 42.5 x 24.1 cm)
Whitney Museum of
American Art, New York;
Purchase 46.9
©Estate of David
Smith/V.A.G.A., N.Y.

705. David Smith
Helmholtzian Landscape,
1946
Painted iron with wood
base, 15⅞ x 19 x 7¾ in.
(40.3 x 48.3 x 19.7 cm)
The Kreeger Museum,
Washington, D.C.
©Estate of David
Smith/V.A.G.A., N.Y.

706. **Herbert Ferber**
The Flame, 1949
Brass, lead, and soft
solder, 64¾ x 25½ x
19¼ in. (164.5 x 64.8 x
48.9 cm)
Whitney Museum of
American Art, New York;
Purchase 51.30

707. **Theodore Roszak**
Thorn Blossom, 1948
Steel and nickel silver,
32¾ x 19¼ x 12½ in.
(83.2 x 48.9 x 31.8 cm)
Whitney Museum of
American Art, New York;
Purchase 48.6

708. **Seymour Lipton**
Pavilion, 1948
Wood, lead, and copper on
slate base, 23 x 28 x
14 in. (58.4 x 71.1 x
35.6 cm) overall
Whitney Museum of
American Art, New York;
Purchase, with funds from
the Painting and Sculpture
Committee 90.26a–b

By 1947, Seymour Lipton, for example, had abandoned the human figure and begun to cut, bend, and weld sheets of steel together to create weighty, somber forms whose heaving surfaces and angular contours suggested the uncertainty, irrationality, and trauma of the nuclear age (fig. 708). Like the artist's figurative, socially responsive sculpture of the 1930s, this new work retained anatomical allusions, but here they were savage and bestial. Gradually, however, Lipton's vision lightened as he came to view death and evil as part of life. "The sense of the dark inside, the evil of things, the hidden areas of struggle became for me a part of the cyclical story of living things," he wrote. "The inside and outside became one in the struggle of growth, death and rebirth in the cyclic renewal process."[194]

The sculptor Herbert Ferber, a practicing dentist like Lipton, shared with his contemporaries an interest in portraying the violence and strife inherent in biological organisms. The gnarled surfaces, ragged shapes, and aggressive thrusts of his sculpture, while abstract and often open, alluded to a world of grotesquely mutated plants and animals. Yet Ferber tempered these evocations of violence and strife by balancing works

BEBOP AND RHYTHM AND BLUES

In the 1940s, the musical world was rocked by the twin revolutions of bebop and rhythm and blues. The former became the foundation for modern jazz. The latter represented a groundswell for hard-driving, bluesy entertainment that led directly into rock and roll in the 1950s. Each emerged from the ferment of World War II, and each in its own way expressed the independent attitude of a generation of black Americans in the years immediately prior to the civil rights movement (fig. 709).

Bebop was a musical movement born of the frustrations of some of the most talented younger African American musicians of the early 1940s, most notably the trumpeter Dizzy Gillespie and alto saxophonist Charlie Parker. Fascinated with the musical possibilities of jazz but stymied by the limitations that racism imposed on their professional ambitions, they turned to the experimental atmosphere of the after-hours jam session. In Harlem clubs such as Minton's Playhouse and Monroe's Uptown House, they forged a new musical idiom aimed at a small but dedicated cadre of jazz aficionados. Bebop was a virtuoso's music, nearly as challenging to listen to as to play. Its rhythmic intricacies, densely chromatic harmonies, and uncompromising focus on improvisation set it defiantly apart from the usual contexts of dance and popular song. As commercial music, bebop was short-lived, fading from public favor by the end of the 1940s. But as the basic language for modern improvisation, it remains directly relevant to today's jazz virtuosos.

Rhythm and blues, by contrast, was a grassroots movement. It is best understood as an updating of the decades-old marketing category of "race records" to reflect new socioeconomic realities. The war years saw the second massive wave of the Great Migration, when hundreds of thousands of African Americans were lured into the industrial economy for the first time by the prospect of defense work. This working-class audience looked for a form of blues entertainment that spoke to its new prosperity and sense of urban sophistication. The success of some early rhythm and blues artists, like the influential alto saxophonist and singer Louis Jordan, depended in part on a crossover appeal to white audiences. But the base for many others, such as Wynonie Harris, T-Bone Walker, and Eddie "Cleanhead" Vinson, was firmly within the African American community. These musicians reached their audiences through the "chitlin' circuit" of theaters and nightclubs in black neighborhoods, and through radio stations catering to the vast new black consumer markets across the South and Midwest. Like bebop, rhythm and blues was recorded not by industry giants such as Victor, Columbia, or Decca but by independent companies specializing in "race music"—Savoy (Newark), Chess (Chicago), King (Cincinnati), and Specialty (Los Angeles).

By the time the term "rhythm and blues" was coined, in 1949, the new idiom had firmly eclipsed jazz as the sound of urban black America. Yet the boundary between rhythm and blues and modern jazz would remain fluid for some time to come. Together, these forms represented the range of black music in the 1940s, from the intellectual challenges of bebop to the hard-rocking fervor of Saturday night. —S. D.

709. **Gjon Mili**
Café Society, New York,
1943–47 (printed 1958)
Gelatin silver print, 19¾ x
15⁵⁄₁₆ in. (50.1 x 38.8 cm)
The Museum of Modern
Art, New York; Purchase

such as *The Flame* on a single point, thereby interjecting the illusion of weightlessness and, by extension, liberation (fig. 706). The spiky, barbed quality of Ferber's work was even more pronounced in Theodore Roszak's post-1945 sculpture. Convinced that the postwar world was "fundamentally and seriously disquieted,"

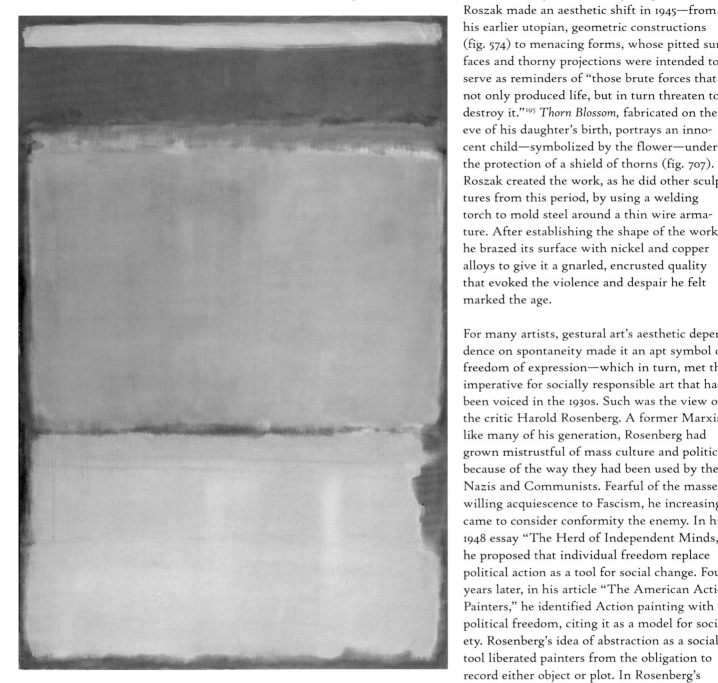

710. **Mark Rothko**
Number 10, 1950
Oil on canvas, 90⅜ x
57½ in. (229.6 x
146.1 cm)
The Museum of Modern
Art, New York; Gift of
Philip Johnson

Roszak made an aesthetic shift in 1945—from his earlier utopian, geometric constructions (fig. 574) to menacing forms, whose pitted surfaces and thorny projections were intended to serve as reminders of "those brute forces that not only produced life, but in turn threaten to destroy it."[195] *Thorn Blossom,* fabricated on the eve of his daughter's birth, portrays an innocent child—symbolized by the flower—under the protection of a shield of thorns (fig. 707). Roszak created the work, as he did other sculptures from this period, by using a welding torch to mold steel around a thin wire armature. After establishing the shape of the work, he brazed its surface with nickel and copper alloys to give it a gnarled, encrusted quality that evoked the violence and despair he felt marked the age.

For many artists, gestural art's aesthetic dependence on spontaneity made it an apt symbol of freedom of expression—which in turn, met the imperative for socially responsible art that had been voiced in the 1930s. Such was the view of the critic Harold Rosenberg. A former Marxist like many of his generation, Rosenberg had grown mistrustful of mass culture and politics because of the way they had been used by the Nazis and Communists. Fearful of the masses' willing acquiescence to Fascism, he increasingly came to consider conformity the enemy. In his 1948 essay "The Herd of Independent Minds," he proposed that individual freedom replace political action as a tool for social change. Four years later, in his article "The American Action Painters," he identified Action painting with political freedom, citing it as a model for society. Rosenberg's idea of abstraction as a social tool liberated painters from the obligation to record either object or plot. In Rosenberg's formulation, what counted was the "act" of painting and the authenticity and immediacy of the painter's own experiences. The painting itself was the site of self-revelation, inseparable from the artist's life.

Spontaneous self-expression was not limited to the visual arts. It showed up immediately following the war in the improvisational, psyche-mining style of "method acting" promoted by the Actors Studio, and in bebop, a polyrhythmic form of jazz that featured complex, improvisational solos, performed by such musicians as Dizzy Gillespie, Thelonious Monk, and Charlie Parker.

CHROMATIC ABSTRACTION

Between 1947 and 1950, while Gesture painters were developing their language of subjective immediacy, another group of painters—the former Myth Makers—pursued a vocabulary allied with immaterial, transcendent experience. Known as Chromatic Abstractionists (or sometimes as Color Field painters) because of their use of expansive fields of resonant color, artists such as Mark Rothko, Barnett Newman, William Baziotes, and Clyfford Still suppressed all references to specific subject matter in order to represent awe and exultation. Their goal was not to depict personal experience but to render pure, abstract states of consciousness detached from the world of concrete materiality—states that would answer, in Newman's words, "man's natural desire for the exalted, for a concern with our relationship to the absolute emotions."[196] In doing so, they ignored neither the terror of modern life nor the "moral crisis of a world in shambles."[197] Instead, they sought to defy humanity's tragic condition through images of renewal and transcendence. Their impulse was spiritual; their goal was to stimulate the state of rapt consciousness in which the mind is devoid of ego and the distractions of the everyday world.

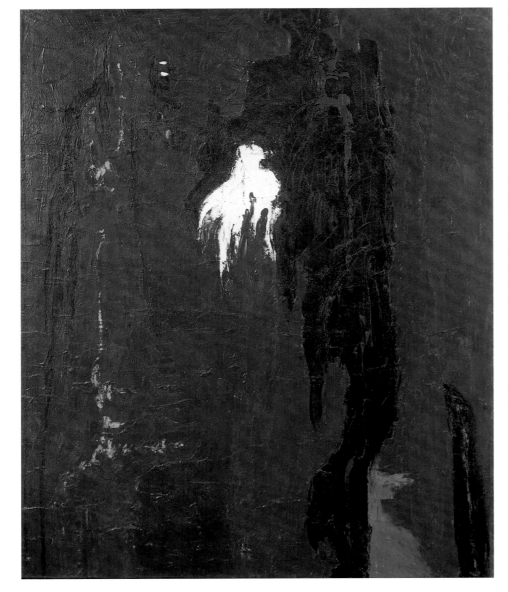

711. **Clyfford Still**
Untitled, 1945
Oil on canvas, 42⅜ x 33⅝ in. (107.6 x 85.4 cm)
Whitney Museum of American Art, New York; Gift of Mr. and Mrs. B. H. Friedman 69.3

To represent this exultant state required a formless, dimensionless art so expansive that it engaged the viewer's entire field of vision. To achieve it, the Chromatic Abstractionists divested their compositions of all traces of representational imagery and personal gesture. They purged all shapes, even abstract ones, since these implied "things." In order to maximize the impact and immediacy of their work, they sheared color of all distracting detail and applied it in chromatic expanses that saturated the eye. Because they wanted their paintings to envelop viewers and screen out everyday surroundings, they preferred their pictures to be exhibited in small rooms and viewed from close range.

By 1947, Mark Rothko had replaced his automatist calligraphy and biomorphic forms with thin washes of resplendent color deployed in indistinctly defined rectangles. Three years later, these coalesced into larger rectangles of approximately similar width, stacked symmetrically (fig. 710). Devoid of all reference to any particular visual experience, Rothko's blocks of dematerialized, glowing color drew on light as a symbol of divine, spiritual presence; their blurred outlines and amorphous forms established a profound silence, redolent both of tragedy and ecstasy.

No less preoccupied with "intimations of mortality" than with cosmic unity, Rothko fused ambient color and unbroken atmospheres in order to represent an undifferentiated world, one that existed before rational thought.[198] By means of expansive fields of luminous, subtly modulated color, he evoked a state of detached contemplation removed from ego, time, and objects. Freed of familiar, finite associations and filled with luminous, expressive silence, his paintings became "doorways to the spirit."[199]

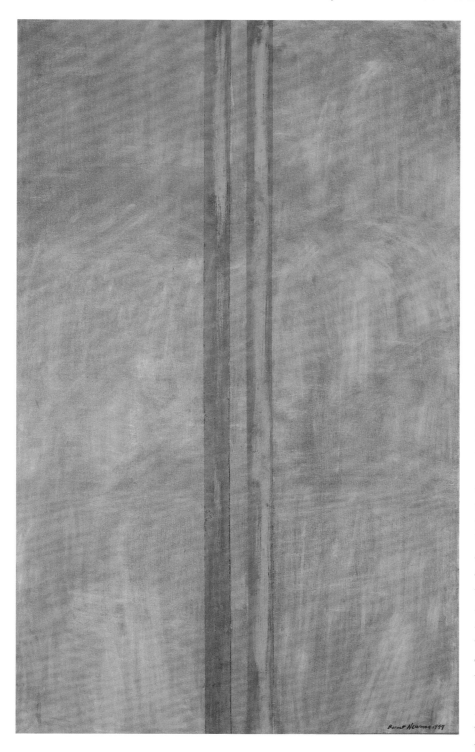

Rothko's close-valued, atmospheric color harmonies owed a debt to Milton Avery, but his rejection of automatist drawing was beholden to Clyfford Still, with whom he taught at the California School of the Arts in San Francisco in the summer of 1947. Using thick, impastoed paint, troweled on with a palette knife, Still created jagged areas of tactile color that were inseparable from their backgrounds. His stark contrasts of light and dark shapes, interlocked across the picture surface, described a world of dualities (fig. 711). Still's color areas, which appeared to extend in all directions, implied a boundlessness that some observers associated with the isolation and silence of the Great Plains, where he spent his childhood. Indeed, the craggy shapes and torn, meandering contours of his upwardly thrusting forms did connote a prehistoric time when humanity and nature waged a primordial contest.

Yet however much Still's paintings evoked the freedom and expansiveness of unfettered landscape, they were not landscape paintings. Like Pollock, who was born in Wyoming, Still revered the West's limitless, open space. He derived from his childhood experience there a moralistic regard for individualism and a contempt for the conformity and corruption he came to associate with the art world. Neither artist, though, ever sought to represent the American West, only to encapsulate those sensations of freedom and unrestricted vision it afforded.

Barnett Newman, born and raised in New York City, drew his inspiration from the mystical elements of Jewish literature in the Cabala and Talmud. Until his first one-artist exhibition at the Betty Parsons Gallery in 1950, Newman was viewed more as a theoretician than a painter. In the paintings he showed at Parsons, he announced the vocabulary and themes that would occupy him for the rest of his career. Using a single, unmodulated field of color, interrupted by one or more narrow vertical bands of contrasting color—"zips," as he called them—he sought to establish the

712. **Barnett Newman**
Concord, 1949
Oil on canvas, 89¾ x 53⅝ in. (228 x 136.2 cm)
The Metropolitan Museum of Art, New York; George A. Hearn Fund, 1968

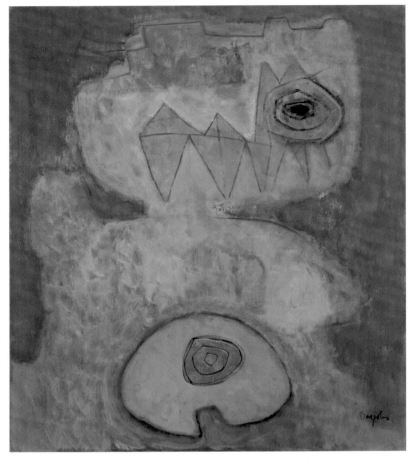

713. **William Baziotes**
Dwarf, 1947
Oil on canvas, 42 x
36⅛ in. (106.7 x 91.8 cm)
The Museum of Modern Art,
New York; A. Conger
Goodyear Fund

714. **William Baziotes**
Green Form, 1945–46
Oil on canvas, 40 x 48 in.
(101.6 x 121.9 cm)
Whitney Museum of
American Art; Gift of Mr.
and Mrs. Samuel M. Kootz
and exchange 49.23

infinity of the universe and the individual's relationship to it. His zips, either centered or placed in a mathematical relation to the center, compositionally energized the color field and prevented it from becoming amorphous and inert (fig. 712). As Newman explained it, "My drawing declares . . . the whole space."[200] Philosophically, the paintings attested to the solitude of the individual before the unknown and the perfection and exultation that come from oneness with it.

A similar fusion of terror and grace permeated the canvases of William Baziotes. An early disciple of automatism and one of the handful of American artists included in the "First Papers of Surrealism" exhibition, Baziotes spent the first half of the forties creating biomorphic images of violence, turmoil, and deformity. Even after he reduced his imagery to monumental, iconic forms that filled the entire canvas, these misshapen menacing abstract creatures infused his paintings with the "quiet horror" he claimed to want in his art (fig. 713).[201] Increasingly, however, these mutated

ARCHITECTURAL PROTOTYPES FOR A NEW FRONTIER

With the end of World War II, America was on the move. Characterized by the proliferation of automobiles, highways, telecommunications, and new electronic appliances, the emerging period of prosperity brought major changes to daily living. The single-family house on its own lot became a possibility for almost all, the fulfillment of an "American dream." The best of these houses were essentially reduced versions of the modernist villa of the thirties, now built to formula for the less well-to-do.

Thanks to the Veterans Administration, the Fair Housing Authority, and the GI Bill of Rights, single-family tract houses pushed the boundaries of the city far into the countryside. Key prototypes for the new suburban dwelling can be seen in the projects of three Bauhaus architects who came to the United States as exiles from Hitler's Europe: the Germans Ludwig Mies van der Rohe and Walter Gropius and the Hungarian-born Marcel Breuer. In 1938, Mies expressed his vision of a new America in a glass-and-steel project he designed for the Resor family on a site in Wyoming, which was first intended as a country retreat (fig. 716). The simplicity of the open pavilion generated the ideas behind Mies' later experiments in economical housing and the invention of new suburban house forms by a generation of young architects. In a collaboration that lasted from 1937 to 1941, Gropius and Breuer adapted the forms associated with the Bauhaus to the vernacular wood tradition of New England, creating widely imitated prototypes for the new suburb (fig. 715). Gropius, with his wartime housing units, also made a major contribution to the mechanization and standardization that rendered cheap "homes for better living" a postwar reality.

Perhaps the most inventive proposals were the Case Study Houses, sponsored by the Los Angeles-based magazine *Arts and Architecture* and meant to address the region's phenomenal housing boom. The work of architects such as Charles Eames, Raphael Soriano, Craig Ellwood, and Richard Neutra, these influential prototypes for suburban housing were designed with open plans in flexible systems to accommodate the growing middle-class family of the baby boom. Helping to disseminate the principles of a modern, technologically advanced, and affordable architecture, the Case Study Houses favored the integration of "based on merit" appliances. With their interlocking inside/outside spaces, built-in shelves, and integration of movie projectors, television centers, and electric sewing machines, Neutra's Case Study Houses are evidence of the mobile, efficiency-minded, and consumer-oriented mass culture that entered architectural debate after World War II.

But it is projects like Levittown (17,500 single-family tract houses built on Long Island between 1947 and 1951) that best show the reality of the postwar suburban

715. **Walter Gropius** and **Marcel Breuer**
South and east elevations for *Abele Residence, Framingham, Massachusetts,* 1940–41 (detail)
Graphite on paper, 15⅜ x 31¹⁄₁₆ in. (39.0 x 79.5 cm)
Busch-Reisinger Museum, Harvard University Art Museums, Cambridge, Massachusetts; Gift of Walter Gropius

716. **Ludwig Mies van der Rohe**
Model for *Resor House, Jackson Hole, Wyoming,* 1937–38
Mixed media, 5¾ x 48⅜ x 28 in. (14.6 x 122.8 x 71.4 cm)
The Museum of Modern Art, New York; Gift of Mrs. Stanley Resor

beings gave way to more harmonious representations of marine organisms enveloped in dreamy, ethereal hazes of radiant color. By 1950, he had enlisted layered, close-valued color to create images of peaceful coexistence—of the serenity that comes with mystic equilibrium.

These Chromatic Abstractionists shared with their gestural colleagues a desire to address the dualism of fear and ecstasy they believed constituted the human condition. For most Americans, however, no such reconciliation of opposites was necessary. Exhausted after nearly two decades of hardship, uncertainty, and privation, they welcomed the bland normalcy and unabashed materialism of postwar America. What mattered to the majority of middle-class Americans

boom (fig. 717). The developers' answer to the housing shortage created a modern, affordable, neighborly residential environment. But the communities often reinforced class, racial, and ethnic segregation under the guise of neighborhood planning. They also announced the end of a rich period of experimentation and the beginning of an often banal, monotonous, and increasingly traditional suburban architecture upheld by the ferocious capitalism of property developers.

Having derived its approach from the ideology of modernity, the suburb was now expanding at an unprecedented pace, with little or no regard for inventive new ways of living. Indeed, some have seen in this movement not the dream of a new frontier but a forced invitation to support the profit motives of the consumer society. —N. O.

717. *Levittown, New York,* 1954

was a new lifestyle—defined by television, long-playing records, which had been introduced in 1948, and new fashions, which for women involved voluptuously curved designs whose copious folds replaced the slim styles of the fabric-rationed war years. Nowhere was the change more evident than in Levittown, New York, which opened in 1949. A prefabricated development of nearly identical plain houses on Long Island, it epitomized the postwar years' acceptance of anonymity and conformity in the name of comfort and security (fig. 717).

The masses' lack of interest in metaphysics and ambiguity was matched by an art that emphasized objective, non-ambiguous formal values. The reductive, steel-and-glass architecture known as International Style had been introduced to the American domestic landscape following the arrival of the émigré architects Marcel Breuer, Walter Gropius, and Ludwig Mies van der Rohe in the late 1930s; it became nearly ubiquitous in the public sphere after the war (figs. 715, 716). Spare and unornamented, it used geometric forms to suggest an ideal Platonic world removed from the vicissitudes of everyday life. Geometric painting and sculpture, somewhat eclipsed during the war, acquired a renewed respectability in the hands of Burgoyne Diller, Fritz Glarner, Josef Albers, Richard Lippold, and Ad Reinhardt (figs. 718–21). American classical music, encouraged by the example of the émigré

composers Arnold Schoenberg, Igor Stravinsky, and Paul Hindemith, saw the emergence of a new generation of atonal, formalist composers. In dance, the success of George Balanchine's abstract, non-narrative choreography led to the founding in 1948 of the New York City Ballet under his direction. And in literary criticism, the immediate postwar years saw university and college faculties embrace the New Criticism, which rejected the traditional focus on content in favor of an objective, formal analysis of language and structure.

MODERNISM IN MUSIC

A shift in aesthetic attitudes toward contemporary music marked the postwar years in victorious America. As the nationalist fervor fomented in part by wartime receded, populism began to look dated, turning into a reminder of the Depression and the war—just what everybody wanted to forget as fast as possible. In its place, a second wave of modernism appeared as the mainstream path for an ambitious younger generation of composers.

Part of the impetus behind these new trends came from the powerful symbolic leadership of émigré Europeans, fleeing the theater of the European war. Arnold Schoenberg was the first to arrive, in 1933, followed by Paul Hindemith in 1937 and Igor Stravinsky in 1940. Their music, deeply grounded in abstract compositional methods, helped derail "Americanist" folk-oriented composition. Thus an ideology of Eurocentric individualism empowered the resurgence of inevitably elitist modernist styles.

Many influential American composers, often employed at prestigious private universities, followed this path as well, although not necessarily adhering to one musical language. Both Walter Piston at Harvard and Roger Sessions at Princeton advocated a pan-national universalism, an idea that if taken at face value could hardly be objected to. However, Sessions' aesthetic position was based on a belief that America had to find itself by seeking to discern the fundamental universality of all peoples. This notion not only reinforced his own preference for European modernism but enabled Sessions to reject the legacy of Aaron Copland and his circle. Later, his colleague Milton Babbitt, equally disdainful of "Americanist" precedents, promoted Schoenberg-derived dissonant composition and "twelve-tone" approaches to composition that yielded highly complex, difficult music.

Inevitably, second-wave modernism, however Eurocentric, turned to the American avant-garde of the 1940s, with revivals of interest in the music of Charles Ives, Henry Cowell, and Ruth Crawford that would prove crucial to the sensibility of a young John Cage, whose influence peaked in later decades. —J. T.

In the decades to come, American art would increasingly command international acclaim. A new generation of artists would build on and reformulate the themes that engaged the nation in the first half of the twentieth century. During this fifty-year period, American artists had mirrored the nation's changing sense of itself and its people and, in the process, helped construct myths of national identity. By identifying the symbols and images through which people revealed what they thought and felt about their world and their experiences, art served as a barometer of cultural values—a visual embodiment of the assumptions and ideologies of its age. It thus provided a frame of reference for understanding the nation and its changing sense of self. Ultimately, the quest for national and personal identity is a search for meaning and value; in this search, art has been an indispensable tool.

718. **Burgoyne Diller**
Third Theme, 1946–48
Oil on canvas, 42 x 42 in.
(106.7 x 106.7 cm)
Whitney Museum of American Art, New York; Gift of May Walter 58.58
©Estate of Burgoyne Diller/V.A.G.A., N.Y.

719. **Fritz Glarner**
Relational Painting,
1949–51
Oil on canvas, 65 x 52 in.
(165.1 x 132.1 cm)
Whitney Museum of
American Art, New York;
Purchase 52.3

720. **Josef Albers**
Homage to the Square,
1950
Oil on panel, 16 x 16 in.
(40.6 x 40.6 cm)
The Josef and Anni Albers
Foundation, Inc., Orange,
Connecticut

721. **Richard Lippold**
Primordial Figures,
1947–48
Brass and copper wire,
96 x 24 x 18 in.
(243.8 x 61 x 45.7 cm)
Whitney Museum of
American Art, New York;
Purchase, with funds from
the Friends of the Whitney
Museum of American Art
and Charles Simon 62.27

Notes

1. The Society of American Artists was founded in 1877 by William Merritt Chase, Kenyon Cox, Augustus Saint-Gaudens, and several young artists who, on returning to New York from study in Europe, were frustrated by the nativist bias of older National Academy of Design members. Considered a more liberal and progressive association, this new exhibiting society sponsored annual exhibitions of paintings and sculpture that rivaled the National Academy's spring presentations. However, with age, the society's membership grew more moderate, and by 1897 many of the original members had been elected to the National Academy. After 1900, the two institutions began sharing exhibition space, and their exhibitions, which featured many of the same artists, were all but indistinguishable. After a series of conferences in 1905 and early 1906, a formal amalgamation of the two institutions was announced on April 7, 1906. That ended the separate existence of the Society of American Artists. See Elizabeth Milroy, *Painters of a New Century: The Eight and American Art*, exh. cat. (Milwaukee: Milwaukee Art Museum, 1991), pp. 21–22.

2. In his review of the Photo-Secession's 1904 exhibition at the Carnegie Institute, Hartmann condemned the Pictorialists' use of gum printing, the glycerine process, and handwork on negatives and prints, asserting that fine-art photography could "only be accomplished by straight photography." Sadakichi Hartmann, quoted in Beaumont Newhall, *The History of Photography from 1839 to the Present*, 5th ed. (New York: The Museum of Modern Art, 1993), p. 167.

3. White bought an old farmhouse on Georgetown Island, Maine, in 1910 and opened a summer school, which he named the Seguinland School of Photography. In 1916, he moved this school to East Canaan, Connecticut, and, in 1917, to nearby Canaan, where it remained until his death in 1925. He opened a second school, the Clarence H. White School of Photography, in Manhattan in 1914. See Bonnie Yochelson, "Clarence H. White, Peaceful Warrior," in Marianne Fulton, ed., *Pictorialism into Modernism: The Clarence H. White School of Photography* (New York: Rizzoli, 1996), p. 38.

4. White's group, beginning in 1913, published its own journal, *Platinum Print: A Journal of Personal Expression*. It was renamed *Photo-Graphic Art* in 1916 and was replaced in 1917 with the publication of the Pictorial Photographers of America's first annual report. Starting in 1920, the annual reports included short essays and lavishly reproduced prints.

5. Alvin Langdon Coburn, quoted in William Sharpe, "New York, Night, and Cultural Mythmaking: The Nocturne in Photography, 1900–1925," *Smithsonian Studies in American Art*, 2 (Fall 1988), p. 9.

6. Sidney Allan [Sadakichi Hartmann], "The 'Flat-Iron' Building—An Esthetical Dissertation," *Camera Work*, no. 4 (October 1903), p. 40.

7. Alfred Stieglitz, quoted in Dorothy Norman, *Alfred Stieglitz: An American Seer* (New York: Random House, 1973), p. 45.

8. What attracted Stieglitz to the steerage image were its formal qualities. He later described them: "A round straw hat, the funnel leaning left, the stairway leaning right, the white drawbridge with its railings made of circular chains—white suspenders crossing on the back of a man in the steerage below, round shapes of iron machinery, a mast cutting into the sky, making a triangular shape. . . . I saw shapes related to each other. I saw a picture of shapes and underlying that the feeling I had about life." Alfred Stieglitz, "How *The Steerage* Happened" (1942), reprinted in Nathan Lyons, ed., *Photographers on Photography* (Englewood Cliffs, New Jersey: Prentice-Hall, 1966), p. 131.

9. During production, the film's title had alternated between *Manhatta* and *Mannahatta*, a reference to Walt Whitman's poem "Mannahatta." The film premiered at New York's Rialto Theater on July 24, 1921, as *New York the Magnificent;* two years later, Marcel Duchamp screened it at a Dada festival in Paris as *Fumée de New York (Smoke of New York)*. Eventually, the film came to be known only as *Manhatta*. The length of the 35mm film is often mistakenly given as six and a half minutes, its running time in modern 16mm transfers. See Matthew Yokobosky, in Francis M. Naumann with Beth Venn, *Making Mischief: Dada Invades New York*, exh. cat. (New York: Whitney Museum of American Art, 1996), p. 27.

10. Joseph Pennell, quoted in Edward Bryant, *Pennell's New York Etchings* (Hamilton, New York: Picker Art Gallery of Colgate University in association with Dover Publications, 1980), p. xiv.

11. Joseph Pennell, quoted in Marianne Doezema, *American Realism and the Industrial Age*, exh. cat. (Cleveland: The Cleveland Museum of Art, 1980), p. 45.

12. Thomas Eakins, quoted in Lloyd Goodrich, *Thomas Eakins: His Life and Work* (New York: Whitney Museum of American Art, 1933), p. 139.

13. Robert Henri, quoted in Robert Hughes, *American Visions: The Epic History of Art in America* (New York: Alfred A. Knopf, 1997), p. 325.

14. Robert Henri, *The Art Spirit* (Philadelphia: J. B. Lippincott, 1923), p. 108. The second part of the quotation is found in Sam Hunter, *American Art of the 20th Century* (New York: Harry N. Abrams, n.d.), p. 30.

15. Henri, *The Art Spirit*, p. 17.

16. John Sloan, quoted in Hunter, *American Art of the 20th Century*, p. 352.

17. Irving Berlin, quoted in Hollis Alpert, *Broadway! 125 Years of Musical Theatre*, exh. cat. (New York: Museum of the City of New York, 1991), pp. 59–60.

18. George Luks, quoted in Bernard Danenberg, *George Luks: 1867–1933, Retrospective Exhibition*, exh. cat. (New York: ACA Galleries, 1967), n.p.

19. John Sloan, quoted in *John Sloan: Paintings, Prints, Drawings*, exh. cat. (Hanover, New Hampshire: Hood Museum of Art, Dartmouth College, 1981), p. 11.

20. Riis' photographs raise a question about the objectivity of documentary photography. As Maren

Stange, Rebecca Zurier, and Robert W. Snyder have pointed out, by carefully arranging his photographs, Riis depicted his subjects in the worst possible circumstances, thereby sensationalizing—even disparaging at times—the people whose lives he sought to improve. See Mecklenburg, Virginia M., Rebecca Zurier, and Robert W. Snyder, *Metropolitan Lives: The Ashcan Artists and Their New York.* (New York: W. W. Norton, 1995), and Maren Stange, *Symbols of Ideal Life: Social Documentary Photography in America, 1890–1950* (New York: Cambridge University Press, 1989).

21. The National Child Labor Committee was run by Felix Adler, who had founded the Ethical Culture School. Hine began photographing for the committee on a freelance basis in 1906.

22. Abastenia St. Leger Eberle, quoted in Charlotte Streifer Rubinstein, *American Women Sculptors: A History of Women Working in Three Dimensions* (Boston: G. K. Hall, 1990), p. 211.

23. *The Masses* started in January 1911 under the directorship of Piet Vlag but ceased publication in August 1912. It resumed in December 1912 under Max Eastman.

24. John Sloan, quoted in Milroy, *Painters of a New Century,* p. 46.

25. Art Young, quoted in Rebecca Zurier, *Art for The Masses: A Radical Magazine and Its Graphics, 1911–1917* (Philadelphia: Temple University Press, 1988), p. 140.

26. Bruce St. John, ed., *John Sloan's New York Scene: From the Diaries, Notes and Correspondence, 1906–1913* (New York: Harper & Row, 1965), p. 402.

27. Alfred Stieglitz, quoted in William Innes Homer, *Alfred Stieglitz and the American Avant-Garde* (Boston: New York Graphic Society, 1977), p. 16.

28. Arthur Dove, quoted in Waldo Frank et al., eds., *America and Alfred Stieglitz* (New York: Doubleday, 1934), p. 245.

29. After seeing an exhibition of Cézanne's work at the Bernheim-Jeune Gallery, Steichen proposed that he and Stieglitz play a joke on the critics in New York. "I can make a hundred watercolors like those at Bernheim's in a day," he said. "They were not signed. I need not sign mine. You can announce, 'Exhibition of Watercolors by Cézanne.'" Steichen did, in fact, create an unsigned landscape in the style of Cézanne, which was included in the exhibition Stieglitz mounted in March 1911. Several buyers were interested in Steichen's watercolor, but they were quickly informed that the work was on loan and not for sale. Edward Steichen, quoted in Norman, *Alfred Stieglitz,* p. 80.

30. Alfred Stieglitz, quoted in Frank et al., eds., *America and Alfred Stieglitz,* p. 129.

31. Elie Nadelman, quoted in John I. H. Baur, *The Sculpture and Drawings of Elie Nadelman,* exh. cat. (New York: Whitney Museum of American Art, 1975), p. 7.

32. Georgia O'Keeffe, *Georgia O'Keeffe* (New York: Viking Press, 1976), n.p.

33. See Barbara Haskell, *Joseph Stella,* exh. cat. (New York: Whitney Museum of American Art, 1994), p. 56.

34. Walter Lippmann, quoted in Keith Davis, *An American Century of Photography: From Dry-plate to Digital* (Kansas City, Missouri: Hallmark Cards, 1995), p. 82.

35. Arthur Dove, "An Idea" (1927), reprinted in Barbara Haskell, *Arthur Dove,* exh. cat. (San Francisco: San Francisco Museum of Modern Art, 1974), p. 135.

36. Oscar Bluemner, quoted in Judith Zilczer, *Oscar Bluemner* (Washington, D.C.: Smithsonian Institution Press, 1979), pp. 11–12.

37. John Marin, quoted in Barbara Rose, *American Art Since 1900* (1967; rev. ed. New York and Washington, D.C.: Praeger Publishers, 1975), p. 38.

38. Marcel Duchamp, "The Richard Mutt Case," *The Blind Man,* no. 2 (May 1917), p. 5.

39. Arthur Gleizes, quoted in "French Artists Spur on an American Art," *New York Tribune,* October 24, 1915, reprinted in Rudolf E. Kuenzli, ed., *New York Dada* (New York: Willis Locker & Owens, 1986), p. 130.

40. Quoted in Margaret Reeves Burke, "Futurism in America, 1910–1917," Ph.D. diss. (Newark: University of Delaware, 1986), pp. 52, 53.

41. Joseph Stella, "The Brooklyn Bridge (A Page of My Life)," *Transition,* nos. 16–17 (June 1929) pp. 86–88 (originally printed privately by Stella in 1928 under the title *New York*), quoted in Haskell, *Joseph Stella,* pp. 206–7.

42. Francis Picabia, quoted in "French Artists Spur On an American Art," *New York Tribune,* October 24, 1915, reprinted in Gail Stavitsky, "Reordering Reality: Precisionist Directions in American Art, 1915–1941," in *Precisionism in America, 1915–1941: Reordering Reality* (Montclair, New Jersey: The Montclair Art Museum, 1994), p. 12.

43. Paul B. Haviland, untitled editorial statement in *291,* nos. 7–8 (September–October 1915), reprinted in Francis M. Naumann, *New York Dada, 1915–23* (New York: Harry N. Abrams, 1994), pp. 61–62.

44. Tristan Tzara, quoted in William S. Rubin, *Dada, Surrealism, and Their Heritage,* exh. cat. (New York: The Museum of Modern Art, 1968), p. 12.

45. Joseph Stella, quoted in Margery Rex, "'Dada Will Get You If You Don't Watch Out: It Is on the Way Here," *New York Evening Journal,* January 29, 1921, reprinted in Kuenzli, ed., *New York Dada,* p. 140.

46. Marsden Hartley, "The Importance of Being 'DADA,'" afterword to *Adventures in the Arts: Informal Chapters on Painters, Vaudeville and Poets* (New York: Boni and Liveright, 1921), pp. 247–54, quoted in Francis M. Naumann, "New York Dada: Style with a Smile," in *Making Mischief,* p. 11.

47. Alfred Stieglitz, quoted in E. G. Fitz, "A Few Thoughts on the Wanamaker Exhibition," *The Camera,* 22 (April 1918), p. 202, reprinted in Charles W. Millard III, "Charles Sheeler: American Photographer," *Contemporary Photographer,* 6 (1967), n.p.

48. Paul Strand, quoted in John Pultz and Catherine B. Scallen, *Cubism and American Photography, 1910–1930,* exh. cat. (Williamstown, Massachusetts: Sterling and Francine Clark Art Institute, 1981), p. 22.

49. Paul Strand, quoted ibid., p. 45.

50. Alfred Stieglitz, quoted in Anne Tucker, *Target II: 5 American Photographers,* exh. cat. (Houston: The Museum of Fine Arts, 1981), p. 45.

51. Paul Strand, "Photography and the New God," *Broom,* 3 (1922), pp. 252–58, reprinted in Peter C. Bunnell, ed., *A Photographic Vision: Pictorial Photography, 1889–1923* (Salt Lake City: Peregrine Smith, 1980), p. 202.

52. Paul Strand, quoted in Maria Morris Hambourg and Christopher Phillips, *The New Vision: Photography Between the World Wars,* exh. cat. (New York: The Metropolitan Museum of Art, 1989), p. 24.

53. F. Scott Fitzgerald, *This Side of Paradise* (New York: Charles Scribner's Sons, 1920), p. 282.

54. See Milton Brown, "Cubist-Realism: An American Style," *Marsyas,* 3 (1946), pp. 139–60, quoted in Karen Tsujimoto, *Images of America: Precisionist Painting and Modern Photography,* exh. cat. (San Francisco: San Francisco Museum of Modern Art, 1982), p. 22.

55. Charles Sheeler, quoted in Lillian Dochterman, *The Quest of Charles Sheeler* (Iowa City: State University of Iowa Press, 1963), p. 11.

56. Louis Lozowick, "The Americanization of Art," from *The Machine Age Catalogue,* in *The Little Review,* 12 (May 1927), supplement, p. 18, reprinted in Virginia Hagelstein Marquardt, ed., *Survivor from a Dead Age: The Memoirs of Louis Lozowick* (Washington, D.C.: Smithsonian Institution Press, 1997), pp. 281–82.

57. Ibid., pp. 18–19.

58. George Ault, quoted in Tsujimoto, *Images of America,* p. 71.

59. Calvin Coolidge, quoted in Karen Lucic, *Charles Sheeler and the Cult of the Machine* (Cambridge, Massachusetts: Harvard University Press, 1991), p. 188.

60. Bruce Barton, quoted in William E. Leuchtenburg, *The Perils of Prosperity, 1914–32* (Chicago: University of Chicago Press, 1958), p. 189.

61. Charles Sheeler, quoted in Tsujimoto, *Images of America,* p. 85.

62. Charles Sheeler, quoted ibid., p. 82.

63. Charles Sheeler, quoted ibid., p. 85.

64. Elsie Driggs, quoted ibid., p. 69.

65. Jane Heap, "Machine Age Exposition," *The Little Review,* 11 (Spring 1925), p. 36.

66. Paul Strand, "Photography and the New God," *Broom,* 3 (1922), pp. 252–58, reprinted in Bunnell, ed., *A Photographic Vision,* p. 205.

67. Ralston Crawford, quoted in an undated (late 1940s), unpublished essay by Malcolm Preston, p. 39; courtesy of Malcolm Preston, Truro, Massachusetts.

68. William Carlos Williams, *Contact,* no. 1 (December 1920), title page, quoted in Patrick

Leonard Stewart, Jr., "Charles Sheeler, William Carlos Williams and the Development of the Precisionist Aesthetic, 1917–1931," Ph.D. diss. (Newark: University of Delaware, 1981), p. 17.

69. Marcel Duchamp and Albert Gleizes, quoted in Barbara Haskell, *Charles Demuth*, exh. cat. (New York: Whitney Museum of American Art, 1987), p. 90.

70. Henry McBride, "Art News and Reviews," *New York Herald*, October 15, 1922, sec. 7, p. 6, reprinted in Daniel Catton Rich, ed., *The Flow of Art: Essays and Criticisms of Henry McBride* (New York: Atheneum, 1975), p. 165; Malcolm Cowley, *Exiles Return: A Literary Odyssey of the 1920's* (New York: Penguin Books, 1976), p. 107.

71. Matthew Josephson, "After Dada," *Broom*, 2 (July 1922), pp. 346–51.

72. Fernand Léger, "A New Realism—The Object," *The Little Review*, 11 (Winter 1926), pp. 7–8.

73. Gerald Murphy, quoted in Wanda M. Corn, "Identity, Modernism, and the American Artist after World War I: Gerald Murphy and *Américanisme*," *Studies in the History of Art*, 29 (1991), p. 152.

74. Stuart Davis, quoted in James Johnson Sweeney, *Stuart Davis*, exh. cat. (New York: The Museum of Modern Art, 1945), p. 23.

75. Stuart Davis quoted in Patricia Hills, *Stuart Davis* (New York: Harry N. Abrams, 1996), p. 65.

76. Edward Steichen, quoted in Patricia Johnston, *Real Fantasies: Edward Steichen's Advertising Photography* (Berkeley: University of California Press, 1997), p. 85.

77. Edward Hopper, quoted in Gail Levin, *Edward Hopper: An Intimate Biography* (New York: Alfred A. Knopf, 1995), p. 216.

78. Henry Louis Gates, Jr., "Harlem on My Mind," in Richard J. Powell et al., *Rhapsodies in Black: Art of the Harlem Renaissance*, exh. cat. (London: Hayward Gallery and the Institute of International Visual Arts, 1997), p. 162.

79. Langston Hughes, quoted in Romare Bearden and Harry Henderson, *A History of African-American Artists from 1792 to the Present* (New York: Pantheon Books, 1993), p. 123.

80. Augusta Savage, quoted ibid., p. 173.

81. Langston Hughes, quoted in Steven Watson, *The Harlem Renaissance: Hub of African-American Culture, 1920–1930* (New York: Pantheon Books, 1995), p. 157.

82. Alain Locke, quoted ibid.

83. Alfred Stieglitz, quoted in Norman, *Alfred Stieglitz*, pp. 131, 135.

84. "I was born in Hoboken," Stieglitz wrote. "I am an American. Photography is my passion. The search for Truth my obsession"; Stieglitz, quoted in Doris Bry, *Alfred Stieglitz: Photographer* (Boston: Museum of Fine Arts, Boston, 1965), p. 19.

85. Alfred Stieglitz, quoted ibid.

86. Georgia O'Keeffe, quoted in Herbert J. Seligmann, *Alfred Stieglitz Talking: Notes on Some of His Conversations, 1925–1931* (New Haven: Yale University Library, 1966).

87. Georgia O'Keeffe, quoted in Tsujimoto, *Images of America*, p. 71.

88. Edward Weston, quoted in Davis, *An American Century of Photography*, p. 99.

89. Edward Weston, quoted ibid.

90. Lewis Mumford, quoted in Anna C. Chave, "O'Keeffe and the Masculine Gaze," *Art in America*, 78 (January 1990), p. 119.

91. Paul Rosenfeld, "Marsden Hartley," *Port of New York* (New York: Harcourt, Brace, 1924), pp. 85, 92.

92. Paul Rosenfeld, quoted in Debra Bricker Balken, "Continuities and Digressions in the Work of Arthur Dove from 1907 to 1933," in Balken et al., *Arthur Dove: A Retrospective*, exh. cat. (Andover, Massachusetts: Addison Gallery of American Art, 1997), p. 23.

93. Paul Strand, "American Water Colors at the Brooklyn Museum," *The Arts*, 2 (January 20, 1922), p. 152; Paul Rosenfeld, "American Painting," *The Dial*, 71 (December 1921), p. 663.

94. Marsden Hartley, "Pictures," in *Marsden Hartley/Stuart Davis*, exh. cat. (Cincinnati: Cincinnati Modern Art Society, 1941), pp. 4, 6.

95. Marsden Hartley to Georgia O'Keeffe, January 14, 1920, reprinted in Robert Northcutt Burlingame, "Marsden Hartley: A Study of His Life and Creative Achievement," Ph.D. diss. (Providence: Brown University, 1934), p. 46.

96. Marsden Hartley to Kenneth H. Miler, June 20, 1920, Hartley files, Whitney Museum of American Art, New York.

97. John Marin, quoted in *John Marin* (New York: The Museum of Modern Art, 1936), p. 20.

98. Georgia O'Keeffe, "About Painting Desert Bones," in *Georgia O'Keeffe: Paintings—1943*, exh. cat. (New York: American Place, 1944), n.p.

99. Ansel Adams, quoted in Maria Morris Hambourg, "From 291 to The Museum of Modern Art: Photography in New York, 1910–37," in Hambourg and Christopher Phillips, *The New Vision*, p. 59.

100. Franklin Delano Roosevelt, quoted in Bruce I. Bustard, *A New Deal for the Arts* (Washington, D.C.: National Archives and Records Administration; Seattle: University of Washington Press, 1997), p. 6.

101. Edward Rowan, quoted ibid.

102. Edward Bruce, quoted in Richard D. McKinzie, *The New Deal for Artists* (Princeton: Princeton University Press, 1973), p. 57.

103. Thomas Hart Benton, "American Regionalism: A Personal History of the Movement," reprinted in *An American in Art: A Professional and Technical Autobiography* (Lawrence: University Press of Kansas, 1969), p. 149.

104. Thomas Hart Benton, quoted in Erika Doss, *Benton, Pollock, and the Politics of Modernism: From Regionalism to Abstract Expressionism* (Chicago: University of Chicago Press, 1991), pp. 130–31.

105. Quoted in Wanda M. Corn, *Grant Wood: The Regionalist Vision* (New Haven: Yale University Press, 1983), p. 35.

106. Grant Wood, quoted in Karal Ann Marling, *Wall-to-Wall America: A Cultural History of Post-Office Murals in the Great Depression* (Minneapolis: University of Minnesota Press, 1982), p. 92.

107. Malcolm Vaughan, quoted in Matthew Baigell, *The American Scene: American Painting in the 1930's* (New York and Washington, D.C.: Praeger Publishers, 1974), p. 129.

108. The term was coined by Van Wyck Brooks in his essay "On Creating a Usable Past," *The Dial*, 64 (April 11, 1918), p. 337.

109. John Dos Passos, quoted in Marling, *Wall-to-Wall America*, p. 38.

110. Quoted ibid., p. 104.

111. John Steuart Curry, quoted in M. Sue Kendall, *Rethinking Regionalism: John Steuart Curry and the Kansas Mural Controversy* (Washington, D.C.: Smithsonian Institution Press, 1986), p. 88.

112. John Steuart Curry, quoted ibid., p. 68.

113. Herbert Hoover, quoted in Lawrence W. Levine, "The Historian and the Icon: Photography and the History of the American People in the 1930s and 1940s," in Carl Fleischhauer and Beverly W. Brannan, eds., *Documenting America, 1935–1943* (Berkeley: University of California Press, 1988), p. 18.

114. Ernest Hemingway, quoted in Leuchtenburg, *The Perils of Prosperity*, p. 149.

115. Harry Hopkins, quoted in Marling, *Wall-to-Wall America*, p. 42.

116. Barnett Newman, quoted in Dore Ashton, *The New York School: A Cultural Reckoning* (New York: Viking Press, 1973), p. 19.

117. Roy Stryker, quoted in Levine, "The Historian and the Icon," p. 40.

118. Arthur Rothstein, quoted ibid., p. 38.

119. Rexford Tugwell, quoted ibid.

120. Walker Evans, quoted in Helen Levitt and James Agee, *A Way of Seeing* (1965; reprt. Durham: Duke University Press, 1989), p. viii.

121. Roy Stryker, quoted in Levine, "The Historian and the Icon," p. 33.

122. Quoted ibid., p. 31.

123. Archibald MacLeish, *Land of the Free* (New York: Harcourt, Brace, 1938), pp. 1–2, quoted in Alan Trachtenberg, "From Image to Story: Reading the File," in Fleischhauer and Brannan, eds., *Documenting America*, p. 46.

124. This shift was dealt with extensively in William Stott, *Documentary Expression and Thirties America* (Chicago: University of Chicago Press, 1986).

125. Quoted ibid., p. 130.

126. Archibald MacLeish, quoted in Alfred Kazin, *On Native Grounds: An Interpretation of Modern American Prose Literature* (New York: Harcourt Brace, 1995), p. 503.

127. Helen Harriton, quoted in Richard J. Powell, *Homecoming: The Art and Life of William H. Johnson*, exh. cat. (Washington, D.C.: National Museum of American Art, Smithsonian Institution, 1991), p. 123.

128. Moses Soyer, quoted in Baigell, *The American Scene*, p. 61.

129. Although Stieglitz stopped taking photographs, he continued to print from his earlier negatives.

130. Diego Rivera, quoted in Ellen G. Landau, "'A Certain Rightness': Artists for Victory's 'America in the War' Exhibition of 1943," *Arts*, 60 (February 1986), p. 43.

131. The artists' trade union changed its name from Unemployed Artists Group to Artists' Union in 1934 in accordance with its activist role.

132. Rosalind Bengelsdorf, "The New Realism," in *American Abstract Artists 1938* (New York: privately printed, 1938), n.p.

133. Gorky's remarks were reported by Ilya Bolotowsky, quoted in Susan Larsen, "The American Abstract Artists Group: A History and Evaluation of Its Impact upon American Art," Ph.D. diss. (Chicago: Northwestern University, 1974), p. 225. Paradoxically, Gorky did not read French, and his claim to do so was another example of how he constructed a false identity for himself.

134. Alexander Calder, quoted in Richard Marshall, *Alexander Calder: Sculpture of the Nineteen Thirties*, exh. cat. (New York: Whitney Museum of American Art, 1987), p. 5.

135. Alexander Calder, quoted in Joan M. Marter, *Alexander Calder* (New York: Cambridge University Press, 1991), p. 110.

136. Quoted in Tiska Blankenship, *Vision and Spirit: The Transcendental Painting Group*, exh. cat. (Albuquerque: Jonson Gallery of the University of New Mexico Art Museums, 1997), p. 3.

137. Roy Stryker, quoted in Levine, "The Historian and the Icon," p. 38.

138. Roy Stryker, quoted in Maren Stange, "'The Record Itself': Farm Security Administration Photography and the Transformation of Rural Life," in Pete Daniel et al., *Official Images: New Deal Photography* (Washington, D.C.: Smithsonian Institution Press, 1987), p. 4.

139. Henry Luce, "The American Century," *Life*, February 17, 1941, p. 65. "The world of the 20th Century," wrote Luce, "if it is to come to life in any nobility of health and vigor, must be to a significant degree an American Century"; Luce, quoted ibid., p. 64.

140. Henry Luce, quoted in Wendy Kozol, *Life's America: Family and Nation in Postwar Photojournalism* (Philadelphia: Temple University Press, 1994), p. 57.

141. Grant Wood, quoted in Cécile Whiting, *Antifascism in American Art* (New Haven: Yale University Press, 1989), p. 113.

142. For example, one of Shahn's posters, which depicted French workers being subjected to "slavery, starvation, death," was deemed too harsh to be distributed by the Office of War Information. See Stephen Polcari, *From Omaha to Abstract Expressionism: American Artists Respond to World War II* (New York: Baruch College/CUNY, 1995), p. 11.

143. Thomas Hart Benton, quoted in Whiting, *Antifascism in American Art*, p. 116.

144. Quoted in George H. Roeder, Jr., *The Censored War: American Visual Experience During World War Two* (New Haven: Yale University Press, 1993), p. [34].

145. W. Eugene Smith, quoted in *W. Eugene Smith: His Photographs and Notes* (New York: Aperture, 1969), n.p.

146. The Naval Aviation Photographic Unit was headed by Edward Steichen. For the photographs taken under its auspices, see Christopher Phillips, *Steichen at War* (New York: Harry N. Abrams, 1981).

147. Rosenthal took three photographs of the event: the first was of the initial planting of a small American flag; the second shot was of a second Marine detail planting a larger, more visible flag; and the third was a posed photo of the second detail. The picture that became famous was the unposed shot of the planting of the large flag. Because of its drama, however, some scholars have mistakenly assumed that the famous photograph was the posed, restaged one.

148. "Manifesto: Towards a Free Revolutionary Art" was signed by Breton and Diego Rivera but written by Breton and Trotsky.

149. Clement Greenberg, "Avant-Garde and Kitsch" (1939), reprinted in John O'Brian, ed., *Clement Greenberg: The Collected Essays and Criticism*, vol. 1 (Chicago: University of Chicago Press, 1986), p. 9.

150. In 1933, Hofmann opened his first school at 444 Madison Avenue. It was later relocated to 137 East 57th Street, and finally to 52 West 8th Street. In 1935, he opened a summer school in Provincetown, Massachusetts, which became the focus of a large art community on Cape Cod.

151. Clement Greenberg, "Art," *The Nation*, May 2, 1942, p. 526.

152. Edward Alden Jewell, quoted in Larsen, "American Abstract Artists Group," p. 356.

153. Clarence John Laughlin, quoted in Nancy Hall-Duncan, *Photographic Surrealism*, exh. cat. (Cleveland: New Gallery of Contemporary Art, 1979), p. 10.

154. Samuel Kootz, quoted in Serge Guilbaut, *How New York Stole the Idea of Modern Art: Abstract Expressionism, Freedom, and the Cold War*, trans. Arthur Goldhammer (Chicago: University of Chicago Press, 1983), p. 65.

155. John Graham, *Systems and Dialetics of Art* (New York: Delphic Studios, 1937), p. 23, quoted in Irving Sandler, *Abstract Expressionism and the American Experience* (Mexico City: Litográfica Turmex, 1996), p. 11.

156. John Graham, "Primitive Art and Picasso," *Magazine of Art*, 30 (April 1937), p. 237.

157. Graham was born Ivan Gratianovich Dombrovsky of Polish parents in Kiev on December 27, 1886, by the old Gregorian calendar, or January 9, 1887, by the Julian calendar, instituted in Russia only after the revolution. In his early years in the United States, he spelled his name Dabrowsky, though the correct transliteration from the Polish is Dombrovsky. Gorky, whose fictitious name was translated as "Achilles the Bitter One," claimed that he was the nephew of the Russian poet Maxim Gorky.

158. Other artists included were Jean Arp, Hans Bellmer, Oscar Dominguez, Pablo Picasso, Paul Delvaux, René Magritte, Alberto Giacometti, Meret Oppenheim, Henry Moore, Marc Chagall, Esteban Francés, Gordon Onslow-Ford, Paul Klee, Hedda Sterne, André Breton, Leonora Carrington, Jimmy Ernst, Max Ernst, Victor Brauner, Morris Hirshfield, Joan Miró, Kurt Seligmann, Giorgio de Chirico, Marcel Duchamp, Roberto Matta, Yves Tanguy, André Masson, Kay Sage, Wifredo Lam, and Frederick Kiesler.

159. It has often been assumed that Duchamp used sixteen miles of string in his installation because that was the amount purchased and cited in the press. But he actually used only one mile in the installation. See Bruce Altshuler, *The Avant-Garde in Exhibition: New Art in the 20th Century* (New York: Harry N. Abrams, 1994), p. 152.

160. As one distraught American noted, "*Life* came every week to deliver the war to our doorstep and replenish our fear"; quoted in Stephen Polcari, *Abstract Expressionism and the Modern Experience* (New York: Cambridge University Press, 1991), p. 17.

161. Robert Motherwell, "Notes on Mondrian and Chirico," *VVV*, 1 (June 1942), p. 59.

162. Robert Motherwell, quoted in Guilbaut, *How New York Stole the Idea of Modern Art*, pp. 73–74.

163. Adolph Gottlieb and Mark Rothko, with the assistance of Barnett Newman, letter to Edward Alden Jewell, art editor, *New York Times*, June 13, 1943, reprinted in Lawrence Alloway and Mary Davis MacNaughton, *Adolph Gottlieb: A Retrospective* (New York: Arts Publisher in association with the Adolph and Esther Gottlieb Foundation, 1981), p. 169.

164. Adolph Gottlieb and Mark Rothko, "The Portrait and the Modern Artist," typescript of a broadcast on "Art in New York," Radio WNYC, October 13, 1943, reprinted in Alloway and MacNaughton, *Adolph Gottlieb*, pp. 170–71.

165. Mark Rothko, letter to Edward Alden Jewell, art editor, *New York Times*, July 8, 1945, quoted in Michael Leja, "The Formation of an Avant-Garde in New York," in Michael Auping et al., *Abstract Expressionism: The Critical Developments*, exh. cat. (Buffalo: Albright-Knox Art Gallery, 1987), p. 19.

166. Barnett Newman, "The New Sense of Fate," *The Tiger's Eye* (March 1948), reprinted in John P. O'Neill, ed., *Barnett Newman: Selected Writings and Interviews* (New York: Alfred A. Knopf, 1990), p. 168.

167. Mark Rothko, quoted in Irving Sandler, *The Triumph of American Painting: A History of Abstract Expressionism* (New York and Washington, D.C.: Praeger Publishers, 1970), p. 175.

168. Adolph Gottlieb and Mark Rothko, with the assistance of Barnett Newman, letter to Edward Alden Jewell, art editor, *New York Times*, June 7, 1943, reprinted in Alloway and MacNaughton, *Adolph Gottlieb*, p. 169.

169. Mark Rothko, quoted in Sandler, *The Triumph of American Painting*, p. 175.

170. Barnett Newman, "The First Man Was an Artist," *The Tiger's Eye* (October 1947), pp. 59–60, quoted in Sandler, *Abstract Expressionism and the American Experience*, p. 48.

171. Barnett Newman, *Northwest Coast Indian Painting*, exh. cat. (New York: Betty Parsons Gallery, 1946), reprinted in O'Neill, ed., *Barnett Newman: Selected Writings and Interviews*, p. 106.

172. Richard Pousette-Dart, quoted in W. Jackson Rushing, *Native American Art and the New York Avant-Garde: A History of Cultural Primitivism* (Austin: University of Texas Press, 1995), p. 156.

173. Jackson Pollock, quoted in Francis V. O'Connor, "The Life of Jackson Pollock, 1912–1956: A Documentary Chronology," in O'Connor and Eugene V. Thaw, eds., *Jackson Pollock: A Catalogue Raisonné of Paintings, Drawings, and Other Works*, vol. 4 (New Haven: Yale University Press, 1978), p. 232.

174. Clement Greenberg, "Wassily Kandinsky, Piet Mondrian, Jackson Pollock," *The Nation*, April 7, 1945, p. 397, quoted in Elizabeth Frank, *Jackson Pollock* (New York: Abbeville Press, 1983), p. 51.

175. Barnett Newman, "The New Sense of Fate," *The Tiger's Eye* (March 1948), reprinted in O'Neill, ed., *Barnett Newman: Selected Writings and Interviews*, p. 169.

176. "A *Life* Roundtable on the Pursuit of Happiness," *Life*, July 12, 1948, p. 97, quoted in Doss, *Benton, Pollock, and the Politics of Modernism*, p. 395.

177. Aaron Siskind, quoted in Jonathan Green, *American Photography: A Critical History, 1945 to the Present* (New York: Harry N. Abrams, 1984), p. 55.

178. Yasuo Kuniyoshi, quoted in Lloyd Goodrich, "Yasuo Kuniyoshi, 1889–1953," in Goodrich, Susan Lubowsky, and Tom Wolf, *Yasuo Kuniyoshi*, exh. cat. (New York: Whitney Museum of American Art, 1986), n.p.

179. Adolph Gottlieb, "The Ides of Art: The Attitudes of 10 Artists on Their Art and Contemporaneousness," *The Tiger's Eye* (December 1947), p. 43, quoted in Sandler, *Abstract Expressionism and the American Experience*, p. 21.

180. Robert M. Coates coined the term "Abstract Expressionism" in reference to Hans Hofmann in an article in the May 26, 1945, issue of *The New Yorker*; Clement Greenberg, "The Decline of Cubism," *Partisan Review*, 15 (March 1948), reprinted in O'Brian, ed., *Clement Greenberg: The Collected Essays and Criticism*, vol. 2 (Chicago: University of Chicago Press, 1986) p. 215.

181. Although Still was part of the initial group that founded the school, he withdrew and went back to California before it opened. Barnett Newman was added to the faculty for the second term.

182. After the demise of Subjects of the Artist, the school was renamed Studio 35. Three professors at New York University's School of Art Education—Robert Inglehart, Tony Smith, and Hale Woodruff—paid the rent. Their students were primarily responsible for organizing the activities and lectures connected with Studio 35.

183. Roundtable discussions were held on Wednesdays (until 1954) and lectures, symposia, and concerts were presented on Fridays.

184. Willem de Kooning, quoted in Rudi Blesh, *Modern Art USA: Man, Rebellion, Conquest, 1900–1956* (New York: Alfred A. Knopf, 1956), p. 253.

185. Jackson Pollock, "My Painting," *Possibilities 1: An Occasional Review* (Winter 1947–48), p. 79.

186. Jean-Paul Sartre, *Action* (December 29, 1944), quoted in Jonathan Fineberg, *American Art Since 1940: Strategies of Being* (New York: Harry N. Abrams, 1995), p. 36.

187. Willem de Kooning, quoted in Sandler, *The Triumph of American Painting*, p. 98.

188. Willem de Kooning, "Content Is a Glimpse," *Location*, 1 (Spring 1963), p. 47, cited in Sandler, *The Triumph of American Painting*, p. 131.

189. Mark Tobey, quoted in Eliza E. Rathbone, *Mark Tobey: City Paintings*, exh. cat. (Washington, D.C.: National Gallery of Art, 1984), pp. 30–31.

190. Robert Motherwell, quoted in Fineberg, *American Art Since 1940*, p. 70.

191. Franz Kline, quoted in Katherine Kuh, *The Artist's Voice: Talks with Seventeen Artists* (New York and Evanston: Harper & Row, 1960), p. 144.

192. Franz Kline, quoted in Frank O'Hara, "Franz Kline Talking," *Evergreen Review*, 6 (Autumn 1958), p. 64.

193. David Smith, quoted in the typescript of The Museum of Modern Art's 1952 panel "The New Sculpture: A Symposium," p. 7.

194. Seymour Lipton, quoted in Sam Hunter, *Seymour Lipton Sculpture*, exh. cat. (Charlotte, N.C.: Mint Museum of Art, 1982), p. 9.

195. Theodore Roszak, quoted in H. H. Arnason, *Theodore Roszak*, exh. cat. (Minneapolis and New York: Walker Art Center in collaboration with the Whitney Museum of American Art, 1956), p. 26; Theodore Roszak, quoted in the typescript of The Museum of Modern Art's 1952 panel "The New Sculpture: A Symposium," p. 18.

196. Barnett Newman, "The Sublime Is Now," *The Tiger's Eye* (December 1948), reprinted in John O'Neill, ed., *Barnett Newman: Selected Writings and Interviews*, p. 173.

197. Barnett Newman, quoted in Harold Rosenberg, *Barnett Newman* (New York: Harry N. Abrams, 1978), pp. 27–28.

198. Mark Rothko, quoted in Dore Ashton, *About Rothko* (New York: Oxford University Press, 1983), p. 154.

199. Agnes Martin recalled that Rothko described his paintings as "doorways to the spirit"; Martin, in conversation with the author, April 1992, New Mexico.

200. Barnett Newman, quoted in Dorothy Gees Seckler, "Frontiers of Space," *Art in America*, 50 (Summer 1962), p. 87.

201. William Baziotes, quoted in David Rubin, *William Baziotes: A Commemorative Exhibition*, exh. cat. (Reading, Pennsylvania: Freedman Gallery, Albright College, 1987), p. 11.

Selected Bibliography

Painting, Sculpture, and Photography
General

Altshuler, Bruce. *The Avant-Garde in Exhibition: New Art in the 20th Century.* New York: Harry N. Abrams, 1994.

Andersen, Wayne V. *American Sculpture in Process, 1930/1970.* Boston: New York Graphic Society, 1975.

Armstrong, Tom, et al. *200 Years of American Sculpture* (exhibition catalog). New York: Whitney Museum of American Art, 1976.

Baigell, Matthew. *A History of American Painting.* New York and Washington, D.C.: Praeger Publishers, 1971.

Baur, John I. H. *Revolution and Tradition in Modern American Art.* Cambridge, Massachusetts: Harvard University Press, 1951.

Bearden, Romare, and Harry Henderson. *A History of African-American Artists from 1792 to the Present.* New York: Pantheon Books, 1993.

Brown, Milton W. *American Painting from the Armory Show to the Depression.* Princeton: Princeton University Press, 1955.

Brown, Milton W., et al. *American Art.* New York: Harry N. Abrams, 1988.

Carlebach, Michael L. *American Photojournalism Comes of Age.* Washington, D.C.: Smithsonian Institution Press, 1997.

Chadwick, Whitney. *Women, Art, and Society.* London: Thames and Hudson, 1990.

Clarke, Graham. *Oxford History of Art: The Photograph.* New York: Oxford University Press, 1997.

Craven, Wayne. *American Art: History and Culture.* New York: Brown & Benchmark, 1994.

Davis, Keith F. *An American Century of Photography: From Dry-Plate to Digital.* Kansas City, Missouri: Hallmark Cards, 1995.

Doezema, Marianne, and Elizabeth Milroy, eds. *Reading American Art.* New Haven: Yale University Press, 1998.

Doty, Robert, ed. *Photography in America* (exhibition catalog). New York: Whitney Museum of American Art, 1974.

Fort, Ilene Susan. *The Figure in American Sculpture.* Los Angeles: Los Angeles County Museum of Art, 1995.

Galassi, Peter. *American Photography, 1890–1965* (exhibition catalog). New York: The Museum of Modern Art, 1995.

Goldberg, Vicki. *The Power of Photography: How Photographs Changed Our Lives* (1991). Rev. ed. New York: Abbeville Press, 1993.

Green, Jonathan. *American Photography: A Critical History, 1945 to the Present.* New York: Harry N. Abrams, 1984.

Greenough, Sarah, et al. *On the Art of Fixing a Shadow: One Hundred and Fifty Years of Photography* (exhibition catalog). Washington, D.C. and Chicago: National Gallery of Art and The Art Institute of Chicago, 1989.

Guimond, James. *American Photography and the American Dream.* Chapel Hill: University of North Carolina Press, 1991.

Hall-Duncan, Nancy. *The History of Fashion Photography* (exhibition catalog). Rochester, New York: International Museum of Photography, 1977.

Hills, Patricia, and Roberta K. Tarbell. *The Figurative Tradition and the Whitney Museum of American Art* (exhibition catalog). New York: Whitney Museum of American Art, 1980.

Hughes, Robert. *American Visions: The Epic History of Art in America.* New York: Alfred A. Knopf, 1997.

Joachimides, Christos M., and Norman Rosenthal, eds. *American Art in the 20th Century: Painting and Sculpture, 1913–1993.* Munich: Prestel-Verlag, 1993.

Karlstrom, Paul J., ed. *On the Edge of America: California Modernist Art, 1900–1950.* Berkeley: University of California Press in association with the Archives of American Art, Smithsonian Institution, and the Fine Arts Museums of San Francisco, 1996.

Karlstrom, Paul J., and Susan Ehrlich. *Turning the Tide: Early Los Angeles Modernists, 1920–1956.* Santa Barbara: Santa Barbara Museum of Art, 1990.

Kleeblatt, Norman L., and Susan Chevlowe, eds. *Painting a Place in America: Jewish Artists in New York, 1900–1945* (exhibition catalog). New York: The Jewish Museum, 1991.

Kleihues, Josef Paul, and Christina Rathgeber, eds. *Berlin/New York: Like and Unlike: Essays on Architecture and Art from 1870 to the Present.* New York: Rizzoli, 1993.

Lewis, Samella. *African American Art and Artists.* Berkeley: University of California Press, 1990.

Lucie-Smith, Edward. *American Realism.* New York: Harry N. Abrams, 1994.

Marter, Joan M., Roberta K. Tarbell, and Jeffrey Wechsler. *Vanguard American Sculpture, 1913–1939* (exhibition catalog). New Brunswick, New Jersey: Rutgers University Art Gallery, 1979.

McCabe, Cynthia Jaffee. *The Golden Door: Artist-Immigrants of America, 1876–1976* (exhibition catalog). Washington, D.C.: Hirshhorn Museum and Sculpture Garden, Smithsonian Institution, 1976.

McShine, Kynaston, ed. *The Natural Paradise: Painting in America, 1800–1950* (exhibition catalog). New York: The Museum of Modern Art, 1976.

Newhall, Beaumont. *The History of Photography from 1839 to the Present.* 5th ed. New York: The Museum of Modern Art, 1993.

Newhall, Nancy. *From Adams to Stieglitz: Pioneers of Modern Photography.* New York: Aperture, 1989.

O'Doherty, Brian. *American Masters: The Voice and the Myth.* New York: Random House, 1988.

Perry, Regenia A. *Free Within Ourselves: African-American Artists in the Collection of the National Museum of American Art* (exhibition catalog). Washington, D.C.: National Museum of American Art, Smithsonian Institution; San Francisco: Pomegranate Artbooks, 1992.

Powell, Richard J. *Black Art and Culture in the 20th Century*. London: Thames and Hudson, 1997.

Powell, Richard J. *The Blues Aesthetic: Black Culture and Modernism*. Washington, D.C.: Washington Project for the Arts, 1989.

Prince, Sue Anne. *The Old Guard and the Avant-Garde: Modernism in Chicago, 1910–1940*. Chicago: University of Chicago Press, 1990.

Reynolds, Gary A., and Beryl J. Wright. *Against the Odds: African-American Artists and the Harmon Foundation* (exhibition catalog). Newark, New Jersey: The Newark Museum, 1989.

Rose, Barbara. *American Art Since 1900* (1967). Rev. ed. New York and Washington, D.C.: Praeger Publishers, 1975.

———, ed. *Readings in American Art, 1900–1975*. New York and Washington, D.C.: Praeger Publishers, 1975.

Rosenblum, Naomi. *A History of Women Photographers*. New York: Abbeville Press, 1994.

———. *A World History of Photography*. New York: Abbeville Press, 1984.

Rubinstein, Charlotte Streifer. *American Women Sculptors: A History of Women Working in Three Dimensions*. Boston: G. K. Hall, 1990.

Schimmel, Julie, William H. Truettner, and Charles C. Eldredge. *Art in New Mexico, 1900–1945: Paths to Taos and Santa Fe* (exhibition catalog). Washington, D.C.: National Museum of American Art, Smithsonian Institution, 1986.

Smith, Terry. *Making the Modern: Industry, Art, and Design in America*. Chicago: University of Chicago Press, 1993.

Solomon-Godeau, Abigail. *Photography at the Dock: Essays on Photographic History, Institutions, and Practices*. Minneapolis: University of Minnesota Press, 1991.

Stange, Maren. *Symbols of Ideal Life: Social Documentary Photography in America, 1890–1950* (1989). Reprt. New York: Cambridge University Press, 1992.

Susman, Warren I. *Culture as History: The Transformation of American Society in the Twentieth Century*. New York: Pantheon Books, 1984.

Szarkowski, John. *Photography Until Now* (exhibition catalog). New York: The Museum of Modern Art, 1989.

Taylor, Joshua C. *America as Art*. New York: Harper & Row, 1976.

Trachtenberg, Alan. *Reading American Photographs: Images as History, Mathew Brady to Walker Evans*. New York: Hill and Wang, 1989.

Travis, David. *Photography Rediscovered: American Photographs, 1900–1930* (exhibition catalog). New York: Whitney Museum of American Art, 1979.

Trenton, Patricia, ed. *Independent Spirits: Women Painters of the American West, 1890–1945* (exhibition catalog). Los Angeles: Autry Museum of Western Heritage, 1995.

Udall, Sharyn Rohlfsen. *Modernist Painting in New Mexico, 1913–1935*. Albuquerque: University of New Mexico Press, 1984.

Weber, Nicholas Fox. *Patron Saints: Five Rebels Who Opened America to a New Art, 1928–1943*. New York: Alfred A. Knopf, 1992.

Westerbeck, Colin, and Joel Meyerowitz. *Bystander: A History of Street Photography*. Boston: Bulfinch Press/Little, Brown, 1994.

Willis, Deborah, ed. *Picturing Us: African American Identity in Photography*. New York: New Press, 1994.

1900–1919

The Last Flourish of the Gilded Age

Burns, Sarah. *Inventing the Modern Artist: Art and Culture in Gilded Age America*. New Haven: Yale University Press, 1996.

Corn, Wanda M. *The Color of Mood: American Tonalism, 1880–1910* (exhibition catalog). San Francisco: M. H. De Young Memorial Museum and the California Palace of the Legion of Honor, 1972.

Cotkin, George. *Reluctant Modernism: American Thought and Culture, 1880–1900*. New York: Twayne, 1992.

Eldredge, Charles C. *American Imagination and Symbolist Painting* (exhibition catalog). New York: Grey Art Gallery and Study Center, New York University, 1979.

Fairbrother, Trevor J. *The Bostonians: Painters of an Elegant Age, 1870–1930* (exhibition catalog). Boston: Museum of Fine Arts, 1986.

Hills, Patricia. *Turn-of-the-Century America: Paintings, Graphics, Photographs, 1890–1910* (exhibition catalog). New York: Whitney Museum of American Art, 1977.

Lears, T. J. Jackson. *No Place of Grace: Anti-modernism and the Transformation of American Culture, 1880–1920*. Chicago: University of Chicago Press, 1984.

May, Henry F. *The End of American Innocence: A Study of the First Years of Our Own Time, 1912–1917*. New York: Columbia University Press, 1992.

Morgan, H. Wayne. *New Muses: Art in American Culture, 1865–1920*. Norman: University of Oklahoma Press, 1978.

Wilson, Richard Guy, Dianne H. Pilgrim, and Richard N. Murray. *The American Renaissance, 1876–1917* (exhibition catalog). New York: The Brooklyn Museum, 1979.

Pictorial Photography and the Photo-Secession

Bunnell, Peter C., ed. *A Photographic Vision: Pictorial Photography, 1889–1923*. Salt Lake City: Peregrine Smith, 1980.

Doty, Robert. *Photo-Secession: Photography as a Fine Art* (exhibition catalog). Rochester, New York: George Eastman House, 1960.

Fulton, Marianne, ed. *Pictorialism into Modernism: The Clarence H. White School of Photography*. New York: Rizzoli, 1996.

Homer, William Innes. *Alfred Stieglitz and the Photo-Secession*. Boston: New York Graphic Society, 1983.

Peterson, Christian A. *After the Photo-Secession: American Pictorial Photography, 1910–1955*. New York: W. W. Norton, 1997.

Modernity and Urban Realism

Berman, Avis. *Rebels on Eighth Street*. New York: Atheneum, 1990.

Doezema, Marianne. *American Realism and the Industrial Age* (exhibition catalog). Cleveland: Cleveland Museum of Art, 1980.

Homer, William Innes. *Robert Henri and His Circle*. Ithaca: Cornell University Press, 1969.

Mecklenburg, Virginia M., Robert W. Snyder, and Rebecca Zurier. *Metropolitan Lives: The Ashcan Artists and Their New York*. New York: W. W. Norton, 1996.

Milroy, Elizabeth. *Painters of a New Century: The Eight and American Art* (exhibition catalog). Milwaukee: Milwaukee Art Museum, 1991.

O'Neill, William L., ed. *Echoes of Revolt: The Masses, 1911–1917*. Chicago: Quadrangle Books, 1966.

Perlman, Bennard B. *The Immortal Eight: American Painting from Eakins to the Armory Show (1870–1913)*. New York: Exposition Press, 1962.

Shi, David E. *Facing Facts: Realism in American Thought and Culture, 1850–1920*. New York: Oxford University Press, 1995.

Weinberg, H. Barbara, Doreen Bolger, and David Park Curry. *American Impressionism and Realism: The Painting of Modern Life, 1885–1915* (exhibition catalog). New York: The Metropolitan Museum of Art, 1994.

Young, Mahonri Sharp. *The Eight: The Realist Revolt in American Painting*. New York: Watson-Guptill, 1973.

Zurier, Rebecca. *Art for The Masses: A Radical Magazine and Its Graphics, 1911–1917*. Philadelphia: Temple University Press, 1988.

Early American Modernism

Brown, Milton W. *The Story of the Armory Show*. 2nd ed. New York: Abbeville Press in association with the Joseph H. Hirshhorn Foundation, 1988.

Crunden, Robert M. *American Salons: Encounters with European Modernism, 1885–1917*. New York: Oxford University Press, 1993.

Davidson, Abraham A. *Early American Modernist Painting, 1910–1935*. New York: Harper & Row, 1981.

Dijkstra, Bram. *Cubism, Stieglitz, and the Early Poetry of William Carlos Williams: The Hieroglyphics of a New Speech*. Princeton: Princeton University Press, 1969.

Gardiner, Henry G. *Color and Form, 1909–1914: The Origin and Evolution of Abstract Painting in Futurism, Orphism, Rayonnism, Synchromism and the Blue Rider* (exhibition catalog). San Diego: Fine Arts Gallery of San Diego, 1971.

Green, Jonathan, ed. *Camera Work: A Critical Anthology*. New York: Aperture, 1973.

Green, Martin. *New York 1913: The Armory Show and the Paterson Strike Pageant*. New York: Charles Scribner's Sons, 1988.

Heller, Adele, and Lois Rudnick, eds. *1915, the Cultural Moment: The New Politics, the New Woman, the New Psychology, the New Art and the New Theatre in America*. New Brunswick, New Jersey: Rutgers University Press, 1991.

Homer, William Innes. *Alfred Stieglitz and the American Avant-Garde*. Boston: New York Graphic Society, 1977.

———, ed. *Avant-Garde Painting and Sculpture in America, 1910–25*. Wilmington: Delaware Art Museum, 1975.

Kuenzli, Rudolf E., ed. *New York Dada*. New York: Willis Locker & Owens, 1986.

Levin, Gail. *Synchromism and American Color Abstraction, 1910–1925* (exhibition catalog). New York: Whitney Museum of American Art, 1978.

Morrin, Peter, Judith Zilczer, and William C. Agee. *The Advent of Modernism: Post-Impressionism and North American Art, 1900–1918* (exhibition catalog). Atlanta: High Museum of Art, 1986.

Naumann, Francis M. *New York Dada, 1915–23*. New York: Harry N. Abrams, 1994.

Naumann, Francis M., with Beth Venn. *Making Mischief: Dada Invades New York* (exhibition catalog). New York: Whitney Museum of American Art, 1996.

Norman, Dorothy. *Alfred Stieglitz: An American Seer* (1960). Reprt. New York: Random House, 1973.

Pultz, John, and Catherine B. Scallen. *Cubism and American Photography, 1910–1930*. Williamstown, Massachusetts: Sterling and Francine Clark Art Institute, 1981.

Rudnick, Lois Palken. *Utopian Vistas: The Mabel Dodge Luhan House and the American Counterculture*. Albuquerque: University of New Mexico Press, 1996.

Turner, Elizabeth Hutton. *In the American Grain: Arthur Dove, Marsden Hartley, John Marin, Georgia O'Keeffe, and Alfred Stieglitz* (exhibition catalog). Washington, D.C.: The Phillips Collection, 1995.

Versaci, Nancy, and Judith Tolnick. *Over Here: Modernism, the First Exile, 1914–1919*. Providence, Rhode Island: David Winton Bell Gallery, Brown University, 1989.

Watson, Steven. *Strange Bedfellows: The First American Avant-Garde*. New York: Abbeville Press, 1991.

Weinberg, Jonathan. *Speaking for Vice: Homosexuality in the Art of Charles Demuth, Marsden Hartley, and the First American Avant-Garde*. New Haven: Yale University Press, 1993.

Wertheim, Arthur Frank. *The New York Little Renaissance: Iconoclasm, Modernism, and Nationalism in American Culture, 1908–1917*. New York: New York University Press, 1976.

Young, Mahonri Sharp. *Early American Moderns: Painters of the Stieglitz Group*. New York: Watson-Guptill, 1974.

1920–1929
Modern Art and American Culture

Cassidy, Donna M. *Painting the Musical City: Jazz and Cultural Identity in American Art, 1910–1940*. Washington, D.C.: Smithsonian Institution Press, 1997.

Coben, Stanley. *Rebellion against Victorianism: The Impetus for Cultural Change in 1920s America*. New York: Oxford University Press, 1991.

Douglas, Ann. *Terrible Honesty: Mongrel Manhattan in the 1920s*. New York: Farrar, Straus & Giroux, 1995.

Hambourg, Maria Morris, and Christopher Phillips. *The New Vision: Photography Between the World Wars* (exhibition catalog) (1989). Reprt. New York: The Metropolitan Museum of Art, 1994.

Leuchtenburg, William E. *The Perils of Prosperity, 1914–32*. Chicago: University of Chicago Press, 1958.

Lynes, Barbara Buhler. *O'Keeffe, Stieglitz, and the Critics, 1916–1929*. Ann Arbor, Michigan: UMI Research Press, 1989.

Tashjian, Dickran. *William Carlos Williams and the American Scene, 1920–1940* (exhibition catalog). New York: Whitney Museum of American Art, 1978.

Turner, Elizabeth Hutton. *Americans in Paris (1921–1931): Man Ray, Gerald Murphy, Stuart Davis, Alexander Calder* (exhibition catalog). Washington, D.C.: The Phillips Collection, 1996.

Precisionism and the Machine Age

Lucic, Karen. *Charles Sheeler and the Cult of the Machine*. Cambridge, Massachusetts: Harvard University Press, 1991.

Friedman, Martin L. *The Precisionist View in American Art* (exhibition catalog). Minneapolis: Walker Art Center, 1960.

Stavitsky, Gail, et al. *Precisionism in America, 1915–1941: Reordering Reality*. Montclair, New Jersey: The Montclair Art Museum, 1994.

Stewart, Patrick Leonard, Jr. "Charles Sheeler, William Carlos Williams and the Development of the Precisionist Aesthetic, 1917–1931." Ph.D. diss. Newark: University of Delaware, 1981.

Tashjian, Dickran. *Skyscraper Primitivism: Dada and the American Avant-Garde, 1910–1925*. Middletown, Connecticut: Wesleyan University Press, 1975.

Tsujimoto, Karen. *Images of America: Precisionist Painting and Modern Photography* (exhibition catalog). San Francisco: San Francisco Museum of Modern Art, 1982.

Wilson, Richard Guy, Dianne H. Pilgrim, and Dickran Tashjian. *The Machine Age in America, 1918–1941* (exhibition catalog). New York: The Brooklyn Museum, 1986.

Harlem Renaissance

Baker, Houston A., Jr. *Modernism and the Harlem Renaissance*. Chicago: University of Chicago Press, 1987.

Driskell, David C., et al. *Harlem Renaissance: Art of Black America* (exhibition catalog). Introduction by Mary Schmidt Campbell. New York: The Studio Museum in Harlem, 1987.

Huggins, Nathan Irvin, ed. *Voices from the Harlem Renaissance*. New York: Oxford University Press, 1995.

Hutchinson, George. *The Harlem Renaissance in Black and White*. Cambridge, Massachusetts: Belknap Press/Harvard University Press, 1995.

Powell, Richard J., and David A. Bailey. *Rhapsodies in Black: Art of the Harlem Renaissance* (exhibition catalog). London: Hayward Gallery and the Institute of International Visual Arts, 1997.

Watson, Steven. *The Harlem Renaissance: Hub of African-American Culture, 1920–1930*. New York: Pantheon Books, 1995.

1930–1939
Federal Support of the Arts

Bustard, Bruce I. *A New Deal for the Arts*. Washington, D.C.: National Archives Records and Administration; Seattle: University of Washington Press, 1997.

Contreras, Belisario R. *Tradition and Innovation in New Deal Art*. Lewisburg, Pennsylvania: Bucknell University Press; London: Associated University Presses, 1983.

Daniel, Pete, et al. *Official Images: New Deal Photography*. Washington, D.C.: Smithsonian Institution Press, 1987.

Fleischhauer, Carl, and Beverly W. Brannan, eds. *Documenting America, 1935–1943*. Berkeley: University of California Press, 1988.

Harris, Jonathan. *Federal Art and National Culture: The Politics of Identity in New Deal America*. New York: Cambridge University Press, 1995.

Marling, Karal Ann. *Wall-to-Wall America: A Cultural History of Post-Office Murals in the Great Depression*. Minneapolis: University of Minnesota Press, 1982.

McDonald, William F. *Federal Relief Administration and the Arts*. Columbus: Ohio State University Press, 1969.

McKinzie, Richard D. *The New Deal for Artists*. Princeton: Princeton University Press, 1973.

Melosh, Barbara. *Engendering Culture: Manhood and Womanhood in New Deal Public Art and Theater*. Washington, D.C.: Smithsonian Institution Press, 1991.

O'Connor, Francis V. *Federal Support for the Visual Arts: The New Deal and Now* (1969). 2nd ed. Greenwich, Connecticut: New York Graphic Society, 1971.

Park, Marlene, and Gerald E. Markowitz. *Democratic Vistas: Post Offices and Public Art in the New Deal*. Philadelphia: Temple University Press, 1984.

Realism and National Identity

Baigell, Matthew. *The American Scene: American Painting of the 1930's*. New York and Washington, D.C.: Praeger Publishers, 1974.

Dennis, James M. *Renegade Regionalists: The Modern Independence of Grant Wood, Thomas Hart Benton, and John Steuart Curry*. Madison: University of Wisconsin Press, 1998.

Doss, Erika. *Benton, Pollock, and the Politics of Modernism: From Regionalism to Abstract Expressionism*. Chicago: University of Chicago Press, 1991.

Gambone, Robert L. *Art and Popular Religion in Evangelical America, 1915–1940*. Knoxville: University of Tennessee Press, 1989.

Heller, Nancy, and Julia Williams. *Painters of the American Scene* (1976). Reprt. New York: Galahad Books, 1982.

Kendall, M. Sue. *Rethinking Regionalism: John Steuart Curry and the Kansas Mural Controversy*. Washington, D.C.: Smithsonian Institution Press, 1986.

Marquis, Alice G. *Hopes and Ashes: The Birth of Modern Times, 1929–1939*. New York: Free Press, 1986.

Pells, Richard H. *Radical Visions and American Dreams: Culture and Social Thought in the Depression Years*. New York: Harper & Row, 1973.

Stewart, Rick. *Lone Star Regionalism: The Dallas Nine and Their Circle, 1928–1945*. Austin: Texas Monthly Press, 1985.

Stott, William. *Documentary Expression and Thirties America* (1973). Reprt. Chicago: University of Chicago Press, 1986.

Todd, Ellen Wiley. *The "New Woman" Revised: Painting and Gender Politics on Fourteenth Street*. Berkeley: University of California Press, 1993.

Westphal, Ruth Lilly, and Janet Blake Dominik, eds. *American Scene Painting: California, 1930s and 1940s*. Irvine, California: Westphal, 1991.

Wooden, Howard E. *American Art of the Great Depression: Two Sides of the Coin* (exhibition catalog). Wichita, Kansas: Wichita Art Museum, 1985.

Social Realism

Artists Against War and Fascism: Papers of the First American Artists' Congress. Introduction by Matthew Baigell and Julia Williams. New Brunswick, New Jersey: Rutgers University Press, 1986.

Brown, Milton. *Social Art in America, 1930–1945*. New York: ACA Galleries, 1981.

Hills, Patricia. *Social Concern and Urban Realism: American Painting of the 1930s* (exhibition catalog). Boston: Boston University Art Gallery, 1983.

Nelson, Cary. *Repression and Recovery: Modern American Poetry and the Politics of Cultural Memory, 1910–1945*. Madison: University of Wisconsin Press, 1989.

Shapiro, David, ed. *Social Realism: Art as a Weapon*. New York: Frederick Ungar, 1973.

Whiting, Cécile. *Antifascism in American Art*. New Haven: Yale University Press, 1989.

American Abstract Art

Blankenship, Tiska. *Vision and Spirit: The Transcendental Painting Group* (exhibition catalog). Albuquerque: Jonson Gallery of the University of New Mexico Art Museums, 1997.

Elderfield, John. *Geometric Abstraction, 1926–1942*. Dallas: Dallas Museum of Fine Arts, 1972.

Lane, John R., and Susan C. Larsen, eds. *Abstract Painting and Sculpture in America, 1927–1944* (exhibition catalog). New York: Museum of Art, Carnegie Institute, 1983.

Larsen, Susan C. "The American Abstract Artists Group: A History and Evaluation of Its Impact upon American Art." Ph.D. diss. Chicago: Northwestern University, 1974.

Rose, Barbara. *American Abstract Artists: The Early Years*. New York: Sid Deutsch Gallery, 1981.

Toher, Jennifer, ed. *Beyond the Plane: American Constructions, 1930–1965*. Introduction by Joan Marter. Trenton: New Jersey State Museum, 1983.

Troy, Nancy J. *Mondrian and Neo-Plasticism in America*. New Haven: Yale University Art Gallery, 1979.

1940–1949

Surrealism and European Emigration

Barron, Stephanie, with Sabine Eckmann. *Exiles and Émigrés: The Flight of European Artists from Hitler* (exhibition catalog). Los Angeles: Los Angeles County Museum of Art, 1997.

Berman, Greta, and Jeffrey Wechsler. *Realism and Realities: The Other Side of American Painting, 1940–1960* (exhibition catalog). New Brunswick, New Jersey: Rutgers University Art Gallery, 1981.

Ehrlich, Susan, ed. *Pacific Dreams: Currents of Surrealism and Fantasy in California Art, 1934–1957* (exhibition catalog). Los Angeles: UCLA at the Armand Hammer Museum of Art and Cultural Center, 1995.

Sawin, Martica. *Surrealism in Exile and the Beginning of the New York School*. Cambridge, Massachusetts: MIT Press, 1995.

Tashjian, Dickran. *A Boatload of Madmen: Surrealism and the American Avant-Garde, 1920–1950*. New York: Thames and Hudson, 1995.

Wechsler, Jeffrey, with Jack J. Spector. *Surrealism and American Art, 1931–1947* (exhibition catalog). New Brunswick, New Jersey: Rutgers University Art Gallery, 1976.

Abstract Expressionism

Anfam, David. *Abstract Expressionism*. New York: Thames and Hudson, 1990.

Ashton, Dore. *The New York School: A Cultural Reckoning*. New York: Viking Press, 1973.

Auping, Michael, et al. *Abstract Expressionism: The Critical Developments* (exhibition catalog). Buffalo: Albright-Knox Art Gallery, 1987.

Belgrad, Daniel. *The Culture of Spontaneity: Improvisation and the Arts in Postwar America*. Chicago: University of Chicago Press, 1998.

Carmean, E. A., Jr., and Eliza E. Rathbone, with Thomas B. Hess. *American Art at Mid-Century: The Subjects of the Artist* (exhibition catalog). Washington, D.C.: National Gallery of Art, 1978.

Fineberg, Jonathan. *Art Since 1940: Strategies of Being*. New York: Harry N. Abrams, 1995.

Gibson, Ann Eden. *Abstract Expressionism: Other Politics*. New Haven: Yale University Press, 1997.

———. *Issues in Abstract Expressionism: The Artist-Run Periodicals*. Ann Arbor, Michigan: UMI Research Press, 1990.

Guilbaut, Serge. *How New York Stole the Idea of Modern Art: Abstract Expressionism, Freedom, and the Cold War*. Translated by Arthur Goldhammer. Chicago: University of Chicago Press, 1983.

Hobbs, Robert Carleton, and Gail Levin. *Abstract Expressionism: The Formative Years* (exhibition catalog). Ithaca: Herbert F. Johnson Museum of Art, Cornell University; New York: Whitney Museum of American Art, 1978.

Kingsley, April. *The Turning Point: The Abstract Expressionists and the Transformation of American Art*. New York: Simon and Schuster, 1992.

Leja, Michael. *Reframing Abstract Expressionism: Subjectivity and Painting in the 1940s*. New Haven: Yale University Press, 1993.

Livingston, Jane. *The New York School: Photographs, 1936–1963*. New York: Stewart, Tabori & Chang, 1992.

Phillips, Lisa. *The Third Dimension: Sculpture of the New York School* (exhibition catalog). New York: Whitney Museum of American Art, 1984.

Polcari, Stephen. *Abstract Expressionism and the Modern Experience*. New York: Cambridge University Press, 1991.

Ross, Clifford, ed. *Abstract Expressionism: Creators and Critics*. New York: Harry N. Abrams, 1990.

Rushing, W. Jackson. *Native American Art and the New York Avant-Garde: A History of Cultural Primitivism*. Austin: University of Texas Press, 1995.

Sandler, Irving. *The Triumph of American Painting: A History of Abstract Expressionism*. New York and Washington, D.C.: Praeger Publishers, 1970.

Schimmel, Paul, et al. *The Interpretive Link: Abstract Surrealism into Abstract Expressionism: Works on Paper, 1938–1948* (exhibition catalog). Newport Beach, California: Newport Harbor Art Museum, 1986.

Seitz, William C. *Abstract Expressionist Painting in America*. Cambridge, Massachusetts: Harvard University Press for the National Gallery of Art, Washington, D.C., 1983.

Shapiro, David, and Cecile Shapiro. *Abstract Expressionism: A Critical Record*. New York: Cambridge University Press, 1990.

Versaci, Nancy R., Judith E. Tolnick, and Ellen Lawrence. *Flying Tigers: Painting and Sculpture in New York, 1939–1946*. Introduction by Kermit Champa. Providence, Rhode Island: Bell Gallery, Brown University, 1985.

Architecture

Banham, Reyner. *Theory and Design in the First Machine Age.* 2nd ed. Cambridge: MIT Press, 1992.

Brooks, Harold Allen. *The Prairie School: Frank Lloyd Wright and His Midwest Contemporaries.* New York: W. W. Norton, 1976.

Cohen, Jean-Louis. *Scenes of the World to Come: European Architecture and the American Challenge, 1893–1960* (exhibition catalog). Montreal: Canadian Centre for Architecture, 1995.

Handlin, David P. *American Architecture.* London: Thames and Hudson, 1985.

Jordy, William H. *American Buildings and Their Architects.* Vol. 4, *Progressive and Academic Ideals at the Turn of the Twentieth Century.* New York: Oxford University Press, 1972.

———. *American Buildings and Their Architects.* Vol. 5, *The Impact of European Modernism in the Mid-Twentieth Century.* New York: Oxford University Press, 1972.

Ockman, Joan, with Edward Eigen. *Architecture Culture, 1943–1968.* New York: Columbia University Graduate School of Architecture, Planning, and Preservation; New York: Rizzoli, 1993.

Smith, Elizabeth A. T., et al. *Blueprints for Modern Living: History and Legacy of the Case Study Houses* (exhibition catalog). Los Angeles: Museum of Contemporary Art, 1989.

Stern, Robert A. M., Gregory Gilmartin, and John Montague Massengale. *New York 1900: Metropolitan Architecture and Urbanism, 1890–1915.* New York: Rizzoli, 1983.

Stern, Robert A. M., et al. *New York 1930: Architecture and Urbanism Between the Two World Wars.* New York: Rizzoli, 1987.

Willis, Carol. *Form Follows Finance: Skyscrapers and Skylines in New York and Chicago.* New York: Princeton Architectural Press, 1995.

Wright, Gwendolyn. *Building the Dream: A Social History of Housing in America.* New York: Pantheon Books, 1981.

Dance

Anderson, Jack. *Art Without Boundaries: The World of Modern Dance.* Iowa City: University of Iowa Press, 1997.

Croce, Arlene. *Afterimages.* New York: Alfred A. Knopf, 1977.

———. *Sight Lines.* New York: Alfred A. Knopf, 1987.

Delamater, Jerome. *Dance in the Hollywood Musical.* Ann Arbor, Michigan: UMI Research Press, 1981.

Frank, Rusty E. *Tap!: The Greatest Tap Dance Stars and Their Stories, 1900–1955.* New York: Da Capo Press, 1994.

Graff, Ellen. *Stepping Left: Dance and Politics in New York City, 1928–1942.* Durham: Duke University Press, 1997.

Jowitt, Deborah. *The Dance in Mind: Profiles and Reviews, 1976–83.* Photographs by Lois Greenfield. Boston: D. R. Godine, 1985.

Kendall, Elizabeth. *Where She Danced.* New York: Alfred A. Knopf, 1979.

McDonagh, Don. *The Complete Guide to Modern Dance.* Garden City, New York: Popular Library, 1976.

Mordden, Ethan. *The Hollywood Musical.* New York: St. Martin's Press, 1981.

Stearns, Marshall, and Jean Stearns. *Jazz Dance: The Story of American Vernacular Dance.* New York: Macmillan, 1968.

Decorative Arts

Cumming, Elizabeth, and Wendy Kaplan. *The Arts and Crafts Movement.* London: Thames and Hudson, 1991.

Davies, Karen. *At Home in Manhattan: Modern Decorative Arts, 1925 to the Depression* (exhibition catalog). New Haven: Yale University Art Gallery, 1983.

Duncan, Alastair. *American Art Deco.* New York: Harry N. Abrams, 1986.

Eidelberg, Martin, ed. *Design, 1935–1965: What Modern Was: Selections from the Liliane and David M. Stewart Collection* (exhibition catalog). Montreal: Musée des Arts Décoratifs de Montréal, 1991.

Hanks, David A., et al. *High Styles: Twentieth-Century American Design* (exhibition catalog). New York: Whitney Museum of American Art, 1985.

Hiesinger, Kathryn B., and George H. Marcus. *Landmarks of Twentieth-Century Design: An Illustrated Handbook.* New York: Abbeville Press, 1993.

Kaplan, Wendy. *"The Art That Is Life": The Arts and Crafts Movement in America, 1875–1920* (exhibition catalog). Boston: Museum of Fine Arts, 1987.

Kardon, Janet, ed. *Craft in the Machine Age, 1920–1945: The History of Twentieth-Century American Craft* (exhibition catalog). New York: American Craft Museum, 1995.

Lichtenstein, Claude, and Franz Engler, eds. *Streamlined: A Metaphor for Progress: The Esthetics of Minimized Drag.* Baden, Switzerland: Lars Müller, 1993.

Marling, Karal Ann. *George Washington Slept Here: Colonial Revivals and American Culture, 1876–1986.* Cambridge, Massachusetts: Harvard University Press, 1988.

Meikle, Jeffrey L. *Twentieth Century Limited: Industrial Design in America, 1925–1939.* Philadelphia: Temple University Press, 1979.

Meyer, Marilee Boyd. *Inspiring Reform: Boston's Arts and Crafts Movement* (exhibition catalog). Wellesley, Massachusetts: Davis Museum and Cultural Center, Wellesley College, 1997.

Ostergard, Derek E. *Art Deco Masterpieces.* New York: Macmillan, 1991.

Ostergard, Derek E. *Merchandising Interior Design: Methods of Furniture Fabrication in America Between the World Wars.* New Haven: Yale University School of Architecture, 1991.

Trapp, Kenneth R., ed. *The Arts and Crafts Movement in California: Living the Good Life.* New York: Abbeville Press, 1993.

Yevalich, Susan. *Design for Life: Our Daily Lives, the Spaces We Shape, and the Ways We Communicate, as Seen Through the Collections of Cooper-Hewitt, National Design Museum* (exhibition catalog). New York: Cooper-Hewitt, National Design Museum, Smithsonian Institution, 1997.

Film

Alton, John. *Painting with Light.* Berkeley: University of California Press, 1995.

Barsam, Richard Meran. *Nonfiction Film: A Critical History.* Bloomington: Indiana University Press, 1992.

Basinger, Jeanine. *A Woman's View: How Hollywood Spoke to Women, 1930–1960.* New York: Alfred A. Knopf, 1993.

Bordwell, David, Janet Staiger, and Kristin Thompson. *The Classical Hollywood Cinema: Film Style and Mode of Production to 1960.* New York: Columbia University Press, 1985.

Curtis, David. *Experimental Cinema.* New York: Universe Books, 1971.

Ellis, Jack C. *A History of Film.* Englewood Cliffs, New Jersey: Prentice-Hall, 1979.

Gitt, Robert, et al. *American Movie Makers: The Dawn of Sound* (exhibition catalog). New York: The Museum of Modern Art, 1989.

Guerrero, Ed. *Framing Blackness: The African American Image in Film.* Philadelphia: Temple University Press, 1993.

Haines, Richard W. *Technicolor Movies: The History of Dye Transfer Printing.* Jefferson, North Carolina: McFarland, 1993.

Heisner, Beverly. *Hollywood Art: Art Direction in the Days of the Great Studios.* Jefferson, North Carolina: McFarland, 1990.

Kaplan, E. Ann, ed. *Women in Film Noir.* London: British Film Institute, 1978.

Kendall, Elizabeth, *The Runaway Bride: Hollywood Romantic Comedy of the 1930s.* New York: Alfred A. Knopf, 1990.

Koszarski, Richard. *An Evening's Entertainment: The Age of the Silent Feature Film, 1915–1928.* New York: Scribner, 1990.

Leff, Leonard J., and Jerold L. Simmons. *The Dame in the Kimono: Hollywood, Censorship, and the Production Code from the 1920s to the 1960s.* New York: Grove Weidenfeld, 1990.

May, Lary. *Screening Out the Past: The Birth of Mass Culture and the Motion Picture Industry.* Chicago: University of Chicago Press, 1983.

Pirie, David, ed. *Anatomy of the Movies.* New York: Macmillan, 1981.

Rabinovitz, Lauren. *Points of Resistance: Women, Power and Politics in the New York Avant-Garde Cinema, 1943–1971.* Urbana: University of Illinois Press, 1991.

Ritchie, Michael. *Please Stand By: A Prehistory of Television*. Woodstock, New York: Overlook Press, 1994.

Salt, Barry. *Film Style and Technology: History and Analysis*. 2nd ed. London: Starwood, 1992.

Schatz, Thomas. *Hollywood Genres: Formulas, Filmmaking, and the Studio System*. New York: Random House, 1981.

Silver, Alain, and James Ursini, eds. *Film Noir Reader*. New York: Proscenium, 1996.

Sitney, P. Adams. *Visionary: The American Avant-Garde*. 2nd ed. New York: Oxford University Press, 1979.

Sklar, Robert. *Movie-Made America: A Social History of American Movies* (1975). Rev. ed. New York: Vintage Books, 1994.

Youngblood, Gene. *Expanded Cinema*. New York: E. P. Dutton, 1970.

Zierold, Norman J. *Sex Goddesses of the Silent Screen*. Chicago: Henry Regnery, 1973.

Literature

Abel, Lionel. *The Intellectual Follies: A Memoir of the Literary Venture in New York and Paris*. New York: W. W. Norton, 1984.

Allen, Frederick Lewis. *Only Yesterday: An Informal History of the Nineteen-Twenties* (1931). Reprt. New York: Harper & Row, 1957.

Andrews, William L., ed. *The African-American Novel in the Age of Reaction: Three Classics*. New York: Mentor, 1992.

Baker, Houston A., Jr. *Blues, Ideology, and Afro-American Literature: A Vernacular Theory*. Chicago: University of Chicago Press, 1984.

Bruce, Dickson D. *Black American Writing from the Nadir: The Evolution of a Literary Tradition, 1877–1915*. Baton Rouge: Louisiana State University Press, 1989.

Hoffman, Frederick J. *The Twenties: American Writing in the Postwar Decade*. New York: Viking Press, 1955.

Kellner, Bruce, ed. *The Harlem Renaissance: A Historical Dictionary for the Era* (1984). Reprt. New York: Methuen, 1987.

Lewis, David Levering. *When Harlem Was in Vogue*. New York: Alfred A. Knopf, 1981.

Michaels, Walter Benn. *Our America: Nativism, Modernism, and Pluralism*. Durham: Duke University Press, 1995.

The Norton Anthology of African American Literature. Edited by Henry Louis Gates, Jr., and Nellie Y. McKay. New York: W. W. Norton, 1996.

The Norton Anthology of American Literature. Edited by Nina Baym et al. New York: W. W. Norton, 1994.

Music

Berlin, Edward A. *Ragtime: A Musical and Cultural History*. Berkeley: University of California Press, 1980.

Block, Geoffrey Holden. *Enchanted Evenings: The Broadway Musical from "Show Boat" to Sondheim*. New York: Oxford University Press, 1997.

Chase, Gilbert. *America's Music: From the Pilgrims to the Present*. Foreword by Richard Crawford; discographical essay by William Brooks. 3rd ed. Urbana: University of Illinois Press, 1987.

DeVeaux, Scott. *The Birth of Bebop: A Social and Musical History*. Berkeley: University of California Press, 1997.

Floyd, Samuel A., Jr., ed. *Black Music in the Harlem Renaissance: A Collection of Essays*. New York: Greenwood Press, 1990.

Furia, Philip. *The Poets of Tin Pan Alley: A History of America's Greatest Lyricists*. New York: Oxford University Press, 1990.

George, Nelson. *The Death of Rhythm and Blues*. New York: Pantheon Books, 1988.

Gitler, Ira. *Swing to Bop: An Oral History of the Transition in Jazz in the 1940s*. New York: Oxford University Press, 1985.

Hamm, Charles. *Music in the New World*. New York: W. W. Norton, 1983.

Harrison, Daphne Duval. *Black Pearls: Blues Queens of the 1920s*. New Brunswick, New Jersey: Rutgers University Press, 1988.

Hennessey, Thomas J. *From Jazz to Swing: African-American Jazz Musicians and Their Music, 1890–1935*. Detroit: Wayne State University Press, 1994.

Mellers, Wilfrid. *Music in a New Found Land: Themes and Developments in the History of American Music*. New York: Oxford University Press, 1987.

Schuller, Gunther. *Early Jazz: Its Roots and Musical Development*. New York: Oxford University Press, 1989.

Schwartz, Elliott, and Daniel Godfrey. *Music Since 1945: Issues, Materials, and Literature*. New York: Schirmer Books, 1993.

Shaw, Arnold. *Honkers and Shouters: The Golden Years of Rhythm and Blues*. New York: Macmillan, 1978.

———. *The Jazz Age: Popular Music in the 1920s*. New York: Oxford University Press, 1987.

Southern, Eileen. *The Music of Black Americans: A History*. New York: W. W. Norton, 1997.

Stowe, David. *Swing Changes: Big-Band Jazz in New Deal America*. Cambridge, Massachusetts: Harvard University Press, 1994.

Wilder, Alec. *American Popular Song: The Great Innovators, 1900–1950*. New York: Oxford University Press, 1972.

Zuck, Barbara. *A History of Musical Americanism*. Ann Arbor, Michigan: UMI Research Press, 1978.

Theater

Bordman, Gerald. *American Musical Theatre*. 2nd ed. New York: Oxford University Press, 1992.

Erenberg, Lewis. *Steppin' Out: New York Nightlife and the Transformation of American Culture, 1890–1930*. Chicago: University of Chicago Press, 1984.

Fields, Armond, and L. Marc Fields. *From the Bowery to Broadway: Lew Fields and the Roots of American Popular Theatre*. New York: Oxford University Press, 1993.

Goldstein, Malcolm. *The Political Stage: American Drama and Theater of the Great Depression*. New York: Oxford University Press, 1974.

McArthur, Benjamin. *Actors and American Culture, 1880–1920*. Philadelphia: Temple University Press, 1984.

Miller, Jordan Y., and Winifred L. Frazer. *American Drama Between the Wars: A Critical History*. Boston: Twayne, 1991.

Murphy, Brenda. *American Realism and American Drama, 1880–1940*. New York: Cambridge University Press, 1987.

Nasaw, David. *Going Out: The Rise and Fall of Public Amusements*. New York: Basic Books, 1993.

Riis, Thomas L. *Just Before Jazz: Black Musical Theater in New York, 1890–1915*. Washington, D.C.: Smithsonian Institution Press, 1989.

Snyder, Robert W. *The Voice of the City: Vaudeville and Popular Culture in New York*. New York: Oxford University Press, 1989.

Swain, Joseph P. *The Broadway Musical: A Critical and Musical Survey*. New York: Oxford University Press, 1990.

Toll, Robert C. *On with the Show! The First Century of Show Business in America*. New York: Oxford University Press, 1976.

Valgamae, Mardi. *Accelerated Grimace: Expressionism in American Drama of the 1920s*. Carbondale: Southern Illinois University Press, 1972.

Wainscott, Ronald Harold. *The Emergence of the Modern American Theater, 1914–1929*. New Haven: Yale University Press, 1997.

Woll, Allen L. *Black Musical Theatre: From Coontown to Dreamgirls* (1989). Reprt. New York: Da Capo Press, 1991.

Notes on Contributors

Mindy Aloff is the dance critic for *The New Republic*. She has written frequently on dance, literature, music, and the visual arts for *The New York Times*, *The New Yorker*, *Parnassus*, *The Nation*, and *The Village Voice*, among other national and international publications. Her essay on dance photography was recently published in *The International Encyclopedia of Dance* (1997).

May Castleberry is librarian and associate curator for Special Collections at the Whitney Museum of American Art. Among the exhibitions she has organized for the Museum are "Rockwell Kent by Night" (1997), "Perpetual Mirage: Photographic Narratives of the Desert West" (1996), and "Fables, Fantasies, and Everyday Things" (1992). As editor of the Museum's Artists and Writers Series, she has published seventeen fine-press publications, including *The Magic Magic Book* (1994), *Mesa Verde* (1992), and *The First Picture Book* (1991).

Ann Charters is professor of English at the University of Connecticut and a specialist in the short story and the Beat writers. She has published extensively on the work of Jack Kerouac and has edited numerous anthologies of short fiction. Her photographs of the Beat writers and blues musicians have been exhibited at Columbia University (1983), the Gotham Book Mart (1986), and Brown University (1990).

Scott DeVeaux is associate professor in the McIntire Department of Music at the University of Virginia. His book *The Birth of Bebop: A Social and Musical History* (1997) won several awards, including the ASCAP-Deems Taylor Award and the American Musicological Society's Otto Kinkeldey Award. He is also co-editor, with William H. Kenney III, of *The Music of James Scott* (1992). He writes and lectures frequently on the history of jazz, bebop, and the recording industry.

Ann Douglas is Parr Professor of Comparative Literature at Columbia University. Her books include *Terrible Honesty: Mongrel Manhattan in the 1920s* (1995) and *The Feminization of American Culture* (1977). She is a frequent contributor on literature, music, theater, and culture to *The New York Times* and is currently working on *If You Live You Burn*, a study of Cold War culture in the United States, 1939–65, scheduled for publication in 2002.

Peter Gibian teaches courses on American literature, mass culture, and critical theory at McGill University, Montreal, where he is associate professor in the English department. He edited an anthology of essays on North American popular culture, *Mass Culture and Everyday Life* (1997), and has completed the forthcoming book *Oliver Wendell Holmes and the Culture of Conversation*.

Tom Gunning is professor of film studies in the University of Chicago art department. His many publications on the invention, early history, and theory of American, French, and Russian cinema include *Early Cinema and the Attractions of Modernity* (1997) and *D. W. Griffith and the Origins of American Narrative Film: The Early Years at Biograph* (1991), as well as essays on the films of Buster Keaton and Jean Renoir, and film noir.

Charles Hamm is Arthur R. Virgin Professor Emeritus at Dartmouth College and a past president of the American Musicological Society. He is the author of *Music in the New World* (1983) as well as studies on Irving Berlin, John Cage, George Gershwin, and contemporary popular music of South Africa and China.

Phillip Brian Harper is professor of English and American Studies at New York University. He is the author of *Are We Not Men? Masculine Anxiety and the Problem of African-American Identity* (1996) and *Framing the Margins: The Social Logic of Postmodern Culture* (1994).

Wendy Kaplan is associate director, exhibitions and curatorial affairs, at The Wolfsonian–Florida International University. She has authored and edited numerous publications on the decorative arts, including *Charles Rennie Mackintosh* (1996), *Designing Modernity: The Arts of Reform and Persuasion, 1885–1945* (1995), and *"The Art That Is Life": The Arts and Crafts Movement in America, 1875–1920* (1987).

Peter Ohlin is professor of English and American literature at McGill University, Montreal. He is author of *Colours, Dreams, Shadows: The Narrative Crisis in the Self-Reflexive Film, 1960–1970* (1979), *Agee* (1966), and articles on American literature, Ingmar Bergman, and the cinema.

Nicholas Olsberg is chief curator at the Centre Canadien d'Architecture/Canadian Centre for Architecture, Montreal. He authored *Breuer's Whitney: An Anniversary Exhibition, Whitney Museum of American Art* (1996) and contributed an introduction to *Frank Lloyd Wright: Designs for an American Landscape, 1922–1932* (1996). He worked with Martin Carrier to prepare his contributions to this volume.

Derek Ostergard is associate director and founding dean of The Bard Graduate Center for Studies in the Decorative Arts, New York. He has authored numerous publications and curated exhibitions on nineteenth- and twentieth-century decorative arts and design for the American Federation of the Arts, the American Craft Museum, and The Bard Graduate Center.

Vera Roberts is Distinguished Professor Emeritus at Hunter College and the Graduate Center of the City University of New York. She has published three books and dozens of articles about theater and currently edits *The Journal of American Drama and Theatre*. She was one of the original founders of Arena Stage, Washington, D.C.

Robert Sklar is professor of cinema at the Tisch School of the Arts, New York University. He is the author of numerous studies on the history of film, including *City Boys: Cagney, Bogart, Garfield* (1992), *Film: An International History of the Medium* (1993), and *Movie-Made America: A Cultural History of American Movies* (1975; revised 1994).

Sally Sommer is professor of dance at Duke University. She is the author, with Margaret Harris, of *La Loie: The Life and Art of Loie Fuller* (1989) and *Feet, Talk to Me! One Hundred Years of Tap Dance* (1985). She is a regular contributor to *Dance Review* and *Dance Ink* and served as creative consultant to the "Great Performances: Dance in America" television series (1991).

Jon Spayde is a fiction writer, poet, and journalist. A former senior editor and now contributing editor at *Utne Reader*, he writes on popular culture, literature, and art. His fiction has appeared in *Spindrift* and the *Harvard Review*.

Kevin Stayton is department head and curator of decorative arts at the Brooklyn Museum of Art and adjunct professor at The Bard Graduate Center for Studies in the Decorative Arts, New York. He is a specialist in American decorative arts, particularly of the nineteenth century, and has curated numerous exhibitions, including "Converging Cultures: Art and Identity in Spanish America" (1996). His recent publications include *Dutch by Design: Tradition and Change in Two Historic Brooklyn Houses* (1990).

Judith Tick is professor of music at Northeastern University. Her articles and books on the history of American music and on women in music include *Ruth Crawford Seeger: A Composer's Search for American Music* (1997) and the co-edited anthology *Women Making Music: The Western Art Tradition, 1150–1950* (1987). She is a member of the board of principal advisors for *The New Grove Dictionary of American Music* and is associate editor of *Musical Quarterly*.

Jonathan Warren teaches nineteenth- and twentieth-century literature in the department of English at the University of Toronto. He is co-editor with Deborah Esch of the forthcoming Norton Critical Edition of Henry James' *The Turn of the Screw*. He has published on James and Marcel Proust and on historical lexicography and philology.

Don Wilmeth is Asa Messer Professor and professor of theater and English in the department of theater, speech, and dance at Brown University. He is the author, editor, or co-editor of numerous books, most recently *Staging the Nation: Plays from the American Theater, 1787–1909* (1998) and *The Cambridge Guide to American Theatre* (1993). He has been a consultant to television documentary projects on vaudeville, minstrelsy, and the history of American theater.

Matthew Yokobosky is an exhibition designer and curator specializing in film, video installation, and performance. At the Whitney Museum of American Art, he designed "Joseph Stella" (1994) and "The 1995 Biennial Exhibition" (1995) and curated "No Wave Cinema, '78–'87" (1996), which toured internationally. He was the design consultant and film and video curator for "The American Century: Art and Culture 1900–1950" and is also known as a designer of numerous theatrical productions.

Acknowledgments

A book of this scope necessarily requires the contributions of many people. Over the past three years, I have received invaluable counsel and advice from the following friends and colleagues: William Agee, Matthew Baigell, Rosemarie Haag Bletter, George Boziwick, John Carlin, Wanda Corn, Ann Douglas, Susan Ehrens, Tom Gunning, David Hanks, Neil Harris, Patricia Hills, Glenn Horowitz, Margo Jefferson, Wendy Kaplan, Robin Kelley, Elizabeth Kendall, T.J. Jackson Lears, Michael Leja, William E. Leuchtenburg, Richard Marschall, Robert Marx, Donald E. McCormick, Madeleine Nichols, Chon Noriega, Carol Oja, Nicholas Olsberg, Robert G. O'Meally, Derek Ostergard, Christopher Phillips, Richard Powell, Leland Rice, Naomi Rosenblum, Robert Sklar, Kevin Stayton, Sally Stein, Robert N. Taylor, Judith Tick, Alan Trachtenberg, Jonathan Weinberg, Deborah Willis, Peter Wollen, and Rebecca Zurier. A number of these advisers contributed essays to this book. To them and to the other authors who lent their knowledge and literary grace to the publication, I am truly grateful.

I am also indebted to the other scholars whose publications laid the foundation for this manuscript: Bruce Bustard, Keith Davis, Marianne Doezema, Erika Doss, Jonathan Fineberg, Carl Fleishhauer, James Guimond, William Innes Homer, Susan Larsen, Karal Ann Marling, Elizabeth Milroy, Gerald Monroe, Francis Naumann, Stephen Polcari, W. Jackson Rushing, Martica Sawin, Gail Stavitsky, Patrick Stewart, William Stott, Warren Susman, Dickran Tashjian, Ellen Wiley Todd, H. Barbara Weinberg, and Cecile Whiting.

This book would not have been realized without the Publications Department of the Whitney Museum and Jim Mairs of W. W. Norton, who guided the project with remarkable grace through its many potential hazards. Katy Homans produced an original and elegant book design under conditions made all the more difficult by compressed deadlines. Leon Botstein and Elizabeth Dunbar likewise gave valuable advice in clarifying aspects of the manuscript. The financial commitment made early on to the publication by Susan and Edwin Malloy expressed a faith in the project and enabled us to achieve our amibitious goals.

To all of these individuals, I am deeply indebted. But my greatest debt is to the project's core staff—Susan Cooke, Elizabeth Dunbar, Anne Wehr, and Tamara Bloomberg—for the central role they played in researching, selecting and procuring loans, and organizing all other facets of the project. The successful realization of this publication and exhibition is unimaginable without their intelligence, diligence, and grace under pressure. They were joined in the project's initial stage by Elizabeth Gibbens and Ann Sass. This core group guided the work of a number of temporary assistants, including Gwendolyn Allday, Elizabeth D'Agostino, Annie Gally, Judith Gura, Duane Hanson, Jr., Heather Horton, Paul Krasnow, Carrianne Mack, Maggie Simonelli Manderson, Seema Reddy, Sydelle Rubin, Jane Schoelkopf, Christine Smith-Moog, and Roberta Tryon. My gratitude likewise goes to my colleagues in other Museum departments, on whose gracious support this exhibition depended, especially Willard Holmes, deputy director and chief operating officer, Susan Courtemanche, former associate director for external affairs, Matthew Yokobosky, consulting curator, Kathryn Potts, head of Adult Programs, and Chris Mueller and Lana Hum, who developed a thoughtful and sensitive installation design.

All exhibitions rely on the generosity of public and private collectors, but the scope of this project made this generosity all the more exigent. I am deeply grateful for the support the project has received both from public institutions and private lenders, who relinquished important pieces in order to share them with the public.

The collaboration of Intel Corporation in this project enabled the Whitney Museum to realize this huge, massively scaled, interdisciplinary survey. I am immensely grateful to Intel chairman Andrew S. Grove and his staff, Dana Houghton, Kevin Teixeira, Ralph Bond, and Vince Thomas, for their willingness to turn the company's commitment to the future into a celebration of American art and for working with us to bring *The American Century* to an international audience through the Internet.

This celebration was kept on track by the support and active involvement of Leonard A. Lauder, chairman of the Whitney Museum Board of Trustees; David A. Ross, now director of the San Francisco Museum of Modern Art, who initiated the project while director of the Whitney Museum; and current Whitney Museum director Maxwell L. Anderson, who guided *The American Century* to completion.

Finally, I would like to thank those who lovingly supported my absorption in an undertaking that required more effort and extended over a longer period than anyone anticipated. To them, especially Clara and Max, I dedicate this book.

PHOTOGRAPH AND REPRODUCTION CREDITS

America in the Age of Confidence, 1900–1919

2/4/5 © Collection of The New-York Historical Society. **7** Photograph © Hunt Commercial Photography. All Rights Reserved. **8** Geoffrey Clements. **13** Marianne Gurley. **14** Erik Gould. **15** Reprinted with permission of Joanna T. Steichen; photograph © The Metropolitan Museum of Art, New York. All Rights Reserved. **16** Cooper-Hewitt, National Design Museum, Smithsonian Institution/Art Resource, New York; photograph Ken Pelka. **18** Photograph © 1998 ASaP of Holderness, New Hampshire. **22** Photograph © 1998 The Museum of Modern Art, New York. **24** Photograph © The Metropolitan Museum of Art, New York. All Rights Reserved. **25** Photograph © 1993 The Metropolitan Museum of Art, New York. **26** Photograph © 1994 The Metropolitan Museum of Art, New York. **27** Estate of Robert Henri; photograph Geoffrey Clements. **29** Photograph © Worcester Art Museum, Massachusetts. **31** Photograph © 1998 Museum of Fine Arts, Boston. All Rights Reserved. **32** Photograph © 1995 The Metropolitan Museum of Art, New York. **33** © The Corcoran Gallery of Art, Washington, D.C. **35** Photograph Lyle Peterzell © 1998 Board of Trustees, National Gallery of Art, Washington, D.C. **36** Victor Pustai. **37** Photograph Jose A. Naranjo © 1998 Board of Trustees, National Gallery of Art, Washington, D.C. **40** Geoffrey Clements. **44** Sheldan C. Collins. **46** Graydon Wood. **47** John White, courtesy American Craft Museum. **48** Geoffrey Clements. **51** Photograph © 1994 Andrew Smith Gallery, Santa Fe. **54** Geoffrey Clements. **56** © Reiko Sunami Kopelson; photograph Geoffrey Clements. **58** Sheldan C. Collins. **59** Cooper-Hewitt, National Design Museum, Smithsonian Institution/Art Resource, New York. **60** Photograph © 1998 Museum Associates, Los Angeles County Museum of Art. All Rights Reserved. **62** Ezra Stoller © Esto. **65** Photograph © 1988 The Metropolitan Museum of Art, New York. **67** Photograph © 1998 Trustees of Princeton University, New Jersey. **69** Reprinted with permission of Joanna T. Steichen; photograph © The Metropolitan Museum of Art, New York. All Rights Reserved. **70** Photograph © The Metropolitan Museum of Art, New York. All Rights Reserved. **71** Photograph © 1998 The Museum of Modern Art, New York. **76** © 1981 Center for Creative Photography. Arizona Board of Regents. **77** Photograph © The Metropolitan Museum of Art, New York. All Rights Reserved. **79** Geoffrey Clements. **80** Photograph © 1998 Board of Trustees, National Gallery of Art, Washington, D.C. **82** Geoffrey Clements. **83** © 1983 Amon Carter Museum, Fort Worth, Texas. **85** Reprinted with permission of Joanna T. Steichen; photograph © 1989 The Metropolitan Museum of Art, New York. All Rights Reserved. **86** Reprinted with permission of Joanna T. Steichen; photograph Ron Gordon. **87** Photograph © 1998 The Art Institute of Chicago. All Rights Reserved. **88** UPI/Corbis-Bettmann, New York. **89/90** © Collection of the New-York Historical Society. **91** © The Architectural Archives of the University of Pennsylvania. **93** Photograph © 1998 Board of Trustees, National Gallery of Art, Washington, D.C. **94** Geoffrey Clements. **95** © 1971 Aperture Foundation, Inc., Paul Strand Archive, Millerton, New York; photograph Geoffrey Clements. **97** © 1983 Aperture Foundation, Inc., Paul Strand Archive, Millerton, New York. **98** Sandak/Macmillan Publishing Company. **99** Photograph © The Metropolitan Museum of Art, New York. All Rights Reserved. **101** Joseph Painter. **102** Photograph © The Metropolitan Museum of Art, New York. All Rights Reserved. **103** G. H. Farley. **106** Photograph © The Metropolitan Museum of Art, New York. All Rights Reserved. **110** Photograph © 1987 The Detroit Institute of Arts. **112** Photograph © 1998 The Art Institute of Chicago. All Rights Reserved. **113/115** Geoffrey Clements. **116/118** Sheldan C. Collins. **121** Estate of Robert Henri; photograph © Wichita Art Museum, Kansas. **122** Estate of Robert Henri. **123** Geoffrey Clements. **125** Sheldan C. Collins. **127** Geoffrey Clements. **128** Photograph © Addison Gallery of American Art, Phillips Academy, Andover, Massachusetts. All Rights Reserved. **129** Lee Stalsworth. **134** Photograph © 1998 The Museum of Modern Art, New York. **136/137/138/ 139/141/144/146** Geoffrey Clements. **147** Photograph © 1998 Museum of Fine Arts, Boston. All Rights Reserved. **148** Photograph © The Chrysler Museum of Art, Norfolk, Virginia. **149** Geoffrey Clements. **150** Estate of Robert Henri; photograph Peter Accettola. **151** Greg Herns. **152/157** Sheldan C. Collins. **158** Ben Blackwell. **159** Photograph © The Metropolitan Museum of Art, New York. All Rights Reserved. **161** Library of Congress LC-USZ62-46392. **163** Photograph © Museum of the City of New York.

165/166 © 1971 Aperture Foundation, Inc., Paul Strand Archive, Millerton, New York. **167** Photograph © Museum of the City of New York. **173** Photograph © The Metropolitan Museum of Art, New York. All Rights Reserved. **175** Geoffrey Clements. **180** Photograph © 1998 The Museum of Modern Art, New York. **181** Jerry L. Thompson. **182** Geoffrey Clements. **183** Sandak/Macmillan Publishing Company. **184** © 1999 The Georgia O'Keeffe Foundation/Artists Rights Society (ARS), New York; photograph © 1998 Board of Trustees, National Gallery of Art, Washington, D.C. **185** © 1999 The Georgia O'Keeffe Foundation/ Artists Rights Society (ARS), New York; photograph Geoffrey Clements. **186/190/192/195/ 196/197** Geoffrey Clements. **198** Malcolm Varon. **199** Photograph © 1998 The Art Institute of Chicago. All Rights Reserved. **201/203** Sheldan C. Collins. **204** Photograph © 1985 The Metropolitan Museum of Art, New York. **206/209** Sheldan C. Collins. **212** Geoffrey Clements. **213** Photograph © The Metropolitan Museum of Art, New York. All Rights Reserved. **214** © 1999 Artists Rights Society (ARS), New York/ADAGP, Paris; photograph D. James Dee. **216** © 1999 Man Ray Trust/Artists Rights Society, New York/ADAGP, Paris. **221** © 1999 Man Ray Trust/Artists Rights Society, New York/ADAGP, Paris; photograph Geoffrey Clements. **222** © 1999 Man Ray Trust/Artists Rights Society, New York/ADAGP, Paris; photograph Thomas R. DuBrock. **223** © 1999 Man Ray Trust/Artists Rights Society, New York/ADAGP, Paris. **224** © 1999 Man Ray Trust/Artists Rights Society, New York/ADAGP, Paris; photograph David Allison. **225/226/ 227** © 1999 Man Ray Trust/Artists Rights Society, New York/ADAGP, Paris. **228** Geoffrey Clements. **229** Steven Sloman. **230** Robert E. Mates. **231** © 1976 Aperture Foundation, Inc., Paul Strand Archive, Millerton, New York; photograph © The Metropolitan Museum of Art, New York. All Rights Reserved. **233** © 1971 Aperture Foundation, Inc., Paul Strand Archive, Millerton, New York; photograph © 1998 The Art Institute of Chicago. All Rights Reserved. **234** Photograph © 1998 The Art Institute of Chicago. All Rights Reserved.

Jazz Age America, 1920–1929

235 Sarah Wells. **236** Granger Collection. **237** Culver Pictures. **238** Sheldan C. Collins. **240** Geoffrey Clements. **242** Photofest. **243** UPI/Corbis-Bettmann, New York. **246** © 1983 Amon Carter Museum, Fort Worth, Texas. **247** Reprinted with permission of Joanna T. Steichen. **248** © Andrew Bordwin. **251** © 1998 The Frank Lloyd Wright Foundation, Scottsdale, Arizona. **253** Sandak/G. K. Hall. **255** Reprinted with permission of Joanna T. Steichen. **258** Sheldan C. Collins. **259** Cooper-Hewitt, National Design Museum, Smithsonian Institution/Art Resource, New York; photograph Dave King. **260** Cathy Carver. **264** Photograph © 1980 The Metropolitan Museum of Art, New York. **267** Michael Agee. **268** Geoffrey Clements. **269/270/271** Sandak/Macmillan Publishing Company. **272** Photograph © 1998 The Museum of Modern Art, New York. **273** Photograph © The Cleveland Museum of Art. **274** Peter Accettola. **275/276** Geoffrey Clements. **277** Jerry L. Thompson. **279** Cooper-Hewitt, National Design Museum, Smithsonian Institution/Art Resource, New York. **280** Cooper-Hewitt, National Design Museum, Smithsonian Institution/Art Resource, New York. **281** © 1999 The Georgia O'Keeffe Foundation/Artists Rights Society (ARS), New York; photograph © 1998 The Art Institute of Chicago. All Rights Reserved. **286** Estate of Margaret Bourke-White. **287** Estate of Margaret Bourke-White; photograph © The Museum of Modern Art, New York. **289** Photograph © 1998 The Art Institute of Chicago. All Rights Reserved. **290** Geoffrey Clements. **291** Sheldan C. Collins. **293** Estate of Elsie Driggs; photograph Geoffrey Clements. **294/295** Geoffrey Clements. **296** © 1971 Aperture Foundation, Inc., Paul Strand Archive, Millerton, New York. **297** © G. Ray Hawkins Gallery, Santa Monica. **298** © Ralph Steiner Estate; photograph © 1998 The Art Institute of Chicago. All Rights Reserved. **302** Steven Sloman. **303** D. James Dee. **305** © 1981 Center for Creative Photography. Arizona Board of Regents. **306** M. Lee Fatherree. **307** © Trustees of the Ansel Adams Publishing Rights Trust; photograph © 1998 The Art Institute of Chicago. All Rights Reserved. **308** © Arthur Noskowiak. **309** Ben Blackwell. **Page 166** The lines from "I will be" copyright 1923, 1925, 1951, 1953, © 1991 by the Trustees for the E. E. Cummings Trust. Copyright © 1976 by George James Firmage, from *Complete Poems: 1904–1962* by E. E. Cummings, Edited by George James Firmage. Reprinted by permission of Liveright Publishing Corporation. **310** Used by permission of Scribner, a Division of Simon & Schuster. **311** Geoffrey Clements. **312** Courtesy of The Estate of Irving Berlin. **314** Courtesy Warner Brothers. **315/316** Honoria Murphy

Donnelly; photograph © 1998 Dallas Museum of Art. All Rights Reserved. **317** Honoria Murphy Donnelly; photograph Geoffrey Clements. **318** Photograph © 1996 The Metropolitan Museum of Art, New York. **319/320** © Estate of Stuart Davis/Licensed by VAGA, New York, NY; photograph © 1998 The Museum of Modern Art, New York. **321** © Estate of Stuart Davis/Licensed by VAGA, New York, NY; photograph Sheldan C. Collins. **322** Bill Jacobson. **323/324** © Ralph Steiner Estate. **325** Geoffrey Clements. **326** © Ralph Steiner Estate. **328/329** © G. Ray Hawkins Gallery, Santa Monica. **330/331** Reprinted with permission of Joanna T. Steichen. **332** © 1925 (renewed 1953, 1981) The Condé Nast Publications, Inc. **333** Photograph © 1998 Museum of Fine Arts, Boston. All Rights Reserved. **334** © 1927 (renewed 1955, 1983) The Condé Nast Publications, Inc. **336** Geoffrey Clements. **337** Photograph © 1998 Dallas Museum of Art. All Rights Reserved. **338** Bill Jacobson. **339** Photograph Michael Tropea © 1997 Des Moines Art Center. **341** The Estates of Yvonne Pène du Bois McKenney and William Pène du Bois; photograph Geoffrey Clements. **342** The Estates of Yvonne Pène du Bois McKenney and William Pène du Bois; photograph © 1989 The Metropolitan Museum of Art, New York. **343** Geoffrey Clements. **344** © T.H. Benton and R.P. Benton Testamentary Trusts/Licensed by VAGA, New York, NY; photograph Robert E. Mates. **346/347** Corbis-Bettmann, New York. **348** Frank Driggs/Corbis-Bettmann, New York. **352** Courtesy Warner Brothers. **354** Used by permission of HarperCollins, Publishers, Inc. **355** Used by permission of HarperCollins, Publishers, Inc. **356** Sheldan C. Collins. **357** © Donna M. VanDerZee; photograph D. James Dee. **359** © Donna M. VanDerZee; photograph M. Lee Fatherree. **360/361** © Donna M. VanDerZee; photograph D. James Dee. **363** Robert E. Mates. **365** Geoffrey Clements. **366** Sheldan C. Collins. **367** Reprinted by permission of Alfred A. Knopf, Inc. **368** Manu Sassoonian. **369** © 1927 The Viking Press, Inc., renewed © 1955 by Grace Nail Johnson. Used by permission of Viking Penguin, a division of Penguin Putnam Inc. **371** Manu Sassoonian. **373** Geoffrey Clements. **375** © Archie Motley. **376** Photograph © 1998 Board of Trustees, National Gallery of Art, Washington, D.C. **377** Jerry L. Thompson. **378** Sheldan C. Collins. **379** © 1999 The Georgia O'Keeffe Foundation/Artists Rights Society (ARS), New York; photograph Geoffrey Clements. **381** Robert E. Mates. **382** Courtesy of the Rockwell Kent Legacies; photograph Geoffrey Clements. **383** © 1999 The Georgia O'Keeffe Foundation/Artists Rights Society (ARS), New York; photograph Steven Sloman. **384** Steven Sloman. **387/388** © 1981 Center for Creative Photography. Arizona Board of Regents. **390** Ben Blackwell. **391** Photograph © 1998 Board of Trustees, National Gallery of Art, Washington, D.C. **392** Steven Sloman. **394** Jerry L. Thompson. **395** Ben Blackwell. **396** Photograph © 1998 Museum of Fine Arts, Boston. All Rights Reserved. **397** © 1999 Man Ray Trust/Artists Rights Society, New York/ADAGP, Paris. **398** © 1981 Center for Creative Photography. Arizona Board of Regents. **399** © 1981 Center for Creative Photography. Arizona Board of Regents; photograph © 1998 Museum of Fine Arts, Boston. **400** © 1981 Center for Creative Photography. Arizona Board of Regents; photograph © 1998 The Art Institute of Chicago. All Rights Reserved. **402** Sandak/Macmillan Publishing Company. **403/404** Geoffrey Clements. **405** Roy Elkind. **407** Robert E. Mates. **408** © 1971 Aperture Foundation, Inc., Paul Strand Archive, Millerton, New York; photograph Dean Beasom © 1998 Board of Trustees, National Gallery of Art, Washington, D.C. **409** © 1999 The Georgia O'Keeffe Foundation/Artists Rights Society (ARS), New York; photograph Steven Sloman. **410** Bill Jacobson. **411** © 1999 The Georgia O'Keeffe Foundation/Artists Rights Society (ARS), New York; photograph Geoffrey Clements. **412** © 1979 Amon Carter Museum, Fort Worth, Texas; photograph Rynda Lemke. **413** © 1981 Center for Creative Photography. Arizona Board of Regents; photograph © 1998 Museum of Fine Arts, Boston. All Rights Reserved. **414** Ben Blackwell. **415** © Trustees of the Ansel Adams Publishing Rights Trust; photograph © 1998 The Art Institute of Chicago. All Rights Reserved.

America in Crisis, 1930–1939

416 UPI/Corbis-Bettman. **417** © The Dorothea Lange Collection, The Oakland Museum of California, City of Oakland. Gift of Paul S. Taylor. **418/419** Geoffrey Clements. **420** Courtesy San Francisco Art Commission. **423** Reprinted with permission of Joanna T. Steichen. **424** © Time Inc. **426** Gamma One. **427** Photograph © Wichita Art Museum, Kansas. **428** © T.H. Benton and R.P. Benton Testamentary Trusts/Licensed by VAGA, New

York, NY. **429** © T.H. Benton and R.P. Benton Testamentary Trusts/Licensed by VAGA, New York, NY; photograph Robert E. Mates. **430/431/432** © T.H. Benton and R.P. Benton Testamentary Trusts/Licensed by VAGA, New York, NY. **434** © Estate of Grant Wood/Licensed by VAGA, New York, NY; photograph Sandak/Macmillan Publishing Company. **435** © Estate of Grant Wood/VAGA, New York, NY. All rights reserved by The Art Institute of Chicago and VAGA, New York, NY. **436** © Estate of Grant Wood/Licensed by VAGA, New York, NY. **437** Geoffrey Clements. **438** Photograph © Wichita Art Museum, Kansas. **442/443** Geoffrey Clements. **444** © T.H. Benton and R.P. Benton Testamentary Trusts/Licensed by VAGA, New York, NY. **445** © Reiko Sunami Kopelson; photograph Geoffrey Clements. **446** © Estate of Grant Wood/Licensed by VAGA, New York, NY; photograph © 1988 The Metropolitan Museum of Art, New York. **448** Geoffrey Clements. **452** Photograph © 1997 The Metropolitan Museum of Art, New York. **453** Courtesy of the artist and the Francine Seders Gallery, Seattle, Washington. **454** Courtesy of the artist and the Francine Seders Gallery, Seattle, Washington; photograph © 1998 The Museum of Modern Art, New York. **455** Courtesy of the artist and the Francine Seders Gallery, Seattle, Washington. **456** Manu Sassoonian. **462** © Estate of Ben Shahn/Licensed by VAGA, New York, NY; photograph Ben Blackwell. **464** Springer/Corbis-Bettmann, New York. **465** National Archives MO 70-117B. **466** National Archives 69-N-22577. **468** National Archives 96-P-1. **471** © Estate of Ben Shahn/Licensed by VAGA, New York, NY. **472** Estate of Margaret Bourke-White. **474** © Estate of Ben Shahn/Licensed by VAGA, New York, NY. **475** Photograph © The Chrysler Museum of Art, Norfolk, Virginia. **476/477** © 1942 Gordon Parks. **478** © The Estate of Marion Post Wolcott. **479** © Time Inc. **480** M. Lee Fatherree. **481** Ben Blackwell. **482** Used with permission from Ayer Company Publishers, Inc.; photograph Geoffrey Clements. **483** © The Dorothea Lange Collection, The Oakland Museum of California, City of Oakland. Gift of Paul S. Taylor; photograph Ben Blackwell. **484** Ben Blackwell. **485** © 1939, 1940 by James Agee © 1941 by James Agee and Walker Evans © renewed 1969 by Mia Fritsch Agee and Walker Evans. Reprinted by permission of Houghton Mifflin Co. All Rights Reserved; photograph Geoffrey Clements. **486** Geoffrey Clements. **487** © 1941 by Richard Wright. Reprinted by permission of John Hawkins & Associates, Inc.; photograph Geoffrey Clements. **488** © Walker Evans Archive, The Metropolitan Museum of Art, New York. **490** © Walker Evans Archive, The Metropolitan Museum of Art, New York; photograph © 1998 The Art Institute of Chicago. **491** © Walker Evans Archive, The Metropolitan Museum of Art, New York. **492** © Walker Evans Archive, The Metropolitan Museum of Art, New York; photograph Scott Hess. **493** Cover © 1939, renewed © 1967 by John Steinbeck. Used by permission of Viking Penguin, a division of Penguin Putnam Inc. **495** Excerpt from *Land of the Free* © 1938 © renewed 1966 by Archibald MacLeish. Reprinted by permission of Houghton Mifflin Co. All Rights Reserved. **496** Geoffrey Clements. **497** © Estate of Yasuo Kuniyoshi/Licensed by VAGA, New York, NY; photograph Sandak. **498** C. J. Walker. **500** Geoffrey Clements. **504** Corbis-Bettmann, New York. **505** Geoffrey Clements. **507/508** © Aaron Siskind Foundation/courtesy Robert Mann Gallery. **509** Geoffrey Clements. **510** © Estate of Raphael Soyer. All Rights Reserved. Used by permission, courtesy Forum Gallery, New York; photograph Geoffrey Clements. **511/512** Geoffrey Clements. **514** Photograph © 1998 The Museum of Modern Art, New York. **516** © Walker Evans Archive, The Metropolitan Museum of Art, New York; photograph © 1998 The Museum of Modern Art, New York. **517** © Walker Evans Archive, The Metropolitan Museum of Art, New York. **518** Photograph © Museum of the City of New York. **519** National Archives 69-ANP-1-2329-325. **520** Library of Congress LC-USF33-002679-M4. **525** © Disney Enterprises, Inc. **526** Reproduced by permission of The Modern Library, a division of Random House, Inc. **527** Used by permission of HarperCollins, Publishers, Inc. **530** Library of Congress LC-USZC2-921. **531/532** Geoffrey Clements. **533** Photograph courtesy Virginia Hagelstein Marquardt. **535** Lee Stalsworth. **536/537** Geoffrey Clements. **538** Lee Stalsworth. **539** Geoffrey Clements. **540** Gamma One. **541** Geoffrey Clements. **542** © Estate of Ben Shahn/Licensed by VAGA, New York, NY; photograph © 1999 The Museum of Modern Art, New York. **543** Sheldan C. Collins. **544** © Estate of Ben Shahn/Licensed by VAGA, New York, NY; photograph Geoffrey Clements. **545** Geoffrey Clements. **546** Sandak. **547** © 1999 Estate of Alexander Calder/Artists Rights Society (ARS), New York; photograph Jerry L. Thompson. **549** © Estate of Alice Trumbull

Mason/Licensed by VAGA, New York, NY; photograph Graydon Wood. **550** © 1999 Estate of Ad Reinhardt/Artists Rights Society (ARS), New York; photograph Geoffrey Clements. **551** Geoffrey Clements. **552** © Estate of Stuart Davis/Licensed by VAGA, New York, NY; photograph Geoffrey Clements. **553** © 1999 Estate of Alexander Calder/Artists Rights Society (ARS), New York; photograph Jerry L. Thompson. **554** © Estate of Ilya Bolotowsky/Licensed by VAGA, New York, NY; photograph Geoffrey Clements. **555** © 1999 Willem de Kooning Revocable Trust/Artists Rights Society (ARS), New York; photograph Geoffrey Clements. **556** Geoffrey Clements. **557** © 1999 Estate of Arshile Gorky/Artists Rights Society (ARS), New York; photograph © 1998 Board of Trustees, National Gallery of Art, Washington, D.C. **558/559** © 1999 Estate of Arshile Gorky/Artists Rights Society (ARS), New York; photograph Geoffrey Clements. **560/561** Geoffrey Clements. **564** Photograph © 1998 The Museum of Modern Art, New York. **565** © Estate of Burgoyne Diller/Licensed by VAGA, New York, NY; photograph Geoffrey Clements. **566/567** Geoffrey Clements. **568** © 1998 The Frank Lloyd Wright Foundation, Scottsdale, Arizona. **570** Photograph David Heald © The Solomon R. Guggenheim Foundation, New York. **571** Photograph Ellen Labenski © The Solomon R. Guggenheim Foundation, New York. **573** Tom Jenkins. **574** Estate of Theodore Roszak; photograph Geoffrey Clements. **575** © 1999 Artists Rights Society (ARS), New York/VG Bild-Kunst, Bonn; photograph Geoffrey Clements. **576** © 1999 Artists Rights Society (ARS), New York/VG Bild-Kunst, Bonn; photograph © 1998 The Cleveland Museum of Art. **577** Estate of Theodore Roszak; photograph Ben Blackwell. **578** Ben Blackwell. **579** The Museum of Modern Art, New York. All Rights Reserved. **581** Estate of Margaret Bourke-White. **582** Estate of Margaret Bourke-White; photograph © 1998 The Museum of Modern Art, New York. **584** Cooper-Hewitt, National Design Museum, Smithsonian Institution/Art Resource, New York. **585/586** Sheldan C. Collins. **587** Cooper-Hewitt, National Design Museum, Smithsonian Institution/Art Resource, New York; photograph Dennis Cowley. **589** Ezra Stoller © Esto. **590** Courtesy Dion Neutra. **591** Cooper-Hewitt, National Design Museum, Smithsonian Institution/Art Resource, New York; photograph Ken Pelka.

War and Its Aftermath, 1940–1949
593 Geoffrey Clements. **595** Jerry L. Thompson. **596** © Estate of George Platt Lynes. **597** Geoffrey Clements. **598** © Estate of George Platt Lynes. **599** Reproduced by permission of Martha Graham Dance Company; photograph Geoffrey Clements. **600** Courtesy of The Rodgers and Hammerstein Organization; photograph Geoffrey Clements. **601** © The Curtis Publishing Company. **602** © Estate of Ben Shahn/Licensed by VAGA, New York, NY. **605** Printed by permission of the Norman Rockwell Family Trust © 1943 Norman Rockwell Family Trust; Library of Congress LC-USZC4-1606. **606** © T.H. Benton and R.P. Benton Testamentary Trusts/Licensed by VAGA, New York, NY. **607** © Estate of David Smith/Licensed by VAGA, New York, NY. **608** Geoffrey Clements. **610** The Metropolitan Museum of Art, New York. All Rights Reserved. **611** © Time Inc. **613** © Heirs of W. Eugene Smith/Black Star. **615/616** © Time Inc. **618** Courtesy of the artist and the Francine Seders Gallery, Seattle, Washington; photograph Geoffrey Clements. **619** Robert E. Mates. **620** © 1999 Estate of Alexander Calder/Artists Rights Society (ARS), New York; photograph Jerry L. Thompson. **621** Geoffrey Clements. **622** © 1999 Estate of Alexander Calder/Artists Rights Society (ARS), New York; photograph Geoffrey Clements. **623** Robert E. Mates. **624** Geoffrey Clements. **625** © 1999 Man Ray Trust/Artists Rights Society (ARS), New York/ADAGP, Paris; photograph Geoffrey Clements. **626** Sheldan C. Collins. **627** Geoffrey Clements. **629** © The Joseph and Robert Cornell Memorial Foundation; photograph © 1997 Des Moines Art Center. **630/631** Ben Blackwell. **632** © The Historic New Orleans Collection. **633** © 1999 Estate of Arshile Gorky/Artists Rights Society (ARS), New York; photograph Geoffrey Clements. **634** © 1999 Willem de Kooning Revocable Trust/Artists Rights Society (ARS), New York; photograph Lee Stalsworth. **635** Photograph © 1998 The Museum of Modern Art, New York. **636** © 1999 Estate of Yves Tanguy/Artists Rights Society (ARS), New York; photograph Robert E. Mates. **637** Jerry L. Thompson. **638** Lee Stalsworth. **639** Gamma One. **640/641** Geoffrey Clements. **642** © 1999 Estate of Arshile Gorky/Artists Rights Society (ARS), New York. **643** © 1999 Estate of Arshile Gorky/Artists Rights Society (ARS), New York; photograph Geoffrey Clements. **645** Courtesy Lillian Kiesler. **646/647/648/649** Geoffrey

Clements. **650** © The Joseph and Robert Cornell Memorial Foundation; photograph Geoffrey Clements. **651** Geoffrey Clements. **652/653** © Helen Levitt. **654** © 1940 Helen Levitt. All Rights Reserved; photograph © 1998 The Museum of Modern Art, New York. **655** Robert E. Mates. **656** Courtesy of the artist and the Francine Seders Gallery, Seattle, Washington; photograph Geoffrey Clements. **657** Photograph © 1997 The Art Institute of Chicago. All Rights Reserved. **659** © Ruth Orkin. **660** Photograph © 1998 The Art Institute of Chicago. All Rights Reserved. **662** © Walker Evans Archive, The Metropolitan Museum of Art, New York. **663** © The Lisette Model Foundation, Inc. Used by permission. **664** © The Lisette Model Foundation, Inc. Used by permission; photograph Geoffrey Clements. **665/666** © 1994 International Center of Photography, New York. Bequest of Wilma Wilcox. **667/668** Reproduced by permission of Martha Graham Dance Company; photograph Geoffrey Clements. **669** Photograph © 1998 The Museum of Modern Art, New York. **670** © Louise Bourgeois/Licensed by VAGA, New York, NY; photograph Jerry L. Thompson. **671** Jerry L. Thompson. **672** © 1999 Kate Rothko Prizel and Christopher Rothko/Artists Rights Society (ARS), New York; photograph Geoffrey Clements. **673/674** © Adolph and Esther Gottlieb Foundation/Licensed by VAGA, New York, NY; photograph Geoffrey Clements. **675** Geoffrey Clements. **677** Peter Accettola. **678** © 1999 Pollock-Krasner Foundation/Artists Rights Society (ARS), New York. **679** © Louis Faurer/Licensed by VAGA, New York, NY; photograph © Addison Gallery of American Art, Phillips Academy, Andover, Massachusetts. All Rights Reserved. **680** © David Vestal. **681** M. Lee Fatherree. **682/683** © Robert Frank; photograph © 1998 Board of Trustees, National Gallery of Art, Washington, D.C. **684** © Louis Faurer/Licensed by VAGA, New York, NY; photograph © Addison Gallery of American Art, Phillips Academy, Andover, Massachusetts. All Rights Reserved. **685** © Ted Croner. **686** © Aaron Siskind Foundation/courtesy Robert Mann Gallery; photograph Geoffrey Clements. **687** © Aaron Siskind Foundation/courtesy Robert Mann Gallery; photograph © 1998 The Museum of Modern Art, New York. **688** © Aaron Siskind Foundation/courtesy Robert Mann Gallery. **689** Geoffrey Clements. **690** © Estate of Ben Shahn/Licensed by VAGA, New York, NY; photograph Geoffrey Clements. **692** © Estate of Yasuo Kuniyoshi/ Licensed by VAGA, New York, NY; photograph Sheldan C. Collins. **695** Courtesy of Anthology Film Archives & Arthouse, New York. **696** © 1999 Pollock-Krasner Foundation/Artists Rights Society (ARS), New York. **697** Geoffrey Clements. **698** © 1999 Pollock-Krasner Foundation/Artists Rights Society (ARS), New York; photograph Geoffrey Clements. **699** © 1999 Willem de Kooning Revocable Trust/Artists Rights Society (ARS), New York; photograph © 1986 The Metropolitan Museum of Art, New York. **700** © 1999 Artists Rights Society (ARS), New York/Pro Litteris, Zurich; photograph Geoffrey Clements. **701** Photograph © 1997 Museum Associates, Los Angeles County Museum of Art. All Rights Reserved. **702** Photograph © 1998 The Museum of Modern Art, New York. **703** © Estate of David Smith/Licensed by VAGA, New York, NY; photograph Geoffrey Clements. **704** © Estate of David Smith/Licensed by VAGA, New York, NY. **705** © Estate of David Smith/Licensed by VAGA, New York, NY; photograph Andrew D. Lautman. **706** Jerry L. Thompson. **707** Estate of Theodore Roszak; photograph Geoffrey Clements. **708** Geoffrey Clements. **709** © Time Inc.; photograph © 1998 The Museum of Modern Art, New York. **710** © 1999 Kate Rothko Prizel and Christopher Rothko/Artists Rights Society (ARS), New York; photograph © 1998 The Museum of Modern Art, New York. **711** Geoffrey Clements. **712** © 1999 Barnett Newman Foundation/Artists Rights Society (ARS), New York; photograph © 1997 The Metropolitan Museum of Art, New York. **713** From the Estate of Ethel Baziotes, of William Baziotes. Courtesy of the Joseph Helman Gallery, New York; photograph © 1998 The Museum of Modern Art, New York. **714** From the Estate of Ethel Baziotes, of William Baziotes. Courtesy of the Joseph Helman Gallery, New York; photograph Geoffrey Clements. **715** Photograph © President and Fellows Harvard College, Harvard University Art Museums, Cambridge, Massachusetts. **716** Photograph © 1999 The Museum of Modern Art, New York. **717** UPI/Corbis-Bettmann, New York. **718** © Estate of Burgoyne Diller/Licensed by VAGA, New York, NY; photograph Robert E. Mates. **719** Geoffrey Clements. **720** © 1999 The Josef and Anni Albers Foundation/Artists Rights Society (ARS), New York. **721** Geoffrey Clements.

Index

Page numbers in *italics* refer to pages with illustrations.

Abandoned Farmhouse on Large Mechanized Cotton Farm (Lange), *215*
Abbey, Edwin Austin (1852–1911), 12, *14*
Abbott, Berenice (1898–1991), 251, *251*, 262, 336
Abbott Laboratories, 311
ABC, 187
ABC's (Ford), 336, *336*
Abele Residence, Framingham, Massachusetts (Gropius and Breuer), *376*
Abe Lincoln in Illinois (Sherwood), 230, 232, 277
Abie's Irish Rose (Nichols), 161
Abstract Expressionism, 362–77
Abstraction, Number 2 (Dove), *110*
Abstraction-Création, 285
Abstraction-Création, 285
Academy Awards, 134, 272–73, 305
Acrobats (Demuth), *99*
Action painting, *see* Abstract Expressionism
Actors' Equity, 109
Actors Studio, 372
Adams, Ansel (1902–1984), 163, *165*, 212, *213*
Adams, Henry (1838–1918), 22–24, 25
Adams, James Truslow (1878–1949), 230
Addams, Jane (1860–1935), 82
Adding Machine, The (Rice), 159, 161
Adelaide M. Tichenor House, Long Beach, California (Greene), *39*
Advertisement for George P. Ide Co. (Outerbridge), *176*
advertising, 167, 236
 art graphics and, 169, 170–72
 commercial photography and, 172–77
 Surrealism's influence on, 335
Aeolian Piano Company, 104
Aeroplane, The (Stieglitz), *48*
Aestheticism, 22, 31, 40, 96
Agee, James (1909–1955), 250, 251, 252
Age of Innocence, The (Wharton), 24
Agrarian movement, 230
Aiken, Conrad (1889–1973), 237
"Ain't We Got Fun" (Whiting, Egan, and Kahn), *168*
Albers, Josef (1888–1976), 284, 377, *379*
Albert-Alberta, Hubert's Forty-Second Street Flea Circus, New York (Model), *342*
Albright Art Gallery, 46
Alcott, Louisa May (1832–1888), 33
Aldington, Richard (1892–1962), 108
Alexander, John White (1856–1915), 13
"Alexander's Ragtime Band" (Berlin), 78, *78*
Alfred Stieglitz (de Zayas), *120*
Algonquin Round Table, 166
All About Eve (film), 354
Allen, Gracie (1905–1964), 75, 272
Alma Mater (ballet), 308
Alphabet for Adults (Ray), 336
Alsberg, Henry (1881–1970), 236, 237
Always Camels (Steiner), *174*
American Abstract Artists (AAA), 284–85, 295, 320, 322
American Artists' Congress, 280, 281, 310, 319
American Ballet Caravan, 306, 308
American Ballet Theatre, 309
American Casualties on Beach, New Guinea (Strock), *316*
American Document (ballet), 306, 307
American Exodus, An (Lange and Taylor), 245–50, *249*, 251
American Farm (Jones), 229

American Gothic, Washington, D.C. (Parks), 247
American Gothic (Wood), 224, *225*
American Guide Series (FWP), 237–38, *237*
American Impressionists, 25
American Jitters, The (Wilson), 254
American Mutoscope and Biograph Company, 75
Americans, The (Frank), 354
American Scene painting, 179–83, 344
American Tragedy (Evergood), 281, *282*
America Today (Benton), 221–23, *222*
Amistad Mutiny Murals, The (Woodruff), 231, 235
Analytical Cubism, 109
Anatomical Painting (Tchelitchew), *330*
Anderson, Maxwell (1888–1959), 161, 276, 277
Anderson, Sherwood (1876–1941), 177, 196, 254, 278
Anger, Kenneth (1930–), 363
Anna Christie (O'Neill), 161
Annie Get Your Gun (Berlin), 310
Anshutz, Thomas (1851–1912), 16, *21*, 64, 97
Apotheosis of Pennsylvania, The (Abbey), *14*
Appalachian Spring (ballet), 239, 306, 307, 308, 345
Après le Cubisme (Le Corbusier and Ozenfant), 145
Arbus, Diane (1923–1971), 343
architecture:
 Art Deco and, 137
 Arts and Crafts movement and, 38–39
 Bauhaus and, 376
 of Depression era, 218–19
 De Stijl and, 289
 engineering projects and, 218
 of exotic movie theaters, 133
 geometric abstraction and, 294
 growth of cities and, 50–51
 New York World's Fair and, 300
 Precisionism and, 147, 153–54
 streamline design and, 300–303
 of suburban housing projects, 376–77
 see also skyscrapers
Archive of American Folk Song, 239
Ardrey, Robert (1908–1980), 277
Arens, Egmont (1889–1966), 301, *301*
Arensberg, Louise (1879–1953), 107, 108, 123, 126, 127
Arensberg, Walter (1878–1954), 107, 108, 123, 126, 127
Arent, Arthur (1905–), 276
Armco Steel (Weston), *164*
Armory Show (1913), 104–8, *109*, 115, 170, 182, 196
Armstrong, Louis (1900–1971), 184, *184*, 186
Arnautoff, Victor (1896–1979), 216, *217*
Art Critics, The—! How Do They Serve the Public? What Do They Say? How Much Do They Know? Let's Look at the Record (Reinhardt and Greene), 322
Art Deco, 136–37, 142, 156, 191
Art Deco Gown, Photographed in the Apartment of Nina Price (Steichen), *178*
Art Front, 278–80, 295
Artist and His Mother, The (Gorky), *327*
Artists for Victory, 314
Artists' Union, 279
Art Nouveau, 30–31, 37, 137
Art of This Century, 337, 352, 363–64
Arts and Architecture, 376

Arts and Crafts movement, 36–39
Arts of Life in America, The (Benton), 223
Art Students League, 256, 320
Aryan Fold (Smith), *313*
Asbury, Lenore (1866–1933), 37
Ashcan School, 92, 147, 166, 170, 226, 256, 367
Aspects of Negro Life (Douglas), 231, 235
Associated American Artists (AAA), 226
Association of American Painters and Sculptors, 104, 105–6, 107
Astaire, Adele (1898–1981), 271
Astaire, Fred (1899–1987), 270–71, *270*, 273
At Five in the Afternoon (Motherwell), *367*
At Land (film), 362
At Mouquins (Glackens), *62*
At the Piano (Hassam), *22*
Attic (de Kooning), 366
Augusta, Georgia ("The Lord Jesus is Coming Today") (Bourke-White), 246
Ault, George (1891–1948), 150, *153*
Autobiography of an Ex-Colored Man (Johnson), 72
Automat (Hopper), *181*
automatism, 322, 334, 344, 348, 352, 364–65
Autumn (Seeley), *43*
Avery, Milton (1885–1965), 349, 374
Awake and Sing (Odets), 277
Awakening of Ethiopia, The (Fuller), 191, *193*
Axis Devastation (Smith), 311
Ayres, Agnes (1896–1940), *134*

Babbitt, Milton (1916–), 378
Babes in Toyland (Herbert), 104, *104*
Bachelor's Wallpaper (Gibson), *18*
Backyards, Greenwich Village (Sloan), *81*
Bacon, Peggy (1895–1987), 196
Baker, Josephine (1906–1975), 194, *194*
Baker, Ray Stannard (1870–1946), 82
Balanchine, George (1904–1983), 270, 307, 308, 345–46, 378
Ballad for Americans (Robinson), 305–6
Ballad of the Jealous Lover of Lone Green Valley (Benton), *221*
ballet, 270–71, 306, 307–8, 345–46
Ballet Caravan, 308
Ballet Russe de Monte Carlo, 308
Ballet Society, 308, 346
"Banal Sojourn" (Stevens), *169*
Baptism in Kansas (Curry), 224–26, *226*
Baptism in River, South Carolina (Ulmann), 254
Bara, Theda (1890–1955), 133
Barber, Samuel (1910–1981), 306
Barker, George (1913–), 363
Barnes, Albert (1872–1951), 194
Barr, Alfred H., Jr., (1902–1981), 323
Barrell, Robert (1912–1995), 351
Barry, Philip (1896–1949), 161, 277
Barrymore, John (1882–1942), 133
Barthé, Richmond (1901–1989), 194, *194*, 236
Barton, Bruce (1886–1967), 153
Basie, William (Count) (1904–1964), 260
Battle Hymn (Blankfort and Gold), 230, *233*
Battle of Angels (Williams), 358
Battle of Lights, Coney Island, Mardi Gras (Stella), 118, *118*
Battle of Midway, The (film), 314
Battleship Potemkin, The (film), 243
Bauer, Rudolf (1889–1953), 292, 296

Bauhaus, 295, 376
Baum, L. Frank (1856–1919), 75
Bayer, Herbert (1900–1985), 335
Baziotes, William (1912–1963), 331, 334,
 336, 346, 363, 373, 375, 376–77
Beach, Amy (1867–1944), 105
Beal, Gifford (1879–1956), 60
Beals, Carleton (1893–), 251
Beals, Jessie Tarbox (1870–1942), 86, 87
Beaudoin, Kenneth (1913–), 351
Beaumont, Harry (1888–1966), 133
Beaux, Cecilia (1863–1942), 13, 17
bebop, 371, 372
Bechet, Sidney (1897–1959), 184
Beethoven, Ludwig van (1770–1827),
 104
Behrman, S. N. (1893–1973), 161, 277
Belasco, David (1853–1931), 109
Bell for Adano, A (Hersey), 353
Bellocq, E. J. (1873–1940), 86, 89
Bellow, Saul (1915–), 237, 354
Bellows, George (1882–1925), 57, 59, 60,
 65, 66, 92, 92, 93, 182, 183
Benchley, Robert (1889–1945), 166
Benét, Stephen Vincent (1898–1943),
 230
Ben-Hur (film), 133
Bennett, Edward H. (1874–1954), 50
Benson, Frank W. (1862–1951), 23, 25
Benton, Thomas Hart (1889–1975),
 182, 183, 221–23, 221, 222, 224, 226,
 230, 257, 280, 281, 311, 313, 352
Bergman, Ingrid (1915–1982), 314
Bergson, Henri (1859–1941), 96
Berkeley, Busby (1895–1976), 270, 271,
 273
Berlin, Irving (1888–1989), 73, 77, 78,
 78, 79, 168, 305, 309, 310, 354
Berman, Eugene (1899–1972), 327, 331,
 331
Bernstein, Leonard (1918–1990), 307,
 309
Betrothal II, The (Gorky), 333, 334–36
Beyond the Horizon (O'Neill), 161
Biederman, Charles (1906–), 287, 289,
 293
Big Money, The (Dos Passos), 275
Big Parade, The (film), 134
Big Sleep, The (film), 354
Billy the Kid (ballet), 239, 307–8, 307
Bing, Siegfried (1838–1905), 30
Biograph Company, 75, 76, 77
Bi-Polar in Red (Roszak), 297
Birth of a Nation, The (film), 77
Bishop, Isabel (1902–1988), 256
Bisttram, Emil (1895–1976), 296
Biyazh, Navaho Boy (Moon), 34
Black and White (O'Keeffe), 212
Black Belt (Motley), 259
Black Children and White Doll (Parks),
 247
Black Christ and Other Poems, The
 (Cullen), 189
Black Spot No. 2 (O'Keeffe), 199
Blake, Eubie (1883–1983), 131, 186, 186
Blankfort, Michael (1907–), 230, 233
Blashfield, Edwin (1848–1936), 12
Blavatsky, Madame Helena Petrovna
 (1831–1891), 295
Blessed Art Thou Among Women
 (Käsebier), 41
Blind Man, 123
Blind Woman (Strand), 88
Blitzstein, Marc (1905–1964), 244, 275,
 276
Blossom Restaurant, 103 Bowery,
 Manhattan, October 24, 1935
 (Abbott), 269
Bluemner, Oscar (1867–1938), 113–15,
 115, 196, 197, 199, 210, 212

blues, 186–87, 309
Blues (Motley), 195
Blume, Peter (1906–1992), 323, 323
Böcklin, Arnold (1827–1901), 96
Bogart, Humphrey (1899–1957), 314
Bolotowsky, Ilya (1907–1981), 284, 289,
 289
Bolton, Guy (1883–1979), 74
Bonnard, Pierre (1867–1947), 30
Book of American Negro Poetry, The
 (Johnson), 189
Bootblack, Corner of 14th Street and 8th
 Avenue (Rothstein), 269
Bootleggers (Benton), 183
Borglum, Gutzon (1867–1941), 104–5,
 230, 232
Bostonians, The (James), 25
Boughton, Alice (1865–1943), 40
Bourgeois, Louise (1911–), 336, 347, 348
Bourgeois Gallery, 121
Bourke-White, Margaret (1904–1971),
 153, 155, 219, 245, 246, 248, 250–52,
 262, 280, 297, 299, 306, 318, 319,
 616
Bourrée Fantasque (ballet), 346
Bow, Clara (1905–1965), 133, 135
Boy's King Arthur, The (Lanier), 32, 32
Braithwaite, William Stanley
 (1878–1962), 189
Brancusi, Constantin (1876–1957), 107,
 348
Brandon, Tom, 243
Brazilian Clipper (Bourke-White), 299
Breman, Lucille (1923–), 271
Breton, André (1896–1966), 319, 322,
 327, 331, 334, 335, 336–37
Breuer, Marcel (1902–1981), 142, 376,
 376, 377
Bridal Veil Fall, Yosemite Valley
 (Adams), 213
Bride of Frankenstein, The (film), 273
Bride Stripped Bare by Her Bachelors,
 Even, The (The Large Glass)
 (Duchamp), 120–21, 121, 153
Brigman, Anne W. (1868–1950), 40, 42,
 43
Broadacre, 302
Brodovitch, Alexey (1898–1971), 177
Bronx Morning, A (film), 243
Brook Farm, 274
Brookhardt, Theodore C., 301, 301
Brooklyn Bridge, The: Variation on an
 Old Theme (Stella), 119
Brooklyn Bridge (Marin), 115
Brooklyn Bridge (Steichen), 49
Brooklyn Bridge (Stella), 118
Brooklyn Bridge at Night (Redfield), 56
Brooklyn Bridge from Ferry Slip, Late
 Afternoon (Struss), 49
Brooks, Van Wyck (1886–1963), 129,
 196, 278
Broom, 167
Broughton, James, 362
Broun, Heywood (1888–1939), 166
Brown, John (1800–1859), 230
Brown, Milton (1911–1998), 145
Browne, Byron (1907–1961), 284, 289,
 320
Browne, Rosalind Bengelsdorf
 (1916–1979), 284, 289
Browning, Robert (1812–1889), 76
Brown Shapes White (Mason), 286
Bruce, Edward (1879–1943), 216, 217, 220
Bruce, Patrick Henry (1881–1936), 93,
 113, 114, 172, 175
Bruehl, Anton (1900–1982), 172, 176,
 297, 299
"Brush Up Your Shakespeare"
 (Porter), 310
Bryan, William Jennings (1860–1925),
 108

Bryce Canyon, No. 2 (Gilpin), 213
Bubble, The (Brigman), 42
Bubble, The (White), 42
Bubbles, John (1902–1986), 270
Bubley, Esther (1921–1998), 341, 343, 355
Bucks County Barn (Sheeler), 148
Buildings, Lancaster (Demuth), 174
Burchfield, Charles (1893–1967), 100,
 101, 177–79, 179
Burleigh, Henry Thacker (1866–1949),
 105
burlesque, 73
Burnham, Daniel H. (1846–1912), 50
Burning of Rome, The (Seeley), 40
Burns, George (1896–1997), 75, 272
Busa, Peter (1914–1985), 334, 351
Bushman, Francis X. (1883–1966), 133
Bywaters, Jerry (1906–), 226, 228

Cadman, Charles Wakefield
 (1881–1946), 105
Cadmus, Paul (1904–), 216, 216, 217,
 281, 282
Café (Johnson), 259
Café (Kuniyoshi), 256
Café Francis, The (Luks), 62
Café Martin, Formerly Delmonico's
 (Shinn), 64
Café Society, New York (Mili), 371
Caffin, Charles (1854–1918), 45, 96
Cage, John (1912–1992), 378
Cagney, James (1899–1986), 272, 272
Cahiers d'Art, 285, 289
Cahill, Holger (1887–1960), 236, 239–41
Cain, James M. (1892–1977), 275,
 361–62
cakewalk (dance), 131
Cake Walk (Luks), 69
Calder, Alexander (1898–1976), 285–88,
 286, 288, 320, 320, 321, 336, 337
Calderberry Bush (Calder), 288
Caldwell, Erskine (1903–1987), 250–52,
 277, 306
California: A Guide to the Golden State
 (FWP), 237
Calumet River Chicago (Nordfeldt), 58
Camera Club of New York, 45
Camera Notes, 96
Camera Work, 45–46, 45, 47, 96, 100, 102,
 126, 129
Cane (Toomer), 189
Cantor, Eddie (1892–1964), 73, 74, 75,
 272
Canyon de Chelly (Curtis), 34
Capa, Robert (1913–1954), 314, 315, 315
Čapek, Karel (1890–1938), 159
Capone, Al(fonso) (1899–1947), 272
Capra, Frank (1897–1991), 272, 305, 305,
 314
"Carefully Taught" (Rodgers and
 Hammerstein), 310
Carle, Frankie (1903–), 354
Carles, Arthur B. (1882–1952), 93, 97,
 98
Carousel (Rodgers and Hammerstein),
 309
Carroll Galleries, 107, 120
Carter, Howard (1873–1939), 133
Carter, Michael, 262
Caruso, Enrico (1873–1921), 104
Casablanca (film), 314
Case Study Houses, 376
Castellon, Federico (1914–1971), 323, 325
Castle, Irene (1894–1969), 77, 79, 131
Castle, Vernon (1887–1918), 77, 79, 131
"Castle Walk, The" (Europe and
 Dabney), 78
Catch-22 (Heller), 353
Cathedrals of Broadway, The
 (Stettheimer), 143

Cave of the Heart (dance), 345, 346–48,
 346
Cement Works, Monolith, California
 (Van Dyke), 164
Central Park (Prendergast), 63
Central Park South (Frank), 356
Cézanne, Paul (1839–1906), 95, 97, 106,
 363
Chabrier, Emmanuel (1841–1894), 346
Chandler, Raymond (1888–1959), 275,
 362
Changing New York (Abbott and
 McCausland), 251, 251
Chaplin, Charlie (1889–1977), 76, 76,
 77, 134, 159, 310
Charleston (dance), 131, 131, 184, 187,
 261
Chase, William Merritt (1849–1916),
 25, 65, 93, 121
Chatfield-Taylor, Hobart (1865–1945),
 108
Chatterton, Ruth (1893–1961), 135
Cheever, John (1912–1982), 237
Chekhov, Anton (1860–1904), 276
Chesnutt, Charles (1858–1932), 188
Chicago (1948) (Siskind), 357
Chicago (1949) (Siskind), 357
Chicago Lake Front Development with
 Tower (Saarinen), 138
Chicago World's Fair (1933), 297, 303
Chief (Kline), 368
Chinese Restaurant (Weber), 117
Chocolate Grinder, No. 2 (Duchamp),
 120–21, 120, 153
Chop Suey (Hopper), 181
Christensen, Lew (1909–1984), 306, 307,
 308
Christmas Dinner, A (Lee), 252
Christy, Howard Chandler
 (1873–1952), 13, 18, 32
Chromatic Abstraction, 373–77
Chrysler Corporation (Bourke-White),
 155
Church Street El (Sheeler), 148
Cinema 16, 363
Circus (Calder), 288
Citizen Kane (film), 361, 361
City, The (film), 243, 244
City Life (Arnautoff), 217
City of Ambition, The (Stieglitz), 48
City Perspectives (Jonson), 296
City Walls (Spencer), 148
Civilian Conservation Corps (CCC),
 242
Civilian Conservation Corps Enrollee
 Wielding Sledgehammer (Mead),
 245
Civil Works Administration (CWA),
 216
Clarence White School, 172
Clarke, Mae (1907–1992), 272
Classic Landscape (Sheeler), 154–56, 158
Climbing into the Promised Land, Ellis
 Island (Hine), 84
Club, the, 363
Clurman, Harold (1901–1980), 275, 277
Coal Miner's House, Scott's Run, West
 Virginia (Evans), 252
Coburn, Alvin Langdon (1882–1966),
 40, 46, 47, 48, 49, 100, 127–29, 129
Cockfight—Variation (Smith), 369
Cocktail (Murphy), 169, 170
Cocktails (Motley), 195
Cohan, George M. (1878–1942), 79
Colbert, Claudette (1903–1996), 272
Cole, Bob (1868–1911), 74
Cole, Nat King (1919–1965), 353
Coleman, Glenn (1887–1932), 65, 90
Collier's, 13, 32, 82, 353
Colonial Williamsburg, 240
Colored American Magazine, 72

Color Field: *see* Chromatic
 Abstraction
Column of Life (Hoffman), 29, 31
Comden, Betty (1917–), 309
Communist Party, U.S., 262, 278
Communists, Communism, 353
 Depression era and, 278–80
 Social Realism and, 278–80
 Surrealism and, 322
 WPA and, 279
Como, Perry (1912–), 354
Composition (Scarlett), 295
Composition II (Bruce), 114
Composition on Green (Ferren), 284
*Comrade Gulliver: an Illustrated
 Account of Travel Into That
 Strange Country, The United
 States of America* (Gellert), 279
Concerto Barocco (ballet), 345
Concord (Newman), 374
Confessions of a Nazi Spy (film), 310
Congolais (Prophet), 192
Conkle, E. P. (1899–), 230
Connelly, Marc (1890–1980), 166, 186
Conroy, Jack (1899–1980), 275
Conspirators (Guston), 281
Constellation (Calder), 321
Constructivism, 147–50, 289
Contact, 166
*Contending Forces: A Romance of Negro
 Life North and South* (Hopkins),
 72
Cook, Howard (1901–1980), 147
Cook, Will Marion (1869–1944), 74
Coolidge, Calvin (1872–1933), 150–53
Cooper, Merian C. (1893–1973), 134
Coordinating Council of French
 Relief Societies, 336
Copland, Aaron (1900–1990), 239, 306,
 307, 378
Corbusier, Le (Charles-Édouard
 Jeanneret) (1887–1965), 142, 145,
 156
Cornell, Joseph (1903–1972), 323–27, 325,
 336
Corot, Camille (1796–1875), 106
Cortlandt Street Ferry (Pennell), 56
Cotton Club, 185, 186, 187
Cotton Pickers (Shahn), 245
Couple Descending a Staircase (adver-
 tisement for Arrow Shirt
 Company) (Leyendecker), 132
Couple in Car, Ossining, New York
 (Evans), 268
Couple in Raccoon Coats (VanDerZee),
 190
*Couple on the Lower East Side, New
 York* (Hine), 84
Courbet, Gustave (1819–1877), 106
Covarrubias, Miguel (1904–1957), 191,
 191, 192
Covert, John (1882–1960), 93, 108,
 123–25, 125, 126
Cowell, Henry (1897–1965), 378
Cowley, Malcolm (1898–1989), 166
Cox, Kenyon (1856–1919), 11, 11, 12
Coyotes (Sommer), 326
Cradle Will Rock, The (Blitzstein), 276,
 277
Cradling Wheat (Benton), 229
Craftsman, The, 37
Craftsman Workshops, 36
Crane, Hart (1899–1932), 189
Crane, Stephen (1871–1900), 60, 61
Crane (Lozowick), 159
Craven, Thomas (1889–1969), 223
Crawford, Cheryl (1902–), 275, 277
Crawford, Joan (1904–1977), 133, 133
Crawford, Ralston (1906–1978), 159–61,
 162, 163
Crawford, Ruth (1901–1953), 239, 378

Cret, Paul Philippe (1876–1945), 51, 218
Crime of Cuba, The (Beals), 251
Crisis, 191, 192
Criterion, 275
Critic, The (Dove), 126
Critic, The (Weegee), 343
Croly, Herbert (1869–1930), 159
Croner, Ted (1919–), 354–59
Crosby, Bing (1904–1977), 353
Crosland, Alan (1894–1936), 134, 135
Crotti, Jean (1878–1958), 108
Crushed Bowl (Ohr), 31
"Cubic" Pattern Coffee Service
 (Magnussen), 141
Cubism, 95, 109–16, 121–23, 125, 126–29,
 141, 142, 145, 170, 285, 289, 310
Cullen, Countee (1903–1946), 188, 189,
 191
Cummings, E. E. (1894–1962), 166
Cunningham, Imogen (1883–1976), 40,
 44, 163, 200, 201, 204, 206
Cunningham, Merce (1919?–), 345
Curry, John Steuart (1897–1946), 221,
 224–26, 226, 227, 229, 230, 233, 280,
 281, 311
Curtis, Edward (1868–1952), 33–37, 34
Curtiz, Michael (1888–1962), 134

Dada, 115, 120–26, 292
 World War I and, 121, 125
"Daisy Miller" (James), 25
Dalí, Salvador (1904–1989), 322, 323,
 327, 331
Dames (film), 273
dance:
 Americana theme in, 307–8
 ballet, 271, 306, 307–8
 cakewalk, 131
 Charleston, 131, 184, 187, 261
 Depression-era, 261
 feminism and, 35
 in films, 270–71
 jazz, 184–85
 lindy hop, 261
 Orientalism and, 33
 political dimension of, 307
 in postwar era, 345–48, 378
 ragtime and, 77, 79
 social, 79, 131, 184–85, 261
 Surrealism and, 271
Daniel, Charles, 145
Daniel Gallery, 107
Dark Figure, The (Castellon), 325
Daughter of the South, A (Gibson), 19
Daughters of Revolution (Wood), 225
Daughters of the American
 Revolution, 224
Daum, Howard (1918–1988), 351
Davidson, Donald (1893–1968), 230
Davies, Arthur B. (1862–1928), 27, 31,
 91, 92, 105–6
Davis, Edward Wyatt, 170
Davis, Stuart (1892–1964), 90, 92,
 170–72, 172, 173, 279–80, 285, 287
Dawson, Manierre (1887–1969), 102,
 103
Day, Doris (1924–), 354
Day, F. Holland (1864–1933), 40, 44, 45
Day, Richard (1896–1972), 270
Day Dreams (Vonnoh), 25
*D Day, Omaha Beach, Normandy,
 France, June 6, 1944* (Capa), 315
D Day, Tarawa (Eby), 318
D Day Rescue (Rosenblum), 316
Death of a Salesman (Miller), 358–59,
 358
Deaths and Entrances (dance), 345
De Camp, Joseph (1858–1923), 25
de Chirico, Giorgio (1888–1978), 322
decorative arts: *see* design
Deer in the Forest (Thompson), 102

de Kooning, Willem (1904–1997), 257,
 284, 289, 328, 329, 331, 363, 364,
 366–67, 366
Delacroix, Eugène (1798–1863), 106
Delano, Jack (1914–1997), 245, 251, 306
Delaunay, Robert (1885–1941), 113
Deliverance (Kuniyoshi), 360
Dell, Floyd (1887–1969), 90
de Meyer, Baron Adolf (1868–1949),
 16, 20, 46, 95, 177
de Mille, Agnes (1909–1993), 239, 307,
 308, 309
De Mille, Cecil B. (1881–1959), 77, 133,
 136
Democracy, an American Novel
 (Adams), 24
Dempsey, William Harrison (Jack)
 (1895–1983), 182
Dempsey and Firpo (Bellows), 183
Demuth, Charles (1883–1941), 90, 93,
 97, 98, 99, 145, 146, 153–54, 154,
 156, 157, 169–70, 171, 172, 174, 196,
 203, 204
Departure of the Joads (Benton), 226
Depression era, 215–55
 architecture in, 218–19
 Colonial Revival in, 240–41
 Communists and, 278–80
 depiction of everyday life in,
 236–38
 documentary film in, 243–44
 federal art funding in, 216–20
 film genres in, 272–73
 geometric abstraction and, *see* geo-
 metric abstraction
 literary response to, 274–75
 public murals in, 220, 221–23, 231
 Regionalism and, 221–26
 rural documentary photography
 in, 242–55
 social dance in, 261
 Social Realism in, 275–83
 theater in, 276–77
 "usable past" as theme in, 226–30
 WPA and, 239–41
Deren, Maya (1917–1961), 362, 363, 363
design, decorative arts, 30–31, 36, 38,
 141–42
 Art Deco and, 142
 Bauhaus and, 295–97
 biomorphism and, 292
 consumer products and, 297
 Cubism and, 141, 142
 du Pont collection and, 240
 ergonomic, 301
 as fine art, 37–38
 industrial, 297–301
 International Style and, 142
 machine imagery and, 142, 300–301
 New York World's Fair of 1939
 and, 297–300
 planned obsolescence and, 301
 skyscrapers and, 141–42
 streamlining and, 300–303
 technology and, 136, 295–300
*Design for Aviation Building by William
 Lescaze and J. Gordon Carr
 Associates for 1939–40 New York
 World's Fair* (Ferriss), 303
Design Laboratory of New York, 295
De Stijl, 141, 289
Detail of a La Salle (Bourke-White),
 299
determinism, 61
Dewey, John (1859–1952), 50
Dewing, Thomas (1851–1938), 25, 28
de Zayas, Marius (1880–1961), 95, 108,
 120, 120, 127, 177
Dialectics, 275
Diana (Manship), 144
Dickinson, Emily (1830–1886), 345

Dickinson, Preston (1889–1930), 145,
 146
Dies, Martin (1901–1972), 241
Diller, Burgoyne (1906–1965), 284, 289,
 293, 377, 378
Dining Room of Saarinen House
 (Saarinen), 142
Dinner for Threshers (Wood), 224
Disinherited, The (Conroy), 275
Disney, Walt (1901–1966), 273, 273
Disney Studios, 270
*Ditched, Stalled, and Stranded, San
 Joaquin Valley* (Lange), 249
Diversion of Angels (dance), 345
Dixieland Jazz Band, 185
Dodge, Mabel (1879–1962), 90, 107, 108
Doll/New York City (Frank), 355
Donaldson, Walter (1893–1947), 168
Don Juan (film), 134–35
Doolittle, Hilda (1886–1961), 108
Doris Humphrey in the Shakers
 (Sunami), 230
Dorsey, Tommy (1905–1956), 260, 354
Dos Passos, John (1896–1970), 167, 226,
 275
Double Akeley, New York (Strand), 160
Double Indemnity (film), 354, 361–62
Douglas, Aaron (1800–1979), 191, 192,
 231, 235
Douglass, Frederick (1817–1895), 231
Douglass Lighter (Steichen), 177
Dove, Arthur G. (1880–1946), 93, 95,
 102, 109, 110, 126, 196, 197, 203, 210,
 211, 212
Dow, Arthur Wesley (1857–1922), 100
Downing, A. J. (1815–1852), 218
Doylestown House: Stairwell (Sheeler),
 128
Dracula (film), 273
Dracula's Daughter (film), 273
Draped Seated Nude (Lachaise), 205
"Dream of Venus" pavilion, 323
Dreier, Katherine (1877–1952), 107, 108,
 196, 288
Dreiser, Theodore (1871–1945), 60, 60,
 61, 254
Dreyfuss, Henry (1904–1972), 297, 300,
 301, 301
Driggs, Elsie (1898–1992), 156, 158
Drouth Stricken Area (Hogue), 227
Drums Along the Mohawk (film), 305
du Bois, Guy Pène (1884–1958), 92,
 179, 182, 182, 188, 195
Du Bois, W.E.B. (1868–1963), 72, 187
Duchamp, Marcel (1887–1968), 106–7,
 107, 108, 115, 116, 120–21, 120,
 123, 125, 126, 129, 137, 150, 153, 156,
 166, 196, 288, 334, 335, 335, 336–37
Dunbar, Paul Laurence (1872–1906),
 74, 188
Duncan, Isadora (1878–1927), 33, 35
du Pont, Henry Francis (1880–1969),
 240
Dvořák, Antonin (1841–1904), 105
Dwan, Allan (1891–1885), 133
Dwarf (Baziotes), 375
Dyn, 331
Dynamo, 275
Dynamo (O'Neill), 159, 161
Dynaton, 351

Eagle, Arnold (1909–1992), 269
Eakins, Thomas (1844–1916), 16, 20, 64
Eames, Charles (1907–1978), 292, 292,
 376
Eames, Ray Kaiser (1912–1988), 292
Eames Molded Plywood Chairs
 (Eames), 292
Early Sunday Morning (Hopper), 267
East 86th Street, New York (Vestal), 355
Eastman, Charles (1907–1978), 72

Eastman, Max (1883–1969), 90
Eberle, Abastenia St. Leger (1878–1942), 86, 89
Eby, Kerr (1890–1946), 315, 318
Eddy, Arthur Jerome (1859–1920), 107
Edison, Thomas A(lva) (1847–1931), 51, 75, 240
Egan, Raymond (1891–1938), 168
Egg Beater No. 1 (Davis), 287
Egyptomania, 136
Eickemeyer, Rudolf E., Jr. (1862–1932), 16, 19, 20
Eight, The, 91–93
Eighth Street Club, 363
Einstein, Albert (1879–1955), 96
Eisenstaedt, Alfred (1898–1995), 315–19, 317
Eisenstein, Sergei (1898–1948), 243
Electric Furnace, Ludlum Steel Co., Dunkirk, New York (Bourke-White), 155
Elegy to the Spanish Republic (Motherwell), 367, 367
Elevator Doors for the Chrysler Building (Van Alen), 137
Eliot, T. S. (1888–1965), 24, 25, 167, 189
Ellington, Edward K. (Duke) (1899–1974), 185, 185, 186, 187, 260, 260
Ellis, Havelock (1859–1939), 203
Ellison, Ralph (1914–1994), 237
Ellwood, Craig (1922–), 376
Elman, Mischa (1891–1967), 135
Emerson, Ralph Waldo (1803–1882), 179
Emotional Seasons (Kamrowski), 332
Emperor Jones, The (O'Neill), 161, 194
Employment Agency (Soyer), 265
Entombment I (Rothko), 348
Epic of America, The (Adams), 230
Equivalent (Stieglitz), 196
Ernst, Max (1891–1976), 322, 323, 327, 335–36
Erosions No. 2: Mother Earth Laid Bare (Hogue), 228
Errand into the Maze (dance), 345
Esprit Nouveau, L', 145
Esther (Adams), 24
"Esthétique du Mal" (Stevens), 169
Eugene, Frank (1865–1936), 40
Europe, James Reese (1881–1919), 184, 185
Eva Green (Henri), 66
Evans, Walker (1903–1975), 245, 250–51, 250, 252, 253, 268, 337, 341, 343
Evergood, Philip (1901–1973), 281, 282, 323, 324
"Exhibition of Independent Artists" (1910), 92–93, 94, 104
existentialism, 364–66
Exposition Internationale des Arts Décoratifs et Industriels Modernes (1925), 142
Expressionism (German), 106
Eye That Never Sleeps, The (Laughlin), 326

Factory Building, San Francisco (Adams), 165
Fain, Sammy (1902–1989), 354
Fairbanks, Douglas (1883–1939), 77, 136
Fairmount Parkway, Philadelphia, 50, 51
Fallingwater, Bear Run, Pennsylvania (Wright), 294, 294
Fall Plowing (Wood), 224
Fancy Free (ballet), 307, 309
Fantasia (film), 270
"Fantastic Art: Dada and Surrealism" (1936), 323
Farewell to Arms, A (Hemingway), 236, 353

Farmer and Sons, Dust Storm, Cimarron, Oklahoma (Rothstein), 246
Farm Security Administration, 239, 242–55, 275
Farrar, Geraldine (1882–1967), 104
Farrell, James T. (1904–1979), 274, 275
Farwell, Arthur (1872–1952), 105
fashion photography, 16, 177
Fashion Show, Hotel Pierre, New York (Model), 342
Faulkner, William (1897–1962), 275
Faurer, Louis (1916–), 354, 355, 356
Fauvism, 97–100, 106, 109
Favrile glass, 30
Federal Art Project (FAP), 220, 236–38, 239, 262, 279, 284, 295
Federal Dance Project, 307
Federal Music Project (FMP), 236–38, 239
Federal Project Number One, 236, 239, 241
Federal Theatre Project (FTP), 236–38, 239, 241, 275–77
Living Newspapers of, 236–38, 275–77
Federal Writers' Project (FWP), 236–38
American Guide project of, 237–38, 237
Federation of Modern Painters and Sculptors, 280, 319, 344
Feininger, Lyonel (1871–1950), 72, 75
Fellig, Arthur, *see* Weegee
Ferber, Herbert (1906–1991), 370, 371–72
Ferren, John (1905–1970), 284, 285
Ferriss, Hugh (1889–1962), 150, 151, 303
Ferry Boat Wreck (Dove), 211
Fields, Dorothy (1905–1974), 186
Fields, W. C. (1880–1946), 73, 74, 75
Fifth Avenue (Struss), 52
Fifth Avenue, Noon (Hassam), 56
Figure 5 in Gold, The (Demuth), 169, 171
Filling Station (ballet), 306, 307, 308
film, 75–77, 159, 166, 305
animated, 272–73
choreography in, 270–71
documentary, 133–34, 236, 239, 242, 243–44, 254, 272–73
Europeanization of, 167
exoticism in, 136
experimental, 362–63
film noir style of, 354, 361–62
genres of, 134, 272–73
Hollywood and, 77, 133–34, 243, 260, 270, 305, 314
of Jazz Age, 133–34
literature and, 76
newsreel, 236, 314
radio and, 134
reform movement and, 86
Social Realism and, 275
sound, 134–35, 272
technology and, 133, 134
theater and, 76–77
vaudeville and, 76, 77
in war propaganda, 310, 314
Film and Photo League, 243
Film Exercises 1–5 (film), 363
Fire!, 188
Fireworks (film), 362–63
Firpo, Luis Angel (1923–), 182
First Church of Christ Scientist (Maybeck), 39
"First Papers of Surrealism" (1942), 334, 335, 336, 337, 348, 376
First Theme (Diller), 293
Fitzgerald, Ella (1917–1996), 354
Fitzgerald, F. Scott (1896–1940), 136, 166–67, 167, 236
Fitzgerald, Zelda (1900–1948), 166–67
Fitzmaurice, George (1895–1941), 134

Five Cents a Spot, Unauthorized Lodgings in a Bayard Street Tenement (Riis), 83
Flagg, James Montgomery (1877–1960), 13
Flaherty, Robert J. (1884–1951), 133, 134
Flame, The (Ferber), 370, 372
Flanagan, Hallie (1890–1969), 236, 276
Flatiron, The (Steichen), 49
Flatiron Building, 47–51, 49
Fleet's In, The (Cadmus), 216, 217
Fletcher, Alice C. (1838–1923), 105
Flight of the Night (Manship), 29
Flint, F. S., 108
Flowers (Maurer), 96
Fog Horns (Dove), 197, 198
folk art, 100
folk music, 105, 184, 239, 307
Follies, 73, 74
Footlight Parade (film), 273
Ford, Charles Henri (1913–), 335, 336, 336
Ford, Henry (1863–1947), 150, 240
Ford, John (1895–1973), 230, 255, 305, 314
Forms Abstracted (Hartley), 112
Forms in Space (Storrs), 150
Fort Peck Dam, Montana (Bourke-White), 219
Fortune, 252
Fortune, La (Ray), 323, 324
Forum, 129
"Forum Exhibition of Modern American Painters" (1916), 129
Fountain (Duchamp), 115, 116, 129
Four American Indian Songs (Cadman), 105
Four Freedoms (Rockwell), 311
Four Temperaments, The (ballet), 346
14th Street School, 256
42nd Parallel (Dos Passos), 275
42nd Street (film), 272, 273
Forty-five Minutes from Broadway (Cohan), 79
Foy, Bryan, 135
France, Anatole (1844–1924), 109
Frances Hope Modeling a Chanel Sheared Lambskin Coat over Tweed Dress, Holding Binoculars (Sheeler), 178
Frank, Robert (1924–), 354, 355, 356
Frank, Waldo (1889–1967), 129, 159, 189, 196, 278
Frankenstein (film), 273
Frankl, Paul Theodore (1886–1958), 141, 141, 142
Freedom From Want (Rockwell), 312
Free Speech (Gropper), 278
Freiberg, Conrad, 243, 244, 275
French, Daniel Chester (1850–1931), 12, 14, 31
French, Jared (1905–1987), 339, 343
Freud, Sigmund (1856–1939), 96, 108, 203, 331
Freylinghuysen, Suzi (1911–1988), 284
Freytag-Loringhoven, Elsa von (1874–1927), 108, 121, 122
From the Back Window (Stieglitz), 52
From the Deep Woods to Civilization (Eastwood), 72
Front Elevation for Reinhardt Theatre (Urban), 137
Frontier (dance), 230
Frontier Films, 243, 262
Fry, Roger (1866–1934), 105
f/64, 163, 212
Fugitive, 230
Fuller, Alvan T. (1878–1958), 281
Fuller, R. Buckminster (1895–1983), 302, 302
Fuller, Loie (1862–1928), 35
Fuller, Meta Warrick (1877–1968), 191, 193

furniture, 37, 292
Eames, 292
skyscraper, 141–42
Futurama, 300
Future Generation (Zorach), 305, 306
Futurism, 106, 127
impact of, 109, 116–18

Gable, Clark (1901–1960), 272
Gadski, Johanna (1872–1932), 104
Gala, The (Christy), 18
Galerie Neuf, 351
Gallatin, A. E. (1881–1952), 289
Gallatin's Gallery of Living Art, 289
Gamin (Savage), 194
Garbo, Greta (1905–1990), 135
García Lorca, Federico (1898–1936), 367
Garland, Judy (1922–1969), 271
Garland, The (Dewing), 28
Garrison films, 243
Garvey, Marcus (1887–1940), 190
Gates, William, 37
Gates Pottery, 37
Geddes, Norman Bel (1893–1958), 109, 297, 300
Gellert, Hugo (1892–1985), 278, 278, 279
Genthe, Arnold (1869–1942), 35, 71
Gentlemen Prefer Blondes (Loos), 166, 167
Geography of the Body (film), 363
geometric abstraction, 284–303, 319–22, 329, 344, 377
George Washington Bridge (Steichen), 219
Georgia O'Keeffe: A Portrait—Hand and Breasts (Stieglitz), 203
Gershwin, George (1898–1937), 73, 168, 185, 186, 309
Gershwin, Ira (1896–1983), 73
Gerson Sisters (Käsebier), 19
Gertrude Vanderbilt Whitney (Henri), 21
Gibson, Charles Dana (1867–1944), 13, 18, 19, 32
Gilbert, Cass (1859–1934), 50, 51
Gilbert, John (1895–1936), 135
Gill, Irving (1870–1936), 38
Gillespie, Dizzy (1918–1993), 371, 372
Gilpin, Laura (1891–1979), 47, 213
Girl in Fulton Street, New York (Evans), 268
Girl in White (Hawthorne), 17
Girl Playing Solitaire (Benson), 23
Girl Sitting Alone in the Sea Grill, a Bar and Restaurant, Waiting for a Pick-up, Washington, D.C. (Bubley), 341
Gish, Lillian (1896–1993), 75, 77, 133
Glackens, William (1870–1938), 62, 64–65, 64, 69, 79, 80, 91, 104, 105
Glarner, Fritz (1899–1972), 284, 322, 377, 379
Glass Menagerie, The (Williams), 358
Gleizes, Albert (1881–1953), 108, 115–16, 125–26, 150, 166
Gloria Swanson (Steichen), 136
Gloria Swanson in the Lion's Den— Fantasy Sequence from "Male and Female" (Struss), 136
Gluck, Alma (1884–1938), 104
Gluck-Sandor, Senia (?–1978), 307
God (Schamberg and Freytag-Loringhoven), 121, 122, 153
"God Bless America" (Berlin), 305
God's Trombones (Johnson), 189, 193
Gold, Michael (1893–1967), 230, 233, 278
Gold Diggers of 1933 (film), 271, 273
Golden Bowl, The (James), 25
Golden Boy (Odets), 277

Goldman, Emma (1869–1940), 90
Gold Rush, The (film), 134
Goldwyn Follies, The (film), 270
Goncharova, Natalia (1881–1962), 167
Gone With the Wind (Mitchell), 275
Good Furniture, 142
Good Housekeeping, 32–33
Goodman, Benny (1909–1986), 260, 354
Good Shepherd, The (Tanner), 26
Gorky, Arshile (1904–1948), 284, 285, 289, 290, 291, 327, 329–31, *333*, 334–36
Gottlieb, Adolph (1903–1974), 346, 348, 349
Grafton Gallery, 105
Graham, John (1887–1961), 284, 320, 329, *329*, 331, 351
Graham, Martha (1894–1991), 35, 230, 239, 306, 307, *308*, 345, *345*, 346–48, *346*
Grain Elevators, Buffalo (Crawford), *162*
Grand Central Palace Exhibition (1917), 129
Grand Central Terminal, New York, 51
Granville Smith, Walter (1870–1938), 13, *18*
Grapes of Wrath, The (film), 226, 254, 305
Grapes of Wrath, The (Steinbeck), 254, 255, 275, 305
Grass (film), 134
Grauman's Chinese Theater, 133
Graves, Morris (1910–), 337–43, *337*
Great Dictator, The (film), 310
"Great Figure, The" (Williams), 170
Great Gatsby, The (Fitzgerald), 166, *167*, 236
Green, Adolph (1915–), 309
Green, Paul (1894–1981), 277
Greenberg, Clement (1909–1994), 319–20, 348, 362
Greene, Balcolm (1904–1990), 280, 284, 285, 322
Greene, Charles Sumner (1868–1957), 37, *37*, 39, *39*
Greene, Gertrude (1904–1956), 284, 289, *319*, 320
Greene, Henry Mather (1870–1954), 37, *37*, 39
Greenfield Village, 240
Green Form (Baziotes), *375*
Green Grow the Lilacs (Riggs), 309
Green Pastures, The (Connelly), 186, 187
Greer, Jane (1924–), 362, *362*
Greyhound Bus Passengers (Bubley), 355
Griffes, Charles Tomlinson (1884–1920), 105
Griffith, D. W. (1875–1948), 76, 77, 136
Gropius, Walter (1883–1969), 138, 376, *376*, 377
Gropper, William (1897–1977), 278, *278*, 279
Grossman, Sidney (1914–1955), 262
Group Theatre, 275–77
Grueby Pottery, 36, 37
Guernica (Picasso), 311, 352
Guggenheim, Peggy (1898–1979), 335, 337, 352
Guggenheim, Solomon (1861–1949), 292
Guglielmi, O. Louis (1906–1956), 323, 324
Guston, Philip (1913–1980), 281, *281*
Guthrie, Woody (1912–1967), 218, 239, *239*, 306
Gypsy Family at Ellis Island (Sherman), *71*

Haas Gallery, 105
Habitat Group for a Shooting Gallery (Cornell), 323–27, *325*
Hagemeyer, Johan (1884–1962), 137, *144*
Hairy Ape, The (O'Neill), 161
Hale, Lilian Westcott (1881–1963), *23*, 25
Halpert, Samuel (1884–1930), 93
Hals, Frans (1581/5–1666), 64
Halsted Street (film), 243, 244, 275
Hamilton, Alexander (1755–1804), 196
Hammerstein, Oscar, II (1895–1960), 74, 168, 306, 309, *309*, 310
Hammerstein's Roof Garden (Glackens), 69
Hammett, Dashiell (1894–1961), 274, 275
Hammid, Alexander (1910–), 362
Hammond, Arthur (1880–1962), 300
Hanging Spider (Calder), 320
Hapgood, Hutchins (1869–1944), 90
Harding, Warren G. (1865–1923), 133
Hare, David (1917–1992), 336, 347, 348, 363
Hare Corner (Howard), 291
Harlem Document, 262
Harlem: Mecca of the New Negro, 188, 189
Harlem Renaissance, 185, 187–95
Harlequin for President (ballet), 308
Harmon Foundation, 194–95
Harper's Bazaar, 177, 354
Harper's Weekly, 32
Harrington, Francis, 241
Harris, Roy (1898–1979), 239, 306
Harris, Wynonie (1915–1969), 371
Hart, Lorenz (1895–1943), 186
Hartley, Marsden (1877–1943), 90, 94, 102, 109–13, *111*, *112*, 125, 145, 196, 203, 204–8, *208*, 230, 232
Hartmann, Sadakichi (Sidney Allan) (c. 1867–1944), 45, 46, 47, 96
Hassam, Childe (1859–1935), 22, 25, 55, 56, 60
Haviland, Paul (1880–1950), 120
Hawk, The (Yolande in Large Hat) (Sloan), 67
Hawkins, Erick (1909–1994), 345
Hawthorne, Charles (1872–1930), 13, *17*
Haymarket, The (Sloan), 68
Haymes, Dick (1916–1980), 354
Hays, Will H. (1879–1954), 133
Hayter, Stanley William (1901–1988), 336
Haywood, William "Wild Bill" (1869–1928), 90
Hayworth, Rita (1918–1987), 271, 362
Heart of the Storm (Brigman), 43
Helburn, Theresa (1887–1959), 309
Held, John, Jr. (1889–1958), *131*, *132*, 133–36
Heller, Joseph (1923–), 353
Hell-Hole (Sloan), 62
"Hello! Ma Baby" (Howard), 78
Hello Steve (Wheeler), 351
Helmholtzian Landscape (Smith), 368, 369
Hemingway, Ernest (1899–1961), 167, 236, 275, 353
Henri, Robert (1865–1929), 16, 21, 61–72, 66, 67, 80, 91, 92, 93, 94–96, 104, 166, 170, 179
Herbert, Victor (1859–1924), 74, 104
Here, This is Stieglitz/Faith and Love (Ici, c'est ici Stieglitz/Foi et Amour) (Picabia), 120, *120*
Herodiade (dance), 345, 346
Hersey, John (1914–1993), 353
Heyward, DuBose (1885–1940), 137, *186*
Hindemith, Paul (1895–1963), 346, 378

Hine, Lewis W. (1874–1940), 83–86, 84–86, 153, *155*, 245, 250
Hiroshima (Hersey), 353
Historical American Buildings Survey, 238
Historical Records Survey, 238
History of the Standard Oil Company, The (Tarbell), 82
"Hitchy Coo" (Muir), 78
Hoffman, Malvina (1885–1966), 29, 31
Hoffmann, Josef (1870–1956), 46
Hofmann, Hans (1880–1966), 320, 351
Hogue, Alexandre (1898–1994), 226, 227, 228
Holiday, Billie (1915–1959), 354
Hollywood, 77, 133–34, 243, 260, 270, 305, 314
Holty, Carl (1900–1973), 284, 285, 320, 321
Holtzman, Harry (1912–1987), 284, 289
Homage to the Square (Albers), 379
Home of the Brave (Croner), 356
Home Town (Anderson), 254
Hood, Raymond (1881–1934), 138
House and Garden, 36
House and Street (Davis), *173*
House Beautiful, 37
House Committee on Un-American Activities, 241, 353
*Houseman, John (1902–1988), 276, 277
House of a Thousand Windows (Coburn), 48
House of Connelly (Green), 277
House of Mirth, The (Wharton), 24
Howard, Charles (1899–1978), 289, 291
Howard, Joseph, 78
Howard, Sidney (1891–1939), 161, 276, 277
Howe, George (1886–1955), 140, *140*
Howells, John Mead (1868–1959), 138
How Green Was My Valley (film), 305
How the Other Half Lives (Riis), 82, 83, 250
Hoyningen-Huene, George (1900–1968), 194
Hudson Bay Fur Company (Marsh), 258
Hughes, Langston (1902–1967), 188, 191, *191*, 192, 194–95, 275, *275*
Hughes, Rupert (1872–1956), 105
Hull House Settlement, 82
Hulme, T. E. (1883–1917), 108
Humphrey, Doris (1895–1958), 230, *230*, 307, 308
Humpty Dumpty (Noguchi), 347
Hunt, Richard Morris (1828–1895), 12
Huntington, Henry E. (1850–1927), 32
Hurston, Zora Neale (1901?–1960), 188, 189, 237, 275
Hurwitz, Leo (1909–1991), 243–44

Ibsen, Henrik (1828–1906), 276
Ice Glare (Burchfield), 179
Iceman Cometh, The (O'Neill), 358
Ici, c'est ici Stieglitz/Foi et Amour (Here, This is Stieglitz/Faith and Love) (Picabia), 120, *120*
Iconograph, 351
"I'll Be Seeing You" (Fain), 354
I'll Take My Stand, 230
illustration, 13, 166–67
 Americana in, 32–33
 in Jazz Age, 133
 literature and, 32
 of New Left magazines, 278
 realism and, 32–33

"I'll Walk Alone" (Styne), 354
Imagists, 108
"I'm Gonna Wash That Man Out of My Hair" (Rodgers and Hammerstein), 310
"I'm Just Wild about Harry" (Sissle and Blake), 186
Immaculate School, 145
Immigrant, The (film), 76
Immigrant Girl: Ellis Island (Stella), 70
immigrants, 72–77, 78
Impressionism, 40, 61, 64, 106
 American, 25
Improvisation No. 27 (Kandinsky), 106
In Advance of the Broken Arm (Duchamp), 123
Incense of a New Church (Demuth), 153, *154*
In Dahomey (Williams and Walker), 74, *74*
Index of American Design, 238, 240–41, *241*
Indian Boyhood (Eastman), 72
Indian Space painters, 351
Indian Suite for Orchestra (MacDowell), 105
industrial design, 297–301
Industrial Workers of the World (IWW), 82, 90
Industry (Bruce), 217
Industry (Dickinson), *146*
Industry (Rittase), *155*
Industry (Sheeler), *156*
Infants of the Spring (Thurman), 189
Informer, The (film), 305
Ingres, Jean-Auguste-Dominique (1780–1867), 106
In My Studio (Evelyn Nesbit) (Eickemeyer), *19*
In Our Time (Hemingway), 353
Institute of Design, 295
Interior (Sheeler), *146*
"International Exhibition of Modern Art" (1913), see Armory Show
"International Exhibition of Modern Art" (1926), 288
"International Exhibition of Pictorial Photography" (1910), 46, 95
International Ladies' Garment Workers' Union, 277
International Style, 142, 377
"International Theme" plot, 24
Intimate Gallery, 196, 200–203
Into the Valley (Hersey), 353
Iowa: A Guide to the Hawkeye State (FWP), 237
Isadora Duncan (Genthe), 35
It Can't Happen Here (Lewis), 276, *276*
It Happened One Night (film), 272–73, *272*, 305
Ives, Charles (1874–1954), 378
Iwerks, Ub (1901–1971), 273

Jackson, Arthur, *186*
James, Harry (1916–1983), 354
James, Henry (1843–1916), 16, 22–25
Jane Lawrence (Teske), 326
Jar (Tiffany), *31*
jazz, 166–67, 184–86, 309, 371, 372
"Jazz" Punch Bowl (Schreckengost), *141*
Jazz Singer, The (film), 135, *135*
Jefferson, Blind Lemon (1897–1929), 184
Jefferson, Thomas (1743–1826), 196
Jewel-Bearing Tree of Amity (Davies), 27
Jewell, Edward Alden (1888–1947), 322, 344–46
jitterbug (dance), 261
Joe's Auto Graveyard, Pennsylvania (Evans), 253

John Brown Going to His Hanging (Pippin), 230, 233
John Brown's Body (Benét), 230
John Reed Club, 278, 279, 281
Johnson, Billy, 74
Johnson, Charles (1893–1956), 187
Johnson, James Weldon (1871–1938), 72, 187, 188–89, 191, 193, 194
Johnson Wax Administration Building (Wright), 302–3, 302
Johnston, Francis Benjamin (1864–1952), 16
Jolson, Al (1886–1950), 135
Jones, Joe (1909–1963), 226, 229
Jones, Robert Edmond (1887–1954), 90, 109
Jonson, Raymond (1891–1982), 296
Joplin, Scott (1868–1917), 78
Jordan, Louis (1908–1975), 371
Josephine and Mercie (Tarbell), 23
Josephine Baker (Hoyningen-Huene), 194
Josephson, Matthew (1899–1978), 159, 167
J. Pierpont Morgan (Steichen), 17
Jubilee Songs of the United States of America (Burleigh), 105
Judgment Day (Farrell), 274
Julien Levy Gallery, 322–23, 362
Julius Caesar (Shakespeare), 276
Jung, Carl (1874–1961), 329–31, 364
Jungle, The (Sinclair), 82, 82
J. Von Sternberg House (Neutra), 303

Kahn, Albert (1869–1942), 153, 303
Kahn, Gus (1886–1941), 168
Kamrowski, Gerome (1914–), 332, 334
Kandinsky, Wassily (1886–1944), 96, 102, 106, 292, 334
Kansas Cornfield (Curry), 227
Karloff, Boris (1887–1969), 273
Käsebier, Gertrude (1852–1934), 16, 19, 33, 40, 41, 46–47
Kaufman, George S. (1889–1961), 161, 166
Kawa, Florence Kathryn (1912–), 240
Kazan, Elia (1909–), 243
Keaton, Buster (1859–1966), 134, 159
Keats, John (1795–1821), 189
Keeler, Ruby (1909–1993), 270
Keiley, Joseph (1869–1914), 33, 40
Kelly, Gene (1912–1996), 270, 271
Kelly, George (1887–1974), 161
Kelpe, Paul (1902–1985), 286
Kent, Rockwell (1882–1971), 65, 92, 102, 103, 104, 197, 199
Kenton, Louis N., 16, 20
Kepes, Gyorgy (1906–), 295, 298
Kern, Jerome (1885–1945), 74, 74, 168, 186
Key Largo (Anderson), 277
Kiesler, Frederick (1890–1965), 337
Kin-der-Kids Abroad, The (Feininger), 72, 75
Kingsley, Sidney (1906–1995), 277
Kirchner, Ernst Ludwig (1880–1938), 106
Kirkland, Jack, 277
Kirstein, Lincoln (1907–1996), 307–8
Kiss, The (Rodin), 31
Kiss Me Kate (Porter), 310
kitsch, 319–20
Klee, Paul (1879–1940), 125
Kline, Franz (1910–1962), 359, 364, 367–68, 368
"K. McB." (Williams), 169
Knave of Hearts, The (Parrish), 32
Knickerbocker Holiday (Weill), 277
Kootz, Samuel (1898–) 320, 329, 362
Krasner, Lee (1908–1984), 364, 365

Kroll, Leon (1884–1974), 59, 60
Kuhn, Walt (1877–1949), 92, 104-6
Ku Klux Klan, 166
Kuniyoshi, Yasuo (1889–1953), 256, 256, 359, 360
Kupka, František (1871–1957), 113

Lachaise, Gaston (1882–1935), 137, 196, 203–4, 205
Ladies' Home Journal, 13, 37
Lady From Shanghai, The (film), 362
Lam, Wifredo (1902–1982), 335
Lamb, Joseph (1887–1960), 78
Landing in Italy (Rodger), 316
Land of the Free, USA (MacLeish), 254, 255
Lang, Fritz (1890–1976), 362
Lange, Dorothea (1895–1965), 215, 242, 245–50, 248, 249, 251, 337
Laning, Edward (1906–1981), 256
Larsen, Nella (1891–1964), 188, 189
Lassaw, Ibram (1913–), 284, 289, 291
Last Evening of the Year (Bluemner), 199
Late Afternoon, New York (Hassam), 56
Laughing Boy Rolling (Wheeler), 351
Laughing Child (Henri), 80
Laughlin, Clarence John (1905–1985), 326, 327
Laurent, Robert (1890–1970), 100, 101
"Lava" glass, 30
Lavenson, Alma (1897–1989), 163, 165
Lawrence, Jacob (1917–), 231, 234, 315, 318, 339, 343
Lawson, Ernest (1873–1939), 55, 55, 104
Lawson, John Howard (1895–1977), 277
Lay My Burden Down: A Folk History of Slavery (FWP), 238
L. C. Smith Typewriter (Sheeler), 178
League of Nations, 166
"Leaves From the Mental Portfolio of an Eurasian" (Sui Sin Far), 72
Ledbetter, Huddie (Leadbelly) (1888–1949), 239
Lee, Russell (1903–1986), 245, 252
Léger, Fernand (1881–1955), 167–69, 289, 322
Leipzig, Arthur (1918–), 262
L'Enfant, Pierre Charles (1754–1825), 218
Lerner, Irving (1909–1976), 243
LeRoy, Mervyn (1900–1987), 271
Lescaze, William (1896–1969), 140, 140, 303
Leslie's Weekly, 32
Letter to the World (dance), 345
Let Us Now Praise Famous Men (Evans and Agee), 250, 251, 252
Leutze, Emanuel (1816–1868), 224
Levitt, Helen (1913–), 337, 338
Levittown, New York, 376–77, 377
Levy, Julien (1906–1981), 335
Lewenthal, Reeves (1910–1987), 226
Lewis, Sinclair (1885–1951), 82, 82, 177, 179, 276, 276
Lewis, Wyndham (1882–1957), 127
Leyda, Jay (1910–), 243
Leyendecker, J. C. (1874–1951), 132, 136
Liberator, 278
Library of Congress, 238, 239, 311
Libsohn, Sol (1914–), 262
Lie, Jonas (1880–1940), 58, 60
Life, 132, 236, 250, 254, 310, 315, 354
Lift Every Voice and Sing (Savage), 193, 194
Lighthouse Hill (Hopper), 180
Light of the World (Blume), 323, 323
Lights of New York (film), 135
Lilac Time (film), 134
Lily and the Sparrows (Evergood), 324

Lincoln, Abraham (1809–1865), 230
Lindbergh, Charles (1902–1974), 261
Lindsay, Vachel (1879–1931), 108
lindy hop (dance), 261
Lindy Hop, The (Covarrubias), 191
Lippmann, Walter (1889–1974), 107-8, 159
Lippold, Richard (1915–), 377, 379
Lipton, Seymour (1903–1986), 370, 371
Lissitzky, El (1890–1941), 150
literature:
 Agrarian movement and, 230
 American Guide Series and, 237
 collectivism vs. individualism in, 275
 of Depression era, 274–75
 documentary, 236, 237, 254
 film and, 76
 "hard-boiled," 275
 of Harlem Renaissance, 188–91
 illustration and, 32
 in Jazz Age, 166–67
 "little magazines" and, 108
 modernism in, 24–25
 naturalism in, 60–61, 64–65, 274–75
 Old World culture in, 22–25
 race and ethnicity in, 72
 small-town themes in, 177
 Social Realism and, 275, 277–78
 women and, 13–24
 World War II and, 353, 354
 see also magazines; poetry
Little Ball with Counterweight (Calder), 386
Little Caesar (film), 272
Little Galleries of the Photo-Secession, 46, 46, 93–94
Little Johnny Jones (Cohan), 79
"little magazines," 108
Little Review, 108
Little Round Mirror (Steichen), 42
Little Theatre movement, 109
Little Women (Alcott), 33
Liver Is the Cock's Comb, The (Gorky), 333, 334
Living Newspapers, 236–38, 275–77
Living Room Armchair From the Robert R. Blacker House (Greene and Greene), 37
Llewellyn, Richard (1906–1983), 305
Lloyd, Harold (1894–1971), 134, 159
Locke, Alain (1886–1954), 187–90, 195
Loewy, Raymond (1893–1986), 172, 297, 300, 301
Logan, Joshua (1908–1988), 310
Loie Fuller, 35
Lollipop (Steiner), 175
Lomax, Alan (1915–), 239
Lomax, John A. (1867–1948), 238, 239
London, Jack (1876–1916), 93
Lonedale Operator, The (film), 76
Lonely Villa, The (film), 76
Long Day's Journey Into Night (O'Neill), 358
Look, 236
Look Homeward, Angel (Wolfe), 177
Loos, Adolf (1870–1933), 138
Loos, Anita (1893–1981), 166, 167
Lord Is My Shepherd, The (Benton), 221
Lorentz, Pare (1905–1995), 239, 242, 243, 244, 244
Loring, Eugene (1911–1982), 239, 306, 307, 307, 308
Lost Generation, 189
Louisville Flood, The (Bourke-White), 248
Lowell, Amy (1874–1905), 108
Loy, Mina (1882–1966), 108
Lozowick, Louis (1892–1973), 147–50, 149, 153, 156, 159, 167, 278

Luce, Henry (1898–1967), 310
Lucky Strike (Davis), 172
Lugosi, Bela (1882–1956), 272, 273
Luks, George (1867–1922), 57, 60, 62, 64–65, 69, 70, 79, 79, 91
Lunch Hour (Bishop), 257
Lunchtime, New York (Hine), 85
Lundeberg, Helen (1908–), 323, 325
Lure, The (Scarborough), 86, 89
Lynes, George Platt (1907–1955), 307

Maas, Willard (1911–1971), 363
McAlmon, Robert (1896–1956), 166
MacArthur, Douglas (1880–1964), 215
Macbeth (Shakespeare), 276
Macbeth Galleries, 91–92, 93
McBride, Henry (1856–1937), 166
McCausland, Elizabeth (1899–1966), 251, 251
McClure's, 82, 132
McCormack, John (1884–1945), 104
McCoy, Horace (1897–1955), 275
McCullers, Carson (1917–1967), 354
Macdonald-Wright, Stanton (1890–1973), 93, 113, 114, 129
MacDowell, Edward (1861–1908), 105
"Machine Age Exposition" (1927), 156, 172
Machine Ornament (Lozowick), 159
McHugh, Jimmy (1894–1964), 186
McKay, Claude (1891–1948), 188, 189, 191
McKim, Mead and White, 12–13, 12, 51
McKinley, William (1843–1901), 11
MacLeish, Archibald (1892–1982), 167, 254, 255, 311
MacRae, Elmer L. (1875–1955), 104
McSorley's Bar (Sloan), 61
Maddow, Ben (1909–1992), 244
Madison Gallery, 104
Madison Square Garden (White), 13
Maeterlinck, Maurice (1863–1949), 96
Magafan, Ethel (1916–1993), 220
magazines, 13
 "little," 108
 of New Left, 275, 277–78
 photo-, 236, 250–51
 Surrealism's influence on, 335–36
Maggie: A Girl of the Streets (Crane), 60
Magician's Game (Hare), 347
Magnolia Blossom (Cunningham), 202
Magnus Fossum Copying the 1770 Coverlet "Boston Town Pattern," 241
Magnussen, Erik (1884–1961), 141, 141, 142
Mailer, Norman (1923–), 353
Main Street (Lewis), 177, 179
Maison de l'Art Nouveau, La, 30
Making Human Junk (Hine), 86
Male and Female (Pollock), 352
Maltese Falcon, The (Hammett), 274
Man (Ray), 120
Manet, Édouard (1832–1883), 64
Manhatta (Strand and Sheeler), 54, 147
Man in Derby Hat (Strand), 88
Man Nobody Knows, The (Barton), 153
Manship, Paul (1885–1966), 29, 31, 137, 144
Man Who Married a Dumb Wife, The (France), 109
Man With a Camera, The (film), 243
"Maple Leaf Rag" (Joplin), 78
"March of Time, The," 236
Marcus Garvey in a Regalia (VanDerZee), 190
Marin, John (1870–1953), 93, 94, 97, 98, 115, 115, 116, 147, 196, 197, 203, 208, 209
Marines Under Fire, Saipan (Smith), 316

Marmon Crankshaft (Outerbridge), *160*

Marsh, Mae (1895–1968), 77

Marsh, Reginald (1898–1954), 256, 281

Martin, Ira (1896–1960), 153

Martin, Mary (1913–1990), 310

Martinelli, Giovanni (1885–1969), 135

Marx, Chico (1886–1961), 272

Marx, Groucho (1890–1977), 272

Marx, Harpo (1888–1964), 272

Marx, Zeppo (1901–1979), 272

Mason, Alice Trumbull (1904–1971), 286

Mason, Charlotte (?–1945), 194, 195

Masque of Pandora (Mathews), 27

Masses, The, 79, 90, 129, 278

Massine, Léonide (1896–1979), 308

Masson, André (1896–1987), 322, 327, 335

Masters, Edgar Lee (1868–1950), 108, 177

Matches and Matchboxes (Steichen), 177

Mathews, Arthur (1860–1945), 27, 31

Matisse, Henri (1869–1954), 31, 93, 94, 95, 97, 107, 113

Matta, Robert (1911–), 327, 331

Matter, Herbert (1907–1984), 335

Maurer, Alfred (1868–1932), 93, 94, 96, 97

Maybeck, Bernard (1862–1957), 39, *39*

May Night (Metcalf), 26

Mechanical Abstraction (Schamberg), 122

Medals for Dishonor (Smith), 311, 368

Melford, George (1877–1961), 133

Men at War (Hemingway), 353

Men at Work (Hine), 250

Men in Bataan (Hersey), 353

Menken, Marie (1910–1970), 363

Men of the Docks (Bellows), 59

Mercury Theater, 276, 277

Merman, Ethel (1908–1984), 310

Meshes of the Afternoon (film), 362, *363*

Metcalf, Willard (1858–1925), 25, 26

method acting, 372

Metronome, 260

Metropolis of Tomorrow, The (Storrs), 150

Metropolitan Museum of Art, 314

Metropolitan Opera, New York, 105

Michelangelo Buonarroti (1475–1564), 182

Michener, James (1907–1997), 310

Midnight Ride of Paul Revere (Wood), 230, *231*

Mielziner, Jo (1901–1976), 277, 358, 359

Mies van der Rohe, Ludwig (1886–1969), 39, 376, *376*, 377

Migrant Mother, Nipomo, California (Lange), 245, *248*

Migration of the Negro, The (Lawrence), 231, *234*

Mili, Gjon (1904–1984), 371

Miller, Arthur (1915–), 354, 358–59, *358*

Miller, Glenn (1904–1944), 354

Miller, Kenneth Hayes (1876–1952), 256, *256*

Miner at Ludlow, Colorado (Sloan), 90

Minneapolis (Lozowick), *149*

Miró, Joan (1893–1983), 288, 289, 322, 334, 352

Mission, The (Soyer), 265

Mitchell, Margaret (1900–1949), 275

Mitchum, Robert (1917–1997), 362

Model, Lisette (1901–1983), 342, 343–44

Modern American Painters (Kootz), 320

Modern Gallery, 107, 120, 127

Modern Quarterly, 275

Modern Times (film), 159

Modotti, Tina (1896–1942), 204

Moholy-Nagy, László (1895–1946), 284, 295–97, *297*, 298

Mondrian, Piet (1872–1944), 288, 289, 322

Monk, Thelonious (1919–1983), 372

monologue, as literary form, 166

Monroe, Harriet (1860–1936), 108

Moon, Karl (1878–1948), 33, *34*

Moon and Clouds (Strand), 201

Moon for the Misbegotten, A (O'Neill), 358

Moonlight (Weir), 26

Moonrise—Mamaroneck, New York (Steichen), 43

Moore, Colleen (1900–1988), 133

Moore, Marianne (1887–1972), 108

More Stately Mansions (O'Neill), 358

Morgan, J. P. (1837–1913), 13, 32, 33

Morgan Library (White), *13*

Morning Sky (O'Keeffe), 102

Morris, George L. K. (1905–1975), 285, *285*

Morris, William (1834–1896), 45

Moses, Robert (1888–1981), 218

Mother (film), 243

Mother and Daughter at Penn Station (Orkin), *341*

Motherwell, Robert (1915–1991), 331, 332, 334, 336, 363, 364, 367

Motion Picture Association of America, 133

Motion Picture Producers and Directors of America, 133

Motley, Archibald, Jr. (1891–1981), 195, *195*, 259

Mowbray, H. Siddons (1858–1928), 12

Mr. and Mrs. Chester Dale Dine Out (du Bois), *182*

Mr. Deeds Goes to Town (film), 305, *305*

Mrs. Charles Hunter (Sargent), *15*

Mrs. Ellis Hoffman (Eickemeyer), *20*

Mrs. Fiske Warren (Gretchen Osgood) and Her Daughter Rachel (Sargent), *15*

Mrs. Larz Anderson (Isabel Weld Perkins) (Beaux), *17*

Muir, Lewis F. (1838–1914), 78–79

Mules and Men (Hurston), 189

Mullican, Lee (1919–1998), *350*, 351

Mumford, Lewis (1895–1990), 159, 278, 280

Muni, Paul (1895–1967), 272

Municipal Art Gallery, 284

Mural, Williamsburg Housing Project (Swinden), *293*

Mural, Williamsburg Housing Project, New York (Bolotowsky), 289

Murnau, F. W. (1888–1931), 135

Murphy, Gerald (1888–1964), 167–69, *169*, *170*

"Museum" Dinner Service (Zeisel), 292

Museum of Living Art, 289

Museum of Modern Art, 284, 288, 314, 322, 323, 349, 352

music:

 African Americans and, 74, 77, 105, 186–87, 354, 371

 atonal, 378

 bebop, 371, 372

 blues, 186–87, 309

 classical, 104–5

 country-western, 354

 European emigré composers and, 377–78

 exoticism in, 104–5

 folk, 105, 184, 239, 307

 genres of, 354

 of Harlem Renaissance, 190–91

 jazz, *see* jazz

 modernism and, 377–78

 Native American, 105

 nonrepresentational art and, 102–4

 onset of World War II and, 305–6

popular, 77–79, 168, 186–87, 306, 354

 of postwar era, 353–54, 371

 ragtime, 74, 77, 78–79, 131, 309

 recording industry and, 187

 rhythm and blues, 354, 371

 sheet, 168

 swing, 260, 353–54

 Tin Pan Alley and, 78, 79, 168, 186–87

musical theater, 73–74, 79, 309–10, 345

Music—Pink and Blue II (O'Keeffe), *197*, 198

Musgrove Brothers, Westmoreland County, Pennsylvania (Shahn), *238*

Musketeers of Pig Alley, The (film), 75

Mydans, Carl (1907–), 251

My Egypt (Demuth), 154, *157*

Myers, Jerome (1867–1940), 104

Myth Makers, 346, 348

Nabis, 106

Nadelman, Elie (1882–1946), 97–100, *100*, 137

Nagel, Isabel, 203

Naked and the Dead, The (Mailer), 353

Naked City (Weegee), 336

Nanook of the North (film), 133–34, *134*

National Academy of Design, 91, 92, 93, 104

National Arts Club, 45, 46

National Association for the Advancement of Colored People (NAACP), 82, 187, 281

National Association of Manufacturers, 245

National Child Labor Committee, 86

National Life Insurance Company Office Building, Chicago (Wright), *138*

National Urban League, 82

National Youth Administration (NYA), 242

Native Land (film), 244, 275

Native Son (Wright), 275

Nativity (Stella), 197

Naturalism, 60–61, 64–65, 82, 274–75

Naughty Marietta (Herbert), 104

Nautical Composition (Morris), 285

Navajo War Dance No. 2, for Piano (Farwell), 105

Naval Aviation Photographic Unit, 315

Negri, Pola (1894–1987), 135

Negro Church (Evans), 253

"Negro History Week," 189

Neil, Nude (Weston), 207

Nei-san-Koburi/The Dream (Cunningham), 44

Neoclassical art, 11–12, 61

Neo-Dada, 125

Neo-Impressionism, 106

Neoplasticism, 289–92

Neutra, Richard (1892–1970), 294, 303, *303*, 376

New Bauhaus, 295

New Classicists, 145

New Criticism, 378

"Newer Super Realism" exhibition (1931), 322

New Left, 275, 277–78

Newman, Barnett (1905–1970), 241, 346, 353, 373, 374–76, *374*

New Masses, 275, 277–78, *278*

Newmeyer, Fred C. (1888–1937), 134

New Negro, The: An Interpretation (Locke), *189*, 190, 191

New Negro movement, 187–89

New Republic, 108

New Romanticism, 331

New School for Social Research, 138, *138*, *140*, 221–23, *222*, 331

Newsies at Skeeter Branch, St. Louis (Hine), *85*

New Society of Younger American Artists, 93, 94

newsreels, 236, 314

New Theatre League, 277

New York, City Hall Park (Strand), *54*

New York (Levitt), *338*

New York (Lozowick), *149*

New York (Ray), 123, *123*

New York (Walkowitz), *117*

New York Camera Club, 45

New York City (Faurer), *355*

New York City Ballet, 308, 378

New York Dada (movement), 125–26

New York Dada (magazine), 123, 125

New Yorker, 166, 353

New York Herald, 65

New York Movie (Hopper), 266

"New York's Art War and the Eight 'Rebels,'" *91*

New York School of Art, 65, 92

New York Times, 141, 322, 329, 344–46, 348

New York World, 65

New York World's Fair (1939), 297, 300, *300*, 303, *303*, 323

Niblo, Fred (1874–1948), 133

Nicholas, Fayard (1914–), 270

Nicholas, Harold (1919–), 270

Nichols, Anne (c. 1891–1966), 161

nickelodeons, 76

Nigger Heaven (Van Vechten), 194

Nighthawks (Hopper), 340

Night Journey (dance), 345, 346–48

Night Shadow (La Sonnambula) (ballet), 346

Nighttime, Enigma and Nostalgia (Gorky), 291

Nike (Berman), *331*

1919 (Dos Passos), 275

Noah's Ark (film), 134

Noguchi, Isamu (1904–1988), 292, *292*, 345, 346, 347, 348, 363

Nordfeldt, B.J.O. (1878–1955), 58, 60–61

Norris, Frank (1870–1902), 60, 61, 93

North American Indian, The (Curtis), 33

Noskowiak, Sonya (1900–1975), 163, *165*

Novarro, Ramon (1899–1968), 133

Noyes, John Humphrey (1811–1886), 274

Nude (18N) (Weston), 207

Nude Descending a Staircase, No. 2 (Duchamp), 106–7, *107*, 116

Nude No. 6 (Sheeler), 206

Nude on Azotea (Weston), 207

Number 2—1950 (Tomlin), 365

Number 10 (Rothko), 372

#16, 9/1938 (Biederman), *293*

Number 27 (Pollock), 364

Nutting, Wallace (1861–1941), 241

N. W. Ayer and Son, 177

Nye, Gerald, 310

Nykino, 243, 244

N.Y. 7 (Siskind), *357*

O'Connor, Donald (1925–), 270

Octopus, The (Coburn), 49

Octopus, The (Norris), 60

Odets, Clifford (1906–1963), 277, *277*

Odol (Davis), *173*

O'Donnell, May, 345

Office of Facts and Figures (OFF), 311

Office of War Information (OWI), 311, 314, 343

O'Flaherty, Liam (1896–1984), 305

Of Mice and Men (Steinbeck), 275, 277

Ohr, George E. (1857–1918), 30, 31, *31*

O'Keeffe, Georgia (1887–1986), 100–102, *101*, *102*, 150, 152, 196, 197–203, *198*, *199*, *200*, 204, 209–12, *211*, *212*
Oklahoma! (Rodgers and Hammerstein), 306, 308, *309*
Old Glory Goes Up on Mount Suribachi, Iwo Jima (Rosenthal), *317*
Old Ring Box, The (Hale), *23*
Oliver, Joe (King) (1885–1938), 184
Oneida Community, 274
O'Neill, Eugene (1888–1953), 109, 159, 161, *161*, 194, 277, 358
One of the Winter's Leading Social Functions (Granville-Smith), *18*
One-Third of a Nation (Arent), 276, *276*
Onslow-Ford, Gordon (1912–), 327, 331–34, 351
On the Road Toward Los Angeles (Lange), *248*
On the Town (Bernstein, Comden and Green), 309
On Your Toes (film), 270
Open-Air School in Hogan's Alley, The (Luks), *64*
Opera Box (du Bois), *182*
Oppenheim, James (1882–1932), 129
Opportunity, 187, 191, *192*
Orange and Gold (Holty), *321*
Orchard, The (White), *41*
Organization (Gorky), 290
Orientalism, 33
"Oriental": Synchromy in Blue-Green (Macdonald-Wright), *114*
Origin of the Cakewalk, The; or Clorindy (Dunbar and Cook), 74
Orkin, Ruth (1921–1985), 262, *341*, *343*
Orozco, José Clemente (1883–1949), 280, 352
Orpheus Descending (Williams), 358
Orphism, 113
Ossorio, Alfonso (1916–1990), 332
Others, 108
Oud, J. J. P. (1890–1963), 39
Our Daily Bread (film), 230
Our Dancing Daughters (film), *133*
Our Town (Wilder), 254, 275, 277
Outerbridge, Paul, Jr. (1869–1958), 159, *160*, 172, 176
Out of the Past (film), *362*, 362
Overseas Highway (Crawford), 161, *163*
Ozenfant, Amédée (1886–1966), 145, 322

Paalen, Wolfgang (1907–1959), 327, 331, 334, 351
Pach, Walter (1883–1958), 94, 105–6, 107
Paddy Flannigan (Bellows), *66*
Page, Ruth (1900–1991), 307
Pageant of the Paterson Silk Strike, The, 90
Paine, John Knowles (1839–1906), 105
Painting, New York, January 1936 (Biederman), 387
Painting, Number 5 (Hartley), *111*
Painting (Bruce), *175*
Painting (Gorky), *290*
Palais de Cristal, Le (Symphony in C) (ballet), 346
Palomar Ballroom, 260
Pan, Hermes (1905?–1990), 271
Parade Watchers (Siskind), *263*
Paramount Pictures, 77, 311
Parker, Charlie (1920–1955), 371, 372
Parker, Dorothy (1893–1967), 166
Parks, Gordon (1912–), 245, *247*
Parrish, Maxfield (1870–1966), 32, *32*, 33
Partisan Review, 275, 285, 319, 322

Passion of Sacco and Vanzetti, The (Shahn), 281, *282*, *283*
Pastoral (Kent), *103*
Path of Gold (Lie), 58
Patton, Charley (1891–1934), 184
Pavilion (Lipton), 370
Paxton, William M. (1869–1941), 24, *25*
Pedestrians (Hagemeyer), *144*
Pelton, Agnes (1881–1961), *198*
Pennell, Joseph (1857–1926), 56, 60
Pennsylvania Academy of the Fine Arts, 64, 97, 127
Pennsylvania Railroad Station, 50
Pennsylvania Station Excavation (Bellows), 57
"People, Yes, The" (Sandburg), 254
People's Art Guild, 107
Pepper No. 35 (Weston), 202
Pereira, Irene Rice (1902–1971), 284
Perisphere (1939 New York World's Fair), *300*, 300
Perkins, Maxwell (1884–1947), 166
Perspective for Auditorium, New School for Social Research (Urban), *140*
Perspective for Casas Grandes, Homer Laughlin Project (Gill), 38
Peters, Paul, 279
Peterson, Sidney (1912–), 362
Philadelphia Press, 64, 170
Phillips, Coles (1880–1927), 132, 136
Phillips, Duncan (1886–1966), 107
Philosophy (Ferriss), *151*
photography, 96, 236
 abstract nature painting and, 196–200
 advertising and, 172–77
 commercialism in, 46–47
 Cubism and, 126–29
 documentary, 242–55, 354
 fashion, 16, 177
 of Harlem Renaissance, 190–91
 illustrated magazines and, 218
 immigrant influx and, 72–77
 myth of the frontier and, 33–37
 photo-essay and, 250–51
 photograms and, 295
 Photo-Secession and, 45–47, 200
 pictorial, 40, 45, 46–47, 47–55, 95, 127, 172, 177
 in postwar era, 337–44, 354–59
 Precisionism and, 147, 150, 154, 159, 161–65
 reform movement and, 83–89, *83*, 84–86, 87, 88
 Surrealism and, 327
 symbolic portraiture and, 40
 urban life as subject of, 48–55, 48–50, 51, 52–54, 55, 71, 72, 150
 World War II and, 315–19
Photo League, 262
Photo Notes, 262
Picabia, Francis (1879–1953), 108, 115, 120, *120*, 121, 125, 150, 196
Picasso, Pablo (1881–1973), 93, 95–96, 109, 289, 311, 331, 352, 363
Pickford, Mary (1893–1979), 76, 133, *135*
Picnic Grounds, The (Sloan), *63*
pictographs, 349
Pictorialism, 16, 51, 127
Picture Shop Window (Sloan), *63*
Pie in the Sky (film), 243
Pictorial Photographers of America, 47
Pins and Needles (ILGWU), 277
Pinza, Ezio (1892–1957), 310
Pippa Passes (Browning), 76
Pippin, Horace (1888–1946), 230, *233*
Piston, Walter (1894–1976), 378
Pittsburgh (Driggs), *158*

Pittsburgh (Lozowick), *149*
Pittsburgh Survey (1908), 83
Pitt Street, Three Children on Swings (Rosenblum), *263*
Plant and Animal Analogies (Lundeberg), *325*
Plant Forms (Dove), *110*
Plastique, 285
Playwrights' Company, 277
Pleasure Dome of Kubla Khan, The (Griffes), 105
Plow That Broke the Plains, The (film), 239, 242, 244, *244*
Plumes (Kuhn), 259
Pocahontas (ballet), 306, 308
Poems of Childhood (Fields), 32
poetry:
 of Harlem Renaissance, 189–90
 in Jazz Age, 166, 169
 modernism and, 108, 169
 Surrealism and, 322
Poetry, 108
Polk, Prentice Hall (1898–1984), 191
Pollitzer, Anita (1894–1975), 100
Pollock, Jackson (1912–1956), 331, 334, 346, 351–52, *352*, 363–65, *364*, 374
Pop Art, 172
Poppies (Demuth), *98*
Popular Front, 278–80
Porch Shadows (Strand), *128*
Porgy and Bess (Gershwin and Heyward), 186
Porter, Cole (1893–1964), 167, 168, 310
Portrait—Miss N. (Evelyn Nesbit) (Käsebier), *19*
Portrait of a Lady, The (James), 24
Portrait of an Old Man (Stella), 70
Portrait of Langston Hughes (Reiss), *191*
Possibilities, 363
Post-Impressionism, 31, 106
Potted Psalm, The (film), 362
pottery, 36–37, *37*
Pound, Ezra (1885–1972), 24, 108, 127, 167, 169
Poussette-Dart, Richard (1916–1992), 346, 350, 351
Powell, Eleanor (1910–1982), 270
Power (film), 277
Powerhouse Mechanic (Hine), *155*
Preacher's Family, South Carolina, The (Ulmann), 247
Precisionism, 145–65
Prelude to Afternoon Meal, Carroll County, Georgia (Delano), 306
Preminger, Otto (1905–1986), 362
Prendergast, Maurice (1859–1924), 29, 31, 63, 91
Prestidigitator (Stella), *127*
Prière, La (Ray), *206*
Primitive Art Gallery, 351
Primordial Figures (Lippold), 379
Prognostic (Dawson), *103*
Progressivism, 82
Prohibition, 133, 186, 194, 260, 272
Prologue to Glory (Conkle), 230
Prometheus (Orozco), 352
Prophet, Nancy Elizabeth (1890–1960), 191, *192*
Proposal for Kauffman Store Renovation (Urban), *140*
Proposed Civic Center Plaza (Burnham and Bennett), 50
Proposed Scheme for the Philadelphia Parkway (Cret), *51*
Provincetown (Hartley), *112*
Provincetown Players, 109
Pryor, Arthur (1870–1942), 78
Public Enemy, The (film), 272, *272*
Public Works of Art Project (PWAP), 216, 220, 231, 279

Pudovkin, Vsevolod (1893–1953), 243
Pulitzer Prize, 277, 310, 359
Purist art, 167–69
Putzel, Howard (1898–1945), 331
Puvis de Chavannes, Pierre (1824–1898), 106
Puzzled America (Anderson), 254
Pyle, Howard (1853–1911), 32, *33*, *33*

Quarantania (Bourgeois), *347*
Queen Mary, The (Bruehl), *299*
Queen of Hearts (de Kooning), *328*
Quencher, The (Night Fires) (Stella), *154*
Quest of the Silver Fleece, The (Du Bois), 72
Quinn, John (1870–1924), 107

Rachmaninoff, Sergei (1873–1943), 104
radio, 134, 166, 168, 187, 236, 260
ragtime, 74, 77, 78–79, 131, 309
Railroad Sunset (Hopper), *180*
Rainey, Ma (1886–1939), 184
Rancheros de Taos Church, New Mexico (Strand), 210
Ransom, John Crowe (1888–1974), 230
Rape of Persephone (Gottlieb), 346
Ray, Man (1890–1976), 120, 123–25, *123*, 124, 126, 196, 204, 206, 295, 323, 324, 335, *335*, *336*, 348
Razor (Murphy), 169
Reading from Left to Right (Soyer), *264*
readymades, 115, *116*, 123, *123*
Rebay, Hilla (1890–1967), 292, 295
Reconstruction (Shahn), 359
Redes/The Waves (film), 243
Redfield, Edward Willis (1869–1965), 55, 56, 60
Red Gladioli (Demuth), 204
Redon, Odilon (1840–1916), 105, 106
Red Rock Canyon (Weston), *213*
Red Star (Ossorio), 332
Reed, John (1887–1920), 90
Regionalism, 221–26, 275, 280, 310–11, 319, 320, 344
Region of Brooklyn Bridge Fantasy (Marin), 209
Reid, Robert (1862–1929), 25
Reinhardt, Ad (1913–1967), 287, 322, 377
Reiss, Winold (1887–1953), 189, 191, *191*
Relational Painting (Glarner), 379
Remington, Frederic (1861–1909), 33
Renoir, Pierre Auguste (1841–1919), 79
Resettlement Administration (RA), 242, 245, 250, 252, 262
Resor House, Jackson Hole, Wyoming (Mies van der Rohe), *376*
Resurrection (Covert), *125*
Revolving Door Series, III, IV, VII–X (Ray), *124*
Revue (Shinn), *80*
Rexroth, Kenneth (1905–1982), 237
Rhapsody (Held), *131*
rhythm and blues, 354, 371
"Rhythm Club" (radio show), 187
Rice, Elmer (1892–1967), 159, 161, 277
Richardson, Henry Hobson (1838–1886), 50
Ridgefield Gazook, 123
Rieti, Vittorio (1898–1984), 346
Riggs, Lynn (1899–1954), 309
Riis, Jacob (1849–1914), 82, 83, *83*, 250
Rinehart, Frank (1861–1928), 33
Rising Wave, Indian Point, Georgetown, Maine (Hartley), 208, *208*
Rita de Acosta Lydig (de Meyer), *20*
Rittase, William (1894–1968), 153, *155*, 297, 299
Ritual in Transfigured Time (film), 362
River, The (film), 239, 242, 243, *244*
Rivera, Diego (1886–1957), 231, 275

River Rouge Plant (Sheeler), *156*
RKO Studios, 270, 271
"Road to Victory" (1942), 314
Robbins, David, 262
Robbins, Jerome (1918–1998), 307, 309
Robeson, Paul (1898–1976), 305–6
Robie House (Wright), *38*
Robin Hood (film), 133
Robin Hood Cove, Georgetown, Maine (Hartley), 208, *208*
Robinson, Bill (1878–1949), 270
Robinson, Boardman (1876–1952), 90
Robinson, Earl (?–1991), 305–6
Robinson, Edward G. (1893–1973), 272
Robinson, Theodore (1852–1896), 55
rock and roll, 371
Rockefeller, John D. (1839–1937), 82, 240
Rockwell, Norman (1894–1978), 311, *312*
Rockwood Pottery, 36, 37
Rodchenko, Aleksandr (1891–1956), 150
Rodeo (ballet), 239, 306, *307*
Rodger, George (1908–), *316*, 317, 319
Rodgers, Richard (1902–1979), 168, 186, 306, 309, 309, 310
Rodin, Auguste (1840–1917), 31, 93, 96, 191
Rogers, Ginger (1911–1995), 270, *270*, 271, 273
Rogers, J. A. (1863–1965), 187
Rogers, Will (1879–1935), *73*, 74, *75*
Rohde, Gilbert (1894–1944), 292, 301
Romeo and Juliet (Shakespeare), 76
Rongwrong, 123
Room in a Tenement Flat (Beals), *87*
Roosevelt, Franklin D. (1882–1945), 179, 215, 216, 236, 237, 241, 243, 310, 311
Roosevelt, Theodore (1858–1919), 11, 22, 65
Rose, A (Anshutz), *21*
Rosenberg, Harold (1906–1978), 372
Rosenblum, Walter (1919–), 262, *316*
Rosenfeld, Paul (1890–1946), 196, 203
Rosenthal, Joe (1911–), 315, *317*
Rosskam, Edwin (1903–), 251, *251*
Roszak, Theodore (1907–1981), 295, 297, 297, 298, 320, 370, 372
Rothko, Mark (1903–1970), 346, 348–49, *348*, 363, 372, 373–74
 Avery's influence on, 349
 style of, 348–49, 373–74
Rothstein, Arthur (1915–1985), 245, 246, 251, 269
Roundhouse at High Bridge (Luks), *57*
Rousseau, Henri (1844–1910), *94*, 95
Roxy Theatre, 133, 134, *135*
Rubinstein, Artur (1887–1982), 104
Runnin' Wild (Sissle and Blake), 131
R.U.R. (Čapek), 159
Russell, Charles Marion (1864–1926), 33
Russell, Morgan (1886–1953), 93, 113, *113*
Russo-Japanese War, 11, 75
Ruth St. Denis (Sunami), *35*
Ryan, Peggy (1924–), 270

Saarinen, Eliel (1873–1950), 138, *138*, 142, *142*
Sacco, Nicola (1891–1927), 277, 281
Safety Last (film), 134
Sage, Kay (1898–1963), 348
Sailors and Floosies (Cadmus), *216*
St. Denis, Ruth (1879–1968), 33, 35
Saint-Gaudens, Augustus (1848–1907), 12, *14*, 31
St. Louis and Kansas City (Benton), 223
Salome (Henri), *67*
Sand Barge (Dove), *210*
Sandburg, Carl (1878–1967), 254, 314
Sand Dune (Weston), *213*

Sandrich, Mark (1900–1945), 270
Sargent, John Singer (1856–1925), 13, *15*, 24
Saroyan, William (1908–1981), 277
Sartre, Jean-Paul (1905–1980), 366
Satin and Fur (VanDerZee), *190*
Saturday Evening Post, 32, 311, *311*
Savage, Augusta (1892–1962), 191–94, *193*, *194*, *195*
Savoy Ballroom, 260
Say, Is This the U.S.A. (Caldwell and Bourke-White), *306*
Scarborough, George (1875–1951), 89
Scarface (film), 272
Scarlett, Rolph (1889–1984), 292, 295
Schamberg, Morton Livingston (1881–1918), 93, 108, 121, *122*, 126, 153
Schapiro, Meyer (1904–1996), 280
Scheibler, Frederick G. (1872–1958), 39
Schindler, Rudolph M. (1887–1953), *294*, 294
Schoedsack, Ernest B. (1893–1979), 134
Schoenberg, Arnold (1874–1951), 378
Schomburg, Arthur A. (1874–1938), 189
Schreckengost, Victor (1906–), 141, *141*
Schwitters, Kurt (1887–1948), 125
Science and Society, 275
Scopes, John (1900–1970), 131
Scottsboro Limited (Hughes), 275, *275*
Scribners, 82
Sculpture in Steel (Lassaw), 291
Sea Change (Pelton), *198*
Seastrom, Victor (1879–1960), 135
Seeger, Charles (1886–1979), 239
Seeger, Pete (1919–), 239
Seeger, Ruth Crawford, 239, 378
Seeley, George (1880–1955), 40, *40*, *43*, *46*
Seligmann, Kurt (1900–1962), 327, 331
Semi-Lunar (Hammond), *300*
Sessions, Roger (1896–1985), 378
"Seven Americans" (1925), 196, 203
Seven Arts, 108, 129
Shahn, Ben (1898–1969), *238*, 245, *245*, 246, 281, *282*, *283*, 311, *311*, 337, 359
Shakers, The (Humphrey), 230, *230*, 308
Shakespeare, William (1564–1616), 76, 310
"Shame of the Cities, The" (Steffens), 82
Share Cropper (Bywaters), 228
Shaw, George Bernard (1856–1950), 276, 277
Shawn, Ted (1891–1972), 33, 35
Sheeler, Charles (1883–1965), *54*, 108, 126, 127, *128*, 145–47, *146*, *148*, 153–56, *156*, 158, 159, 161, 162, 177, *178*, 200, 204, 206, *218*
Sheik, The (film), 133, 134
Shelton with Sunspots, The (O'Keeffe), 152
Sherman, Augustus (c. 1865–1925), *71*
Sherwood, Robert (1896–1955), 161, 230, 277
"Shimmee Baby" (Jackson), *186*
Shinn, Everett (1876–1953), 64–65, *64*, *68*, 79, *80*, 91, 104
Shop in Chinatown, San Francisco (Genthe), *71*
Shopper (Miller), *256*
Shoppers, The (Glackens), *80*
Shore, Dinah (1917–1994), 353
Shore, Henrietta (1880–1963), 200, *201*, 203
Shorty, the Bowery Cherub, Welcomed the New Year, Sammy's on the Bowery (Weegee), *342*
Showboat (Kern and Hammerstein), 74, *74*, 168

Shuffle Along (Sissle and Blake), 186, *186*, 187
Simmons, Edward (1852–1931), 25
Simon, Henry, 314
Simonson, Lee (1888–1967), 109, *161*
Sinatra, Frank (1915–1998), 353, 354
Sinclair, Upton (1878–1968), 82, *82*
Siodmak, Robert (1900–1973), 362
Siqueiros, David Alfaro (1896–1974), 280
Siskind, Aaron (1903–1991), 262, 357, 359
Sissle, Noble (1889–1975), 131, 186, *186*
Sister Carrie (Dreiser), 60, *60*, 61
Situation in Yellow, A (Bluemner), 210
Sketch for Mural, Central Nurses Home, Welfare Island (Brown), 289
Sklar, George (1908–), 279
Skyscraper (Cook), 147
Skyscraper Bookcases (Frankl), *141*
skyscrapers, 47, 138–42
 European modernism and, 138–39
 first, 140
 furniture and, 141–42
 machine imagery and, 142
 technological advances and, 140
 see also architecture
Slaughterhouse Five (Vonnegut), 353
Sloan, John (1871–1951), *61*, 62, *63*, 64, 65, 67, 68, 79, *81*, 90, *90*, 91–92, 94, 104, 170, 179
Slobodkina, Esphyr (1914–), 284
Smart Set, 108
Smith, Bessie (1898?–1937), *184*, 186, 187
Smith, David (1906–1965), 311, *313*, 368, 369
Smith, Jessie Willcox (1863–1935), 33
Smith, Kate (1909–1986), 305
Smith, Mamie (1883–1946), 186
Smith, Pamela Coleman (1878–1925), *28*, *31*, 96
Smith, W. Eugene (1918–1978), 315, *316*
Snowden, Shorty, 261
Snow White and the Seven Dwarfs (film), 273
Social History of the State of Missouri, A (Benton), 223
Socialism, 82
Social Realism, 275–83
Social Reform Movement, 79–90
Société Anonyme, 125, 196, 288
Society of Amateur Photographers of New York, 45
Society of American Artists, 25, 91
Soil, The, 108
Sokoloff, Nikolai (1886–1965), 236
"Some Enchanted Evening" (Rodgers and Hammerstein), 310
Somervell, Brehon (1892–1955), 241
Sommer, Frederick (1905–1999), 326, 327, 336
Sonata For Piano (Griffes), 105
S-1 Locomotive, Designed for the Pennsylvania Railroad Company (Loewy), 301
Sonnambula, La (Night Shadow) (ballet), 346
Son of Frankenstein (film), 273
Soriano, Raphael, 376
Southern Holiday (Sternberg), 280
Sousa, John Philip (1854–1932), 78
South Pacific (Rodgers and Hammerstein), 310
Souvenir of Lidice (Spruance), 314
Soyer, Isaac (1907–1981), 261
Soyer, Moses (1899–1975), 261
Soyer, Raphael (1899–1987), 261
Space (Bauer), 296
Space Construction (Greene), 319
Space Modulator (Moholy-Nagy), 297

Space Motive, a New Jersey Valley (Bluemner), *115*
Spanish-American War, 11
Spencer, Herbert (1820–1903), 22
Spencer, Miles (1893–1952), 147, *148*
Spielers, The (Luks), 70
Spiral Rhythm (Weber), 117
spiritualism, 292–95
Spoon River Anthology (Masters), 108, 177
Spring Morning in Washington Square, A (Glackens), 64
Spring Sale at Bendel's (Stettheimer), *143*
Spruance, Benton (1904–1967), 314, *314*
Squibb Gallery, 285
Stackpole, Peter (1913–1997), 219
Stafford, Jo, 354
Stag at Sharkey's (Bellows), 92
Stagecoach (film), 305
Stage Scene (Shinn), 68
Standard Oil Tanks (Lavenson), *165*
Standing Lincoln (French), *14*
Standing Woman (Lachaise), 203, *205*
Stanwyck, Barbara (1907–1990), 362
Star Cage (Smith), 368, *369*
Staten Island Ferry, New York City (Faurer), *356*
State Park (French), *339*
Steamboat Willie (film), 273, *273*
Steam Turbine (Sheeler), 162
Steel Foundry, Coatesville, Pennsylvania (Crawford), 162
Steerage, The (Stieglitz), 51–55, *53*, 75
Steffens, Lincoln (1866–1936), 82, 90
Steichen, Edward (1879–1973), 16, *17*, 40, 42, 43, 46, 47, 49, 93, 136, 172–77, *177*, *178*, 200, 219, 314
Stein, Gertrude (1874–1946), 93, 97
Stein, Leo (1872–1947), 93, 97
Stein, Michael (1865–1938), 93, 97
Stein, Sarah (1870–1953), 93, 97
Steinbeck, John (1902–1968), 254, *255*, 275, 277, 305
Steiner, Ralph (1899–1986), 156, 159, 160, 172, 174, *175*, *176*, 243, *243*, 244
Stella, Joseph (1877–1946), 70, 83, 108, 116–18, *118*, 120, 125, 127, 147, 154, *197*, *197*
Sternberg, Harry (1904–), 280, *281*
Sterne, Maurice (1878–1957), 90, 93
Stettheimer, Florine (1871–1944), 137, *143*
Stevedore (Barthé), 236
Stevedore (Peters and Sklar), 279
Stevens, Wallace (1879–1955), 108, 169
Stevenson Memorial (Thayer), 12
Stickley, Gustav (1858–1942), 36, *36*, 37
Stieglitz, Alfred (1864–1946), 45–55, *52*, *53*, 75, 93–97, 100–102, 109, 126–27, 129, 150, 161, 177, 196–97, *196*, 200–203, *203*, 204, 209, 262, 359
Still, Clyfford (1904–1980), 346, 363, 373, *373*, 374
Still Life with Compote (Carles), *98*
stock market crash of 1929, 215, 274, 276
Stokowski, Leopold (1882–1977), 104
Stordahl, Axel, 354
Storrs, John (1885–1956), 93, 150, *150*
Story of the Grail and the Passing of Arthur, The (Pyle), 32, *33*
Storyville Portrait (Bellocq), 89
Stowe, David, 260
Strand, Paul (1890–1976), 46, 54, 86, *88*, 95, 126–27, *128*, 147, 156–59, *160*, 177, 196, 204, 210, 212, 243, 244, 275
Strand, Rebecca Salsbury (1891–1968), 200, *201*, 204

Strange Interlude (O'Neill), 161, *161*
Strasberg, Lee (1901–1982), 275, 277
Stravinsky, Igor (1882–1971), 346, 378
"Streamliner" *Meat Slicer, Model No. 410* (Arens and Brookhardt), *301*
streamline style, 300–303
Street, The (Bellows), 92
Streetcar Named Desire, A (Williams), 358)
Street Drawing (Levitt), *338*
Street Elevation for New School for Social Research (Urban), *138*
Street of Gamblers, The (Genthe), *71*
Strock, George (1911–1977), 315, *316*
Struss, Karl (1886–1981), 47, 49, 51, 52, 136
Stryker, Roy (1893–1975), 242, 244, 245, 250, 252, 343
Stuck, Franz von (1863–1928), 96
Study for Maximum Mass Permitted by the 1916 New York Zoning Law, Stage 4 (Ferriss), *151*
Study in Choreography for Camera, A (film), 362
Styne, Jule, (1905–1994), 354
Subjects of the Artist, 363
Subway Portrait (Evans), *341*
Sui Sin Far (Edith Eaton), 72
Sullivan Street Abstraction (Ault), *153*
Summer and Smoke (Williams), 358
Summer Days (O'Keeffe), 208–12, *211*
Summer Residence for Charles H. Wolfe, Avalon, Catalina Island, California (Schindler), *294*
"Summertime" (Gershwin), *186*
Summertime (Hopper), *340*
Sunami, Soichi (1885–1971), 35, 230
Sunday, Women Drying Their Hair (Sloan), *81*
Sunrise (film), 135
Sunset, Maine Coast (Marin), *97*
Sunset and Landscape Window (Tiffany Studios), *30*
Sunset Boulevard (film), 354
Suprematism, 141
Surrealism, 126, 271, 292, 322–37, 344, 352, 364
Survey, The, 86
Survey Graphic, 189, 190
Swanson, Gloria (1897–1983), 136, *136*
Swinden, Albert (1901–1961), 284, 289, 293
swing music, 260, 353–54
Swing Time (film), 273
Symbolism, 22, 24–25, 37, 40, 96
Symphonie Concertante (ballet), 346
Symphony in C (Le Palais de Cristal) (ballet), 346
Symphony No. 4 "Folksong" (Harris), 239
Synchromists, 113
Synchromy in Blue Violet (Russell), *113*
synesthesia, 31
Synthetic Cubism, 109, 113, 170, 285, 289, 319
Syrian Bull, The (Rothko), 346
Systems and Dialectics of Art (Graham), 320

Table for A. Conger Goodyear (Noguchi), 292
"Tale of Possessors Self-Dispossessed, A" (O'Neill), 358
Tall-case Clock (Stickley), *36*
Taming of the Shrew (Shakespeare), 310
Tamiris, Helen (1905–1966), 307
Tango (Nadelman), *100*
Tanguy, Yves (1900–1955), 322, 327, 330, 331, 337

Tanner, Henry Ossawa (1859–1937), 26, 31
Tanning, Dorothea (1901–), 335
Tarbell, Edmund (1862–1938), 23, 25
Tarbell, Ida (1857–1944), 82
Tate, Allen (1899–1979), 230
Taylor, Frederick (1856–1915), 159
Taylor, Henry Fitch (1853–1925), 104
Taylor, Paul Schuster (1895–), 242, 245, 249, 251
Taylor, Prentiss (1907–), 275
Taylor, Sam, 134
Tchelitchew, Pavel (1898–1957), 327, 330, 331
Teague, Walter Dorwin (1883–1960), 297, 300
Tea Leaves (Paxton), 24
Tea Service (Tiffany and Company), *15*
technology, 127
 Art Deco and, 136–37
 Colonial Revival and, 240
 Dada and, 120
 decorative arts and, 136, 295–300
 film and, 133, 134
 geometric abstraction and, 295–97
 immigration and, 115–16
 Precisionism and, 150–61
 skyscrapers and, 140
 Surrealism and, 323–27
Teco ware, 36–37
Ted Shawn, 35
Ted Shawn (Weston), *44*
Telephone, Model No. 302 (Dreyfuss), *301*
Telephone, Study of Form (Outerbridge), *176*
Telephone (Schamberg), *122*
"Telephone Call, The" (Parker), 166
Temple, Shirley (1928–), 243, 270
Ten, The, 25
Ten Commandments, The (Dove), 109
Tender is the Night (Fitzgerald), 167
Tennessee Valley Authority (TVA), 218
Terror in Brooklyn (Guglielmi), 324
Teske, Edmund (1911–1996), 326, 327
Texas Regionalists, 226
Textile (Kawa), 240
Thatcher, Molly Day, 243
Thayer, Abbott Handerson (1849–1921), 11, *12*
Thayer, Webster, 281
theater, 159, 161
 African Americans and, 274, 276
 Armory Show and, 109
 Broadway, 277, 309–10
 burlesque, 73
 of Depression era, 276–77
 Little Theater movement and, 109
 method acting and, 372
 motion pictures and, 76–77
 musical, 306, 309–10
 in postwar era, 358–59
 "proletarian," 276–77
 reform movement and, 86
 Social Realism and, 275–77
 vaudeville and, 73–77
 World War II and, 309–10
Theatre Collective, 277
Theatre Guild, 109, 277, 309
Theatre of Action, 277
Their Eyes Were Watching God (Hurston), 275
theosophy, 295
"There Is Nothing Like a Dame" (Rodgers and Hammerstein), 310
These Are Our Lives (FWP), 238
Thief of Bagdad, The (film), 133

Thinker, The: Portrait of Louis N. Kenton (Eakins), 20
Third Suite for Reduced Orchestra (Stravinsky), 346
Third Theme (Diller), 378
"Thirteen Ways of Looking at a Blackbird" (Stevens), 169
This Is America (poster series), 311, *312*
This Is Nazi Brutality (Shahn), 311
This Is the Army (Berlin), 309
"This Land is Your Land" (Guthrie), 306
Thistles near the Sun (Mullican), 350
Thomas Edison Company, 75, 77
Thomson, Virgil (1896–1989), 137, 239, 244, 306, 308
Thorn Blossom (Roszak), 370, *372*
Three Figures Shot (Motherwell), 332
Three Members of the Northeasterners Inc. Strolling on Seventh Avenue in Harlem, 190, 391, 123
Throckmorton, Cleon (1897–1965), 109
Thurman, Wallace (1902–1934), 188, 189
Tiffany, Louis Comfort (1848–1933), 30–31, *31*
Tiffany and Company, 13, 15, 16, 30, *30*
Tiger's Eye, 363
Time, 223, 224
Tin Pan Alley, 78, 79, 168, 186–87, 354
TNT, 123
Tobacco Road (Caldwell), 251, 277
Tobey, Mark (1890–1976), 364, 367, *367*
Tolstoy, Leo (1828–1910), 276
Tombstones (Lawrence), *339*
Tomlin, Bradley Walker (1899–1953), 364, *365*
"Tonight's Dreamer" (radio show), 134
Tony Award, 310
"Too Darn Hot" (Porter), 310
Toomer, Jean (1894–1967), 188, 189, 191, 194
Top Hat (film), 270, 273
Top Hats (Weber and Heilbroner Advertisement) (Bruehl), *176*
Tornado, The (Curry), 229
Torn Movie Poster, Truro, Massachusetts (Evans), 253
Toscanini, Arturo (1867–1957), 104
To the Lynching! (Cadmus), 282
Touch of the Poet, A (O'Neill), 358
Toulouse-Lautrec, Henri (1864–1901), 30, 94
Toussaint L'Ouverture, François (1743–1803), *11*
Tower Construction Begins, San Francisco—Bay Bridge (Stackpole), 219
Tradition (Cox), *11*
Traffic in Souls (film), 86
Tragic America (Dreiser), 254
Tragic Prelude, The (Curry), 230, 233
Transcendental Painting Group, 295
Trapper, The (Kent), *199*
Treasury of American Folklore, A (FWP), 238
Treasury Relief Art Project (TRAP), 220, 236
Trees and Barns: Bermuda (Demuth), *146*
Triangle Shirtwaist Factory, 82
Trip to Coontown, A (Cole and Johnson), 74
Trotsky, Leon (1879–1940), 319, 322
Trylon (1939 New York World's Fair), 300
Tubman, Harriet (1820?–1913), 231
Tucker, Sophie (1888–1966), 73, 74, 75
Tugwell, Rexford (1891–1979), 242
Tunnel Builders (Coburn), *48*

Twachtman, John H. (1853–1902), 25, 26, 91
Twain, Mark (1835–1910), 60
12 Million Black Voices (Wright and Rosskam), 251, *251*
Twenty Cent Movie (Marsh), 258
Two Alternatives for Philadelphia Savings Fund Society (Howe and Lescaze), *140*
Two Callas (Cunningham), 202
Two Cells at Play (Bisttram), 296
291 (gallery), 93–97, 100, 105, 109, 115, 126, 196
291 (magazine), 120, 123
 aesthetic program of, 96–97
Two Shells (Weston), 201
Two Sisters (Les Mamelles d'outre-mer) (Graham), 329
Two Worlds (Shore), 201
Two Young Couples in a Juke Joint, near Moorehaven, Florida (Wolcott), 247
Typewriter Keys (Steiner), *176*
Tyrolean Mountains (Marin), *98*
Tzara, Tristan (1896–1963), 125

Ulmann, Doris (1884–1934), 245, 247, 252, 254
Ulmer, Edgar G., 362
Unemployed at the New York Municipal Lodging House During the Depression, 215
Union Pacific (ballet), 308
United American Artists, 279
Universal Field (Tobey), 367
Universal Negro Improvement Association (UNIA), 190
Universal Studios, 77, 273
University Club, New York (McKim, Mead and White), 12, *13*
Untitled, from Harlem Document (Siskind), *263*
Untitled, from One-Third of A Nation (Eagle and Robbins), 269
Untitled, New York (Levitt), *338*
Untitled (de Kooning), 289
Untitled (Kelpe), *286*
Untitled (Moholy-Nagy), *298*
Untitled (Reinhardt), 287
Untitled (Rittase), *299*
Untitled (Roszak), *298*
Untitled (Still), *373*
Untitled (Destitute Mother with Twins) (Beals), *87*
Untitled (Girl in a Cotton Mill) (Hine), 85
Untitled (Nude Youth with Laurel Wreath Against Rocks, Standing in Stream) (Day), *44*
Untitled (Photograph for Direction Magazine) (Kepes), *298*
Untitled (Pipes and Metal Braces) (Noskowiak), *165*
Untitled (Power Switches) (Steiner), *160*
Untitled (Two Sisters) (Cunningham), *206*
Up From Slavery (Washington), 72
Urban, Joseph (1872–1933), 73–74, 137, 138–40, *138*, *140*
Urban League, 187
urban realism, 61–72, 66, 67, 147–50
U.S.A. (Dos Passos), 275
U.S. One: From Maine to Florida (FWP), 237

Vachon, John (1914–1975), 245
Valentin Gallery, 352
Valentino, Rudolph (1895–1926), 133, 134, 136
Valley Town (film), 244

Van Alen, William (1883–1954), *137*
Van Briggle Pottery, 36, 37
VanDerZee, James (1886–1983), *189*, 190–91, *190*
Van Doran, Harold, 300
Van Dyke, Willard (1906–1986), 163, *164*, 243, 244
Vanity Fair, 166, 177, 200
Van Vechten, Carl (1880–1964), 90, 137, 186, 194
Vanzetti, Bartolomeo (1888–1927), 277, 281
Varèse, Edgard (1883–1965), 108
Vase (Ashbury), *37*
Vase (Tiffany and Company), *16*
vaudeville, 73–77, 131
Velázquez, Diego (1599–1660), 64
Vertov, Dziga (1896–1954), 243
Very Good Eddie (Kern and Bolton), 74
Vestal, David (1924–), 354, 355
Victory (Saint-Gaudens), *14*
"Victory" newsreels, 314
Vidor, King (1894–1982), 134, 230
View, 335, 336, 363
View of Boulder Dam (Sheeler), *218*
View of Manhattan from the Terminal Yards (Kroll), *59*
Vigil (Gottlieb), 349
Vinson, Eddie (Cleanhead), 371
Visual Variations on Noguchi (film), 363
Vitagraph, 76
Vitaphone, 135
VJ Day, Times Square, New York City (Eisenstaedt), *317*
Vogel, Amos, 363
Vogel, Marcia, 363
Vogue, 177
Vonnegut, Kurt, Jr. (1922–), 353
Vonnoh, Bessie Potter (1872–1955), 25, *25*
Von Weigand, Charmion (1899–1983), 284
Vorticism, 127
Vortograph (Coburn), *129*
Vortographs, 127–29, *129*
Voyager's Return (Gottlieb), 349
Vroman, Adam Clark (1856–1916), 33
Vuillard, Édouard (1868–1940), 31
VVV, 335–36, 348

Waiting (Bishop), 266
Waiting for Lefty (Odets), 277, *277*
"Waiting for the Robert E. Lee" (Muir), 78–79
Walker, Aida Overton, 74
Walker, George (1873–1911), 74, *74*, 131
Walker, T-Bone, 371
Walkowitz, Abraham (1880–1965), 93, 116, *117*
Wall, The (Hersey), 353
Wallace Nutting Chain of Colonial Homes, 241
Waller, Fats (1904–1943), 186, 187

Wall Street, New York (Strand), *54*
Walsh, Raoul (1887–1980), 133
"Waltz, The" (Parker), 166
Warner Brothers, 77, 134, 270, 272, 273
War of the Worlds, The (Wells), 236, 276
Warren, Robert Penn (1905–1989), 230
War Series: Victory (Lawrence), *318*
Washington, Booker T. (1856–1915), 72
Washington Crossing the Delaware (Leutze), 224
Washington Square Gallery, 107
Washington Square Players, 109, 277
Waste Land, The (Eliot), 189
Watch (Murphy), *169, 170*
Watching the Dancers (Curtis), *34*
Watch Your Step (Berlin), 77, 78, 79
Watson-Schütze, Eva (1867–1935), 40
Wave, The (Smith), *28*
Wave on Rock (Marin), 209
Weary Blues, The (Hughes), 192
Weber, Kem (1889–1963), 301, *301*
Weber, Max (1881–1961), 93, 95, 100, 102, 105, 116, *117*, 147, 172
Wedding Day (VanDerZee), 189
Weegee (Arthur Fellig) (1899–1968), 336, *336*, 342, 343–44, *343*
Weill, Kurt (1900–1950), 277
Weiner, Dan (1919–1959), 262, 354
Weir, J. Alden (1852–1919), 25, 26, 91, 104–5
Welles, Orson (1915–1985), 236, 275, 276, 361, *361*, 362
Wellman, William A. (1896–1975), 134, 272
Wells, H. G. (1866–1946), 236, 276
Weston, Brett (1911–1993), 163, *213*
Weston, Edward (1886–1958), 40, 44, 161–63, *164*, 200, 201, 202, 204, 207, 212, 213
Wharton, Edith (1862–1937), 16, 22–24, 25
What the United States Government Says About Child Labor in Tenements, 86
Wheeler, Steve (1912–1991), 351, *351*
Whelan, Rebecca, 16
Whistler, James McNeill (1834–1903), 25, 40, 60
White, Clarence H. (1871–1925), 16, 40, 41, 42, 46–47, 100
White, Clifford, 216
White, Stanford (1853–1906), 12–13, *13*
White Angel Breadline, San Francisco, The (Lange), 249
White Calico Flower, The (O'Keeffe), 200
"White Christmas" (Berlin), 354
White Horses—Sea Movement off Deer Isle, Maine (Marin), 209
Whiteman, Paul (1892–1968), 185
White Slave (Eberle), 89
White Squares (Krasner), *365*

Whiting, Richard, *168*
Whitman, Walt (1819–1892), 118
Whitney, James, 363
Whitney, John, 363
Whitney Museum of American Art, 223, 284, 327
Whoopie (film), 270
Why Not Use the "L"? (Marsh), 264
Why We Fight (film), 314
Wiggins, Guy (1883–1962), 55
Wildenstein Gallery, 344
Wilder, Billy (1906–), 361–62
Wilder, Thornton (1897–1975), 254, 275, 276, 277
Williams, Bert (1874–1922), 74, *74*, 75, 131
Williams, Tennessee (1911–1983), 354, 358
Williams, William Carlos (1883–1963), 108, 166, 167, 169–70
Wilson, Edmund (1895–1972), 254
Wilson, Woodrow (1856–1924), 82, 129
Wind, The (film), 135
Wind Figure (Wright), *117*
Winesburg, Ohio (Anderson), 177
Wings (film), 134, 135
Wings of the Dove, The (James), 24
Winter (Wyeth), 359, *360*
Winter Harmony (Twachtman), *26*
Winter on the River (Lawson), 55, *55*
Winterset (Anderson), 277
Wire Wheel (Strand), *128*
Wish, The (Tanguy), 330
Within the Room (Pousette-Dart), 350
Wizard of Oz, The (Baum), 75
Wodehouse, P. G. (1881–1975), 74
Wolcott, Marion Post (1910–1990), 245, 247
Wolfe, Thomas (1900–1938), 177
Woman (Ray), *120, 121*
Women from Guadeloupe, West Indies, at Ellis Island (Sherman), *71*
Women Gossiping in a Drugstore over Cokes, Washington, D.C. (Bubley), *341*
Wood, Grant (1892–1942), 220, 221, 224, 224, 225, 231
 war propaganda and, 310–11, *311*
Wood, Roger, *307*
Woodruff, Hale (1900–1980), 231, 235
Woodson, Carter G., 189
Woollcott, Alexander (1887–1943), 166
Woolworth Building, New York (Gilbert), *50*
Woolworth Building Lobby, New York (Gilbert), *50*
Workers Film and Photo League, 262
Workers Laboratory Theatre, 276–77
Works Progress Administration (WPA), 220, 236, 237, 239–41, 262, 279, 295
World Magazine, 91

World's Fairs:
 Chicago (1933), 297, 303
 New York (1939), 297, 300, *300*, 303, *303*
World Today, The (film), 243
World War I, 115, 131, 141, 145, 166, 322
 American art world and, 129
 Dada and, 121, 125
World War II, 223, 261, 271, 337, 353
 onset of, 305
 photography and, 315–19
 theater and, 309–10
Wrestlers, The (Luks), *79*
Wright, Alice Morgan (1881–1975), 116, *117*
Wright, Frank Lloyd (1869–1959), 38–39, *38*, 138, *138*, 294, *294*, 302–3, *302*
Wright, Richard (1908–1960), 237, 252, *251*, 275
Wright, Russell, 301
Wright, Willard Huntington (1888–1939), 129
Wyeth, Andrew (1917–), 359, *360*
Wyeth, N. C. (1882–1945), 32, *32*, 33

Year of Peril, The (Benton), 311, *313*
Years of Dust (Shahn), 246
Yeats, William Butler (1865–1939), 108
"Yes Sir! That's My Baby" (Kahn and Donaldson), *168*
You Can't Take It With You (film), 305
You Have Seen Their Faces (Bourke-White and Caldwell), 250–52
Young, Art, 90, 92
Young Cherry Trees Secured Against Hares (Breton), 336
"Younger American Painters, The" (1910), 94, 95
Young Lonigan: A Boyhood on the Chicago Street (Farrell), 274
Young Manhood of Studs Lonigan, The (Farrell), 274
Young Mr. Lincoln (film), 230, 305
Young Russian Jewess (Hine), 84
Young Worshipper of the Truth (Hartley), 230, 232

Zakheim, Bernard, 216
Zeisel, Eva (1906–), 292
"*Zephyr*" Digital Clock, Model No. 304–P40 (Weber), *301*
Ziegfeld, Florenz (1869–1932), 73–74
Zola, Émile (1840–1902), 60
Zorach, Marguerite Thompson (1887–1968), 102, *102*, 137
Zorach, William (1889–1966), 100, 102, 102, 137, 305, *306*
Zorina, Vera (1917–), 270
Zukor, Adolph (1873–1976), 76

This exhibition and publication were organized by Barbara Haskell, Curator, with the assistance of Tamara Bloomberg, Research Assistant; Susan Cooke, Associate Curator; Elizabeth Dunbar, Curatorial/Research Assistant; Anne Wehr, Research Assistant.

This publication was produced by the Publications Department at the Whitney Museum and W. W. Norton & Company.

Whitney Museum of American Art
Mary E. DelMonico, Head, Publications; *Production*: Nerissa Dominguez Vales, Production Manager; Jennifer Cox, Publications Assistant; *Editorial*: Sheila Schwartz, Editor; Dale Tucker, Copy Editor; Susan Richmond, Production Coordinator/Editorial Assistant; *Design*: Deborah Littlejohn, Senior Graphic Designer; Roy Brooks, Graphic Designer; *Rights and Reproductions*: Anita Duquette, Manager, Rights and Reproductions; Jennifer Belt, Photographs and Permissions Coordinator; Jane Austrian, Volunteer; Judy Greene, Volunteer. Additional editorial assistance: Jennifer Bernstein.

W. W. Norton & Company
James L. Mairs, Vice President; Nancy Palmquist, Managing Editor; Otto Sonntag, Copy Editor; Nina Gielen, Editorial Assistant

Catalog design: Katy Homans
Printing: Balding + Mansell
Printed and bound in Great Britain